Cultural Heritage and Mass Atrocities

Cultural Heritage and Mass Atrocities

EDITED BY JAMES CUNO AND THOMAS G. WEISS

Getty Publications, Los Angeles

This publication was created using Quire™, a multiformat publishing tool from Getty.

The free online edition of this open-access publication is available at getty.edu/publications/cultural-heritage-mass-atrocities/ and includes zoomable illustrations. Also available are free PDF, EPUB, and Kindle/MOBI downloads of the book.

 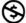
First edition, 2022
github.com/thegetty/cultural-heritage-mass-atrocities/

Published by Getty Publications, Los Angeles
1200 Getty Center Drive, Suite 500
Los Angeles, California 90049-1682
getty.edu/publications

Laura diZerega, *Project Editor*
Greg Albers, *Digital Manager*
Martin J. Burke, *Manuscript Editor*
Erin Cecele Dunigan and Dina Murokh, *Assistant Digital Editors*
Victoria Gallina, *Production*
Jeffrey Cohen, *Cover Designer*
Nancy Rivera, *Image and Rights Acquisition*
Eriksen Translations, *Translation Services*

Getty Publications gratefully acknowledges Morgan Conger, senior project manager in the Office of the President and CEO, J. Paul Getty Trust, for her work on this publication.

Distributed in the United States and Canada by the University of Chicago Press

Distributed outside the United States and Canada by Yale University Press, London

Library of Congress Cataloging-in-Publication Data
Names: Cuno, James B., editor. | Weiss, Thomas G. (Thomas George), 1946– editor.
Title: Cultural heritage and mass atrocities / edited by James Cuno and Thomas G. Weiss.
Description: First edition. | Los Angeles : Getty Publications, 2022. | Includes bibliographical references. | Summary: "This volume focuses on protecting vulnerable, immovable cultural heritage using the framework provided by the Responsibility to Protect (R2P), a 2005 United Nations resolution permitting international intervention against war crimes. Essays offer critical insights from the political, humanitarian, and cultural heritage sectors, emphasizing strategies for safeguarding both culture and people" — Provided by publisher.
Identifiers: LCCN 2022013796 (print) | LCCN 2022013797 (ebook) | ISBN 9781606068076 (paperback) | ISBN 9781606068106 | ISBN 9781606068090 (mobi) | ISBN 9781606068083 (epub)
Subjects: LCSH: Cultural property—Protection. | Cultural property—Protection—International cooperation. | Cultural property—Destruction and pillage. | Historic preservation—International cooperation. | War and civilization.
Classification: LCC CC135 .C823 2022 (print) | LCC CC135 (ebook) | DDC 363.6/9–dc23/eng/20220528
LC record available at https://lccn.loc.gov/2022013796
LC ebook record available at https://lccn.loc.gov/2022013797

Front cover: Two views of the courtyard and ablutions fountains, Great Umayyad Mosque of Aleppo, Aleppo, Syria, with structural damage, as of December 2013, documented in the bottom photograph. Images: Joel Carillet / Getty Images (top); Molhem Barakat / Reuters / Alamy Stock Photo (bottom)

Contents

Foreword

Irina Bokova

In 2012, Agence France-Presse interviewed a man said to be part of the extremist group controlling Timbuktu, Mali. "There is no world heritage," he claimed. "It doesn't exist."[1] This mindset encapsulates the challenge posed by the rise of a violent extremism that has perpetrated deliberate destruction of cultural heritage as well as mass atrocities against people on cultural and religious grounds, in not just Mali but also Afghanistan, Syria, Iraq, and elsewhere.

When I became director-general of the United Nations Educational, Scientific and Cultural Organization (UNESCO) in 2009, I could not have imagined that the organization, which is the standard-setter and guardian of world heritage and culture, would have to confront a brutal and systematic destruction of emblematic cultural sites in the Middle East that shocked the world. Most significantly, this destruction was not collateral damage. On the contrary, it was used as a tactic of war to intimidate populations, attack their identities, destroy their link with the past, eliminate the existence of diversity, and disseminate hatred—what I labeled "cultural cleansing" after my second visit to Iraq in May 2015.[2] While not a legal term, it has since been used by myself and others in public statements, speeches, and interviews to raise awareness about the systematic and deliberate nature of attacks on cultural heritage and diversity perpetrated by extremist groups in Iraq and Syria.

The challenges have been enormous. How should we apply the international legal and institutional regime in such a way that it enables us to keep pace with new forms of "modern" warfare by nonstate actors? How can one make a convincing case that heritage is not only about bricks and stones but also about humanity in all its diversity, and that it gains meaning when it is inscribed in the lives of people and local communities? How can one convince the humanitarian and security communities therefore that heritage matters, that destroying heritage means destroying the social fabric of communities and societies, depriving people of their identity?

I was honored when my friends and colleagues James Cuno and Thomas G. Weiss asked me to write a brief essay to begin this edited volume, *Cultural Heritage and Mass Atrocities*. This collection of essays is an essential guide: it provides critically important reading for my former colleagues throughout the UN system and in governments, as

well as for scholars and other practitioners, from humanitarians to international legal experts. It is a singular resource for all those interested in this essential topic.

My experience as head of UNESCO for two four-year terms strengthened my conviction in the growing relevance of heritage and culture. In the face of the deliberate destruction and looting of cultural heritage by extremist groups, a new understanding of why it matters has emerged: protection of heritage cannot be separated from that of human lives in times of conflict, and it is therefore a key security imperative. I also grew more convinced that protecting cultural heritage is not a luxury that can be left for better days but rather a tool for peace and reconciliation in many parts of the world today. Often the first victim of war, cultural heritage heals and can restore ties that have been broken. While it has always been the victim of war—as collateral damage or looting—what we have seen in the last few decades is quantitatively and qualitatively different.

The 1993 destruction of the Old Bridge in Mostar during the Yugoslav wars and that of the Bamiyan Buddhas in Afghanistan by the Taliban in 2001 were alarms that something had changed, with the intent behind these actions directly refuting the widely and unanimously accepted legal and ethical approach to the protection of heritage as a global public good. This was the deep and transformative meaning of the 1972 Convention Concerning the Protection of the World Cultural and Natural Heritage, which was based on the idea that the "outstanding universal value" of a site is the main criterion for its inscription on the World Heritage List.

What happened later was unthinkable. In 2012, extremists took control of the northern part of Mali and destroyed many of Timbuktu's ancient mausoleums and mosques. About 4,200 manuscripts of the Institut des Hautes Études et de Recherches Islamiques Ahmed Baba (IHERI-AB) were also burned by the armed groups. This was in a city considered the center of Islamic learning from the thirteenth to the seventeenth century, and that at one time counted nearly two hundred schools and universities attracting thousands of students from across the Muslim world. It is thanks to this history of enlightenment that the entire city of Timbuktu was inscribed on the World Heritage List in 1988.

In addition, all six World Heritage Sites in Syria have been damaged by fighting or performative actions over the last ten years, including the Old Cities of Aleppo and Damascus. Aleppo's al-Madina Souk, the world's largest covered historical market and part of the Old City, was burned and partly destroyed in fighting that began in 2012, and the following year the Great Umayyad Mosque became a battlefield, leading to the decision of the World Heritage Committee already in 2013 to place them both on the List of World Heritage in Danger so as to draw attention to the risks they were facing. Nonetheless, in 2015, the Arch of Triumph and the Temple of Bel, both part of the World Heritage Site of Palmyra, were blown up. On 18 August that year extremists from the Islamic State of Iraq and Syria (ISIS, also known as ISIL or Da'esh) also publicly beheaded Dr. Khaled al-Asaad, the renowned guardian of Palmyra, who had helped

evacuate the city museum before the takeover. He was tortured in an unsuccessful attempt to get him to reveal the location of hidden artifacts and then brutally murdered.[3]

In autumn 2014, I decided to go to Iraq, which was then largely occupied by Da'esh, to see the destruction for myself and explore with the authorities how UNESCO could help to prevent further damage and looting of unique cultural sites. I chose the symbolic date of 2 November, on which the United Nations marked for the first time the International Day to End Impunity for Crimes against Journalists. In addition, I wanted to send a message that extremists not only destroy heritage but also persecute people and stifle freethinking and speech.

My conviction about the connection between the persecution of people and attacks on culture and heritage only deepened after visiting the Baghdad Museum, the city of Erbil and its Baharka refugee camp (where most of the refugees had fled Da'esh) In 2014, and after a long meeting with representatives of different minority communities: Christian, Turkomen, Yezedi, Assyrian, Chaledean, Turkomen, Shabak, Baha'i, Sabean Mandean, and Kaka'i. "Cultural cleansing" was not an exaggeration.

The case of Mali sounded another alert. In January 2013 the extremists were pushed out of the northern areas they had controlled. Subsequently, on 23 April, the UN Security Council adopted resolution 2100, which established the Multidimensional Integrated Stabilization Mission (MINUSMA). For the first time the protection of cultural and historical sites was included in the mandate of a peacekeeping operation,[4] constituting a breakthrough in linking heritage protection to peace and security. It was a geopolitical recognition that heritage—both tangible and intangible—plays an important role in peace and reconciliation. While this part of MINUSMA's mandate was eliminated by the Security Council in 2018, it remains an important reminder of why heritage and culture matter; it also suggests that concrete enforcement of international norms and mandates is feasible. One positive result of the original decision by the council was the introduction of training on cultural heritage protection for UN peacekeeping forces through the involvement of experts from the Blue Shield network, a nongovernmental organization established in the late 1990s to "protect cultural heritage in emergency situations."[5]

In May 2015, I returned to Iraq in order to launch a new UNESCO campaign called "#Unite4Heritage" at the University of Baghdad along with young Iraqi students. The campaign became a major social network platform for raising awareness about the importance of heritage, knowledge about the "other," and respect and sharing of intercultural experience. My approach was strongly supported by the reports of two consecutive special rapporteurs for the UN Human Rights Council in the field of cultural rights, Farida Shaheen (2009–2015) and Karima Bennoune (2015–2021), who both defended the view that destruction of heritage is a human rights violation. Bennoune stressed the protection of heritage in her reports: "Destruction [of heritage] is often accompanied by other grave assaults on human dignity and human rights. We must care

not only about the destruction of heritage, but also about the destruction of the lives of human beings. They are interrelated."[6]

Three lines of action emerged within UNESCO in response to the destruction: working closely with the humanitarian and security communities in member states and within the United Nations broadly; leveraging all relevant legal and institutional frameworks; and public awareness raising. In pursuit of the first, in November 2015, for example, UNESCO convened an expert meeting on the responsibility to protect (R2P). While most of those present agreed on the challenges and difficulties of applying the concept of R2P to heritage protection, and that it may not be realistic to expect that it represents a viable path for international cooperation vis-à-vis the destruction of heritage in Syria and Iraq, the meeting adopted recommendations that highlighted the "preventive aspects" of R2P and noted "that acts of intentional destruction and misappropriation of cultural heritage can constitute war crimes and crimes against humanity, can indicate genocidal intent, and are frequently associated with ethnic cleansing and its accompanying 'cultural cleansing.'"[7]

In relation to the second line of action, as the guardian of a comprehensive set of international conventions, covering tangible and intangible cultural heritage and the diversity of cultural expressions, UNESCO has the legitimacy and a particular responsibility for the protection of heritage and cultural diversity as a global public good. Over its seventy-five years of existence, the organization has created an entirely new space for international cooperation, adopting legal instruments and documents and coordinating practical action by governments, experts, and civil society. It was important to see how and to what extent these legal instruments could be applied within the framework of "modern" conflicts, where nonstate actors were often the main perpetrators of the destruction.

Four treaties have a particular relevance to the protection of heritage in conflict: the 1954 Hague Convention for the Protection of Cultural Property in the Event of Armed Conflict (and its two 1999 protocols); the 1970 Convention on the Means of Prohibiting and Preventing the Illicit Import, Export and Transfer of Ownership of Cultural Property; the 1972 Convention Concerning the Protection of the World Cultural and Natural Heritage; and the 2003 Convention for the Safeguarding of the Intangible Cultural Heritage.

Wider ratification of these treaties is still very much needed to enable further national legal and institutional measures for the strengthening of international cooperation. This is particularly the case with regard to the 1954 convention and protocols, and that of 1970, the latter of which still has important international players missing.

The 1954 convention was adopted in the wake of the massive destruction of cultural heritage during World War II, and was the first multilateral treaty focusing exclusively on the protection of cultural heritage in the event of armed conflict. It covered "immovable and movable cultural heritage, including monuments of architecture, art or

history, archaeological sites, works of art, manuscripts, books and other objects of artistic, historical or archaeological interest, as well as scientific collections of all kinds regardless of their origin or ownership."[8] With French ratification of its Second Protocol in 2016, and the ratification by the United Kingdom the following year of the convention and both protocols, all five permanent members of the Security Council are now states parties to the treaty—important for its effective implementation and a strong message of the importance of heritage today.

While the 1970 convention was an important platform for international cooperation, it did not make provisions for a periodic monitoring body and lacked other mechanisms of monitoring and follow-up in terms of national legislation, training, and exchange of best practices. In addition, prior to 2012 only one meeting of its conference of states parties had ever been held, in 2003. In an attempt to remedy this, UNESCO's executive board approved a proposal for a second meeting, held in June 2012.[9] In order to monitor implementation, the states parties established a subsidiary committee and agreed to convene a further meeting every two years. These important changes created a concrete platform for stronger international cooperation in the fight against illicit trafficking of cultural objects, which saw a substantial increase with the conflicts in Syria and Iraq.

No doubt the emblematic 1972 convention, with 193 parties the most widely ratified international legal instrument in modern history, played a critical role. The World Heritage Committee, which administers the treaty, has taken numerous important decisions to raise awareness among the international community of states on the need to mobilize support for the protection of cultural heritage in conflict, including by placing sites that have been attacked and damaged on the List of World Heritage in Danger, such as Timbuktu and the Tomb of Askia in Mali,[10] or the six Syrian World Heritage Sites;[11] and by authorizing missions and creating funds for emergency conservation measures.

The implementation of a new comprehensive strategy became the primary vector for pursuing UNESCO's second line of action—building broad coalitions by linking humanitarian, security, and cultural imperatives. In fact the adoption of the strategy for "Reinforcement of UNESCO's Action for the Protection of Culture and the Promotion of Cultural Pluralism in the event of Armed Conflict" in November 2015 by the thirty-eighth General Conference of UNESCO was a milestone.[12] This is especially the case considering the organization's intergovernmental character, with the General Conference, which consists of representatives of UNESCO's member states, responsible for setting its broad agenda. The strategy document made clear that "attacks on culture are characterized by the deliberate targeting of individuals and groups on the basis of their cultural, ethnic or religious affiliation. Combined with the intentional and systematic destruction of cultural heritage, the denial of cultural identity, including books and manuscripts, traditional practices, as well as places of worship, of memory and learning, such attacks have been defined as 'cultural cleansing.'" It went on to say that "cultural cleansing, intended in this way, aims to eradicate cultural diversity from a

geographical area and replace it with a single, homogeneous cultural and religious perspective."[13]

In February 2015, the Security Council unanimously adopted resolution 2199, which broke new ground by banning trade in cultural heritage from Iraq and Syria; it also cited Chapter VII of the UN Charter as a means of enforcing counterterrorism. Linking cultural issues and security concerns, it acknowledged that cultural heritage should be placed at the forefront of security and political responses to the crisis. The resolution also gave special responsibility to various intergovernmental organizations, including UNESCO, the International Criminal Police Organization (Interpol), the UN Office on Drugs and Crime (UNODC), the World Customs Organization, and the International Council of Museums (ICOM). In response, and in further pursuit of the second line of action, UNESCO established a new platform for close cooperation among these organizations, with regular exchanges both at an expert level and that of the organizations' heads.

Additionally, the Rome Statute of the International Criminal Court (ICC) has become critical to protecting heritage because it declares the intentional destruction without military justification of buildings dedicated to religion, education, art, science, or charitable purposes a war crime. And so a partnership was established between UNESCO and the ICC, seeking to bring to justice those who commit such crimes. After scrupulous joint work by the organizations' teams, ICC chief prosecutor Fatou Bensouda declared on 1 July 2012 that the destruction of mausoleums in Mali constituted a war crime, and launched a preliminary examination into the violence that had been engulfing the country since January that year.[14]

The first suspect for this destruction, Ahmad al-Faqi al-Mahdi, was arrested and transferred by the authorities of Mali and Niger to the ICC in The Hague on 26 September 2015.[15] In August the following year he pled guilty before the court to the intentional damage of nine mausoleums and a mosque in Timbuktu. *The Prosecutor v. Ahmad Al Faqi Al Mahdi* was the first time the court took action for the war crime of cultural destruction. He was sentenced to nine years' imprisonment on 27 September 2016. This conviction made history in the fight against impunity, recognizing the restoration of justice and the rule of law as essential steps in any recovery process. Subsequently, in November 2017, the ICC and UNESCO signed a letter of intent formalizing and further enhancing collaboration.[16]

Other important initiatives have also demonstrated the commitment of the international community of states to protect heritage in the face of extremism and conflict. For example, on 21 September 2017 the European Union adopted a policy to protect cultural heritage from terrorism and mass atrocities in cooperation with UNESCO and other international organizations.

Although it has long been recognized that intangible cultural heritage has direct relevance and is often affected during armed conflict, it has been ignored by decisionmakers and experts, including within UNESCO frameworks. Such destruction is

sometimes "invisible" within policy-making circles, because the criteria for recognizing intangible heritage as part of the overall heritage of humanity is not its "outstanding universal value," as it is for sites on the World Heritage List; yet, intangible heritage may have great value for a community. MINUSMA recognized the link between tangible and intangible protection in Mali, and that between heritage and recovery from violence: "The oral expressions and traditions existing in Mali allow populations to express and transmit their values and knowledge and are, in particular, tools for the resolution of conflicts and to create inter- and intra-community cohesion."[17] Peacekeepers from various countries, including France and Italy, have subsequently begun to integrate the protection of heritage into the training of their armed forces.

A telling example among the eight Malian items on the List of the Intangible Cultural Heritage of Humanity is the "Charter of Manden," proclaimed in the early thirteenth century by the founder of the Mandingo Empire, which was situated between the present-day states of Guinea and Mali. The charter is one of the oldest constitutions in the world, albeit mainly in oral form, and contains a preamble of seven chapters advocating social peace in diversity, the inviolability of the human being, education, food security, and freedom of expression and trade. Although the empire disappeared, its charter's words and the rituals associated with it are still transmitted orally.

In pursuit of the third line of action, raising public awareness of the scale of destruction and looting, UNESCO mobilized civil society, experts, academia, and youth around the common understanding of why protection of heritage matters, to counter the hateful narratives of extremists. These efforts were accompanied by a global coalition of the #Unite4Heritage campaign, which has touched millions by creating a platform for sharing experiences and stories that challenge the extremists' narrative about identity, culture, and values. A 2016 memorandum of understanding was signed between Italy and UNESCO establishing a #Unite4Heritage Task Force for the protection of cultural heritage at risk.[18] It was entrusted to the Special Cultural Command Unit of the Italian Carabinieri police force and tasked with intervening in crises, using its experience and technical knowledge to protect populations and cultural heritage worldwide. The task force also includes cultural heritage experts.

My tenure at UNESCO demonstrated the power of culture and heritage to mobilize, rebuild, reconcile, renew, and heal. Accompanying then French president François Hollande to Timbuktu in February 2013,[19] I witnessed the pain, suffering, and devastating effect of the destruction of ancient heritage on local communities. Two years later I returned to inaugurate fourteen mausoleums which had been reconstructed by local masters with traditional materials under UNESCO's guidance. The local communities had recovered their identities. The destruction and reconstruction of the mausoleums is a most compelling example of how attacks against culture are attacks against the very identity of communities and peoples, and the very notion of sharing common histories, narratives, and values: without reconstruction, reconciliation becomes all the more difficult. A decade earlier, in Bosnia and Herzegovina, we learned

the same lesson when former enemies joined forces in 2004 to rebuild the Mostar Bridge. While there are over a thousand sites on the World Heritage List, only two were inscribed following their reconstruction: the Mostar Bridge and the Historic Centre of Warsaw, the latter almost totally destroyed during World War II.

The link between culture and heritage, on the one hand, with humanitarian and security concerns, on the other, has been enshrined in several Security Council resolutions linking heritage protection and mass atrocities. Resolution 2347 of March 2017, promoted by UNESCO and sponsored by France and Italy, is a milestone in the efforts to preserve heritage amid armed conflict. The first resolution to recognize that attacks on cultural heritage are a threat to international peace and security—the basis for council action—it not only deplored the unlawful destruction of cultural heritage, religious sites, and artifacts, as well as the smuggling of cultural property by terrorist groups during armed conflict, but also affirmed that such attacks might constitute a war crime. Also important is resolution 2379, in September the same year, related to Da'esh accountability, which similarly underscored the link between attacks on heritage and on human lives.

All of this strengthened the understanding that heritage is not just marvelous sites in tourist brochures; it entails a vision for peace and mutual respect, carved in stone and cultural landscapes, with the power to change the minds of women and men, and to shape a different future for all. Heritage preservation shows us that cultures have always influenced each other and are irresistibly intertwined. The result is a formidable and unprecedented diversity.

Balancing the benefits of integrating into a globalized world against protecting the uniqueness of local culture requires great care. Placing culture at the heart of development policies does not mean confining and fixing it but rather investing in the potential of local resources, knowledge, skills, and materials to foster creativity and sustainable progress. Recognition and respect for the diversity of cultures also creates the conditions for mutual understanding, dialogue, and peace.

Finally, cultural heritage can play a substantial role in the critical debate about living together in a globalized and connected world, about reconciling different cultures through intercultural dialogue, and using cultural diversity as a force for creativity and peace rather than for destruction, hatred, and conflict. World heritage is an open book of diversity and knowledge about the other that must be taught in schools and embraced by education systems globally. Cultural heritage can give confidence and help reconcile individuals with a globalizing world. Protecting cultural heritage of "outstanding universal value"—an idea that did not exist merely six decades ago—is an extraordinary way of knowing one another, of respecting one another's cultures, and of living together.

Without cultural heritage and understanding the past, there can be no future. This is why I enthusiastically urge scholars and practitioners to read carefully the pages of *Cultural Heritage and Mass Atrocities*. Its five sections address the essential dimensions:

values, concrete case studies, populations at risk, public international law, and military perspectives. Jim Cuno and Tom Weiss have assembled a diverse team of leading specialists who connect the dots between cultural, humanitarian, and security concerns.

In short, when cultural heritage is destroyed anywhere in the world, we are all diminished, whether it is from another region, another period, another culture, or another religion. My own years at the helm of the leading international organization charged with advancing culture lead me to salute this volume because it helps us to understand the crucial dimensions of how best to tackle the challenges of protecting heritage. It reminds us that preserving diverse cultural heritage, and particularly the concept of "world heritage," is one of the most positive, visionary, and transformative ideas that have emerged in the last century, embodied in the 1972 UNESCO convention for the protection of the world's cultural and natural heritage. Humanity stands united in all its diversity around shared values. All cultures are different but differences do not divide; they unite.

NOTES

1. Franceinfo, "Les mausolées de la plus grande mosquée de Tombouctou ont été détruits," 6 December 2016, https://www.francetvinfo.fr/culture/patrimoine/les-mausolees-de-la-plus-grande-mosquee-de-tombouctou-ont-ete-detruits_3330445.html.

2. Irina Bokova, *UNESCO's Response to the Rise of Violent Extremism: A Decade of Building International Momentum in the Struggle to Protect Cultural Heritage*, Occasional Papers in Cultural Heritage Policy no. 5 (Los Angeles: Getty Publications, 2021), https://www.getty.edu/publications/occasional-papers-5/.

3. Kareem Shaheen and Ian Black, "Beheaded Syrian Scholar Refused to Lead Isis to Hidden Palmyra Antiquities," *Guardian*, 19 August 2015, https://www.theguardian.com/world/2015/aug/18/isis-beheads-archaeologist-syria.

4. MINUSMA, "Cultural Heritage," https://minusma.unmissions.org/en/cultural-heritage.

5. Blue Shield International, "Who We Are," https://theblueshield.org/about-us/what-is-blue-shield.

6. UN News, "Destruction of Cultural Heritage Is an Attack on People and Their Fundamental Rights—UN Expert," 27 October 2016, https://news.un.org/en/story/2016/10/543912-destruction-cultural-heritage-attack-people-and-their-fundamental-rights-un.

7. UNESCO, "Expert Meeting on the 'Responsibility to Protect' and the Protection of Cultural Heritage: Recommendations," 27 November 2015, http://www.unesco.org/new/fileadmin/MULTIMEDIA/HQ/CLT/pdf/R2P-Recommendations-EN.pdf.

8. UNESCO, "1954 Hague Convention for the Protection of Cultural Property in the Event of Armed Conflict," http://www.unesco.org/new/en/culture/themes/armed-conflict-and-heritage/convention-and-protocols/1954-hague-convention/.

9. UNESCO, "Second Meeting of States Parties to the 1970 Convention," http://www.unesco.org/new/en/culture/themes/illicit-trafficking-of-cultural-property/meeting-of-states-parties/2nd-msp-2012/.

10. UNESCO, "End of 36th Session of the World Heritage Committee Marked by Concern for World Heritage Sites in Mali," 6 July 2012, http://www.unesco.org/new/en/media-services/single-view/news/end_of_36th_session_of_the_world_heritage_committee_marked_b/.

11. UNESCO, "Syria's Six World Heritage Sites Placed on List of World Heritage in Danger," 20 June 2013, https://en.unesco.org/news/syria's-six-world-heritage-sites-placed-list-world-heritage-danger.

12. UNESCO, "Reinforcement of UNESCO's Action for the Protection of Culture and the Promotion of Cultural Pluralism in the Event of Armed Conflict," UN doc. 38/C/49, 2 November 2015, https://en .unesco.org/system/files/235186e1.pdf.

13. UNESCO, Art. 6.

14. Mark Kersten, "Prosecuting Crimes against Cultural Property in Northern Mali: Why It Matters," Justice in Conflict, 21 August 2012, https://justiceinconflict.org/2012/08/21/prosecuting-crimes -against-cultural-property-in-northern-mali-why-it-matters/.

15. ICC, "Case Information Sheet: The Prosecutor v. Ahmad Al Faqi Al Mahdi," doc. no. ICC-PIDS-CIS-MAL-01-09/22_Eng, updated January 2022, https://www.icc-cpi.int/CaseInformationSheets/Al -MahdiEng.pdf.

16. ICC, "The ICC Office of the Prosecutor and UNESCO Sign Letter of Intent to Strengthen Cooperation on the Protection of Cultural Heritage," press release, 6 November 2017, https:// www.icc-cpi.int/Pages/item.aspx?name=171106_OTP_Unesco.

17. MINUSMA, "Cultural Heritage."

18. Italian Government and UNESCO, "Memorandum of Understanding between the Government of the Italian Republic and the United Nations Educational, Scientific and Cultural Organization ('UNESCO') on the Italian National 'Task Force in the Framework of UNESCO's Global Coalition Unite4Heritage' for Initiatives in Favour of Countries Facing Emergencies that May Affect the Protection and Safeguarding of Culture and the Promotion of Cultural Pluralism," 16 February 2016, https://www.beniculturali.it/mibac/multimedia/MiBAC/documents/1455616287505_2. _Memorandum_of_Understanding__11II2016_DRAFT_Finale_UNESCO_versione_Italia.pdf.

19. UNESCO, "Director-General Visits Mali with French President François Hollande," 3 February 2013, https://whc.unesco.org/en/news/979.

Preface and Acknowledgments

In December 2016, the American Academy of Arts and Sciences and the J. Paul Getty Trust convened a meeting at the British Academy, London, to discuss an international framework for the protection of cultural heritage in zones of armed conflict. Our timing was compelled by the purposeful destruction of cultural heritage in Syria and Iraq, and by the recent conviction of Ahmad al-Faqi al-Mahdi by the International Criminal Court for the war crime of attacking historic and religious buildings in Timbuktu.

Three months later, in March 2017, the United Nations Security Council passed resolution 2347, which condemned the "unlawful destruction of cultural heritage, and the looting and smuggling of cultural property in the event of armed conflicts, notably by terrorist groups, and the attempt to deny historical roots and cultural diversity in this context can fuel and exacerbate conflict and hamper post-conflict national reconciliation." The resolution gave formal, international attention to the protection of cultural heritage and its links to cultural cleansing.

In October 2017, as cochairs of this project, we spoke at a meeting at UN headquarters in New York on the issue of "Protecting Cultural Heritage from Terrorism and Mass Atrocities: Links and Common Responsibilities." The meeting was hosted by, among others, Angelino Alfano, minister of foreign affairs and international cooperation, Italy; Frederica Mogherini, high representative from the European Union; Irina Bokova, director-general of UNESCO; and Simon Adams, then executive director of the Global Centre for the Responsibility to Protect. The consensus of the meeting was that cultural heritage is worthy of protection, not only because it represents the rich and diverse legacy of human artistic and engineering ingenuity, but also because it is intertwined with the very survival of a people as a source of collective identity and the revitalization of civil society and economic vitality after armed conflict.

Over three days at the Getty Center in May 2019, as volume editors we convened nineteen scholars and practitioners of different specialties and experience to discuss the topic "Cultural Heritage under Siege." In one way or another, we had been discussing this topic for three years. The purpose of the convening was to begin to finalize the shape and substance of the book we decided needed to be written, the book that has become this volume: *Cultural Heritage and Mass Atrocities*. Although many of the participants in the convening have contributed essays in the pages that follow, all of the participants contributed to its shape and substance in one important way or another. We remain deeply grateful to everyone who attended that meeting. The presentations,

discussions, and debates were inspiring, and the warmth of friendship was gratifying. Before the event's opening dinner, Irina Bokova, who had recently stepped down as UNESCO director-general, set the stage for our convening with poignant and illuminating remarks. We are delighted that she has done the same here by contributing the insightful and thought-provoking foreword to this volume.

The development of this volume occurred via Zoom in June 2020 and February 2021, when abstracts and then final drafts were discussed by the authors and by other contributors. Due to the international COVID-19 pandemic, we missed the camaraderie and intellectual sparks that would have animated our discussions, but the commitment of our team of authors was still very much in evidence and contributed to the quality of the final drafts that now comprise the body of this text.

The design of this collection of essays reflects our own interpretations of the most pressing issues and necessary perspectives required to frame changes in policy- and decision-making about the protection of cultural heritage amid atrocities. In putting together this collection, we sought to better understand the origins, history, contributions, problems, and prospects of international efforts to protect the world's immovable cultural heritage. This endeavor, we hope, will result in improved strategies and tactics in the coming decades. A better comprehension of the deficiencies of existing laws, norms, and organizations should lead to the identification of appropriate remedies.

At the outset, readers will find a lengthy list of abbreviations. Contemporary international problem-solving and conversations are bedeviled with acronyms and abbreviations. Institutions and parts of them, along with individual operations, treaties, and conferences, are almost always referred to by their initials. This may be off-putting to some readers, but it is a contemporary reality. To save space, contributors as well as public documents and media treatments use these short-cuts extensively, and so readers may need to consult the list with some frequency.

"Suggested Readings" follow each essay and are compiled at the end of the book, providing readers with our contributors' recommendations for the most authoritative and recent published sources on the subject matter of their essays.

A pleasant assignment after putting a book into production is to acknowledge significant contributions from many individuals. Kara Kirk and Karen Levine, respectively Getty Publications publisher and editor in chief, never once doubted the importance of our project and fully supported it from the beginning. Our editor at Getty Publications, Laura diZerega, worked most closely with us, our authors, manuscript editor Martin J. Burke, and designers to make this handsome and user-friendly text available to readers. Additional thanks are due to Greg Albers and Erin Dunigan for their expert management of our digital publication, Victoria Gallina, our production coordinator, and Jeffrey Cohen, our designer. But it is to Morgan Conger, senior project manager in the Office of the Getty President, and Lizzie Udwin, former executive assistant to the Getty president, that we owe our greatest debt. For over the years we

worked on this project, they dealt tirelessly with the incorrigible habits and quirkiness of its coeditors, planning numerous meetings and making sure all of our Zoom trains ran on time. Morgan Conger managed the transmittal of our publication's many components to our authors, editor, and copyeditor, and diligently ensured that all revisions were captured during the various stages of the editing process. It is no exaggeration to say that we could not have successfully completed a complex project of this type without their able helping hands.

This "Cultural Heritage at Risk" project is one of several related efforts by the J. Paul Getty Trust to address threats to the world's cultural heritage. The Getty Conservation Institute's work on the wall paintings at the Mogao Grottos, Dunhuang, China, for example, dates back to 1997. This was followed by the GCI's Iraq Cultural Heritage Conservation Initiative, 2004–2011, and, in partnership with the Getty Foundation, the scientific analysis and conservation treatment of Roman era mosaics in the Middle East and North Africa beginning in 2012. Most recently, the Getty Conservation Institute has developed an open-source software platform for cultural heritage management, and in 2017 the Getty Trust began publishing a series of Occasional Papers in Cultural Heritage Policy, which has formed the foundation of this book.

When we set out to edit this volume, our initial task was to find a diverse group of authors to write about the vast range of topics, cases, and perspectives in the thirty-two chapters that follow this preface and our introduction and precede our conclusion. Brief biographies are found in the list of contributors at the end of this book. All authors have researched and written extensively about the subject of their chapters or worked in a related field; many have done both. All are acknowledged experts working on the problems and prospects of protecting human beings and their cultural heritage. We will not be bashful: these pages reflect the distinctive products of a world-class team with expertise on the historical, legal, and humanitarian consequences of cultural heritage at risk from Asia to South America to the Mediterranean basin. For this we are grateful to all of our colleagues.

Sadly, there is one voice missing. Edward C. Luck, who had provided both of us with clear-headed guidance and advice from the outset, was working on his chapter about major powers in February 2021 when he died after a brave battle with lung cancer. Ed's premature death deprives our intellectual and policy communities, and especially his family and friends, of his warmth, insights, and humor.

JC and TGW
Los Angeles and Chicago
December 2021

✦　✦　✦

We had just put the finishing touches on this three-year-long research project when Russia invaded Ukraine and thereby upset the (admittedly weak) basic principles of a rules-based international order that had been evolving since 1945. The tragic events in Ukraine have reminded us yet again why we initiated this effort to explore the links between mass atrocities and the destruction of cultural heritage.

Early on, the most publicized and horrific reports emerged from Bucha, where bodies lay piled in the streets and more than one hundred people were buried in a communal grave at the city's cemetery. The numbers grew more tragic in the weeks immediately following: at least four thousand civilians killed, more than fourteen thousand deaths total, over five million refugees, and perhaps twice as many internally displaced Ukrainians.

At the same time, as we wrote in the *Wall Street Journal* in mid-April, Russia was systematically destroying Ukraine's national heritage. The UN Educational, Scientific and Cultural Organization (UNESCO) continued to update its list of damaged and destroyed Ukrainian religious sites, historic buildings, museums, and monuments. These included the Ivankiv Historical and Local History Museum, with its collection of folk art and paintings by the self-taught artist Maria Prymachenko; the Holocaust memorials in Drobitsky Yar, on the outskirts of Kharkiv, and Babyn Yar, in Kyiv; a Gothic revival building in Chernikhiv that had once served as a museum and is now a library; and a museum in Mariupol dedicated to the nineteenth-century landscape painter Arkhip Kuindzhi.

Still at risk, even as we write these words, are seven UNESCO World Heritage Sites dating to the Byzantine era, including Kyiv's Saint Sophia Cathedral and its related monastic buildings, architecture built between the eleventh and nineteenth centuries and intended to rival Istanbul's Hagia Sophia in a "new Constantinople." Not only a tragedy, such assaults on cultural heritage are a step toward what then UNESCO director general Irina Bokova first termed "cultural cleansing" in 2015—actions intended to destroy a society by eradicating its history and memory. Bokova's words figure in her foreword to this volume and throughout its chapters.

We've been here before, unfortunately. The following pages contain analyses of the destruction of the Mostar Bridge in Bosnia and Herzegovina, the Bamiyan Buddhas in Afghanistan, shrines and libraries in Mali, Uyghur mosques in China, and the Great Umayyad Mosque of Aleppo in Syria. All represent one ethnic or religious group's efforts to make another "disappear." These atrocities, in fact, resemble Russia's campaign, ongoing since 2014, to eliminate Tatar traces in occupied Crimea with the aim of eradicating any evidence of the Ottoman Empire.

The 1954 Hague Convention for the Protection of Cultural Property in the Event of Armed Conflict has been the primary means of protecting the world's cultural heritage. Its distinctive "Blue Shield" is attached to buildings and sites as a warning to combatants to respect those sites covered by the convention. But that is not enough.

The war in Ukraine has made our own conclusion at the end of this volume even clearer: it is now essential to lay the foundations of an independent international consortium of art museums, cultural institutions, universities, intergovernmental and nongovernmental organizations, and government agencies—including, for instance, the US Departments of State and Defense—to raise consciousness about the vulnerability of tangible cultural heritage and those who work to preserve it. Such a consortium would be modeled on the World War II Monuments Men—military and civilian personnel who worked to safeguard and, in some cases, rescue cultural heritage.

The consortium's mission would be twofold. The first part would be to ensure the enforcement of public international law vigorously and across the board. Since the entry into force of the Rome Statute in 2002, the International Criminal Court in The Hague has successfully prosecuted the destruction of cultural heritage as a war crime. It convicted Ahmad al-Faqi al-Mahdi for destroying, in 2012, nine mausoleums and a mosque at one world heritage site. But the unprecedented scale of destruction in Ukraine poses significant challenges in terms of evidence gathering, documentation, and the like. Without the assistance of an outside entity such as the consortium we propose, there's the danger that many of these crimes could go unpunished. This cannot be allowed to happen.

The second part would involve dedicated military personnel. Their mandate would be similar to that of the North Atlantic Treaty Organization's (NATO) personnel in Kosovo and the UN's forces in Mali. In addition to safeguarding humans and fostering rebuilding, peacekeepers in these locations protected cultural heritage. Such efforts can constitute a "force multiplier" by removing hazards, suppressing looting, and deterring politically motivated attacks. In fact, NATO insiders speak increasingly of the "security-heritage nexus."

The international entity for the protection of cultural heritage and museum professionals that we envision would help mitigate the grave threats to cultural heritage in conflict zones. At present, officials in both the private and public sectors are expressing concern, and museums and other entities in the United States and elsewhere are working with their Ukrainian counterparts on these issues. But the network is loose-knit and ill-prepared at best. This consortium would mobilize and foster cooperation among the various actors tasked to protect cultural heritage in political crises with significant humanitarian dimensions

similar to those in Ukraine. While the temporary relocation of cultural objects remains fraught, the protection of trained and knowledgeable local cultural custodians is less so. Aided by an established network of organizations to assist with documentation, travel, and placement, cultural heritage workers could continue to carry out their duties with temporarily stored treasures, even while displaced.

It is worth repeating a quote found in our introduction from the nineteenth-century German poet Heinrich Heine, words also employed by Raphael Lemkin, the proponent of the term "cultural genocide": "First they burn the books, then they burn the bodies." The war crime of destroying cultural heritage is yet another reason to oppose Russian recolonization. It is also the reason why the analyses and recommendations in the pages that follow make for even more essential reading now than when we finalized them.

JC and TGW
May 2022

List of Abbreviations

AFP	Agence France-Presse
AKTC	Aga Khan Trust for Culture
ALIPH	International Alliance for the Protection of Heritage in Conflict Areas
AP	Associated Press
AP I	Additional Protocol I to the 1949 Geneva Conventions
AP II	Additional Protocol II to the 1949 Geneva Conventions
AQIM	al-Qaeda in the Islamic Maghreb
B/C	benefit-cost (ratios)
BCE	Before the Common or Christian Era
BRI	Belt and Road Initiative
BSI	Blue Shield International
CAVR	Commission for Reception, Truth and Reconciliation in East Timor
CCP	Chinese Communist Party
CE	Common or Christian Era
CEDAW	Convention on the Elimination of All Forms of Discrimination against Women
CESCR	Committee on Economic, Social and Cultural Rights
CNN	Cable News Network
CPP	cultural property protection
DGAM	Directorate General for Antiquities and Museums
EAMENA	Endangered Archaeology in the Middle East and North Africa

ECOSOC	UN Economic and Social Council
EU	European Union
GAL	*Geschichte der arabischen Litteratur*
GDP	gross domestic product
HRC	Human Rights Committee
IAC	international armed conflict
ICC	International Criminal Court
ICCPR	International Covenant on Civil and Political Rights
ICCROM	International Centre for the Study of the Preservation and Restoration of Cultural Property
ICESCR	International Covenant on Economic, Social and Cultural Rights
ICG	International Crisis Group
ICISS	International Commission on Intervention and State Sovereignty
ICJ	International Court of Justice
ICOM	International Council of Museums
ICOMOS	International Council on Monuments and Sites
ICRC	International Committee of the Red Cross and Red Crescent
ICTY	International Criminal Tribunal for the former Yugoslavia
IDP	internally displaced person
IHL	international humanitarian law
ILA	International Law Association
IMT	International Military Tribunal at Nuremberg
Interpol	International Criminal Police Organization
IRR	internal rate of return
ISIL	Islamic State of Iraq and the Levant
ISIS	Islamic State of Iraq and Syria (also known as ISIL or Da'esh)

KFOR	NATO's Kosovo Force
KLA	Kosovo Liberation Army
LIDAR	Light Detection and Ranging
LOAC	law of armed conflict
LTTE	Liberation Tigers of Tamil Eelam
MFAA	Monuments, Fine Arts, and Archives Section (of the Civil Affairs and Military Government Sections of the Allied Armies; in World War II)
MINUSMA	UN Multidimensional Integrated Stabilization Mission in Mali
MOJWA	Movement for Oneness and Jihad in West Africa
MOU	memorandum of understanding
NACLA	North American Congress on Latin America
NAGPRA	Native American Grave Protection and Repatriation Act
NATO	North Atlantic Treaty Organization
NGO	nongovernmental organization
NIAC	non-international armed conflict
NPV	net present value
NSAG	nonstate armed group
OHCHR	Office of the UN High Commissioner for Human Rights
QIP	quick impact projects
R2P	responsibility to protect
RAC	Records of the American Commission for the Protection and Salvage of Artistic and Historical Monuments in War Areas
RASHID	Research, Assessment and Safeguarding of the Heritage of Iraq in Danger
SAA	Society for American Archaeology
SCPR	Syrian Center for Policy Research
SHOSI	Safeguarding of the Heritage of Syria and Iraq Project

SOAS	School of Oriental and African Studies, University of London
SPLM/A	Sudan People's Liberation Movement/Army
TCCH	Technical Committee on Cultural Heritage in Cyprus
TRADOC	Training and Doctrine Command, US Army
UN	United Nations
UNAMI	UN Assistance Mission for Iraq
UNDP	UN Development Programme
UNDRIP	UN Declaration on the Rights of Indigenous Peoples
UNESCO	UN Educational, Scientific and Cultural Organization
UNFICYP	UN Peacekeeping Force in Cyprus
UNHCR	UN High Commissioner for Refugees [Office of the]
UNICEF	UN Children's Fund
UNIDROIT	International Institute for the Unification of Private Law
UNIFIL	UN Interim Force in Lebanon
UNITAD	UN Investigative Team to Promote Accountability for Crimes Committed by Da'esh/ISIL
UNITAR	UN Institute for Training and Research
UNMIK	UN Interim Administration Mission in Kosovo
UNODC	UN Office on Drugs and Crime
UNTSO	UN Truce Supervision Organization
UNWCC	United Nations War Crimes Commission
USAID	US Agency for International Development
WHC	Convention Concerning the Protection of the World Cultural and Natural Heritage
WTP	willingness to pay
XUAR	Xinjiang Uyghur Autonomous Region

Introduction

James Cuno
Thomas G. Weiss

The destruction of cultural heritage in times of war, intentional and performative acts of violence, and mass atrocities are not new. However, such destruction has become a familiar aim of state and nonstate actors across a growing portion of the world since the purposeful destruction of the Mostar Bridge (Stari Most) in Bosnia and Herzegovina during the 1993 Croat–Bosniak War; the destruction of the Bamiyan Buddhas in Afghanistan by the Taliban eight years later; the 2012 physical attacks on Sufi shrines in Timbuktu, Mali; the ongoing destruction of cultural sites and monuments throughout China's Xinjiang Uyghur Autonomous Region; and numerous other attacks in Syria, Yemen, and Iraq. Shocking to specialists and nonspecialists alike was the saber-rattling early in 2020 by then US president Donald Trump, who threatened to destroy Iranian cultural sites after Tehran claimed it would retaliate for the assassination of Major General Qassim Suleimani. Although Trump later backed off, his initial statement as well as the dramatic earlier instances focused attention on the role of cultural heritage in times of political and military turmoil.[1]

Do today's politics and public sensitivities offer an opportunity to confront and eliminate this ancient, violent tactic? In significant ways, this contested backdrop resembles the moment over two decades ago when the responsibility to protect (R2P) emerged as a demand-driven normative response to mass murder and ethnic cleansing.[2] Long before Trump's bluster, protecting cultural heritage had become more visible on the international public policy agenda. Perhaps most dramatically, it followed the public beheading by the Islamic State of Iraq and Syria (ISIS, also known as ISIL or Da'esh) of Khaled al-Asaad, a Syrian archaeologist who had refused to reveal where Palmyrene cultural artifacts were hidden for their protection during Syria's deadly civil war in summer 2015. The media's treatment of the death of hundreds of thousands and the forced displacement of half the Syrian population had become a tragic but stale story. After four years, the drone of lamentations about the human tragedy no longer seemed newsworthy. But a sudden image that grabbed the attention of the public and policymakers was the large-scale destruction of the ruins of the ancient city of Palmyra, including the performative murder by beheading of al-Asaad and the targeted assault

on the two-thousand-year-old Temple of Baalshamin and other archaeological sites with bulldozers and explosives.

These were spectacular targets, World Heritage Sites identified by the United Nations Educational, Scientific and Cultural Organization (UNESCO). However, there were also examples of immovable cultural heritage of local importance that, while less visible to international viewers, have become targets of destruction: Uyghur mosques and temples in China, Christian cemeteries in Iraq, and Rohingya shrines in Myanmar. In short, as another recent volume makes clear, "cultural heritage has become increasingly 'conflict prone.'"[3]

Can anything be done? This introduction and the subsequent thirty-two substantive chapters and conclusion argue that the answer to that question is yes. Action is possible on the normative and policy fronts. UNESCO calls such intentional destruction "strategic cultural cleansing"[4]—that is, "the deliberate targeting of individuals and groups on the basis of their cultural, ethnic or religious affiliation . . . combined with the intentional and systematic destruction of cultural heritage, the denial of cultural identity, including books and manuscripts, traditional practices, as well as places of worship, of memory and learning."[5]

International observers and audiences link images of heritage destruction to mass murder, forced displacement, rape, ethnic cleansing, human trafficking, slavery, and terrorism. Many governments and citizens loudly deplore such destruction but do little to prevent it—tragically, they see little that can be done.

Some observers may recall that an analogous political reaction—symbolically throwing up diplomatic hands—initially greeted the reactions to those who murdered and abused civilians in the wars of the 1990s. Such resignation lasted until ad hoc humanitarian interventions were followed by the International Commission on Intervention and State Sovereignty (ICISS) and the 2001 publication of its report and accompanying research volume.[6] The topics are linked, as Hugh Eakin, a journalist covering both issues, wrote: "While the United Nations has adopted the 'responsibility to protect' doctrine, to allow for international intervention to stop imminent crimes of war or genocide, no such parallel principle has been introduced for cultural heritage."[7]

Why return to ICISS when the politics of the UN General Assembly have evolved significantly since the 2005 World Summit's agreement about R2P, including the creation of administrative and operational bodies in the UN secretariat as well as in governments and nongovernmental organizations (NGOs)? The original framework and the pertinence of the R2P analogy remain convincing for two reasons. First, the original three-part responsibility for protection—prevention, reaction, and rebuilding—reflects the same conceptual framework that cultural specialists apply to protect heritage; yet typically, they do not interact with R2P's normative champions. Second, the major constraint impeding robust action to protect immovable heritage is the same as for the

protection of people: the claimed sacrosanct nature of sovereignty for state perpetrators, and the law of the jungle for nonstate actors.

This introduction begins with a counterfactual: what if Raphael Lemkin's original draft of the 1948 Convention on the Prevention and Punishment of the Crime of Genocide had been left intact to include cultural as well as physical genocide? It continues with a discussion of the "value" (for the perpetrators of destruction) of attacking heritage and the tenets of existing international law. It then explores what is new in contemporary debates before applying the conceptual and political lessons of R2P's normative journey to possible efforts to address the destruction of immovable cultural heritage. Finally, it discusses the complications of the dual challenge of protecting immovable heritage and people, and the value added of combining such protection as a central component of concerns to halt atrocity crimes.

Lemkin's Logic

A growing body of scholarship gives only fleeting attention to a largely forgotten emphasis in Lemkin's early work on the question of biological *and* cultural genocide.[8] His 1933 submission to a League of Nations conference included not only "barbarity" but also "vandalism";[9] but the 1948 convention dropped the latter, so that "genocide" encompasses only material, not cultural annihilation. In addition, a shortcoming for the purposes of minimizing or halting the destruction of immovable cultural heritage is that Lemkin's legal remedies have resulted in an emphasis on "punishment" (after the fact) rather than "protection" (before the fact).

As our late colleague Edward Luck pointed out in a Getty Occasional Paper in Cultural Heritage Policy, the politics surrounding the draft convention were a mirror image of the reluctance toward R2P in parts of the Global South today.[10] Opposition to including "vandalism" in the 1948 convention essentially came from the West: former or then colonial powers (Belgium, Denmark, France, the Netherlands, and the United Kingdom) as well as settler countries (the United States, Canada, Brazil, Australia, and New Zealand). Their governments feared accountability for crimes against Indigenous and local populations. Had that debate occurred after decolonization, the politics might have been turned upside down. In the post–Cold War era, the most ardent defenders of humanitarian intervention and R2P have been from the West, whereas the bulk of those most resistant have been from the Global South.

Government delegates in the 1948 negotiations agreed to include the physical and biological aspects of genocide in the convention but eliminated the cultural and social elements from earlier drafts.[11] While counterfactuals are often dismissed as the playthings of social scientists, they can help focus the mind.[12] What if Lemkin's vandalism had been included as part of the 1948 Genocide Convention? Would the prospects for protecting heritage have fared better in the ongoing tragedies in Syria, Yemen, Myanmar, and Xinjiang as well as earlier ones in Afghanistan, Iraq, the Balkans, and Mali?

Lemkin's experience before and during World War II led him to link biological and cultural destruction. His conceptual judgment was correct, but his political perspicacity fell short. The relationship is direct (and often personal) between protecting people and their cultures, whether one stresses the intrinsic or extrinsic value of immovable cultural heritage.[13] Cosmopolitans emphasize the former, the value of cultural heritage in and of itself as well as its direct link to safeguarding life. As early as the fourth century BCE, a school of Greek philosophers known as Cynics coined the expression *cosmopolitanism* to mean "citizen of the cosmos" or the world.[14] We use *humanity* as a synonym because humans benefit from all manifestations of cultural heritage and suffer from their destruction. In contrast, humanitarians emphasize the extrinsic value of cultural heritage because those who commit mass atrocities are cognizant that the annihilation of heritage is often a prelude to or even an integral part of such atrocities. There is no reason for R2P proponents to overlook or downgrade the value and meaning of the destruction of immovable cultural heritage if it almost invariably foreshadows mass atrocities or accompanies them.

The connections between attacks on cultural heritage and assaults on civilian populations vary. They may be iconoclastic, like the ISIS attacks on Palmyra, the Islamist attacks on the mausoleums and tombs of Sufi saints in Timbuktu, and the series of coordinated terrorist suicide bombings on Easter Sunday in Colombo, Sri Lanka. Alternatively, they may result from targeted military attacks, like damage to the Great Umayyad Mosque of Aleppo in Syria.

It is worth revisiting the relationship between protecting people and the cultural heritage with which they identify. While better data and causal links would be helpful for decisionmakers and policymakers, nonetheless it is a fool's errand to split intrinsic from extrinsic perspectives; we argue that just as in the case of protecting people and schools and hospitals, the protection of people and cultural heritage is inseparable, virtually impossible to disentangle.

The "Value" of Eliminating Heritage

State and nonstate actors who destroy immovable cultural heritage—our focus in these pages—are unreasonable thugs, but they are not irrational. Their crude calculations of the costs and benefits associated with mass atrocities and the destruction of tangible cultural heritage differ from ours. These pages address the fate and legacy of tangible and immovable (not intangible or movable) cultural heritage. Language, music, costume, food, and works of art of a certain size and scale are important to any culture; they are movable and thus more easily removed for their protection. Our concern here is focused on immovable cultural heritage: tangible objects that are of a size or physical condition that impedes their movement or are integral to their physical setting and thus more vulnerable to damage and destruction.

Readers will notice that we use the term *heritage* rather than *property*. Many discussions and legal documents refer to *cultural property*. But the title of this volume

consciously favors *cultural heritage*, which is now widespread and refers to *inheritance and identity* rather than *ownership and objecthood*. Views differ about the value of each term, but we prefer the latter. Why? Because *heritage* implies a broader and more cosmopolitan affiliation, a shared human value, the idea that as humans we have obligations to others beyond their particular cultural affiliation.[15] People and political organizations can share a responsibility for protecting cultural heritage. Moreover, many different people can "identify" and thus be moved to want to protect cultural heritage in ways that they may not be moved or even allowed to protect if peoples claim a property to be theirs and only theirs.

The most obvious costs, both direct and indirect, of attacks on cultural heritage are borne by vulnerable populations: lost lives and livelihoods, forced displacement, reduced longevity, and misery. The violent destruction of tangible and intangible heritage often sounds an alarm about forthcoming mass atrocities—the nineteenth-century German poet Heinrich Heine famously said, "First they burn the books, then they burn the bodies." Targeted destruction of cultural heritage, as experienced during Kristallnacht in Nazi Germany in 1938, almost invariably precedes violence against civilian populations. Museum and cultural workers, recognizing the warning signals, have died while attempting to save heritage in the face of violent attacks.

These brutal human costs are apparent and are our point of departure. But the loss of cultural heritage incorporates a full range of consequences. First, destruction is ruinous for cultural identity and social cohesion. The buildings, museums, cemeteries, libraries, and infrastructure around which societies organize themselves help define a culture and a people. Second, destruction of high-profile sites impedes postcrisis recovery; the negative impact on the economics of post-conflict financing is essential but often downplayed.[16] Third, the destruction of heritage deepens a society's wounds and intensifies lingering animosities and the accounts to be settled among belligerents. With this reality in mind, for instance, the 1995 Dayton Accords addressed specifically the reconstruction of lost heritage as a crucial component of peace, a necessary prelude to and prerequisite for peacebuilding in the former Yugoslavia.

Moral hazard appears throughout discussions and debates regarding the costs and benefits of all international actions, whether to protect cultural heritage or to intervene on behalf of vulnerable populations. The metaphor of the economics of insurance can be applicable whenever an incentive exists to increase the exposure to risk. For example, when individuals or corporations are insured, they may choose to run risks because they assume the insurer will bear the associated costs. In terms of protecting cultural heritage, disparate political, economic, and military calculations reflect the incentives and disincentives for acting sooner or later or not at all.

Delaying action could lead, for instance, to the kinds of deterioration resulting from refugees seeking shelter from the government of Bashar al-Assad in the World Heritage Site called the Ancient Villages of Northern Syria. Though these sites survived the

ravages of several empires and the weather for centuries, their use as informal camps presented a different kind of war-related threat, as the displaced can often out of necessity weaken or destroy foundations, cart off materials, or make additions to structures.[17] Alternatively, another type of hazard can result when declaring a visible heritage site off-limits for the military. That may attract enemy forces (regular troops or the armed opposition) deploying there specifically because they are more likely to be safe from assault. Weighing the benefits and costs when resources are limited provides a variation on calculations, especially when data is inconclusive or nonexistent. As such, determining what kinds of heritage are worth protecting and downplaying "military necessity" is complicated.

Attacks on cultural heritage for propaganda or performative reasons are another hazard that can result in dramatic and threatening images and results; the presence of outside forces can provide an irresistible target that can justify any action in response, including destroying local manifestations of cultural heritage. Indeed, it is possible that an unintended consequence of elevating the protection of cultural heritage is to instigate damage and destruction. This potential "dark side of cultural heritage protection"[18] may mean, ironically, that the more media and diplomatic coverage are afforded to the protection of a visible monument, the more interesting it becomes for groups to target it. Clearly, states and international organizations need to recognize possible negative side effects and attempt to counterbalance them in future policies and action. Hence, both ISIS and UNESCO "instrumentalize"[19] the protection of world heritage, with different worldviews and for distinctly different purposes.

Finally, when cultural heritage is destroyed, there are costs to all of us. Many observers view culture as a shared endeavor across peoples, time, and place—as evidence of our common humanity. The possibility of identifying with or becoming curious about the cultures of peoples distant in time and place and experiencing their cultures by traveling to cultural sites, visiting museums, and reading primary texts are time-tested paths to learning. When cultural heritage is destroyed, we lose that opportunity. Further, the elimination of artifacts, archives, and sites precludes future study and inhibits the resolution of archaeological, anthropological, and historical questions. "It is as though we lost a close relative," Haymen Rifai explained as she stood with her two daughters before the heavily damaged Great Umayyad Mosque in Aleppo. "I have always visited to this mosque, its feel, its smell—it is the essence of Aleppo. Zacaria [a prophet and father of John the Baptist in Islamic belief] is the protector of Aleppo. He is within our city."[20]

We have examined the value of lost cultural heritage from our point of view; but from the perspective of many belligerents, cultural heritage destruction brings distinct benefits. A handful of nonstate armed groups adhere to the principles of international humanitarian law; some have signed deeds of commitment with the NGO Geneva Call.[21] However, most take pleasure and even pride in flouting international law. Pariahs do

not lose but benefit from pillage and publicity. They have used destruction and damage to cultural heritage as a profitable tactic: performative, destructive, and violent theater. Far from hiding acts of vandalism, they celebrate them and even send photos and videos to print and broadcast media. Dismantling ancient infrastructure or targeting the cultural heritage of a particular population makes possible looting and profitable trafficking. It also has enabled "beneficial" public relations for supporters and facilitated outreach via social media to reportedly help recruitment.

International Legal Tools

Public international law, for cultural heritage as for many issues, is not the main problem. Rather, the challenge is the absence of the requisite political will to enforce existing hard and soft law (the latter consisting of such quasi-legal instruments as nonbinding declarations and resolutions). The judgment by Gary Bass in his history of humanitarian intervention is apt: "We are all atrocitarians now—but so far only in words, and not yet in deeds."[22]

A substantial body of international legal tools have been codified over the last century. And while states are bound by the provisions of public international law, they also provide normative guidance to other actors. A helpful place to begin is with the conventions deposited at UNESCO, such as the 1954 Convention for the Protection of Cultural Property in the Event of Armed Conflict; the 1970 Convention on the Means of Prohibiting and Preventing the Illicit Import, Export and Transfer of Ownership of Cultural Property; and the 1972 Convention Concerning the Protection of the World Cultural and Natural Heritage.[23] The common feature of these conventions is the "value" or "importance" of cultural heritage as the criterion for determining their status as "cultural property" or "cultural heritage." The 1972 definition, in particular, outlines the "outstanding universal value" of an artifact or site that elevates it to protected status; the 1954 definition implies this by pointing to "the cultural heritage of every people." The shared human value of immovable and movable cultural heritage is not limited to those who have inherited it directly or indirectly; this definition contrasts starkly with the more state-centric 1970 convention that makes "cultural property" contingent upon its specific designation by a state.

The 1954 convention aims to protect sites and artifacts during armed conflicts because such cultural heritage benefits humanity. By 1970, however, post-colonial sensitivities and nationalism stressed that heritage should remain within the borders of the state in which it was most recently discovered. This convention focuses more on interdicting trafficking in movable cultural heritage, whereas the earlier 1954 convention is concerned with preventing destruction, primarily of immovable cultural heritage.

The 1970 approach prioritizes the accidents of geography, arbitrary borders, and current political entities over any other value that a cultural heritage object or site may have. The case of the Hagia Sophia illustrates the difficulty in designating only the

current owner because it was built 1,500 years ago as an Orthodox Christian cathedral, subsequently converted into a mosque after the Ottoman conquest in 1453, a secular museum in 1934, and again a mosque in 2020. The state in power has the authority and political right to claim cultural heritage to be what it wants it to be. From such an attitude, the consolidations of Germany and Yemen, or the opposite in the implosion of the Soviet Union and the former Yugoslavia or the division of Sudan, created new "owners" of what national law claims as cultural "property." Conversely, the 1972 World Heritage Convention returns to a universal emphasis on the value of protecting cultural heritage. It aims less to oblige states to protect heritage within their borders and more to establish principles for UNESCO's World Heritage Committee, the body that selects sites to be included on the World Heritage List, among other functions.

State-centric views, unsurprisingly, characterize intergovernmental deliberations. But they also present obvious barriers to effective protection of immovable cultural heritage. For example, destroying the Bamiyan Buddhas, over several weeks beginning on 2 March 2001, arguably was a legal act by the then governing political authority: according to the 1970 convention, the Taliban government, as the representative of the Afghan state, was exercising its sovereign authority over the Buddhas. It did not consider the Buddhas valuable—indeed, quite the opposite: their value lay in the political act of their destruction and having it publicly documented and publicized. In addition, the value of the cultural heritage of minority groups—of Rohingya and Uyghur mosques in Myanmar and Xinjiang, churches and synagogues in Syria, Yezidi shrines anywhere, or the Maya heritage in Guatemala—depends on their being designated worth protecting by governments of states that do not value these cultural monuments but instead are often committed to destroying them to advance political agendas.

The lack of enforcement mechanisms is the largest deficit in global governance.[24] Its absence renders immovable cultural heritage especially vulnerable. The universality of cultural heritage in the 1954 and 1972 conventions does more to advance contemporary international protection efforts than the state-based conceptions of cultural property in the 1970 convention. The 1907 Hague Convention (IV) and the 1998 Rome Statute of the International Criminal Court (ICC) make destruction of cultural heritage a war crime.[25] Moreover, the latter's definition of crimes against humanity contains clauses that the current chief prosecutor and other experts interpret as promising avenues to provide additional legal protection for cultural heritage.

In brief, there are sufficient international legal tools to protect immovable cultural heritage should states decide to do so.

Is Anything New?

We began by stating the obvious: the wanton destruction of cultural heritage is not new. The Roman removal of war booty taken during the Dacian campaigns between 101–106 CE is just one ancient example; it is celebrated as such on the great sculpted column raised by the Emperor Trajan in Rome in 113 CE. "To the victors belong the spoils" is a

proverb that summarizes accurately the sad history of warfare and its aftermath. While recent examples have drawn increased attention, the destruction of cultural heritage has long been the legacy of the victor. The Mosque-Cathedral of Córdoba represents the changes wrought by damage and destruction at the hands of successive victors. It occupies a site that was first a small Visigoth church prior to becoming a mosque in the eighth century. The massive current cathedral is the result of a conversion of the mosque in the thirteenth century, during the Reconquista, with later modifications and additions. Each change erased the traces of the previous culture as an integral part of the campaign to establish a new orthodoxy.

Each destruction and reconstruction systematically serves to assert new masters and rewrite the record. Murdering people is one tactic; eliminating evidence of their history and identity is another. Former UNESCO director-general Irina Bokova, author of the foreword to this volume, used the term *cultural cleansing* to characterize contemporary cases.[26] This designation has an evocative appeal, albeit no legal meaning. Its provocative power resembles that of its cousin, *ethnic cleansing*—coined in the early 1990s to describe forced displacements in the former Yugoslavia—which also has no formal legal definition. Both cultural and ethnic cleansing, however, capture atrocity crimes that shock the human conscience with or without any definitive legal status.

While destroying cultural heritage is not new, neither is the impulse to protect and preserve it. Yet the contemporary convergence of two factors has altered the possibilities for the politics of protection and the feasibility of international action to support it. The first factor was introduced earlier: the destruction of cultural heritage has held the attention not only of curators, archaeologists, historians, and activists but also of major media outlets and popular audiences. Cultural specialists sound a clarion call when heritage is at risk for a variety of reasons—including deterioration due to environmental damage, lack of care and maintenance, and excessive economic development.

However, there is a wider and more immediate international recognition of the scale and significance of contemporary catastrophic assaults on cultural heritage amid mass atrocities. The destruction of the Buddhas, carved into the side of a cliff in the Bamiyan Valley of central Afghanistan between 570 and 618 CE, elicited almost universal condemnation. Other cases in the Balkans, Western Asia, and Africa also attracted media treatments around the world—none more than the televised destruction of the ancient remains of Palmyra.

What appeared to be a promising moment for mobilizing action when we conceived this project in 2017 has seemed less propitious of late. A widespread turning inward accompanied the ugliness of COVID-19, which mixed with the toxic burgeoning of new nationalisms and populisms. The pandemic etched in stark relief the extent of increasing interdependence and the urgent need for global cooperation at a moment when enthusiasm for the latter was in short supply. With a global depression brought on

by the coronavirus, the planet will remain hard-pressed to respond to current and future threats, including those to cultural heritage, without greater collaboration across borders and more robust intergovernmental institutions.

The onslaught against multilateralism is an unfortunate fact of international life. The new nationalisms and populisms appear to be metastasizing, not diminishing—for example, in Putin's Russia, Erdoğan's Turkey, Xi's China, Modi's India, Bolsonaro's Brazil, Duterte's Philippines, López Obrador's Mexico, el-Sisi's Egypt, Orbán's Hungary, Maduro's Venezuela, and rising right-wing political parties across Europe and elsewhere.

The protection of cultural heritage benefits from its association with the high politics of international security. Given the emotive power and ubiquity of the so-called Global War on Terror, the destruction of remote cultural heritage has become sufficiently politicized to draw the ire of groups ranging from UN member states to domestic political actors, NGOs, and individual consumers of the evening news. Governments frame the destruction of cultural heritage by terrorists as another front in the war on terror. As a result, official resources to protect cultural heritage could be more readily mobilized.

Since 2013, the need to protect cultural heritage under siege has become "a threat to international peace and security," the trigger in the UN Charter for Security Council decisions. The expansion of the definition of what constitutes a legitimate topic for council decision-making resembles the earlier shift toward vigorous humanitarian action in the 1990s. At the outset of that decade, diplomats viewed as exceptional the military interventions to protect people in northern Iraq and Somalia. Resolutions to protect Kurds followed the first UN enforcement action since Korea in the early 1950s; the resolution approving the Somalia intervention included eighteen mentions of the word "humanitarian" to underline how unusual the case was. The 1995 report by the Commission on Global Governance proposed that humanitarian catastrophes be the subject of a UN Charter amendment so that the Security Council could act—until then, some critics had questioned the legality and legitimacy of such decisions.[27] By the time the commission's report became publicly available, their recommendation was moot. The Security Council had already decided to respond robustly to other humanitarian catastrophes.

"Securitization" has many detractors, who point to the ease with which governments of all stripes can readily depict any critic as a "terrorist" to be repressed, in addition to creating barriers for humanitarians engaging with nonstate actors. However, advocates for elevating an issue often want it "securitized" because governments then tend to take such issues more seriously than "softer" threats; they devote more resources to addressing them. As such, the protection of immovable cultural heritage clearly has been securitized. In the same way that the Security Council's consideration of humanitarian disasters became a legitimate basis for action, decisions about the

protection of heritage have recently established precedents that have cleared the way for and could facilitate future decisions about more robust international action to safeguard cultural heritage.

Nonstate actors have attracted special attention in relationship to cultural heritage because of the political vacuums in Afghanistan and Iraq, the Arab Spring, and the expansion of numerous nonstate armed groups. While cultural heritage was previously absent from its deliberations, since 2013 the Security Council has passed four resolutions that address the protection of cultural heritage and the maintenance of international peace and security.

In April 2013, the Security Council unanimously passed resolution 2100, creating the Multidimensional Integrated Stabilization Mission in Mali (MINUSMA). This force comprised some twelve thousand peacekeepers, whose mandate included a special provision for support of cultural preservation: "to assist the transnational authorities of Mali, as necessary and feasible, in protecting from attack the cultural and historical sites in Mali, in collaboration with UNESCO." This was the first—and to date only—time that cultural protection specifically was included in the mandate of a UN peace operation. Protection later disappeared from the mandate's renewal, yet the successful involvement of local communities in heritage management and rebuilding in Mali was an early investment in a "virtuous circle" of peacebuilding. This precedent suggests the potential value of a more routine use of UN personnel to protect immovable cultural heritage, which could help foster social cohesion after traumatic violence.[28] The complementarity of military and civilian efforts can take the rough edges off "securitization" and foster "stabilization." Otherwise, as Hugh Eakin has argued in the *New York Times*, a brutal war could in fact be followed by "something that could be even worse: a dangerous peace."[29]

Passed unanimously in February 2015, Security Council resolution 2199 focused primarily on halting terrorist financing, but also mentioned the role of illicit trade in cultural heritage and the intentional and collateral damage to immovable cultural heritage, in Iraq and Syria, specifically by ISIL and the al-Nusrah Front. Resolution 2253, also passed unanimously in December 2015, built on resolution 2199 and expanded the jurisdiction of the Al-Qaida Sanctions Committee, renaming it the "ISIL (Da'esh) and Al-Qaida Sanctions Committee." Noting specifically the role of illicit trafficking of cultural heritage in terrorist financing, the Security Council encouraged public–private partnerships to implement sanctions.

To date, resolution 2347 is the most explicit and focused Security Council decision on protecting cultural heritage. Passed unanimously in March 2017, its operative passage begins with the admonition that the council "deplores and condemns the unlawful destruction of cultural heritage, inter alia destruction of religious sites and artefacts, as well as the looting and smuggling of cultural property from archaeological sites, museums, libraries, archives, and other sites, in the context of armed conflicts, notably

by terrorist groups." A half year earlier, in September 2016, the ICC found guilty Ahmad al-Mahdi, a member of an armed extremist group from northern Mali. The judgment against him was for committing a war crime in the deliberate 2012 attack on the UNESCO World Heritage Site of Timbuktu. The council noted the ICC verdict, making clear that states have the primary responsibility for protecting their cultural heritage, specifically calling attention to the threats of illegal excavation, illicit trade, and direct attacks. Resolution 2347 also encourages member states to provide one another with "all necessary assistance." In listing specific recommendations to facilitate domestic protection of cultural heritage, the resolution identifies two notable tools: for states with endangered cultural heritage, the use of a network of "safe havens" for endangered movable cultural property; and for states committed to the protection of immovable cultural heritage, contributions to multilateral funds dedicated to preventive and emergency operations. Specifically, it cites UNESCO's Heritage Emergency Fund and the International Alliance for the Protection of Heritage in Conflict Areas (ALIPH), a multilateral but French-led initiative that began in December 2016 in Abu Dhabi, the United Arab Emirates. The resolution also encourages member states to ratify the 1954 convention as well as other relevant international conventions—reflecting the fact that Mali's ratification of the ICC's Rome Statute had permitted the extradition, trial, and conviction of al-Mahdi.

During the opening week of the General Assembly in September 2017, the Global Centre for the Responsibility to Protect, the European Union, the Permanent Mission of Italy to the United Nations, UNESCO, and the UN Office on Drugs and Crime (UNODC) hosted a high-level meeting on "Protecting Cultural Heritage from Terrorism and Mass Atrocities: Links and Common Responsibilities." This marked a shift in discourse related to the protection of immovable cultural heritage: it embraced the R2P norm. Advocates will recognize a familiar theme: the onus of protection primarily reflects the responsibility of the state, an approach that builds on the point of departure for the original ICISS report, the 2005 World Summit decision, and UN Secretary-General Ban Ki-moon's 2009 reformulation of R2P. More significantly, UN member states laid the foundation for moving away from a virtually exclusive preoccupation with the looting of artifacts to finance terrorism to also focusing on the relationship between mass atrocities and cultural heritage.

The possible convergence of a new alliance of analysts and advocates in addition to the greater visibility of immovable cultural heritage on the Security Council's agenda could be interpreted as a half-full glass. It encourages policy steps to protect both people and cultural heritage because they are so difficult to disentangle. By building on the growing attention to and concern about destruction, norm entrepreneurs can link the once seemingly disparate and remote instances of mass atrocities and destruction of immovable heritage—an atrocity pattern that requires systematic international responses.

The fundamental question underlying this book is whether today's politics can be used to protect cultural heritage. How can we best research and publicize the conundrum? And can we mobilize sufficient political will to act?

Learning from R2P's Normative Journey: Conceptual and Political Steps

The development and emergence of R2P reflected an altered political reality: suddenly, it was no longer taboo to discuss how best to halt mass atrocities. Although specific decisions about when and where to invoke R2P remain controversial, few observers question whether to organize global responses to mass atrocities. Instead, the debate now centers on how to achieve R2P's lofty aims.

We tend to forget how breathtakingly brief the journey has been. Gareth Evans, former head of the International Crisis Group and ICISS cochair, described the period since the release of the ICISS report in December 2001 as "a blink of the eye in the history of ideas."[30] R2P has moved from the passionate prose of an international commission to being a mainstay of international public policy debates. Edward Luck reminded us that the lifespan of successful norms customarily is "measured in centuries, not decades."[31] But R2P is already embedded in the values of international society and occasionally in specific policies and responses to crises; it also has the potential to evolve further in customary international law and to contribute to ongoing conversations about the qualifications of states as legitimate, rather than rogue, sovereigns.

It is illustrative to track intergovernmental discourse since the official approval of R2P by the UN General Assembly in October 2005. The Security Council made specific references to R2P on two occasions in the year following the summit: in April, in resolution 1674 on the protection of civilians, and in August, in resolution 1706 on Darfur, which was the first to link R2P to a particular conflict. By 31 December 2021, some eighty-three resolutions and four presidential statements of the Security Council had been informed by R2P, along with sixty referencing the norm from the UN Human Rights Council and twenty-eight from the General Assembly.[32]

Could the destruction of immovable cultural heritage amid mass atrocities elicit not only enhanced international opprobrium but also more vigorous policies and actions? This research project is based on an optimistic reply to this question. Moreover, we believe we can learn conceptual and political lessons from that earlier journey.

Conceptual Steps

The 2005 World Summit decision to protect people is directly pertinent to the protection of immovable cultural heritage. As mentioned, ICISS's original three-pronged framework to ensure the protection of people—the responsibilities to prevent, to react, and to rebuild—is relevant for the protection of immovable cultural heritage. So too are former UN Secretary-General Ban Ki-moon's three pillars—the primary responsibility of states to protect their own heritage, the responsibility of others to help build that

capacity, and the international responsibility to respond in a timely and decisive manner if the first two pillars fail and mass atrocities occur.

"Military intervention" is typically the contested headline, but according to the original ICISS formulation, "prevention is the single most important dimension of the responsibility to protect."[33] Addressing both root and direct causes entails measures ranging from early warning to significant investments in political, economic, legal, and military infrastructure to promote human rights and justice. The real goal for the prevention of atrocities, or the protection of people, is to exhaust measures that "make it absolutely unnecessary to employ directly coercive measures against the state concerned" by helping and encouraging states to promote healthy societies. Regardless of whether one is a partisan of universal value or of national ownership, the destruction of immovable cultural heritage is a loss for humanity as well as for a state and its citizens. Prevention of its destruction is clearly the best form of protection and preferable to reconstruction.

The second responsibility, "to react," includes a range of options, from sanctions to international criminal justice to military intervention. Less intrusive actions should be pursued and exhausted before more intrusive options are taken. Hence, military force should be deployed in rare cases of profound humanitarian distress and, by extension, serious attacks on immovable cultural heritage—for itself and as a precursor for the mass atrocities that undoubtedly follow. Once less coercive means have been exhausted, or seriously considered and found lacking, military intervention presents itself as the remaining tool. At that time, "just cause" for intervention must be evident; the *2005 World Summit Outcome* document specifically enumerated four triggers: "genocide, war crimes, ethnic cleansing and crimes against humanity." As for just war theory, four precautionary principles also apply to R2P according to the original ICISS formulation: right intention, last resort, proportional means, and reasonable prospects. Both the triggers of the four mass atrocity crimes as well as R2P's precautionary principles should also govern international reactions to the destruction of immovable cultural heritage.

ICISS's third responsibility, "to rebuild," aims to shepherd post-conflict states toward more peaceful societies. Undertaking a military operation entails "a genuine commitment to helping to build a durable peace, and promoting good governance and sustainable development."[34] Rebuilding requires a consolidation of peace through security, the implementation of robust reconciliation programs, and sustainable economic development. Without these, forceful intervention may be for naught. Libya is a telling example of intervention without follow-up.[35] Despite the benefits of remaining in the country long enough to cultivate the institutions necessary for a durable peace, prolonged occupation also entails liabilities; this double-edged sword also applies to immovable cultural heritage. Large and sudden influxes of external funds into local economies may create harmful dependency and prevent the restoration of a responsible

state. In addition, reconstruction can easily become, but should not be, political—for example, the announced Russian reconstruction of the Great Umayyad Mosque in Aleppo to curry favor with the Assad government, to render it more dependent on the Russians, and to give Putin's government a larger foothold in Syria.[36]

Although R2P originally had three sequential responsibilities, the norm's reconceptualization has continued, as will undoubtedly the efforts to counter the destruction of immovable cultural heritage. The formal adoption of R2P by the General Assembly in paragraphs 138–40 of the *2005 World Summit Outcome* document referred not only to the primary responsibility of each state to prevent and react to atrocity crimes, but also to the international responsibility to build that capacity and to react when mass atrocities nonetheless result—two of the three ICISS responsibilities to protect.[37]

However, ICISS's original three responsibilities have invited criticism, even from advocates of robust human security. Some argue that the implied sequencing of prevention, reaction, and rebuilding is too mechanical and can impede operational plans and implementation. Reluctant states can manipulate the stages to forestall action against mass atrocities—for example, if not every single potential preventive measure has been tried, intervention could be forestalled as "premature" despite demonstrable risks of delaying. Opponents of ICISS's emphasis on state culpability in crimes and on conditional, instead of absolute, sovereignty reflect familiar and long-standing criticisms from parts of the Global South about the Trojan horse of Western imperialism.

As noted, then UN secretary-general Ban influenced the operational development of R2P by reformulating the original ICISS framework in his 2009 report, *Implementing the Responsibility to Protect.*[38] Subsequent annual follow-up reports provided more details about the three pillars, which emphasized the primary responsibility of a state to its own citizens, along with the responsibility of other states to help build capacities, and the international responsibility to respond in the face of a manifest demonstration of an inability or unwillingness to protect citizens. The three original ICISS responsibilities can be characterized as part of Ban's second and third pillars—although without specific reference to prevention, reaction, and rebuilding that track the vocabulary of protecting immovable cultural heritage. The pillars do not explicitly mention postintervention rebuilding.[39] They also reflect a renewed sensitivity to sovereignty and an allergy to forcible intervention, especially military. Nonetheless, they have framed conversations about R2P in UN circles ever since 2005, including for the annual General Assembly informal interactive dialogues on R2P, held from 2009 to 2017, and for the assembly's regular agenda since 2018.

Although the three pillars may be an easier political sell, ICISS's original three responsibilities provide a more logical starting point to fashion a workable framework for protecting cultural heritage amid mass atrocities. If a site is partially or totally destroyed (that is, no effective prevention has occurred), the next option is to intervene

to protect what remains or defend other sites nearby. If prevention and intervention fall short, the remaining responsibility is to rebuild both the destroyed sites and monuments and the societies in which they are located.

Political Will and the R2P Process

Four features of the effort to formulate, modify, and apply the responsibility to protect furnish guidance about how best to pursue an international framework for the protection of cultural heritage amid mass atrocities. First, major states backed ICISS. Canada did the heavy lifting both financially and politically; but Norway, Switzerland, and Sweden, along with foundations (especially the MacArthur Foundation), were helpful. Such financial and political backing was essential for the work of the commission itself and for follow-up.

Second, in addition to key states, ICISS enlisted input and support from a diverse range of actors. To ensure that the project had legitimacy among various international audiences and to promote buy-in, the sponsors recruited commissioners from the Global North and South (including one of each as cochairs) and from major regions. The countries represented by the commissioners included Australia, Algeria, Canada, Germany, Guatemala, India, the Philippines, Russia, South Africa, Switzerland, and the United States. In addition, ICISS itself held thirteen consultations worldwide to explore the issues and receive a range of feedback from the public and private sectors.

Third, ICISS built R2P on earlier conceptual foundations. The R2P framework's dual responsibility—internal and external—drew substantially on pioneering work by Francis Deng and Roberta Cohen, both then at the Brookings Institution. Their concept of "sovereignty as responsibility," developed for internally displaced persons (IDPs), was an essential building block.[40] It emphasized the need—indeed, the duty—of the international community of states, embodied by the United Nations and mandated since its creation, to deliver "freedom from fear" by doing everything possible to prevent mass atrocities. Deng and Cohen's advocacy confronted head-on the paradox of sovereignty in the face of massive abuse by a state: the protection of IDPs depended on cooperation from the very state authorities that caused the forced displacement of their citizens in the first place. Ironically, citizens who remained within the boundaries of their own countries and dodged government perpetrators had fewer protections than refugees. At least the latter could call upon international humanitarian law, intergovernmental organizations, and NGOs when crossing borders.

Fourth, tenacity and patience were required. After its initial launch at the 2001 General Assembly, R2P required ongoing promotion, invocation, and support for half a decade before the World Summit decision and a decade before the Security Council applied it to the Libyan crisis. The ICISS report, completed in August 2001, met a temporary setback with the attacks on September 11. The United Nations and its most powerful member state and largest funder were focused almost entirely on counterterrorism. Nevertheless, the ICISS report was presented to the UN Secretary-

General and to the General Assembly in December and received wide acclaim. Canada continued its advocacy—until the Stephen Harper administration in 2006—which relied on the cochairs, Gareth Evans and Mohamed Sahnoun, and two of the commissioners, Ramesh Thakur and Michael Ignatieff. Advocacy and monitoring work continued through two New York–based NGOs, the Global Centre for the Responsibility to Protect and the International Coalition for the Responsibility to Protect. In addition, academic and policy communities grew.

The momentum continued in the lead-up to the September 2005 World Summit on the UN's sixtieth anniversary. The UN High-level Panel on Threats, Challenges and Change published *A More Secure World: Our Shared Responsibility*, which affirmed R2P. The following year, UN Secretary-General Kofi Annan's five-year progress report on the Millennium Declaration, *In Larger Freedom*, called on the Security Council to adopt a set of principles that would affirm its authority to mandate the use of force to prevent and react to crimes of atrocity.[41] Paragraphs 138–40 of the *2005 World Summit Outcome* document cited the primary responsibility of each state to prevent and react to atrocity crimes, as well as the international responsibility to build that capacity and to react when mass atrocities nonetheless resulted. Since then, this language has been the basis for numerous intergovernmental resolutions and for states to create the Joint Office of the Special Advisor on the Prevention of Genocide and on the Responsibility to Protect.

The Value Added of Protecting Heritage as Well as People

This volume considers the destruction of immovable cultural heritage in the face of mass atrocities, wherever they occur, whether during an "armed conflict" (that is, war declared or not, international or non-international) or an internal disturbance.[42] International policy or action that could prevent or attenuate large-scale intentional attacks on immovable cultural heritage reflects R2P's four mass atrocity crimes: genocide, war crimes, crimes against humanity, and ethnic cleansing. The emphasis on protecting heritage and people thus has analytical, legal, and political traction.

This focus examines destruction that arises not only from such interstate and intrastate (or civil) wars as Iraq, Syria, Afghanistan, and Mali, but also from state and nonstate perpetrators no matter the context. It does not distinguish immovable heritage with outstanding universal value (for example, UNESCO's World Heritage Sites) from more common sites, such as places of worship, cemeteries, or libraries. Equally, our emphasis includes rapid (the Rohingya in Myanmar) or slower-motion ethnic cleansing (the Uyghurs in China); decisions by rogue states (the Taliban's destruction of the Bamiyan Buddhas); and actions taken in the contested Global War on Terror by nonstate armed groups (ISIS on Yezidi shrines, and al-Qaeda on Shia and Sufi mosques).

Effectively addressing the deliberate destruction of cultural heritage does not require additional public international law. It necessitates accelerating the ongoing international normative and policy momentum, which builds on the international legal regime. The ways and means by which states and nonstate actors wage war as well as

perpetrate atrocities have changed substantially, and responses by the international community of states should as well. Responsible members of this community view the commission of mass atrocity crimes as a matter of international concern, not only of national jurisdiction. The destruction of immovable cultural heritage should be viewed similarly, given, as we have argued, the close linkage between attacks on cultural objects, structures, and monuments, on the one hand, and attacks on civilian populations, on the other.

The value added for advocates of R2P is the potential to widen support for the norm. It is counterproductive to establish a hierarchy of protection; the choice between either protecting people or protecting heritage is false. In referring to the Middle East and Asia, but with general relevance, we agree with a 2016 succinct judgment from three NGOs: "The fight to protect the peoples of the region and their heritage cannot be separated."[43]

The wanton destruction of cultural heritage is not another crime to add to the four mass atrocities agreed by the 2005 World Summit. Such destruction is a war crime and, arguably, a crime against humanity. As an underlying offense under two of the four existing mass atrocity crimes, it thus is a fundamental aspect of the responsibility to protect. The R2P norm requires understanding better the connections between vulnerable people and their cultural heritage; the imperative is to protect both.

The attempt to annihilate history, Raphael Lemkin argued, proceeds with "the destruction of the cultural pattern of a group, such as the language, the traditions, monuments, archives, libraries, and churches. In brief," he summarized, "the shrines of a nation's soul."[44] Our book appears at a moment when cultural heritage seems to occupy as prominent a place in private and public space as it did when Lemkin was advocating actively for measures to counteract cultural genocide. Quite simply, murdering people cannot be separated from destroying the cultural artifacts and monuments of their history. Despite the current political moment in which many countries are circling the wagons and looking inward, we nonetheless believe that it is time to begin a longer-term project of constructing an international regime to protect immovable cultural heritage and the peoples who identify with and benefit from it today and into the future.

NOTES

1. Parts of this chapter draw on Thomas G. Weiss and Nina Connelly, *Cultural Cleansing and Mass Atrocities: Protecting Heritage in Armed Conflict Zones*, Occasional Papers in Cultural Heritage Policy no. 1 (Los Angeles: Getty Publications, 2017), https://www.getty.edu/publications/occasional-papers-1/; and "Protecting Cultural Heritage in War Zones," *Third World Quarterly* 40, no. 1 (2019): 1–17.

2. James Cuno and Thomas G. Weiss, eds., *Cultural Heritage under Siege: Laying the Foundation for a Legal and Political Framework to Protect Cultural Heritage at Risk in Zones of Armed Conflict*, Occasional Papers in Cultural Heritage Policy no. 4 (Los Angeles: Getty Publications, 2020), https://www.getty.edu/publications/occasional-papers-4/.

3. Frederik Rosén, "Introduction," in *Cultural Heritage and Armed Conflict: Preserving Art While Protecting Life*, ed. Frederik Rosén (Oxford: Oxford University Press, forthcoming).

4. See Matthew Clapperton, David Martin Jones, and M. L. R. Smith, "Iconoclasm and Strategic Thought: Islamic State and Cultural Heritage in Iraq and Syria," *International Affairs* 93, no. 5 (2017): 1205–31.

5. UNESCO, "Strategy for the Reinforcement of UNESCO's Action for the Protection of Culture and the Promotion of Cultural Pluralism in the Event of Armed Conflict," doc. no. 39 C/57, 24 October 2017.

6. ICISS, *The Responsibility to Protect* (Ottawa: International Development Research Centre, 2001); and Thomas G. Weiss and Don Hubert, eds., *The Responsibility to Protect: Research, Bibliography, Background* (Ottawa: International Development Research Centre, 2001).

7. Hugh Eakin, "Use Force to Stop ISIS' Destruction of Art and History," *New York Times*, 3 April 2015.

8. Donald Bloxham and A. Dirk Moses, eds., *The Oxford Handbook of Genocide Studies* (Oxford: Oxford University Press, 2010); Douglas Irvin-Erickson, *Raphaël Lemkin and the Concept of Genocide* (Philadelphia: University of Pennsylvania Press, 2017); John Cooper, *Raphael Lemkin and the Struggle for the Genocide Convention* (New York: Palgrave Macmillan, 2008); and William Korey, *An Epitaph for Raphael Lemkin* (New York: Blaustein Institute, 2001).

9. Raphael Lemkin, "Acts Constituting a General (Transnational) Danger Considered as Offences Against the Law of Nations," 1933, http://www.preventgenocide.org/lemkin/madrid1933-english.htm; and *Axis Rule in Occupied Europe: Laws of Occupation, Analysis of Government, Proposals for Redress* (Washington, DC: Carnegie Endowment for International Peace, 1944), xiii. For a discussion, see James Waller, *Confronting Evil: Engaging Our Responsibility to Prevent Genocide* (Oxford: Oxford University Press, 2016), 7–8; and Philippe Sands, *East West Street* (New York: Vintage Books, 2016), 160–61.

10. Edward C. Luck, *Cultural Genocide and the Protection of Cultural Heritage*, Occasional Papers in Cultural Heritage Policy no. 2 (Los Angeles: Getty Publications, 2018), 23–27, https://www.getty.edu/publications/occasional-papers-2/.

11. A. Dirk Moses, "Raphael Lemkin, Culture, and the Concept of Genocide," in *The Oxford Handbook of Genocide Studies*, ed. Bloxham and Moses, 19–41.

12. Philip E. Tetlock and Aaron Belkin, eds., *Counterfactual Thought Experiments in World Politics: Logical, Methodological, and Psychological Perspectives* (Princeton, NJ: Princeton University Press, 1996).

13. Helen Frowe and Derek Matravers, *Conflict and Cultural Heritage: A Moral Analysis of the Challenges of Heritage Protection*, Occasional Papers in Cultural Heritage Policy no. 3 (Los Angeles: Getty Publications, 2019), https://www.getty.edu/publications/occasional-papers-3/.

14. Kwame Anthony Appiah, *Cosmopolitanism: Ethics in a World of Strangers* (New York: W. W. Norton, 2006), xiv.

15. Appiah, *Cosmopolitanism*, xv.

16. Graciana del Castillo, *Obstacles to Peacebuilding* (London: Routledge, 2017).

17. Ben Hubbard, "War Exiles Find Shelter in the Eighth Century," *New York Times*, 20 April 2021.

18. Frederik Rosén, "The Dark Side of Cultural Heritage Protection," *International Journal of Cultural Property* 27, no. 4 (2020): 495–510.

19. Lynn Meskell, *A Future in Ruins: UNESCO, World Heritage, and the Dream of Peace* (New York: Oxford University Press, 2018), 203.

20. Quoted by Patrick J. McDonnell, "'There Are No Words that Can Describe My Sadness': Syrians Return to Aleppo to Find Their Beloved Mosque Destroyed," *Los Angeles Times*, 15 May 2017.

21. See Geneva Call, "Where We Work: Humanitarian Norms," https://www.genevacall.org/where -we-work/.

22. Gary Bass, *Freedom's Battle: The Origins of Humanitarian Intervention* (Princeton, NJ: Princeton University Press, 2008), 382.

23. The complete texts are available at http://www.unesco.org/new/en/culture/themes/culture-and -development/the-future-we-want-the-role-of-culture/the-unesco-cultural-conventions.

24. Thomas G. Weiss and Ramesh Thakur, *Global Governance and the UN: An Unfinished Journey* (Bloomington: Indiana University Press, 2010).

25. For the text of these treaties, see the International Committee of the Red Cross, https://ihl -databases.icrc.org/ihl/INTRO/195; and ICC, https://www.icc-cpi.int/nr/rdonlyres/ea9aeff7-5752 -4f84-be94-0a655eb30e16/0/rome_statute_english.pdf.

26. She first used the term in December 2014 in UNESCO, *Heritage and Cultural Diversity at Risk in Iraq and Syria* (Paris: UNESCO, 2014), www.unesco.org/new/fileadmin/MULTIMEDIA/HQ/CLT/ CLT/pdf/IraqSyriaReport-en.pdf. For her interpretation of her term as director-general of UNESCO, see Irina Bokova, *UNESCO's Response to the Rise of Violent Extremism: A Decade of Building International Momentum in the Struggle to Protect Cultural Heritage*, Occasional Papers in Cultural Heritage Policy no. 5 (Los Angeles: Getty Publications, 2021), https://www.getty.edu/ publications/occasional-papers-5/.

27. Commission on Global Governance, *Our Global Neighbourhood* (Oxford: Oxford University Press, 1995), 90.

28. Mathilde Leloup, "Heritage Protection as Stabilization, the Emergence of a New 'Mandated Task' for UN Peace Operations," *International Peacekeeping* 26, no. 4 (2019): 408–30. See also Roger Mac Ginty and Oliver P. Richmond, "The Local Turn in Peace Building: A Critical Agenda for Peace," *Third World Quarterly* 34, no. 5 (2013): 763–83.

29. Hugh Eakin, "Saving an Enemy's Culture," *New York Times*, 1 December 2020.

30. Gareth Evans, *The Responsibility to Protect: Ending Mass Atrocity Crimes Once and for All* (Washington, DC: Brookings, 2009), 28.

31. Edward C. Luck, "The Responsibility to Protect: The First Decade," *Global Responsibility to Protect* 3, no. 4 (2011): 387.

32. For up-to-date tallies, see the Global Centre for the Responsibility to Protect, "UN Security Council Resolutions and Presidential Statements Referencing R2P," "R2P References in United Nations Human Rights Council," and "R2P References in United Nations General Assembly Resolutions," https://www.globalr2p.org/resources/.

33. ICISS, *The Responsibility to Protect*, ix and 23.

34. ICISS, *The Responsibility to Protect*, 39.

35. Srinjoy Bose and Ramesh Thakur, "The UN Secretary-General and the Forgotten Third R2P Responsibility," *Global Responsibility to Protect* 8, no. 4 (2016): 343–65.

36. Frederick Deknatel, "What Would Reconstruction Really Mean in Syria?," *Los Angeles Review of Books*, 6 August 2019, https://lareviewofbooks.org/contributor/frederick-deknatel/.

37. UN, *2005 World Summit Outcome*, UN doc. A/RES/60/1, 24 October 2005.

38. Ban Ki-moon, *Implementing the Responsibility to Protect: Report of the Secretary-General*, UN doc. A/63/677, 12 January 2009.

39. Mohamed Sahnoun, foreword to *Responsibility to Protect: Cultural Perspectives in the Global South*, ed. Rama Mani and Thomas G. Weiss (London: Routledge, 2011), xx–xxvi.

40. Francis M. Deng, "Frontiers of Sovereignty," *Leiden Journal of International Law* 8, no. 2 (1995): 249–86; and "Reconciling Sovereignty with Responsibility: A Basis for International Humanitarian Action," in *Africa in World Politics: Post–Cold War Challenges*, ed. John W. Harbeson and Donald Rothschild (Boulder, CO: Westview, 1995), 295–310. For more details, see

Thomas G. Weiss and David A. Korn, *Internal Displacement: Conceptualization and Its Consequences* (London: Routledge, 2006).

41. Kofi A. Annan, *A More Secure World: Our Shared Responsibility* (New York: United Nations, 2004); and *In Larger Freedom: Towards Development, Security, and Human Rights for All* (New York: United Nations, 2005).

42. Patty Gerstenblith, "The Destruction of Cultural Heritage: A Crime against Property or a Crime against People?," *John Marshall Review of Intellectual Property Law* 15, no. 336 (2016): 336–93.

43. Middle East Institute, Asia Society, and the Antiquities Coalition, *#CultureUnderThreat: Recommendations for the U.S. Government*, April 2016, 1, http://www.academia.edu/30873427/Culture_Under_Threat_Recommendations_for_the_U.S_Government.

44. Donna-Lee Frieze, *Totally Unofficial: The Autobiography of Raphael Lemkin* (New Haven, CT: Yale University Press, 2013), 172.

PART 1
Cultural Heritage and Values

Introduction: Part 1

James Cuno

Thomas G. Weiss

This volume begins where all serious investigations about any topic should—namely, "values." Part 1 comprises six distinctive essays, each exploring the perceived value of cultural heritage by individuals who identify with or against it, as well as threats against such heritage.

Kwame Anthony Appiah, the distinguished philosopher from New York University's School of Law, has long explored the nature and complexity of the value of identity. In his 2006 book *Cosmopolitanism: Ethics in a World of Strangers*, he argued that the connection through a local identity is as imaginary as the connection through humanity. "The Nigerian's link to the Benin bronze, like mine, is a connection made in the imagination; but to say this isn't to pronounce either of them unreal. They are among the realest connections that we have." Twelve years later, in his book *The Lies That Bind: Rethinking Identity*, from which two passages are here reproduced, he argued that identities—racial, religious, ethnic, and political—matter: "not only does your identity give *you* reasons to do things, it can give others reasons to do things *to* you." Few thinkers have examined the complexities of identity with more precision than Appiah. This is why we begin this book with his question, "Who Are We? Identity and Cultural Heritage." Appiah's question provides insights into what follows in subsequent chapters: the appalling and numerous examples of mass atrocities and cultural heritage destruction as well as the range of normative, legal, and military responses that seek to attenuate the worst aspects. Much of what divides human beings—and leads to mass atrocities and cultural heritage destruction—are shallow parochial views that fail to capture the extent to which all of us possess multiple human identities, the extent to which all cultures are a hodgepodge or combination of other influences, languages, and cultures. Thus, reinterpreting and reforming excessively narrow notions of circumscribed identities are essential tasks for human solidarity, and make it possible to cooperate and govern societies—or at least not commit atrocities and destroy the cultural heritage of others.

Chapter 2 asks, "Why Do We Value Cultural Heritage?" This thorny question, as well as some thought-provoking answers, emanate from Neil MacGregor, former director of the Humboldt Forum, Berlin, the British Museum, and London's National Gallery. For

him, cultural heritage is meaningful not because of its economic value but rather because of its association with a community of individuals who see in it narratives about themselves and earlier generations with whom they identify. Preventing or limiting a loss of or damage to cultural heritage is "the purpose of this book," MacGregor reminds us. It requires our understanding that, as the American writer Joan Didion pointedly put it, "we tell ourselves stories in order to live." MacGregor judges the most essential and yet controversial aspect of cultural heritage to be the assumption that it reflects a community of shared values. He builds his case on two recent examples—the statues and images of slave traders and colonial champions following the 2020 demonstrations of the Black Lives Matter movement, and the cultural heritage of postwar Eastern Europe in the 1990s following the implosion of the Soviet Union. What matters is not the artistic value of sites or artifacts, but the communal or political narratives that they sustain. MacGregor asks whether an offensive narrative and its symbols must be destroyed for the society to become what it could and should be; whether the political importance of destroying the symbols of disgraced ideologies—no matter how important for collective memory—may override the legal, moral, or normative considerations of protecting them. In MacGregor's terms, it is the "embedding of meaning that makes an archaeological site, a building, or a monument into a piece of cultural heritage." He muses about the applicability of the classical economist Joseph Schumpeter's theory of "creative destruction" to the realm of cultural heritage. Does getting rid of the old to make way for the new mean that authorities and dissidents are faced with decisions about editing or censoring the past, about what and how to remember and protect, and what and how to forget and rebuild?

Chapter 3 is aptly titled "Cultural Heritage under Attack: Learning from History." Hermann Parzinger is the president of the Prussian Cultural Heritage Foundation and an authority on the culture of the ancient Scythians. He begins his essay by pointing out what should perhaps be obvious, but is not always—namely, that there is a host of motivations behind the impulse to destroy cultural heritage. Some are perhaps more easily understandable than others, but the main motivation is cultural erasure as official propaganda. "It may not always be possible to clearly differentiate between the various reasons driving the destruction of cultural heritage," he notes, but such motivating factors must be parsed correctly if we are to formulate appropriate international policy proposals, explore feasible political mobilization, and take meaningful action. The intertwined motivations driving destruction range from notoriety to plunder, from iconoclasm (for religious, racial, or ethnic purposes) to appropriation for conversion, from ideological subjugation to crass economic profit. The last motivation is often overlooked, even if "economic reasons are also always present." In this respect, Parzinger's overview begins with Ancient Greece and Rome, then continues to Byzantium, the Protestant Reformation, and the French Revolution before discussing the early twentieth-century destructions during British colonialism, the Bolshevik and Chinese Revolutions, and the Third Reich. He concludes with an

assessment of recent attacks on the cultural heritage of communities caught in the crosshairs of armed conflicts of the late twentieth and early twenty-first centuries. Parzinger characterizes contemporary wars, often fought among nonstate actors, as constituting a distinct departure from earlier threats because today's attacks can so readily be exploited for propaganda purposes: "the most fundamental distinction relative to earlier times" results because their destruction can "play out in front of a global audience."

In chapter 4, Glen W. Bowersock, professor emeritus of ancient history at the Institute for Advanced Study, Princeton, examines "The Cultural Heritage of Late Antiquity." He begins with the Peloponnesian War and the Thracians attacking Mycalessus, sacking its houses and temples and butchering its inhabitants. He then describes the Romans' deliberate and systematic assault on Corinth, followed by the attack by King Mithridates and his army and their massacre of eighty thousand Roman citizens in the space of a single day. Among the lessons Bowersock extracts from his insightful historical overview is the difficulty of formulating meaningful generalizations, including the anomalous absence of atrocities and large-scale heritage destruction, despite numerous conquests, during the first four centuries of the Roman Empire. Determining whether this period was the exception that proves the rule is further complicated because of two prominent exceptions during this period of Roman rule. They involved deliberate and fierce assaults on monuments precisely because of their religious significance—the Second Jewish Temple in Jerusalem and the Serapeum in Alexandria and its library. An encouraging lesson for Bowersock is the resilience of peoples across time and place. Individuals tenaciously maintain their cultures and rebuild their cultural institutions despite the high costs of resistance in the first place and of efforts to rebuild amid threats and repression. He observes that "there is no single answer as to what causes damage or loss where cultural heritage is at risk, and so there is no single answer to the question of how to preserve such heritage." He concludes, after an account of the deliberate destruction of so much of Palmyra by Da'esh (ISIS), that "those of us who struggle, as many try to do, to protect and conserve the cultural heritage of peoples must try to defeat and crush a group such as Da'esh with the same tenacity that we bring to annihilating an invisible natural enemy" like the plague or climate change.

The following essay, chapter 5, is Professor Sabine Schmidtke's comprehensive look at threats to "The Written Heritage of the Muslim World." One of Bowersock's colleagues at the Institute for Advanced Study, Princeton, she explores the written heritage that is menaced throughout the contemporary Middle East by conflicts ranging from Bosnia-Herzegovina (in the former Yugoslavia), especially in 1992, to Iraq and Iran, and from Yemen and Syria to Libya. Her in-depth investigation focuses on Muslim authors writing in Arabic, but her detailed descriptions of the centuries-long threats in the Arab world also are directly relevant to the destruction of such Muslim manuscripts as those in Timbuktu (Mali) in 2012, Sukur (Nigeria) in 2015, and Mosul (Iraq) in 2015. Schmidtke

concludes by noting the additional threat to "libraries holding books and manuscripts that are seen as containing deviant views," as they "are targeted for destruction," joining numerous "historical monuments, shrines, and religious sites" that "have been destroyed over the past several decades by Muslim extremists in an attempt to 'purify' Islam." In short, intolerance, sectarianism, and numerous types of censorship pose distinct threats to Islamic cultural heritage worldwide and not simply in the Arab world. Holding narrow notions of what is allegedly authentic is a conscious strategy of Wahhabism, Salafism, and jihadism in a wide variety of locations.

Chapter 6 offers the final perspective of part 1. "Valuing the Legacy of Our Cultural Heritage" represents the analytical perspective of Ismail Serageldin, emeritus librarian of the Library of Alexandria and former vice president of the World Bank. Applying his economist's lens to our concerns, he pushes the reader to ask tough questions about assigning a specific "value" to cultural heritage under siege, not as measured by the subjective variables of humanists but rather by the more concrete ones of harder-nosed financial analysts. He explains why: "the purposeful actions of nonstate armed groups, militias, despotic governments, or invading armies in attacking tangible cultural heritage inflict losses that far exceed the mere physical destruction of monuments or the disappearance of objects." He discusses tools that were developed for the deterioration of sites—for example, from environmental degradation, myopic decisions about investments, or the misguided use of development assistance—and ignored many shadow costs. Serageldin argues that the destruction of tangible and immovable cultural heritage inflicts significant externalities, which, if appropriately calculated, entail costs that dwarf those of their physical disappearance. Arguing that "destructive actions are akin to cultural and social genocide," he asserts that the true value, measured in both use and nonuse terms, of such heritage would justify substantial expenditures. They would be defensible to maintain as well as to protect cultural heritage from destruction during wars or civil unrest, and to rebuild it afterward. But at least as powerful from Serageldin's perspective are the cosmopolitan and humanistic values attached to local and national identity, self-confidence, and pride. Maintaining the links to the past are essential for all populations to design their own futures; they are especially necessary for the survivors of attacks by the murderous perpetrators of atrocities.

1

Who Are We? Identity and Cultural Heritage

Kwame Anthony Appiah

I have been writing and ruminating on questions of identity for more than three decades now. My theoretical thinking about identity began, actually, with thoughts about race, because I was genuinely puzzled by the different ways in which people in different places responded to my appearance. That wasn't so much the case in Asante, where, so it seemed to me, one local parent was usually enough to belong. Jerry Rawlings, Ghana's head of state from 1981 to 2001, had a father from Scotland; he wasn't chosen by the people originally—he came to power twice through coups d'état—but his fellow countrymen eventually elected him to the presidency twice. Unlike my three sisters, born, like my father, in Asante, I have never been a Ghanaian citizen. I was born in England, before Ghana's independence, with an English mother, and showed up in Asante at the age of one. So I'd have had to apply for Ghanaian citizenship, and my parents never applied for me. By the time it was up to me, I was used to being a Ghanaian with a British passport. My father, as president of the Ghanaian Bar Association, was once involved in writing one of our many constitutions. "Why don't you change the rules, so that I can be both Ghanaian and British?" I asked him. "Citizenship," he told me, "is unitary." I could see I wasn't going to get anywhere with him! But despite my lack of that legal connection, sometimes, when I do something noteworthy, I am claimed, at least by some, for the place that is home to half my ancestry.

The story in England was complex, too. In my grandmother's village, Minchinhampton, in Gloucestershire, where I spent much time in my childhood, those we knew never appeared to doubt our right to be there. My aunt and uncle lived in this picturesque market town in the West of England, too. My aunt had been born there. My grandfather had spent time as a child at a house in the valley, which belonged to his uncle, whose mill had once woven cloth for the tunics of British soldiers and green baize for billiard tables. My great-grandfather, Alfred Cripps, had briefly served as the

member of parliament for Stroud, a few miles to the north, and *his* great-grandfather, Joseph Cripps, had represented Cirencester, a few miles east, for much of the first half of the nineteenth century. And there were Crippses in that area—some buried in Cirencester churchyard—dating back to the seventeenth century.

But the skins and the African ancestry I shared with my sisters marked us out as different, in ways we weren't always conscious of. I recall going to a sports day, a few years ago, at a school in Dorset I'd attended as a preteen, and coming upon an elderly man who had been headmaster in my day. "You don't remember me," I apologized, as I introduced myself to him. Hearing my name, he brightened and took my hand warmly. "Of course, I remember you," he said. "You were our first colored head boy." When I was young, the idea that you could be properly English and not white seemed fairly uncommon. Even in the first decade of the twenty-first century, I remember the puzzled response of an older Englishwoman who had just heard a paper on race I gave at the Aristotelian Society in London. She just didn't understand how I could really be English. And no talk of thirteenth-century ancestors in Oxfordshire could persuade her!

In America, once I got there, things seemed at first relatively simple. I had an African father and so, like President Obama later, I was Black. But the story here, too, is complicated . . . and has changed over the years, in part because of the rise of the idea of mixed race people as an identity group. Color and citizenship, however, were quite separate matters: after the Civil War no sensible person doubted you could be Black and American. At least so far as the law was concerned, despite a persistent undercurrent of white racial nationalism. I'll say more about the ideas of race that shaped these experiences later but hope it's clear why I might have ended up puzzled about how to make sense of them.

When I turned over the years to thinking about nationality and class and culture and religion as sources of identity, and added in gender and sexual orientation, I began to see three ways in which these very disparate ways of grouping people do have some important things in common.

Labels and Why They Matter

The first is obvious: every identity comes with labels, so understanding identities requires first that you have some idea about how to apply them.[1] Explaining to someone what Ewes or Jains or *kothis* are begins with some suggestion as to what it is about people that makes each label appropriate for them. That way, you could look for someone of that identity, or try to decide, of someone you'd met, whether the label applied.

So, the label "Ewe" (usually pronounced eh-vey or eh-wey) is an ethnic label, what social scientists call an "ethnonym"; which means that if your parents are both Ewe, you're Ewe, too. It applies, in the first place, to people who speak one of the many dialects of a language that is called "Ewe," most of whom live in Ghana or Togo, though there are some in many other parts of West Africa and, increasingly, around the world.

As is typical of ethnic labels, there can be arguments about whether it applies to someone. If only one of your parents is Ewe and you never learned any of the many dialects of the Ewe language, are you Ewe? Does it matter (given that the Ewe are patrilineal) if the parent was your mother rather than your father? And, since Ewe belongs to a larger group of languages (usually called "Gbe" because that's the word for language in all of them) that shade off into one another, it's not easy to say exactly where the boundaries between Ewe people and other Gbe-speaking people lie. (Imagine looking for the boundaries of Southern speech in America or a cockney accent in London and you'll grasp the difficulty.) Nevertheless, large numbers of people in Ghana and Togo will claim that they're Ewe and many of their neighbors will agree.

That's because of the second important thing identities share: they matter to people. And they matter, first, because having an identity can give you a sense of how you fit into the social world. Every identity makes it possible, that is, for you to speak as one "I" among some "us": to belong to some "we." But a further crucial aspect of what identities offer is that they give you reasons for doing things. That's true about being a Jain, which means you belong to a particular Indian religious tradition. Most Jains are the children of two Jains (just as most Ewes are the children of two Ewes), but there's much more to it than that. And anyone can join who is willing to follow the path set by the *jinas*, souls who have been liberated by conquering their passions and can spend a blissful eternity at the summit of the universe. Jains are typically expected to heed five *vratas*, which are vows or forms of devotion. These are: nonviolence, not lying, not stealing, chastity, and nonpossessiveness. (Like taboos, which are also central to many identities, the *vratas* define who you are by *what* as well as *who* you are *not*. There's a lot of "Thou shalt not's" in the Ten Commandments, too.)[2]

The detailed content of each of these ideals depends, among other things, on whether you are a layperson on the one hand, or a monk or nun on the other. The general point, though, is that there are things people do and don't do *because they are Jains*. By this, I mean only that they themselves think from time to time, "I should be faithful to my spouse . . . or speak the truth . . . or avoid harming this animal . . . because I am a Jain." They do that, in part, because they know they live in a world where not everyone is a Jain, and that other people with other religions may have different ideas about how to behave.

Though there are Ewe religious traditions (lots of different ones), being Ewe isn't, by contrast, a religious identity, and doesn't come with the same sort of specified ethical codes. Ewes can be Muslim, Protestant, or Catholic, and many practice the traditional rites that go by the name of voodoo. (Like the Haitians, they borrowed this word from the Fon peoples, who are their neighbors. It means "spirit.") But, all the same, Ewe people sometimes say to themselves, "As an Ewe, I should . . ." and go on to specify something they believe they should do or refrain from doing. They do things, in short, because they are Ewe. And this, too, depends, in part, on their recognition that not everyone is Ewe, and that non-Ewes may well behave differently.

People who give reasons like these—"Because I'm a this, I should do that"—are not just accepting the fact that the label applies to them; they are giving what a philosopher would call "normative significance" to their membership in that group. They're saying that the identity matters for practical life: for their emotions and their deeds. And one of the commonest ways in which it matters is that they feel some sort of solidarity with other members of the group. Their common identity gives them reason, they think, to care about and help one another. It creates what you could call norms of identification: rules about how you should behave, given your identity.

But just as there's usually contest or conflict about the boundaries of the group, about who's in and who's out, there's almost always disagreement about what normative significance an identity has. How much can one Ewe or one Jain legitimately ask of another? Does being Ewe mean you ought to teach the Ewe language to your children? Most Jains think that their religion requires them to be vegetarian, but not all agree that you must also avoid milk products. And so on. While each Ewe or each Jain will have done things because of their identity, they won't always do the same things. Still, because these identities sometimes help them answer the question "What should I do?" they're important in shaping their everyday lives.

One further reason that's true is the third feature all identities share: not only does your identity give *you* reasons to do things, it can give others reasons to do things *to* you. I've already mentioned something people can do to you because of your identity: they can help you just because you share an identity with them. But among the most significant things people do with identities is use them as the basis of hierarchies of status and respect and of structures of power. Caste in South Asia means some people are born into a higher status than others—as Brahmins, for example. These are members of the priestly caste, who are "polluted" by contact with members of castes that are regarded as lower. In many places in the world one ethnic or racial group regards its members as superior to others, and assumes the right to better treatment. The English poet Shelley, in "Ozymandias," refers to the "frown / And wrinkled lip, and sneer of cold command" on the stone face of the sculpture of a long-dead Pharaoh. The royal ancestry of this "king of kings" would have meant that he was used to obedience. Dominant identities can mean that people will treat you as a source of authority; subordinate identities can mean you and your interests will be trampled upon or ignored.

And so an important form of struggle over identity occurs when people challenge the assumptions that lead to unequal distributions of power. The world is full of burdensome identities, whose price is that other people treat you with disrespect. *Kothis* in India know this very well. They are people who, though assigned a male identity at birth, themselves identify as feminine, and experience erotic attraction to men who are more typically masculine. And *kothis* have been subjected over the years to insult and abuse, and to rejection by their families; many of them have been forced by their marginal position into sex work. In recent years, emerging ideas about gender and

sexuality—about homosexuality, intersexuality, and transgender identity, and about the complexity of the connection between biological sex and human behavior—have created movements that seek to alleviate the social exclusion of people whose gender and sexuality fall outside traditional norms. The Indian Supreme Court has even declared that individuals are entitled to be recognized as male, female, or third-gender, as they themselves decide.

Once identities exist, people tend to form a picture of a typical member of the group. Stereotypes develop. They may have more or less foundation in reality, but they are almost always critically wrong about something. *Kothis*, some Indians think, really want to be women: they are, many people suppose, what Europeans and Americans would now often call "transgender." But that's not necessarily so. Ewes, other Ghanaians fear, are particularly likely to use "juju"—witchcraft or "black magic"—against their enemies. But witchcraft is traditional all over Ghana, so this isn't, actually, much of a distinction. (I once wrote an account of my father's funeral, in the course of which I discussed how we had to deal with the threat of witchcraft in our family. We, as you know, were Asante, not Ewe.)[3] People believe that Jains are so obsessed with nonviolence that they insist on covering their faces with white cloth to avoid killing insects by ingesting them. In fact, most Jains don't wear the *muhapatti*, as the white cloth is called, and its use has a variety of rationales that have nothing to do with saving the lives of insects.

In sum, identities come, first, with labels and ideas about why and to whom they should be applied. Second, your identity shapes your thoughts about how you should behave; and, third, it affects the way other people treat you. Finally, all these dimensions of identity are contestable, always up for dispute: who's in, what they're like, how they should behave and be treated.

✦ ✦ ✦

A "Culture" War

Like many Englishmen who suffered from tuberculosis in the nineteenth century, Sir Edward Burnett Tylor went abroad on medical advice, seeking the drier air of warmer regions. Tylor came from a prosperous Quaker business family, so he had the resources for a long trip. In 1855, in his early twenties, he left for the United States, traveling on in the early part of the next year to Cuba, where he met another rich English Quaker, Henry Christy; and they ended up riding together through Mexican towns and countryside, visiting Aztec ruins and dusty pueblos.

Christy was already an experienced archaeologist. Under his tutelage, Tylor learned how to work in the field. He grew impressed by what he called "the evidence of an immense ancient population, shown by the abundance of remains of works of art."[4] Tylor published an extensive account of his Mexican journey when he returned to England, but that sojourn fired in him an enthusiasm for the study of faraway societies, ancient and modern, that lasted the rest of his life. In 1871, he produced his masterwork, *Primitive Culture*, which can lay claim to being the first work of modern

anthropology. Over the decades, as his beard morphed from a lustrous Garibaldi to a vast, silvery cumulonimbus that would have made Gandalf jealous, Tylor added to his knowledge of the world's peoples through study in the museum and the library.

Primitive Culture was, in some respects, a quarrel with another book that had "culture" in the title: Matthew Arnold's *Culture and Anarchy*, a collection that had appeared just two years earlier. For Arnold, the poet and literary critic, culture was the "pursuit of our total perfection by means of getting to know, on all the matters which most concern us, the best which has been thought and said in the world." Arnold wasn't interested in anything as narrow as class-bound connoisseurship—the postprandial flute duet, the recited Keats sonnet. He had in mind a moral and aesthetic ideal, which found expression in art and literature and music and philosophy.[5]

But Tylor thought that the word could mean something quite different, and in part for institutional reasons, he was able to make sure that it did. For Tylor was eventually appointed to direct the University Museum at Oxford, and then, in 1896, he became Oxford's first professor of anthropology. It is to Tylor more than anyone else that we owe the idea that anthropology is the study of something called "culture," which he defined as "that complex whole which includes knowledge, belief, arts, morals, law, customs, and any other capabilities and habits acquired by man as a member of society."[6] Civilization was merely one of culture's many modes.

Nowadays, when people speak about culture, it's usually either Tylor's or Arnold's notion that they have in mind. The two concepts of culture are, in some respects, antagonistic: Arnold's ideal was "the man of culture" and he would have considered "primitive culture" an oxymoron; Tylor's model denies that a person could be devoid of culture. Yet, in ways we'll explore, these contrasting notions of culture are locked together in our concept of Western culture, which many people think defines the identity of modern Western people. In this chapter I'm going to talk about culture as a source of identity, and to try to untangle some of our confusions about the culture, both Tylorian and Arnoldian, of what we've come to call the West.

You may have heard this story: someone asked Mahatma Gandhi what he thought of Western civilization, and he replied "I think it would be a very good idea." Like many of the best stories, alas, this one is probably apocryphal; but also like many of the best stories, it has survived because it has the flavor of truth. I have argued elsewhere that many of our thoughts about the identities that define us are misleading, and that we would have a better grasp on the real challenges that face us if we thought about them in new ways. In this chapter I want to make an even more stringent case about a "Western" identity: whether you claim it, as many in Europe and the Americas might, or rebuff it, as many elsewhere around the world do, I think you should give up the very idea of Western civilization. It's at best the source of a great deal of confusion, at worst an obstacle to facing some of the great political challenges of our time. I hesitate to disagree with even the Gandhi of legend, but I believe Western civilization is not at all a good idea, and Western culture is no improvement.

One reason for the confusions that "Western culture" spawns comes from confusions about the West. We have used the expression "the West" to do a variety of very different jobs. Rudyard Kipling, England's poet of empire, wrote, "Oh, East is East and West is West, and never the twain shall meet," contrasting Europe and Asia, but ignoring everywhere else.[7] During the Cold War, "the West" was one side of the Iron Curtain; "the East" its opposite and enemy. This usage, too, effectively disregarded most of the world. Often, in recent years, "the West" means the North Atlantic: Europe and her former colonies in North America. The opposite here is a non-Western world in Africa, Asia, and Latin America—now dubbed "the Global South"—though many people in Latin America will claim a Western inheritance, too. This way of speaking takes notice of the whole world, but lumps a whole lot of extremely different societies together; at the same time, it delicately carves around non-Indigenous Australians and New Zealanders and South Africans, so that "Western" here can look simply like a euphemism for white.

And, as everyone knows, we also talk today of the Western world to contrast it not with the South but with the Muslim world. Muslim thinkers themselves sometimes speak in a parallel way, distinguishing between Dar al-Islam, the home of Islam, and Dar al-Kufr, the home of unbelief.[8] This contrast is the one I want to explore in this chapter. European and American debates today about whether Western culture is fundamentally Christian inherit, as we'll see, a genealogy in which "Christendom" was replaced by "Europe" and then by the idea of "the West."

Creating the European

For the Greek historian Herodotus, writing in the fifth century BCE, the inhabited earth was divided into three parts. To the east was Asia, to the south was a continent he called Libya, and the rest was Europe. He knew that people and goods and ideas could travel between the continents with little hindrance: he himself traveled up the Nile as far as Aswan, and on both sides of the Hellespont, the traditional boundary between Europe and Asia. Herodotus, the "father of history," admitted to being puzzled, in fact, as to "why the earth, which is one, has three names, all women's."[9] Still, for the Greeks and their Roman heirs, these continents were the largest significant geographical divisions of the world. It is a division we have inherited.

Now, here's the important point: it wouldn't have occurred to Herodotus to think that these three names corresponded to three kinds of people, Europeans, Asians, and Africans. He was born at Halicarnassus, Bodrum in modern Turkey. But being born in Asia Minor didn't make him an Asian; it left him a Greek. And the Celts—about whom he says only that they live "beyond the pillars of Hercules" in the far west of Europe—were much stranger to him than the Persians or the Egyptians, about whom he knew rather a lot. Herodotus uses the word "European" only as an adjective, never as a noun. It was a place, not an identity. For more than a millennium after his day, no one else spoke of Europeans as a people either.

Then the geography Herodotus knew was radically reshaped by the rise of Islam, which burst out of Arabia in the seventh century, spreading with astonishing rapidity north and east and west. After the Prophet's death in 632, the Arabs managed in a mere thirty years to defeat the two great empires to their north, Rome's residue in Byzantium and the Persian empire that reached through Central Asia as far as India.

The Umayyad dynasty, which began in 661, pushed on west into North Africa and east into Central Asia. In early 711, its army crossed the Strait of Gibraltar into Spain, which the Arabs called al-Andalus, and attacked the Visigoths who had ruled much of the Roman province of Hispania for two centuries. Within seven years, most of the Iberian Peninsula was under Muslim rule; not until 1492, nearly eight hundred years later, was the whole peninsula under Christian sovereignty again.[10]

The Muslim conquerors of Spain had not planned to stop at the Pyrenees, and they made regular attempts in the early years to continue moving north. But at Tours, in 732, Charles Martel, Charlemagne's grandfather, defeated the forces of Abd al-Rahman al-Ghafiqi, the governor of al-Andalus, and that turned out to be the decisive battle in ending the Arab attempts at the conquest of Frankish Europe. Edward Gibbon, surely overstating somewhat, observed that if the Arabs had won at Tours, they could have sailed on up the Thames. "Perhaps," he added, "the interpretation of the Koran would now be taught in the schools of Oxford, and her pulpits might demonstrate to a circumcised people the sanctity and truth of the revelation of Mahomet."[11]

What matters for our purposes is that the first recorded use of a word for Europeans as a kind of person seems to have come out of this history of conflict. A Latin chronicle, written in 754 in Spain, refers to the victors of the Battle of Tours as *"Europenses,"* Europeans. Simply put, the very idea of a "European" was first used to contrast Christians and Muslims.[12]

Nobody in medieval Europe would have used the word "Western" to contrast Europeans with Muslims. For one thing, the westernmost point of Morocco, home of the Moors, lies west of all of Ireland. The Muslim world stretched from west of Western Europe into Central and South Asia; much of it, if the points of the compass matter, was south of Europe. And, as we've just seen, parts of the Iberian Peninsula—which was uncontroversially part of the continent that Herodotus called Europe—were under Arab or Berber Muslim rule from 711 to 1492. The natural contrast was not between Islam and the West, but between Christendom and Dar al-Islam, each of which regarded the other as infidels, defined by their unbelief.

Neither of these was the name of a single state: the Muslim world divided politically into two major states—Umayyad and Abbasid—in 750, and gradually split further over the centuries as it spread farther east. Christendom was divided among even more rulers, although in Europe the great majority of them respected to some degree the authority of the popes in Rome. Each of the two religions covered vast areas—the Umayyad empire at its height extended for over 4.3 million square miles and comprised nearly 30 percent of the world's population; Charlemagne's Holy Roman Empire covered

some 460,000 square miles in Western Europe, and the Byzantine Empire (the eastern heir to the Roman Empire) was only a little smaller at the time of Charlemagne's death, in 814.

At the end of the eleventh century, the First Crusade opened up another military front between European Christians and the Muslim world. In 1095, at Clermont in France, Pope Urban II, at the urging of Alexios I Komnenos, emperor of Byzantium, declared that anyone who, "for the sake of devotion, but not for money or honor," set out to liberate Jerusalem from Muslim control would no longer need to do any other penance for their sins. What followed was a series of invasions of the Holy Land by Christian armies, from all over Europe, which recaptured Jerusalem in 1099 and set up a number of crusader states there and in other parts of Palestine and Syria. Meanwhile, over the next three hundred years, the Turks who created the Ottoman Empire gradually extended their rule into parts of Europe: Bulgaria, Greece, the Balkans, and Hungary. Eastern Europe and Asia Minor were now a patchwork quilt of Muslim and Christian states, created and maintained by ferocious warfare and mired in intolerance. Only in 1529, with the defeat of Suleiman the Magnificent's army by the Holy Roman emperor's forces at Vienna, did the reconquest of Eastern Europe begin. It was a slow process. It wasn't until 1699 that the Ottomans finally lost their Hungarian possessions; Greece became independent only in 1830, Bulgaria even later.

We have, then, a clear sense of Christian Europe (Christendom) defining itself through opposition. And one approach to understanding talk of Western culture is to think of it as a way of talking about that culture in Tylor's sense—the socially transmitted "knowledge, belief, arts, morals, law, customs," and other capabilities— derived from Christian Europe.

The Golden Nugget

The educated people of Christian Europe, however, inevitably inherited many of their ideas from the pagan societies that preceded them. Thus, even though the divide between the West and Islam began with a religious conflict, not everything in Western civilization is supposed to be Christian. This itself is a very old idea. At the end of the twelfth century, Chrétien de Troyes, born a hundred or so miles southwest of Paris, celebrated these earlier roots: "Greece once had the greatest reputation for chivalry and learning," he wrote. "Then chivalry went to Rome, and so did all of learning, which now has come to France." The idea that the best of the culture of Greece was passed by way of Rome into Western Europe in the Middle Ages gradually became a commonplace. In fact, this process had a name. It was called the *translatio studii*, the transfer of learning. And this, too, was an astonishingly persistent idea. More than six centuries later, Hegel, the great German philosopher, told the students of the high school he ran in Nuremberg, "The foundation of higher study must be and remain Greek literature in the first place, Roman in the second."[13]

So from the late Middle Ages through Hegel until now, people have thought of the best in the culture of Greece and Rome as a European inheritance, passed on like a precious golden nugget, dug out of the earth by the Greeks, and transferred, when the Roman Empire conquered them, to Rome, where it got a good polish. Eventually, it was partitioned among the Flemish and Florentine courts and the Venetian Republic in the Renaissance, its fragments passing through cities such as Avignon, Paris, Amsterdam, Weimar, Edinburgh, and London, and finally reunited in the academies of Europe and the United States. This priceless treasure is no doubt nestled now somewhere here in the American academy, where I work . . . perhaps in the university library right around the corner. And its content is the West's Arnoldian culture, not the everyday habits of life that make up much of what Tylor had in mind.

There are many ways of embellishing the story of the golden nugget. But they all face a historical challenge—at least if you want to make the golden nugget the core of a Western civilization opposed to Islam. For the classical inheritance it identifies was shared with Muslim learning. In ninth-century Baghdad, in the Bayt al-Hikmah, the palace library set up under the Abbasid caliphs, the works of Plato, Aristotle, Pythagoras, and Euclid were translated into Arabic. They became the basis of a tradition of scholarship that the Arabs called *falsafa*, adapting the Greek word for philosophy. In the centuries that Petrarch called the Dark Ages, when Christian Europe made little contribution to the study of Greek classical philosophy, and many of the texts were lost to view, these works, and the capacity to interpret them, were preserved by Muslim scholars. And a good deal of what we now know of the texts of classical philosophy and how to read them we know only because that knowledge was recovered by European scholars in the Renaissance from the Arabs.

In the mind of its Christian chronicler, as we saw, the Battle of Tours pitted Europeans against Islam; but the Muslims of al-Andalus, bellicose as they were, did not think that fighting for territory meant that you could not share ideas. Even in its prosperous heyday, under Abd al-Rahman III, who ruled from 912 to 966 and proclaimed himself Caliph of Córdoba, al-Andalus was hardly a paradise of pluralism, to be sure; the character of the autocratic state was not to be challenged. Still, by the end of the first millennium, in Córdoba (then the largest city of Europe) and other cities of the Caliphate, Jews, Christians, and Muslims, Arabs, Berbers, Visigoths, Slavs, and countless others created the kind of cultural goulash—a spicy mixture of various distinct components—that generates a genuine cosmopolitanism.[14] The caliph himself, who, like his father, had a mother from the Christian north, was blue-eyed and fair-haired; mixing in al-Andalus was not merely cultural.

There were no recognized rabbis or Muslim scholars at the court of Charlemagne; in the cities of al-Andalus, by contrast, there were bishops and synagogues. Racemundo, Catholic Bishop of Elvira, was Córdoba's ambassador to Constantine VII, the Byzantine ruler, in Constantinople, and to Otto I, the Holy Roman emperor, in Aachen. Hasdai ibn Shaprut, leader of Córdoba's Jewish community in the middle of the tenth century, was

not only a great medical scholar, he was the chairman of the caliph's medical council; and when the Emperor Constantine in Byzantium sent the caliph a copy of Dioscorides's *De materia medica*, the caliph took up ibn Shaprut's suggestion to send for a Greek monk to help translate it into Arabic. The knowledge they acquired made Córdoba one of the great centers of medical knowledge of Europe as well as of the Muslim world.[15]

The translation into Latin of the works of ibn Rushd, born in Córdoba in the twelfth century, was crucial for the European rediscovery of Aristotle. Ibn Rushd came from a distinguished family—his father and grandfather held the office of chief judge in Córdoba—but though trained, like them, as a Muslim legal scholar, he devoted most of his intellectual energy to recovering Aristotle's original ideas from the encrustations of ideas associated with Platonism. He was known in Latin as Averroes, or more commonly just as "The Commentator," because of his extensive commentaries on Aristotle. Around 1230, for example, Aristotle's *De anima* (On the Soul), which had been unknown in Latin, the language of scholarship throughout the Middle Ages and after, was translated into Latin from Arabic, along with Averroes's commentary, probably by the court astrologer of Holy Roman emperor Frederick II, one of whose titles was King of Jerusalem. (The translation was finished while Frederick was recovering from the disastrous failure of the Fifth Crusade and preparing for the Sixth.) The *De anima* became an important part of the philosophy curriculum in medieval European universities. So the classical traditions that are meant to distinguish Western Civ. from the inheritors of the caliphates are actually a point of kinship with them.

Even the later boundaries of Christendom turn out to be more complicated than we usually recall. In the heyday of the Ottoman Empire, our battle lines were, we imagine, to the east. But in the late sixteenth century, Queen Elizabeth I of England allied with the Ottoman sultan Murad III, in part because of her Protestant isolation from the great powers of continental Europe. (Some in her court shared Murad's skepticism about whether Roman Catholicism succeeded in avoiding idolatry. The Bishop of Winchester declared that the pope was "a more perilous enemy unto Christ, than the Turk; and Popery more idolatrous, than Turkery.")[16] And the Franco–Ottoman alliance, which persisted sporadically through three centuries—from the time of Suleiman the Magnificent through the time of Napoleon—saw Christian and Muslim soldiers fighting alongside each other, largely united by their Hapsburg enemies.[17]

The golden-nugget story imagines Western culture as the expression of an essence that has been passed from hand to hand on its historic journey. And we've seen the pitfalls of this sort of essentialism again and again, such as how the scriptures of a religion are supposed to determine its unchanging nature; or the nation, bound together through time by language and custom; racial quiddity shared by all Blacks or all whites; or the essence of social class.

In each case, people have supposed that an identity that survives through time and across space must be underwritten by some larger, shared commonality; an essence that all the instances share. But that is simply a mistake. What was England like in the days

of Chaucer, "father of English literature," who died more than six hundred years ago? Take whatever you think was distinctive of it, whatever combination of customs, ideas, and material things that made England characteristically English then. Whatever you choose to distinguish Englishness now, it isn't going to be *that*. Rather, as time rolls on each generation inherits the label from an earlier one; and, in each generation, the label comes with a legacy. But as the legacies are lost or exchanged for other treasures, the label keeps moving on. And so, when some of those in one generation move elsewhere from the territory to which English identity was once tied—move, for example, to *New England*—the label can even travel beyond the territory. Identities can be held together by narratives, in short, without essences: you don't get to be called "English" because there's an essence this label follows; you're English because our rules determine that you are entitled to the label—that you are connected in the right way with a place called England.

So how did people in New York and old York; in London, Ontario, and London, England; in Paris, Texas, and Paris, France, get connected into a realm we call the West and gain an identity as participants in something called Western culture?

How the West Was Spun

In English, the very idea of the "West," to name a heritage and object of study, doesn't really emerge until the 1880s and 1890s, during a heated era of imperialism, and gains broader currency only in the twentieth century. So you can wonder about an age-old concept with such a recent name. For that matter, talk of "civilizations," in the plural, is pretty much a nineteenth-century development, too. When scholars in the late nineteenth century offered a view of Western civilization, it was somewhat at odds with our own: they would say Western civilization was rooted in Egypt and Phoenicia; or that Greek seaport towns were the cradle because they brought together elements from Egyptian, Syrian, Persian, and Indian civilizations; or that civilization traveled from East to West.[18]

The kindred term "Western culture," too, is surprisingly modern—certainly more recent than, say, Edison's phonograph. We've seen precursor ideas in the concepts of "Christendom" and "Europe," of course. Apropos of "class," the history of a term isn't always a guide to the history of its referent, but in this instance there is a true intimacy between the label and what it labels. It's significant that Tylor, say, never spoke of Western culture. And, indeed, he had no reason to, since he was profoundly aware of the internal cultural diversity even of his own country. In 1871 he reported evidence of witchcraft in rural Somerset. A blast of wind in a pub had blown some roasted onions stabbed with pins out of the chimney. "One had on it the name of a brother magistrate of mine, whom the wizard, who was the alehouse-keeper, held in particular hatred," Tylor wrote, "and whom apparently he designed to get rid of by stabbing and roasting an onion representing him."[19] Primitive culture, indeed.

The Decline of the West, written by Oswald Spengler around the time of the First World War, was the work that introduced many readers around the world to the concept. (He actually titled it *Der Untergang des Abendlandes*, literally, the decline of the evening lands—those lands nearest the setting sun. The term had once referred to the western provinces of the Roman Empire.) Yet his conception of the West was startlingly different from the one that's now commonplace. Spengler scoffed at the notion that there were continuities between Occidental culture and the classical world. "The word 'Europe' ought to be struck out of history," he further avowed. "There is historically no 'European type.'"[20] For him, critically, the West was defined by contrast to the culture of the classical world, to the culture of the ancient Christians (and Jews and Muslims), and to the "semi-developed" culture of the Slavs. For others, though, the Ottoman incursions remained imaginatively key. During a visit to the Balkans in the late 1930s, Rebecca West recounted her husband's sense that "it's uncomfortably recent, the blow that would have smashed the whole of our Western culture." The "recent blow" in question was the Turkish siege of Vienna in 1683.

If the notion of Christendom was an artifact of a prolonged series of military struggles against Muslim forces, our modern concept of Western culture largely took its present shape in the late 1940s and the 1950s, during the Cold War. In the chill of battle, we forged a grand Plato-to-NATO narrative about Athenian democracy, the Magna Carta, the Copernican Revolution, and so on.[21] Western culture was, at its core, individualistic and democratic and liberty-minded and tolerant and progressive and rational and scientific. Never mind that premodern Europe was none of these things, and that until the past century democracy was the exception in Europe, something that few stalwarts of Western thought had anything good to say about. The idea that tolerance was constitutive of something called Western culture would certainly have surprised Edward Burnett Tylor, who, as a Quaker, had been barred from attending England's great universities. (Tylor's university appointments at Oxford occurred after the passage of the Universities Tests Act in 1871, which allowed people who were not Anglican to enter Oxford and Cambridge.) Indeed, it's possible to feel that if Western culture were real, we wouldn't spend so much time talking it up. Settling over us like a low-hanging fog, "culture," however qualified, has been required to do a great deal of work. I admit I have sometimes wondered whether the concept of culture, like the luminiferous ether that nineteenth-century physicists posited as the medium through which light waves traveled, explains rather less than we might hope.

Still, such historical and intellectual vagaries did not discourage genuinely distinguished scholars from accepting something like that Plato-to-NATO narrative. "The essence of Western culture, the basis of its success, the secret of its wide influence, is liberty," the French political theorist Raymond Aron declared in the 1950s. More recently, the intellectual historian Gertrude Himmelfarb has maintained that justice, reason, and the love of humanity "are, in fact, predominantly, perhaps even uniquely, Western values."[22]

Once Western culture could be a term of praise, it was bound to become a term of dispraise, too. Critics of Western culture, producing a photographic negative—light areas exchanged for dark—emphasizing slavery, subjugation, racism, militarism, and genocide, were committed to the very same essentialism, even if they saw a nugget not of gold but of arsenic.

Mirror, Mirror

In ways we've seen, the assertion of an identity always proceeds through contrast or opposition; and such critics are sometimes preoccupied with another supposed cultural clime, that of Africa. In a battle against the Victorian ideologies of "Eurocentrism," some critics have therefore rallied behind "Afrocentrism." Yet Afrocentrists have not always been certain whether Western culture is a burden to be jettisoned or a prize to be claimed. Starting in the 1950s, Cheikh Anta Diop, the Senegalese man of letters, argued strenuously that Greek civilization had African origins. (He maintained that its achievements derived from a more advanced Egyptian civilization, and that the ancient Egyptians were Black.) His followers were left with certain awkward implications. If the West was spawned by Greece, which was spawned by Egypt, then wouldn't Black people inherit the moral liability of its legacy of ethnocentrism? Other Afrocentrists, favoring a separate development, were happy to disclaim Greece, while elevating the civilizational achievements that were peculiarly African. Either way, this lineage-based model of culture confronts a challenge. If the ideology of "Western culture" posits an implausible unity, equally enrobing Alexander and Alfred and Frederick the Greats, the ideology of Afrocentrism had to make similar claims for the cultural unity of Africa.

Where might such a unifying essence repose? Many took inspiration from Janheinz Jahn's *Muntu: African Cultures and the Western World*, a work that appeared in the United States to great acclaim in the early 1960s. Its author was a German literary scholar who, in part owing to his friendship with the Senegalese poet and statesman Léopold Sédar Senghor, became an enthusiast for Négritude, a movement that stressed the cultural and racial kinship putatively shared by people of African descent. Curiously, though, he discovered the power core of African culture on the other side of the continent, in the concept of "NTU." It's the last syllable of the Kinyaruanda-Bantu words "Muntu" (person), "Kintu" (thing), "Hantu" (place and time), and "Kuntu" (modality). "NTU," Jahn concluded, "is the universal force as such." For the African, force and matter are integrally bound up, and it is in the "cosmic universal force" of NTU that "being and beings coalesce." At the heart of the African conceptual world, then, was a truth that Western rationalists had grown estranged from: a profound recognition of the harmony and coherence of all things.[23]

I recall, when I first encountered these arguments, being drawn into a fantasy in which an African scholar returns from London to Lagos with the important news that she has uncovered the key to Western culture. Soon to be published, *THING: Western Culture and the African World*, a work that exposes the philosophy of ING, written so

clearly on the face of the English language. For ING, in the Euro-American view, is the inner dynamic essence of the world. In the very structure of the terms do*ing* and mak*ing* and mean*ing*, the English (and thus, by extension, all Westerners) express their deep commitment to this conception: but the secret heart of the matter is captured in their primary ontological category of th-*ing*; everyth*ing*—or be-*ing*, as their sages express the matter in the more specialized vocabulary of one of their secret societies—is not stable but ceaselessly changing. Here we see the fundamental explanation for the extraordinary neophilia of Western culture, its sense that reality is change.

I am caricaturing a caricature, of course. At such levels of abstraction, almost everything and its opposite can be claimed of almost anything we might call a culture. When non-Western cultures are extolled for their collectivism, cooperation, and spiritual enlightenment, it is typically in order to criticize the West for complementary vices such as rampant materialism, selfish individualism, and rapacious exploitation. This move is itself a familiar part of Western Europe's cultural repertory. Ventriloquizing the perspective of non-Western interlopers has often served the purposes of social commentary, notably in fictional epistolary works like Montesquieu's 1721 *Persian Letters* (in which one of his Persian travelers tartly reports that "there's never been a kingdom where there were as many civil wars as in that of Christ") or Oliver Goldsmith's 1761 *Citizen of the World* (in which a Chinese philosopher visiting London marvels that, while "their compacts for peace are drawn up with the utmost precision and ratified with the greatest solemnity . . . the people of Europe are almost continually at war").[24] The aim is, in Burns's phrase, to "see ourselves as others see us," or as we imagine they might.

Organic Temptations

Simply as a matter of scale, talk of "Western culture" has an immediate implausibility to overcome. It places at the heart of identity all manner of exalted intellectual and artistic achievements—philosophy, literature, art, and music, the things Arnold prized and humanists study. But if Western culture was there in Troyes in the late twelfth century when Chrétien was alive, it had little to do with the lives of most of his fellow citizens, who didn't know Latin or Greek and had never heard of Plato. Today in the United States the classical heritage plays no greater role in the everyday lives of most Americans. Look around at our modern metropolises, which must count as centers of Western civilization if anything does, and you will see great museums, great libraries, great theater, great music in every genre. Are these Arnoldian achievements what hold us city-dwellers together? Of course not. What holds us together, surely, is Tylor's broad sense of culture: our customs of dress and greeting, the habits of behavior that shape relations between men and women, parents and children, cops and civilians, shop assistants and consumers. Intellectuals like me have a tendency to suppose that the things *we* care about are the most important things. I don't say they don't matter. But they matter less than the story of the golden nugget suggests.

So how have we bridged the chasm here? How have we managed to persuade ourselves that we're rightful inheritors of Plato, Aquinas, and Kant, when the stuff of our existence is more Justin Bieber and Kim Kardashian? Well, by fusing the Tylorian picture and the Arnoldian one, the realm of the everyday and the realm of the ideal. And the key to this was something that was already present in Tylor's work.

Remember his famous definition: it began with culture as a "complex whole."[25] What you're hearing there is something we can call *organicism*. A vision of culture not as a loose assemblage of disparate fragments but as an organic unity, each component, like the organs in a body, carefully adapted to occupy a particular place, each part essential to the functioning of the whole. The Eurovision Song Contest, the cutouts of Matisse, the dialogues of Plato are all parts of a larger whole. As such, each is a holding in your cultural library, so to speak, even if you've never personally checked it out. It's your heritage and possession. Organicism explained how our everyday selves could be dusted with gold.

The trouble is that there just isn't one great big whole called culture that organically unites all these parts. There *are* organic wholes in our cultural life: the music, the words, the set design, and the choreography of an opera are meant to fit together. It is, to use Richard Wagner's term, a *Gesamtkunstwerk*, a total work of art. But the Tylorian cultures of the North Atlantic were not made together. They are not an organic whole. Spain, in the heart of the West, resisted liberal democracy for two generations after it took off in India and Japan in the East, the home of Oriental despotism. Jefferson's cultural inheritance—Athenian liberty, Anglo-Saxon freedom—did not prevent the United States from creating a slave republic. Nor, for that matter, did the Christian heritage of hostility to adultery keep him from having children with Sally Hemings, his slave. At the same time, Franz Kafka and Miles Davis can live together as easily, perhaps even more easily, than Kafka and the waltz king Johann Strauss, his fellow Austro-Hungarian. (Those bleakly comic parables don't keep 3/4 time.) You will find hip-hop in the streets of Tokyo and Takoradi and Tallinn. The same is true in cuisine. In my youth, Britons swapped their fish and chips for chicken tikka masala.[26] (This was a very wise exchange.)

Once we abandon organicism, we can take up the more cosmopolitan picture in which every element of culture—from philosophy or cuisine to the style of bodily movement—is separable in principle from all the others; you really can walk and talk in a way that's recognizably African-American *and* commune with Immanuel Kant and George Eliot, as well as with Bessie Smith and Martin Luther King Jr. No Muslim essence stops individual inhabitants of Dar al-Islam from taking up anything from the Western Civ. syllabus, including democracy. No Western essence is there to stop a New Yorker of any ancestry taking up Islam. Wherever you live in the world, Li Po can be one of your favorite poets, even if you've never been anywhere near China.

Property Crimes

In some of the darker recesses of the Internet, enthusiasts for the idea of North America or Europe as the home of the White Race celebrate the achievements they claim for the West as somehow theirs. They claim National Socialism and Shakespeare, eugenics and Euclid, democracy and Dante. The far-right German movement Pegida (Patriotic Europeans Against the Islamization of the West) has called for the "preservation and protection of our Christian-Jewish Western culture," offering a pleasant compound in which a hyphen masks a history of massacres, expulsions, and mass murder.[27] I will let white nationalists have Nazism and eugenics for themselves; but I begrudge nobody the things I also love, because, like Arnold, I can love what is best in anyone's traditions while sharing it gladly with others. Yet if they believe that something in them, some racial essence, somehow connects them with an organic kernel, a *Geist*, that pervades Western culture, they understand neither race nor civilization. For what is best in Arnoldian culture cuts across color, place, and time. One of Goethe's great poetic cycles is the *West-östlicher Divan*: it is inspired by the poetry of the fourteenth-century Persian poet Hafez, whose tomb in Shiraz is still a place of pilgrimage. (*Diwan* is the Persian word for a collection of poetry, so Goethe's title, "West-eastern Collection," is explicitly meant to bridge the gap.) Matsuo Basho, the magnificent haiku master of the seventeenth century, was shaped to a large degree by Zen Buddhism, and so an Indian—Siddhartha Gautama, the Buddha—is part of Basho's heritage. Kurosawa's *Throne of Blood*—its dark castle walls on Mount Fuji swathed in mist—is a powerful cinematic rendering of *Macbeth*.

That's why we should resist using the term "cultural appropriation" as an indictment. All cultural practices and objects are mobile; they like to spread, and almost all are themselves creations of intermixture. Kente in Asante was first made with dyed silk thread, imported from the East. We took something made by others and made it ours. Or rather, they did that in the village of Bonwire. So, did the Asante of Kumasi appropriate the cultural property of Bonwire, where it was first made? Putative owners may be previous appropriators.

The real problem isn't that it's difficult to decide who owns culture; it's that the very idea of ownership is the wrong model. The Copyright Clause of the United States Constitution supplies a plausible reason for creating ownership of words and ideas: "To promote the progress of science and useful arts, by securing for limited times to authors and inventors the exclusive right to their respective writings and discoveries." But the arts progressed perfectly well in the world's traditional cultures without these protections; and the traditional products and practices of a group—its songs and stories, even its secrets—are not best understood as its property, or made more useful by being tethered to their putative origins.

For centuries, the people on the Venetian island of Murano made a living because glassmakers there perfected their useful art. Their beads, with multicolored filaments, some made of gold, were among the artistic wonders of the world. To keep their

commercial advantage, the Venetian state forbade glassmakers from leaving with their secrets; the penalty for revealing them to outsiders was death. Good for Murano and its profits: bad for everyone else. (As it happens, lots of the skilled artisans escaped anyway and brought their knowledge to a wider European world.) Venetian beads were already being imported into the Gold Coast by the turn of the seventeenth century, arriving across the Sahara, where they had been an important part of the trade on which the empire of Mali had risen to commercial success centuries earlier. Crushed and sintered to make new beads, they developed into the distinctive *bodom* you still see today in Ghana, beads my mother and my stepgrandmother collected and made into bracelets and necklaces.[28] What sorts of progress would have been advanced by insisting that the Venetians owned the idea of glass beads, and policing their claim? Unfortunately, the vigorous lobbying of huge corporations has made the idea of intellectual property (IP) go imperial; it seems to have conquered the world. To accept the notion of cultural appropriation is to buy into the regime they favor, where corporate entities acting as cultural guardians "own" a treasury of IP, extracting a toll when they allow others to make use of it.

This isn't to say that accusations of cultural appropriation never arise from a real offense. Usually, where there's a problem worth noticing, it involves forms of disrespect compounded by power inequities; cultural appropriation is simply the wrong diagnosis. When Paul Simon makes a mint from riffing on mbaqanga music from South Africa, you can wonder if the rich American gave the much poorer Africans who taught it to him their fair share of the proceeds. If he didn't, the problem isn't cultural theft but exploitation. If you're a Sioux, you recognize your people are being ridiculed when some fraternity boys don a parody of the headdress of your ancestors and make whooping noises. But, again, the problem isn't theft, it's disrespect. Imagine how an Orthodox Jewish rabbi would feel if a gentile pop-music multimillionaire made a music video in which he used the Kaddish to mourn a Maserati he'd totaled. The offense isn't appropriation; it's the insult entailed by trivializing something another group holds sacred. Those who parse these transgressions in terms of ownership have accepted a commercial system that's alien to the traditions they aim to protect. They have allowed one modern regime of property to appropriate *them*.

Culture as Project

Although Tylor's notion of culture helped create our own, it wasn't exactly ours. Unlike so many of his colleagues, he saw culture as something you acquired and transmitted, and not as a feature of your racial inheritance. He did not use "culture" in the plural, however; he was a progressivist (like Arnold, in this respect) who thought in terms of stages, advancing from savagery to the happier state of civilization. Still, his fascination with the cultural range of humanity acknowledged, precisely, the humanity of those he studied, in a way that refashioned a discipline. Culture wasn't vaporous to him. He loved the material artifacts that he collected, although his vast beard once got entangled with

a bow he was demonstrating to his students, and his attempts to start fires with flints did not always end well. When he retired from Oxford, he gave the university's committee for anthropology his enormous library on the topic: whatever your origins, he was convinced, you could enter deeply into other forms of life, but you had to put in the work.

We must, as well. This project can start with the recognition that culture is messy and muddled, not pristine and pure. That it has no essence is what makes us free. To be sure, the stories we tell that connect Plato or Aristotle or Cicero or St. Augustine to the contemporary American or European world have some truth in them. These grand arcs are sustained by self-conscious traditions of scholarship and argumentation. Remember those medieval Christians digging back through Averroes looking for Aristotle; or Chrétien claiming chivalry from Rome. The delusion is to think it suffices that we have *access* to these values, as if they're songs in a Spotify playlist we've never quite listened to. These thinkers may be part of our Arnoldian culture, but there's no guarantee that what is best in them will continue to mean something to the children of those who now look back to them, any more than the centrality of Aristotle to Muslim thought for hundreds of years guarantees him an important place in Muslim communities today.

Values aren't a birthright: you need to keep caring about them. Living in the West, however you define it—being Western, however you define *that*—provides no guarantee that you will care about Western Civ. The values that European humanists like to espouse belong as much to an African or an Asian who takes them up with enthusiasm as to a European. By that very logic, they *don't* belong to a European who hasn't taken the trouble to understand and absorb them. The same is true, naturally, of what we term non-Western cultures. The story of the golden nugget suggests that we can't help caring about the traditions of "the West" because they are ours: in fact, the opposite is true. They are ours only if we care about them. A culture of liberty, tolerance, and rational inquiry: that *would* be a good idea. But these values represent choices to make, not tracks laid down by a Western destiny.

In 1917, the year of Edward Burnett Tylor's death, what we've been taught to call Western civilization had stumbled into a death match with itself: the Allies and the Central Powers hurled bodies at each other, marching young men to their deaths in order to "defend civilization." The blood-soaked fields and gas-poisoned trenches must have shocked Tylor's evolutionist, progressivist hopes, and confirmed Arnold's worst fears about what civilization really meant. Arnold and Tylor would have agreed, at least, on this: culture isn't a box to be checked on the questionnaire of humanity; it's a process you join, in living a life with others.

SUGGESTED READINGS

Jerry Brotton, *The Sultan and the Queen: The Untold Story of Elizabeth and Islam* (New York: Penguin, 2016).

Christopher GoGwilt, *The Invention of the West* (Palo Alto, CA: Stanford University Press, 1995).

David Levering Lewis, *God's Crucible: Islam and the Making of Europe* (New York: W. W. Norton, 2009).

James Reston Jr., *Defenders of the Faith: Christianity and Islam Battle for the Soul of Europe, 1520–1536* (New York: Penguin, 2009).

NOTES

1. Publisher's note: this material originally appeared in Kwame Anthony Appiah, *The Lies That Bind: Rethinking Identity* (New York: Liveright, 2018), 6–12 and 189–211, and is reproduced by permission of Liveright Publishing Corporation and Profile Books Ltd.
2. Paul Dundas, *The Jains*, 2nd ed. (New York: Routledge & Kegan Paul, 2002), 158–59.
3. Kwame Anthony Appiah, *In My Father's House: Africa in the Philosophy of Culture* (New York: Oxford University Press, 1992).
4. Sir Edward Burnett Tylor, *Anahuac; or, Mexico and the Mexicans, Ancient and Modern* (London: Longman, Green, Longman & Roberts, 1861), 1. Tylor ended his book with a lament for old Mexico, as the country was gradually being impinged upon by its neighbor to the north: "it was our fortune to travel there before the coming change, when its most curious peculiarities and its very language must yield before foreign influences" (330). Invaluable discussions of Tylor can be found in the work of anthropology's greatest historian, George W. Stocking, notably "Matthew Arnold, E. B. Tylor, and the Uses of Invention," *American Anthropologist* 65, no. 4 (1963): 783–99; and *Victorian Anthropology* (New York: Free Press, 1991). See also Peter Melville Logan, *Victorian Fetishism: Intellectuals and Primitives* (Albany: State University of New York Press, 2009); and the accounts collected at Pitt Rivers Virtual Collections, "The Invention of Museum Anthropology, 1850–1920," http://web.prm.ox.ac.uk/sma/index.php/articles/article -index/335-edward-burnett-tylor-1832-1917.html.
5. Matthew Arnold, *Culture and Anarchy* (Oxford: Oxford University Press, 2006), 5. Arnold pitted culture against the encroachments of "civilization," which, in his industrializing country, was obsessed with money and machinery, in his view. Civilization was the disease for which culture was the treatment. Norbert Elias famously asserted a general contrast in nineteenth-century thought between *Kultur* and *Zivilization*—the German concept being more particularist and spiritual, the French being more universalist and encompassing of economic as well as normative patterns—but his binary is perhaps more imposed than educed.
6. Edward B. Tylor, *Primitive Culture: Researches into the Development of Mythology, Philosophy, Religion, Art and Custom*, vol. 1 (London: John Murray, 1871), 1.
7. "Oh, East is East, and West is West, and never the twain shall meet, / Till Earth and Sky stand presently at God's great Judgment Seat; / But there is neither East nor West, Border, nor Breed, nor Birth, / When two strong men stand face to face, tho' they come from the ends of the earth!" Rudyard Kipling, "The Ballad of East and West"; for the full text see http://www.bartleby.com/ 246/1129.html. So the point of the poem is that people from East and West can come together, even though they come from unchangeably different places.
8. See Majid Khadduri, *War and Peace in the Law of Islam* (Clark, NJ: Lawbook Exchange, 2006), 52.
9. Herodotus, *The Histories*, 4.45.2. The original text is "ὑδ' ἔχω συμβαλέσθαι ἐπ' ὅτευ μιῇ ἐούσῃ γῇ οὐνόματα τριφάσια κέεται ἐπωνυμίας ἔχοντα γυναικῶν."
10. Much of what I say here—including about the use of the word "Europenses"—I learned from reading David Levering Lewis's magisterial *God's Crucible: Islam and the Making of Europe, 570–1215* (New York: W. W. Norton, 2009). Another broad-gauged history I've found valuable is

Hugh Kennedy, *Muslim Spain and Portugal: A Political History of al-Andalus* (London: Longman, 1996).

11. Edward Gibbon, *The Decline and Fall of the Roman Empire* (London: John Murray, 1887), 387.

12. Even this, however, is a bit of a simplification. In the middle of the eighth century, much of Europe was not yet Christian. Charlemagne was to spend three decades of bloody warfare, starting around 770, seeking to convert the pagan Saxons to Christianity. The question of when "European," as a group identity, gained broader traction is taken up, if not entirely resolved, in Peter Burke, "Did Europe Exist before 1700?," *History of European Ideas* 1, no. 1 (1980): 21–29. He notes: "If the first context in which people became aware of themselves as Europeans was that of being invaded by other cultures, the second was that of invading other cultures."

13. G. W. F. Hegel, "On Classical Studies," in *On Christianity: Early Theological Writings*, trans. T. M. Knox and Richard Kroner (Chicago: University of Chicago Press, 1948), 324. The lecture was given in 1809. "The perfection and glory of those masterpieces," he continued, "must be the spiritual bath, the secular baptism that first and indelibly attunes and tinctures the soul in respect of taste and knowledge."

14. Mark R. Cohen in *The Crescent and the Cross: The Jews in the Middle Ages*, 2nd ed. (Princeton, NJ: Princeton University Press, 2008), xvii, xix, suggests that "the 'myth of the Islamic-Jewish interfaith utopia' and the 'countermyth of Islamic persecution of the Jews' equally distort the past. . . . When all is said and done, however, the historical evidence indicates that the Jews of Islam, especially during the formative and classical centuries (up to the thirteenth century), experienced much less persecution than did the Jews of Christendom." And see David Nirenberg, *Communities of Violence: Persecution of Minorities in the Middle Ages*, 2nd ed. (Princeton, NJ: Princeton University Press, 2015).

15. A compelling account of Hasdai ibn Shaprut's career appears in Jane S. Gerber, *The Jews of Spain: A History of the Sephardic Experience* (New York: Free Press, 1992), 46–53.

16. Jerry Brotton, *The Sultan and the Queen: The Untold Story of Elizabeth and Islam* (New York: Penguin, 2016), 61.

17. James Reston Jr., *Defenders of the Faith: Christianity and Islam Battle for the Soul of Europe, 1520–1536* (New York: Penguin, 2009).

18. See, for instance, Jan Helenus Ferguson, *The Philosophy of Civilization: A Sociological Study* (London: W. B. Whittingam, 1889), 319; William Cunningham, *An Essay on Western Civilization in Its Economic Aspects*, vol. 1: *Ancient Times* (Cambridge: Cambridge University Press, 1898); and A. L. Kip, *Psychology of the Nations* (New York: Knickerbocker Press, 1902). In Germany, the culturally fraught use of the Occident, the *Abendland*, can be traced back a few generations earlier.

19. "My friend, apparently, was never the worse, but when next year his wife had an attack of the fever, there was shaking of heads among the wise." See Chris Wingfield, "Tylor's Onion: A Curious Case of Bewitched Onions from Somerset," at the Pitt Rivers Virtual Collections, http://web.prm.ox.ac.uk/england/englishness-tylors-onion.html. The article quotes from a letter of Tylor's to an uncle in 1872, owned by Sarah Smith née Fox and transcribed by Megan Price. See also Chris Wingfield, "Is the Heart at Home? EB Tylor's Collections from Somerset," *Journal of Museum Ethnography* 22 (December 2009): 22–38.

20. Oswald Spengler, *The Decline of the West*, trans. Charles Francis Atkinson (New York: Oxford University Press, 1932), 12, n.5. (The translation was originally published by Knopf in two volumes, appearing in 1926 and 1928.)

21. See, inter alia, Christopher GoGwilt, *The Invention of the West* (Stanford, CA: Stanford University Press, 1995), 220–42; and David Gress, *From Plato to NATO: The Idea of the West and Its Opponents* (New York: Free Press, 1998). GoGwilt nimbly argues that the late-nineteenth-century emergence of the idea of the West "can be traced to the convergence of two distinct discursive

contexts: the 'new imperialism' of the 1890s that gave wider currency to oppositions between East and West, and the influence of nineteenth-century Russian debates on Western European ideas of Europe."

22. Raymond Aron, *The Opium of the Intellectuals* (New York: W. W. Norton, 1962), 258. The first English edition of Aron's book appeared in 1957; it was originally published as *L'Opium des intellectuels* in 1955. Gertrude Himmelfarb, "The Illusions of Cosmopolitanism," in Martha C. Nussbaum, *For Love of Country?*, ed. Joshua C. Cohen (Boston: Beacon Press, 2002), 75. Amartya Sen responded with a gentle rebuttal: "Because I have gained so much in the past from reading Himmelfarb's careful analysis of historical literature, I can only conclude that she simply has not yet taken much interest in the not insubstantial literature on these and related matters in Sanskrit, Pali, Chinese, and Arabic." Amartya Sen, "Humanity and Citizenship," in Nussbaum, 117.

23. Janheinz Jahn, *Muntu: African Cultures and the Western World*, trans. Marjorie Grene (London: Faber & Faber, 1961), 101. A longer discussion can be found in my "Europe Upside Down: Fallacies of the New Afrocentrism," *Sapina Journal* 5, no. 3 (1993).

24. "*Aussi puis-je t'assurer qu'il n'y a jamais eu de royaume où il y ait eu tant de guerres civiles que dans celui du Christ.*" Montesquieu, *Lettres persanes*, 29.

25. Raymond Williams, a century later, picked up on it when he encouraged us to think about culture not just as "the arts and learning" but as "a whole way of life," emphasis, again, on whole. See Williams, "Culture Is Ordinary" (1958), reprinted in his *Resources of Hope: Culture, Democracy, Socialism* (London: Verso, 1989), 3–14, although the phrase turns up often in his work.

26. "Chicken Tikka Massala is now a true British national dish, not only because it is the most popular, but because it is a perfect illustration of the way Britain absorbs and adapts external influences. Chicken Tikka is an Indian dish. The Massala sauce was added to satisfy the desire of British people to have their meat served in gravy." Robin Cook, April 2001, when British foreign minister. See Robin Cook, "Robin Cook's Chicken Tikka Masala Speech," 19 April 2001, *Guardian*, https://www.theguardian.com/world/2001/apr/19/race.britishidentity.

27. Or, in its official statement, "*den Erhalt und den Schutz unserer christlich-jüdisch geprägten Abendlandkultur.*" Quoted in Christian Volk, "Why We Protest: Zur politischen Dimension transnationaler Protestbewegungen," in *Herrschaft in den Internationalen Beziehungen*, ed. Christopher Daase et al. (Wiesbaden: Springer, 2017), 160. See also Matthias Gretzschel, "Das Abendland—ein Mythos der Romantik," *Hamburger Abendblatt*, 26 April 2016, https://www .abendblatt.de/hamburg/kirche/article207470743/Das-Abendland-ein-Mythos-der-Romantik .html; and Hannes Schammann, "Reassessing the Opinion-Policy Gap: How PEGIDA and the AfD Relate to German Immigration Policies," in *Fortress Europe? Challenges and Failures of Migration and Asylum Policies*, ed. Annette Jünemann, Nicolas Fromm, and Nikolas Scherer (Wiesbaden: Springer, 2017), 139–58.

28. Suzann Gott, "Ghana's Glass Beadmaking Arts in Transcultural Dialogues," *African Arts* 47, no. 1 (2014): 10–29; Alexandra Robinson, "'Citizens of the World': The Earle Family's Leghorn and Venetian Business, 1751–1808," in *Slavery Hinterland: Transatlantic Slavery and Continental Europe, 1751–1808*, ed. Felix Brahm and Eve Rosenhaft (Rochester, NY: Boydell Press, 2016), 60–61.

2

Why Do We Value Cultural Heritage?

Neil MacGregor

We tell ourselves stories in order to live.

—Joan Didion

. . . because being American is more than a pride we inherit.
It's the past we step into, and how we repair it.

—Amanda Gorman

This is essentially a book about things. Things from the past, usually the distant past, and what may and should be done to prevent their destruction. The words used to describe those things—"cultural heritage"—are of course a metaphor, carrying over the European legal idea of ownership and inheritance from the private or family sphere into the public domain. And like all metaphors, it is helpful only to a certain point. This chapter seeks to explore the limits of that metaphor in helping us understand the creation and destruction of cultural heritage and in achieving our aim—the purpose of this book—to prevent or limit its loss.

All cultural heritage is in large measure intangible: the most important aspect of physical cultural heritage is usually less the thing itself than the narrative which communities, local or global, choose to attach to it. That explains why it is most in danger when that community narrative changes, or when one object becomes the focus of conflicting narratives. Although most of the intense recent debates have concerned ancient monuments in the Middle East, I shall focus on modern examples in Europe, where issues are often more sharply articulated, and motives and results are perhaps easier to discern. We may best be able to understand why people value cultural heritage if we consider why they so often choose to destroy it.

Anthropologists contend that from the beginning of time societies have needed communal narratives in order to survive, let alone to flourish: that a shared understanding across generations of who we are and who we want to be is a prerequisite for the continuing success of a community. The problems with which this book is concerned arise when those life-sustaining stories which communities tell themselves crystallize in vulnerable, valuable things.

In the context of European family law, heritage—what can be inherited—is predominantly concerned with things of economic value, even if, like a copyright or a public office, they themselves are abstract. Normally heirs enjoy the right to make whatever use of those things they please: to exploit them financially, to wear them out by use, to alter them, and even willfully to destroy them if they think that advances their purpose—as Cleopatra famously dissolved her magnificent pearl to impress Mark Antony, and as Prospero will drown his magic book to usher in a new, better order for his duchy at the end of *The Tempest*. In this understanding of heritage, there may be disputes about who is the rightful heir: there is little argument about what they may choose to do with their inheritance.

But cultural heritage is clearly different. It is not principally about the economic value of the object, but about the meaning attributed to it. And just as meaning cannot belong to only one person, but presupposes a consensus and a community of language, so ownership of cultural heritage is also always multiple. It posits a community of shared assumptions, people who see embodied in a physical object the story that they choose to tell about themselves, usually one that sets their current existence in a context going far beyond the span of a single human life. And that is what transforms some— but only some—antiquities into cultural heritage.

A powerful demonstration of this was the response of the vigorously secular French state to the burning of the Catholic cathedral of Notre Dame in Paris in 2019. The appeal to the public to contribute funds for rebuilding did not focus on the cathedral's medieval structure (much of the external stonework is modern restoration) or on its aesthetic qualities—many would argue that Chartres, Amiens, or Beauvais rank higher on that score. Even less was it based on the building's prime purpose as a place of Christian worship. The slogan on the appeal posters asked people to donate simply, *"Parce que c'est* Notre *Dame,"* part of *our* story as French citizens, part of what it means to be French, in the past and in the future. What was at stake was not so much the building itself as the meaning projected on to it by most of the population—a meaning derived as much from Victor Hugo's novel *Notre Dame de Paris* and the films it inspired as by the great events of French history that have taken place there over centuries. The cathedral's significance as "cultural heritage," a potent emblem of national survival and renewal, was in large measure the result of fiction and popular imagining, and entirely separable from the religious purpose for which it had been built and maintained.

The essential value of material cultural heritage is not that it provides physical evidence for the investigation of the past (as all archaeological sites do), nor even that it

is of great beauty, but that it underpins the *intangible* heritage of a community, substantiating the story—or myth—by which they now live, the story which sustains and shapes their present. It matters little if the thing is "authentic," provided the narrative still energizes the community.

By the same token, a powerful, sustaining story will often demand the elimination of objects which appear to contradict it. When the group's narrative changes—as at moments of religious conversion or political revolution—the consequences for the material cultural heritage which carried the old narrative are always profound, and often calamitous. It cannot be otherwise—whether in the iconoclasms of the Protestant Reformation, of the French or Russian revolutions, or of the Islamic State of Iraq and Syria (ISIS). Their very destruction speaks to the power of those symbols to perpetuate the inherited worldview, and so to impede the building of a new society. Only very occasionally can you put new stories into old monuments.[1]

This book came into existence between two episodes of cultural destruction which caught the public's attention with rare intensity. It was conceived in the aftermath of the worldwide revulsion against the destruction of monuments of ancient civilizations and living religions across the Middle East in the armed conflicts that followed the 2003 US invasion of Iraq. It is being published in the wake of the forcible destruction or removal of public statues by generally peaceful crowds in Africa, Europe, and the Americas in the summer of 2020, especially following the killing of George Floyd by a police officer kneeling on his neck in Minneapolis on 25 May.

The years since 2003, scarred by many cultural losses, have led to a more informed and lively debate than ever before about the significance of the sites and monuments of the past; about the extent to which they may properly be considered the concern of all humanity rather than a particular group; and—critically—about who has the right or duty to protect them, and whether anyone, either external enemy or internal reformer, has the right to destroy them.

This last point—the right to destroy—was at the center of the widely publicized removal on 7 June 2020 of the statue in Bristol, England, of Edward Colston, a seventeenth-century slave trader and an outstandingly generous benefactor to the city.[2] Inaugurated in 1895 and bearing an inscription stating that it was "erected by the citizens of Bristol as a memorial of one of the most virtuous and wise sons of their city," the statue was without question part of the urban fabric of Bristol, a civic celebration of a significant philanthropist. It was a work of considerable artistic merit, but since the 1990s had been the object of vociferous public controversy: should a city (especially one now home to a sizeable Afro-Caribbean population suffering high and entrenched levels of deprivation) honor so unequivocally a benefactor whose wealth derived from exploitation of the enslaved? Campaigners argued that the statue as it stood perpetuated the cancer of racial injustice from which the city, and the whole United Kingdom, still

suffered. They urged that at the very least the inscription on the plinth with its words "most virtuous and wise" should be altered to acknowledge the inhumanity of Colston's business activities.

After many years of inconclusive discussions with the city council and other local bodies, protesters taking part in a peaceful Black Lives Matter demonstration in June 2020 took matters into their own hands, dragging the statue from its plinth, and—in an eloquent gesture—kneeling on its neck for eight minutes and forty-six seconds (the time it had taken for George Floyd to die). Then the graffiti-splattered image of the slave trader was dragged along the street and thrown into the harbor. It was powerful street theater, all the more effective for being apparently unplanned. The pictures were seen and discussed around the world. The police were present, but, in the light of the mood of the crowd, decided not to intervene. The police superintendent explained: "whilst I'm disappointed people would damage one of our statues, I do understand why it happened: it is very symbolic." Even for the police, this was a rational (if regrettable) act of cultural destruction.

Polling suggested that public opinion in Bristol supported the police decision, was strongly in favor of the statue's removal, but was more divided about the process by which this should have been accomplished. Many felt that a negotiated solution had been frustrated by unacceptably long delay, and most believed there should be no criminal prosecution. The mayor was reluctant to condemn. The Crown Prosecution Service eventually pressed four charges of criminal damage. The paint-smeared statue was recovered from the harbor and taken into the care of the Bristol Museum.

As cultural destruction goes, the daubing, dragging, and dunking of the Colston statue is a small-scale, provincial affair, but it highlights some fundamental issues. The Bristol of 1895 that put up the statue has since been transformed by immigration. The symbolic meaning of this statue (the aspect underlined by the superintendent of police) was now in open contradiction to the self-understanding and aspirations of many of its citizens, far beyond the Black community. What was at issue was not the statue as an artifact in itself, but the narrative which it appeared to embody and condone, of suffering tolerated and justice denied. In large measure, the Bristol debates echoed the arguments in the southern United States about monuments honoring Confederate leaders, many of which were also removed or destroyed in the summer of 2020.

Colston's statue was unquestionably the cultural heritage of a certain Bristol. And that was precisely the problem: because for a different Bristol that cultural heritage had come to be seen as a toxic inheritance which had to be repudiated, whose very existence now inhibited the building of a more just society. Its presence at the heart of the city seemed to torpedo the story which many thought Bristol now needed to tell itself in order to flourish as a community.

That leads to an uncomfortable question: has a community the right—perhaps even the duty—to destroy those parts of its heritage which undermine its ethical foundations, which it believes prevent it from becoming what it wants to be? There are, for example,

medieval artworks in Germany that even today might, if exhibited, encourage anti-Jewish sentiment and behavior. If the community which owned such works decided it would be wiser to destroy them, who would have the right to stop them?

The answer to that last question, as far as Bristol was concerned, was given firmly by the British government's secretary of state for communities, Robert Jenrick. Writing in the *Sunday Telegraph*, he declared that statues could not be removed "on a whim or at the behest of a baying mob,"[3] apparently overlooking the fact that such actions are hardly ever the result of a whim, but generally reflect a long and deep shift in the way that people want to shape their society. Writing further on the government's main website, Jenrick continued: "We cannot—and should not—now try to edit or censor our past."[4] (He did not explain who that "we" and that "our" encompass.) "That is why I am changing the law to protect historic monuments." Such a change in the law cannot of course be decreed by a minister, but requires the approval of Parliament. If that consent is obtained, in the future any removal of a statue (or even changing the inscription describing Colston as "one of the most virtuous and wise sons of their city") would require a formal application for planning permission—a process which would ensure that the secretary of state has the power to overrule the decision of a local authority and make the ultimate determination. Moving a statue and changing the narrative of a city are ultimately not to be matters for that city: public narratives anywhere in England are the concern of, and so, it is suggested, should be under the control of, central government.

Jenrick's proposal is a striking demonstration of the importance which cultural heritage has everywhere assumed in political discourse. The government in London wishes to decide how "our" past is to be edited or censored. It will determine, in an increasingly diverse society which now embraces many different traditions, what "our" past is and how it may be presented or changed.

It is particularly revealing that this statement came from the communities secretary, not the culture or education secretary, underlining the fact that the central concern here is not in fact cultural, but societal. In the Colston controversy there was much talk about "history," but the question is surely not really about history, about what a society *was*, but about what it wants to become, and whether preserving a particular statue, or a piece of cultural heritage in the wider sense, can help prolong a societal status quo. By the same logic, destruction of long revered sites and monuments is often deemed essential by religious reformers and political revolutionaries, in order to clear the path to the new order. Cultural heritage is about the future.

Economic theory is familiar with Schumpeter's notion of creative destruction—that some businesses need to die so that those which better serve the public need can be born and flourish. Is there a need for a comparable, equally uncomfortable theory in the field of cultural heritage? The reason why we so value material cultural heritage is precisely the reason why to so many it seems necessary—and reasonable—to eliminate it.

That need to eliminate evidence of the past has rarely been more acute than in Eastern Europe following the collapse of the Soviet Union in 1990 and the subsequent withdrawal of its occupying forces. For decades, official histories, state ceremonies, and large-scale public monuments had celebrated the long-agreed (or perhaps more accurately, long-imposed) story of the courageous Soviet soldiers fighting the Nazis with huge loss of life, who came in 1944 as welcome liberators, and then stayed on as generous brothers in the joint struggle to build a democratic socialist society.

But in the newly independent countries emerging from Soviet-supported dictatorships after 1990, nation-building required a different story. Complex memories of collaboration and resistance during the fifty years of Nazi or Soviet occupation had to be recovered and adjudicated, then rearranged and given formal expression by new political leaders. Each of the reestablished republics painstakingly constructed its new national narrative, usually based on a selective reading of distant and recent history, which would allow it to build a cohesive independent state, both at ease with itself and distinct from its neighbors. But there was a major problem: in streets and public squares everywhere, existing monuments contradicted—sometimes entirely negated—that new and necessary history, which had been designed to sustain the community.

In the space of a few decades, the cultural heritage of postwar Eastern Europe was in consequence reshaped: songs, ceremonies, and national legends were reconfigured, and everywhere statues and monuments from the Soviet era were destroyed, buried, hidden, relocated, or presented in a new context—this time as memorials of oppression. Individual cases frequently led to intense argument, and sometimes violence.

One of the many Soviet war memorials to become the focus of bitter dispute, the *Bronze Soldier of Tallinn*, is a particularly telling example. Estonians of ethnic Russian origin simply refused to accept a new national narrative in which resistance to the Soviet occupier was privileged and celebrated.[5] For Russo-Estonians, the statue honoring the sacrifices made by their Russian comrades, long a landmark in the center of Tallinn, was a key part of their cultural heritage and their communal identity. For ethnic Estonians on the other hand, it was a dangerously corrosive lie. The statue has now been re-sited in a less prominent location. But that may be only a temporary solution to a problem which seems at the moment intractable.

In North America and Europe (though not of course in Russia) there has generally been a tolerant acceptance that damage to significant cultural heritage was a price which probably had to be paid if the post-Soviet countries of Eastern Europe were to become what they had chosen to be. Yet this contrasts sharply with the general international condemnation in the same period of damage caused in attempts to build a society based on a purified reading of Islam—whether Saudi Arabia's destruction of buildings in Mecca connected to the life of the Prophet, or the more public purgings of the Taliban and ISIS. As the *Bronze Soldier* makes clear, we all value the cultural heritage which supports our understanding of history—and our preferred options for the future.

It would be misleading to see the years since 1990 in Eastern Europe as exclusively ones of cultural heritage lost. In parallel with the elimination of one inheritance has gone the restoration or creation of another. The new communal narratives (at least the ones selected by the governments) are seen as an essential part of building a strong state, to be reinforced by changes in school curricula and supported by a new material cultural heritage in which those narratives are to be made publicly visible. So new monuments, buildings, and museums have taken the place of the old, to promote a story of long national struggle and ultimate, triumphant survival.

The aim of rebuilding a sense of national confidence is exactly the ambition articulated for the United States in Amanda Gorman's poem at the inauguration of President Joseph R. Biden. "Repairing" the past which Eastern Europeans stepped into and strengthening their inherited pride in national identity has taken many forms. I want to conclude with three examples. Since 1945 the royal palaces in Warsaw, Vilnius, and Berlin, each of which had been razed to the ground specifically to eliminate national memories in calculated acts of deliberate destruction of cultural heritage, have all been rebuilt, and in each case been invested with recovered—or sometimes entirely new—meaning.

One of the first steps in the Nazi attempt to destroy the Polish nation was the demolition, ordered by Hitler in October 1939, of the eighteenth-century Royal Castle in Warsaw. At the heart of the city, the residence of the last king had long been a key symbol of Poland as an independent European power. After the crushing of the Warsaw Uprising in 1944, the German army blew up everything of the castle that remained, to make way for a *Volkshalle* or people's hall in what was planned to be a totally German city. Nazi mass atrocity and the destruction of cultural heritage marched in step— coordinated elements in the intended cultural genocide of Poland.

In 1949, in spite of the huge economic challenges facing postwar Poland, the Polish parliament resolved to rebuild the Royal Castle, exactly as it had been in 1939, faithfully following photographs and drawings. The work continued for decades, and today visitors are confronted with a meticulously executed, utterly convincing facsimile, both inside and out. There must be some walking through the state rooms today who do not realize that this is *not* the original eighteenth-century palace, the showpiece of the Polish Enlightenment, but a totally modern building.

History here has been denied and reversed. It is as though nothing at all happened on this site between 1939 and 1945. But one thing has most definitely happened: Polish survival has been affirmed, and since 1990 and the subsequent ending of all military cooperation with Russia, the castle has become more than ever a symbolic declaration that no foreign invader or occupier can destroy the Polish people or crush their spirit. As a piece of cultural heritage, sustaining the central national story, the significance of the building demolished by Hitler has been completely recovered. The Royal Castle is without question more effective in its mythic function now than it was before its destruction. The old meaning has been successfully transferred to a new building. The

value of the restored castle as a source of information about the eighteenth century is negligible. What it says about Poland's view of itself today is profound. In some circumstances, cultural heritage can be recovered, even from total destruction.

The Renaissance Palace of the Grand Dukes of Lithuania in Vilnius was the seat of the rulers of the Lithuanian–Polish Commonwealth, which around 1600 stretched from the Baltic to the Black Sea. The building was razed to the ground by the Russians in 1801, after their annexation of Lithuania in the final partition of Poland. As in Warsaw, the invaders' aim was to remove a key symbol of national identity in a country that was henceforth to be—in this case—Russian. And, apart from a brief period between 1918 and 1939, Russian it remained until Lithuania declared its independence in 1990.

The decision to reconstruct the Palace in Vilnius was more complicated than in Warsaw, as much less was known about the building's original appearance, especially its interiors. The new palace, formally inaugurated in 2018 to mark the centenary of Lithuania's brief interwar independence from Russia, is a scholarly approximation, replicating what was thought to have been there in the sixteenth century, and it does not pretend to be more than a well-founded, partly imaginative reconstruction. The style of that reconstruction, however, and the selection of objects displayed inside the building, are more important than strict historical truth. Together, they present a view of a court and a society with strong links to the German-speaking lands and closely engaged with Rome and the Italian Renaissance. The message they carry is unequivocal and easily legible: that Lithuania has long been part of the Western European cultural tradition and owes little of significance to Russia, or indeed to Poland.

However questionable as history, this is the foundation narrative of the new Lithuania, now a member of the European Union and of the North Atlantic Treaty Organization (NATO), a country looking resolutely west—and that story can be seen and visited here. A powerful piece of cultural heritage has been created, very successfully as far as can be judged, and the national narrative is now securely anchored in a new "sixteenth-century" building.

Finally, Berlin. Built around 1700, the Berlin Palace, seat of the king of Prussia and German kaiser, was the heart of the Hohenzollern capital, the baroque culmination of the grand avenue Unter den Linden. Though damaged by bombing in World War II, it could well have been completely restored after 1945, and indeed some parts of it were. But in 1950 the government of the German Democratic Republic decided to blow it up. To them the palace was the supreme expression of Prussian cultural heritage, a symbol of hierarchy, militarism, and imperialist aggression, a building which could have no place in a new German state based on the teachings of Marx and Engels. The state of Prussia had been abolished; now its rulers' palace must follow it into oblivion. Unlike Warsaw or Vilnius, this destruction was—significantly—carried out not by an occupying

enemy power, but by Germans themselves: the new East German state, seeking to differentiate itself from its Western, capitalist, and allegedly imperialist counterpart, the Federal Republic. One strand of German tradition and self-understanding was repudiating another by dynamiting their shared past.

In the early 2000s, with Berlin again the capital of a united Germany, the federal parliament, the Bundestag, took the decision to rebuild the Royal Palace, reconstructing as accurately as possible the original three baroque facades. But although reconstructed, this was in no sense to *be* a royal palace—there was no ambition here to return to a proud national past, real or imagined, on the lines of Warsaw or Vilnius. Rather, the purpose was to show how different Germany had now become from its previous self. Instead of imperial reception rooms, or glorious periods of German national history, the visitors will find on the inside the African, American, Asian, and Oceanian collections of the Berlin museums. This reconstructed palace is intended to carry a message quite different from the original: it is to embody the narrative of a new, peaceful Germany, turning its back on its past—respectful of other traditions, welcoming debate, and hospitably open to the cultures of the world beyond Europe. And to make the point absolutely clear, it will not be called the Royal Palace, but the Humboldt Forum, in honor of the two scholarly brothers, Alexander and Wilhelm von Humboldt, who in the first half of the nineteenth century changed Europe's understanding of the ecology and cultures of the world.[6]

As the building only recently opened to the public, it is too soon to say how successful it will be in giving visible—and visitable—form to this new German self-understanding. The old Royal Palace was never held high in public affection, so there is little emotional connection to build on. Some see the building as a dangerous exercise in escapist nostalgia. Critics are concerned that the Roman architecture of the reconstructed facades is in irresoluble conflict with the non-European contents: the sculpted military trophies and triumphal arch motifs might be thought to endorse the colonial conquest by which parts of the African and Oceanian collection were acquired. While it may in time become a much loved building, it is not clear that it will be able to carry any coherent symbolic charge, even less to embody an ennobling narrative of national identity. It will take time before we can say whether this is merely a new museum, beset by controversy, or whether a powerful piece of cultural heritage, bearing a meaning beyond itself, has been brought into being.

From these different examples, a few conclusions may be drawn. There is no doubt that when a communal myth or narrative can be embedded in a monument, that combination has a rare power to strengthen and sustain a society's belief in itself. It is that embedding of meaning that makes an archaeological site, a building, or a monument into a piece of cultural heritage. And, encouragingly for such objects, as the Eastern European examples show, destruction is not necessarily the end of the story.

Much historical information may be irrecoverably lost when cultural sites perish, but the strengthening, vivifying role that they play in building community can on occasion be just as effectively performed by a reconstruction or a replacement, perhaps even more powerfully because they were once destroyed. They can live again.

SUGGESTED READINGS

International Bar Association, *Contested Histories in Public Spaces: Principles, Processes, Best Practices* (London: International Bar Association, 2021), https://ibanet.org/contested-histories.

Neil MacGregor, *À monde nouveau, nouveaux musées: Les musées, les monuments et la communauté réinventée* (Paris: Musée du Louvre / Hazan, 2021).

Andrea Theissen, ed., *Enthüllt: Berlin und seine Denkmäler* (Berlin: Stadtgeschichtliches Museum Spandau, 2017).

Rodolphe Tolbiac, *La destruction des statues de Victor Schoelcher en Martinique* (Paris: L'Harmattan, 2020).

Marjorie Trusted and Joanna Barnes, eds., *Toppling Statues: Papers from the 2020 PSSA Webinar Co-hosted by* The Burlington Magazine (Watford, UK: Public Statues and Sculpture Association, 2021).

NOTES

Epigraphs: Joan Didion, *The White Album* (New York: Farrar, Straus and Giroux, 1979), 11; Amanda Gorman, "The Hill We Climb," read at the inauguration of US president Joseph R. Biden, Washington, DC, 20 January 2021.

1. Kavita Singh gives a memorable example of the Hazara inhabitants of the Bamiyan Valley, who had attached a completely new meaning to the colossal Buddhas, transforming them into a legendary hero and his princess. See Kavita Singh, commentary in "Social and Cultural Costs," *Cultural Heritage under Siege: Laying the Foundation for a Legal and Political Framework to Protect Cultural Heritage at Risk in Zones of Armed Conflict*, ed. James Cuno and Thomas G. Weiss, Occasional Papers in Cultural Heritage Policy no. 4 (Los Angeles: Getty Publications, 2020), 52, https://www.getty.edu/publications/occasional-papers-4.
2. For a full discussion of the disputes around the Colston statue, see International Bar Association, *Contested Histories in Public Spaces: Principles, Processes, Best Practices* (London: International Bar Association, February 2021), 19–50.
3. Robert Jenrick, "We Will Save Britain's Statues from the Woke Militants," *Sunday Telegraph*, 17 January 2021.
4. Government of the United Kingdom, "New Legal Protection for England's Heritage," press release, 17 January 2021, https://www.gov.uk/government/news/new-legal-protection-for-england-s-heritage.
5. See International Bar Association, *Contested Histories in Public Spaces*, 147–74.
6. For a full account of the evolving ideas for the reconstruction of the Berliner Schloss and its use, see Peter-Klaus Schuster and Horst Bredekamp, *Das Humboldt-Forum: Die Wiedergewinnung einer Idee* (Berlin: Wagenbach Klaus, 2016).

3

Cultural Heritage under Attack: Learning from History

Hermann Parzinger

The history of the intentional destruction of cultural heritage is long and diverse,[1] with motivations similarly varied. Ideologically or politically motivated iconoclasm seeks to destroy symbols and representational signs that characterize a past that has been vanquished, or a deposed system to purge its memory. Religious iconoclasm is fed by the hatred of images of another religion, as well as by the fight against idolatry and false gods in the service of the true faith. Economically motivated cultural destruction is characterized by the pillage and plunder of culturally significant sites or monuments for financial gain, which at times may give rise to shadow economies. It may not always be possible to clearly differentiate between the various reasons driving the destruction of cultural heritage, but they are closely intertwined. Cultural destruction also often goes hand in hand with human rights violations and other atrocities, particularly when the latter involve ethnic cleansing and genocide. These interconnections will be explored in detail throughout this essay.

The Beginnings: Cultural Destruction during Antiquity

Ancient sources support the notion that a plurality of motivations drive the destruction of cultural heritage. Craving recognition, Herostratus set ablaze the Temple of Artemis in Ephesus, in Asia Minor, in 365 BCE. Seeking revenge, Alexander the Great destroyed the Persian capital of Persepolis in 330 BCE, Rome sacked the Greek city of Corinth in 146 BCE, and both were surprising in their ruthlessness and made little sense militarily. And for political reasons, Carthage was razed on the orders of Roman general Scipio (in the same year as Corinth) to vanquish one of Rome's most important contemporary competitors.[2] The civilian populations were also gravely affected by such destruction, as it was commonly accompanied by massacres and enslavement.

Pillage and plunder of the spoils of a defeated city by the victorious power was commonplace in ancient times and in later eras was deemed the right of the victor,

while the defeated population was for the most part barred from any rights and protection. Anything valuable and somewhat usable was stolen. However, at stake in these attacks was not any targeted destruction of works of art and cultural artifacts in the sense of an iconoclastic campaign, driven by the social belief in the importance of the destruction of icons and other images or monuments for political or religious reasons. In fact, such artifacts were often subject to political appropriation and rededication: by exhibiting them as trophies of victory in the public domain, military victories over other peoples could be permanently memorialized and claims to domination effectively visualized.[3] The destruction of cultural heritage during ancient times was thereby in most cases politically motivated.

Cultural heritage destruction coupled with atrocities against populations are also known from the time of Ancient Mesopotamia. Thus, after the demise of the Assyrian Empire around 600 BCE, an intense hatred was unleashed on cities like Assur and Nineveh, leaving behind clearly visible traces of destruction of works of art: e.g., sarcophagi of the Assyrian rulers were demolished and their faces systematically purged from the palace reliefs because the vanquished were to be denied the possibility of immortalizing their glorious feats for posterity. The Assyrians had previously reacted similarly in obliterating particular rulers and dynasties from collective memory by destroying their sculpted images, a familiar practice throughout the ancient world.[4]

After the rise of Christianity in late antiquity, particularly the eastern parts of the Roman Empire saw clashes between the followers of Christianity and practitioners of pagan cults.[5] The forces driving these hostilities also strove for political and economic power. On the Christian side, the focus was not solely on the obliteration of pagan sanctuaries and their conversion to churches; rather, a central concern was also the seizure of each temple's wealth in gold, silver, precious stones, and other treasures.

The destruction and looting of a temple known as the Serapeum of Alexandria in 392 CE was the climax of antipagan violence and seizures. Serapis was revered equally by the Egyptian and Greek inhabitants of the city—in fact, the Serapeum was deemed Alexandria's most significant sanctuary. The violent suppression of all pagan cults that was orchestrated by the Christian bishop Theophilos resulted in extreme polarization of the population of the early Christian Roman Empire. He provoked bloody clashes, then accused the pagans of rioting. After the pagans had barricaded themselves inside the temple, the imperial order came down authorizing its destruction and the future suppression of any exercise of pagan cults. The Serapeum of Alexandria and other temples were leveled, a devastation that went hand in hand with widespread pillage and plunder. The central idol of the Serapeum of Alexandria was hacked into pieces and scattered for public display at different locations within the city, only to be subsequently burned at the amphitheater. A more horrific desecration is scarcely conceivable.[6]

Ideological-religious conflicts in late antiquity resulted in enormous destruction of cultural heritage. Aside from securing the victory of Christianity, another concern was the redistribution of resources that could confer wealth, prestige, and power to the

holder. Religious contradictions were not the driving force, but more often merely a pretext. Particularly in the Eastern Roman Empire, during late antiquity the state was more often the driven, and not the driving, force in these conflicts. The late Roman administration often had few instruments at its disposal to counter the organizational capability, military prowess, and mobilization potential of the Byzantine church. Contemporary sources widely disregard the consequences for the population, yet the devastation of pagan sanctuaries, besides being provoked by economic motives, was associated with massacres among the members of their practitioner communities, though the latter were not the actual target.

Religion and Power: From the Iconoclastic Controversy in Byzantium to the *Bildersturm* of the Protestant Reformation

The period between the eighth and sixteenth centuries saw multiple iconoclastic controversies.[7] Unlike the cultural destruction of late antiquity, a theological conflict on the permissibility of "iconic" depictions in religious contexts stood at the center of this debate. Particularly the question of if, and if so to what extent, it was permissible for believers to create and worship human-like images of God, icons of Jesus, and representations of the saints.

Between 730 and 841, Christian monasteries in the Eastern Roman or Byzantine Empire safeguarded cultural images and relics that had ascribed to them the most varied curative powers. Yet in order for popular interaction with these images and for their curative powers to emerge, the monastery was owed payment. Such measures helped monasteries strengthen their economic power as whole town populations became increasingly interdependent with monasteries, which were built as regular fortresses and enjoyed tax advantages. At the end of the seventh century, one-third of imperial lands were in the hands of churches and monasteries, and an ever more impoverished state stood opposite an increasingly affluent Byzantine church.[8]

By the eighth century, a gradual shift in the power structure had advanced to such a perilous degree that the monasteries found themselves gravely challenged. As pagan temples had been looted during late antiquity for their accumulated treasures, the Byzantine state appropriated the riches of the Christian monasteries during the eighth and ninth centuries. This political and economic struggle needed an ideological-theological foundation, a realization that resulted in the Byzantine iconoclastic controversy. From its very beginning, this debate had political implications and was ordered from the top by the state. Indiscriminate, unbridled destruction was to be avoided at all cost, and the population was for the most part not involved.

Moving westward, the Central European Hussite Wars of the early fifteenth century were different. The Bohemian preacher Jan Hus revived criticism of idolatry and challenged wealth, worldly passions for grandeur, moral decay, the Church's trade in indulgences, and the supreme authority of the pope in questions of faith. In 1415, at the Council of Constance, despite assurances of safe conduct, Hus was accused of heresy and

convicted and burned along with his writings. His reformist critical teachings subsequently morphed into a revolutionary mass movement in Bohemia, culminating in the Hussite Wars of 1419–34.[9]

Known in German as the *Bildersturm* (picture storm), the iconoclasm of the sixteenth-century Protestant Reformation was similar. For Martin Luther, the fight against idolatry was secondary, with his rage directed at other grievances against the Church, particularly the sale of indulgences by which it accumulated tremendous assets, including art treasures. Although Luther was not a radical iconoclast, his teachings had lasting consequences for the production of art in territories under Protestant rule: the fabrication of elaborate altars, tableaux, and sculptures, as well as luxurious chasubles or liturgical utensils of precious metals, plummeted.[10]

In contrast, the Swiss reformers Ulrich Zwingli and Johannes Calvin demonstrated a visibly more iconoclastic attitude. They rejected any representation of God and ordered the removal of all such images from the churches, arguing they promoted idolatry and carnal desire. The systematic removal of representational images throughout Europe during the Reformation was typically organized by government authorities in efforts to avoid spontaneous acts of violence.[11] A significant number of works of art, images, and sculptures was sold for profit, resulting in an enormous influx of wealth to state coffers.[12] Still, again and again, radicalized masses engaged in unbridled orgies of destruction during which images were damaged, mutilated, and "executed" or derided in mock trials.[13] The loss of works of art was enormous, far greater than the violence enacted upon the population, although violence also increased, climaxing in the Thirty Years' War in the seventeenth century, when one-third of the population of Central Europe is thought to have perished.

Revolution and Colonization: The Long Nineteenth Century

The period between the beginning of the French Revolution in 1789 and the breakdown of the old European order after World War I is referred to as the "long nineteenth century."[14] The revolution was a turning point in the history of the destruction of cultural heritage.[15] The iconoclasm of the revolutionaries was no longer religiously motivated, but was propelled by a secular cultural ideology. After the storming of the Bastille at the start of the French Revolution, the overriding objective of the new government was overcoming the political and social conditions of the ancien régime. Countless representatives of the fallen system fled abroad or ended up on the guillotine, and the works of art of that period were seen as symbolic of a hated despotism that had to be eliminated. In 1791, iconoclasm was legalized and elevated to a political program. During the next few years, destruction of cultural heritage went hand in hand with politically and socially motivated executions and persecutions, one a by-product of the other without a direct causal link.

Palaces were looted and sprawling landed properties owned by the Church and the aristocracy were nationalized with the intent of mitigating the chronic financial

shortages of the revolutionary state.[16] Tableaux and sculptures, illuminated manuscripts, luxurious furniture, and decorative arts, but also liturgical items such as reliquaries and monstrances of precious metal, fell into the hands of the revolutionaries, who melted them down or sold them. Even the mausoleums and tombs of the French kings, such as those in Saint Denis, a northern suburb of Paris, were looted and devastated. Bishop Henri Grégoire denounced this unrestrained destructive frenzy driven by blind rage and coined the term "vandalism" to describe it.[17]

Parallel to the growing resistance to the revolutionary destructive madness, a basic rethinking introduced a new phase in French cultural policy. This new approach was based on the understanding that it does not make sense to nationalize works of art while simultaneously destroying or selling them abroad. Rather, proponents of the new view believed that the nationalization of cultural wealth came with the obligation to preserve and maintain it. This impulse was the beginning of a new understanding of the concept of cultural heritage (French *patrimoine*).[18] And administrative mechanisms ultimately channeled and institutionalized the iconoclasm of the revolution, resulting in a growing respect for works of art and the birth of the modern museum, viewed also as an institution of learning, which found a home in the Louvre.[19] After the politically motivated iconoclasm of the French Revolution there emerged a new appreciation for art based on the understanding that it can make a crucial contribution to higher learning and the self-realization of humankind.

The nineteenth century was also the climax of the conquest of the world by European colonial powers. Lasting half a millennium, this global subjugation and exploitation resulted in the destruction of cultural heritage of staggering proportions. Destruction was always accompanied by atrocities against Indigenous populations, of a severity that, at the time, would have been unfathomable within Europe itself. This occurred as early as the sixteenth century, during the colonial conquest of Central and South America by the Spanish and Portuguese. Two large and growing empires—that of the Aztecs in present-day Mexico and the Incas in the Andes region in South America— were completely obliterated.[20] The devastation ranged from the destruction of monumental buildings and the looting of shrines to the incineration of written traditions or codes (fig. 3.1). Not only did this result in an immense loss of knowledge, it was the start of cultural as well as physical genocide.

From the middle of the nineteenth century China also found itself in the crosshairs of European colonial powers. At the end of the Second Opium War in 1860, British and French troops seized the capital of Beijing and attacked the imperial Old Summer Palace in Yuanmingyuan—the Chinese version of the Palace of Versailles in Paris—northwest of the city. Marauding soldiers went on an unimaginable rampage, burning down the entire palace district and looting thousands of important works of art and cultural artifacts of gold, silver, jade, ivory, and so on.[21] The estimated tally stands at over a million items stolen and sold to museums around the world.

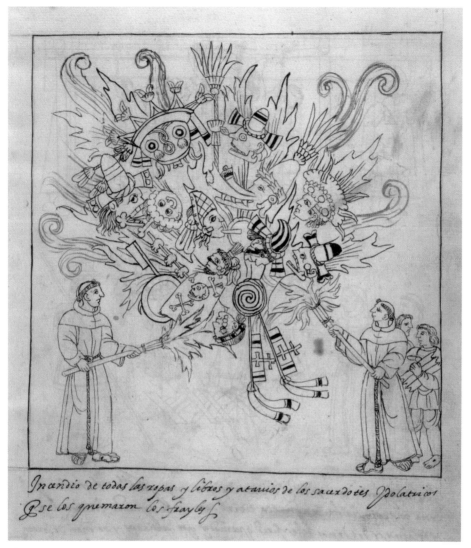

Figure 3.1 Folio 242r from Diego Muñoz Camargo's *Historia de Tlaxcala* (1585) depicting the burning of Aztec ritual objects by Spanish missionaries. Image: University of Glasgow, Archives & Special Collections, MS Hunter 242

In 1900, what became known as the Boxer Rebellion broke out in opposition to increasing European influence in China but was crushed by an international military force the following year. The expedition turned into a merciless retaliatory campaign of revenge against the Chinese people and culture in which the invaders were responsible for appalling atrocities, destruction, pillage, and plunder. Many palace and temple installations inside and around Beijing were devastated and the palace complex known as the Forbidden City was desecrated and looted. Hundreds of thousands of art treasures and artifacts were destroyed or stolen, accompanied by executions and massacres.[22] These events are burned into the collective memory of the Chinese people.

Around the same time, the British conducted a punitive expedition against Benin in southwest Nigeria, one of the most flourishing kingdoms in the sub-Saharan Africa of

the late nineteenth century. Its metal foundry works, including commemorative heads and relief plates of bronze and brass, as well as ivory carvings, were of particularly excellent quality. After the British conquered Benin's capital in 1897, thousands of works of art from the palace districts were brought to London, and from there they were scattered around half the globe.[23]

While the historical context of each of these examples of cultural destruction is distinct, they nonetheless share the merciless brutality by which entire civilizations were debased, robbed, and sometimes annihilated. Yet the conflicts in China and Benin occurred during the period when the 1899 Hague Convention (II) with Respect to the Laws and Customs of War on Land was being drafted.[24] This expressly prohibited the looting and destruction of historically, culturally, and religiously significant locales and monuments. However, neither the Kingdom of Benin nor the Chinese Empire were signatories and so these rules were not applied to them. Moreover, outside Europe, plunder and attacks against civilian populations were considered legitimate during colonial wars. In his notorious "Hun Speech" Kaiser Wilhelm II expressly instructed the German East Asia squadron to be ruthless.[25] This had to have been understood as an invitation to commit atrocities against the civilian population.

Nevertheless, the targeted destruction of works of art and artifacts played little role in World War I, the first industrially fought mass war resulting in millions of deaths. Among the few exceptions were the atrocities committed by German troops against a civilian population at the very beginning of the war in the Belgian city of Leuven. Its historical downtown, lined with important sacral and civic buildings from the late Middle Ages and Early Modern period, was looted and burned to the ground. The destruction of the city's famous university library also resulted in an enormous loss of cultural artifacts. These events were a public relations disaster for the Germans, as shocked international observers spoke of the "holocaust of Leuven." To make matters worse, Leuven was not an isolated incident: other Belgian cities with important historical centers were destroyed and looted during the first months of the war, a clear breach of the 1899 Hague Convention.[26] It has been suggested that anti-Catholic resentment by the Prussian military, which was indebted to the Protestant confession, was instrumental in the decision to destroy the spiritual centers of Belgian Catholicism, robbing the population of its cultural identity.[27] But these territories were slated to be incorporated into the German Reich after the end of the war, so this must remain speculative.

Radical Ideologies and Totalitarian Systems: The Catastrophes of the Twentieth Century

The breakdown of the old European order as a consequence of World War I, the "seminal catastrophe" of the twentieth century, fundamentally changed the world's political landscape. The old German, Russian, Austro-Hungarian, and Ottoman Empires collapsed or were broken up into many new independent states. Territorial losses and

newly drawn borders sowed discontent and ultimately destabilized an entire continent. This development paved the way for radical ideologies, such Bolshevism, National Socialism, Maoism, and that of the Red Khmer, all of whose propaganda of the utopian society had consequences for views on art and culture.

In Eastern Europe the war brought the demise of the Russian Empire and its replacement by the Soviet Union. Similar to the aftermath of the storming of the Bastille, the change was accompanied by looting and the destruction of monuments representing the old system.[28] Revolution, civil war, and purges meant death for millions of Russians during the transition and in later years. Nonetheless, unlike the activists of the French Revolution, the new Bolshevik government in Russia was not interested in a targeted iconoclastic strategy. Even though monuments of the czars and any symbols and emblems directly linked to them were removed and their former owners expelled or executed, following an initial period of looting and vandalism there was a rather immediate impulse to protect and preserve cultural heritage, and the imperial palaces were quickly placed under government supervision and repurposed as museums, declared the property of the people.[29]

The Bolsheviks gradually confiscated cultural artifacts and other valuables from palaces, manor houses, museums, and churches. But art was preserved first and foremost because of its monetary value, and treated as a commodity. Necessitated by the never-ending financial difficulties of the young Soviet government, especially to fund rearmament and the repair of a dilapidated infrastructure, the most valuable incunabula and manuscripts, as well as thousands of works of art, including masterpieces from Russian museums, were sold abroad for hard currency. The hub for this sell-off of Russian cultural heritage was galleries in Berlin. Only when Hitler and the National Socialist Party came to power in Germany did this trafficking in Russian art end.[30]

Immediately after the Nazis' *Machtergreifung* (seizure of power) on 30 January 1933, the German government began a frontal assault on the arts and representatives of the arts, which was all the more destructive because, aside from its politico-ideological underpinnings, it was also characterized by a strong racial component.[31] The book burnings of 1933, and the traveling propaganda exhibition *Entartete Kunst* (*Degenerate Art*) that began in 1937, marked the more prominent milestones on the path to discrediting and obliterating art and culture, along with its makers.[32]

The Law on Confiscation of Products of Degenerate Art of 1938 finally created a legal footing for the destruction of modern art. During the following few years, some twenty thousand works by about 1,400 artists were confiscated from over a hundred German museums.[33] Hermann Göring, the second most powerful figure in the Third Reich until the later war years, was purportedly the first to float the idea of economic exploitation of this art. Commissioning transactions through selected art dealers, including Hildebrand Gurlitt, a systematic international sale of the confiscated "degenerate" art was organized via Swiss galleries in efforts to secure urgently needed hard currency for

the Third Reich in support of the preparation and execution of its planned war of aggression.[34]

With the systematic extermination of Jewish life and culture as a core goal of the Nazis, discrimination, disenfranchisement, and looting started immediately after they took control of the government in 1933 (fig. 3.2). Major art collections owned by Jews, for example, were seized and placed in public museums, libraries, and archives.[35] Remedying this injustice has become a special moral obligation the world over, leading to the search and restitution of illegally confiscated cultural artifacts and art looted by the Nazis prior to and during World War II, based on the Washington Principles. The Nazi genocide against the Jewish population of Europe was also a cultural genocide, with all visible signs of Jewish culture obliterated.

Plunder, persecution, and oppression were also routine in the countries that the German army occupied during the war. The systematic looting of art and cultural artifacts reached staggering proportions, with Eastern Europe treated with particular cruelty. In their crazed fantasies of a large Germanic empire and *Lebensraum* (living

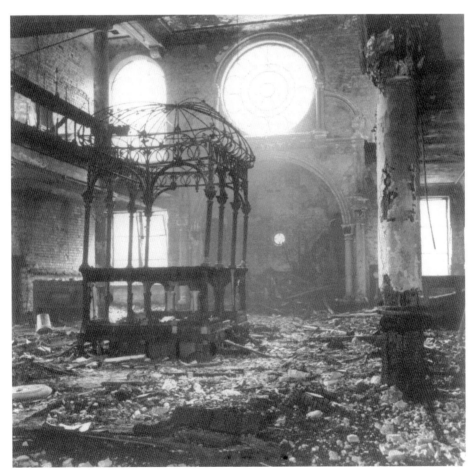

Figure 3.2 The gutted interior of the Nuremberg synagogue after burning and looting by an organized Nazi mob on 9 November 1938. Image: Granger Historical Picture Archive

space) in the east, the Nazis planned, in addition to the Holocaust, the mass murder of the Slavic and other non-Jewish populations of Poland and the Soviet Union. This was coupled with cultural genocide: all works of art and cultural artifacts that aroused the Nazis' fancy were looted and transported to Germany, with the rest systematically destroyed.[36] Museums, libraries, and archives, as well as palaces, mansions, and churches, in fact entire historical parts of towns of the highest cultural value, were obliterated. It was an iconoclasm of genocidal proportions, intended to rob human beings of their cultural identity.

From its early days, the intentional destruction of cultural heritage also played a crucial role in Mao Zedong's communist movement in China. Already during the 1920s and 1930s the communists looted and demolished temples and ritual representational images as remnants of a feudal Chinese past. In 1966, under the People's Republic, Mao generated the Cultural Revolution, which lasted until his death in 1976 and triggered a far greater wave of cultural destruction. Red Guards paramilitary revolutionary groups set their crosshairs on countless temples, shrines, cult images, and ritual objects, as well as porcelain, paintings, books, and manuscripts, in a campaign that sought to radicalize the entire nation and propagate Maoism as a religion.[37] Artists whose works were declared "degenerate" were persecuted. The losses to Chinese cultural heritage were enormous. Yet works of art and artifacts were not only destroyed but also widely sold abroad—again, economic motivations played an important role.

The suppression of Tibetan culture in southwestern China has also been devastating. Tibet had declared independence in 1911, but Mao forcibly reincorporated it into the Chinese state shortly after the founding of the People's Republic in 1949. The war against Tibetan culture, which has centrally embraced Buddhism for perhaps fifteen hundred years, was executed ruthlessly and without consideration. For example, of over six thousand Buddhist temples and monasteries in Tibet before 1949, only thirteen still existed by the end of the Cultural Revolution.[38]

In Cambodia in 1975, a reign of terror began as the Khmer Rouge, a Maoist nationalist guerrilla movement, came to power under Pol Pot. Enamored with a preindustrial form of communism, they glorified agricultural life and deported a large segment of the urban population to the countryside. The land became a huge work and prison camp, with millions of people ending their lives in the "killing fields" of Cambodia, acts constituting crimes against humanity and arguably genocide. The wealthy and educated elite were exterminated, books were burned, universities closed down, and dance and music forbidden. The exercise of religion was also forbidden, and most of the country's Buddhist temples and shrines were destroyed, along with churches and mosques. Works of art were demolished and incinerated to eliminate the prior cultural identity of the Cambodian people. In addition, there was systematic looting of historical sites and the sale and resale of valuable objects abroad:[39] one aspect of this was the orchestration of the destruction of cultural heritage by promoting illegal

excavations and organized trafficking in antiques—the first time this form of cultural destruction is known.

Ethnic and Religious Conflicts: The Crises of the Present

Throughout the last few decades, destruction of cultural heritage has often been encountered in the context of ethnic conflict. In the case of the wars in the former Yugoslavia in the 1990s, the cultural heritage destruction was not random or unintentional—collateral damage in the course of military strife—but systematic and targeted. Serbs and Croats targeted mosques for bombing (fig. 3.3), Croats and Bosnians did the same to churches, and Serbs and Bosnians to Catholic places of worship—the sacral architecture of the enemy ethnic group was a preferred target. While the destruction of the symbolic Muslim bridge of Mostar awakened the international community, the Catholic episcopal palace, including its library, and the largest Catholic churches in the region were also severely damaged.[40] The war was fought on parallel tracks—against the people and their culture and heritage—with particular ruthlessness. The intent was to thus make ethnic cleansing campaigns irreversible.

Serbs and Albanians also adhered to this strategy during the 1998–99 Kosovo War. Again, mosques and churches were in the crosshairs. Countless Orthodox churches and monasteries were destroyed, as were the majority of the mosques.[41] The cultural and particularly the architectural heritage of the region became a symbolic battlefield.

Similar developments have occurred in the Middle East, where a devastating iconoclasm by Islamist extremists called attention to itself at the beginning of the twenty-first century. Yet the Quran does not unambiguously call for a ban on images. The early Islamic art of the Umayyad Caliphate (661–750) and even that of the succeeding Abbasids (750–1258) was replete with representational images that afterward survived in Islamic illumination.[42] In contrast, the early Islamic Hadith literature, the collected sayings of Muhammed, contains critical statements regarding images; since then, the issue of whether representational images of a human likeness are permitted has been raised intermittently.

The beginnings of the militant Islamic attitude toward images is closely tied to the Sunni Wahhabi movement originating in the Arabian Peninsula in the eighteenth century, which subscribed to the verbatim implementation of all the early Islamic rules.[43] The Wahhabis insist that any representation of Allah, any prayer directed at an image, or the veneration of a picture of a saint constitute blasphemy. In 1802, the Wahhabis conquered Karbala in Iraq—one of the most important destinations for Shiite pilgrimage—where they destroyed and looted the Imam Husayn shrine, killing thousands of Shiite faithful. In the nineteenth and early twentieth centuries, Wahhabi extremists intermittently destroyed holy sites in Mecca and Medina.[44]

In the early twenty-first century, the iconoclasm of the Islamists finally alerted the world to their cause when the Taliban demolished the colossal Buddha statues in Bamiyan, Afghanistan.[45] This barbaric act was documented on film and reported

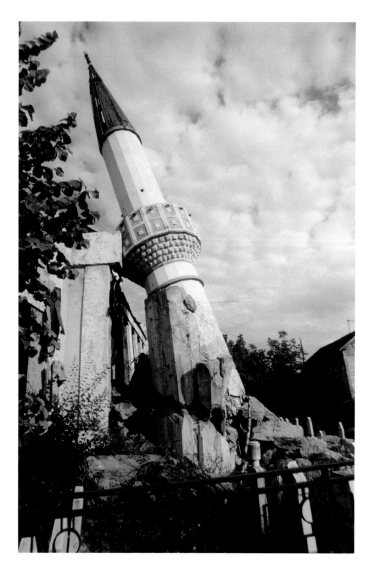

Figure 3.3 The main mosque in Banja Luka, Bosnia-Herzegovina, destroyed during the war in the former Yugoslavia. Image: Wolfgang Maria Weber / Interfoto

worldwide, making it an act of performative iconoclasm before a global audience. The destruction of the statues was also an attack on a hegemonic conception of Western thought and on what the West understood as cultural heritage. Of course the cultural heritage of Afghanistan has been pillaged and plundered ever since the Soviet invasion in 1979: the Taliban utilized existing structures for unlawful illicit excavations and sold substantial parts of the country's cultural heritage worldwide.[46]

Another recent example of cultural destruction motivated by fundamentalist thinking is found in Mali. In 2012, Islamist militias including Ansar Dine attempted to set up an independent Islamic state in the north of the country. When they conquered Timbuktu, one of the most significant cultural and intellectual centers of northern Africa, they destroyed most of the mausoleums that had been declared World Heritage Sites by the UN Educational, Scientific and Cultural Organization (UNESCO). They also demolished many Sufi shrines and damaged mosques. A spokesperson for Ansar Dine

put a shocked global public on notice that anything considered by sources outside Mali as constituting "world heritage" would be destroyed.[47] It is a miracle that three hundred thousand volumes of the most valuable manuscripts and prints from the twelfth to the twentieth century were able to be rescued and removed from Timbuktu, one of the world's most important bookselling centers.[48] In 2016, the International Criminal Court in The Hague convicted Ahmad al-Faqi al-Mahdi, an Ansar Dine leader, for acts committed in Timbuktu: it is significant as the first ever sentence at an international criminal tribunal for cultural destruction as a war crime.

Iraq and Syria, however, were hit hardest by recent acts of cultural destruction, when the Islamic State of Iraq and Syria (ISIS, also known as ISIL or Da'esh) propagated a reign of terror from at least 2013 that lasted several years. Nevertheless, the destruction of cultural heritage started much earlier in the region, with illicit excavations generating an illegal trade in ancient artifacts, masterminded from abroad. While this is a tradition going back decades, parallel to the breakdown of the authority of the state in Iraq and Syria, the plunder of archaeological sites has become ever more professional and has currently reached virtually industrial proportions.

ISIS's terroristic tactics and governance inaugurated a particularly dark age for the cultural heritage of the Middle East, with hate crimes against culture accompanied by egregious human rights violations. Most prominently, the persecution of the Yezidis, nothing short of ethnic cleansing and genocide, was coupled with the annihilation of their cultural heritage.[49] In addition, the images of the destruction at the museums in Mosul, Nineveh, Nimrud, Hatra, and particularly the devastation to the Roman ruins of Palmyra (fig. 3.4), accompanied by the savage murder of the site's chief archaeologist, Khaled al-Asaad, have not been forgotten. The documentation of demolitions of important ancient monuments by ISIS and the global online dissemination of the pictures have turned these infamous acts into special cases of a performance-based, quasi-religious iconoclasm.[50]

The devastation by ISIS resulted, on the one hand, in the physical loss of important archaeological, historical, cultural, and religious places and objects, and on the other deprived entire communities of their cultural and religious modes of expression and identity. Oppression or destruction of cultural identities and religious communities are nowadays more seldom perpetrated by state actors, but with increasing frequency by nonstate armed groups such as ISIS.[51] The group was not only instrumental in demolishing ancient works of art and monuments, it also systematically pillaged and plundered sites and channeled their treasures to the global illegal markets for antiquities and used the proceeds to finance their activities.

The conflicts of the late twentieth and early twenty-first centuries that have seen the intentional destruction of cultural heritage (such as in the aforementioned Bosnia, Kosovo, Afghanistan, Iraq, and Syria) are side effects of a growing form of armed conflict: internal disputes and civil wars. The number of these conflicts has visibly increased since the last decade of the twentieth century, while the number of interstate

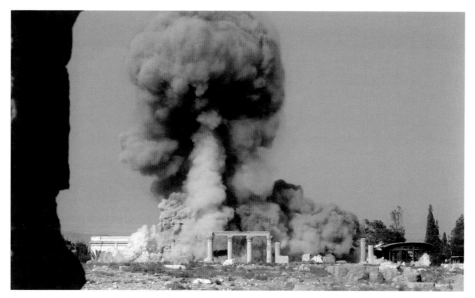

Figure 3.4 Demolition of the Temple of Bel in Palmyra by ISIS in 2015. Image: akg-images / Pictures from History

wars has notably decreased. In the unfolding of these internal conflicts, cultural heritage is involved for two reasons. First, such disputes are deep manifestations of the identities of rival ethnic or religious groups, which turns representations of the cultural heritage of a group into an important and preferred target. This can result in the intentional destruction of cultural artifacts that is rarely required purely for military advantage. And second, conflicts that involve nonstate actors are generally perpetuated by so-called shadow or war economies, and include the plunder of archaeological sites and other cultural monuments, and the illegal sale and resale of artifacts discovered and forcibly torn from their respective historical context.[52]

Final Thoughts

A review of the long history of the destruction of cultural heritage and a search for links with mass atrocities, including genocide, reveals clear distinctions over time. In ancient times, wars were typically accompanied by the intentional destruction of cultural heritage and by massacres and enslavement. In late antiquity, cultural artifacts as well as people could become targets in disputes between emerging Christianity and resident pagan cults, for example. However, at the core of such strife was the redistribution of political and economic power.

This holds true for Byzantine iconoclasm. Although justified theologically, the state pursued political and economic objectives in the conflict, intent on breaking the power of the churches, and particularly the monasteries. The iconoclasm of the Reformation, including preludes throughout the fifteenth century, led to a comprehensive obliteration, and in part also a sell-off, of works of Catholic art in territories under Protestant rule, where art production also plummeted and where artists were often

forced to work for patrons outside the Church. Works of art were damaged, mutilated, "executed," or ridiculed in mock trials, but not their originators or owners—this difference is significant.

The French and Russian Revolutions that flank the long nineteenth century both initially targeted elites and other representatives of their deposed systems as well as works of art and cultural artifacts that were perceived as a reflection of them. In Russia, the destructive frenzy could be reined in faster than in France, where such vandalism had devasting consequences. Yet through nationalization, France did arrive at a novel understanding of its cultural heritage, while during the early Stalin years in the Soviet Union, art was treated as a commodity, resulting in an unparalleled sell-off. Both revolutions represent profound turning points in the history of their countries, creating countless victims and resulting in massive destruction and loss of cultural artifacts.

The European colonial conquests propelled new ruthlessness into the destruction of cultural heritage. The annihilation of the Aztec and Inca Empires by Spanish conquistadores was also a cultural genocide paralleling the violent reduction of the Indigenous population, either perpetrated directly or occurring indirectly due to the devastating effect of imported diseases. Events in China and Africa also demonstrate how the destruction of cultural heritage was often accompanied by massacres among the population and that, although the 1899 Hague Convention was in force in Europe, it was willfully not applied elsewhere.

The crimes of National Socialism, whether against the Jewish population of Europe or in the occupied territories of Poland and the Soviet Union, reached a new dimension in the extermination of cultural artifacts and their originators and carriers, wherein the Holocaust remains unparalleled: systematically orchestrated physical genocide was accompanied by cultural genocide. In the 1970s, we find a somewhat similar reign of terror by the Khmer Rouge in Cambodia that resulted not only in the demolition of countless cultural artifacts but also in the deaths of over one million people. The Nazis and the Khmer Rouge shared, among other traits, the desire to engage in genocide and in the destruction of cultural artifacts, but they also both sold works of art on a grand scale abroad to obtain foreign currency.

Since the 1990s, the intentional destruction of cultural heritage and the pillage and plunder of cultural locales have increasingly become ancillary effects of new types of conflict,[53] whether civil wars as in the Balkans, or involving mainly terrorist groups as in the Middle East. They are characterized by their concern for nationality, identity, and group membership, defined ethnically, socially, religiously, politically, territorially, and even linguistically. In this context, as in others, cultural artifacts are an enormously important symbolic resource that strengthens the feeling of belonging and cohesion of a community, and provides a united symbolic repertoire that simultaneously distinguishes a given group from others. Cultural artifacts can, with the aid of memory, ritual, and mythos, establish or revive continuity with past generations.

The goal of such conflicts, fought largely between nonstate armed groups, is often the destruction of a shared history and collective memory that can be accomplished through ethnic cleansing and genocide. These events are particularly likely to occur in weak, failed, or disintegrating states that are no longer actors in their own right but have been subverted and ultimately co-opted by criminal or terrorist groups.[54] These conflicts, which have substantially increased in number throughout recent decades, have become considerably more perilous for cultural heritage than the classic interstate wars of the past. When an armed group in these recent conflicts has attempted to exterminate a particular community, this has usually been accompanied by cultural heritage destruction. Due to the communication options available today, such an act also tends to play out in front of a global audience, often self-consciously from the perspective of the armed groups uploading media. Perhaps this is the most fundamental distinction relative to earlier times.

Looking back at this long history of intentional destruction of cultural heritage, we find continuities as well as differences. First, the examples clearly demonstrate that despite differing motivations, which may have been political, ideological, or religious, from antiquity to the current day, economic factors are also always present, from the redistribution of temple and church treasures of the past to the almost industrial scale of illegal archaeology and illicit trafficking of antiquities today. Second, there is a combination of physical and cultural genocide in modern times, which started with the Spanish colonization of the Americas. It reached a historically unique dimension in the Nazi period, and became a regular companion of the ethnic conflicts and terrorist activities of the later twentieth and early twenty-first centuries.

And third is the growing consciousness of the need for cultural heritage protection. Beginning in the Reformation, Protestant states attempted to avoid the uncontrolled loss of precious objects that often accompanies anarchic conditions. An important shift occurred during the course of the French Revolution, as a new understanding of cultural heritage developed, and the creation of museums provided new institutions for cultural heritage preservation. Today we follow the impulse to protect and to preserve by passing laws at the national and international levels, by declaring the intentional destruction of cultural heritage a war crime or crime against humanity, and even by debating the use of military action to protect heritage. However, if we are not able to develop sharper and more effective means of protection, such destruction will merely continue.

SUGGESTED READINGS

Stacy Boldrick, Leslie Brubaker, and Richard Clay, eds., *Striking Images, Iconoclasms Past and Present* (Farnham, UK: Ashgate, 2013).

Noah Charney, ed., *Art Crime: Terrorists, Tomb Raiders, Forgers and Thieves* (London: Palgrave Macmillan, 2016).

Dario Gamboni, *The Destruction of Art: Iconoclasm and Vandalism since the French Revolution* (London: Reaction Books, 1997).

Joris D. Kila and Marc Balcells, eds., *Cultural Property Crime: An Overview and Analysis of Contemporary Perspectives and Trends* (Leiden, the Netherlands: Brill, 2015).

Kristine Kolrud and Marina Prusac, eds., *Iconoclasm from Antiquity to Modernity* (Farnham, UK: Ashgate, 2014).

James Noyes, *The Politics of Iconoclasm: Religion, Violence and the Culture of Image-Breaking in Christianity and Islam* (London: I. B. Tauris, 2016).

Hermann Parzinger, *Verdammt und vernichtet: Kulturzerstörungen vom Alten Orient bis zur Gegenwart* (Munich: C. H. Beck, 2021).

Jo Tollebeek and Eline van Assche, eds., *Ravaged: Art and Culture in Times of Conflict* (Leuven: Mercatorfonds, 2014).

NOTES

1. Hermann Parzinger, *Verdammt und vernichtet: Kulturzerstörungen vom Alten Orient bis zur Gegenwart* (Munich: C. H. Beck, 2021).
2. Alexander Demandt, *Vandalismus: Gewalt gegen Kultur* (Berlin: Siedler, 1997), 272; and Nigel Bagnall, *Rom und Karthago: Der Kampf ums Mittelmeer* (Berlin: Siedler, 1995).
3. Sabine Holz, "Das Kunstwerk als Beute: Raub, Re-Inszenierung und Restitution in der römischen Antike," in *Der Sturm der Bilder: Zerstörte und zerstörende Kunst von der Antike bis in die Gegenwart*, ed. Uwe Fleckner, Maike Steinkamp, and Hendrik Ziegler (Berlin: Akademie Verlag, 2011), 35–43.
4. Stefan Maul, "Zerschlagene Denkmäler: Die Zerstörung von Kulturschätzen im eroberten Zweistromland im Altertum und in der Gegenwart," *Bildersturm* (Winter 2006): 163–76.
5. Johannes Hahn, "The Conversion of Cult Statues: The Destruction of the Serapeum 392 A.D. and the Transformation of Alexandria into the 'Christ-Loving' City," in *From Temple to Church: Destruction and Renewal of Local Cultic Topography in Late Antiquity*, ed. Johannes Hahn, Stephen Emmel, and Ulrich Gotter (Leiden, the Netherlands: Brill, 2008), 335–65.
6. Tom M. Kristensen, "Religious Conflict in Late Antique Alexandria: Christian Responses to 'Pagan' Statues in the Fourth and Fifth Centuries CE," in *Alexandria: A Cultural and Religious Melting Pot*, ed. George Hinge and Jens A. Krasilnikoff (Aarhus: Aarhus University Press, 2009), 158–75.
7. Charles Barber, *Figure and Likeness: On the Limits of Representation in Byzantine Iconoclasm* (Princeton, NJ: Princeton University Press, 2002).
8. Horst Bredekamp, *Kunst als Medium sozialer Konflikte: Bilderkämpfe von der Spätantike bis zur Hussitenrevolution* (Frankfurt: Edition Suhrkamp, 1975), 166–76.
9. Franz Machilek, ed., *Die hussitische Revolution: Religiöse, politische und regionale Aspekte* (Cologne: Böhlau, 2012).
10. Bob Scribner, ed., *Bilder und Bildersturm im Spätmittelalter und in der Frühen Neuzeit* (Wiesbaden: Harrassowitz, 1990).
11. Sergiusz Michalski, "Die Ausbreitung des reformatorischen Bildersturms 1521–1537," in *Bildersturm: Wahnsinn oder Gottes Wille?* ed. Cécile Dupeux (Zurich: NZZ-Verlag, 2000), 46–51.
12. Martin Warnke, "Ansichten über Bilderstürmer: Zur Wertbestimmung des Bildersturms in der Neuzeit," in *Bilder und Bildersturm im Spätmittelalter*, ed. Bob Scribner, 299–305.

13. Sergiusz Michalski, "Das Phänomen Bildersturm: Versuch einer Übersicht," in *Bilder und Bildersturm im Spätmittelalter*, ed. Bob Scribner, 69–124.

14. Jürgen Kocka, *Das lange 19. Jahrhundert: Arbeit, Nation und bürgerliche Gesellschaft* (Stuttgart: Klett-Cotta, 2002); and Jürgen Osterhammel, *Die Verwandlung der Welt: Eine Geschichte des 19. Jahrhunderts* (Munich: C. H. Beck 2009).

15. Simone Bernard-Griffiths, ed., *Révolution française et vandalisme révolutionnaire* (Paris: Universitas, 1994).

16. Richard Clay, *Iconoclasm in Revolutionary Paris: The Transformation of Signs* (Oxford: Voltaire Foundation, 2012), 39–48.

17. Christine Tauber, *Bilderstürme der Französischen Revolution: Die Vandalismusberichte des Abbé Grégoire* (Freiburg: Rombach, 2009).

18. Paul Wescher, *Kunstraub unter Napoleon* (Berlin: Gebrüder Mann, 1976), 33.

19. Stanley Idzerda, "Iconoclasm during the French Revolution," *American Historical Review* 60 (1954): 13–26.

20. John H. Elliot, "The Spanish Conquest and Settlement of America," in *The Cambridge History of Latin America*, ed. Leslie Bethell, vol. 1 (Cambridge: Cambridge University Press, 1984), 149–206.

21. Bernard Brizay, *Le sac du Palais d'Été: L'Expédition anglo-française de Chine en 1860* (Monaco: Du Rocher, 2003).

22. Diana Preston, *Rebellion in Peking: Die Geschichte des Boxeraufstands* (Stuttgart: Deutsche Verlags-Anstalt, 2001).

23. Leonhard Harding, *Das Königreich Benin: Geschichte—Kultur—Wirtschaft* (Oldenburg: Walter de Gruyter, 2010).

24. Jost Dülffer, *Regeln gegen den Krieg? Die Haager Friedenskonferenzen von 1899 und 1907 in der internationalen Politik* (Vienna: Ullstein, 1981).

25. Thomas Klein, "Die Hunnenrede (1900)," in *Kein Platz an der Sonne: Erinnerungsorte der deutschen Kolonialgeschichte*, ed. Jürgen Zimmerer (Frankfurt: Campus Verlag, 2013), 164–76.

26. Mark Derez, "The Burning of Leuven," in *Ravaged: Art and Culture in Times of Conflict*, ed. Jo Tollebeek and Eline van Assche (Leuven: Mercatorfonds, 2014), 81–85.

27. Derez, *Ravaged*, 84.

28. Natalya Semyonova and Nicolas V. Iljine, eds., *Selling Russia's Treasures: The Soviet Trade in Nationalized Art* (New York: Abraham Foundation, 2013), 14.

29. Semyonova and Iljine, *Selling Russia's Treasures*.

30. Semyonova and Iljine, *Selling Russia's Treasures*, 17.

31. Peter Adam, *Kunst im Dritten Reich* (Hamburg: Rogner & Bernhard, 1992).

32. Peter-Klaus Schuster, ed., *Die "Kunststadt" München 1937: Nationalsozialismus und "Entartete Kunst"* (Munich: Prestel, 1998).

33. Thomas Kellein, ed., *1937: Perfektion und Zerstörung* (Bielefeld, Germany: Ernst Wasmuth Verlag, 2007).

34. Stefan Koldehoff, *Die Bilder sind unter uns: Das Geschäft mit der NS-Raubkunst und der Fall Gurlitt* (Berlin: Verlag Galiani, 2014).

35. Martin Friedenberger, *Fiskalische Ausplünderung: Die Berliner Steuer- und Finanzverwaltung und die jüdische Bevölkerung 1933–1945* (Berlin: Metropol-Verlag, 2008).

36. Ulrike Hartung, *Raubzüge in der Sowjetunion: Das Sonderkommando Künsberg 1941–1943* (Bremen: Edition Temmen, 1997).

37. Guobin Yang, *The Red Guard Generation and Political Activism in China* (New York: Columbia University Press, 2016).

38. Martin Slobodník, "Destruction and Revival: The Fate of the Tibetan Buddhist Monastery Labrang in the People's Republic of China," *Religion, State and Society* 32, no. 1 (2004): 7–19.

39. Tess Davis and Simon Mackenzie, "Crime and Conflict: Temple Looting in Cambodia," in *Cultural Property Crime: An Overview and Analysis of Contemporary Perspectives and Trends*, ed. Joris D. Kila and Marc Balcells (Leiden, the Netherlands: Brill, 2015), 292–306.

40. András J. Riedlmayer, *Destruction of Cultural Heritage in Bosnia-Hercegovina, 1992–1996: A Postwar Survey of Selected Municipalities* (Cambridge: Fine Arts Library, 2002).

41. Michelle Defreese, "Kosovo: Cultural Heritage in Conflict," *Journal of Conflict Archaeology* 5, no. 1 (2009): 257–69.

42. Finbarr B. Flood, "Between Cult and Culture: Bamiyan, Islamic Iconoclasm, and the Museum," *Art Bulletin* 84, no. 2 (2002): 641–59.

43. James Noyes, *The Politics of Iconoclasm: Religion, Violence and the Culture of Image-Breaking in Christianity and Islam* (London: I. B. Tauris, 2016), 60–69.

44. Jamal J. Elias, "The Taliban, Bamiyan, and Revisionist Iconoclasm," in *Striking Images, Iconoclasm Past and Present*, ed. Stacy Boldrick, Leslie Brubaker, and Richard Clay (Farnham, UK: Ashgate, 2013), 145–63.

45. Finbarr B. Flood, "Religion and Iconoclasm: Idol-Breaking as Image-Making in the 'Islamic State,'" *Religion and Society* 7 (2016): 116–38.

46. Hermann Parzinger, "Götterdämmerung in Pakistan," in *Schliemanns Erben: Von den Herrschern der Hethiter zu den Königen der Khmer*, ed. Gisela Graichen (Bergisch Gladbach, Germany: Gustav Lübbe Verlag, 2001), 132–91.

47. Elias, "Taliban, Bamiyan, and Revisionist Iconoclasm," 157; and Sabine von Schorlemer, *Kulturgutzerstörung: Die Auslöschung von Kulturerbe in Krisenländern als Herausforderung für die Vereinten Nationen* (Baden-Baden: Nomos, 2016), 842.

48. Dmitry Bondarev and Eva Brozowsky, *Rettung der Manuskripte aus Timbuktu* (Hamburg: University of Hamburg Press, 2014), 7–18.

49. Von Schorlemer, *Kulturgutzerstörung*, 76.

50. Flood, "Religion and Iconoclasm," 120; and Horst Bredekamp, *Das Beispiel Palmyra* (Cologne: Walther König, 2016), 14–17.

51. Von Schorlemer, *Kulturgutzerstörung*, 100; and Joris D. Kila, "Inactive, Reactive, or Pro-active? Cultural Property Crimes in the Context of Contemporary Armed Conflicts," *Journal of Eastern Mediterranean Archaeology and Heritage Studies* 1, no. 4 (2013): 319–42.

52. Sigrid van der Auwera, "Contemporary Conflict, Nationalism, and the Destruction of Cultural Property during Armed Conflict: A Theoretical Framework," *Journal of Conflict Archaeology* 7, no. 1 (2012): 49–65.

53. Mary Kaldor, *New and Old Wars: Organized Violence in a Global Era* (Cambridge: Polity Press, 1999); and Parzinger, *Verdammt und vernichtet*, 287–90.

54. Van der Auwera, "Contemporary Conflict, Nationalism, and the Destruction," 61.

4

The Cultural Heritage of Late Antiquity

Glen W. Bowersock

In the later years of the Peloponnesian War in the early fifth century BCE, the Athenians enlisted a contingent of Thracian soldiers to join their ill-fated expedition to Sicily, an expedition that ended disastrously in Syracuse near the Assinarus River. The Thracians had been recruited to supplement the Athenian contingent even though the Greeks looked down on Thracians as barbarians. But they could be useful because they were notoriously fierce fighters. Unfortunately, the Thracian forces arrived after the Greeks had already set sail for Sicily. So they were sent back northward along the eastern coast to return to their homeland.

They ultimately came to the small and peaceful town of Mycalessus, which, lacking supervision or direction, they undertook to destroy. Thucydides tells what they did there in one of the most memorable and horrifying chapters of his *History of the Peloponnesian War*. They committed an atrocity of horrendous proportions as their Athenian commander made use of the returning troops to harm enemies on the way. The Thracians arrived at Mycalessus in the morning, with none of the inhabitants expecting them as they awoke in a city with old and weak walls and its gate wide open. Thucydides tells us what happened next:

> The Thracians bursting into Mycalessus sacked the houses and temples, and butchered the inhabitants, sparing neither youth nor age but killing all they fell in with, one after the other, children and women, and even beasts of burden, and whatever other living creatures they saw—the Thracian people, like the bloodiest of the barbarians, being ever most murderous when it has nothing to fear. Everywhere confusion reigned, and death in all its shapes; and in particular they attacked a boys' school, the largest that there was in the place, into which the children had just gone, and massacred them all. In short, the disaster falling upon the whole city was

unsurpassed in magnitude, and unapproached by any in suddenness and in horror. [7,29][1]

Thucydides knew the horrors of war from personal experience. His opinion of the Thracian action at Mycalessus reflects more than the considered judgment of one of the world's greatest historians. It combines an innate Greek prejudice against the Thracians with a visceral hostility to an attack on a peaceful local community, its old buildings, and its innocent people. This is perhaps the most egregious example of atrocity and destruction in classical antiquity, and it is emblematic of sensational atrocities in the following centuries.

Two further examples from classical antiquity show a comparable fusion of murder with the annihilation of a deeply rooted culture, although both had a much greater impact than what happened at Mycalessus. In 146 BCE, the Romans under Lucius Mummius took over the Greek mainland after a local revolt, and demonstrated their control of the region by deliberately and systematically wiping out Corinth, a city second only to Athens in importance. Corinth is near the Aegean Sea and the gulf that bears its name. It was a rich site of temples and cults when reduced to rubble; what happened mirrored the personal tragedies that its inhabitants suffered through the Roman conquest. The devastation on the ground not only ended many lives but led directly to the pillaging of cultural heritage.

Polybius described the scene in a lost passage that Strabo has preserved for posterity: "Polybius ... mentions the contempt of the soldiers for works of art and votive offerings. He says he was present himself and saw pictures thrown on the ground with the soldiers gambling on top of them. He names the painting of Dionysus by Aristeides which some say gave rise to the phrase 'nothing like Dionysus,' and a picture of Heracles writhing in the tunic of Dianeira" (8.6.23).[2] By the time of Julius Caesar, Corinth was a dead city. As such, it provided an ideal opportunity for him to enlarge his international influence by founding a colony, and so he dispatched soldiers from his campaigns to settle in this ancient center of classical Greek civilization. The city prospered as it took a prominent place in the revival of classical styles in the region under the Roman emperor Augustus.

In 88 BCE, between the destruction of Corinth and the creation of Caesar's colony, another of the great atrocities of antiquity occurred. In Anatolia, the western part of mainland Turkey, the powerful and ruthless King Mithridates Eupator of Pontus, whose kingdom was a rival to the encroaching empire of Rome, launched a massacre of eighty thousand Roman citizens. He accomplished this horror by organizing surprise assaults all within the space of a single day. Mithridates also tried to destabilize Athens by inciting riots against a Roman governor, Sulla, but without success. Yet when Augustus assumed power in Rome in 27 BCE, Caesar's colony at Corinth was thriving, and the Roman communities in Anatolia had recovered their strength and become some of the most conspicuous and successful of its overseas settlements. With the Hellenic culture

that they absorbed from the Greeks, who had been there for generations, the post-Mithridatic Romans obliterated the damage that the Pontic king had wrought and prepared the way for numerous magnificent cities in the region, such as Ephesus, Pergamum, and Aphrodisias.

This brief overview of murderous assaults and subsequent recovery illustrates the resilience of peoples in the eastern Roman Empire and the tenacity of their culture—but the cost was high. The Romans were more likely to carry off the treasures of the people they conquered than to destroy them where they were. That is why many of the most exquisite pieces of Greek sculpture ended up in the opulent gardens of villas in Italy. Paradoxically, the heritage of the Hellenistic Greeks partially owed its survival to the *Kunstraub* (art theft) that often followed a conquest: the link between atrocities and the fate of cultural heritage is more complicated than it might appear.

An alien power confronting a great civilization inevitably experienced both wonder at what it found and jealousy in the face of what appeared to be the glory of a competing culture. This confrontation inevitably provoked destruction, theft, and appropriation. In the early days of the Roman Empire, the conquerors in the eastern Mediterranean simply carried off what they found, as with the great statue of Laocoön and his sons entangled with a huge snake. If an object or monument was too large to be removed, it would be left in place, like the massive altar at Pergamum, to be incorporated into the new Roman environment. This was an environment that acknowledged an alien presence by co-opting and absorbing its traditions and culture. Such an appropriation of Indigenous culture was utterly different from what the Romans did at Corinth or Mithridates in Asia Minor. But it arose from the same disposition that impelled Julius Caesar to rebuild Corinth.

It is both ironic and instructive that the very Roman who undertook to resurrect Corinth was also the perpetrator of a devastating assault on the Indigenous cultural heritage of Egyptian Alexandria. It was not long before Augustus became the first emperor of Rome that the fabulous Ptolemaic library of Alexandria was demolished by Julius Caesar. He destroyed the library, renowned in the Hellenistic world for its books and the great scholars who worked there, not long before he was murdered in 44 BCE, just as he was recreating his new Roman city on the ruins of Corinth. In wiping out the Alexandrian library he abruptly ended several centuries of scholarship on Greek literature and all the books contained therein. Caesar's action deliberately wrought a terrible vengeance on the Ptolemaic dynasty of Egypt. This calamity was echoed centuries later when another library at Alexandria, which belonged to the Serapeum or temple and was an offshoot of the great Hellenistic library, was wiped out along with the Serapeum itself in a vicious assault in 381 CE.

It is paradoxical that in the three centuries following the establishment of the Roman Empire in 27 BCE there were no mass atrocities at all and, with two spectacular exceptions, there was no deliberate destruction of monuments of cultural heritage. The greatest devastation of an ancient local culture in this period was entirely due to natural

causes: the eruption of Mt. Vesuvius that obliterated Pompeii and Herculaneum in perhaps the most remarkable case of widespread destruction of this kind.

But the two exceptions to the absence of human agency in acts of cultural destruction in the imperial age were the Romans' devastating assault on the Second Jewish Temple at Jerusalem in 70 CE, which brought to an end the great war that elevated Vespasian to the throne, and then, centuries later, the demolition of the Alexandrian Serapeum and its library at the end of the fourth century CE. As we have seen, this event was a tragic reprise of Julius Caesar's devastation long before.

Both of these deliberate and fierce assaults on great monuments of cultural heritage were linked to religious conflict. In Jerusalem the annihilation of the Second Temple proclaimed the military triumph of the Romans over a militant Jewish population that had risen up against Rome several years before. In Alexandria it was again religion, Christianity this time, that impelled the marauders to destroy a cultural heritage that was anchored in Egypt's pagan past. The common denominator was an Indigenous religion that threatened the dominant international power. But neither in Jerusalem nor in Alexandria was physical destruction connected with any mass atrocity. Horrors such as occurred in Asia Minor under Mithridates were not repeated, even though the Jewish War of Vespasian caused major losses among the local population.

Nonetheless, it remains a remarkable fact that throughout much of the Roman imperial age widespread damage to culture came principally through the theft of its precious remains. This theft led to the widespread imitation and appropriation of styles in both culture and architecture. It constituted the Romans' homage to what they found in their eastern empire. For the most part this homage was not characterized by an effort or even a desire to eliminate it. It was only local religions that threatened to stand in the way of state cultic observances, such as the worship of Jupiter in Jerusalem or of the Christian god in Alexandria, that provoked assaults on monuments of cultural heritage.

This widespread acceptance and appropriation of cultural heritage in late antiquity calls for an explanation, which cannot simply lie in the deep roots that the late Roman and Byzantine Empires undoubtedly had in the world they inherited. In searching for an explanation it may be useful to remember that late antiquity was often shaken by unusually turbulent and difficult conditions. These appear to have preempted any impulse to destroy remains from the past. I am thinking of the exceptionally harrowing circumstances of simply living and ruling at that time. As we endure our present global pandemic it is worth remembering that three major plagues overwhelmed the world of late antiquity: under Emperor Marcus Aurelius in the second century CE, under the rule of Decius and Gallienus in the next, and for a long period under that of Justinian in the Byzantine Empire in the sixth century.

The armies of Marcus's co-regent Lucius Verus in the mid-second century brought back a deadly virus from their eastern campaigns, and this quickly spread as the soldiers returned to their homeland. It gravely disrupted the philosophic reflections of

Marcus Aurelius, who is best known for his *Meditations*, and it left still visible traces in the amulets and apotropaic inscriptions of threatened citizens even as far away as Britain. The Antonine Plague, as it is now called, left no room for vengeance against earlier or alien cultures. The simple desire for survival is a strong disincentive to the urge to destroy.

A comparable emergency can be detected in the third century, with the devastating spread of what seems to have been smallpox. We hear about this crisis in the letters of the Christian saint Cyprian, but we can also find traces of it in fragments of Dexippus's lost history of the time. This Cyprianic plague, as it is known, wiped out pagans and Christians alike, and we may presume that the prevalent fear, stoked by the mounds of corpses that could be seen in the streets, would scarcely have allowed for attacks on cultural heritage. Certainly there is no sign of such assaults, even as Roman armies advanced into Persia and contemplated the imposing monuments of both Achaemenids and Sassanians. Valerian and Gallienus were well acquainted with this heritage, and they craved to associate themselves with it. But they had manifestly no desire to destroy it.

Similarly, Emperor Justinian in the sixth century was confronted with a devastating plague, now known to be caused by the bacterium *Yersinia pestis*, and which we tend to call the bubonic plague. Although Justinian made systematic efforts to convert pagans to Christianity, as we know from the Syriac chronicle of John of Ephesus, there is small evidence that he expected his missionaries, John above all, to damage or remove the cultural monuments of any preexisting cults or worship. Again, we may suspect that the encompassing plague superseded any malice or resentment in the face of earlier cultures.

It was no accident that the most arresting cases of destruction of cultural heritage during the many centuries of Roman intervention in the east are what happened at those two widely separated moments in Egyptian Alexandria. Shortly before Augustus became *princeps* or ruler of the Roman Empire, the great Ptolemaic library in that city, attracted, as we have already observed, the attention and fury of Julius Caesar in his struggle with the next-to-last of the Ptolemies. By the end of the fourth century Christianity was solidly entrenched in Alexandria and such local Egyptian erudition as still survived by that date had to compete with that of the pagan Greeks. Hence the library that was attached to the shrine of the Egyptian divinity Serapis harbored Egyptian traditions that posed a threat to the religious authorities of the Constantinian empire.

It was all too clear that the Christians in Alexandria could be both unruly and violent in asserting their faith. This was demonstrated tragically in the century that followed the destruction of the Serapeum and its library, when mobs of Christian fanatics assaulted the brilliant mathematician Hypatia and literally tore her apart, limb from limb. This terrible episode was a kind of aftershock of the destruction of the Serapeum and its library. They had both stood as celebrated vestiges of Egyptian culture over

many centuries, and the cult of Serapis was known far outside Egypt. But the patriarch and his followers found this intolerable and took irreversible action.

We can see in the religious fervor of the Mediterranean world after Constantine a fierce wave of hostility to cultural heritage that was no less deleterious than the plagues in the ages of Gallienus and Justinian, and no less merciless and undiscriminating in finding victims than Mummius at Corinth or Mithridates in Anatolia. These examples demonstrate that cultural heritage in late antiquity could suffer equally from human savagery and from external and impersonal forces such as a volcano, climate, or disease. There is no single answer as to what causes damage or loss where cultural heritage is at risk, and so there is no single answer to the question of how to preserve such heritage.

Late antiquity therefore provides a context within which to consider this question. Among the variables involved are what constitutes cultural heritage—whether objects, monuments, embedded traditions, or styles that are contemporary but reflect the past. The concept of cultural heritage is both capacious and imprecise. Efforts to protect such heritage must be clear about what is involved. For example, the great Buddhas at Bamiyan that were deliberately destroyed in Afghanistan in 2001 are undoubtedly part of the cultural heritage of the region. But is this because of the representation of sacred figures, or because of the veneration they received? These figures were important to the culture of Central Asia precisely because they were numinous. They were more than magnificent objects or monuments, and they were a still-living part of local culture. As such they were vulnerable. Attacking them was a kind of assassination, designed to terminate the life of an animate being.

We know that it is in the nature of cultural heritage to be an integral part of the contemporary world to which it belongs and not a movable object that would be equally numinous in a museum. Museums have been precious repositories of the heritage of many peoples and nations, and their work has often, and legitimately, been justified in terms of preserving what might have been destroyed or lost. Nevertheless, as modern nations have become increasingly assiduous in repatriating objects from museums to their countries of origin, it has become obvious that captured heritage, whether by theft or benevolent custody, remains captured nonetheless. No one could dispute that a captured piece from the heritage of another culture is better than a destroyed or gravely damaged one, nor could anyone dispute that the presence of heritage in an alien environment can be fruitful for that alien environment. But this is not the same as heritage in the culture to which it belongs.

In late antiquity the profound impact of stolen cultural objects on cultures other than those from which the objects came was immense. The Roman infatuation with Hellenistic art led to imitations that have in many cases served as the only surviving examples of lost originals. This is particularly true of classical Greek sculpture, where copies became a genre of their own. They served to do almost as much to preserve cultural heritage as the originals themselves might have done. Paul Zanker has

admirably addressed this phenomenon in several of his books. The achievement of the imitators in no way compensates for the loss of original works of cultural heritage, nor does it justify theft or destruction. Yet it is a kind of consolation.

The fate of the great monuments of cultural heritage in late antiquity is obviously different from that of movable objects. But comparable considerations arise even in those cases. The huge Pergamon Altar in modern Turkey is instructive. It was impossible in antiquity to take it away to another place. Only German enthusiasts managed to do this in the nineteenth century. So it stood proudly in place where it had been built, and fortunately no hostile forces, of which many rampaged through the region, sought to destroy it.

By contrast, the Parthenon in Athens, which was comparable in scale and majesty, was savagely desecrated and defiled. Its transformation into a mosque was not unlike the late antique destruction of the Serapeum of Alexandria. Both of these assaults on major monuments of cultural heritage were due to religious extremism. The Christians in Alexandria had no less a burden of responsibility than the Muslims in Athens who transformed the Parthenon into a mosque. The latter's enemies, the Venetians, set off an explosion inside which gravely damaged the Parthenon, but fortunately did not destroy it.

For late antiquity the most prominent recent case of cultural heritage at risk is undoubtedly Palmyra. This great caravan city in the desert of Syria was, alongside Petra, the most important and most beautiful of the eastern Roman cities. Its monumental temples, shrines, tombs, and rich portrait sculptures made it known throughout the western world. Among the modern Arabs Palmyra was always a source of pride, and the citizens of the adjacent modern town considered themselves descendants and heirs of Palmyra's most celebrated ruler, Zenobia. Until a few years ago I was convinced that this heritage was so strong among Arabs that Palmyra might well be spared the depredations of the Islamic State of Iraq and Syria (ISIS, also known as ISIL or Da'esh). To my profound sorrow I was wrong. When Da'esh invaded the city in 2015, it greatly damaged the Temple of Bel and, to the horror of the world, beheaded the noble director of the Palmyra museum for protecting the treasures for which he was responsible. Da'esh staged his execution in the Palmyra theater.

This savage assault on a glorious city of late antiquity cannot be undone. Nor can the damage be repaired by visual restorations through multiple digital photographs, as has been proposed by a misguided team in Britain. Such photos are valuable for memory and for study, but the only purpose that a large digital restoration can serve is to lament what we have lost. The public display, through digital photography, of a great Palmyrene portal in Trafalgar Square served no purpose except to raise funds for the organization that created it. But much of the excellent work of archaeologists at the site of Palmyra—Polish, Swiss, and Danish among others—has survived the Da'esh assault, and a precious collection of Palmyrene portrait sculpture is maintained in Copenhagen, where it can be systematically studied.

The damage to cultural heritage in this terrible case was not associated with mass atrocity, although, as in the case of the museum director, individual atrocities certainly occurred. The most frightening part of this whole episode was that I was not alone in believing that the prestige of Palmyra among those who lived in Syria would protect its heritage. Da'esh has proven decisively that local consciousness of cultural heritage cannot be counted on. The raids of Da'esh were devastating and cruel everywhere: before invading Palmyra they had shown their savagery in many places, but they had until that point never shown that they would feel absolutely no share in a heritage of which most Arabs in the region were proud. This has taught us a bitter lesson.

Unfortunately nothing can protect cultural heritage in the face of marauding and brutal assailants who are driven by a fierce conviction. Their beliefs, manifestly religious in character although by no means representative of devout adherents throughout the world, are similar to the convictions of the Christians who demolished the Serapeum of Alexandria and tore apart the helpless body of the great mathematician and philosopher Hypatia. It is hard not to recall the famous line (101) from the first book of Lucretius's poem on the nature of things, *De rerum natura*, after a description of the sacrifice of the innocent girl Iphigeneia to win the gods' support for launching the Trojan War: "Tantum religio potuit suadere malorum" (Religion was able to cause so many evils).

Late antiquity serves to teach us this painful lesson. It is scarcely comforting or consoling to see that human agency can be no less ruinous to what humans have created than plague or climate. Those of us who struggle, as many try to do, to protect and conserve the cultural heritage of peoples must try to defeat and crush a group such as Da'esh with the same tenacity that we bring to annihilating an invisible natural enemy.

SUGGESTED READINGS

Aziz al-Azmeh, *The Emergence of Islam in Late Antiquity* (Cambridge: Cambridge University Press, 2014).

Alan Cameron, *The Last Pagans of Rome* (Oxford: Oxford University Press, 2011).

Kyle Harper, *The Fate of Rome: Climate, Disease, and the End of an Empire* (Princeton, NJ: Princeton University Press, 2017).

Fergus Millar, *A Greek Roman Empire: Power and Belief under Theodosius II, 408–450* (Berkeley, CA: University of California Press, 2006).

NOTES

1. Thucydides, *History of the Peloponnesian War*, trans. Richard Crawley, Everyman's Library (London: J. M. Dent, 1910), 506.
2. Strabo, *Geography*, trans. Horace Leonard Jones, vol. 4, Books 8–9, The Loeb Classical Library (Cambridge, MA: Harvard University Press, 1927), 201.

5

The Written Heritage of the Muslim World

Sabine Schmidtke

Over the past several decades, digital collections of texts produced by Muslim authors writing in Arabic during the premodern period have mushroomed. Major libraries include al-Maktaba al-Shāmila, currently containing some seven thousand books;[1] Noor Digital Library, with 35,169 books to date;[2] PDF Books Library, currently containing 4,355 books;[3] Arabic Collections Online (ACO), providing access to 15,131 volumes;[4] Shia Online Library, with 4,715 books;[5] and al-Maktaba al-Waqfiyya, containing some ten million pages of published books (in addition to a growing number of manuscript surrogates),[6] to name only the most important. Moreover, since printing technologies were adopted in the Islamic world at a relatively late stage and slow rate (fig. 5.1), much of the written cultural production of the Islamic world is still preserved in manuscript form. And although there has been a steady rise in the publication of manuscript catalogues all over the Islamic world over the past hundred years, much material is still unaccounted for, and discoveries of titles that were believed to have been lost or that were entirely unknown regularly occur. In parallel, numerous libraries have started to digitize their collections of Islamic manuscripts, with a fair number providing open access to their holdings through institutional digital repositories, in addition to a growing number of online gateways to such manuscripts.[7] At the same time, what is available online, whether published or in manuscript form, is only the tip of the iceberg.

We do not possess reliable data that would allow us to quantify the overall literary production by Muslim scholars over the past 1,500 years, nor do we have estimates of the total number of preserved manuscripts. However, the following figures, randomly chosen, may provide some idea of the overall scope of the corpus. The Süleymaniye Library in Istanbul, one of the most important libraries in Turkey, though just one among many, holds some one hundred thousand manuscripts in Arabic, Persian, and Ottoman Turkish, and the estimated number of Islamic manuscripts in all Turkish libraries is three hundred thousand (fig. 5.2).[8] The Union Catalogue of Manuscripts in

Figure 5.1 Page from a lithograph print, Tabriz 1877, of Ja'far b. al-Hasan al-Muhaqqiq al-Hilli's (d. 1205–6) *Sharāʾiʿ al-Islām*, with several layers of commentary in the margin. Image: Hathitrust.org

Iranian Libraries, published in 2011 in thirty-five volumes, lists some four hundred thousand manuscripts in Arabic and Persian, not including the holdings of the many uncatalogued private collections in the country. Estimates of the total number of manuscripts in the countless public and private libraries in Yemen, most of which are only partly catalogued, if at all, range from forty thousand to one hundred thousand codices. Moreover, libraries with significant holdings of Islamic manuscripts are not confined to regions that are (or were) part of the Islamic world—they are spread all over the world. Important and substantial collections of Islamic manuscripts can be found across Europe, Russia, North America, and Australia as well as East Asia (fig. 5.3).

Further, while Jan Just Witkam rightly remarks that "Arabic traditional literature is probably the largest body of literature in the world,"[9] it should be kept in mind that

Figure 5.2 Entrance to the Süleymaniye Library, Istanbul. Image: Rebecca Erol / Alamy Stock Photo

Figure 5.3 Worldwide distribution of Islamic manuscripts. Image: María Mercedes Tuya, with kind permission. View map at www.getty.edu/publications/cultural-heritage-mass-atrocities/part-1/05-schmidtke/#fig-5-3-map.

Arabic is only one of many Islamic languages. The geographical expansion of the Islamic world to reach from West Africa and Islamic Spain to Central and South and East Asia, sub-Saharan Africa, the Indonesian archipelago, and the Volga region and other parts of Eastern Europe, as well as the linguistic variety that this spread implies, gave rise to a

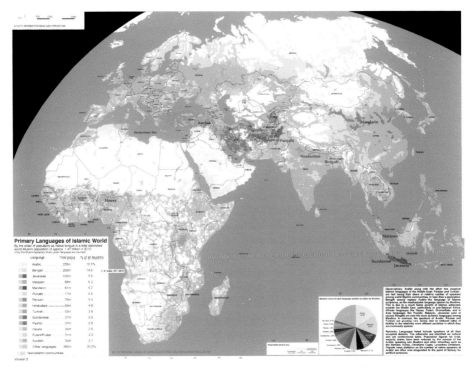

Figure 5.4 Michael Izady, "Primary Languages of [the] Islamic World." Image: Dr. Michael Izady (https://gulf2000.columbia.edu/images/maps/Languages_Islam_lg.png). View map at www.getty.edu/publications/cultural-heritage-mass-atrocities/part-1/05-schmidtke/#fig-5-4-map.

highly variegated literary production of enormous dimensions. And although one might distinguish geographically between core and periphery (the historical heartlands of Islam versus regions that became part of the Islamic world in later periods) and of philology (Arabic as the language of the Qur'an and of the Prophet Muhammad versus any other Islamic languages), the resulting conventional hierarchy is unjustified and illusory, as is any attempt to define orthodoxy versus heresy (fig. 5.4). Moreover, starting in the second half of the twentieth century there has been a Muslim diaspora in Western Europe, the United States, and Australia, stimulating its own cultural production in languages that until recently had not been considered Islamic languages.

Modern Attempts to Account for the Arabic/Islamic Written Heritage

By the beginning of the twentieth century, several bibliographical enterprises were underway that attempted to provide overviews of the literary production of the Muslim world, or at least parts of it. One of these was the renowned *Geschichte der arabischen Litteratur* (GAL) compiled by the German orientalist Carl Brockelmann (1868–1956). Volume 1 was published in 1898, covering the classical period up to 1258, and volume 2 in 1902, covering the thirteenth through nineteenth centuries. To render his enterprise feasible, from the outset Brockelmann restricted the project's scope: while his conceptualization of "literature" was broad, encompassing "all verbal utterances of the human mind,"[10] he considered only Arabic titles, excluding writings by Muslims in any

other language, and he limited himself to listing surviving works, ignoring titles that were known only from quotations and references. He also excluded titles by non-Muslim authors. Brockelmann's GAL prompted others to compile counterparts to fill in some of these gaps: Moritz Steinschneider (1816–1907) surveyed Arabic literature by Jewish authors in *Die arabische Literatur der Juden* (1902), and the British scholar Charles Ambrose Storey (1888–1968) devoted most of his academic career to *Persian Literature: A Bio-bibliographical Survey* (1927–90).[11] Georg Graf (1875–1955) covered Christian Arabic literature in the five-volume *Geschichte der christlichen arabischen Literatur* (GCAL, 1944–53).

The GAL was based on the few available sources at the time—namely *Kashf al-ẓunūn*, a bibliographical encyclopedia by the seventeenth-century Ottoman polymath Hajji Khalifa (or Katib Çelebi, d. 1656), listing some fifteen thousand book titles, mostly in Arabic, as well as some thirty-five published manuscript catalogues of collections in Europe, Istanbul, Cairo, and Algiers.[12] Brockelmann estimated in the preface to volume 1 of the GAL that "it would take at least a further century of hard philological work before even the most important landmarks of Arabic literature would be known and accessible"[13]—a serious underestimation, in fact, of what lay ahead.

The GAL turned out to be unsatisfactory from the beginning. Between 1937 and 1942, Brockelmann published three supplementary volumes, followed in 1943 and 1949 by an updated version of the original two volumes, containing about twenty-five thousand titles by some eighteen thousand authors. To illustrate the quantitative discrepancy between the corpus of extant Arabic Islamic literature described by Brockelmann and what has become accessible since, it suffices to juxtapose his list of thirty-five manuscript catalogues consulted for the first edition and the expanded list of 136 consulted for the updated edition[14] with the *World Survey of Islamic Manuscripts* (1992–94), published in four volumes with close to 2,500 pages in total, constituting a "comprehensive bibliographical guide to collections of Islamic manuscripts in all Islamic languages in over ninety countries throughout the world."[15] Today, close to three decades after its publication, the *World Survey of Islamic Manuscripts* is seriously outdated, and a revised enlarged edition would easily fill six or more volumes.[16] Although Brockelmann's GAL is still regularly consulted by scholars as a first point of departure (in fact, an English translation was published as late as 2017),[17] it is widely agreed that any attempt to publish a revised and enlarged version is unrealistic.[18] Today, scholars engaged in surveying the written production of Muslims restrict themselves to specific subjects, areas, and time periods. The Turkish-German scholar Fuat Sezgin (1924–2018), for example, who published a biobibliographical survey of Arabic literature, *Geschichte des arabischen Schrifttums* (GAS, 1967–2015), in seventeen volumes, limited his focus to the early Islamic centuries, up to the mid-eleventh century (fig. 5.5).

Other examples in Western scholarship include Ulrich Rebstock's three-volume survey of Arabic literature by Mauritanian authors, *Maurische Literaturgeschichte*

Figure 5.5 Fuat Sezgin's copy of Brockelmann's GAL, with notes. Image: Hilal Sezgin / CC BY-SA 4.0

(2001), describing some ten thousand titles by about five thousand authors from the sixth through eighteenth centuries;[19] and international projects such as "Islam in the Horn of Africa: A Comparative Literary Approach" (IslHornAfr), funded by the European Research Council.[20] There are also born-digital initiatives such as "Historia de los Autores y Transmisores Andalusíes" (HATA), providing information on "works written and transmitted in al-Andalus from the eighth to the fifteenth century with a total of 5,007 Andalusi authors and transmitters, 1,391 non Andalusi authors and transmitters and 13,730 titles written and transmitted in al-Andalus,"[21] and HUNAYNNET, an "attempt at compiling a digital trilingual and linguistically annotated parallel corpus of Greek classical scientific and philosophical literature and the Syriac and Arabic translations thereof," also funded by the European Research Council.[22] Digital platforms and tools are being developed in a number of current projects, with the aim of continuing Brockelmann's earlier bibliographical endeavors and developing innovative ways to survey and study Arabic written heritage. Among the most important such projects are Bibliotheca Arabica, funded by the Saxon Academy of Sciences and Humanities in Leipzig (which began in 2018 and is proposed to continue until 2035),[23] and "KITAB: Knowledge, Information Technology, and the Arabic Book," funded by the European Research Council and the Aga Khan University, London.[24]

Middle Eastern scholars also began to embark on large-scale bibliographical enterprises around the beginning of the twentieth century. Like Brockelmann, who took Hajji Khalifa's *Kashf al-ẓunūn* as his point of departure, the Ottoman Iraqi scholar Ismaʿil Basha al-Baghdadi (d. 1919) expanded on Hajji Khalifa's work in his *Īḍāḥ al-maknūn fī dhayl ʿalā Kashf al-ẓunūn*, with entries for more than forty thousand titles by some nine thousand authors ranging from the seventh to the early twentieth century.[25] But this is,

again, only the tip of the iceberg—Ismaʿil Basha al-Baghdadi not only focused on Arabic material but also disregarded works composed by non-Sunni scholars and by authors who flourished beyond the main centers of learning.

Challenged by the statements of Christian Lebanese Jurji Zaydan (1861–1914) in his *Tārikh ādāb al-lugha al-ʿarabiyya* (1910–13, published in four volumes) belittling the contributions of Twelver Shiʿites to Arabic literature, a number of Shiʿite scholars strove to counter this claim by collecting, transcribing, and publishing as many earlier Shiʿite texts as possible. Their endeavors resulted in two biobibliographical encyclopedias— namely, the four-volume *Kashf al-astār ʿan wajh al-kutub wa-l-asfār* by al-Sayyid Ahmad al-Husayni al-Safaʾi al-Khwansari (1863/64–1940/41), and, more importantly, Agha Buzurg al-Tihrani's (1876–1970) monumental *al-Dharīʿa ilā taṣānīf al-Shīʿa*, a comprehensive bibliographical encyclopedia of Twelver Shiʿite literature, consisting of twenty-eight volumes and describing a total of 53,510 books. Agha Buzurg not only consulted available manuscript catalogues and publications but also traveled widely to visit the relevant public and private libraries in Iraq, Iran, Syria, Palestine, Egypt, and the Hijaz (a western region of Saudi Arabia), in all of which he had unprecedented access to a large number of manuscripts. The result is an unsurpassed work of meticulous scholarship, and the *Dharīʿa* still constitutes the most important reference work for scholars engaged in the study of Twelver Shiʿism.

Book Inventories in the Premodern Islamic World

Whereas the biobibliographical works of Muslim scholars such as Ismaʿil Basha al-Baghdadi or Agha Buzurg al-Tihrani are de facto modern publications, they continue a centuries-long tradition that can be traced back to the early Islamic era. In 988, some three hundred years after the death of the Prophet Muhammad, the Baghdad bookseller Ibn al-Nadim (d. 990) compiled a comprehensive *Catalog* of the entire Arabic textual corpus that he had been able to get his hands on, and his bibliographical work in its current, incomplete state lists the works of some 3,500 or 3,700 authors—an impressive monument to the book revolution that had been brought about by the nascent Islamic civilization by the early ninth century (fig. 5.6).[26] Many of the titles Ibn al-Nadim includes have not come down to us, and the information he provides in the *Catalog* is thus of primary significance. Comparable enterprises from later centuries include *Miftāḥ al-saʿāda wa-miṣbāḥ al-siyāda*, a comprehensive inventory of books arranged according to disciplines of learning by Ottoman scholar Ahmad b. Mustafa Taşköprüzade (d. 1560), and *Fahrasat al-kutub wa-l-rasāʾil*, an overview of Ismaʿili literature by Daʾudi Bohra scholar Ismaʿil b. ʿAbd al-Rasul al-Majduʿ (d. 1769/70).

Moreover, the historical sources refer to large-scale libraries in the intellectual hubs of the Muslim world from early on. The Fatimid royal libraries, for example, are said to have amassed some 1.5 million volumes toward the end of the dynasty in the early twelfth century. Whether or not the figure is exaggerated, there is no doubt that their holdings were enormous and comprised the full range of what existed at the time in

Figure 5.6 Title page of a manuscript in the Chester Beatty Library in Dublin, Ar 3315. One of the oldest extant copies of Ibn al-Nadim's *Catalog*, which was purchased in 1421 by the prominent Egyptian scholar Taqi l-Din Ahmad b. 'Ali al-Maqrizi (d. 1442). Image: © The Trustees of the Chester Beatty Library, Dublin

Arabic.[27] One of the most important libraries during the Abbasid period was founded in Karkh (Baghdad), attached to the academy of learning (*dar al-'ilm*), by the Shi'i Shapur b. Ardashir (d. 1035/36), the erstwhile vizier of the Buyid ruler Baha' al-Dawla. The library existed for six decades, and its holdings amounted to some ten thousand volumes, until it was destroyed in 1059, during the Seljuq Tughril Beg's march on Baghdad (fig. 5.7).

Although we know very little about the history, holdings, and organization of most early rulers' libraries, as the narrative sources provide primarily anecdotal evidence, an increasing number of documentary sources have come to light over the past several

Figure 5.7 Illustration of a library in al-Ha'iri's *Maqāmat*, dated 1237, Ms. Paris, Bibliothèque nationale de France, Ms. arabe 5847, fol. 5v. Image: The History Collection / Alamy Stock Photo

decades—inventories of property and records of sold objects, endowment deeds, inheritance inventories, confiscation registers, gift registers, court records, account books, and library catalogues, as well as paratextual material in manuscript codices— informing us about the history, organization and management, arrangement, and holdings of a growing number of libraries from the tenth century onward, and more discoveries can be expected within this vibrant field of scholarship. Fairly detailed descriptions are available, for example, of the private library of Baghdad scholar Abu Bakr al-Suli (d. 947).[28]

Among the earliest extant library catalogues are a register of the holdings of the library of the Great Mosque of Qayrawan in Tunisia (dated 1294)[29] and a catalogue of the library of the mausoleum of al-Malik al-Ashraf (r. 1229–37) in Damascus, which lists some two thousand books.[30] The thirteenth-century Twelver Shi'ite scholar Radi al-Din Ibn Tawus compiled a since-lost catalogue of the holdings of his personal library, *al-Ibāna fī maʿrifat (asmāʾ) kutub al-khizāna*, to which he later added as a supplement his *Saʿd al-suʿūd*, which is partly preserved (and was perhaps never completed). The latter work contains detailed information on some of the books Ibn Tawus had in his possession, together with extensive quotations from those books.[31] The Ottoman Mu'ayyadzade ʿAbd al-Rahman Efendi, a close friend and confidant of the future Ottoman sultan Bayazid II (r. 1481–1516), assembled an impressive personal library with an estimated seven thousand volumes. A six-folio partial inventory of his library, listing some 2,100 titles, is extant in manuscript.[32] Bayazid II also commissioned an inventory of books held in the library of the Topkapı Palace in Istanbul. The inventory,

dated 1503–4, records over seven thousand titles.[33] The Hanbali Damascene scholar Ibn ʿAbd al-Hadi (d. 1503) compiled a catalogue of his library, comprising close to three thousand titles.[34] An endowment deed dated 1751 records the donation of a private book collection of more than one hundred volumes by the otherwise unknown al-Hajj al-Sayyid Mustafa b. al-Hajj Efendi.[35] From the early nineteenth century, the inventory of the private collection—amounting to almost 1,200 volumes—of the founder of the Khalidiyya branch of the Naqshbandiyya order in Damascus, Sheikh Khalid al-Shahrazuri al-Naqshabandi (d. 1827), which was compiled on the occasion of a lawsuit involving the collection, has come down to us.[36] These are but a few examples.

Closely related to catalogues and inventories of library collections are notebooks containing detailed descriptions of works and excerpts from them, many of which are otherwise lost. A prominent example is the *Kitāb al-Funūn* by the Hanbali author Ibn ʿAqil (d. 1119), a personal notebook consisting of quotations from works by others together with the author's own comments and thoughts on the material. The book is only partly extant in a single manuscript and is believed to have consisted of two hundred or more volumes in its original form. Another example of an entirely different character is the *Tadhkira*, a literary notebook by the Hanafi littérateur and historian Kamal al-Din ʿUmar b. Ahmad Ibn al-ʿAdim (d. 1262).[37]

Following Ibn Tawus, the tradition of compiling catalogues with extensive excerpts from the books being described was continued among Shiʿite scholars, particularly among those from al-Hilla, Ibn Tawus's hometown, located some one hundred kilometers south of Baghdad. Ibrahim b. ʿAli b. al-Hasan al-Kafʿami (d. 1499/1500), who resided both in al-Hilla and Najaf, compiled *Majmūʿ al-gharāʾib wa-mawḍūʿ al-raghāʾib*, listing the books he had access to and quoting extensively from them. Collections of selections gleaned from—now often lost—books and manuscripts also circulated under the title *Fawāʾid*, as in the case of a notebook by the Twelver Shiʿi Iranian scholar ʿAbd Allah al-Afandi al-Isfahani (d. 1718), the author of a biographical dictionary titled *Riyāḍ al-ʿulamāʾ*, who provides information in the notebook that often complements the data provided in the dictionary. Mention should also be made of the various excerpts (*fawāʾid*) from earlier philosophical works by the Jewish philosopher ʿIzz al-Dawla Ibn Kammuna (d. circa 1284), compiled for his own study purposes.[38] The Iraqi Shiʿi scholar and politician Muhammad Rida al-Shabibi (d. 1965) also produced copies and excerpts of many of the manuscripts he inspected during his study sojourns in various libraries, as is the case with the notes he took during a visit to the Rawda al-Haydariyya in Najaf in 1911, which are extant in manuscript.[39]

The Interplay of Oral and Written Culture and the Predominance of a Writerly Culture in Islamic Societies

The reasons for the eminent status of the written word and the development of the codex include the early codification of the Qurʾan and its central place in Islamic practice, its continuous transmission through carefully produced copies, and the

ubiquity of Qur'anic passages in the visual cultures of the Islamic world, in addition to its oral recitation and aural consumption. At the same time, the reports and utterances of the Prophet Muhammad, the *sunna*, also held a prominent position among Muslims from early on. The codification of the prophetic traditions was concluded only centuries later, privileging orality/aurality over written transmission during the first centuries of Islam.

The shift from a nonliterate mode to a literate one, from oral to written transmission, or rather to a combination of oral/aural and literary practices, is commonly dated to the ninth century, and the ways in which oral/aural and written practices interacted and complemented each other is another vibrant field of scholarship.[40] The interplay between oral/aural and writerly culture gave rise to a variety of literary genres and documentary sources, which provide important information about literary cultural production among Muslims (fig. 5.8). The backbone of oral transmission was a solid chain of transmitters to guarantee the authenticity of the transmitted content, especially in view of the canonical status of the *sunna*.

Within the larger context of Sunnism, a number of literary genres emerged, reflecting the changing landscape of traditional *ḥadith* scholarship during the canonical (ninth and tenth centuries) and postcanonical periods (eleventh century and beyond) and related social practices. Among other purposes, they evolved into an efficient means for documenting the internal scholarly tradition, often including extensive booklists.[41] The starting point in the organizational structure of such works was the list of

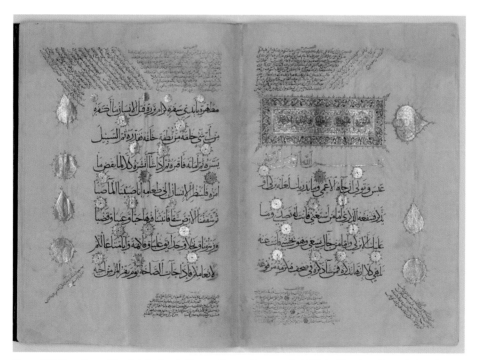

Figure 5.8 Page from a Mamluk Qur'an, in Marcus Fraser, *Geometry in Gold: An Illuminated Mamlūk Qur'ān Section* (London: Sam Fogg, 2005). Image: Courtesy of Sam Fogg

transmitters with whom a scholar or collector of *ḥadith* had studied over the course of his or her life. From the ninth century onward, Sunni *ḥadith* scholars compiled catalogues of their sheikhs, and the two genres that were most popular among scholars of the eastern and central lands of Islam were the *mashyakha* and the *mujam al-shuyūkh*. The entries in this type of book characteristically consist of two core elements—the names of the transmitters with whom the sheikh in question studied and some sample *ḥadith* from the sheikh.

From about the eleventh century onward, compilers of *mashyakha*s and *mujam*s increasingly focused on their transmitters and/or chains of transmission for the books they had studied, often going beyond the narrow confines of *ḥadith* literature and applying the practice to the whole array of disciplines of learning. Such books were arranged sometimes according to book title, sometimes by the name of the transmitters. The Egyptian Shafiʿi scholar Ibn Ḥajar al-ʿAsqalani (d. 1449), for example, provides an inventory of his teachers and the books he studied in a series of works, viz. his *al-Mujam al-mufahris* (arranged according to book title) and *al-Majmaʿ al-muʾassis li-l-Mujam al-mufahris* (arranged by transmitters).

With respect to the early modern period, mention should be made of *al-Nafas al-Yamanī wa-l-rawḥ al-rayḥānī fī ijāzāt Banī l-Shawkānī* by the Shafiʿi scholar of the Yemeni town of Zabid, Wajih al-Din ʿAbd al-Rahman b. Sulayman al-Ahdal (d. 1835), detailing his teachers and the chains of transmission for the books he studied with them. The overall structural framework of *al-Nafas al-yamanī* is an *ijāza*, or "license to transmit," issued by ʿAbd al-Rahman al-Ahdal to members of the family of the Yemeni scholar Muhammad b. ʿAli al-Shawkani (d. 1834). Al-Shawkani, in turn, provides in his *Itḥāf al-akābir bi-isnād al-dafātir* the chains of authority for each book title he mentions.

Presenting chains of transmission for books became particularly popular among scholars in the Islamic west, with compilations that were typically referred to as *fihrist, fahrasa, barnāmaj*, or *thabat*, a genre whose beginnings can be dated to the late tenth century. Among the earliest extant examples is Abu Muhammad ʿAbd al-Haqq Ibn ʿAtiyyaʾs (d. 1147) *Fahrasa*, while the *Fahrasa* of the Andalusi scholar Abu Bakr Muhammad Ibn Khayr al-Ishbili (d. 1179) is the first work in which the material is arranged according to discipline. The *fihrist* by Abu l-ʿAbbas Ahmad b. Yusuf al-Fihri al-Labli (d. 1291), known as *Fihrist al-Lablī*, is an example of a work within this genre containing extensive material on the Ashʿarite tradition. The "license to transmit" played a central role also among the Shiʿites, and in many ways it resembles in structural organization and social functions the various genres for documenting transmission that prevailed among the Sunnis. Although the earliest extant *ijāza*s date from the tenth century, more detailed ones have been increasingly issued over the centuries. Arranged as a rule according to transmitters, such documents include detailed bibliographical information on the books the recipient of an *ijāza* (the *mujāz*) has studied in one or often several disciplines of learning, thus providing a comprehensive picture of the literary canon that was available to the scholar. Moreover, an essential function of

comprehensive, text-independent *ijāzas* is the documentation of the scholarly tradition, first and foremost the scholars making up the chains of transmission of the scholar granting the *ijāza* (the *mujīz*). This type of *ijāza* often fulfills functions similar to those of biographical dictionaries, and in many cases the boundary between the two genres is blurred. A prominent example is the *Kitāb al-Wajīz* by the prominent Shafi'i transmitter Abu Tahir Ahmad b. Muhammad al-Silafi (d. 1180), an inventory of scholars from whom he received an *ijāza* (and whom he knew only through correspondence) with detailed, and often unique, biobibliographical information about each.

Imamis and Zaydis also compiled collections of *ijāzas*, many of which contain dozens or even hundreds of such documents. Taken together, these provide detailed insights into the scholarly tradition and its literary output over the course of several centuries. Mention should be made, by way of example, of the collection of *ijāzas* that was granted to Ayat Allah al-'Uẓma Shihab al-Din al-Husayni al-Mar'ashi al-Najafi (d. 1990) over his lifetime, compiled by his son, al-Sayyid Mahmud al-Mar'ashi. Among the Zaydis, *Majmū' al-ijāzāt*, a collection of dozens of *ijāzas* that Ahmad b. Sa'd al-Din al-Maswari (d. 1668) culled from the manuscripts available to him, is transmitted in several manuscripts.

Muslim Scholarly Practices throughout the Centuries

The eminent status of the written tradition also gave rise from early on to scholarly methods among Muslims that in many ways predate some of the text-critical approaches of modern scholarship. A first attempt at analysis was Franz Rosenthal's *The Technique and Approach of Muslim Scholarship* (1947). Toward the end of the twentieth century, systematic analysis in this area of scholarship boomed. The principal directions, which are closely related to each other, include, first of all, codicology and manuscript studies, a field that has blossomed over the past few decades, as is evident from the growing number of handbooks,[42] specialized journals,[43] book series,[44] and research initiatives[45] produced. This has led to a deeper appreciation of paratextual materials found in manuscripts, which in turn has prompted scholars to combine aspects of intellectual and social history to study, for example, not only the intellectual contents of the codices and the social practices of the producers of knowledge (the scholars and the authors), but also the habits, interests, and practices of the consumers of knowledge, the readers (fig. 5.9). The increased consultation of documentary sources, such as endowment deeds and library registers, has made possible a growing number of studies devoted to individual libraries, a new focus that is complemented by studies on the collections brought together by Western collectors and preserved today in European and North American libraries.[46]

The following examples, randomly chosen, provide a taste of Muslim scholarly practices throughout the centuries, focusing on critical editions, referencing, and the continuation of the manuscript culture into the twentieth century. First, in terms of critical editions, the twelfth-century Shi'ite scholar Fadl Allah b. 'Ali al-Rawandī al-Kashani was the most important transmitter of the writings of two prominent Twelver

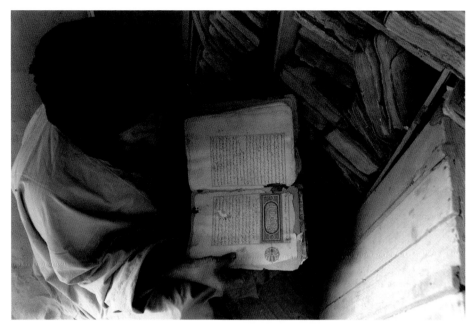

Figure 5.9 Sheikh Baye looking at an illuminated Qur'an dating back to the fourteenth century, in his library, Bouj Beha, Mali, in April 2003. Image: Xavier Rossi / Gamma-Rapho via Getty Images

Shi'ite scholars and officials in tenth- and eleventh-century Baghdad, the brothers al-Sharif al-Murtada 'Ali b. al-Husayn al-Musawi and al-Sharif al-Radi Muhammad b. al-Husayn al-Musawi.[47] Of their writings, the most important were al-Murtada's *Kitāb al-Ghurar*, a book containing a variety of exegetical and literary materials divided into sessions (*majālis*), which was popular among both Shi'is and Sunnis, and the *Kitāb Nahj al-balāgha*, a collection of utterances of semicanonical status attributed to 'Ali b. Abi Talib, compiled by al-Sharif al-Radi. The majority of extant copies of these works were transmitted through Fadl Allah, with his name showing up in nearly all chains of transmission. The rigorous editorial principles Fadl Allah applied are documented, for example, in Ms. Istanbul, Süleymaniye, Reisülküttab 53, transcribed by Muhammad b. Aws b. Ahmad b. 'Ali b. Hamdan al-Rawandi (dated 1170). The scribe explains that he had a copy in the possession of Fadl Allah al-Rawandī as antigraph, written in the hand of Ibn Ikhwa (d. 1153), Fadl Allah's teacher, and he quotes Fadl Allah's colophon in full. In it, Fadl Allah explains the editorial principles he followed when working on his copy: he collated it with two other copies, one of them transcribed by a direct student of al-Murtadā. In addition, Fadl Allah reports that he consulted the relevant collections of poetry to render properly the poetry included in the *Ghurar*. The manuscript also contains copious marginal glosses and corrections, indicating a similarly careful transcription process, and many of these originated with Fadl Allah. They include, for example, comments in which Fadl Allah recorded different copies of source texts that he had consulted; mentions of alternative interpretations or additional perspectives derived from his own studies, with precise details; and references to other works containing elaborations relevant to the discussion at hand (fig. 5.10). Fadl Allah excelled

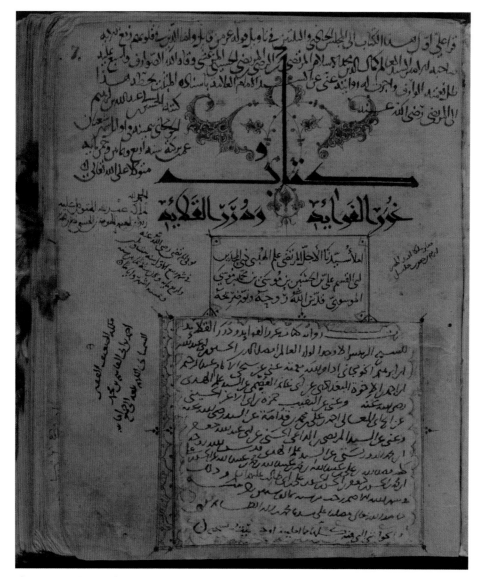

Figure 5.10 Title page of Ms. San Lorenzo, El Escorial, códice árabe 1485, fol. 7r, containing another copy of al-Murtada's *K. al-Ghurar*, transmitted through Fadl Allah al-Rawandi. Image: Patrimonio Nacional, Biblioteca del Real Monasterio de San Lorenzo de El Escorial, códice árabe 1485

as a critical editor of and commentator on other works as well, notably the *K. al-Ḥamāsa*, an anthology of poetry by Abu Tammam Habib b. Aws al-Ta'i (d. 842/45). Fadl Allah's revised edition of the *Ḥamāsa*, together with his glosses, is preserved in a single manuscript held by the British Library.

On the second issue of Muslim scholarly practices throughout the centuries discussed here, referencing—the authorial practice of indicating the sources that one has consulted when composing a book, either in a separate bibliographical section or throughout the book and typically including the chains of transmission—is encountered from very early on. The Sunni scholar Ibn Abi l-Hatim al-Razi (d. 938) lists his sources at

the beginning of his Qur'an exegesis, while the Twelver Shi'ite scholar Muhammad b. 'Ali Ibn Babawayh (d. 991) concludes his *hadith* work *Man lā yaḥḍuruhu l-faqīh* with a chapter discussing his sources. The Andalusi scholar Abu 'Abd Allah Muhammad al-Qurtubi (d. 1104) appended to his *Kitāb Aqḍiyat rasūl Allāh* a list of the books he had consulted; Abu Ishaq Ahmad b. Muhammad al-Tha'alabi (d. 1035/36) mentions in the introduction to his Qur'an exegesis, *al-Kashf wa-l-bayān fī tafsīr al-Qur'ān*, all the works he used while composing the work; and a list of sources is also provided by Muhammad b. Ahmad al-Dhahabi (d. 1348) in his renowned *Tārīkh al-Islam*. Another example is the Hanafi scholar of Bukhara, Uzbekistan, 'Imad al-Din Mahmud al-Faryabi (d. 1210/11), who completed in 1200 his *Kitāb Khāliṣat al-ḥaqā'iq wa-niṣāb ghā'iṣat al-daqā'iq*, a book on piety, ethics, and moral conduct, which concluded with a bibliography of sources; it is one of the earliest works, by the way, in which the author does not indicate his chains of transmission for the named sources. The *Kitāb al-Baḥr al-muḥīṭ fī uṣūl al-fiqh*, an important work on legal theory by the Shafi'ite scholar Badr al-Din Muhammad b. Bahadur al-Shafi'i al-Zarkashi (d. 1392), also opens with a section in the course of which he lists his sources. Since many of the books al-Zarkashi used no longer exist, his often elaborate quotations allow at least a partial reconstruction of what has been lost. An exceptional example is the aforementioned Ibn Tawus, who, throughout his writings, documents his sources with great accuracy, often indicating the volume, quire, or even folio or page of the codex he is quoting.[48]

On the third issue of Muslim scholarly practices throughout the centuries, in many parts of the Islamic world we can observe an extraordinary continuity of manuscript culture, which has even persisted into the twenty-first century. While the reason is evident for countries with poor technological infrastructure, such as Yemen, there were and are many other reasons for this phenomenon, such as the desire to evade censorship, which can easily be applied to printed works but is impossible to enforce on the transcription of manuscripts.[49] Most importantly, however, the production of manuscripts, as contrasted with printed works, was perceived as a pious exercise.

Many modern scholars and scribes in contrast have also pursued scholarly purposes when transcribing books of earlier times by hand. Mention should be made, by way of example, of the Iraqi scholar Muhammad b. Tahir b. Habib al-Samawi (d. 1950). Al-Samawi hailed from Samawa in southern Iraq, and he spent several decades in Najaf, one of the most important intellectual centers of Twelver Shi'ism, in pursuit of scholarship. Al-Samawi was an avid collector of manuscripts who transcribed hundreds of Shi'ite and non-Shi'ite texts for his personal library. Many of his transcriptions are apographs of copies held by the Rawḍa al-Haydariyya, one of the oldest libraries of Iraq. In his colophons he typically identifies his antigraphs, fully quoting their colophons and commenting on their quality and, accordingly, on his own contribution during the transcription and editing of the text.[50]

Islamic Manuscript Culture under Threat

There are many reasons why a certain book has come down to us while others fall into oblivion and eventually get lost. What becomes part of the canon at any given time and what is discarded is continuously renegotiated, and many of the registers discussed above not only record what was there but also silently exclude what was meant to be left out.[51] At the same time, Islamic manuscript heritage continues to be threatened in many ways—exposed to improper handling, exposure, theft, inclement climatic conditions, and willful destruction, to name a few dangers. Over the past few decades, there have been repeated cases of deliberate destruction of Islamic manuscripts. They include the bombing of libraries, archives, and museums in Kosovo and Bosnia by Serbian nationalists, most importantly the tragic burning of the National Library of Bosnia-Herzegovina in August 1992, when some two million books were destroyed by fire.[52] Moreover, a large portion of the manuscript holdings of the libraries of Iraq was either destroyed or looted in the aftermath of the 1991 Gulf War and again in March 2003, following the invasion of Iraq by American and British troops (fig. 5.11).[53] It is also worrying that Islamic manuscripts of uncertain provenance continue to be auctioned off into private hands.[54] Sectarianism and multiple forms of censorship pose another threat to Islamic cultural heritage. Reducing the intellectually rich and diverse Islamic literary heritage to the bare minimum of what is seen as allegedly authentic is a strategy that is characteristic of Wahhabism, Salafism, and jihadism, and their proponents. Whatever goes against their interpretation of Islam is classified as "heretical" and banned from distribution (fig. 5.12). Moreover, libraries holding books and manuscripts that are seen as containing deviant views are targeted for destruction, and the same holds for historical monuments, shrines, and religious sites, which have been destroyed over the past several decades by Muslim extremists in an attempt to "purify" Islam (fig. 5.13). Particular mention should be made of the attempts by Islamic militants to destroy important manuscript holdings in Timbuktu, Mali, in 2013; the destruction of cultural heritage in Sukur, Nigeria, in 2015;[55] the destruction of books and manuscripts in the libraries of Mosul at the hands of the Islamic State of Iraq and Syria (ISIS, also known as ISIL or Da'esh) in 2015; and attacks on Zaydi libraries in Yemen (fig. 5.14).

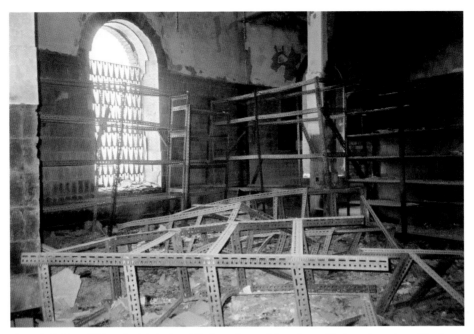

Figure 5.11 Bayt al-ḥikma, Baghdad, view of the burned second floor. Image: Photograph courtesy of Prof. Nabil al-Tikriti

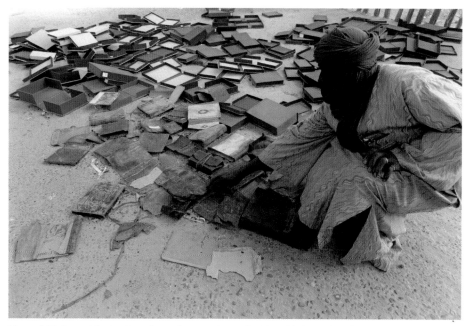

Figure 5.12 A man tries to salvage burned manuscripts at the Ahmed Baba Institute in Timbuktu, Mali. Image: Reuters / Alamy Stock Photos

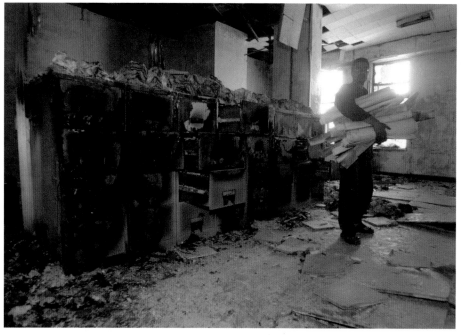

Figure 5.13 Burned books in the National Library, Baghdad, April 2003. Image: Reuters / Alamy Stock Photo

Figure 5.14 Evidence of ongoing illicit trafficking of manuscripts from Yemen. Image: Ahmed Shaker, with kind permission

SUGGESTED READINGS

Hassan Ansari and Sabine Schmidtke, *Al-Šarīf al-Murtaḍā's Oeuvre and Thought in Context: An Archaeological Inquiry into Texts and Their Transmission* (Córdoba: Córdoba University Press, 2022).

Hassan Ansari and Sabine Schmidtke, "Bibliographical Practices in Islamic Societies, with an Analysis of MS Berlin, Staatsbibliothek zu Berlin, Hs. or. 13525," *Intellectual History of the Islamicate World* 4, nos. 1–2 (2016): 102–51.

Jonathan M. Bloom, *From Paper to Print: The History and Impact of Paper in the Islamic World* (New Haven, CT: Yale University Press, 2001).

François Déroche et al., *Islamic Codicology: An Introduction to the Study of Manuscripts in Arabic Script* (London: al-Furqān Islamic Heritage Foundation, 2015).

Beatrice Gründler, *The Rise of the Arabic Book* (Cambridge, MA: Harvard University Press, 2020).

Konrad Hirschler, *The Written Word in the Medieval Arabic Lands: A Social and Cultural History of Reading Practices* (Edinburgh: Edinburgh University Press, 2012).

NOTES

1. Al-Maktaba al-Shāmila, https://shamela.ws. For a short history, see Peter Verkinderen, "Al-Maktaba al-Shāmila: A Short History," Knowledge, Information Technology, & the Arabic Book (KITAB), 3 December 2020, https://kitab-project.org/Al-Maktaba-al-Shāmila-a-short-history/.
2. Noor Digital Library, http://www.noorlib.ir.
3. PDF Books Library, http://alfeker.net.
4. ACO, http://dlib.nyu.edu/aco/about/.
5. Shia Online Library, http://shiaonlinelibrary.com.
6. Al-Maktaba al-Waqfiyya, https://waqfeya.net.
7. See "Islamic Manuscript Studies: Resources for the Study of Manuscripts Produced in the Islamic World and the Manuscript Cultures They Represent," curated by Evyn Kropf, University of Michigan Library, https://guides.lib.umich.edu/c.php?g=283218&p=1886652.
8. Süleymaniye Library, http://yazmalar.gov.tr/sayfa/manuscript-books/9.
9. Jan Just Witkam, "Introduction by Jan Just Witkam," in *Brockelmann Online*, https://referenceworks.brillonline.com/entries/brockelmann/introduction-by-jan-just-witkam-COM_001.
10. Carl Brockelmann, *Geschichte der arabischen Litteratur*, vol. 1 (1898), 1 ("alle Erzeugnisse des menschlichen Geistes . . . die in sprachliche Form gekleidet sind"). The English translation of the phrase is taken from Witkam, "Introduction by Jan Just Witkam."
11. See *Encyclopaedia Iranica*, s.v. "Storey, Charles Ambrose," by Yuri Bregel, https://www.iranicaonline.org/articles/storey-charles-ambrose.
12. Brockelmann, *Geschichte der arabischen Litteratur*, vol. 1, iii–vii, 3–6.
13. Brockelmann, iii. The English translation of the phrase is again taken from Witkam, "Introduction by Jan Just Witkam."
14. See Brockelmann, 4–5 for the first edition, and Brockelmann, 4–13 for the updated edition.
15. See Geoffrey Roper, *World Survey of Islamic Manuscripts*, 4 vols. (Leiden, the Netherlands: Brill, 1992–94), https://brill.com/view/serial/9ROP.
16. The contents of the *World Survey of Islamic Manuscripts* are also accessible from the al-Furqan Islamic Heritage Foundation, https://digitallibrary.al-furqan.com/world_library. This is based on the *Survey* but has some added value, including an interactive map to access information about the various manuscript libraries.
17. See "Brockelmann: The History of Arabic Literary Culture," https://brill.com/view/package/brob?language=en.
18. See also, for example, Max Krause's review, published in *Der Islam* 24 (1937): 307–11, of Brockelmann's first supplementary volume of 1937, with a list of corrections and additions to 539 entries in Brockelmann's work.
19. See Oriental Manuscript Resource (OMAR), http://omar.ub.uni-freiburg.de/.
20. IslHornAfr, http://www.islhornafr.eu/index.html.
21. Knowledge, Heresy and Political Culture in the Islamic West: Eighth–Fifteenth Centuries (KOHEPOCU), http://kohepocu.cchs.csic.es/.
22. HUNAYNNET, https://hunaynnet.oeaw.ac.at.
23. See, "Bibliotheca Arabica: Towards a New History of Arabic Literature," Saxon Academy of Sciences and Humanities, https://www.saw-leipzig.de/de/projekte/bibliotheca-arabica/intro.
24. KITAB, http://kitab-project.org/.
25. Maxim Romanov, "Cultural Production in the Islamic World," al-Raqmiyyāt, last updated 14 October 2017, https://alraqmiyyat.github.io/2017/10-14.html.
26. A term coined by François Déroche, *Le livre manuscrit arabe: Préludes a une histoire* (Paris: Bibliothèque nationale de France, 2004), 44. See also Beatrice Gründler, *The Rise of the Arabic Book* (Cambridge, MA: Harvard University Press, 2020), 2. Jonathan Bloom describes the same phenomenon as an "explosion of books and book learning." See Jonathan M. Bloom, *From Paper*

to Print: The History and Impact of Paper in the Islamic World (New Haven, CT: Yale University Press, 2001), 110.

27. Paul E. Walker, "Libraries, Book Collection and the Production of Texts by the Fatimids," *Intellectual History of the Islamicate World* 4, nos. 1–2 (2016): 7–21.

28. Letizia Osti, "Notes on a Private Library in Fourth/Tenth-Century Baghdad," *Journal of Arabic and Islamic Studies* 12 (2012): 215–23.

29. Miklos Muranyi, "Geniza or Ḥubus: Some Observations on the Library of the Great Mosque in Qayrawān (Tunisia)," *Jerusalem Studies in Arabic and Islam* 42 (2015): 183–99.

30. Konrad Hirschler, *Medieval Damascus: Plurality and Diversity in an Arabic Library* (Edinburgh: Edinburgh University Press, 2016).

31. Sabine Schmidtke, "Notes on an Arabic Translation of the Pentateuch in the Library of the Twelver Shīʿī Scholar Raḍī al-Dīn ʿAlī b. Mūsā Ibn Ṭāwūs (d. 664/1266)," *Shii Studies Review* 1, nos. 1–2 (March 2017): 72–129.

32. Judith Pfeiffer, "Emerging from the Copernican Eclipse: The Mathematical and Astronomical Sciences in Müʾeyyedzade ʿAbdurrahman Efendi's Private Library (fl. ca. 1480–1516)," in *The 1st International Prof. Dr. Fuat Sezgin Symposium on History of Science in Islam Proceedings Book*, ed. Mustafa Kaçar, Cüneyt Kaya, and Ayşe Zişan Furat (Istanbul: Istanbul University Press, 2019), 151–91.

33. *Treasures of Knowledge: An Inventory of the Ottoman Palace Library (1502/3–1503/4)*, vol. 1: *Essays*, vol. 2: *Transliteration and Facsimile "Register of Books" (Kitāb al-kutub)*, Ms. Török F. 59; and Magyar Tudományos Akadémia Könyvtára Keleti Gyűjtemény (Oriental Collection of the Library of the Hungarian Academy of Sciences), series: Muqarnas, supplements, vol. 14, ed. Gülru Necipoğlu, Cemal Kafadar, and Cornell H. Fleischer (Leiden, the Netherlands: Brill, 2019).

34. Konrad Hirschler, *A Monument of Medieval Syrian Book Culture: The Library of Ibn ʿAbd al-Hādī* (Edinburgh: Edinburgh University Press, 2020).

35. Hassan Ansari and Sabine Schmidtke, "Bibliographical Practices in Islamic Societies, with an Analysis of MS Berlin, Staatsbibliothek zu Berlin, Hs. or. 13525," *Intellectual History of the Islamicate World* 4, nos. 1–2 (2016): 102–51.

36. Frederik de Jong and Jan Just Witkam, "The Library of al-Šayḫ Ḫālid al-Šahrazūrī al-Naqšbandī (d. 1242/1827): A Facsimile of the Inventory of His Library (Ms Damascus, Maktabat al-Asad, No. 259)," *Manuscripts of the Middle East* 2 (1987): 68–87.

37. Fuat Sezgin, ed., *The Literary Notebook Tadhkira by Ibn al-ʿAdīm Kamāl al-Dīn ʿUmar ibn Aḥmad (d. 1262 A.D.)* (Frankfurt: Institute for the History of Arabic-Islamic Science, 1992).

38. Reza Pourjavady and Sabine Schmidtke, *A Jewish Philosopher of Baghdad: ʿIzz Al-Dawla Ibn Kammāna (d. 683/1284) and His Writings* (Leiden, the Netherlands: Brill, 2006).

39. Sabine Schmidtke, "Saʿd b. Manṣūr Ibn Kammūna's Writings and Transcriptions in the Maktabat al-Rawḍa al-Ḥaydariyya, Najaf: Preservation, Loss, and Recovery of the Philosophical Heritage of Muslims and Jews," *Intellectual History of the Islamicate World* (Leiden, the Netherlands: Brill, published online 25 June 2021; forthcoming in print), https://doi.org/10.1163/2212943X-bja10003.

40. Recent important studies include Shawkat Toorawa, *Ibn Abī Ṭāhir Ṭayfūr and Arabic Writerly Culture: A Ninth-Century Bookman in Baghdad* (London: Routledge, 2005); Konrad Hirschler, *The Written Word in the Medieval Arabic Lands: A Social and Cultural History of Reading Practices* (Edinburgh: Edinburgh University Press, 2012); and Gründler, *Rise of the Arabic Book*. Mention should also be made of Gregor Schoeler's seminal studies, including his *Écrire et transmettre dans les débuts de l'islam* (Paris: Presses Universitaires de France, 2002).

41. The majority of examples are discussed in some more detail in Ansari and Schmidtke, "Bibliographical Practices in Islamic Societies." See also Garrett A. Davidson, *Carrying on the Tradition: A Social and Intellectual History of Hadith Transmission across a Thousand Years* (Leiden, the Netherlands: Brill, 2020).

42. E.g., Adam Gacek, *Arabic Manuscripts: A Vademecum for Readers* (Leiden, the Netherlands: Brill, 2009); and François Déroche et al., *Islamic Codicology: An Introduction to the Study of Manuscripts in Arabic Script* (London: al-Furqān Islamic Heritage Foundation, 2015). Important is also the oeuvre of Jan Just Witkam: see Robert M. Kerr and Thomas Milo, "List of Publications of Prof. JJ Witkam," in *Writings and Writing: From Another World and Another Era*, ed. Robert M. Kerr and Thomas Milo (Cambridge: Archetype, 2010), xv. Needless to say, pathbreaking contributions to this field have also been made by scholars writing in languages other than English, especially Persian and Arabic.

43. E.g., *Journal of Islamic Manuscripts* and *Manuscripta Orientalia*.

44. E.g., Islamic Books and Manuscripts (by Brill).

45. E.g., the Comparative Oriental Manuscript Studies (COMSt) network, hosted by the University of Hamburg.

46. See, e.g., Boris Liebrenz and Christoph Rauch, eds., *Manuscripts, Politics and Oriental Studies: Life and Collections of Johann Gottfried Wetzstein (1815–1905) in Context* (Leiden, the Netherlands: Brill, 2019); Sabine Mangold-Will, Christoph Rauch, and Siegfried Schmitt, eds., *Sammler, Bibliothekare, Forscher: Zur Geschichte der orientalischen Sammlungen an der Staatsbibliothek zu Berlin* (Frankfurt am Main: Vittorio Klostermann, 2022).

47. For a detailed study of Faḍl Allāh al-Rāwandī and his role as transmitter of the *K. al-Ghurar* by al-Murtaḍā, see Hassan Ansari and Sabine Schmidtke, *Al-Šarīf al-Murtaḍā's Oeuvre and Thought in Context: An Archaeological Inquiry into Texts and Their Transmission* (Córdoba: Córdoba University Press, 2022), chapter 1.4.

48. It is on the basis of the detailed information Ibn Tawus provides throughout his oeuvre that the contents of his library have been reconstructed. See Etan Kohlberg, *A Medieval Muslim Scholar at Work: Ibn Ṭāwūs and His Library* (Leiden, the Netherlands: Brill, 1992).

49. See, e.g., Sabine Schmidtke, *Traditional Yemeni Scholarship amidst Political Turmoil and War: Muḥammad b. Muḥammad b. Ismāʿīl b. al-Muṭahhar al-Manṣūr (1915–2016) and His Personal Library* (Córdoba: Córdoba University Press, 2018), 41 n.138.

50. For other examples of scholars engaged in the transcription of manuscripts during the twentieth century, see Ansari and Schmidtke, *Al-Šarīf al-Murtaḍā's Oeuvre*, chapter 2.4.

51. This is a complex question, the methodological consequences of which are discussed in Arnold Esch, "Überlieferungs-Chance und Überlieferungs-Zufall als methodisches Problem des Historikers," *Historische Zeitschrift* 240, no. 3 (1985): 529–70.

52. Anna Burgess, "Harvard Librarian Puts This War Crime on the Map," *Harvard Gazette*, 21 February 2020, https://news.harvard.edu/gazette/story/2020/02/harvard-librarian-puts-this-war-crime-on-the-map/.

53. See Ian M. Johnson, "The Impact on Libraries and Archives in Iraq of War and Looting in 2003: A Preliminary Assessment of the Damage and Subsequent Reconstruction Efforts," *International Information & Library Review* 37, no. 3 (2005): 209–71; D. Vanessa Kam, "Cultural Calamities: Damage to Iraq's Museums, Libraries, and Archaeological Sites during the United States–Led War on Iraq," *Art Documentation: Journal of the Art Libraries Society of North America* 23, no. 1 (2004): 4–11; Nabil al-Tikriti, "'Stuff Happens': A Brief Overview of the 2003 Destruction of Iraqi Manuscript Collections, Archives, and Libraries," *Library Trends* 55, no. 3 (2007): 730–45; and Geoffrey Roper, "The Fate of Manuscripts in Iraq and Elsewhere," Muslim Heritage, 11 September 2008, https://muslimheritage.com/fate-of-manuscripts-iraq-elsewhere/.

54. For examples see Sabine Schmidtke, "For Sale to the Highest Bidder: A Precious Shiʿi Manuscript from the Early Eleventh Century," *Shii Studies Review* 4, nos. 1–2 (2020): 184–93, and "Saʿd b. Manṣūr Ibn Kammūna's Writings."

55. Akeem O. Bello, "Countering Boko Haram Insurgency: Investigating Culture Destruction Attempts and Culture Conservation Efforts in North-Eastern Nigeria," paper presented at the

"African Heritage and the Pillars of Sustainability" summer school, July 2016 (updated 2017), https://heritagestudies.eu/wp-content/uploads/2017/08/4.4-ABello_final_clean_13.10.pdf.

6

Valuing the Legacy of Our Cultural Heritage

Ismail Serageldin

The world has witnessed ethnic and religious genocide, by which one party has tried to destroy or displace another by the most extreme measures.[1] In such instances, the attackers have turned on the cultural heritage of the victims as a way of erasing their associations with both locations and buildings, and of erasing their legacies as a people. In so doing they recognize that there is an additional dimension to cultural heritage that makes it much more than just the physical reality of a space, building, or object, and that endows it with a value beyond the commercial attributes of its component parts.

That intangible quality that makes cultural heritage a contributor to a society's sense of identity and a people's sense of belonging has, understandably, been elusive to quantify. In this chapter, I review a number of techniques and methodologies that have been used not just to recognize these intangible values that are attached to cultural heritage, but to quantify them. While some may think that these estimates are subjective and inconclusive, they are now based on powerful and rigorous analytical techniques.

These efforts to bring more rigor to the estimation of the financial and broader economic, tangible, and intangible values of cultural heritage are not only essential in guiding governments on the importance of its protection and maintenance. They also remind us of its significance in strengthening a local and national sense of identity and pride. Indeed, those with strong and living links to their past are more empowered to deal with current challenges and to design their own path toward a better future.

Consequently, the purposeful actions of nonstate armed groups, militias, despotic governments, or invading armies in attacking tangible cultural heritage inflict losses that far exceed the mere physical destruction of monuments or the disappearance of objects. These destructive actions are akin to cultural and social genocide. And in many places, if not most, among the legacies of the past, cemeteries and places of religious worship are considered especially sensitive and important, and their desecration is considered abhorrent. Thus, far from being an academic exercise of little real-life

benefit, the better estimation of the total values of cultural heritage are significant in helping national and international society focus on an additional dimension of the full cost of mass atrocities and the need to counter them.

Most people can easily visualize that art, objects, and monuments are aspects of cultural heritage and that they have values which can be estimated. Some objects can also be traded and auctioned off, thus establishing a market price, such as the Fabergé Easter eggs designed for the Romanovs, one of which was valued at over $30 million. This chapter, however, focuses on immovable heritage rather than traded objects.

Other items of cultural heritage, including buildings, can acquire value by virtue of their association with important historic people, such as the house where Mozart was born and the one he lived in, or with events, such as the house where US president Abraham Lincoln wrote the Emancipation Proclamation. But we also talk of cultural heritage in the context of landscapes and places. Whether natural or human-made, landscapes have value. Natural landscapes can become part of the cultural heritage of the nation or of the world by virtue of their unmatched natural beauty, as in the case of the Grand Canyon, or their environmental and biodiversity value, like the Great Barrier Reef in Australia. However, more commonly, it is human activity that transforms certain landscapes into cultural heritage by virtue of the monuments placed on it, as in well-known cases from Stonehenge to the Giza Pyramids plateau, or even by the association of the site with an important historical event, such as the plain of Runnymede in England in relation to the Magna Carta, and other sites of major battles.

Historic Cities

Another set of landscapes acquires a subtle form of value: the urban texture and character of historic cities or the historical part, the "old town," of larger cities with long histories. Here it is the sense of place and its overall character rather than any individual building that matter most, although historic cities also tend to have more than their share of monuments. Unfortunately, such cities have become major battlegrounds between nonstate armed groups and governments in recent decades, especially in the Middle East and North Africa.

This situation becomes more complicated as people live in such cities, which are also visited by tourists. The violence and fighting are doubly problematic due to the humanitarian problems that they create in addition to the threats to (and actual destruction of) cultural heritage. This chapter does not address these humanitarian aspects, nor the role of local populations and the international community in resolving such conflicts. Rather, it focuses on built and tangible cultural heritage and the cultural genocide that often accompanies conflicts today.

Historic cities that have been subjected to damage on a massive scale include Aleppo in Syria and Mosul in Iraq,[2] as well as urban environments in other countries from Mali to Yemen. In such places, the imperiled cultural heritage includes more than just specific monuments and buildings, although protecting these is also very important. Rather, the

rich heritage of these cities extends to include the "character" and "sense of place" of their irreplaceable historical districts.

In dealing with the aftermath of the damage and destruction wreaked on historic cities, the repair and reconstruction of individual buildings are often treated as discrete, individual projects undertaken by various groups and charitable foundations, such as the Agha Khan Development Network and the International Alliance for the Protection of Heritage in Conflict Areas (ALIPH). But there is a sense where the whole is more than the sum of the parts, and so we have to ensure that the repair and reconstruction of individual buildings is done in a way that does not damage or compromise the unique sense of place and urban character of each district and subdistrict. That is, in addition to dealing with the particular building or monument, we must protect and recapture the unique urban character and sense of place that emanates from a combination of the voids and solids, the mix of buildings—many of which are quite mundane in their architectural design characteristics—that together create a part of our legacy that is worth protecting in its overall character. In terms of urban morphology, the characteristics of historical districts include their variety in the ages of the buildings, the mixed land use—with commercial services and residential spaces cheek by jowl—and a wide array of activities taking place on the street. In such districts, the streets tend to be narrow and frequently have curved alignments with small plazas, and there is a certain volumetric pattern with an interplay of voids and solids. On the whole, dealing with historic cities raises institutional, governance, investment, and taxing issues that deserve separate and longer treatments elsewhere. We can only indicate a few of these aspects here.

Historic cities from old Amsterdam to Venice, to Samarkand, Lahore, Cairo, and Fès—to name but a few—in less developed countries are very special places whose names evoke magic and the stuff of dreams. Yet the realities in the case of developing states are of cities teeming with poor individuals struggling with inadequate infrastructure and deteriorating buildings. But the magic is certainly there, and so is the pride of the inhabitants in their city and the monuments that make it such a precious part of world heritage. The increasing pace of urbanization and population growth adds to the challenge. Thus, intervening in these very special places requires a combination of sound policy, effective participation, innovative institutional arrangements, and public-private partnerships. Above all, it requires the mobilization of considerable investments, targeted specifically to the rejuvenation (or postattack repair and reconstruction) of these very special places. It requires new and fresh thinking about the issues of managing urban growth and creating livable cities.

Mobilizing resources must involve the public sector (both national and local) and the private (both local and international). To mobilize public money, we must be able to convince the public at large (not just the local inhabitants) of the merits of each case. To mobilize private funds, the profit they will make (the financial return on investment) must be encouraging to investors. However, here we must also beware of gentrification

that would lead to involuntary displacement of the currently resident poor population.

Philosophical Foundations for the Institutional Framework

Finance and economics are dependent on processes that bring together the different actors: private and public, international and national, formal and informal. We need to make sure that the investments and efforts of the various actors become mutually reinforcing, pulling in the same directions, supporting the same objectives, so that the whole is more than the sum of the parts. Such processes require not only sound finance and economics, but also impactful political strategies that bring all these actors together to work collaboratively on effective approaches to conservation and socioeconomic rejuvenation in historic cities.

Most approaches involve some combination of restrictions on activities in historical areas, the most obvious of which are not to destroy and replace culturally significant structures, or to damage them by misuse, ugly partial additions, other inappropriate uses, or even by permitting pollution nearby. Buildings that destroy the overall urban character of a historical district are usually forbidden, even if they could be commercially and financially remunerative. Restrictions may go further, however, by requiring particular standards of upkeep or specifying how that upkeep should be carried out, or by constraining both public and private sector activities that can be undertaken in certain locations.

Also important are measures to encourage conservation by other actors. In an urban context, direct intervention to conserve all structures is impractical. Conservation efforts, therefore, are dependent on an incentive framework that will encourage the kind of actions that support the thrust of the conservation programs directly and indirectly. Every type of actor has a different way of looking at the problem of rejuvenating the historic cores of living cities in the rapidly evolving context of developing countries. They will have their own calculus by which they will decide whether to invest their effort and funds in the renewal of the historic core and the preservation of its unique character. But the set of incentives that are necessary for each to act in a particular way are codependent. Thus, social life in historic cities must be designed to give each the necessary set of incentives. This is done in order that the whole acts in concert to reverse the negative downward spiral that could result from the unlimited commercial exploitation of the "old city" and the continued pollution and lack of infrastructure that surrounds poor districts in historic cities, all of which would degrade the unique urban character of the historic city. It is difficult but not impossible, akin to finding a solution to the Rubik's cube puzzle.

Trying to shore up the finances of municipalities through more rigorous taxation may discourage necessary private investment, while excessive incentives to private investors could bankrupt a municipality. Similarly, attracting higher income residents to a historic city may raise revenues and create economic opportunities, but it could also lead to the displacement of the local population. Thus, striking a balance in the

investment framework of historic cities and promoting real public–private partnerships are necessary to protect their unique heritage and maintain their social cohesion.

While adaptive reuse is the only way to keep a historical district living and functioning, it requires very careful attention to the physical restoration and reuse of its buildings. The type of use can be a source of controversy if it is not sensitive to the feelings of the community.

The need to preserve significant structures has to be matched by the need to provide flexibility of reuse. Experience shows that excessively rigid adherence to restoration standards can lead to less-than-optimal use of buildings. This requires a review of prevalent practices in conservation to ensure that purity of purpose does not constrain the ability to reuse buildings, thus strangling the economic and social revitalization of historic cities.

We must also be able to mobilize the necessary amount and the right kind of investment to revitalize the economic base of an old city, restore its glorious monuments, protect its unique character, and meet the sociocultural needs of the inhabitants and the aspirations of the young. This invariably raises a host of technical problems that require expertise, including imaginative reuse of old buildings and mobilization of financing. An interesting new initiative to develop a viable approach to financing cultural heritage and link it to expertise is the Cultural Heritage Financial Alliance (CHiFA), launched in 2019. The mobilization of resources requires the application of rigorous methods of economic and financial analysis that justify the flow of public investments and create adequate incentives for private action. Such methods are not yet systematically applied in the case of historic cities, whether to develop a program of maintenance and upkeep or to rebuild and restore cultural heritage after destructive attacks.

Putting a Dollar Value on Cultural Assets

Beyond historic cities, cultural heritage more generally requires our attention and protection. Monuments need to be maintained and protected against dilapidation and vulnerability to everything from water intrusion to rising damp, from sliding earth to fissures in foundations, all of which require investment. This needs to be justified against competing claims for government funding.

How much is it worth for a society to protect cultural heritage "assets"? Many poor countries need to spend far more than they can currently afford on education, health, infrastructure, and other sectors. How much should such countries spend on the protection of cultural heritage? What is the relative responsibility of different social actors, both public and private, national and international, toward investment in the protection and enhancement of heritage?

Here we need to discuss the techniques for estimating the value of tangible and immovable cultural heritage, including its intangible worth. This relies on cost-effectiveness and cost-benefit techniques for judging the appropriateness of making

investments in cultural heritage assets, whether for routine maintenance or for repair and reconstruction. Note that leaving an aspect of cultural heritage partially destroyed will itself entail major costs—namely, to the credibility of the authorities and the self-esteem of the population.

Proper calculation of costs and benefits—all benefits—will lead to a very clear indication to undertake investment in cultural heritage. This is because the total economic value of a tangible and immovable cultural asset goes far beyond simple direct or indirect use values, with considerable additional intangible nonuse values that must also be taken into account in calculating the benefits society derives from maintaining and protecting the cultural asset. We have a number of methodologies to estimate such intangible values using both revealed and stated preference techniques that were initially developed to establish the value of intangible benefits in relation to the environment but can also be used to estimate the value of cultural heritage.

The basic idea is to ensure that any investment being considered will have total benefits that exceed the total costs of the investment. Thus, except for rare cases of truly priceless and invaluable heritage where we would use cost-effectiveness techniques, most investments compare a cost stream and a benefit stream over time. We say that both costs and benefits should be summed and discounted. We "discount" future costs and benefits because a dollar in the hand today is not equal to a dollar years in the future. The estimation and comparison of these expected streams of costs and benefits, and the discount rate, which determines how much we reduce the value of future costs and benefits, are at the heart of the benefit-cost methodology.

For conservation efforts to succeed, especially in the complex reality of historic cities, a variety of actors need to undertake many disparate actions, some of which can be deliberately chosen and directed by government decisionmakers. Many other actions will be outside their direct control and will depend on independent decisions made by various private local or international actors. Private sector actors (except for philanthropists) will use financial rather than economic analysis, which the government should be using except for special cases where the use of cost-effectiveness is justified.

In a few cases, such as unique monuments that are central to national identity, conservation investments will be justified a priori, for which the only further analysis will be a cost-effectiveness one, i.e., what the most effective means of achieving the desired result is, not whether the investment has sufficient benefits to justify the conservation effort. Examples of using cost-effectiveness (because the benefits are so great that they do not need to enter our calculations) would be restoring the Sphinx in Egypt or moving the Abu Simbel Temple in Nubia when it was threatened by the rising waters of the Aswan High Dam. These are things that are absolutely essential to do, no matter what the cost. But such cases are rare, as the competing priorities for limited funding even between cultural heritage projects in the same country will require the application of cost-benefit analysis. Here we ask if the totality of the cost (over a prescribed time horizon) is justified by the totality of the benefits that will accrue from

the investment (over the same time horizon). These future streams of costs and benefits must be discounted.

Analyses of such efforts must include, therefore, both what we might call an economic and a financial analysis. The economic (or social) analysis asks whether the proposed investments are worth undertaking: do their benefits to society as a whole exceed their costs? The financial (or private) analysis, on the other hand, examines the specific costs and benefits that an investor or group of investors will experience as a result of these investments: do they individually gain or benefit from them? For example, if the government is providing subsidized electricity or water, that subsidized price is the price that the private investor uses in his or her financial analysis. The government, however, should use the full ("economic") price of what it costs to provide this water or electricity (frequently referred to as "shadow pricing") in its economic analysis. That is the essence of applying cost-benefit analyses.[3]

Cost-benefit analyses are key for both public and private decision-making. They compare discounted streams of costs with discounted streams of benefits, using financial values for the private investor and economic (social) values for the public agencies. We can subtract the total costs from the total benefits and obtain the net present value (NPV) for the project. We can divide the total benefits by the total costs to get the benefit-cost ratio (B/C ratios); the result should be greater than one. Because the results of both NPV and B/C ratios are highly sensitive to the discount rate selected for the analysis, many analysts prefer to work with a rate of discount which is defined by the parameters of the project under consideration. This is the internal rate of return (IRR), defined as that rate that would set NPV=0, meaning that it would equate the project's discounted cost and benefit streams. Then that rate is compared to, and should be greater than, the prevailing opportunity cost of capital (the interest rate you would get if you put that money in a certificate of deposit or CD at a bank, or invested it in treasury notes). It also allows the analyst to test for the robustness of the analysis by recalculating the IRR for, say, a 20 percent cost overrun, or a delay of two years in the start of the benefit stream, etc. These analytical tools and the quantification they bring allow comparisons between different projects and may help decisionmakers in setting their priorities in an investment program, or help justify aid donors to invest in the maintenance, or the repair and reconstruction, of cultural heritage in developing countries.

In the past century, a number of economists have argued that the economic benefit stream for such projects should be limited to the tourist benefits they will generate. Tourism revenues are undoubtedly important, but limiting the economic benefit stream to that would lead to three false conclusions. The first error would be to conclude that those aspects of cultural heritage that do not attract visitors willing to spend money are not worth preserving. This of course denies the intrinsic worth of cultural heritage, both for local people and the world at large, who are enriched by its very existence even if they never visit the site. After all, many of us may never have an opportunity to visit any

World Heritage Sites, but we would feel impoverished at the loss of such places, and look with trepidation to conflicts that threaten them.

The second error that a purely tourism-centered outlook brings is for authorities to seek the maximization of tourist numbers since their expenditures at a site increase the benefit stream. In fact, such a development would often destroy the charm of the place and denature the activities that are endogenous to the cultural setting, and lead to such problems as the endless queuing to get to the peak of Mount Everest which resulted in the death of two climbers in May 2021. The third error is the inherent implication of a tourist-centered valuation: if another and mutually exclusive investment—say a casino on the beach—resulted in increased tourist dollars for the country, we should leave the old city without restoration and build the casino.

Clearly, these conclusions are neither justified nor defensible. We must look for the intrinsic value of the cultural heritage *above and beyond* what it is likely to generate in terms of tourist dollars. We need to think through all that enters into estimating the full economic value of cultural assets.

Estimating the Total Economic Value of Cultural Assets
Cultural heritage sites differ from other sites and from each other because of their aesthetic, historical, cultural, and social significance. In similar circumstances, environmental economists generally take a comprehensive look at value, using the concept of total economic value (fig. 6.1).

Total economic value is usually broken down into a number of categories of value. The breakdown and terminology vary slightly from analyst to analyst, but generally

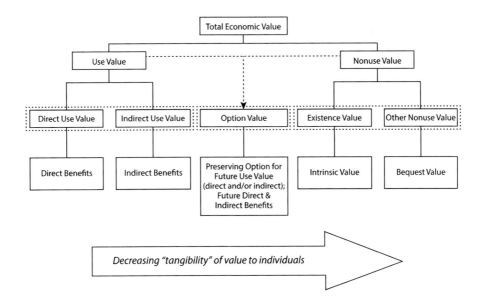

Figure 6.1 Total economic value of an asset (Serageldin et al. 1999)

include use value (both direct and indirect), option value, and nonuse value. Use values include direct (or extractive) and indirect (or nonextractive) uses. Each is often further divided into additional subcategories. By disaggregating the value of a cultural heritage site into various components, the problem generally becomes far more intelligible and tractable.

Direct use value derives from goods which can be extracted from the site or the building, such as direct uses being made of the buildings for living, trading, and renting or selling spaces. Many of these categories of use are captured by markets and transactions in markets. Unlike a forest, the use of a historic city does not deplete it unless the use is inappropriate or excessive, denaturing the beauty of the site or the character of the place. At some level, a parallel exists to extractive use of a forest being kept at sustainable levels. Indirect (or nonextractive) use value derives from the services the site provides. For example, some people just pass through a city and enjoy the scenery without spending money, so their use of the place is not captured by an economic or financial transaction. Note that to the extent that a site involves natural or human-made beauty, it may have enormous value independent of its historical or cultural value. Thus, one can enjoy the charms of an old medieval town center without reference to the history of the individual monuments, although for many the city would evoke both memory and identity through its heritage connotations.

Measuring indirect use value is considerably more difficult than measuring direct use value. Among the indirect use values likely to have clear relevance to the valuation of cultural heritage are aesthetic and recreational values. Aesthetic value consists of the aesthetic benefits obtained from that part of the pleasant sensory experience that is separate from material effects on the body or possessions. Such effects differ from nonuse value because they require a sensory experience, but aesthetic benefits are often closely linked to physical ones. It is the difference between actually walking in that historic city and simply seeing a picture of it. And we can quantify that difference.

In terms of recreational value, although the recreational benefits provided by a site are generally considered together as a single source of value, they are a result of different services which a site might provide. The extent of recreational benefits depends on the nature, quantity, and quality of these services. A historical area could have rest stops, vistas, and attractive meditation spots, in addition to shopping bazaars and, of course, monuments. The enjoyment derived by visitors from each of these will depend on such factors as the cleanliness of the surroundings. Frequently, disaggregating the benefits into components eases the task of valuation. But indirect use values of cultural heritage sites must also include the sense of place and its contribution to local and national identity. That sense of place, its impact on behavior, and the ensuing interactions are also intangible benefits of cultural heritage that cannot be easily measured but are nevertheless real.

Between use and nonuse value there is also option value and quasi-option value. The former is the value obtained from maintaining the option of taking advantage of a site's

use value at a later date, akin to an insurance policy. Quasi-option value is derived from the possibility that even though a site appears unimportant now, information received later might lead us to reevaluate it.

Nonuse value tries to capture the enrichment derived from the continued existence of major parts of a particular cultural heritage site. Even if not likely to visit these locations, one would feel impoverished if they were destroyed. In many cases, this benefit is referred to as existence value—the value that people derive from the knowledge that the site exists, even if they never plan to visit it. People place a value on the existence of tigers and whales even if they have never seen one and probably never will; if tigers or whales became extinct, many people would feel a definite sense of loss. Existence values can also be expressed by bequest values, i.e., I want my children to benefit from the continued existence of these sites after I am gone, and many people make formal bequests of their collections or their historical family residences to be maintained after their death. Nonuse values are the most difficult types of value to estimate, yet this category of value has obvious relevance for the assessment of cultural heritage sites.

In addition to helping evaluate the benefits provided by the site itself, adapted environmental economics techniques can also be useful for evaluating the impact of changes in environmental or aesthetic problems at the site. For example, the enjoyment derived by visitors, and which is felt by the residents for whom the urban environment contributes to their own sense of identity, will be adversely affected by air pollution as well as by inappropriate construction, such as an ugly fourteen-story building in the heart of a medieval townscape.

There are many different actors who are likely to benefit from an investment to protect the cultural heritage in historic cities, and each may have a different appreciation of the benefits that accrue. Their distinct perspectives should be taken into account. Such actors include residents, investors, visitors, and nonvisitors. Residents, making the distinction between renters, owner-residents, and absentee landlords, qualify as a special category of investors, housing usually being regulated differently from businesses. Investors in businesses in the historical area may or may not be residents, including small traders. Visitors to the historic city can be both nationals and international. And there are also nonvisitors, also distinguishing between national and international, the latter of which could be called "the world at large." Further refinements are necessary for meaningful analysis: poor and rich, formal and informal, and so on.

Measuring the Benefits: Appropriate and Inappropriate Methods and Techniques
There are several methods used in measuring benefits. Each has certain advantages and limitations. Note that market price methods, discussed first, are applicable only in traded goods and most of the inherent value of cultural assets are really nontraded. Although many benefits of cultural heritage sites do not enter markets, some do. The

most obvious example is when visitors pay a fee to enter a site. The revenue from fees provides a measure of the value people place on being able to visit the site. Some uses of cultural heritage sites have close substitutes which can be used to estimate the value of those uses. Thus, the value of using a historic building as a school might be estimated using the cost of the next best way to obtain the necessary space: for example, the cost of building and equipping a suitable structure. Cultural heritage sites might also induce a variety of economic activities, again most obviously in the tourism industry (e.g., hotels, restaurants, shops). Standard techniques can be used to value these benefits. The difficulty generally arises from predicting the impact that changes in the cultural heritage site will have on the quantity and quality of such services, not in estimating their value.

To capture nontraded benefits, three broad categories of techniques exist, each discussed in turn below: price-based revealed preference, survey-based stated preference, and adaptive techniques (that seek to adapt the value of one thing to another). First, economists generally prefer price-based revealed preference techniques since they involve actual money paid by people rather than just responses to surveys. Two of these techniques stand out and are discussed below: the travel cost method and hedonic pricing methods. The former uses information on visitors' total expenditure to visit a site to derive their demand curve for the site's services. This method assumes that changes in total travel costs are equivalent to changes in admission fees. From this demand curve, the total benefit obtained by visitors can be calculated. It is important to note that the value of the site is not given by the total travel cost; this information is only used to derive the demand curve to calculate the value the visitors' place on that curve for the various kinds of services that are and could be provided at the site. The travel-cost method was designed for, and has been used extensively to, value the benefits of recreation. But it depends on numerous assumptions, many of which are problematic in the context of international tourism. It is best used to measure the value placed by visitors of the site as a whole, rather than on specific aspects of the site, and can be better applied to local visitors rather than international tourists who have had to come by air.

It is known that many observed prices of goods are actually prices for bundles of attributes. For example, if somebody buys a historic house, the price paid depends on physical attributes of the dwelling (such as number and size of rooms, amenities such as plumbing, and general condition); on the convenience of access to employment, shopping and education; and on a number of less tangible factors such as environmental quality and the value that the purchaser puts on living in a historical district or on the knowledge that he or she lives in a historic house. Because each house differs slightly from others, the influence of the various factors on its price can be broken down using statistical techniques known as hedonic methods, provided sufficient observations are available. This approach is of interest because many dimensions of cultural heritage are likely to be embodied in property values.[4] A historic

structure, for example, may sell for more than an equivalent modern one. Hedonic methods allow this effect to be measured, holding other factors such as size and amenities constant. In essence, the technique estimates the implicit prices for various attributes that together make up the sale price. Although these techniques have obvious applicability to the study of benefits of cultural heritage in urban settings, their use has often been limited by their considerable data requirements.[5]

The second broad category of techniques for capturing nontraded benefits are survey-based stated preferences. Contingent valuation, for example, is carried out by asking consumers directly about their "Willingness To Pay" (WTP) to obtain an environmental good or a cultural benefit derived from the protection and maintenance of cultural heritage.[6] A detailed description of the good (environmental or cultural) accompanies details on how it will be provided or accessed by the respondent. In principle, contingent valuation can be used to value any environmental or cultural benefit. Moreover, because it is not limited to deducing preferences from available data, contingent valuation can be targeted quite accurately to ask about the specific changes in benefits that the proposed project would bring. Contingent valuation methods have long been used to examine aesthetic benefits, and they are especially important in the estimation of existence value because it is the only way to measure it, since by definition existence value will not be reflected in behavior.

Contingent valuation was used effectively in the case of the Exxon Valdez oil spill off Alaska in 1989 and was supported by the courts in an almost $1 billion settlement. As can be imagined, it was subjected to severe criticism, but best practice guidelines have now been developed for its use,[7] and it is now generally accepted that contingent valuation can provide useful and reliable information as long as these guidelines are followed.

The third type of broad category of techniques for capturing nontraded benefits, adaptive techniques, employs the valuation of something else, like the actual cost of repairing an asset as equal to the value of that asset (replacement cost method), or that the benefits measured for one asset will be equal to those for another asset (benefit transfer method). In general, these methods should be avoided as they have many conceptual errors, as explained below.

The cost of replacing a good is often used as a proxy for its value: this is replacement cost.[8] The approach has two problems. First, it simply may not be possible to replace many cultural heritage sites, and when the site is only damaged, restoration cost might be used. Second, when the goal is to decide whether a site is worth restoring, using restoration cost as a measure of value is clearly of little use. It would argue that the more degraded the site, the costlier the restoration and the greater the value. This is clearly faulty reasoning, though this measure may be appropriate for some critical aspects of the site where the value might reasonably be thought to be extremely high. In such cases the appropriate approach is one of cost effectiveness rather than cost benefit.

Second, benefits transfer refers to the use of estimates obtained (by whatever method) in one context to estimate values in a different context. For example, an estimate of the benefit obtained by tourists viewing wildlife in one park might be used to estimate the benefit obtained from viewing wildlife in another park. Because cultural heritage sites are unique, benefits transfer methods have little applicability. Yet there may be some relevance in considering benefits associated with international tourism. Since tourists at a historical site are likely to be drawn from the same pool of potential tourists as those at another site, it seems reasonable to assume they would place similar values on similar services. Thus, while this approach is probably of limited use in valuing unique aspects of a site, it could be used for more generalized aspects. Of course, the original estimates being transferred must be reliable for any attempt at transfer to be meaningful.

Ultimately, the choice of the most appropriate technique depends on the problem under study. Except in simple situations, a variety of techniques will likely be necessary to estimate the full range of benefits for complex projects. Moreover, where substantial investments are contemplated, it might be desirable to cross-check estimates by deriving them from multiple methods.

When bringing together the results of multiple techniques, two important points should be kept in mind: to avoid the twin dangers of underestimation, or not measuring intangible benefits, and of double counting, or using techniques that each capture part of the same benefit and adding them. Another important pitfall comes from limiting the benefit stream to a fairly measurable, solid, and understandable set, such as tourism revenues, as discussed earlier.

Another potential pitfall is the use of the likely impact of investment in (or expenditure on) restoring the heritage on the gross domestic product (GDP). This approach equates the spending with the benefit of that spending. Thus, letting a monument decay and then spending more on its restoration and conservation would appear to promote more benefits than avoiding the decay of the building in the first place. These anomalies are common to GDP calculations, and have been much debated in the economic literature. Although some aspects of the issues can be addressed by such calculations—for example, that spending on cultural heritage restoration projects has a higher multiplier effect than spending on other construction projects—they are likely to be misleading. They should be avoided despite their obvious attractiveness to decisionmakers who have been conditioned to think in terms of contributions to GDP growth as equivalent to increases in welfare and well-being.

Concluding Remarks

Much is being done to add rigor to the financial and economic analysis of cultural heritage conservation projects, including tools that can be used to study repair and reconstruction projects after damage from hostile forces, or even to build protections for the site against possible damage by nonstate armed groups. There are two important

elements to this new work. First, it provides rigorous techniques that have stood the test of major litigation in the United States. Second, it contextualizes the project intervention, its costs and benefits, within the wider realities of multiple interests and actors who deal with cultural heritage, and especially those who make up the living city. Above all, this work tries to give due recognition to the intrinsic existence value of cultural heritage beyond its existence as an object for tourists.

It is important to remind ourselves just how valuable these elements of our cultural heritage are, and how ruthless its intentional destruction is. Reflecting on that provides powerful arguments for how important it is to protect our cultural heritage, with its invaluable contribution to the local and national sense of identity and pride, because those with strong and living links to their past are in the best position to design their own future. The legacies of our cultural heritage are the touchstones of our memory and the wellsprings of our imagination.

SUGGESTED READINGS

Matthew D. Adler and Eric A. Posner, eds., *Cost-Benefit Analysis: Economic, Philosophical, and Legal Perspectives* (Chicago: University of Chicago Press, 2001).

Kenneth Arrow, Robert Solow, Paul P. Portney, Edward E. Leamer, Roy Radner, and Howard Schuman, "Report of the National Oceanic and Atmospheric Administration Panel on Contingent Valuation," *Federal Register* 58, no. 10 (1993): 4601–14.

Marcello Balbo, ed., *The Medina: The Restoration and Conservation of Historic Islamic Cities* (London: I. B. Tauris, 2012).

Stephanie Meeks and Kevin C. Murphy, *The Past and Future City: How Historic Preservation Is Reviving America's Communities* (Washington, DC: Island Press, 2016).

Richard L. Revesz and Michael A. Livermore, *Retaking Rationality: How Cost-Benefit Analysis Can Better Protect the Environment and Our Health* (Oxford: Oxford University Press, 2008).

Ismail Serageldin, *Very Special Places: The Architecture and Economics of Intervening in Historic Cities* (Washington, DC: World Bank, 1999).

Stephen Smith, *Environmental Economics: A Very Short Introduction* (Oxford: Oxford University Press, 2011).

NOTES

1. Earlier versions of the material in this chapter can be found in Ismail Serageldin, *Very Special Places: The Architecture and Economics of Intervening in Historic Cities* (Washington, DC: World Bank, 1999), and "On the Economic Value of Cultural Assets: Reflections with Special Reference to the Case of Historic Cities in the Less Developed Countries," conference paper presented at Florence 1966–2016: Resilience of Art Cities to Natural Catastrophes—The Role of Academies, Accademia Nazionale dei Lincei, Rome, 11–13 October 2016.
2. For Mosul, there is an upcoming study that examines the destruction of the architectural heritage perpetrated by the Islamic State of Iraq and Syria between 2014 and 2017. See Karel

Nováček et al., *Mosul after Islamic State: The Quest for Lost Architectural Heritage* (London: Palgrave Macmillan, 2021).

3. Matthew D. Adler and Eric A. Posner, eds., *Cost-Benefit Analysis: Economic, Philosophical, and Legal Perspectives* (Chicago: University of Chicago Press, 2001).

4. The quality of surroundings impacts the prices of residential property, and thus by extension the quality of a historical district can be a factor. For an example of calculating the impact on residential prices of proximity to a forest using a hedonic price method, see Ken Willis et al., "Assessing Methodologies to Value the Benefits of Environmentally Sensitive Areas," ESRC Countryside Change Initiative Working Paper no. 39, 1993, 15–28.

5. Harold Kalmann, *The Evaluation of Historic Buildings* (Ottawa: Canadian Ministry of the Environment, 1980); and Rob Pickard, "Setting the Scene: A Review of Current Thinking," in *The Economics of Architectural Conservation*, ed. Peter Burman, Rob Pickard, and Sue Taylor (York: University of York, 1995),14–17.

6. For a detailed discussion, see David J. Bjornstad and James R. Kahn, eds., *The Contingent Valuation of Environmental Resources: Methodological Issues and Research Needs* (Cheltenham, UK: Edward Elgar, 1996); and Steven K. Rose, "Non-Market Valuation Techniques for Application to the Preservation of Cultural Heritage: State of the Art," Department of Agricultural, Resource, and Managerial Economics, Cornell University, Ithaca, New York, 1998.

7. Kenneth Arrow et al., "Report of the National Oceanic and Atmospheric Administration Panel on Contingent Valuation," *Federal Register* 58, no. 10 (1993): 4602–14.

8. David W. Pearce and Jeremy Warford, *World without End: Economics, Environment and Sustainable Development* (New York: Oxford University Press, 1993), 105–11.

PART 2

Cultural Heritage under Siege: Recent Cases

Introduction: Part 2

James Cuno

Thomas G. Weiss

Part 2, "Cultural Heritage under Siege: Recent Cases," examines several examples of dramatic attacks on cultural heritage in the contemporary era. We have organized the nine essays in this section of the book by geography, moving, in general, westward from China and ending in Guatemala.

Chapter 7 explores "Uyghur Heritage under China's 'Antireligious Extremism' Campaigns." The author is Rachel Harris, a professor at the University of London's SOAS (School of Oriental and African Studies), whose research and teaching have long explored the fate of the tangible and intangible cultural heritage of the minority Turkic Muslim population of the Xinjiang Uyghur Autonomous Region in the far west of China. Not incidentally, similar techniques had successfully (from Beijing's perspective) been used earlier against Tibetans in the Tibet Autonomous Region. Public attention elsewhere has been drawn to assaults on high-visibility monuments, but in Xinjiang there are no World Heritage Sites designated by the UN Educational, Scientific and Cultural Organization (UNESCO). China's assaults on Uyghur heritage thus have been directed at more commonplace and community sites. The fundamental value of Uyghur mosques, cemeteries, and shrines resides in their historical meanings and connections to local communities. Although strongly denied by China's central government, attacks on the Uyghur population are part of an antireligious campaign, which includes burning villages, ethnic cleansing, execution of large numbers of civilians, rape, and forced sterilization. Perhaps a million Muslims have passed through "reeducation" camps, presumably to overcome any excessively religious views.

While there is debate about whether China's actions qualify as physical genocide, Harris unapologetically labels them "cultural genocide," the result of Beijing's political and economic goals being allied closely with its Belt and Road Initiative. Unlike the crimes perpetrated by small and middle powers, for which modest policy tools exist and can feasibly be recommended to exert international pressure, those same tools in this case have extremely limited utility because China is a major economic and political force, a recently minted "superpower." Nonetheless, Harris sees that "hope for the survival of the unique culture surrounding this religious heritage lies in the very transient nature of its architecture" because constant renovation and rebuilding have

resulted in its resilience. She also holds out the hope, therefore, "that the current campaigns will not result in their final erasure from the collective memory of the people they have served for so long."

Chapter 8, "When Peace Is Defeat, Reconstruction Is Damage: 'Rebuilding' Heritage in Post-conflict Sri Lanka and Afghanistan," surveys cultural destruction of minority heritage in two recent armed conflicts in Central and South Asia. Kavita Singh, professor and former dean of Jawaharlal Nehru University's School of Arts and Aesthetics, pushes the reader to consider what peace looks like after internecine wars: the views about heritage, and perhaps everything, depend on whether they are viewed from the perspective of winners or losers. Singh starts with the civil war in Sri Lanka that ended in 2009 after a quarter century of bitter armed conflict between the victorious majority Sinhala (Buddhist) government and the losing Tamil Tigers, part of a minority Hindu population from the North. During reconstruction, Singh argues, the majoritarian government systematically used a variety of policy tools at its disposal, especially economic ones, to prioritize rebuilding that disempowered the minority ethnic group and fostered the discrimination that had sparked the war in the first place. Prevalent cultural destruction policies aim to erase the tangible and intangible traces of the Tamil presence and rewrite its past; the purpose is to replace it with Buddhist statues, viharas (monasteries), and stupas (funerary monuments). Ten years after the end of the war, on Easter Sunday in 2019, bombings perpetrated by the Islamic State of Iraq and Syria (ISIS, also known as ISIL or Da'esh) on churches and luxury hotels in the capital, Colombo, demonstrated the remaining publicity value of destruction by a radicalized and still smaller Muslim minority.

Singh's second case examines the spectacular and performative demolition of the sixth-century rock-carved Buddhas in the Bamiyan Valley of central Afghanistan. The ruling Taliban, an Islamist movement, effectively publicized propaganda that international actors, particularly Western powers, cared more about the statues than about desperate Afghans. The Taliban sought to conceal the human catastrophe in its accompanying campaign of atrocities perpetrated against the Hazara ethnic minority. While the Hazaras were not Buddhists, they lived in the valley where the Buddhas had dominated for fifteen centuries, and they respected them. As Shiite Muslims, the Hazaras were considered heretics by the Sunni Taliban; their true crime was not only idolatry but also, and perhaps more crucially, being members of the armed opposition to the Taliban. With the Taliban's return to power following the US withdrawal, other ancient Buddhist ruins and artifacts may be targeted.

In both northern Sri Lanka and Afghanistan, Singh explores what happens to cultural heritage when wars end or violence diminishes: "The very processes of reconstruction . . . meant to repair a society can become instruments through which one side continues its domination." In short, "the disturbing shape taken by cultural reconstruction" after the wars in the Jaffna Peninsula and Bamiyan Valley suggest that decision-making intended to repair a community can become instead an effective

instrument through which the majority victors continue to subjugate the minority losers.

The destruction of the Bamiyan Buddhas is an example of a wider phenomenon, the publicity value for iconoclasts who perceive that they have much to gain and little to lose from such crimes. This sad calculation provides a helpful segue to chapter 9, "Performative Destruction: Da'esh (ISIS) Ideology and the War on Heritage in Iraq." While the costs to humanity of cultural destruction are incalculable, the public relations and recruitment benefits perceived by the destroyers are palpable, according to Gil Stein, professor of archaeology and former director of the University of Chicago's Oriental Institute. In "a dangerous new paradigm," ISIS deployed a carefully orchestrated, public strategy that transmitted globally and in real time, through the Internet, images of cultural and physical genocide by targeting heritage and people in Iraq. The attacks accompanied the physical destruction targeting all "infidels" from outside Salafist Islam—namely, any believer who was not a member of what they defined as the purest Muslim group: not only Christians, Yezidis, and Jews but also Sufis and Shias. In fact, the heritage of these "infidel" Muslims has accounted for about two-thirds of the destruction and looting by ISIS. While the pursuit of a geographical caliphate has been defeated, the "model" of transmitting through social media and other Internet-based communications parallel attacks on humans and their heritage has a demonstrated and wider appeal to a broad range of violent and extremist groups that emulate performative destruction and adapt it to local conditions. Indeed, Stein fears that the example could be replicated by malevolent insurgents and governments worldwide. No distinction is made between enemies, on the one hand, and the cultural manifestations of their beliefs, on the other. The atrocities against people and patrimony were not haphazard but carefully planned and executed parts of a coherent and toxic jihadist ideology. The powerful mixture of religion and politics that facilitates recruitment on a global scale through performative destruction will require "innovative new legal and policy strategies to confront and hopefully neutralize this emerging threat."

The following three chapters probe different aspects of Syria's decade-long civil war, which has resulted not only in widespread attacks on cultural heritage but also the forced displacement of half of the country's prewar population, the deaths of upward of six hundred thousand of its citizens, and a litany of mass atrocities, including the use of chemical weapons against civilians. Francesco Bandarin—a special advisor to the Aga Khan Development Network and former UNESCO assistant director-general for culture—analyzes this tragic case in chapter 10, "The Destruction of Aleppo: The Impact of the Syrian War on a World Heritage City." He weaves together attacks on social and physical infrastructure with those on cultural heritage—souks, khans, and mosques. In addition to his concern for substantial damage to individual structures, Bandarin examines the destruction of the entirety of the urban center of Syria's commercial capital, which resulted from the Battle of Aleppo, "one of the longest and most deadly

conflicts since World War II." Like others working in this field, he argues that the existing hard and soft international law to protect people and their heritage provides an adequate legal framework; he sees no political payoff from further efforts to refine the international legal regime. Instead, Bandarin recommends "a more systematic integration of cultural protection in humanitarian interventions and a greater involvement of military forces." He emphasizes the absence of political will and effective means to ensure compliance with the law as the main stumbling blocks. He is encouraged by recent UN Security Council decisions, including the integration of cultural protection measures into the mandate of the United Nations Multidimensional Integrated Stabilization Mission in Mali (MINUSMA) and the European Union's endorsement of the protection of heritage in its Common Security and Defence Policy.

Chapter 11 considers another ravaged Syrian city in "The Lost Heritage of Homs: From the Destruction of Monuments to the Destruction of Meaning." A practicing architect, Marwa al-Sabouni wrote this chapter while living with her family in the city of Homs under siege. She brings to bear the same passion that she did in *The Battle for Home: The Vision of a Young Architect in Syria*, a book based on her personal experience of surviving and continuing to work in the rubble of her hometown. While suffering ongoing hardships in war-torn Syria, her participation in this book project was challenged by a lack of Internet access, resulting from US sanctions against Syria and Syrians. She argues persuasively that architecture plays a substantial role in whether and how a community crumbles or comes together amid communal violence and mass atrocities. In addition to the physical damage to and destruction of immovable heritage, her preoccupations concern the invisible and underlying meanings behind visible structures, which led to their existence in the first place. She argues that losing connections with one's heritage, and recovering and rediscovering its meanings, will be the primary challenge during future rebuilding. It will be "hindered by the same [old] arbitrariness and ignorance" because invisible meanings tend to be forgotten or overlooked in too many processes of restoration and preservation. In lamenting that Homs has been "transformed from a dull city to a dead city," al-Sabouni is intent on exploring the meanings of architecture before and after destruction by targeting or collateral damage. She thus stresses the critical importance for Syria's future of decisions about what to reconstruct and how, a theme that animates her 2021 book *Building for Hope.*

A comparable preoccupation motivates Frederick Deknatel, the executive editor of *Democracy in Exile* and former managing editor of *World Politics Review*, whose chapter 12 uses the ongoing tragedy in Syria to ask, "Reconstruction, Who Decides?" The primary goal of mediators and negotiators is to move beyond armed conflict. Yet, the day-to-day reality of "peace" looks different when judged by winners or losers— although it would be hard to deny that virtually everyone loses from internecine war and cultural heritage destruction. In addition to such destruction during war, another significant danger lurks afterward. In general, the term "post-conflict" peacebuilding is

often a euphemism, more an aspiration than a reality. In Syria in particular, so-called post-conflict rebuilding reflects the dominant political, economic, and cultural priorities of the authorities who exercise influence and power over decisions by both outside donors and investors. In this case, the government of Bashar al-Assad is sustained by Russian and Chechen assistance; it can decide what to rebuild, and what not to. It may appear perplexing to question the importance of reconstructing the symbolically important sites covered by the international media. But at the same time, it is crucial to question the priority afforded such reconstruction when neighborhoods in both Aleppo and Homs remain wastelands. Deknatel argues that the most relevant background information to understanding "victor's justice" in this context is that these cities were once strongholds of the armed opposition that battled the Assad government. Decisions about selective reconstruction by the "pariah state" foster its propaganda goals in two ways: to project an image of the government's effective control, and to reward loyalists. Meanwhile, help from the West and international organizations is held hostage to a political settlement in Syria, which is nowhere in sight.

Warning of possible "echoes of Beirut," Deknatel notes that Syria is hardly unusual and compares decisions made to the history of reconstruction "next door" in Lebanon. Rebuilding there also did not meet the everyday needs of the population, but rather those of the elite and of former warlords turned politicians. If inclusive decision-making is crucial, Deknatel's grim narrative provides a cautionary note for those who clamor for rapid reconstruction without answering several questions: Who is allowed to be visible? Whose presence is kept hidden and suppressed? What is remembered and what is forgotten? What is permitted to occupy space, and what is buried or swept away? The implications are dire for future reconstruction for other countries emerging from armed conflict because the government "retains all power and authority, despite ruling over a country shattered by a war of Assad's own making."

The focus of chapter 13 is on Yemen's movable tangible heritage, which in part reflects the effects of the destruction of a substantial part of Yemen's immovable cultural heritage during the ongoing civil war that has resulted in the world's largest humanitarian crisis in the poorest country in the Arab world. In addition to bombing the World Heritage City of Sana'a, founded two and a half millennia ago, the coalition of Saudi Arabia and the United Arab Emirates has used numerous indiscriminate and disproportionate air strikes to kill and injure thousands of civilians. Saudi jets have destroyed not only mud-brick tower houses, which date back thousands of years, but also libraries. In addition to damage to these physical structures, it has resulted in further losses of heritage, which is the focus in Sabine Schmidtke's second contribution to this volume, "Yemen's Manuscript Culture under Attack." Here, she probes the long history of book preservation in the face of confiscation, censorship, and destruction as well as the ongoing, contemporary threats from the civil war and the indiscriminate sale of archives to collectors. She also mentions the "curse," and simultaneously the ironic "blessing," that some of the most important collections of manuscripts have not been

destroyed because they are currently housed and thus protected in research libraries outside of Yemen.

The parallel destruction of immovable and movable cultural heritage is the focus of chapter 14, "Cultural Heritage at Risk in Mali: The Destruction of Timbuktu's Mausoleums of Saints." The ravages to the northern Malian World Heritage Site during attacks on civilians in 2012 resulted in the leveling of several treasured monuments in the capital of the medieval trading and cultural kingdom. Lazare Eloundou Assomo, director of UNESCO's World Heritage Center, led the reconstruction effort in Mali after the widespread attacks on the civilian population by the Islamist rebels of Ansar Dine and Al-Qaeda in the Islamic Maghreb (AQIM). The "reign of terror" that followed the imposition of sharia law included torture, sexual slavery, and murder; in addition to these atrocities, the militants completely demolished fourteen of sixteen Sufi mausoleums, severely damaged three mosques, and burned over four thousand manuscripts.

International efforts have received attention, including those of the International Criminal Court, where Ahmad al-Faqi al-Mahdi pled guilty and was convicted as a coperpetrator of the war crime of intentionally directing attacks against Timbuktu's religious and historical buildings. Assomo stresses another lesson closer to the scene of the suffering: the crucial importance of relying on local skills, materials, and artisans. This approach not only injected much needed funds into the local economy but also fostered authentic reconstruction, ownership, and peacebuilding. Assomo also points to the lessons for other crises because international inputs facilitated the harmonious combination of ancestral practices with technical adaptations to conditions of climate change in the Sahel region. In addition, "incorporating the masons in decision-making ensured that the mausoleums would be reconstructed using traditional techniques to preserve the city's architectural integrity," and involving of religious authorities and families responsible for the mausoleums made it possible to develop an agreed-upon reconstruction strategy, document the reconstruction process, and allow the local community to retake ownership. The Mali case thus provides thoughtful lessons for other "post-conflict" reconstruction—although Islamist militants remain a threat throughout the north of the country. Expert studies and the mobilization of external resources helped to overcome the psychological trauma from wanton cultural desecration, which in turn facilitated the rebirth of a stable society in Timbuktu as part of the country's recovery from mass atrocities.

The final case study in part 2 is chapter 15, "Indigenous Threatened Heritage in Guatemala," by Victor Montejo, who is professor emeritus in the Department of Native American Studies at the University of California, Davis. His scholarly and practical orientations reflect both his academic training and his Indigenous roots in Guatemala. This chapter, as well as his career as a teacher and researcher, addresses the Maya culture of Central America, which was under siege long before several national administrations more recently committed mass atrocities against Indigenous people and

attacked their ancient culture. Montejo's short summary is telling: "the Guatemalan military government unleashed a scorched earth policy that destroyed entire villages and massacred thousands of Indigenous people." The recent crimes began in the 1960s as an integral part of the central government's strategy to win the civil war and crush the armed Indigenous resistance. That war ended in the mid-1990s, but Montejo contextualizes those decades of repression and destruction of Maya cultural heritage as a continuation of the physical and cultural assaults that had persisted for centuries, and from which the resilient Maya have been unable to escape, even after more than half a millennium of atrocities. The intimate relationship between protecting people and their heritage is clear, and Montejo laments that nearly every aspect of the Maya cultural tradition remains unprotected. In looking toward a better future and as an antidote to continuing "Mayacide," he calls for more vigorous efforts to ensure essential inputs from local scholars and citizens in decisions about the protection of Maya movable and immovable cultural heritage; similar consultations should also characterize archaeological excavations. He makes clear the reason to recognize the links to their heritage: "we must not think of them just as victims of the circumstances around them, but as creators and actors in the protection of their cultural heritage in the twenty-first century." Like other contributors, Montejo pleads with the international community of states to apply pressure on all countries and individuals to comply with the international laws on the books, whose provisions aim to protect people from atrocities and their cultural heritage from destruction, but lack enforcement.

7

Uyghur Heritage under China's "Antireligious Extremism" Campaigns

Rachel Harris

By the forest side, there was a river bed
The tomb was a wonderful place
Those who lay there were all martyrs
Heroes and men of God

.

Flag poles were set out everywhere
This day, at the time of afternoon prayer
They played marches and tambourines
They shouted through the desert plain

 —Zalili, eighteenth-century poet

If one were to remove these . . . shrines, the Uyghur people would lose contact
with [the] earth. They would no longer have a personal, cultural, and
spiritual history. After a few years we would not have a memory of why we
live here or where we belong.

 —Rahile Dawut, scholar and Uyghur folklorist

Over the past few years, government authorities in the Xinjiang Uyghur Autonomous Region of China have destroyed large swathes of the religious heritage of the Turkic Muslim Uyghurs. This campaign of destruction has proceeded in tandem with the heavy securitization of the region, mass incarcerations, and attacks on Uyghur language and other aspects of cultural identity.[1] An estimated 1.8 million people have been arbitrarily

detained in a system of "political education" camps, pretrial detention centers, and prisons. Uyghurs and other Turkic Muslims have been given long prison sentences simply for sharing religious recordings or downloading Uyghur language e-books. Numerous testimonies have reported that detainees in the camp system are subjected to systematic torture and rape, cultural and political indoctrination, and forced labor. Outside the detention facilities, Xinjiang's Turkic Muslim citizens are subject to a pervasive system of mass surveillance, controls on movement, forced sterilization, and family separation.[2]

Although China has denied, downplayed, and sought to justify these moves as necessary to counter terrorism, its actions demonstrably constitute what the UN Educational, Scientific and Cultural Organization (UNESCO) calls "strategic cultural cleansing": the deliberate targeting of individuals and groups on the basis of their cultural, ethnic, or religious affiliation, combined with the intentional and systematic destruction of cultural heritage. This attempt to remodel the region's ethnic and cultural landscape is impelled by China's wider strategic and economic objectives under the Belt and Road Initiative (BRI), President Xi Jinping's cornerstone policy introduced in 2013. Its aim is to secure access to the region's natural resources and transform it into a platform to expand China's influence and trade across Asia.

On the international stage, the destruction of immovable cultural heritage has become strongly associated in public discourse and government policy with groups that are reviled as Islamic extremists and terrorists, such as the looting of sites by the Islamic State of Iraq and Syria (ISIS, also known as ISIL or Da'esh) and the Taliban's demolition of the Bamiyan Buddhas in Afghanistan. In Xinjiang, to the contrary, we find the large-scale destruction of Muslim heritage by a secular state that capitalizes on these prevailing international perceptions, reformulating its destruction as an essential security measure against terrorism and thus aligning its moves with the US-led Global War on Terror. It is important to note that these moves reflect a hardening of policy in the region rather than a post-conflict situation. Although the region has suffered from a spate of violent incidents in recent years, this has not taken the form of organized resistance to Chinese rule. Long-term observers of the region argue that the impression of violent conflict has been largely manufactured by the state in order to enable and justify its acts of cultural erasure.[3]

Heritage with Chinese Characteristics

Over the past three decades, China has become a key player in the international heritage sphere and has developed its own unique heritage discourse. The starting point for this "heritage turn" can be traced to an ideological shift within the Chinese Communist Party (CCP) in the 1990s and its search for new forms of legitimacy beyond communist ideals. Cultural heritage in contemporary China fulfills many functions. Heritage is linked to political goals and serves as a resource for political legitimacy and soft power. It is also treated as an economic asset, utilized to boost local economic

development. But heritage in China is not a purely top-down government initiative. The nationalistic rhetoric surrounding Chinese heritage and the rediscovery of heritage sites and practices has also found deep resonance among large sections of the population.[4] The government's heritage regime, then, reflects domestic concerns, but its global aspirations and heavy involvement in UNESCO have also left their mark on the global heritage regime: China's leading role in the international heritage system makes its approach hard to challenge.

The country's increasing dominance and explicitly political use of heritage make it compelling to analyze the underlying power relations: issues of governmentality, negotiation, and resistance.[5] Key questions revolve around the identities, memories, and traditions of place-making associated with items of heritage and the ways in which they are privileged, downplayed, or suppressed in regimes of heritage management. China's huge geographic and ethnic diversity is an important variable in these questions. It is self-evident that the international heritage system creates special problems for minority and Indigenous populations, since the designation of a recognized "cultural property" can only be proposed by a state. The position of Uyghur heritage within the Chinese system is especially instructive.

In Xinjiang, the management of Uyghur cultural heritage has been tightly linked to government attempts to deepen control over this minority region through a center-led economic development campaign and assimilationist agenda. China argues that government management of Uyghur culture is necessary to preserve it from threats posed by religious extremism and hostile foreign forces. In practice, policy is highly focused on the use of Uyghur heritage as a cultural resource to develop the tourism industry, which is an important part of the central government's economic development plans for Xinjiang and is used to present heavily stage-managed images of normality in the region. Its economic growth facilitates the movement of Han Chinese into the region, both as short-term visitors and as permanent settlers, justifying and whitewashing the ongoing repressive securitization of the region.[6]

No Uyghur monuments have been entered on UNESCO's heritage lists despite the record number of World Heritage Sites now listed in China, many of which are recent designations. Items of Uyghur religious heritage, including mosques and shrines, do appear on China's own national and regional heritage lists, and fall within the purview of China's huge bureaucratic system for designating and managing heritage sites.[7] As such, they are protected by a range of national laws on heritage and ethnic autonomy, but these legal protections seem to have had little impact on protecting sites from the unprecedented destruction of mosques and shrines since 2016. Arguably, the inclusion of Uyghur religious sites on UNESCO's lists would not have afforded them much greater protection. Uyghur culture is strongly represented on the Intangible Cultural Heritage lists in the form of the Muqam musical repertoire and Meshrep community gatherings. The subsequent folkloric promotion of these items has served primarily to cement the long-standing designation of the Uyghurs as a singing and dancing minority people.[8] In

the same way that Uyghur mosques and shrines are closed to local communities but open for tourist business, community gatherings are transformed into glamorous stage shows purveying messages of interethnic harmony within the framework of Chinese nationhood, while local communities are terrorized and torn apart.

China's leading role in inscribing the Silk Road on UNESCO's list of World Heritage Sites in 2014 provides a clear demonstration of how the government positions itself as an international heritage leader and how it uses heritage to support its economic and political goals. Strategic interests and heritage policy are both underpinned by research. The huge upsurge of Silk Road research in recent years is directly linked to the BRI, and research findings typically serve to support current government narratives. Ubul Memeteli's 2015 study, *The Construction of the Xinjiang Section of the Silk Road*, for example, funded by the Chinese Administration of Cultural Heritage, makes (somewhat tenuous) claims of close associations between the structure of Uyghur mosques and ancient Buddhist monasteries.[9] Studies like this underscore China's territorial claims on the region by selectively emphasizing its cultural links. In contrast, Yue Xie notes the similarities in architectural style between the mosques of Xinjiang and those of the neighboring Fergana Valley in eastern Uzbekistan.[10] These continuities are rooted in more recent history: the mid-nineteenth-century rule of Yakub Beg, a military leader from Fergana who led an uprising against rule by the Chinese Qing dynasty in 1865 and controlled the region until 1877. During this period, he commissioned the renovation and expansion of many important mosques and shrines that survived into the early twenty-first century. Central Asian histories and cultural continuities such as these are rarely foregrounded in China's own heritage narratives.

Mosques, Shrines, and Cemeteries and the Transmission of Uyghur History
At the time of the CCP takeover in 1955, religious institutions—mosques, madrasas (religious schools), and shrines—were central to Xinjiang's social and economic life. The mosque community (*jama'at*), comprised of respected senior men led by the imam, formed the main source of authority in the village or neighborhood (*mahalla*). In the early 1950s, Kashgar Prefecture had 12,918 mosques, and those of Kashgar city alone employed 180 muezzins to give the call to prayer and 190 imams to lead prayers and deliver sermons (fig. 7.1). The major mosques were the site of mass celebrations at the festivals of Eid and Qurban. Mosques and shrines often also formed part of a pious foundation (waqf) established by donations in the form of money or land, which provided income for the imams, income for charity, and support for pilgrims to go on the hajj. Some of the larger foundations amassed large amounts of money and power. In 1950, the Kashgar Idgah Mosque controlled three thousand *mu* (nearly five hundred acres) of farmland and sixty commercial premises within the city. Madrasas provided the main source of formal education for Uyghur boys into the early twentieth century. The most distinctive and significant aspect of religious life in the region centered on the

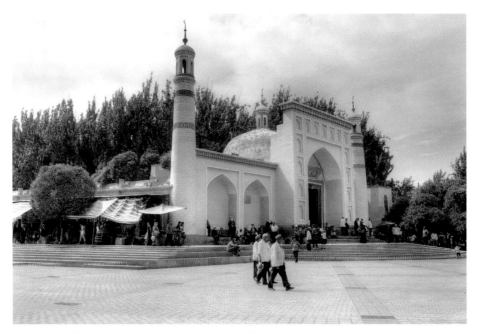

Figure 7.1 Kashgar's Idgah Mosque in 2013. Image: Ivan Vdovin / Alamy Stock Photo

shrines—tombs of martyrs and saints—which were popular pilgrimage destinations and held their own festivals celebrating the saints.[11]

The spread of Islam into the region started in the tenth century with the conversion of the rulers of the Turkic Qarakhanid dynasty and their conquest of neighboring Buddhist kingdoms. Introduced by merchants and missionaries from Central Asia and Persia, the new faith gradually replaced shamanic beliefs, Nestorian Christianity, and Buddhism. Throughout the history of Islam in the region, believers have venerated the heroes and heroines of this religious heritage: convert kings and religious teachers, warriors and martyrs, scholars and mystics. Sufi orders and mystics also played an important role in the spread of Islam in the region. Sufi sheikhs were respected as community leaders and venerated for their healing powers. Revered in death as well as in life, these historical leaders and saints have shrines that became important sites of pilgrimage.

These saints and their shrines have played a crucial role in the culture and history of the region. Historical documents show that the shrines retained their religious authority and socioeconomic importance until the mid-twentieth century.[12] The region boasts seven major pilgrimage sites and numerous smaller shrines visited by local people. Many shrines were associated with fertility and used mainly by women. Most of these are not major architectural monuments like the beautiful (and heavily restored) Timurid madrasa complex of Samarkand, Uzbekistan, or the huge shrine of Ahmad Yasawi in southern Kazakhstan, both designated World Heritage Sites. In Xinjiang, some of the most important shrines are simple mud-brick constructions, distinguished

visually by the huge temporary structures made up of "spirit flags" (*tugh alam*) brought by pilgrims and attached to the shrine or tied together into tall flag mountains.

Shrine worship and pilgrimage are important aspects of religious practice across Central Asia and are central to Uyghur faith traditions, sustained through early twentieth-century wars, communization from 1949, and the Chinese Cultural Revolution (1966–76). While the modernization and urbanization beginning in the 1980s has distanced many Uyghurs from these practices, people in rural southern China sustained their traditions of pilgrimage, and the major shrine festivals continued to attract tens of thousands of people until the closure of the last shrine in 2013. Work by Rahile Dawut and Rian Thum has eloquently described the region's sites of shrine pilgrimage and the routes through the desert traversed by Uyghur pilgrims carrying handwritten copies of *tazkirah*—stories of the saints, kings, and martyrs to whom these shrines were dedicated (fig. 7.2). The repeated retreading of these routes and retelling of these stories formed a collective and sacred history etched into the landscape.[13]

While some of the major shrines lay in remote locations, in many places they were central to community life. Sometimes the neighborhood mosque was also attached to a shrine, thus ensuring daily visits from the surrounding community. Shrines located in towns with weekly bazaars were connected through patterns of trade—people combined trips to both. Cemeteries often grew up around the tombs of saints. People would combine a visit to the family grave with a visit to the shrine, where they would circle the tomb, speak with the sheikh about their problems, sit to weep and pray, and leave offerings. On certain holidays, people would pray through the night, and the sheikh told stories of the saints. They brought fried cakes as offerings for souls of the

Figure 7.2 Pilgrims at the shrine of Imam Aptah. Image: Photo courtesy of Rahile Dawut

dead, and the cakes were distributed to beggars. The provision of food and clothing to the poor, enabled by the donations of pilgrims, was historically an important part of the social role of the shrine.

The major shrine festivals were on a much larger scale. Until its closure in 1997, tens of thousands of people gathered annually at the Ordam Padishah Mazar, which lies in the desert between the cities of Kashgar and Yarkand. The three-day festival was begun on the tenth day of the month of Muharram. Curiously, among the Sunni Uyghurs this festival had many echoes of Shia commemoration of the martyrdom of Imam Husayn ibn Ali, grandson of the Prophet, at the Battle of Karbala in 680. Uyghur pilgrims at the Ordam shrine often wept, mourning the death of their own saint, Ali Arslan Khan, who was martyred in the wars to convert the region to Islam. Central to the festival was the ritual of the meeting of the flags (*tugh soqashturush*). Groups of people processed from their villages holding spirit flags, playing *sunay* and *dap*, traditional Uyghur musical instruments, and reciting the names of God.[14] Another important aspect of the festival was the ritual communal meal, cooked from pilgrims' offerings in a huge pot and shared among the crowd.[15]

Until its closure in 2013, the other major shrine festival of the region was the annual pilgrimage to the shrine of Imam Asim. Situated deep in the desert, north of the village of Jiya in Lop County, it is a long and dusty walk through sand dunes to reach the shrine. From Wednesdays to Fridays throughout May each year, the shrine was surrounded by bazaar booths and food stalls, and a wide range of activities occurred, including camel riding, wrestling, tightrope walking, and magic shows.[16] Pilgrims arrived at a series of burial mounds topped with spirit flags, thickly tied with women's headscarves and other offerings such as rams' horns and tiny knitted dolls. They knelt before the wooden fence that surrounded the tombs, reciting prayers and reading the Quran. Inside the *khaniqa* (Sufi lodge), groups of *ashiq* (mystics) gathered to sing poetry by the Central Asian mystic poets Yasawi, Mashrab, and Nawa'i.[17] In the shade of the mosque, pilgrims listened to the sheikh telling the story of Imam Asim's heroic role in the defeat of the Buddhist kingdom of Khotan in 1006.

The early twentieth-century archaeologist Aurel Stein identified several shrines that overlaid former Buddhist sites in Xinjiang. The shrine of Imam Shakir, for example, which lies in the desert near Khotan, was built on the site of a Buddhist temple mentioned by the seventh-century Chinese pilgrim Xuan Zang. It is important to note that while such shrines are frequently held up as examples of syncretism by scholars outside the tradition, within the local traditions of worship the shrines are considered wholly Islamic, and the histories they tell are those of the Islamic conversion and subsequent thousand years of history that tie the region into the wider Muslim world.[18]

Staging Uyghur Heritage

In his studies of Uyghur architecture, Jean-Paul Loubes notes China's piecemeal approach to heritage. Isolated monuments, which are significant because of their symbolic or tourist value, are not so much preserved as "staged" to suit Chinese tastes.[19] The transformation of the city of Kashgar remains the most notorious of these projects of architectural staging. A gradual process of destruction and reconstruction of Kashgar's old city began in the 1990s and was completed in 2013. The key heritage site of Idgah Mosque was preserved, but several other less well-known historical sites were destroyed along with large swathes of residential areas. The majority of the old city's inhabitants were rehoused elsewhere, and it was reopened in the form of a largely depopulated tourist destination, with former mosques repurposed as tourist bars.

Dawut, an internationally prominent Uyghur academic who has dedicated her life to documenting the shrines, has described the transformation of some of the region's shrines into tourist destinations, often in tandem with the effective exclusion of local people from the sites where they formerly worshipped.[20] In the late 1990s, mass tourism companies, often based in inner China, began to exploit the region's natural and cultural resources. Dawut traces the debates among local governments and commercial interests around the preservation and exploitation of local religious sites. Local authorities worried that supporting religious sites would promote "illegal religious activities." Business interests desired to exploit religious sites for their own economic purposes, and local people were concerned about the effects of tourism on their social and religious life. In general, the voices of local people were not privileged in these debates. The shrine of Sultan Qirmish Sayid in Aqsu Prefecture, for example, is situated by an ancient forest and a natural spring whose water is believed to have healing properties. Formerly a major pilgrimage site, it was designated a county-level protected cultural heritage site in 1982. Dawut describes the local discontent when the site was taken over by a tourist company, which introduced an entry charge that was prohibitively expensive for Uyghur pilgrims and permitted Han Chinese tourists to have picnics and consume alcohol on the sacred site. Such forms of exploitation have been hugely exacerbated by the recent campaigns, while the possibilities for critique are greatly reduced.

At the same time that some of the region's shrines were designated as heritage sites and opened to tourism, local authorities moved to disrupt the religious activities and cultural meanings associated with the shrines, as policy toward pilgrimage practice became caught up in official narratives of Uyghur religious extremism. The links made by the authorities between Islamic extremism and shrine worship might seem ironic given the strong opposition to such practices by Islamists, who regard them as heterodox, but such perceived connections are expressive of the lack of knowledge of local religious practice among Xinjiang officials. The Ordam festival was one of the first shrine festivals to be banned, in 1997. At other sites, shrine visits continued in the 2000s, but reciting the histories of the saints was suppressed and texts were confiscated. This

served to weaken the connection between popular historical knowledge and the shrines.[21] The Imam Asim shrine in Khotan was the last to be closed, in 2013.

The Mosque Rectification Campaign

In the wake of the Cultural Revolution, with the relaxing of controls on religious life, people began to return to their faith, and new forms of piety began to permeate Uyghur society. These trends played out in very similar ways to the revival movements that developed across Central Asia and further east in Hui Muslim Chinese communities. Many Uyghurs returned to family traditions of prayer, fasting, and modest dress. They sent their children to study the Quran. Those with sufficient funds took the hajj or went to study in Turkey or Egypt, often returning with reformist ideas about "correct" religious practice, and people hotly debated the true nature of Islam. Sometimes local revivalist groups sought to counter social problems such as alcoholism or drug abuse, and frequently engaged in organized charity.[22] An important aspect of the religious revival was the building or reconstruction of community mosques. These drew clearly on Central Asian models, rejecting any hint of Chinese influence. Local communities and individual donors sometimes raised considerable amounts of money, and in some places large new gatehouses, minarets, or domes were added to the historical structures. These impressive buildings reflected a renewed pride in the faith and new community confidence and prosperity (fig. 7.3).

By the 1990s, the Xinjiang authorities were viewing these developments with deep suspicion. A series of "strike hard" campaigns was implemented, targeting a wide range of religious practices that lay outside the sphere of the officially controlled mosques.

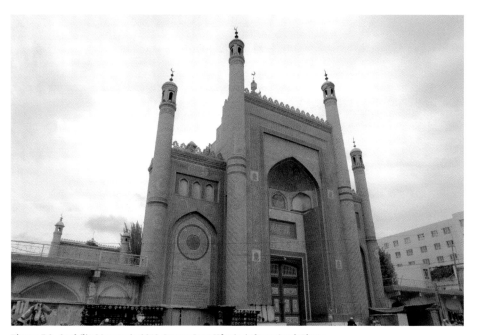

Figure 7.3 Qaghiliq Mosque in 2013. Image: Ivan Vdovin / Alamy Stock Photo

Numerous ordinary aspects of Muslim observance, such as abstinence from pork, daily prayers and fasting, and veiling or growing beards, were criticized as antisocial. Activities that involved groups of people gathering together—including shrine pilgrimage, religious instruction of children, and home-based healing rituals—were designated as "illegal religious activities." They were in turn conflated with Uyghur "separatism."

Soon after the American announcement of a Global War on Terror in late 2001, China began to adopt the rhetoric of religious extremism and terrorism to explain and justify internal security policies.[23] "Illegal religious activities" were now dubbed "religious extremism." State media began to designate local incidences of violence as "terrorist incidents," although the specific reasons underlying local violence were more often related to local power struggles, official corruption, and police brutality. As police intervention into daily life grew more invasive, the number of violent incidents increased. In July 2009, an initially peaceful demonstration in the Xinjiang capital Ürümchi was met by police violence, and the city fell into a night of terrible interethnic violence. The incident was followed by mass arrests and still tighter social controls.

In spite of, or perhaps because of, these measures, 2013 and 2014 saw a spate of bombings and knife attacks on civilians, and in May of the latter year the recently appointed Chinese president, Xi Jinping, called for the construction of "walls made of copper and steel" to defend Xinjiang against terrorism. This heightened rhetoric signaled the territorial nature of this new phase of the campaign and the degree to which the region and its people would be isolated and immobilized. Uyghurs' passports were confiscated and they had to apply for special passes to travel outside their hometown. A tight net of surveillance drew on techniques from the high-tech to the humanly enforced. Security cameras, spy apps, tracking devices, and retina recognition software were deployed at checkpoints, and local residents were mobilized to conduct regular antiterrorist drills, wielding stout wooden poles.

Rather than targeting the small number of people who might reasonably be judged vulnerable to radicalization and violent action, the antireligious extremism campaign in Xinjiang targeted all expressions of Islamic faith and removed large swathes of Islamic architecture and imagery from Uyghur towns and cities. During 2015 and 2016, the Xinjiang authorities destroyed thousands of the mosques constructed by local communities since the 1980s. Under a "Mosque Rectification" campaign launched by the Chinese Central Ethnic-Religious Affairs Department and overseen by the local police, numerous mosques were condemned on the grounds that they were unsafe structures that posed a safety threat to worshippers. The demolitions were rolled out in tandem with the development of the program of mass incarceration.

Given the heavy securitization of the region and the "walls of steel" shielding it from international attention, it has been hard to verify the scale of destruction, but a series of investigations suggest that some ten thousand mosques have been demolished.[24] A local official confirmed in 2017 that of a total of eight hundred mosques in the Qumul region,

two hundred had already been demolished with a further five hundred planned. Those that remained had their distinctive architectural features, such as domes and minarets, removed as part of the campaign to "Sinicize" Islam.[25] A 2019 investigation by Bahram Sintash provided case-by-case evidence of the demolition or modification of a hundred Uyghur mosques.[26] A 2020 investigation by the *Guardian* newspaper used satellite imagery to check the sites of a hundred mosques and shrines, and found that forty mosques and two major shrines had suffered significant structural damage. Around half appeared to have been fully demolished, while others had gatehouses, domes, and minarets removed.[27] The same year, the Australian Strategic Policy Institute conducted a larger-scale survey of religious sites, again drawing on satellite imagery to assess the types and scale of destruction. Their report estimates that around sixteen thousand of the region's mosques (65 percent of the total) had been destroyed or damaged since 2017, with an estimated 8,500 demolished outright (fig. 7.4).[28]

One of these demolitions caused a minor international controversy. The Idgah Mosque in the Xinjiang town of Keriya is believed to date back to the thirteenth century. Expanded in 1665, it was reconstructed with community donations in 1947 and again in 1997, when an enormous gatehouse was constructed in front of the older prayer hall. It became the largest mosque in the Uyghur region, measuring over thirteen thousand square meters, and was designated a national-level protected historical site. Up to twelve thousand men would pray inside or in front of the mosque on festival days and perform the whirling *sama* dance to the sounds of drums and shawms played from the top of the gatehouse.

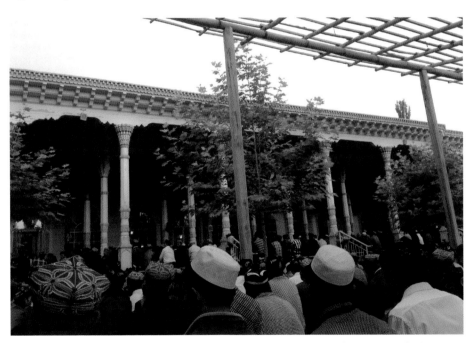

Figure 7.4 Friday prayer at a local mosque in southern Xinjiang in 2012. Image: Photo courtesy of Aziz Isa

The mosque's imam, Imin Damollam, was trained at the Xinjiang Islamic Institute and officially appointed to the role in 1992. This long-serving cleric was detained early in the crackdown and received a life sentence in 2017. The mosque's huge gatehouse was demolished in March the following year, causing a Twitter storm when the independent researcher Shawn Zhang drew attention to its disappearance. Official sources and numerous individuals attacked Zhang on social media, forcing him to retract his original claim that the whole mosque had been demolished and acknowledge that the small and older prayer hall had been left intact, thus enabling the authorities to claim that they had respected heritage law.[29] The imam's sentence was attributed to religious extremism (under China's broad definition), and the disappearance of this towering monument from the landscape was justified by building safety regulations.

Interviews with Uyghur exiles conducted by Bahram Sintash reveal something of the human impact of the demolitions. Abide Abbas, a young woman now residing in Turkey, responded in 2019 to the destruction of her local mosque: "Seeing an image like this is like the feeling one gets when losing a mother, so tragic, painful and traumatizing. . . . I wept looking at the 'Mosque-less' image with a history spanning more than a hundred years. . . . I did not realize the value of this mosque until it was taken away from me."[30]

Reengineering Uyghurs

By 2017, the so-called antireligious extremism campaign had spread beyond the religious sphere. No longer simply branding everyday religious activity as terrorism, its scope had expanded to target all signs of Uyghur nationalist sentiment, foreign connections, or simply insufficient loyalty to the state. Official statements suggested that the whole Uyghur nation was now regarded as a problem in need of an aggressive solution. One government official said in a public speech in late 2017: "You can't uproot all the weeds hidden among the crops in the field one by one—you need to spray chemicals to kill them all; re-educating these people is like spraying chemicals on the crops . . . that is why it is a general re-education, not limited to a few people."[31]

Over the course of 2017, news began to leak out of Xinjiang of the construction of a huge, secretive network of internment camps, dubbed "transformation through education centers" in official Chinese sources. By mid-2018 international organizations were raising concerns that 1.5 million Muslims—primarily Uyghurs but also Kazakhs and other groups, constituting over 10 percent of the adult Muslim population of the region—had been interned for indefinite periods without formal legal charges. Reports by former detainees, teachers, and guards, corroborated by investigation of government construction bids and satellite imagery, described a network of over a hundred detention facilities, heavily secured with barbed wire and surveillance systems and guarded by armed police; some of these facilities were large enough to hold up to a hundred thousand inmates.[32]

Among those taken into the internment camps have been hundreds of prominent Uyghur intellectuals, writers, and artists, whose crimes, although not formally stated,

seemed to be that their work had in some way promoted Uyghur language, culture, or history. Increasingly the term "religious extremism" appears to serve as a gloss for Uyghur culture and identity, now regarded as a "virus" in need of eradication. As part of these new initiatives, Uyghurs across Xinjiang were expected to attend regular Chinese language lessons, and officials made speeches suggesting that speaking Uyghur in public was a sign of disloyalty to the state. This has all suggested that it was now no longer sufficient to reject Islam: a wholesale adoption of Chinese cultural identity was required of Uyghurs. As commentators began to suggest, this was a project to "reengineer" Uyghur society.[33] The children of detainees were taken to orphanages, where they were educated to regard the religion and identity of their parents as backward and dangerous. Men were detained in larger numbers than women, and the Xinjiang authorities began to promote ethnic intermarriage, offering cash incentives to Han men willing to marry Uyghur women. By 2019, the reengineering project had extended to the innermost bodily aspects of Uyghur identity, targeting halal eating practices and enforcing sterilization of large numbers of Uyghur women.[34] Such radical efforts to break down core aspects of faith and identity across the broad population have only been possible because of the regime of terror enforced by the system of detention camps.

Territorial Moves

An official with the Religious Affairs Department, Maisumujiang Maimuer, speaking on state media in late 2018, acknowledged that China intended to "break their lineage, break their roots, break their connections and break their origins."[35] And as Rian Thum remarked the following year, "Nothing could say more clearly to the Uighurs that the Chinese state wants to uproot their culture and break their connection to the land than the desecration of their ancestors' graves, the sacred shrines that are the landmarks of Uighur history."[36]

According to a detailed survey carried out by the Australian Strategic Policy Institute, 30 percent of the region's sacred sites (shrines, cemeteries, and pilgrimage routes, including many protected under Chinese law) have been demolished since 2017, and an additional 28 percent damaged or altered in some way.[37] The tomb of Imam Jafari Sadiq and surrounding buildings were destroyed in March 2018. The mosque and *khanqah* (a building for Sufi gatherings) at the Imam Asim shrine also disappeared in the same month, leaving the tomb as the only structure at the site. The local authorities also transported bulldozers over fourteen kilometers of sand dunes to obliterate the Ordam shrine.[38] Not only the built heritage was targeted: Rahile Dawut was detained in November 2017 not long before the demolitions, and she remains in an internment camp at the time of writing.[39]

In addition to the demolition of the shrines, numerous Uyghur cemeteries were destroyed or relocated during this period (fig. 7.5). Drawing on testimony from Uyghur exiles, satellite images, and government notices, CNN revealed in January 2020 that

Figure 7.5 A local graveyard in southern Xinjiang in 2012. Image: Rachel Harris

more than a hundred cemeteries had been destroyed since 2018.[40] Typically the destruction or relocation of cemeteries was justified by the demands of urban development, but the extremely rapid program of removing human remains and bulldozing structures left local people (even if they were not incarcerated in the camps) scant time to reclaim the bones of their family members. Moreover, numerous important historical shrines were destroyed along with the rest of the cemeteries.

Khotan's Sultanim Cemetery, for example, is believed to have a history of over a thousand years, stretching back to the period when Satuq Bughra Khan introduced Islam into the region. Four of his commanders are said to have died during the conquest of Khotan and were buried at this location. The four tombs of the sultans still stood at the center of the cemetery at the beginning of the twenty-first century, and they remained an important pilgrimage site. Many religious leaders, scholars, and other significant figures in Khotan's history were also buried in the cemetery.

In March 2019, disinterment notices appeared around the city of Khotan, warning that the cemetery would be demolished within three days. "We worry that my grandfather's grave will end up as an unclaimed grave and that the government will treat his remains as trash," said one Uyghur exile. According to CNN's analysis of satellite images, the site had been completely flattened by April 2019, and part of the cemetery appeared to be in use as a parking lot.

Conclusion

In framing its campaigns in Xinjiang as a struggle against religious extremism and terrorism, the Chinese government has attempted to obfuscate and obscure what is better understood as an ongoing struggle over the landscape, in which state projects of development—which do not equally benefit the Uyghurs—attempt to remodel the cultural landscape and to reengineer the desires and actions of its subjects—that is, to shape the ways in which they inhabit that landscape. As one young Uyghur exile, Marguba Yusup, aptly commented in 2019: "In a totalitarian regime . . . architectural decisions are never random. Architecture [becomes] a tool of propaganda, a pure product of the regime. It is for this reason that the Chinese government does not want to leave any trace of Uyghur cultural heritage. They are destroying not only Uyghur architecture, but also the Uyghur language [and] religious belief."[41]

In spite of its own numerous laws addressing the protection of religious and cultural heritage, rights to religious worship and belief, and rights to ethnic autonomy, China has implemented unprecedented processes of cultural erasure in Xinjiang since 2017, seemingly without redress or consequence. International responses to its actions have been mixed and piecemeal. While several governments have condemned its actions as genocide, China has strongly refuted all criticism, conducted a campaign of harassment of Uyghur exiles and activists, and orchestrated statements of support from its allies, including many Muslim majority countries that are recipients of BRI development loans. Observers have long noted UNESCO's apparent incapacity to counter or even protest abuses of the heritage system by state partners, and a direct response to this case is all the more difficult given China's prominence in the international heritage regime.

Ultimately, perhaps, hope for the survival of the unique culture surrounding this religious heritage lies in the very transient nature of its architecture. These humble mud-brick structures have survived wars, changing governments, and the shifting desert sands for nearly a millennium through constant renovation and rebuilding, just as the histories of their saints have been retold and passed down to the present day. In this long history of resilience lies hope that the current campaigns will not result in their final erasure from the collective memory of the people they have served for so long.

SUGGESTED READINGS

Rachel Harris, *Soundscapes of Uyghur Islam* (Bloomington: Indiana University Press, 2020).

Christina Maags and Marina Svensson, eds., *Chinese Heritage in the Making: Experiences, Negotiations and Contestations* (Amsterdam: Amsterdam University Press, 2018).

Sean R. Roberts, *The War on the Uyghurs: China's Campaign against Xinjiang's Muslims* (Manchester, UK: Manchester University Press, 2020).

Nathan Ruser, James Leibold, Kelsey Munro, and Tilla Hoja, *Cultural Erasure: Tracing the Destruction of Uyghur and Islamic Spaces in Xinjiang* (Canberra: Australian Strategic Policy Institute, September 2020), https://www.aspi.org.au/report/cultural-erasure.

Rian Thum, *The Sacred Routes of Uyghur History* (Cambridge, MA: Harvard University Press, 2014).

NOTES

Epigraphs: From the travelogue of the eighteenth-century poet Zalili, translated in Alexandre Papas, "A Sufi Travelogue as a Source for the History of Mazars in the Tarim Basin," in *Mazar: Studies on Islamic Sacred Sites in Central Eurasia*, ed. Jun Sugawara and Rahile Dawut (Tokyo: Tokyo University of Foreign Studies Press, 2016), 253–74; Su Manzi, "An Interview with Rahilä Dawut," in Lisa Ross, *Living Shrines of Uyghur China* (New York: Monacelli Press, 2013), 121–23.

1. Human Rights Watch, *China's Algorithms of Repression: Reverse Engineering a Xinjiang Police Mass Surveillance App* (New York: Human Rights Watch, May 2019), https://www.hrw.org/report/2019/05/01/chinas-algorithms-repression/reverse-engineering-xinjiang-police-mass.

2. Human Rights Watch, *"Break Their Lineage, Break Their Roots"* (New York: Human Rights Watch, April 2021), https://www.hrw.org/report/2021/04/19/break-their-lineage-break-their-roots/chinas-crimes-against-humanity-targeting.

3. Sean R. Roberts, *The War on the Uyghurs: China's Campaign against Xinjiang's Muslims* (Manchester, UK: Manchester University Press, 2020).

4. Marina Svensson and Christina Maags, "Mapping the Chinese Heritage Regime: Ruptures, Governmentality, and Agency," in *Chinese Heritage in the Making: Experiences, Negotiations and Contestations*, ed. Christina Maags and Marina Svensson (Amsterdam: Amsterdam University Press, 2018), 11–38.

5. "Governmentality" is the ensemble of institutions, procedures, and ideology that enable the exercise of state power; the relationship between people, political economy, and security apparatus. See Michel Foucault, "Governmentality," in *The Foucault Effect: Studies in Governmentality*, ed. Graham Burchell, Colin Gordon, and Peter Miller (Chicago: University of Chicago Press, 1991), 87–104.

6. Nicole Morgret, *Extracting Cultural Resources: The Exploitation and Criminalization of Uyghur Cultural Heritage* (Washington, DC: Uyghur Human Rights Project, 2018), https://docs.uhrp.org/pdf/CulturalResourcesIntangibleHeritage.pdf.

7. Svensson and Maags, "Mapping the Chinese Heritage Regime."

8. Rachel Harris, "A Weekly Meshrep to Tackle Religious Extremism: Music-Making in Uyghur Communities and Intangible Cultural Heritage in China," *Ethnomusicology* 64, no.1 (2020): 23–55.

9. Wubuli Maimaitiali [Ubul Memeteli], *Sichouzhilu Xinjiang duan jianzhu yanjiu* (Beijing: Kexue chubanshe, 2015), 122–31.

10. Yue Xie, "Reconstructing a Reference Point: The Eidgah Mosque in Kashgar," master's thesis, SOAS, University of London, 2017.

11. Ildikó Bellér-Hann, *Community Matters in Xinjiang, 1880–1949: Towards a Historical Anthropology of the Uyghur* (Leiden, the Netherlands: Brill, 2008), 316–18.

12. Alexandre Papas, "Pilgrimages to Muslim Shrines in West China," in Lisa Ross, *Living Shrines of Uyghur China* (New York: Monacelli Press, 2013), 11–17.

13. Reyila Dawuti [Rahile Dawut], *Weiwuerzu mazha wenhua yanjiu* (Ürümqi: Xinjiang University Press, 2001); and Rian Thum, *The Sacred Routes of Uyghur History* (Cambridge, MA: Harvard University Press, 2014).

14. Rahile Dawut and Aynur Qadir, "Music of the Ordam Shrine Festival," Sounding Islam in China, 26 July 2016, http://www.soundislamchina.org/?p=1521.

15. Rachel Harris and Rahile Dawut, "Mazar Festivals of the Uyghurs: Music, Islam and the Chinese State," *British Journal of Ethnomusicology* 11, no. 1 (2002): 101–18.

16. Rahile Dawut and Elise Anderson, "*Dastan* Performance among the Uyghurs," *The Music of Central Asia*, ed. Theodore Levin, Saida Daukeyeva, and Elmira Köchümkulova (Bloomington: Indiana University Press, 2015), https://www.musicofcentralasia.org/Tracks/Chapter/24.

17. Liu Xiangchen, dir., *Ashiq: The Last Troubadour*, 2010, Ürümqi, Xinjiang Normal University, 128 minutes.

18. Thum, *Sacred Routes of Uyghur History*.

19. Jean-Paul Loubes, *La Chine et la ville au XXIe siècle: La sinisation urbaine au Xinjiang Ouïghour et en Mongolie intérieure* (Paris: Éditions du Sextant, 2015).

20. Rahile Dawut, "Shrine Pilgrimage and Sustainable Tourism among the Uyghurs," in *Situating the Uyghurs between China and Central Asia*, ed. Ildikó Bellér-Hann et al. (Farnham, UK: Ashgate, 2008), 149–63.

21. Thum, *Sacred Routes of Uyghur History*.

22. Rachel Harris, *Soundscapes of Uyghur Islam* (Bloomington: Indiana University Press, 2020).

23. Roberts, *War on the Uyghurs*.

24. Radio Free Asia, "Under the Guise of Public Safety, China Demolishes Thousands of Mosques," 19 December 2016, https://www.rfa.org/english/news/uyghur/udner-the-guise-of-public-safety-12192016140127.html.

25. "Disappearing Mosques of Xinjiang," *Bitter Winter*, 16 July 2018, https://bitterwinter.org/disappearing-mosques-of-xinjiang/.

26. Bahram K. Sintash, *Demolishing Faith: The Destruction and Desecration of Uyghur Mosques and Shrines* (Washington, DC: Uyghur Human Rights Project, October 2019).

27. Lily Kuo, "Revealed: New Evidence of China's Mission to Raze the Mosques of Xinjiang," *Guardian*, 7 May 2019, https://www.theguardian.com/world/2019/may/07/revealed-new-evidence-of-chinas-mission-to-raze-the-mosques-of-xinjiang.

28. Nathan Ruser, James Leibold, Kelsey Munro, and Tilla Hoja, *Cultural Erasure: Tracing the Destruction of Uyghur and Islamic Spaces in Xinjiang* (Canberra: Australian Strategic Policy Institute, September 2020), https://www.aspi.org.au/report/cultural-erasure.

29. Shawn Zhang, "Clarification of Keriya Etika Mosque's Current Situation," Medium, 22 April 2019, https://medium.com/@shawnwzhang/clarification-of-keriya-etika-mosques-current-situations-9678a6975a51.

30. Sintash, *Demolishing Faith*, 16.

31. Radio Free Asia, "Chinese Authorities Jail Four Wealthiest Uyghurs in Xinjiang's Kashgar in New Purge," 5 January 2018, https://www.rfa.org/english/news/uyghur/wealthiest-01052018144327.html.

32. Adrian Zenz, "'Thoroughly Reforming Them toward a Healthy Heart Attitude': China's Political Re-education Campaign in Xinjiang," *Central Asian Survey* 38, no. 1 (2019): 102–28.

33. Darren Byler, "Imagining Re-Engineered Muslims in Northwest China," Art of Life in Chinese Central Asia, 26 April 2017, https://livingotherwise.com/2017/04/26/imagining-re-engineered-muslims-northwest-china/.

34. Radio Free Asia, "Kazakh and Uyghur Detainees of Xinjiang 'Re-education Camps' Must 'Eat Pork or Face Punishment,'" 23 May 2019, https://www.rfa.org/english/news/uyghur/pork-05232019154338.html; and Adrian Zenz, *Sterilizations, IUDs, and Mandatory Birth Control: The CCP's Campaign to Suppress Uyghur Birthrates in Xinjiang* (Washington, DC: Jamestown Foundation, June 2020, updated March 2021), https://jamestown.org/product/sterilizations-iuds-and-mandatory-birth-control-the-ccps-campaign-to-suppress-uyghur-birthrates-in-xinjiang/.

35. Statement originally posted on a Xinhua News site and later removed. Cited in Austin Ramzy, "China Targets Prominent Uighur Intellectuals to Erase an Ethnic Identity," *New York Times*, 5 January 2019, https://www.nytimes.com/2019/01/05/world/asia/china-xinjiang-uighur-intellectuals.html.
36. Rian Thum, quoted in Kuo, "Revealed."
37. Ruser et al., *Cultural Erasure.*
38. Rian Thum, "The Spatial Cleansing of Xinjiang: *Mazar* Desecration in Context," *Made in China Journal*, 24 August 2020, https://madeinchinajournal.com/2020/08/24/the-spatial-cleansing-of-xinjiang-mazar-desecration-in-context/.
39. Chris Buckley and Austin Ramzy, "Star Scholar Disappears as Crackdown Engulfs Western China," *New York Times*, 10 August 2018, https://www.nytimes.com/2018/08/10/world/asia/china-xinjiang-rahile-dawut.html.
40. Matt Rivers, "More Than 100 Uyghur Graveyards Demolished by Chinese Authorities, Satellite Images Show," CNN, 3 January 2020, https://edition.cnn.com/2020/01/02/asia/xinjiang-uyghur-graveyards-china-intl-hnk/index.html.
41. Sintash, *Demolishing Faith*, 16.

8

When Peace Is Defeat, Reconstruction Is Damage: "Rebuilding" Heritage in Post-conflict Sri Lanka and Afghanistan

Kavita Singh

In the 2000s, two countries near my home in India emerged from a long and brutal period of internal conflict. With the ouster of the Taliban in 2001 and the defeat of the Tamil Tigers in 2009, Afghanistan and Sri Lanka seemed ready to leave their turbulent pasts behind and enter an era of greater peace. But the quiet that descended on these lands came with victory for one side and defeat for another. What does "peace" look like in these circumstances, when a community of winners and a community of losers must live in a nation side by side? As countries riven by civil war or internecine conflicts head into what looks like their "post-conflict" periods, what appears to be peace to one group may look very much like subjugation to the other. In these contexts, even acts of rebuilding and repair can become instruments for the humiliation of the losing side.

This chapter examines the disturbing shape taken by cultural reconstruction in the post-conflict period in regions with predominant religious or ethnic minorities: the northern Jaffna Peninsula in Sri Lanka, home to most of the country's Hindu Tamils; and the Bamiyan Valley in Afghanistan, inhabited by the Hazaras, a Shia minority. In both these cases, we will see how the very processes of reconstruction and heritage conservation, meant to repair a society, can become instruments through which one side continues its domination over the other. In Sri Lanka a majoritarian government has used all the tools at its disposal to effect a "recovery" of heritage that underlines the disempowerment of the Tamil minority; and in Afghanistan the international organizations that have come to assist in the aftermath of the Taliban era have

unwittingly contributed to a subtler power play between the central government and an ethnic minority that has long been at the margins of Afghan life.

Vanquished Tamils and Militant Monks: Inside Sri Lanka's Troubled Peace

In 2009 Sri Lanka's bitter civil war came to a brutal end. As a violent conflict that had cost the lives of more than a hundred and fifty thousand Sri Lankans, displaced an estimated three hundred thousand, and laid waste to the Northern and Eastern Provinces, the civil war had raged for over twenty-six years. The roots of the conflict lay in the majoritarian policies adopted by the Sri Lankan government immediately after independence from British colonial rule in 1948. Dominated by the Buddhist Sinhalas, who constituted approximately 70 percent of the population, the Sri Lankan parliament enacted laws that discriminated against minorities, the largest number of which were Tamils, a Hindu community descended from workers brought from South India to labor on colonial plantations. The Tamils who constituted approximately 11 percent of the Sri Lankan population found themselves disenfranchised. Minor conflicts between Sinhalas and the Tamils often turned into pogroms against the latter, overtly or covertly supported by the state. By the 1970s a militant Tamil resistance took shape, and within a decade there were organized Tamil militias demanding a sovereign Tamil state. Most prominent among these was the Liberation Tigers of Tamil Eelam (LTTE), which developed territorial, airborne, and naval units and made formidable use of suicide attacks.[1] The years that followed saw a full-blown civil war of incredible brutality on both sides. Tamil insurgents managed to control large parts of the Northern and Eastern Provinces for years at a time and successfully targeted prominent Sinhala figures, including former heads of state. The Sri Lankan forces responded with great ferocity. In a war that lasted two and a half decades, both sides were accused of all manner of war crimes. Several rounds of peace talks failed, and the war eventually came to an end when the Tamil forces were comprehensively defeated by the Sri Lankan army.

For the Tamils of Sri Lanka, the end of the war has brought a bitter peace that has only sharpened the discrimination that had sparked the unrest in the first place. Everywhere in the Tamil-majority Northern and Eastern Provinces, the military is an inescapable presence; in some areas, there is one soldier for every three civilians. The military has expropriated approximately one-third of the land in these regions; military camps do not just occupy farmlands and homes that once belonged to Tamils but have been deliberately built over graveyards and memorial sites for the fallen soldiers and leaders of the Tamil side, denying Tamils the right to remember and mourn their dead. The redevelopment work is touted by the Sri Lankan government as one of the great features of the "New Dawn," an era of reconstruction and repair promised by the government after the end of the civil war. The government's projects, however, are seen to selectively benefit the Sinhalas, who are being brought to these provinces to alter the demography while Tamils continue to live in resettlement camps. The state's undeclared policy of Sinhalization also effaces the Tamil presence and rewrites the Tamil past.

While the remembrance of the recent past is managed through the careful control of monuments, memorials, and commemorative practices relating to the civil war, the rewriting of the ancient past is accomplished by an ideologically motivated official archaeological establishment that works in close association with ultranationalist Sinhala Buddhist groups.

The Northern Province, the last stronghold of the LTTE, was for a long time cut off from the rest of the nation. As highways reopened and mobility was reestablished, the North became a popular tourist destination for Sinhala visitors from the South. Today this tourist itinerary includes Buddhist pilgrimage sites as well as a "dark tourism" circuit that includes ruins and battlegrounds where critical events of the civil war unfolded. In Kilinochchi, the de facto capital of the Tamil Eelam or Nation, visitors came to see the ruined home of the former LTTE leader Prabhakaran and the four-story underground bunker that served as his headquarters. On finding that the bunker's elaborate construction elicited admiration from some visitors, it was blown up by the army in 2013. Now the major tourist site there is the War Hero Cenotaph, a public sculpture sponsored by the army that takes the shape of a concrete wall shattered by a giant concrete-piercing bullet—munitions that were critical to the army's success in penetrating LTTE defenses—and surmounted by a lotus flower that suggests peace and regeneration in the aftermath of war (fig. 8.1).

The North of Sri Lanka is dotted with such monuments that advertise the new era in which the army's control of the region is complete. Using an easy-to-read visual symbolism, these military-sponsored memorials are set in manicured complexes and are heavily guarded by soldiers. Dedicatory plaques at the memorial sites recall the "glorious" contribution of the military forces. Their inscriptions are written in Sinhala and English but not in Tamil, making clear their intended audiences.

State-sponsored war memorials are not the only structures that have new prominence in the northern landscape. "Travelling through the Tamil areas in North Sri Lanka, one is shocked to see the changing demography of the land," journalist Amir Ali notes. "A land that was once inhabited by Tamils and a land that had a distinct flavor of Tamil culture and heritage is now in the grip of Sinhalese hegemony, seen in the form of Buddhist statues, viharas (Buddhist monasteries) and stupas (Buddhist funerary monuments) dotting the landscape that is also lined by broken Tamil homes and newly built shanties of Tamil refugees."[2] These Buddhist statues and buildings are clearly meant to alter the landscape and mark it with a Sinhala presence. They are often sponsored by Buddhist ultranationalist groups, who do their work under the protection of the army or the police.

What is even more concerning, and of greater interest, however, is the way the Tamil landscape is being Sinhalized not only through new accretions but also through a reinterpretation of old and ancient structures. Ancient Tamil sites are "discovered" to have been built over preexisting Buddhist structures, and all Buddhist structures are assumed to be Sinhalese. The presumed "priority" of Sinhala presence then justifies the

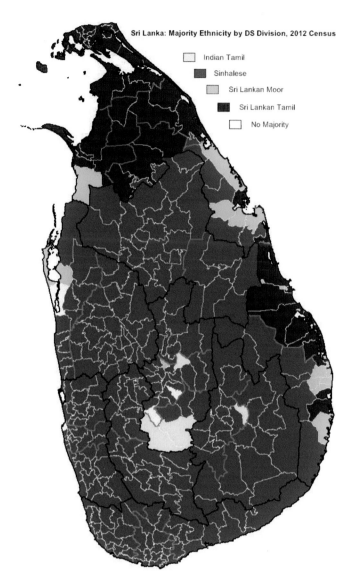

Sri Lanka: Majority Ethnicity by DS Division, 2012 Census

- Indian Tamil
- Sinhalese
- Sri Lankan Moor
- Sri Lankan Tamil
- No Majority

Figure 8.1 Ethnic map of Sri Lanka Image: Obi2canibe / CC0 1.0 Universal Public Domain Dedication. View map at www.getty.edu/ publications/cultural-heritage -mass-atrocities/part-2/08 -singh/#fig-8-2-map.

removal of Tamil traces. The government's Department of Archaeology seems to be fully complicit in this project of overwriting the Tamil past.

To produce a purely Sinhala primordial past, archaeologists have to contend with a history that is complex and interwoven. While Sinhalas would like to project themselves as the oldest inhabitants of Sri Lanka, seeing Tamils as recent migrants who came during the colonial period, in fact Tamils were present on the island in ancient times. The Chola dynasty from nearby Tamil Nadu in India extended its empire to Sri Lankan island territories in the tenth century. Its legacy includes a number of temples and sculptures in classical Chola style that remain in Sri Lanka.

Even before the civil war, the archaeological wealth left by this contact was downplayed. Ancient monuments built by Tamil rulers were left out of a prominent UNESCO-sponsored heritage site development program, and excavations were simply

not undertaken in areas that could have yielded rich finds related to the ancient Tamil presence.[3]

Since the war, the long neglect of Tamil and other non-Sinhala sites is being replaced with a new kind of intense attention. As mentioned, historical sites associated with Tamils are being analyzed afresh and are "discovered" to have had a Buddhist substratum that predates Tamil settlements. The evidence of Buddhist settlements is seen as delegitimizing the Tamil presence, despite the fact that in ancient times many Tamils too were adherents of Buddhism, and that ancient monuments and sculptures can be simultaneously Tamil and Buddhist. These archaeological "finds" add to the Sinhala sense of grievance against Tamils by perpetuating the idea that everywhere and at all times, Tamils violently displaced Sinhalas, destroyed their property, and robbed them of their land. These "discoveries" are then instrumentalized in the present and often result in the dismantling of "later" buildings and the eviction of "illegitimate" users occupying the site. Of particular concern is the willingness of the official archaeological infrastructure to be used as a tool in this political project. Two of the many sites where these procedures are visible are examined here.

In the late twentieth century, archaeologists discovered a richly layered site at Kandarodai in the North of Sri Lanka. Some of the oldest remains were megalithic burials, possibly dating to the second millennium BCE. The burials closely resembled those found in South India, pointing to a shared culture across Tamil Nadu in India and northern Sri Lanka in the pre-Buddhist period. Later burials at the site were believed to be of the Buddhist period, but their construction was similar to that of the ancient megaliths, pointing to continuities in the local culture over a long period. A plaque depicting the goddess Lakshmi and many of the coins, pottery, and other objects found at deep levels of the site were inscribed in Tamil. Buddhist artifacts were found in shallower layers above the Tamil finds. The evidence, unearthed in a 1967 excavation carried out by the University of Pennsylvania, suggested that this was an ancient Tamil and perhaps a Tamil-Buddhist site. But all of the Tamil-related evidence remained unpublished and ignored, while the Buddhist materials were widely publicized. At some point the Sri Lankan government's Department of Archaeology built dagobas, Buddhist funerary monuments, upon the ancient circular stone foundations as a fanciful "reconstruction," giving the site a markedly Buddhist appearance. Today, Kandarodai— whose name has been Sinhalized to Kadurugoda—has been placed under the care of a Sinhala monk and to the many southern Sri Lankan pilgrim-tourists who visit it the complex is projected as proof that Sinhala Buddhists formerly occupied the entire island before being displaced by Tamil intruders.[4] A new signboard in Sinhala claims that excavations uncovered Buddha statues, painted tiles, and coins from the classical Sinhala kingdoms that date to at least eight hundred years after the earliest layers at the site. "This temple," the signboard says, assuming that there was such a structure there, "was destroyed by the Dravida (South Indian) king Sangili who ruled in the 16th century."[5] Subliminally, the history of a sixteenth-century conquest of the North by a

Figure 8.2 Kandarodai site. Image: Southeast Asia / Alamy Stock Photo

Tamil monarch is conflated with the insurgency of the LTTE, whose territory this once was, making the Tamils perpetually disruptive outsiders and making the current Sri Lankan government and Buddhist monastic orders the joint agents in whose pastoral care the land's original identity is finally being safeguarded (fig. 8.2).

The process by which Kandarodai was transformed into a Sinhala-Buddhist site unfolded over decades. It was accomplished first through acts of omission (concealing inconvenient archaeological data) and then by acts of commission (building Buddhist-looking monuments in the name of restoration, placing the site under the care of a Buddhist monk) that have gathered pace over the years.

To see processes by which archaeology abets a Sinhala takeover of Tamil cultural spaces unfolding before us we can turn to Omanthai, a small village that once marked the southern edge of LTTE-held territories. Soon after the area was captured by the Sri Lankan army, a soldier planted a small Buddha statue on the premises of a Hindu temple in the village. Locals who agitated for the removal of the statue were threatened by the army, which put up signs stating that the Hindu temple had been built over an ancient Buddhist site. As the protests by local Tamils grew, the state intervened by sending archaeologists to investigate the site. The statue that caused the friction was itself a small mass-produced artifact of no historical importance, but the archaeologists reported that they had found other artifacts relating to the "Anuradhapura-Polonnaruwa period," the fifth-to-tenth-century period that is the classical age of Sri Lankan Buddhist history. They also found stones with Sinhala inscriptions. "We do not know how these artifacts came to this site," one of the archaeologists said, but indicated they would need further study.[6] The archaeologists were given police protection for the

duration of this visit, in which they found "proof" of prior Buddhist occupation. The presence of these artifacts, which mysteriously appeared thousands of kilometers away from the main centers of Anuradhapura and Polonnaruwa, may well point to the ways in which archaeology—through its experts and artifacts—has been routinely pressed into service in Sri Lanka to produce the narratives of heritage that are most convenient for the ruling majority.

The cases studied by researchers thus far point to the worrying role of archaeology in Sri Lanka, which seems to be a willing tool in the hands of an ethnonationalist state. As Jude Fernando points out, "The fundamental issue is not with the country's Sinhala Buddhist archaeological heritage . . . but rather with the function of Sinhala Buddhist heritage as [providing] the dominant national identity of the state that renders those who do not belong to that heritage as second-class citizens."[7] One might go further: given the way in which archaeology is summoned to provide proof of Sinhala claims to primordial status, which then allows Sinhalas to wrest sites away from the Tamil side, archaeology becomes akin to a military instrument of territorial expansion.

The nexus between archaeology, the ethnonationalist state, and the military was made even more blindingly obvious in 2020, when President Gotabaya Rajapaksa created a special archaeological task force for the survey and preservation of sites in Sri Lanka's Eastern and Northern Provinces and incorporated it into the Ministry of Defence, to be headed by a military general. In Sri Lanka, it seems the overlap between the forces of knowledge production and the force of arms is now complete.

Buddhas and Lovers in Bamiyan: Layers of Meanings versus the "Authentic Original"

Whereas in Sri Lanka we see a Buddhist ethnonationalism using the state apparatuses of archaeology and restoration to rewrite the island nation's history to suit majoritarian beliefs, in Afghanistan we see a Buddhist heritage that, instead of being foregrounded, seems to be suffering multiple erasures through both deliberate and unwitting deeds by many actors—the Taliban and the successor republican government as well as international agencies offering relief and aiding reconstruction.[8]

Afghanistan too has suffered greatly in the past half century. Its economy, society, and polity have been shattered by seemingly endless strife. The era of Taliban rule, from 1996 to 2001, was a particularly low point in its difficult history. This was a brutal government that committed countless atrocities against its own people while supporting the international terrorist organization al-Qaeda, which committed acts of terrorism abroad. The Taliban outlawed most kinds of music, art, and education for Afghans; even chess and soccer were forbidden, and women were no longer allowed to study or to work. All of this was well-known to the international community. But the acts that excited the greatest attention to and condemnation of the Taliban from the outside world were acts directed not against the Afghan people directly, but against works of art.

Prior to the arrival of Islam, Buddhism had been the dominant faith in Afghanistan, and many sites and museum collections were rich with artifacts in the Gandharan style that flourished from the first to the seventh century and that fused Buddhist iconography with a Hellenistic and Roman style. In 2001, the Taliban leader Mullah Omar issued a fatwa that called for the destruction of all pre-Islamic statues and sanctuaries in the land. "These statues have been and remain shrines of unbelievers," he said. "God Almighty is the only real shrine and all fake idols should be destroyed."[9] Within weeks, Taliban forces destroyed thousands of artworks, many of which were in the Kabul Museum. Their most prominent targets, however, were the giant Buddhas of the Bamiyan Valley.

A hundred and fifty miles west of Kabul, the Bamiyan Valley is a broad, fertile basin watered by the Bamiyan River and bordered by rocky cliffs of the Hindu Kush mountains. Here, carved directly into the cliff face, was a 175-foot-tall relief sculpture that was the largest Buddha sculpture in the world. A second sculpture, at 120 feet, was small only in comparison to its colossal neighbor. Other Buddhas, seated and recumbent, were once ranged along the mountainside, and their bodies were covered in brilliant frescoes. Hundreds of artificial caves were dug into the rock to provide cells for meditation and prayer for Buddhist monks. In its heyday the valley housed an enormous monastery and a giant stupa that would have been as eye-catching as the Buddhas.

This extraordinary cluster of Buddhist monuments was mostly built in the sixth and seventh centuries, when Bamiyan was an important node in the ancient Silk Road. As a rare oasis in harsh mountainous terrain it attracted merchants and missionaries and became a prosperous center for religion and trade. From the eighth century Islam began to supplant Buddhism in the region. Buddhist sites fell out of worship, the stupa crumbled, and the vast monastery disappeared, but apart from an attack by a passing conqueror in the twelfth century, when the Buddhas probably lost their faces, the giant sculptures remained relatively intact.

In 2001, as the Taliban tried to destroy the Buddhas, they found it was not an easy task. They first attacked the statues with guns, antiaircraft missiles, and tanks. When these did not suffice, the Taliban brought in explosives experts from Saudi Arabia and Pakistan. On their advice, workers rappelled down the cliff with jackhammers, blasting holes in the sculptures and packing these with dynamite that was detonated in timed explosions. A journalist from the al-Jazeera media network was allowed to film the final stage of the Buddhas' destruction, and shortly afterward a contingent of twenty international journalists was brought in to observe the now-empty niches.

The Taliban's determined assault on the Buddhas went forward even as global leaders pleaded with Mullah Omar to spare them. Governments of Islamic countries including Egypt and Qatar tried to reason with the Afghan leaders, and a delegation of clerics led by the mufti of the al-Azhar seminary in Cairo, the most prestigious Sunni

center for the study of Islamic law, was flown to the Taliban's de facto capital of Kandahar to dissuade Mullah Omar from destroying the statues.

Why, then, did the destruction of the Bamiyan Buddhas become a prestige project for the Afghan leader, a task to be "implemented at all costs"?[10] Why, despite the pressure applied by global leaders, did the Taliban invest so much time, labor, and expense in the difficult task of demolition and in ensuring that it was broadcast to the rest of the world? And why was Mullah Omar so determined to destroy the Buddhas two years after he had solemnly promised to protect them? In 1999 he had declared that as there were no Buddhists remaining in Afghanistan, the Buddhas were not idols under worship, and there was no religious reason to attack them. Instead, he said his government considered them "a potential major source of income for Afghanistan from international visitors. The Taliban states that Bamiyan shall not be destroyed but protected."[11] What accounts for the Taliban's volte-face, in which a religious motivation, earlier dismissed as irrelevant, was used to now justify the attack?

In his essay on the destruction of the Bamiyan Buddhas, Finbarr Barry Flood suggests that the context of the act lies not in medieval religious beliefs but in contemporary world politics.[12] The Taliban was recognized as constituting the country's legitimate government by only three states, and Afghanistan was under economic sanctions. Trying to build links with the international community, it had voluntarily destroyed the country's opium crop. However, its continuing refusal to surrender Osama bin Laden, who was sheltering in Afghanistan at the time, led to a breakdown in negotiations, and the United Nations imposed fresh sanctions on the country. At this point the Taliban gave up attempts to engage with the international community. Instead it chose a dramatic act to demonstrate its own rejection of the community that had rejected it.

The destruction of the Buddhas even gave the Taliban an opportunity to mock the international community for so greatly valorizing these sculptures. As audiences across the globe expressed horror at their destruction, the Taliban claimed they were horrified at a world that would offer to spend millions of dollars on salvaging artworks while intensifying sanctions that denied essential supplies and threatened Afghan lives. As Flood says, what was under attack here "was not the literal worship of religious idols but their veneration as cultural icons," not an "Oriental" cult of idol worship but the Western cult of art.[13]

Flood writes of the destruction of the Bamiyan Buddhas as "a performance designed for the age of the Internet," whose "intended audience was . . . neither divine nor local but global."[14] If so, it certainly worked. More than the terrible suffering of ordinary Afghan people, it was the destruction of the Bamiyan Buddhas that became the symbol of the Taliban's irredeemable barbarity. Viewers seemed to identify with the Buddhas, projecting their own selves into their crumbling bodies, and much of the reportage spoke of the Buddha figure "gazing" down at the valley or suffering "wounds" on "his" body.

The global circulation of images and information on the destruction of the Buddhas, the global outcry that followed the event, and the global efforts to salvage what might remain of them in the valley distill the events at Bamiyan into a struggle between binary opposites. The ability to see the Buddhas as part of world art and world heritage versus the inability to see them as anything but idols becomes the dividing line between the modern and the medieval, the cultured and the barbaric, the secular and the fanatical. Bamiyan became a cause célèbre, and two years after the ouster of the Taliban in late 2001, the "Landscape and Archaeological Remains of the Bamiyan Valley" were inscribed on UNESCO's World Heritage List as well as its List of World Heritage in Danger. The new Afghan government welcomed international archaeologists and conservators to Bamiyan, and teams of French, German, Swiss, Austrian, Japanese, and American conservators and archaeologists went to work there, making new discoveries and attempting to preserve and document what remained.

By cooperating with the international community, the new Afghan government distanced itself from the Taliban and its attitude toward cultural heritage. But the dyad of the Taliban-versus-World Heritage actually obscures a third, crucially important yet often overlooked group who were also a prime audience for the Taliban's destructive actions. For this internal audience that lived in Bamiyan, who were Afghan but not of the Sunni majority, this event had another range of meanings altogether. The Bamiyan Valley is home to the community of Hazaras, a Shia minority that is ethnically, culturally, and religiously distinct from the majority of Afghans. Speaking Hazaragi, a dialect of Persian, and following Shiism, which is considered heretical by orthodox Sunnis, the Hazaras believe themselves to be of Mongol origin, descending from the remnants of the thirteenth-century army of Genghis Khan.

Having displaced the earlier Buddhist inhabitants of the valley, the Hazaras have lived in Bamiyan for centuries and have made the valley and its features their own. The Hazaras may have lost sight of the original meaning of the Buddhas, but they gave them new meanings and incorporated them into their own heritage. In Hazara folklore the taller Buddha statue was identified with a low-born hero called Salsal, and the shorter one was his beloved, a princess called Shahmama. When Shahmama's father, the ruler of Bamiyan, learned about their love, he set Salsal two challenges: to save the Bamiyan Valley from its frequent flooding and to defeat a dragon that was plaguing the land. Hazaras point to the dam on the nearby Band-e Amir Lake: the dam wall, they say, was built by Salsal. They point also to a nearby rock formation, known as Darya Ajdahar, or Dragon Rock: these are the petrified remains of the dragon that Salsal killed.

A victorious Salsal returned to claim his bride. The bride and groom retreated to two chambers carved into the mountain to be readied for their wedding. But, alas, when the day of the wedding dawned, Salsal was dead: the dragon's poison had worked its way into his wounds and killed him overnight. His body was frozen stiff into the mountainside. Seeing him dead, Shahmama let out a shriek, then she too died. According to the Hazara legend, the larger of the two Buddhas was the petrified body of

the hero Salsal; the smaller, his bride, Shahmama. Both remained on the hillside, frozen in eternal separation. This tragic tale shows how the Hazaras adopted the Bamiyan sculptures and knitted them into other local elements—the Dragon Rock, the dam on the lake—to make them part of the environment. Uncreated by human hands, the two sculptures become part of the natural heritage of the Bamiyan Valley.[15]

There were other ways in which Hazaras expressed kinship with the statues. Some claimed that their own ancestors had made them; when medieval invaders damaged the statues and destroyed their faces, they believe this was done because the statues' faces were Hazara faces. This belief reflects the Hazaras' experience as a persecuted minority in Afghanistan. And through the centuries, the statues have been mascots for the Hazara people, sharing in their suffering and subjugation. Human rights groups believe the Hazaras have been the most oppressed community in Afghanistan since the nineteenth century. When they resisted the control of the ruler of Kabul late that century, an estimated 60 percent of the Hazara population was wiped out on his orders. In subsequent decades they were routinely captured and enslaved. Discrimination continued through the twentieth century but intensified in the Taliban era: when the Hazaras aligned with the Northern Alliance, who were resisting the Taliban, the Taliban in turn declared a jihad against the Hazaras.

Through these vicissitudes, the Hazaras have also tried to tend to the statues. When Hazara fighters wrested control of the Bamiyan area during the Russian occupation of the 1980s, the Hazara warlord Abdul Ali Mazari even assigned soldiers to protect the Buddhas.

However, in January 2001 the Taliban gained control of the Bamiyan Valley, and the Buddhas were destroyed shortly after. Their destruction was aimed at striking fear in the Hazara heart, asserting Taliban dominance, destroying a Hazara cultural symbol, and ruining a potential resource for Bamiyan's future economy. But the Buddhas were only one aspect of the destruction the Taliban wrought in Bamiyan: the spectacle was the public face of an event intended for the eyes of television viewers. In its shadow was the other face—turned toward internal animosities against Afghanistan's own minorities. Immediately upon capturing the valley, the Taliban massacred the Hazaras, wiping out entire villages around Bamiyan.

The continuing importance of these now-effaced statues for the Hazaras can be gauged from the frequency with which their names are invoked by the community, at home and in the diaspora. Countless Hazara associations, nongovernmental organizations, and social clubs are named for Shahmama and Salsal. The images of the statues as they once were, as well as the empty niches, are frequently reproduced in Hazara popular culture and social media, becoming a visual symbol of the community and the persecution suffered by it. In 2014, when the Hazara community wished to build a statue to commemorate their leader Abdul Ali Mazari, who was assassinated by the Taliban in 1995, they erected it in front of the ridge where the Buddhas—or rather Salsal and Shahmama—once stood. The homology between the statue commemorating the

Hazara hero who was murdered by the Taliban and the empty niches of the destroyed Buddhas is easy to read.

In the months and years since the demolition, Hazara artists, writers, poets, and filmmakers have dwelt on the Buddhas, grieving their loss, critiquing the Taliban, and wishing for a future when the statues return to their niches. Notable among these is Khadim Ali, a Hazara artist who has settled in Pakistan and whose delicate miniature paintings and woven carpets repeatedly delineate the empty niches in Bamiyan. Hafiz Pakzad, a Bamiyan-born French hyperrealist artist, proposed painting an enormous Buddha that would fill the empty niche; a smaller version hung in the rotunda of the Musée Guimet in Paris from 2006 as a remembrance of the erased past.

While international artists have mounted special events in which holograms of the Buddhas are projected onto the cliff, the Hazaras have expressed their desire to actually rebuild the statues. The reaction of heritage experts has been dismissive. "I think trying to rebuild them is the silliest idea I've ever heard," declared Nancy Hatch Dupree, the American historian who dedicated her life to the cultural heritage of Afghanistan and wielded immense power among the organizations that coordinated relief operations there in the post-Taliban era. "You cannot recreate something that was an artistic creation. It was of its time." Dupree's concerns seem to have been aesthetic, as she believed it was impossible for the reconstructions to replicate the originals perfectly. "Of course, the people of Bamiyan are anxious to have them rebuilt because they think they've lost their tourist attraction," she conceded in an interview, but "I don't think so. I think we can build a site museum."[16]

Dupree imagined the Hazaras' desire to rebuild the sculptures came from the economic ambition to create a tourist attraction. But tourism has not ever been a significant part of the Bamiyan economy. Surely it was possible to attribute other motivations to this longing to repair the damage that the Taliban had wrought? To undo this erasure of their heritage, to heal wounds, and to look to a future when the residents of the valley can shape their own future: this could have been the Hazaras' wish.

For two decades, the future of the statues, however, remained unclear. At the base of the larger Buddha, archaeologists built a shed to hold all the fragments collected after the Buddhas' destruction. But so much had been lost that experts believed that, while it might be possible to piece together half of the smaller Buddha, it would be impossible to rebuild the larger one. With so little of the original statues remaining, whatever would be built would be a new construction, resulting in a loss of authenticity for the site. Were this to occur, international experts warned, the reconstruction would contravene the 1964 International Charter for the Conservation and Restoration of Monuments and Sites, or the Venice Charter, according to which "[restoration] must stop at the point where conjecture begins."[17] If the Buddhas were reconstructed thus, Bamiyan might risk losing its status as a World Heritage Site. UNESCO favored only the conservation of what remained, which in effect was simply stabilizing the crumbling walls of the empty niches.

Some authorities saw value in maintaining the absence of the Buddhas. While a few scholars and Buddhist leaders felt empty niches best expressed the Buddhist concept of sunyata and nonattachment to material things, others found salutary political lessons in the destroyed sculptures. "The two niches should be left empty, like two pages in Afghan history, so that subsequent generations can see how ignorance once prevailed in our country," said Zamaryalai Tarzi, the famous Franco-Afghan archaeologist.[18] These are views of experts and archaeologists who may be Afghan or sympathetic to Afghans or to Buddhism, but who remain removed from the perspective of the Hazara residents of Bamiyan. In contrast, conservator Michael Petzet, president of the German branch of the International Council on Monuments and Sites (ICOMOS), who spent considerable time on-site, seemed more in touch with local sentiments. "I've talked with many Afghans," he said, "and they do not want that their children and grandchildren are forced by the Taliban to see only ruins."[19]

In 2014, Petzet and his team began building supporting structures at the base of the smaller Buddha. The brick columns looked suspiciously like feet. As Petzet admitted later, "These feet . . . [were] for the safety of the whole structure, and maybe in the future if the Afghan government wants to make a little bit more, they can build upon this."[20] If it was intended as a nudge in the direction of reconstruction, it did not produce the desired effect. When UNESCO discovered the construction, it petitioned the central government in Kabul, which rushed a team to the site and ordered that further work be halted and the constructed "feet" be taken down (fig. 8.3).

Hazaras reacted against the standards and protocols that UNESCO expected them to follow at Bamiyan. When they were lectured about preserving material authenticity, they pointed out that other World Heritage Sites have involved the entire rebuilding of destroyed sites without any loss of status. The bridge at Mostar and the city center of Warsaw are examples of where the act of faithful rebuilding has been lauded rather than criticized.

If the statues were destroyed by a Taliban that was "exercising upon them the most radical right of the owner," in the next phase of Afghan history the international community of experts exercises a supraownership by setting up "global" and "professional" standards of custodial care.[21] Valuing the physical remains of a historical past, and defining authenticity in material terms, the officials of world heritage organizations were, as Walter Lanchet notes, executing a "new orthodoxy of cultural globalization" that again took Bamiyan's future out of Hazara hands.[22] But their steadfast desire to rebuild the Buddhas and the international interest evoked by the site led to a prolonged debate about the ethics and purpose of reconstruction. Against a Western obsession with conservation philosophy centering on the "original" meanings and authenticity of historical material, a growing number of voices suggested that conservation should also encompass the conserving of skills and knowledge that allow objects and sites to be repaired and renewed. A third strand of argument began to ask whether the question of repairing and reconstructing should not shift focus from

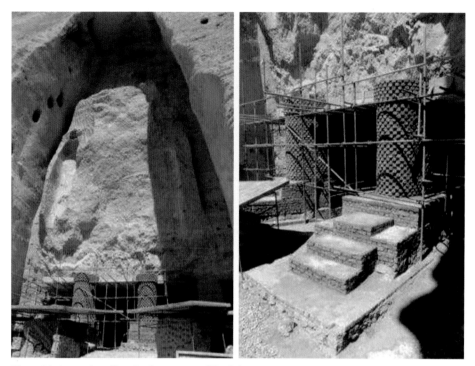

Figure 8.3 Supporting pillars for the eastern Buddha, left, with detail at right

recovering things to recovering their *meaning*. Surely the layers of accreted meaning count for something, where the destroyed statues were not just ancient Buddhas but also mythic lovers and symbols of Hazara suffering.

Despite these debates, Salsal and Shahmama remained absent in Bamiyan. The Taliban had their way, destroying the Buddhas and leaving only empty niches behind. Then the heritage experts had their way, discouraging the rebuilding of the Buddhas, leaving empty niches behind. And now with the return of the Taliban, one can only wonder about the future that lies ahead, not for the Bamiyan Buddhas—for we can guess that—but for the Hazara community that has held them dear for so long.

Conclusion

In the immediate aftermath of a conflict, governments and international organizations first deal with humanitarian issues of critical concern. When they are able to turn their attention to cultural heritage and its reconstruction, it seems a corner has been turned. After all, governments can afford to think of heritage only when more urgent crises are past. The work of post-conflict cultural reconstruction becomes an important sign that the country is on its way to normality and peace.

The truth, unfortunately, is often more complex. In Sri Lanka and Afghanistan, enough time has passed to allow us to see the shape cultural reconstruction can take. When a conflict ends with clear winners and losers, the processes of reconstruction offer yet another opportunity for the powerful to reward their supporters and

dispossess their opponents. Projects of archaeological exploration or monument conservation become instruments by which social hierarchies are reified, majorities are empowered, and minorities become further marginalized. Such processes of "authoritarian reconstruction" only serve to emphasize the fault lines existing in society.[23] Often these are the very fault lines that had generated the conflict in the first place. By emphasizing them, the very processes of post-conflict reconstruction that are seen as offering healing may arouse resentment, foreshadowing the eventual return of conflict. Only a reading close to the ground can make us aware of the inequities that can masquerade as cultural reconstruction and demand accountability in its place.

SUGGESTED READINGS

Sri Lanka

Malathi de Alwis, "Trauma, Memory, Forgetting," in *Sri Lanka: The Struggle for Peace in the Aftermath of War*, ed. Amarnath Amarasingham and Daniel Bass (London: Christopher Hurst, 2016), 147–61.

Jude Fernando, "Heritage & Nationalism: A Bane of Sri Lanka," *Colombo Telegraph*, 30 March 2015, https://www.colombotelegraph.com/index.php/heritage-nationalism-a-bane-of-sri-lanka/.

Sasanka Perera, *Violence and the Burden of Memory: Remembrance and Erasure in Sinhala Consciousness* (New Delhi: Orient BlackSwan, 2016).

Samanth Subramanian, *This Divided Island: Stories from the Sri Lankan War* (London: Penguin Books, 2014).

Nira Wickramasinghe, "Producing the Present: History as Heritage in Post-war Patriotic Sri Lanka," *Economic and Political Weekly* 48, no. 43 (2013): 91–100.

Afghanistan

Finbarr Barry Flood, "Between Cult and Culture: Bamiyan, Islamic Iconoclasm, and the Museum," *Art Bulletin* 84, no. 4 (2002): 641–59.

Ankita Haldar, "Echoes from the Empty Niche: Bamiyan Buddha Speaks Back," *Himalayan and Central Asian Studies* 16, no. 2 (2012): 53–91.

Luke Harding, "How the Buddha Got His Wounds," *Guardian*, 3 March 2001, https://www.guardian.co.uk/Archive/Article/0,4273,4145138,00.html.

Syed Reza Husseini, "Destruction of Bamiyan Buddhas: Taliban Iconoclasm and Hazara Response," *Himalayan and Central Asian Studies* 16, no. 2 (2012): 15–50.

Llewellyn Morgan, *The Buddhas of Bamiyan* (Cambridge, MA: Harvard University Press, 2012).

NOTES

1. There have been several other important Tamil political and militant groups as well, such as the far-left Janatha Vimukthi Peramuna (JVP).
2. Amir Ali, "Erasing the Cultural Leftover of Tamils to Convert Sri Lanka into Sinhala Country," *The Weekend Leader* 2, no. 31, 4 August 2011, https://www.theweekendleader.com/Causes/615/exclusive-inside-lanka.html.

3. Renowned Sri Lankan–Tamil historian and archaeologist Sivasubramaniam Pathmanathan has gone on record to complain that archaeological projects that could show an ancient Tamil presence in Sri Lanka have not been given approval by the archaeological authorities, while those that would show an early Sinhalese Buddhist presence in Tamil homelands have gained funding. See Nira Wickramasinghe, "Producing the Present: History as Heritage in Post-war Patriotic Sri Lanka," *Economic and Political Weekly* 48, no. 43 (2013): 91–100.

4. See Wickramasinghe, "Producing the Present"; and Jude Fernando, "Heritage & Nationalism: A Bane of Sri Lanka," *Colombo Telegraph*, 30 March 2015, https://www.colombotelegraph.com/index.php/heritage-nationalism-a-bane-of-sri-lanka/.

5. Samanth Subramanian, *This Divided Island: Stories from the Sri Lankan War* (London: Penguin Books, 2014), 196–99.

6. TamilNet, "Archaeologists Enter Omanthai Statue Dispute," 7 June 2005, https://www.tamilnet.com/art.html?catid=13&artid=15100.

7. Fernando, "Heritage & Nationalism."

8. This essay was written prior to the Taliban's return to power in 2021. Needless to say, the reinstallation of the Taliban does not augur well for the future of Afghanistan's Buddhist material heritage or for the cultural and human rights of its minorities, including the Shia Hazaras who are the focus of this section of the essay.

9. Quoted in Finbarr Barry Flood, "Between Cult and Culture: Bamiyan, Islamic Iconoclasm, and the Museum," *Art Bulletin* 84, no. 4 (2002): 655.

10. After Mullah Omar decreed that the Taliban would destroy all statues in areas under their control, the Taliban ambassador to Pakistan issued a statement declaring, "The *fatwa* . . . [will] be implemented at all costs." The ambassador clearly understood that this act would adversely affect the Taliban government and would prolong the sanctions against Afghanistan; the act would be carried out in the face of this knowledge. See Jamal J. Elias, "(Un)making Idolatry: From Mecca to Bamiyan," *Future Anterior* 4, no. 2 (2007): 17, citing Ambassador Mullah Abdul Salam Zaeef.

11. Luke Harding, "How the Buddha Got His Wounds," *Guardian*, 3 March 2001, http://www.guardian.co.uk/Archive/Article/0,4273,4145138,00.html.

12. Flood, "Between Cult and Culture."

13. Flood, "Between Cult and Culture," 651.

14. Flood, "Between Cult and Culture," 651.

15. I am grateful to Syed Reza Husseini, who brought the Hazaras to my attention and shared much information about them. For his essay on the subject, see Syed Reza Husseini, "Destruction of Bamiyan Buddhas: Taliban Iconoclasm and Hazara Response," *Himalayan and Central Asian Studies* 16, no. 2 (2012): 15–50.

16. Asia Society, "Preserving Afghanistan's Cultural Heritage: An Interview with Nancy Hatch Dupree [2002]," https://asiasociety.org/preserving-afghanistans-cultural-heritage-interview-nancy-hatch-dupree.

17. International Charter for the Conservation and Restoration of Monuments and Sites (The Venice Charter 1964), Art. 9.

18. Quoted in Frédéric Bobin, "Disputes Damage Hopes of Rebuilding Afghanistan's Bamiyan Buddhas," *Guardian*, 10 January 2015, https://www.theguardian.com/world/2015/jan/10/rebuild-bamiyan-buddhas-taliban-afghanistan.

19. Quoted in Rod Nordland, "Countries Divided on Future of Ancient Buddhas," *New York Times*, 22 March 2014, https://www.nytimes.com/2014/03/23/world/asia/countries-divided-on-future-of-ancient-buddhas.html.

20. Nordland, "Countries Divided on Future of Ancient Buddhas."

21. Dario Gamboni, "World Heritage: Shield or Target?," *Conservation* (Newsletter of the Getty Conservation Institute) 16, no. 2 (2001): 5–11, http://www.getty.edu/conservation/publications _resources/newsletters/16_2/feature.html.

22. Walter Lanchet, "World Heritage in Practice: The Examples of Tunis (Tunisia) and Fez (Morocco)," in Traditional Dwellings and Settlements Working Paper Series, vol. 128, International Association for the Study of Traditional Environments, 2000, 39–47.

23. Steven Heydemann, "Reconstructing Authoritarianism: The Politics and Political Economy of Post-conflict Reconstruction in Syria," in *The Politics of Post-conflict Reconstruction*, ed. Marc Lynch (Washington, DC: George Washington University, September 2018), Project on Middle East Political Science (POMEPS) Studies no. 30, 14.

9

Performative Destruction: Da'esh (ISIS) Ideology and the War on Heritage in Iraq

Gil J. Stein

Well-publicized genocidal actions, combined with ferocious iconoclastic attacks on cultural heritage, characterize the violent expansion of the caliphate of Da'esh, also known as the Islamic State of Iraq and Syria (ISIS or ISIL), over significant areas in the north of both countries from 2013 to 2019. These were not random acts of atrocity but instead formed a coherent, integrated politico-religious strategy of violence, communicated and amplified globally through innovative use of the Internet. In this chapter I suggest that Da'esh's politics of heritage demolition were central to its very identity. Its destruction of cultural heritage monuments was a form of "cultural genocide" closely linked to concurrent acts of human genocide in attempts to exterminate its enemies, both Muslim and non-Muslim, in Syria and Iraq.

This discussion has three parts. I start by showing that Da'esh's actions must be understood as deriving from the group's religious ideology of extremist jihadi Salafism as a distinct strand within Sunni Muslim theology. The second section shows how Da'esh's acts of parallel politico-religious violence against people and iconoclastic attacks on heritage monuments were publicized in a dangerous new paradigm of Internet-based "performative destruction." The third part examines the human and cultural targets of Da'esh's genocidal actions to emphasize that—contrary to the widely held Western perception—most of the heritage monuments destroyed by Da'esh were shrines sacred to rival Muslim groups, rather than ancient or pre-Islamic sites. I conclude by noting that Da'esh's public destruction of heritage is simply the latest and best publicized exemplar of a deep historical pattern in which the erasure of culture is the necessary prelude or accompaniment to the eradication of people. With the advent of Internet-based performative destruction and viral violence, Da'esh has moved genocide and heritage destruction into new and uncharted terrain.

Da'esh's Ideological Roots

"Da'esh" is the Arabic acronym for "al-Dawla al-Islāmiyya fī'l ʿIrāq wa'l Shām" (the Islamic State of Iraq and Syria). Founded in 1999 by Abu Mussaf al-Zarkawi, the organization participated in the insurgency against the US-led occupation of Iraq in 2003. After splitting from al-Qaeda, its parent group, and changing its leadership and name, Da'esh emerged as a major military, political, and ideological force, first in Iraq and then in Syria after the outbreak of the latter's civil war in 2011. In 2014, Da'esh's leader, Abu Bakr al-Baghdadi, declared the establishment of a caliphate as a theocratic polity dedicated to restoring the values of the original "rightly guided" caliphs in the seventh century CE.

By December 2015, Da'esh had conquered a vast area across northern Syria and Iraq. At its peak, Da'esh controlled an estimated eight to twelve million people in a caliphate that enforced its interpretation of Islamic law until its destruction as a territorial entity in 2019. Da'esh differed radically from other groups in its revolutionary politico-religious agenda of restoring the caliphate, in the enemies it targeted, and in its unique focus on the performative destruction of people and heritage. This core strategy of Da'esh fused politics, Islamic fundamentalism espousing jihad (religiously sanctioned war against unbelievers), and the use of the Internet in an unprecedented way as a weapon of war and a recruitment tool.

The political and military actions of Da'esh can only be understood by recognizing the importance of jihadi Salafism as its core ideology. A branch of Sunni Islam, Salafism requires its adherents to emulate "the pious predecessors," equated with the first Muslim communities and the four "righteously guided" caliphs who ruled from 632 to 661 as the earliest successors to the Prophet Muhammad. Salafism encompasses several main ideological strands, united by a core of shared beliefs.[1] Salafis seek to revive the ideological purity of the seventh-century pious ancestors. They believe that the only valid sources of authority are the earliest texts—the Quran and Sunna (words and acts) of the Prophet Muhammad and his companions—rather than later schools of Islamic religious thought. On this basis, Salafis define themselves as the purest Muslim group, "the sect saved (from hellfire)," distinct, superior, and opposed to non-Muslim and even other Muslim groups.[2]

Salafis emphasize an imperative to combat polytheism, idolatry, unbelief, and all attempts to associate other beings or things with God. This includes uncompromising opposition to the belief in "intermediaries" between people and the divine, whether Sufi mystics or Christian clerics. Salafis seek to rid Islam of "reprehensible innovations" in religious beliefs and practices adopted from other faiths, and therefore focus on the "cleansing" of Islam.[3] On that basis, Salafis strongly oppose Shiites as "rejectionists" of the first three caliphs.[4] Although Da'esh is a Salafi organization, it adheres to the most extreme strand of this ideology, a position not even shared by the majority of other Salafis, let alone Muslims in general.

Salafi groups fall into three very different categories. The majority are "quietist" or "scholastic" Salafis, who follow a more traditional outlook, arguing that all forms of overt political organization and violence are forbidden because this can lead to civil strife between Muslims, and, in any case, obedience to Muslim rulers, even unjust ones, is religiously mandated. In contrast, the second Salafi group, known as *hariki* (activists), advocate nonviolent political activism in both Muslim and non-Muslim countries. The third and most radical group are the jihadi Salafis, who call for "violent action against the existing political order (whether Muslim, non-Muslim, or secular) and for the establishment of a unitary state in the form of the caliphate."[5] Da'esh and al-Qaeda are quintessential examples of jihadi Salafi groups.

Da'esh is committed to restoring what adherents see as original Islamic practices through political action, armed violence, and the extermination of those they define as enemies. Their principal targets are Middle Eastern groups that differ the most from Da'esh's version of Islam—that is, non-Muslim communities such as Yezidis, Christians, and Jews. However, Da'esh's enemies also include Muslim groups such as Sufis (seen as polytheists and believers in false intermediaries between God and humanity), Shiites (due to their rejection of the original pure Islam of the first caliphs), and even the governments of modern Sunni Muslim states whose secular or non-Salafi policies are seen as apostasy. Da'esh targeted not only the people directly, but also the mosques, shrines, and monuments of these enemy Muslim groups in order to restore Islam to its original state of purity. This policy of purification extended to include the destruction of ancient pre-Islamic monuments, also defined as idolatrous.

Overall, Da'esh's actions are best understood as deriving from a powerful fusion of religious and political ideologies—deeply held beliefs, not simply political expediency. Jihadi Salafi ideology explains why Da'esh attacked specific people, groups, and monuments, and clarifies the discourse used to explain these actions in new forms of messaging. Although the targeting of people and monuments makes sense in political terms, the religious motivations were equally important as a means of legitimizing the attacks, allowing Da'esh to cast itself as more authentic than other nonstate armed jihadi groups. Although attacks on Sufis and Shiites do not fit the widely accepted Western narrative that emphasizes Da'esh's hostility to Christians and Yezidis, the targeting of these Muslim groups as enemies is also a core element of Da'esh's ideology. While political considerations were clearly important, the core Salafi imperative to combat both modern and ancient idolatry provided the religious rationale for Da'esh's iconoclastic war on pre-Islamic cultural heritage monuments.

Da'esh Iconoclasm and Performative Destruction
Iconoclasm can be defined as the deliberate destruction of the material manifestations of cultural heritage because they represent a particular doctrine or ideology. As such, these objects or monuments stand in opposition to the core beliefs of the group conducting the iconoclastic act. Iconoclasm extends beyond religious icons to include

attacks on ethnic and political symbols.[6] It destroys the past and present to create a new vision of the future.

Da'esh's public statements about iconoclastic acts such as the demolition of monumental sculptures and buildings at the ancient Assyrian capitals at Nimrud and Nineveh, adjacent to the modern Iraqi city of Mosul, made it clear that the demolition was an action against idolatry: "Today we destroy and obliterate another landmark of polytheism, which had been held in high esteem by the people, whereas they did not know that these relics are idols and statues which had been worshipped besides God."[7]

The declaration echoes the well-known precedent for this kind of widely publicized iconoclastic action, the Taliban's destruction in 2001 of the sixth-century monumental standing Buddha statues in the Bamiyan Valley of Afghanistan.[8] The Taliban's edict announcing the destruction of the Buddhas stated that the action had been taken due to the characterization of the statues as "idols" and the need to suppress idolatry: "Edict issued by the Islamic Emirate of Afghanistan, in Kandahar on the 12th of Rabiul-Awwal 1421 (26 February 2001): On the basis of consultations between the religious leaders of the Islamic Emirate of Afghanistan, religious judgments of the ulema and rulings of the Supreme Court of the Islamic Emirate of Afghanistan, all statues and non-Islamic shrines located in different parts of the Islamic Emirate of Afghanistan must be destroyed. These statues have been and remain shrines of unbelievers and these unbelievers continue to worship and respect them."[9]

It is important to emphasize that Da'esh's and the Taliban's focus on destroying pre-Islamic statues or other monuments as "idolatry" has no real historical grounding in the practices of the earliest Muslim "rightly guided" caliphs and does not represent mainstream Sunni Muslim belief or practice. In 2001, after the Taliban announced their edict, Sheikh Yusuf al-Qaradawi, an Egyptian cleric regarded as one of the most respected religious scholars in the modern Arab Muslim world, stated: "The statues made by the elders who came before Islam are part of a historic patrimony. When the Muslims penetrated Afghanistan, in the first century of Hijra, these statues were already there, and they were not destroyed. I advised our brothers of the Taliban movement to reconsider their decision in light of the danger of its negative impact."[10] Similarly, Sabri Abdel Raouf, chief of the Division of Islamic Studies at al-Azhar University in Cairo, stated that "statues intended for worship can be forbidden as contrary to Islam but statues that are not worshipped are not forbidden."[11] The views of these scholars were incorporated into the 2001 Doha Declaration on Islam and Cultural Heritage:

> The *'ulamâ* participating in the Symposium affirmed that the position of Islam with regard to the preservation of the human cultural heritage derives from its appreciation of innate human values and from respect for peoples' beliefs. They explained that the position of Islam regarding the preservation of the cultural heritage is a firm position of principle which expresses the very essence of the Islamic religion. Any individual or collective behaviour which is at variance with

that position in no way reflects the Islamic position as expressed by the *'ulamâ* and *fuqahâ* (Islamic jurists) of the umma (nation of Islam).[12]

Clearly, Da'esh's commitment to the destruction of pre-Islamic and non-Islamic statues, monuments, and art—regardless of whether they were actually being worshipped—represents an extreme fundamentalist view at variance with the formally declared beliefs of mainstream Sunni Islam.

Da'esh's devastation of both ancient and modern cultural heritage was so effective because it took place in a well-integrated system that combined religious ideology, a political agenda, extreme violence, and Internet-based communication. Michael Danti describes Da'esh's attacks on heritage as "performative destruction" to emphasize their public character: "Performative deliberate destructions are scripted productions with ISIL militants delivering speeches and reciting religious passages on camera, purporting that the targeted heritage is idolatrous or heretical within their interpretation of Islam. . . . These diatribes are followed by meticulously edited film sequences showing destructions of architecture and sculpture using explosives, heavy machinery, and hand tools (figs. 9.1, 9.2). Videos and still photos are then posted on the internet with ISIL branding or are featured in the ISIL magazine *Dabiq*."[13] The importance of these actions goes far beyond Da'esh and may foreshadow the emergence of a broader-based new paradigm of performative destruction that could threaten people and patrimony in unprecedented ways at a global level.

Da'esh's performative destruction of objects, monuments, and sites was a religiously and politically motivated public propagandistic act of cultural genocide accompanying the destruction of people and communities through physical genocide as defined in international law.[14] These attacks were so effective because they were embedded in a

Figure 9.1 A Da'esh militant uses a power tool to destroy an Assyrian winged bull dating to the early seventh century BCE at the gate of Nineveh, near present-day Mosul, Iraq. Image: CPA Media Pte Ltd. / Alamy Stock Photo

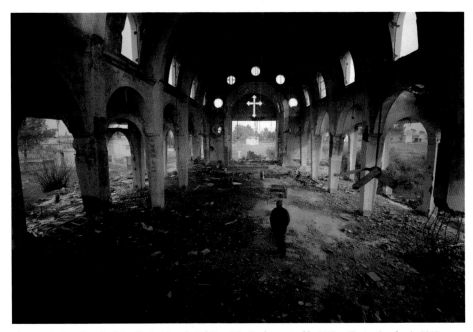

Figure 9.2 The Church of the Virgin Mary in Tel Nasri, Syria, devastated by ISIS on Easter Sunday in 2015. Image: Rodi Said / Reuters / Alamy Stock Photo

well-integrated system that combined religious ideology, a political agenda, extreme violence, and sophisticated propaganda—all amplified at a global scale to reach multiple, targeted audiences through Internet videos, digital magazines, and other social media. Nonhierarchical channels of Internet communication make these messages extremely difficult to counter or suppress.

Public acts of iconoclasm have a long history.[15] Performative destruction as defined here, however, is qualitatively different, innovative, and proven to be a highly effective strategy for propaganda and recruitment at a global scale. Publicly broadcast imagery intensified the visual and emotional impact of victories, killings, and heritage destruction. Da'esh's demolitions of cultural heritage monuments and shrines were performed as acts of religiously justified cultural genocide linked with the actual killing of targeted ethnicities and faith communities. This use of the Internet for performative destruction has been characterized as "digitally mediated iconoclasm"[16] and "socially mediated terrorism": "the use of social and networked media to increase the impact of violent acts undertaken to further a social, political and/or religious cause with the aim of creating physical, emotional or psychological suffering that extends beyond the immediate audience."[17]

In performative destruction, the Internet and social media are used to reach diverse global audiences with targeted messages designed to accomplish multiple goals:

- ✦ Establish the ideological and political legitimacy of the organization;
- ✦ Recruit followers at local and international levels;
- ✦ Terrorize and demoralize local enemies by amplifying victories and atrocities;

✦ Promote the group relative to other competing groups; and

✦ Provoke enemy states through attacks on heritage, while polarizing Western states and the Islamic World.

Nonstate armed groups such as Da'esh require a continuous communicative effort through digital media to legitimize and constantly relegitimize themselves by establishing and maintaining the greater authenticity of their religious credentials as distinct from rival groups.[18] The viral character of Internet communication, including social media, makes these messages nearly impossible to rebut or stifle.

The Da'esh strategy of performative destruction also relied heavily on its online magazine *Dabiq* to complement online videos and social media postings by explaining and amplifying at greater length the ideological bases for its iconoclastic actions. The name of the magazine is significant: Dabiq is a place in northern Syria where, according to early Muslim traditions, the final apocalyptic battle between Islam and Christianity will take place.[19] Published online in Arabic, English, German, and French from 2014 to 2016, *Dabiq* served a number of strategic purposes. A primary goal was to call on Muslims worldwide to support Da'esh by emigrating to Syria and Iraq to join the caliphate. *Dabiq* used carefully written accessible text with high-quality graphics to describe Da'esh's success in gaining the support of the Syrian population, report successful military operations, and graphically portray its own violence against Shiites, Sufis, Yezidis, and other enemies. In fifteen thematic issues, *Dabiq* used classic Islamic texts to explain and justify the nature of the caliphate, its intentions, legitimacy, and authority over all Muslims.[20] *Dabiq* was aimed at multiple audiences, seeking to communicate with both non-Muslim enemies and potential Muslim supporters at a global level. Readers who could not themselves come to the caliphate were asked to encourage others to emigrate. Muslims abroad were asked to organize local allegiance pledges, and to publicize them as much as possible, including by recording and distributing the pledges through social media. *Dabiq* explained that publicized pledges intimidated unbelievers, normalized loyalty to Da'esh, and encouraged others to pledge.[21]

Online magazines, video postings, and the use of social media were seamlessly woven into the core strategies of Da'esh. The US Department of State estimated that at the height of the conflict, Da'esh's supporters posted around ninety thousand messages a day online through a variety of platforms, including YouTube, Facebook, Twitter, and Instagram.[22] This transformed the war in Syria into "the most socially mediated conflict in history."[23] This novel widespread use of social media and video imagery was an essential force multiplier for the emotional, political, and military effectiveness of performative destruction as a weapon. As stated by sociologist Kevin McDonald, "We need to recognise that the camera phone does not simply film contemporary war, it plays an increasingly central role in shaping it."[24]

The War against People: Genocide against Yezidis, Christians, and Muslim Enemies

Da'esh viewed its acts of performative destruction as part of the eternal struggle between monotheism and idolatry, carried out at both ideological and material levels. A key aspect was the "purification" of the earth from any forms of idolatry or its practitioners, explaining why Da'esh barely distinguished between human enemies and material expressions of unbelief, whether modern or ancient—all were seen as targets for destruction.[25] These actions and their religious legitimation were central elements in the way Da'esh differentiated itself from rival nonstate armed groups, allowing it to claim a level of extreme ideological purity that also played a key role in recruiting new followers. The consequences of this outlook and its implementation were horrific for the Yezidi and Christian communities, as well as those Sufi and Shiite Muslim groups that Da'esh defined as enemies.

The Yezidis are a Kurdish-speaking, heterodox ethnoreligious group whose heartland lies in the plains and mountainous areas near Mosul in northern Iraq. The Yezidi faith incorporates elements of Zoroastrianism, Manichaeism, Gnosticism, Christianity, and Islam.[26] Due to the secretive nature of Yezidi religious practices and their veneration of the Peacock Angel ("Tavus Melek" in Kurdish), many Christians and especially Muslims have erroneously accused them of being "devil-worshippers" who are not considered "People of the Book"—i.e., monotheists.[27]

In public statements disseminated through *Dabiq* and other media, Da'esh defined the Yezidis as polytheist idolators[28] and launched a campaign of ethnic cleansing and genocide against them in 2014. In the initial assault, between ten and twelve thousand Yezidi men, women, and children were killed.[29] All victims were abused and tortured, male Yezidis above the age of twelve were killed, and female Yezidis were publicly traded in a complex network of sexual slavery. The thousands who fled to Mount Sinjar in northern Iraq were besieged to ensure their death from thirst and starvation. In total, more than four hundred thousand Yezidis were enslaved, driven from their homeland, or killed.[30] In *Dabiq*, Da'esh framed these actions as consistent with Islamic law: "Enslaving the families of the [nonbelievers] and taking their women as concubines is a firmly established aspect of the Shariah. . . . After capture, the Yazidi women and children were then divided according to the Shariah amongst the fighters of the Islamic State . . . after one fifth of the slaves were transferred to the Islamic State's authority to be divided as *khums*." *Khums* is the one-fifth share or tax on the spoils of war owed to the state. According to a 2016 report by the UN High Commissioner for Human Rights, "No other religious group present in ISIS-controlled areas of Syria and Iraq has been subjected to the destruction that the Yazidis have suffered."[31]

Despite the fact that mainstream Islam considers Christians to be People of the Book, who are tolerated within Islam subject to their payment of the *jizya* tax on non-Muslims, Da'esh viewed both Western and local Middle Eastern Christians as enemies: "We tell Christians everywhere that the Islamic State will spread, God willing, it will reach you even if you are in fortresses. Those who embrace Islam or *jizya* will be safe. But those

who refuse . . . will have nothing from us but the edge of the sword. The men will be killed, the women and children enslaved, and the money seized. That is Allah and the Prophet's judgment."[32] Following the earlier language of Osama bin Laden and al-Qaeda, Da'esh labeled Western Christians as "crusaders" who were enemies of Islam to be destroyed. The fourth issue of *Dabiq*, titled "The Failed Crusade," included an article asserting that "every Muslim should get out of his house, find a crusader and kill him." Syrian and Iraqi Christians, especially Syriac-Aramaic-speaking Assyrians and Chaldeans, were also singled out for persecution, forced conversion, and extermination.

After capturing Mosul on 10 June 2014, Da'esh demanded that the Christian population pay the *jizya* as a condition of their safety and permission to remain in the city. Two days later, Da'esh reneged on this promise, declaring instead that Christians would be killed or forced to convert to Islam if they did not leave Mosul by the following week. The local Syrian Catholic leader, Ignatius Yousef Younan, stated that at least five hundred Christians from his diocese were killed by the militants when they failed to flee Da'esh territory in time. Da'esh's actions of expulsion, expropriation of property, destruction of homes, forced conversions, and targeted killings in Mosul and the adjacent Assyrian Christian heartland of the Nineveh Plain vastly accelerated the devastation of the Iraqi Christian population, which had declined from a population of 1.4 million in 2003 to an estimated 150,000–275,000 by 2016.[33] In the latter year, the legislative bodies of the European Union, the United Kingdom, and the United States voted unanimously to denounce Da'esh's violence against Iraqi Christians as genocide.[34]

Da'esh targeted those Muslim groups whose beliefs differed from Salafi religious principles, most notably Sufi and Shiite communities. Sufism is a mystical form of Islam that emphasizes introspection and spiritual closeness with God, and Sufi practice includes the veneration of saints, often at their tombs and shrines. Although most Sufis are Sunni Muslims, Da'esh violently opposes Sufis as polytheists or idolaters whose veneration of saints is the false belief in intermediaries between humanity and God.[35] As early as 2016, Da'esh began systematically razing the shrines and tombs of Sufi saints in publicized acts of performative destruction. In 2017, it began mass executions of Sufi worshippers during prayer.[36]

Da'esh also took extreme action against Shiites in Iraq, considering them apostates for their refusal to recognize the legitimacy of the first three caliphs as successors to the Prophet and their exclusive acceptance of the fourth, Ali, and his descendants as the legitimate caliphs.[37] This view was highlighted in the thirteenth edition of *Dabiq*, in January 2016, on the theme "The Rafidah ('Rejectionists') from Ibn Saba to the Dajjal." In contrast with other nonstate armed groups such as al-Qaeda, who considered attacks on Shiites detrimental to public support and a distraction from its jihad against the West, Da'esh made bombings and massacres of Shiites a priority, targeting shrines, holy cities, and pilgrimages. In one of its worst atrocities, Da'esh fighters killed 670 Shiite prisoners in a raid on Badush prison northwest of Mosul in June 2014, in addition to bombings and other attacks on Shiites in Baghdad.[38]

The War against Things: Da'esh Attacks on Modern and Ancient Cultural Heritage

Da'esh's extreme violence against Christians, Yezidis, and enemy Muslim groups has been generally recognized as genocide. These acts did not occur in isolation, instead accompanying attacks on the cultural heritage monuments of these groups, along with the destruction of ancient, pre-Islamic heritage sites and monuments. Da'esh's destruction of cultural heritage took two forms: the looting of artifacts from ancient sites for profit, and the performative destruction of both modern and ancient sites and monuments for politico-religious reasons. Both foci of Da'esh activities stood in stark contrast with earlier patterns of conflict-related damage to ancient cultural heritage in Iraq.

From the 1991 Gulf War to the aftermath of the 2003 US invasion of Iraq, there was little or no state-sponsored destruction of Christian, Yezidi, Sufi, Shiite, or ancient heritage sites. During this period, the looting of the Iraq Museum in Baghdad and of numerous ancient sites in southern Iraq were economically motivated crimes by individuals and gangs.[39] However, with the ascendancy of Da'esh and its establishment of a caliphate, attacks on heritage took a qualitatively different form. This was especially true of looting: what had formerly been criminal activities by profit-driven private entities were reinvented as meritorious moral obligations authorized by the central authorities of the caliphate. This Da'esh-sanctioned looting was justified through traditional laws and practices of jihad. In both Syria and Iraq, the group, at this point acting effectively as a state, issued official licenses to looters of archaeological heritage sites, who were obligated to pay 20 percent of their profits to the caliphate as *khums*.[40] Looting became a major source of revenue for Da'esh. Officially sanctioned looting complemented Da'esh's program of performative destruction of modern and ancient cultural heritage, justified in terms of jihadi Salafist ideology and the caliphate's political agenda.

The fight against idolatry, whether modern or ancient, was enormously important for Da'esh as a way to frame its physical genocide of people and cultural genocide against monuments within a discourse of Islamic piety. As stated by Christoph Gunther and Tom Bioly, "Explicitly defining the material representations of its enemy serves as a means to illustrate and sharpen the perceived bipolarity of the situation of conflict, which the Islamic State seeks to fuel. In further suggesting an analogy between themselves and the first generations of Muslims, the followers of the Islamic State claim both legitimacy and authenticity for their actions. This elevates iconoclasm to a virtuous expression of 'genuine' Islam as well as to the struggle for a new system of social order."[41]

Western attention has mainly focused on Da'esh's performative destruction of ancient heritage sites in Syria and Iraq, such as Palmyra, Hatra, Nineveh, and Nimrud.[42] These sites seem to have been deliberately targeted as a way to send a message to two very distinct audiences in the West. At one level the attacks were meant to provoke Western governments and populations into overreactions and thereby to exacerbate the

Denomination/ Category	Sites as percentage of total heritage sites destroyed by Da'esh (n=250)
Sunni-Sufi	17%
Other Sunni	8%
Shia	39%
Yezidi	10%
Christian	9%
Ancient	3%
Other/Misc.	14%

Table 9.1 Main patterns of Da'esh destruction of cultural heritage sites in Iraq and Syria. Data from Michael D. Danti, "Ground-Based Observations of Cultural Heritage Incidents in Syria and Iraq," *Near Eastern Archaeology* 78, no. 3 (2015): 137, Figure 12.

polarization between Christian and Muslim communities in Europe and North America. In tandem, they were also intended to inspire European and North American Muslims and ultimately recruit them as followers.

However destructive and shocking they are to Western eyes, such attacks on ancient pre-Islamic sites and monuments formed only a small part of the overall picture of Da'esh's program of heritage destruction. Statistics compiled by the American Schools of Oriental Research Cultural Heritage Initiative show that at least 64 percent of the cultural heritage monuments destroyed by Da'esh as of 2015 were mosques and shrines of Sufi and Shiite groups, while only 3 percent of the monuments destroyed were at ancient, pre-Islamic heritage sites (table 9.1).[43]

This focus on Sufi and Shiite monuments can also be seen in the analysis of cultural heritage destruction in the Old City of Mosul during the period of Da'esh occupation from 2014 until its recapture by Iraqi security forces in July 2017.[44] Da'esh destroyed or damaged forty-one significant modern heritage sites in this area of the city, and an additional 114 sites on the Nineveh Plain to the east (table 9.2).[45]

Da'esh saw its destruction of Shiite and Sufi tombs and cemeteries as fulfilling the well-established Wahhabi and Salafi doctrine of *taswiyat al-qubur* (leveling of graves)— the religious duty to destroy burial places if they were used as places of worship, since this is considered a form of idolatry.[46] One of the most important heritage shrines destroyed by Da'esh in Mosul was Nebi Yunus—the tomb of the biblical prophet Jonah— a shrine sacred to Muslims, Christians, and Jews.[47] Nevertheless, overall, Da'esh focused its performative destruction on cultural heritage sites belonging to "enemy" Shiite and Sunni Sufi Muslims far more than on Yezidi, Christian, or ancient pre-Islamic ones. The actions against modern heritage sites took place at the same time as Da'esh's demolition

Denomination	Mosul–Old City	Nineveh Plain	Total
Sunni	35	6	41
Shiite	1	73	74
Yezidi	0	26	26
Christian	3	6	9
Other/Misc.	2	1	3
TOTAL	41	114	155

Table 9.2 Patterns of cultural heritage site destruction in the Old City of Mosul and on the Nineveh Plain east of the city, 2014–17. Data from RASHID International, *The Intentional Destruction of Cultural Heritage in Iraq as a Violation of Human Rights* (Munich: RASHID International, August 2017), 9, Table 1.

of the monumental winged bulls that adorned the main gates of the eighth- to seventh-century BCE Assyrian capital of Nineveh, opposite the Old City of Mosul.[48]

In all these attacks on Muslim, Yezidi, Christian, and ancient heritage monuments, Da'esh's performative destruction took the same form: a video record for later posting on the Internet and social media, in which a spokesman justified the action on Islamic religious grounds as a necessary and virtuous act, followed by the actual demolition of the monument. Da'esh defined this destruction of modern heritage sites as religiously sanctioned opposition to idolatry, using the same language it employed to justify genocidal attacks on modern enemy groups. Da'esh's innovation was the widely publicized performative nature of these acts. However, one of the most disturbing aspects of Da'esh's performative destruction framed in Salafi religious discourse was the concomitant genocidal destruction of people and things.

Conclusions: Genocide, Performative Destruction, and the Future of Viral Violence

Heritage destruction, cultural genocide, and the eradication of ethnic and religious communities are inextricably linked. The disturbing connection between cultural and physical genocide assumed special importance during World War II and its aftermath. Raphael Lemkin, who invented the term *genocide*, emphasized this linkage in his definition: "Genocide . . . is . . . a coordinated plan of different actions aiming at the destruction of essential foundations of the life of national groups, with the aim of annihilating the groups themselves."[49] For Lemkin, these foundations were both material and cultural.

Architecture, most notably the structures we consider heritage monuments, is emblematic of a culture and encompasses a complex set of meanings that together play a key role in defining a group's cultural identity. This linkage of the tangible and

intangible makes culturally significant architecture extraordinarily valuable to a group while at the same time making these same structures extremely vulnerable to attack by the people who seek to destroy that culture. For that reason, the destruction of culturally significant monuments has become linked to ethnic cleansing, characterizing various twentieth- and twenty-first-century conflicts.[50] Hannah Arendt captured the fundamental logic behind the power of this connection: "The whole factual world of human affairs depends for its reality and its continued existence, first, upon the presence of others who have heard and seen and will remember, and second, on the transformation of the intangible into the tangibility of things."[51] This explains why genocidal campaigns "inevitably wage war on material culture, why buildings are also seen as the enemy, and their death and humiliation every bit as necessary as those of enemy groups."[52]

This connection lies at the heart of Da'esh's performative destruction of cultural heritage in Syria and Iraq. The uncomfortable truth is that performative destruction works disturbingly well as a tool of propaganda and warfare for extremist groups. It was highly effective as a recruiting tool for Da'esh, who used it to attract roughly forty thousand people from 110 countries to come to Syria and join the caliphate.[53] The global reach of the Internet combined with the strong emotional impact of video imagery gave Da'esh a vastly larger and more diverse audience than it could otherwise have achieved and dramatically amplified the intensity of its ideological messages for friends and foes alike.

The paradox of Da'esh's performative destruction is jarring in that it merges the most modern multimedia communication technologies with religious ideologies that explicitly ground themselves 1,400 years in the past—in the seventh-century origins of Islam. This kind of fusion has only become possible within the last two decades. Acts of terrorism and heritage destruction had been publicized by earlier groups, such as the Taliban in their demolition of the Bamiyan Buddhas in 2001. However, the viral capabilities of the Internet enabled Da'esh to reach more people than any militant group before and to do so with great effectiveness. Da'esh showed a high degree of sophistication in integrating print media (its paper and online magazine *Dabiq*), well-produced video clips of executions and heritage destruction, and the power of the spoken word—as can be heard in the Quranic recitations in the video soundtracks. Da'esh reached large numbers of people comprising very different audiences: supporters to be kept informed, potential supporters to be recruited, and enemies to be polarized and intimidated. The nonhierarchical organization of the Internet made it extremely difficult to block or suppress Da'esh's messages: when they were removed from one platform, followers and supporters downloaded and recirculated the content through more poorly monitored or through encrypted forms of social media. The decentralized character of modern violent extremism meshes perfectly with the decentralized organization of the Internet, and this should be cause for deep concern.

Even after the military defeat of the Islamic State and the destruction of the caliphate as a territorial polity, it is almost certain that this innovative strategy of viral violence will allow Da'esh to survive, morph, and reorganize in a new decentralized form that will be extremely hard to counter or suppress.[54] In their online, post-caliphate life, Da'esh militants have become a community of

> connected content creators through the functionalities and reach of social media. During this time, IS's [Da'esh's] online responsivity to external events and interventions enabled it to make innovations at the collective level, such as multiplatform resource sharing, the move to encrypted messaging and chat rooms, and the use of shoutouts in response to suspensions, meaning that IS remained flexible, potent, and agentic online. Perhaps more significantly, through a combination of the affordances of social media (through which IS could satisfy supporters' key instrumental, identity, and relational needs), the decentralized nature of the group, and the unique psychological processes that occur through online interactions, IS created a new and innovative form of online, shared social identity.[55]

With the emergence of this new form of virtual community, the destruction of the caliphate as a territorial entity in 2019 simply means that Da'esh militants have migrated to a different environment.

The flexibility and potential power of the performative destruction paradigm is not limited to Da'esh and other jihadi Islamist groups and messages. It is likely that a broader range of nonstate armed extremist groups in other parts of the world will also emulate the core elements of the Internet-based performative destruction paradigm and adapt it to their own local conditions, ideologies, and goals.[56] Governments, international security structures, and the heritage community will need to develop innovative new legal and policy strategies to confront and hopefully neutralize this emerging threat.

SUGGESTED READINGS

Michael D. Danti, "Ground-Based Observations of Cultural Heritage Incidents in Syria and Iraq," *Near Eastern Archaeology* 78, no. 3 (2015): 132–41.

Christoph Gunther and Tom Bioly, "Testimonies for a New Social Order: The Islamic State's Iconic Iconoclasm," in *Image Testimonies: Witnessing in Times of Social Media*, ed. Kerstin Schankweiler, Verena Straub, and Tobias Wendl (London: Routledge, 2019), 154–66.

Bernard Haykel, "On the Nature of Salafi Thought and Action," in *Global Salafism: Islam's New Religious Movement*, ed. Roel Meijer (New York: Columbia University Press, 2009), 33–57.

Jack Moore, "European Parliament Recognizes ISIS Killing of Religious Minorities as Genocide," *Newsweek*, 4 February 2016.

Claire Smith, Heather Burke, Cherrie de Leiuen, and Gary Jackson, "The Islamic State's Symbolic War: Da'esh's Socially Mediated Terrorism as a Threat to Cultural Heritage," *Journal of Social Archaeology* 16, no. 2 (2016): 164–88.

NOTES

1. Bernard Haykel, "On the Nature of Salafi Thought and Action," in *Global Salafism: Islam's New Religious Movement*, ed. Roel Meijer (New York: Columbia University Press, 2009), 38–39; and *Oxford Research Encyclopedia of Religion*, s.v. "Salafism," by Joas Wagemakers, 5 August 2016, https://oxfordre.com/religion/view/10.1093/acrefore/9780199340378.001.0001/acrefore -9780199340378-e-255.

2. Wagemakers, "Salafism."

3. Wagemakers, "Salafism."

4. Haykel, "On the Nature of Salafi Thought," 41.

5. Haykel, "On the Nature of Salafi Thought," 48, 49.

6. Leslie Brubaker, "Making and Breaking Images and Meaning in Byzantium and Early Islam," in *Striking Images: Iconoclasms Past and Present*, ed. Stacy Boldrick, Leslie Brubaker, and Richard Clay (Farnham, UK: Ashgate, 2013), 13–24; and José Antonio González Zarandona, César Albarrán-Torres, and Benjamin Isakhan, "Digitally Mediated Iconoclasm: The Islamic State and the War on Cultural Heritage," *International Journal of Heritage Studies* 24, no. 6 (2018): 651–52.

7. Ninawa Media Office, "Fa's al-Khalil" (The Axe of the Khalil), Iraq, 2016, video. Quoted in Christoph Gunther and Tom Bioly, "Testimonies for a New Social Order: The Islamic State's Iconic Iconoclasm," in *Image Testimonies: Witnessing in Times of Social Media*, ed. Kerstin Schankweiler, Verena Straub, and Tobias Wendl (London: Routledge, 2019), 154–66.

8. Finbarr Barry Flood, "Between Cult and Culture: Bamiyan, Islamic Iconoclasm, and the Museum," *Art Bulletin* 84, no. 4 (2002): 641–59; Francesco Francioni and Federico Lenzerini, "The Destruction of the Buddhas of Bamiyan and International Law," *European Journal of International Law* 14, no. 4 (2003): 619–51; and Llewelyn Morgan, *The Buddhas of Bamiyan* (Cambridge, MA: Harvard University Press, 2012).

9. See the unofficial translation published in Flood, "Between Cult and Culture," 655.

10. Quoted in Mounir Bouchenaki, "Safeguarding the Buddha Statues in Bamiyan and the Sustainable Protection of Afghan Cultural Heritage," in *The Future of the Bamiyan Buddha Statues: Heritage Reconstruction in Theory and Practice*, ed. Masanori Nagaoka (Cham, Switzerland, and Paris: Springer and UNESCO, 2020), 24, https://unesdoc.unesco.org/ark:/48223/ pf0000375108.locale=en.

11. Bouchenaki, "Safeguarding the Buddha Statues," 24.

12. UNESCO, *Proceedings of the Doha Conference of 'Ulamâ on Islam and Cultural Heritage*, Doha, Qatar, 30–31 December 2001, 2005, 8, https://unesdoc.unesco.org/ark:/48223/pf0000140834.

13. Michael D. Danti, "Ground-Based Observations of Cultural Heritage Incidents in Syria and Iraq," *Near Eastern Archaeology* 78, no. 3 (2015): 138.

14. Thomas G. Weiss and Nina Connelly, *Cultural Cleansing and Mass Atrocities: Protecting Cultural Heritage in Armed Conflict Zones*, Occasional Papers in Cultural Heritage Policy no. 1 (Los Angeles: Getty Publications, 2017), https://www.getty.edu/publications/occasional-papers-1/; and Edward C. Luck, *Cultural Genocide and the Protection of Cultural Heritage*, Occasional Papers in Cultural Heritage Policy no. 2 (Los Angeles: Getty Publications, 2018), https://www.getty.edu/ publications/occasional-papers-2/.

15. See, e.g., Brubaker, "Making and Breaking Images"; and Natalie Naomi May, ed., *Iconoclasm and Text Destruction in the Ancient Near East and Beyond*, Oriental Institute Seminars, no. 8 (Chicago: Oriental Institute of the University of Chicago, 2012).

16. See González Zarandona, Albarrán-Torres, and Isakhan, "Digitally Mediated Iconoclasm."

17. Claire Smith et al., "The Islamic State's Symbolic War: Da'esh's Socially Mediated Terrorism as a Threat to Cultural Heritage," *Journal of Social Archaeology* 16, no. 2 (2016): 173; Claire Smith, "Social Media and the Destruction of World Heritage Sites as Global Propaganda," in *Proceedings of II International Conference on Best Practices in World Heritage: People and Communities, Mahon, Spain, 9 April–2 May 2015*, ed. Alicia Castillo Mena (Madrid: Universidad Complutense de Madrid, 2016), 27–49; and Claire Smith et al., "The Manipulation of Social, Cultural and Religious Values in Socially Mediated Terrorism," *Religions* 9, no. 5 (2018): 168.

18. Carsten Bockstette, *Jihadist Terrorist Use of Strategic Communication Management Techniques*, Marshall Center Occasional Paper Series, no. 20 (Garmisch-Partenkirchen, Germany: George C. Marshall European Center for Security Studies, 2008), 12; and Smith et al., "The Islamic State's Symbolic War," 177.

19. Jean-Pierre Filiu, *Apocalypse in Islam*, trans. M. B. DeBevoise (Berkeley: University of California Press, 2011); Harleen Gambhir, "*Dabiq*: The Strategic Messaging of the Islamic State," *Backgrounder*, Institute for the Study of War (ISW), 15 August 2014, https://www .understandingwar.org/sites/default/files/Dabiq%20Backgrounder_Harleen%20Final.pdf; Michael Pregill, "ISIS, Eschatology, and Exegesis: The Propaganda of Dabiq and the Sectarian Rhetoric of Militant Shi'ism," *Mizan* 1, no. 1 (2016), www.mizanproject.org/journal-issue/the -islamic-state-in-historical-and-comparative-perspective/; Michael W. S. Ryan, "Hot Issue: *Dabiq*—What Islamic State's New Magazine Tells Us about Their Strategic Direction, Recruitment Patterns and Guerrilla Doctrine," *Hot Issues*, 1 August 2014, https://jamestown.org/program/hot -issue-dabiq-what-islamic-states-new-magazine-tells-us-about-their-strategic-direction -recruitment-patterns-and-guerrilla-doctrine/; and David J. Wasserstein, *Black Banners of ISIS: The Roots of the New Caliphate* (New Haven, CT: Yale University Press, 2017), 177–96.

20. Gambhir, "*Dabiq*"; and Ryan, "Hot Issue: *Dabiq*."

21. Gambhir, "*Dabiq*," 1–2.

22. J. M. Berger and Jonathon Morgan, *The ISIS Twitter Census: Defining and Describing the Population of ISIS Supporters on Twitter*, Brookings Project on US Relations with the Islamic World, Analysis Paper no. 20 (Washington, DC: Brookings Institution, 2015), 2.

23. Smith et al., "The Islamic State's Symbolic War," 172.

24. Kevin McDonald, "ISIS Jihadis' Use of Social Media and 'the Mask' Reveals a New Grammar of Violence," *The Conversation*, 24 June 2014, https://theconversation.com/isis-jihadis-use-of -social-media-and-the-mask-reveals-a-new-grammar-of-violence-28355.

25. Gunther and Bioly, "Testimonies for a New Social Order," 154.

26. *Encyclopædia Iranica*, s.v. "Yazidis," by Christine Allison, 2004, http://www.iranicaonline.org/ articles/yazidis-i-general-1.

27. Valeria Cetorelli and Sareta Ashraph, *A Demographic Documentation of ISIS's Attack on the Yazidi Village of Kocho* (London: London School of Economics and Political Science, 2019), 8.

28. "The Revival of Slavery before the Hour," *Dabiq*, no. 4, October 2014.

29. Cetorelli and Ashraph, *A Demographic Documentation of ISIS's Attack*, 6; and RASHID International, Endangered Archaeology in the Middle East and North Africa (EAMENA), and Yazda, *Destroying the Soul of the Yazidis: Cultural Heritage Destruction during the Islamic State's Genocide against the Yazidis* (Munich: RASHID International, August 2019), 25, https://rashid -international.org/publications/report-destroying-the-soul-of-the-yazidis/.

30. RASHID International, EAMENA, and Yazda, *Destroying the Soul of the Yazidis*, 25.

31. Quoted in Patrick Wintour, "UN Condemns ISIS Genocide against Yazidis in Iraq and Syria," *Guardian*, 16 June 2016.

32. ISIS video quoted in Kareem Shaheen, "ISIS Blows Up Arch of Triumph in 2,000-Year-Old City of Palmyra," *Guardian*, 5 October 2015, https://www.theguardian.com/world/2015/oct/05/isis-blows

-up-another-monument-in-2000-year-old-city-of-palmyra; and Smith et al., "The Islamic State's Symbolic War," 178–79.

33. Counter Extremism Project, *ISIS's Persecution of Religions*, May 2017, https://www .counterextremism.com/sites/default/files/ISIS%27s%20Persecution%20of%20Religions_053017 .pdf.

34. F. Brinley Bruton, "Kerry: ISIS Is Committing Genocide against Yazidis, Christians and Shiite Muslims," NBC News, 17 March 2016, https://www.nbcnews.com/storyline/isis-terror/kerry -designate-isis-atrocities-genocide-n540706; Michael Kaplan, "ISIS Genocide against Christians, Yazidis? European Parliament Recognizes Islamic State Targeting Religious Minorities," *International Business Times*, 4 February 2016, http://www.ibtimes.com/isis-genocide-against -christians-yazidis-european-parliament-recognizes-islamic-state-2294384; and Jack Moore, "European Parliament Recognizes ISIS Killing of Religious Minorities as Genocide," *Newsweek*, 4 February 2016.

35. Haykel, "On the Nature of Salafi Thought," 41.

36. Counter Extremism Project, *ISIS's Persecution of Religions*.

37. Haykel, "On the Nature of Salafi Thought," 41.

38. Lizzie Dearden, "Baghdad Bombing: Iraqis Remind World That Most of ISIS' Victims Are Muslims after More than 160 Killed," *Independent*, 5 July 2016, https://www.independent.co.uk/ news/world/middle-east/baghdad-bombing-attack-isis-islamic-state-iraq-ramadan-shia-most -victims-muslims-killed-a7120086.html.

39. Matthew Bogdanos, "Casualties of War: The Truth about the Iraq Museum," *American Journal of Archaeology* 109, no. 3 (2005): 477–526.

40. Andrew Lawler, "War, More than ISIS, Is Destroying Syria's Ancient Sites," *National Geographic*, 25 November 2015, https://www.nationalgeographic.com/history/article/151125-isis-syria -satellite-images-looting-archaeology.

41. Gunther and Bioly, "Testimonies for a New Social Order," 161.

42. RASHID International, *The Intentional Destruction of Cultural Heritage in Iraq as a Violation of Human Rights* (Munich: RASHID International, 2017).

43. American Schools of Oriental Research, "Cultural Heritage Initiative," http://www.asor.org/chi/.

44. RASHID International, *Intentional Destruction of Cultural Heritage*. See also Roger Matthews et al., "Heritage and Cultural Healing: Iraq in a Post-Daesh Era," *International Journal of Heritage Studies* 26, no. 2 (2020): 120–41.

45. RASHID International, 9 (Table 1), and annex.

46. Miroslav Melcak and Ondrej Beranek, "ISIS's Destruction of Mosul's Historical Monuments: Between Media Spectacle and Religious Doctrine," *International Journal of Islamic Architecture* 6, no. 2 (2017): 389–415.

47. Sigal Samuel, Sara Farhan, and Atoor Lawandow, "ISIS Destroyed Jonah's Tomb, but Not Its Message," *Atlantic*, 24 July 2017, https://www.theatlantic.com/international/archive/2017/07/ tomb-of-jonah-mosul-isis/534414/.

48. Michael Danti, Scott Branting, and Susan Penacho, "The American Schools of Oriental Research Cultural Heritage Initiatives: Monitoring Cultural Heritage in Syria and Northern Iraq by Geospatial Imagery," *Geosciences* 7, no. 4 (2017), 95; and RASHID International, *Intentional Destruction of Cultural Heritage*.

49. Raphael Lemkin, *Axis Rule in Occupied Europe: Laws of Occupation, Analysis of Government, Proposals for Redress* (Washington, DC: Carnegie Endowment for International Peace, 1944), 79.

50. Robert Bevan, *The Destruction of Memory: Architecture at War* (London: Reaktion, 2006), 203.

51. Hannah Arendt, *The Human Condition: A Study of the Central Dilemma Facing Modern Man* (Chicago: University of Chicago Press, 1958), 13.

52. Steven Matthewman, review of *The Destruction of Memory: Architecture at War*, by Robert Bevan, *Journal of Sociology* 43, no. 3 (2007): 319.

53. Richard Barrett, *Beyond the Caliphate: Foreign Fighters and the Threat of Returnees* (Soufan Center and Global Strategy Network, October 2017), 7, https://thesoufancenter.org/research/beyond-caliphate/. See also Meirav Mishali-Ram, "Foreign Fighters and Transnational Jihad in Syria," *Studies in Conflict and Terrorism* 41, no. 3 (2018): 169–90.

54. See, e.g., Tobias Borck and Jonathan Githens-Mazer, "Countering Islamic State's Propaganda: Challenges and Opportunities," in *ISIS Propaganda: A Full-Spectrum Extremist Message*, ed. Stephane J. Baele, Katharine A. Boyd, and Travis G. Coan (New York: Oxford University Press, 2020), 219–41; and Thomas Hegghammer, "The Future of Jihadism in Europe: A Pessimistic View," *Perspectives on Terrorism* 10, no. 6 (2016), https://www.universiteitleiden.nl/perspectives-on-terrorism.

55. Laura Wakeford and Laura Smith, "Islamic State's Propaganda and Social Media: Dissemination, Support, and Resilience," in *ISIS Propaganda*, ed. Baele, Boyd, and Coan, 155–87.

56. See, for example, the discussion in Smith et al., "Manipulation of Social, Cultural and Religious Values"; and in Paul Gill et al., "Terrorist Propaganda after the Islamic State: Learning, Emulation, and Imitation," in *ISIS Propaganda*, ed. Baele, Boyd, and Coan, 242–64.

10

The Destruction of Aleppo: The Impact of the Syrian War on a World Heritage City

Francesco Bandarin

Ten years of war have destroyed Syria's economic, social, and cultural structures. The country that existed in 2011 is hardly recognizable today, except for a few areas that have been preserved from destruction.[1] This chapter addresses the destruction of the World Heritage Site of Aleppo during the conflict that raged in the city from 2012 to 2016. In addition to an assessment of the physical destruction of the city's cultural heritage, housing, and infrastructure, also examined are the impact of the war on the social fabric of the city and the role played by the different national and international actors involved in the conflict. Finally, the effectiveness of international law for the protection of cultural heritage and of civilians during the Syrian war is discussed.

In 2011, Syria was already in poor economic condition, following a long global recession and a chronic inability to develop a modern industrial sector. Over half the national product came from the primary sectors—agriculture and mining—with industry representing just 3–4 percent of the total.

Within a few months of the start of the conflict, the country's economic situation declined precipitously: oil resources largely fell into the hands of the Islamic State of Iraq and Syria (ISIS, also known as ISIL or Da'esh) and the Kurdish forces, deepening a recession caused by sanctions and devastation. Meanwhile, consumer prices also rose sharply,[2] while the national currency, the Syrian pound, depreciated significantly, and black markets arose for essential products, further stretching people's ability to purchase necessary goods.[3] Most basic public social services, from health to education and social assistance, collapsed, with half of all children out of school for most of the decade. Diseases such as typhoid, tuberculosis, hepatitis A, and cholera again became endemic, as did polio, which had previously been eradicated in Syria. The conflict has not spared the health infrastructure of the country, as half of all hospitals have suffered

significant damage, especially in urban areas fought over, including Aleppo, Raqqa, Deir ez-Zor, and Idlib.

Private activities, ranging from services to commerce, arts and crafts, and transport have also suffered losses and disruption. The devastation suffered by Syria's physical infrastructure, including residential and commercial buildings and industrial complexes, has caused a huge loss of income and pushed millions into poverty. The UN Development Programme (UNDP) underlines the problem: by 2016 Syria had fallen to 173rd place on UNDP's Human Development Index, out of 188 countries.[4]

But the worst calamity has been the dispersal of the Syrian population due to the violence. In 2010 Syria had an estimated population of 21.8 million, which shrank to 20.5 million in 2015[5] and 19.4 million in 2018. It is estimated that at least five hundred thousand people were killed and two million wounded during the war; over 6.5 million people were internally displaced, and over five million, equal to over 20 percent of the country's population, became international refugees. According to the United Nations High Commissioner for Refugees (UNHCR), the refugees are, still today, dispersed throughout neighboring countries and Europe: almost 40 percent are in Turkey, 35 percent in Lebanon, and 14 percent in Jordan, with the rest in Egypt, Iraq, and Europe (mostly Germany).[6] And as of mid-2020 this long conflict was not yet over, although fighting was limited to specific pockets of resistance, such as in Idlib Province in the northwest (fig. 10.1).

Damage inflicted on the physical infrastructure of Syria, including its monuments and historical and heritage places, has been immense, due to the direct impact of war and the loss of control by the authorities over the country's vast archeological and cultural heritage. Direct damage was caused to many historical monuments and sites when they were used by armies and militias for shelter or as military outposts to control the surrounding areas.[7] This is the case, for example, for the citadels of Homs, Hama, and Aleppo, the medieval Crusader castle of Crac des Chevaliers/Qal'at al-Ḥusn, and the Qal'at ibn Ma'an fortress in Palmyra. While some monuments were damaged accidentally, such as the al-Wakfya Library in the Great Umayyad Mosque of Aleppo, many were deliberately destroyed, such as the important temples of Bel and Baalshamin in Palmyra, dynamited by ISIS in 2013.[8]

Entire urban areas, many of them of great historical value, have been devastated: besides Aleppo (fig. 10.2), the old cities of Homs, Daraa, and Bosra have suffered heavy damage.[9] The conflict environment also enabled looting on an unprecedented scale. All the major archaeological sites of Syria have been subject to massive illegal excavations aimed at retrieving archaeological "treasures" to sell on the black market, including the ancient Sumerian city of Mari (Tell al-Harīrī), the site of Ebla (Tell Mardikh), the Hellenistic and Roman sites of Apamea (Qal'at al-Madhīq), and Dura-Europos, resulting in a great loss of historical and archaeological value.[10] Damage to natural heritage was also significant, with many forests and oases bombed and burned.

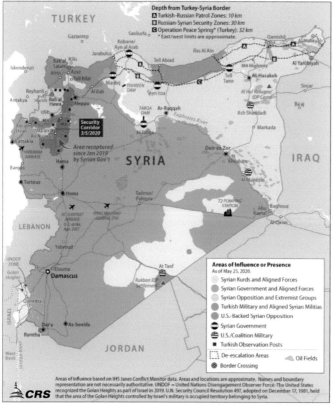

Figure 10.1 The situation in Syria in 2020. Congressional Research Service (CRS), *Armed Conflict in Syria: Overview and US Response* (Washington, DC: CRS, updated 27 May 2020), 4. Image: Foresight Intelligence by IHS Markit. View map at www.getty.edu/publications/cultural-heritage-mass-atrocities/part-2/10-bandarin/#fig-10-1-map.

The War in Aleppo: A Social and Cultural Tragedy

The so-called Battle of Aleppo, one of the longest and most deadly conflicts since World War II, raged for five years, from 2012 to the end of 2016, and involved a range of actors, both on the Syrian government's side (the Syrian army, Hezbollah, other Shiite militias, Iranian government forces, and later the Russian army) and on that of the opposition (the Free Syrian Army, the Aleppo Military Council, ISIS, the Levant Front—also known as al-Jabha al-Shamiya—Jabhat al-Nusra, and the Syrian Islamic Front). Kurdish militias such as the People's Protection Units (YPG), other US-backed groups, and the Turkish army were also involved. Many of these groups were loosely organized, with frequent movements of fighters from one to another.

The war in Aleppo took place over several phases, with different degrees of destruction and impact on a civilian population that paid a very high price, affected directly by aerial bombing, shelling, snipers, mine explosions, fighting, and indirectly by food deprivation, destruction of health facilities, lack of water and electricity, and transfers to refugee camps. Humanitarian organizations involved in the conflict, observers, and scholars[11] have attempted to collect information from the conflict areas, enabling an understanding of the conflict's evolution and its impact on the population, on the city's infrastructure, and on the city's heritage.[12] The war can be schematically

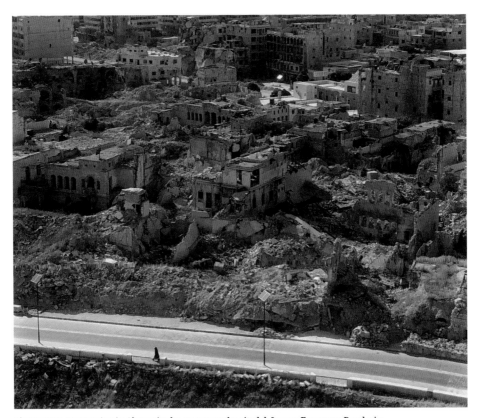

Figure 10.2 Destruction in Aleppo in the area near the citadel. Image: Francesco Bandarin

divided into four phases, each of which is discussed in turn: the opposition takeover of
Aleppo (2012–13), the reaction (Operation Northern Storm, 2013–14), the war of attrition
(2015), and the retaking of the city (2016).

Although military operations started at the beginning of 2012 when the Free Syrian
Army took control of areas in the north of the city, fighting began in July of that year,
when the nearby town of Anadan was captured, opening the way to the capture of the
city. The reaction of government forces was immediate and strong, involving the use of
tanks, snipers, and aerial bombing, destroying many buildings and public facilities. In
September, from the north and east, fighting reached the Old City of Aleppo, and
shelling extensively damaged the central market area of al-Madina Souk, with the loss of
about a thousand shops. In October, the Great Umayyad Mosque suffered its first wave
of destruction when opposition forces attacked it to expel government soldiers.[13] By the
end of 2012, government forces had lost important positions, such as Sheikh Suleiman
army base to the west and the infantry school north of Aleppo, and were increasingly
isolated in the city's western areas. In February 2013, ISIS captured the air defense
facility near Aleppo International Airport, and aerial bombing in the city intensified,
especially on its eastern side. The violence led to the first exodus of the city's civilian
population, with over three hundred thousand people fleeing to Turkey and other parts
of Syria. Heavy fighting took place in the Old City, as the citadel was under the control of

the Syrian army.[14] On 24 April 2013, the medieval minaret of the Great Umayyad Mosque was destroyed.

After having lost most of their strongholds in the Aleppo countryside by mid-2013, government forces were effectively encircled within the city, provoking a counteroffensive, Operation Northern Storm. This was launched in September, and the army, supported by allied militias, managed to retake the air defense facility from ISIS. Shelling and bombing intensified, with great impact on the civilian population. Late that year, infighting started between ISIS and other opposition forces, enabling the government to regain control of some areas of the city, including the strategic Sheikh Najjar industrial district. ISIS itself took control of villages to the north of Aleppo, consolidating its control over northern Syria. However, continued infighting allowed government forces to reorganize, break a blockade of part of the city, and further consolidate their positions. Meanwhile, the situation of the population in Aleppo continued to deteriorate: by this point, over one million people had already left the fifty neighborhoods located in the eastern, opposition-held areas, mostly to escape barrel bombing and shelling, while these neighborhoods also hosted around 512,000 internally displaced persons (IDPs). Then on 8 May 2014, a massive explosion destroyed the Carlton Hotel near the citadel: the opposition had built a seventy-five-meter-long tunnel underneath it, fitted with explosives, a new tactic repeatedly used afterward against government bases in the Old City and citadel, with massively destructive effects.[15]

By 2015 the conflict had become a war of attrition, and, toward the end of the year, Russia increased its military support of the Syrian government and prepared to intervene directly. In October, government forces also launched a new offensive near the city to regain control of the international highway to the south and toward Kuweires military air base to the east, which had been under siege for two years by ISIS. Both operations were successful, with Russian air support and the presence of Iranian militias proving decisive. They also accelerated the displacement of the city's population, with the evacuation of entire districts.[16]

These developments led to the retaking of Aleppo by the government in 2016. At the beginning of the year, a cease-fire brokered by Russia and the United States had briefly allowed life in Aleppo to take a normal turn, but the support provided by Russia, Hezbollah, and the Iranian government continued to change the military balance on the ground. Despite setbacks, by July the government had completed its encirclement of the city, cutting off the corridor linking the areas controlled by the opposition to the Turkish border. Nevertheless, the siege of the city was broken within days by an opposition counterattack on the Ramousah district, opening a way into eastern Aleppo and leading to a response by the Syrian army supported by the Russian air force. Meanwhile, opposition groups and a powerful international force started a campaign to eliminate ISIS from the region. This helped government forces consolidate control of northern parts of the city and again place Aleppo under siege (fig. 10.3).

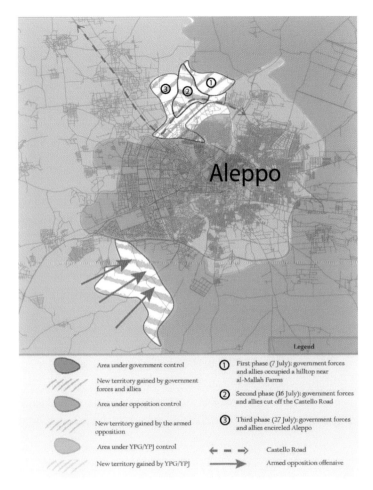

Aleppo

Figure 10.3 The siege of Aleppo, July 2016. Armenak Tokmajyan, *Aleppo Conflict Timeline* (Budapest: Central European University, 2016), 3. Image: Reproduced with kind permission from CEU, The Aleppo Project. View map at www.getty.edu/publications/cultural-heritage-mass-atrocities/part-2/10-bandarin/#fig-10-3-map.

Legend

Area under government control	First phase (7 July): government forces and allies occupied a hilltop near al-Mallah Farms
New territory gained by government forces and allies	
Area under opposition control	Second phase (16 July): government forces and allies cut off the Castello Road
New territory gained by the armed opposition	Third phase (27 July): government forces and allies encircled Aleppo
Area under YPG/YPJ control	Castello Road
New territory gained by YPG/YPJ	Armed opposition offensive

After heavy bombing hit the eastern part of the city controlled by the opposition, pressure from government and allied forces gradually forced the opposition to accept a cease-fire, permitting aid delivery.[17] With the mediation of Turkey and Russia, an agreement was reached to evacuate over thirty-five thousand opposition fighters, as well as part of the civilian population, and transfer them to Idlib Province, an operation carried out between 15 and 22 December 2016, effectively ending the siege and the war in Aleppo.

The Impact of the War on the Population

The population of Aleppo was estimated at around 3,078,000 on the eve of the war, in 2010. It had fallen to less than a million by 2015 at the peak of the fighting.[18] Although it is difficult to know precisely the number of direct casualties from the war in the city, estimates suggest that 25,000–30,000 civilians lost their lives, with a further 10,000–15,000 casualties among combatants.[19] Throughout the conflict, Aleppo was divided in two, the western side controlled by the government and the eastern side by the opposition. Although the entire city was involved in the conflict and suffered

bombing and destruction throughout, most of the fighting took place in the center, the area surrounding the ancient Aleppo Citadel, and on the east side.

The population stranded in the city endured severe hardship, with frequent cuts to the supply of water,[20] electricity, and food,[21] and constant exposure to shelling and bombing. Access to healthcare and basic necessities was severely impeded, and transit between different parts of the city was almost impossible, as well as extremely risky. Hundreds of people were killed by sniper fire at the crossing between areas held by the government and the opposition, and it became increasingly difficult to transport goods through this zone. Relief provided by humanitarian organizations such as the International Committee of the Red Cross (ICRC) and the Syrian Arab Red Crescent was occasionally granted access by the different factions, and food rations were delivered in both opposition- and government-held areas, although this help was always limited and insufficient.[22]

It is estimated that one-third of the school buildings in Aleppo were either damaged or used for other purposes during the conflict, such as shelter for displaced persons. Frequent bombing and casualties among teachers and children forced many schools to close or drastically reduce activities. At one point, only 6 percent of children were attending classes, a situation that prompted the United Nations Children's Fund (UNICEF) to declare Syria's children a "lost generation."[23]

Various aspects of the city's medical services were severely impacted. The city's blood bank was bombed in 2012, leaving the city without blood supplies.[24] By late 2014 all the major hospitals in Aleppo had suffered damage and were forced to cut services, leaving only forty doctors left in Aleppo to serve the needs of over a million people, compared to two thousand doctors before the war. Indeed, the World Health Organization (WHO) ranked Syria as the most dangerous place in the world for health workers.[25] The lack of vaccinations favored the resurgence of infectious diseases, while poor hygienic conditions favored a recurrence of cholera, and the destruction of pharmaceutical plants resulted in a critical shortage of medicines and supplies for a variety of diseases, ranging from diabetes to epilepsy, hypertension, asthma, and cancer.[26] As a result of all this, life expectancy in Syria dropped by twenty years, to fifty-five.

By mid-2016, most of the population of eastern Aleppo had fled, but an estimated 250,000 people still remained under siege.[27] Aerial bombing became particularly intense in the last phase of the war, leading to a dramatic worsening of the condition of the civilian population.[28]

The Impact of the War on Urban Infrastructure and Cultural Heritage

Five years of conflict left Aleppo in rubble. The fighting and bombing campaigns at different stages of the war, with a huge spike in 2016, severely affected housing, commercial and industrial buildings, public services, infrastructure, and the city's monuments and historical districts.

Assessment of physical damage was carried out during and after the war by the World Bank for the entire urban infrastructure, by UN-Habitat in 2014 and by the UN Institute for Training and Research (UNITAR) in 2016 for the building stock, and by the United Nations Educational, Scientific and Cultural Organization (UNESCO), UNITAR, and the Aga Khan Trust for Culture (AKTC) in 2017 for the monumental areas of the city.[29]

Aleppo's thermal power plant, the largest in the country and the main source of electricity for 60 percent of the population, remained in the hands of the opposition until being recaptured by government forces in February 2016, resulting in significant damage and gradually putting it out of commission. As a consequence, from that point on, eastern and southern Aleppo received no power from the public network, while the western part of the city had only two to three hours of service per day. In the latter area, traditionally more affluent, private generators, solar panels, and makeshift wind-powered turbines partially compensated for the lack of power distribution, but at an increasingly high cost. The water distribution infrastructure was also badly damaged, with major interruptions due to shortages of fuel and electricity, although limited repairs were possible during the war, reestablishing some service to the city. Households often had to rely on wells or water trucks, with increasing health-related risks. The sewage treatment plant was not damaged, but suffered stoppages for lack of power. An initial estimate by the World Bank of damage to the city's infrastructure indicates that it quadrupled from 2014 to 2016, to almost $8 billion.[30]

Arguably the most significant damage was to residential buildings. The city had 720,000 housing units in 2011, mostly in multistory buildings, largely in private ownership. About 50 percent of the units were abandoned during the war, due to damage, lack of basic services, and security. The greatest destruction occurred in the more densely populated and poorer eastern districts, where most of the aerial attacks were concentrated. Here, most of the housing is of an "informal" nature, built in areas of uncertain land tenure. Most of the commercial buildings in these districts were also damaged and over 70 percent of industrial structures damaged or destroyed. A 2018 report by UNITAR and UNESCO documented damage at the end of 2016 to more than 33,500 structures in Aleppo.[31] The intensity of structural damage varied from a maximum of 65 percent in the central al-Aqabeh neighborhood to 50 percent in the periphery.[32] Figure 10.4 shows a map of the intensity of damage in different parts of the city in September 2016, before the final fight for control, characterized by massive aerial bombing.

The areas surrounding the citadel suffered heavy damage due to shelling, aerial bombing, and tunnel bombs placed beneath buildings.[33] The more significant losses resulting from the conflict are concentrated to the southeast of the citadel, and include, among other structures, the Madrasa al-Sultaniyya (built in 1223), the al-Khusrawiyya complex (1531–34) designed by Mimar Sinan, the al-Adiliyya Mosque (1553), and the al-Utrush Mosque (1398). Some of the most important historical caravanserais, or inns,

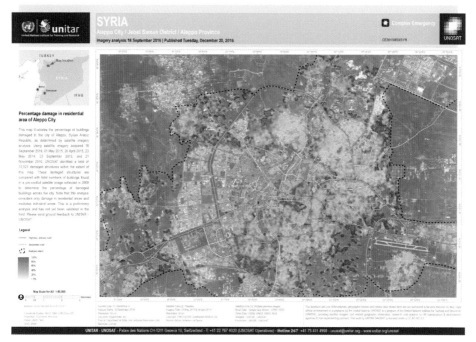

Figure 10.4 Aleppo damage analysis, September 2016. UNITAR, "Percentage Damage in Residential Area of Aleppo City," https://unitar.org/unosat/node/44/2510. Image: UN Satellite Centre – UNOSAT / UNITAR. View map at www.getty.edu/publications/cultural-heritage-mass-atrocities/part-2/10-bandarin/#fig-10-4-map.

the khans, were also severely damaged, including the Khan al-Sabun of the Mamluk period (late fifteenth century), and the Ottoman-era Khan al-Nahhasin (1556). Like the Carlton Hotel, another important building dating from modern times, the New Saray government palace was completely destroyed by tunnel bombs (fig. 10.5). The celebrated Aleppo Citadel was also damaged, as its walls and towers along the north and east sides were hit by shelling. An internal tower and some of the buildings were also destroyed, although damage was relatively limited inside the complex.

The most significant heritage losses involved the Great Umayyad Mosque, including the destruction of its eleventh-century minaret in 2013 (fig. 10.6) and cracks in the structure of the building. Many precious historical manuscripts were also looted; the historical wooden minbar, or pulpit, was dismantled and stolen; and many wooden doors and decorations were burned. Furthermore, many sections of the al-Madina Souk area and other medieval buildings in the city were destroyed, severely damaged, or burned as a result of fighting.[34]

After the end of the conflict in December 2016, the situation in Aleppo rapidly improved, although the city is far from regaining the position of being the economic powerhouse that Syria enjoyed before the war.[35] Many people have returned and life has restarted, and some important restoration projects have been implemented with local and national resources, and with the help of some international agencies, such as UNDP, UN-Habitat, and AKTC.[36] However, economic reconstruction and development have proven slower than expected and hoped, largely due to the international sanctions

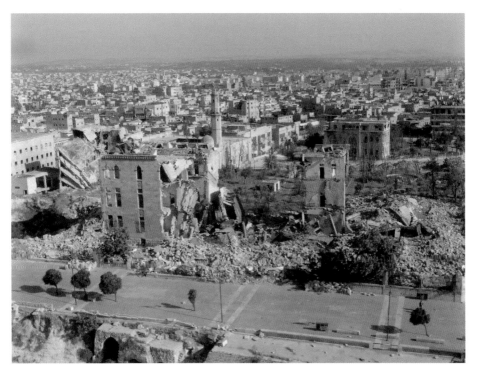

Figure 10.5 The destroyed New Saray. Image: Francesco Bandarin

against the Syrian government, which have prevented foreign investment and the transfer of resources to the country.[37]

Conclusion: Lessons for the Protection of Culture in Armed Conflict

The effectiveness of the international system of protection for populations and cultural heritage during conflict is put into question by the immense suffering the civil war imposed on the population of Aleppo and the massive damage suffered by a World Heritage City of such importance, not to mention the damage suffered by other historical cities such as Homs and Bosra and archaeological sites of global significance, including Palmyra, Apamea, Mari, and Ebla. Yet the United Nations system did, in the post–World War II period, develop tools to address situations of this nature.[38] For cultural heritage protection, the main tools are the 1954 Hague Convention for the Protection of Cultural Property in the Event of Armed Conflict, the 1970 Convention on the Means of Prohibiting and Preventing the Illicit Import, Export and Transfer of Ownership of Cultural Property, and the 1972 Convention Concerning the Protection of the World Cultural and Natural Heritage.

The 1954 Hague Convention introduced very specific obligations for its signatories, to prevent and limit damage to movable or immovable cultural heritage (including "groups of buildings which, as a whole, are of historical or artistic interest") and more generally to buildings dedicated to cultural activities (museums, libraries, archives, etc.). The convention applies also to "conflicts not of an international character." Syria is a

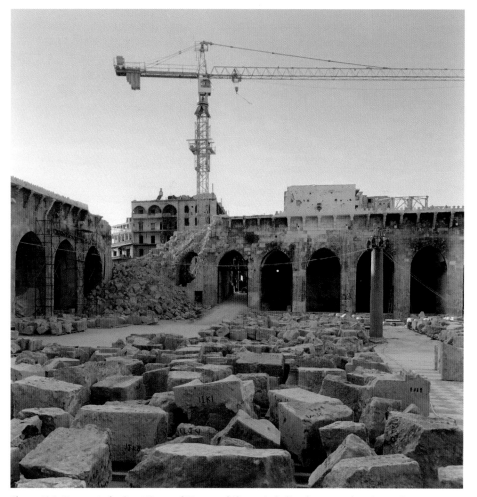

Figure 10.6 Damage to the Great Umayyad Mosque of Aleppo, including damage to the minaret. Image: Francesco Bandarin

signatory to the convention (although not of its First and Second Protocols), as are all the other states directly or indirectly involved in the conflict. It obliges state parties to respect cultural heritage by avoiding its use for military purposes (Article 4.1) and by preventing acts of theft and pillage of cultural properties (Article 4.3). Nonstate actors are also bound to apply its provisions (Article 19.1). Even sanctions are foreseen in case of breach of the convention (Article 28). However, at no time during the conflict in Syria, and in particular in Aleppo, has the Hague Convention been implemented, respected, or applied by the actors involved. While the 1970 convention has been implemented to intercept looted Syrian antiquities, observers agree that its impact on the illicit trade has been very limited. The 1972 convention has no provision for situations of conflict, but it calls for international cooperation for the preservation of World Heritage Sites. All states involved in the conflict are signatories of the 1972 convention and were therefore obliged to limit the damage they caused to Aleppo.

The UN Security Council has acted to protect Syrian cultural heritage by adopting two resolutions, 2199 of February 2015 and 2347 of March 2017, the latter of which "condemn[ed] the unlawful destruction of cultural heritage, inter alia, destruction of religious sites and artefacts, as well as the looting and smuggling of cultural property from archaeological sites, museums, libraries, archives, and other sites . . . notably by terrorist groups" (para. 1).

In spite of these and other important appeals, no effective response mechanism to limit the destruction of cultural heritage was put in place during the conflict. In 2013, UNESCO's World Heritage Committee inscribed all six Syrian World Heritage Sites (Damascus, Aleppo, Palmyra, the Crac des Chevaliers, the Ancient Villages of Northern Syria, and Bosra) on the World Heritage in Danger List, but, again, little concrete help was provided. In fact, most Western countries applied sanctions to Syria that prevented the transfer of money and technical assistance, even for cultural heritage protection, a situation that changed only in 2021. During the conflict, the only help came from the European Commission, a European Union body, which financed a multiyear project, implemented by UNESCO and by the International Centre for the Study of the Preservation and Restoration of Cultural Property (ICCROM), to provide support for the conservation of Syrian sites, although most of the activities were carried on outside the country.[39] However, this project was not extended after its completion in 2020.[40]

Similar observations could be made in relation to the implementation of humanitarian laws in the event of armed conflict, in particular the fourth Geneva Convention of 1949, which has been ratified by all states in the conflict (in fact by all states worldwide). It is clear that these treaties have revealed major shortfalls in providing protection to the population and to cultural heritage during a conflict of a non-international nature, such as the Battle of Aleppo.

UNESCO has worked in the past few years to address the weakness of the present system of international heritage protection by launching important initiatives.[41] It is clear, however, that awareness-raising is not sufficient: to increase heritage protection during conflict, existing mechanisms need to be substantially reinforced through a more systematic integration of cultural protection into humanitarian interventions and a greater involvement of military forces. Recent examples of successful operations (such as that of the UN Multidimensional Integrated Stabilization Mission in Mali [MINUSMA], created in 2013) show that it is possible to embed cultural heritage protection into military operations. Indeed, Security Council resolution 2347 linked the protection of cultural heritage to the maintenance of peace and security, suggesting that peacekeeping operations could be mandated to carry out such tasks. In 2018, the European Union Common Security and Defence Policy endorsed the "protection of cultural heritage" as a line of operation for missions.

This approach should at a minimum be extended to all UN peacekeeping missions where sites of cultural significance are located, while the current trend seems to go in the opposite direction. A more active role for humanitarian organizations, such as the

Red Cross, should also be promoted, and financial support provided to expand their role for cultural heritage protection during protracted conflicts. Short of this, during conflict, the protection of cultural heritage, an essential constituent of social identity and cohesion, will remain in the realm of goodwill declarations.

SUGGESTED READINGS

Leila Amineddoleh, "The Legal Tools Used before and during Conflict to Avoid Destruction of Cultural Heritage," *Future Anterior* 14, no. 1 (2017): 37–48.

Francesco Bandarin, "The Reconstruction and Recovery of Syrian Cultural Heritage: The Case of the Old City of Aleppo," in *Collapse and Rebirth of Cultural Heritage*, ed. Lorenzo Kamel (New York: Peter Lang, 2020), 45–77.

Ross Burns, *Aleppo: A History* (New York: Routledge, 2017).

Raymond Hinnebusch and Adham Saouli, *The War for Syria* (New York: Routledge, 2020).

UNESCO and UNITAR, *Five Years of Conflict: The State of Cultural Heritage in the Ancient City of Aleppo* (Paris: UNESCO, 2018).

Carmit Valensi and Itamar Rabinovich, *Syrian Requiem: The Civil War and Its Aftermath* (Princeton, NJ: Princeton University Press, 2021).

NOTES

1. Samer Abboud, *Syria* (Cambridge: Polity Press, 2016); Ross Burns, *Aleppo: A History* (New York: Routledge, 2017); and Raymond Hinnebusch and Adham Saouli, *The War for Syria* (New York: Routledge, 2020).
2. Syrian Center for Policy Research (SCPR), *The Conflict Impact on Social Capital: Social Degradation in Syria* (Damascus: SCPR and Friedrich Ebert Stiftung, 2017).
3. Aron Lund, *The Factory: A Glimpse into Syria's War Economy* (New York: Century Foundation, 2018).
4. UNDP, *Human Development Report 2016* (New York: UNDP, 2016).
5. SCPR, *Forced Dispersion: A Demographic Report on Human Status in Syria* (Damascus: SCPR, 2016).
6. UNHCR, "Syria: Operational Update," January 2020.
7. Cheikmous Ali, "Syrian Heritage under Threat," *Journal of Eastern Mediterranean Archaeology & Heritage Studies* 1, no. 4 (2013): 351–66.
8. Helga Turku, *The Destruction of Cultural Property as a Weapon of War: ISIS in Syria and Iraq* (London: Palgrave Macmillan, 2018).
9. Susan Schulman, "From Homs to Aleppo: A Journey through the Destruction of the Syrian War," *RUSI Journal* 163, no. 1 (2018): 62–81.
10. Research funded by the American Schools of Oriental Research analyzed 3,641 sites in Syria, comparing pre-2011 imagery with site surveys during the conflict. Of the sites surveyed up to 2017, pre-2011 imagery revealed illegal digging at 450, with an additional 355 added in the post-2011 era. Ninety-nine of the sites already marked by looting pits before 2011 were active again after this; the rest were the work of looters exploring previously undisturbed sites. See Jesse Casana and Elise Jakoby Laugier, "Satellite Imagery-Based Monitoring of Archaeological Site Damage in the Syrian Civil War," *PLoS ONE* 12, no. 11 (2017), https://journals.plos.org/plosone/article?id=10.1371/journal.pone.0188589.

11. There have been several groups monitoring the Syrian conflict, supported by international organizations (see reports by UNDP, UNICEF, UNHCR, UN-Habitat, UNESCO, UNITAR, and the World Bank), governments (including reports by the United States Agency for International Development or USAID, the US Congress, the Atlantic Council, and the International Institute for Environment and Development), and nongovernmental organizations (NGOs) and research organizations (e.g., Caerus Associates, the Shattuck Center, the Syrian Center for Policy Research), to mention but a few.

12. Keith A. Grant and Bernd Kaussler, "The Battle of Aleppo: External Patrons and the Victimization of Civilians in Civil War," *Small Wars & Insurgencies* 31, no. 1 (2020): 1–33; Armenak Tokmajyan, *Aleppo Conflict Timeline* (Budapest: Central European University, 2016); David Kilcullen, Nate Rosenblatt, and Jwanah Qudsi, *Mapping the Conflict in Aleppo, Syria* (Washington, DC: Caerus Associates, 2014); and Reuters, "Timeline: The Battle for Aleppo," 14 December 2016.

13. The opposition groups were part of Liwa al-Tawhid, the largest of the two coalitions forming the Aleppo Military Council (AMC), which led the battle for the city. At some point, the AMC had between eight thousand and ten thousand fighters, and another ten thousand noncombat members.

14. On 1 October 2014, UNESCO director-general Irina Bokova stated that, as a signatory to the 1954 Hague Convention for the Protection of Cultural Property in the Event of Armed Conflict, Syria was obliged to safeguard its heritage from the ravages of war. See Oliver Holmes, "Fighting Spreads in Aleppo Old City, Syrian Gem," Reuters, 1 October 2012.

15. Martin Chulov, "Bomb under Hotel Signals New Focus of Syrian Oppositions, with Struggle for City Likely to Be Final Showdown," *Guardian*, 8 May 2014.

16. Tom Miles, "United Nations Says 120,000 Displaced in October," Reuters, 26 October 2015.

17. According to the Syrian Network for Human Rights (SNHR), Aleppo was hit by 4,045 barrel bombs in 2016, with 225 falling in December.

18. After the end of hostilities in 2016, many people returned to the city, and the population has since then steadily increased, although it still remains at a much lower level than before the war. As of 2020, there are an estimated 1,916,000 people in Aleppo; it will likely take ten more years before the population returns to its 2010 level.

19. These are the victims documented by the Violation Documentation Center in Syria (VDC), an NGO that attempts to document civil rights violations in the country. See VDC, "Monthly Statistical Report on Casualties in Syria: March 2020," https://vdc-sy.net/monthly-statistical-report-casualties-syria-march-2020-en/.

20. El-Dorar, "After the Water Cut Off for 80 Days, Aleppo Water Plants Starts [*sic*] Pumping," 3 March 2016; and al-Arabiya, "Water Returns to Syria's War-Torn Aleppo," 4 March 2016.

21. Tokmajyan, *Aleppo Conflict Timeline*.

22. ICRC, "Syria: Aleppo Civilians under Attack," news release 14/65, 22 April 2014; and "Life in a War-Torn City: Residents of Aleppo Tell Their Stories," *International Review of the Red Cross* 98, no. 1 (2016): 15–20.

23. UNICEF, *Syria's Children: A Lost Generation? Crisis in Syria: Two-Year Report 2011–2013* (New York: UNICEF, 2013).

24. Nayanah Siva, "Healthcare Comes to Standstill in East Aleppo as Last Hospitals Are Destroyed," *British Medical Journal* 355 (2016): 355.

25. From March 2011 to June 2016, there were 382 attacks on medical facilities, and 757 medical personnel were killed, according to the NGO Physicians for Human Rights. The World Health Organization has repeatedly expressed its concern for the destruction of hospital facilities. See WHO, "WHO Condemns Massive Attacks on Five Hospitals in Syria," public statement, 16 November 2016.

26. Physicians for Human Rights, "Syria's Medical Community under Assault," October 2014.

27. BBC, "Syria Conflict: 'Exit Corridors' to Open for Aleppo, Says Russia," 28 July 2016.

28. These are very uncertain figures, varying from over three hundred thousand down to around 130,000, according to different sources (e.g., the UN and the local council of Aleppo). Attempts to provide humanitarian help to the population besieged in eastern Aleppo failed on two occasions in 2016 (March and July) when UN convoys to the area were authorized to provide for a lower number of beneficiaries (sixty thousand), but in the end they were not delivered. See Annabelle Böttcher, "Humanitarian Aid and the Battle of Aleppo," News Analysis, Center for Contemporary Middle East Studies, University of Southern Denmark, January 2017.

29. UNESCO and UNITAR, *Five Years of Conflict: The State of Cultural Heritage in the Ancient City of Aleppo* (Paris: UNESCO, 2018); and AKTC, *Old City of Aleppo: Building Information and Preliminary Damage Assessment in Three Pilot Conservation Areas* (Geneva: AKTC, 2018).

30. World Bank, *Syria Damage Assessment of Selected Cities Aleppo, Hama, Idlib: Phase III, March 2017* (Washington, DC: World Bank, 2017).

31. UNESCO and UNITAR, *Five Years of Conflict*. For a comprehensive analysis of damage to Syrian cities, see REACH and UNITAR, *Syrian Cities Damage Atlas: Thematic Assessment of Satellite Identified Damage* (Châtelaine, Switzerland: REACH, March 2019). See also UN-Habitat, *City Profile, Aleppo: Multi Sector Assessment* (Damascus: UN-Habitat, May 2014).

32. Francesco Bandarin, "The Reconstruction and Recovery of Syrian Cultural Heritage: The Case of the Old City of Aleppo," in *Collapse and Rebirth of Cultural Heritage*, ed. Lorenzo Kamel (New York: Peter Lang, 2020), 45–77.

33. Maamoun Abdulkarim, "Challenges Facing Cultural Institutions in Times of Conflict: Syrian Cultural Heritage," in *Post-trauma Reconstruction*, vol. 2, *Proceedings Appendices*, Colloquium at ICOMOS Headquarters, Charenton-le-Pont, France, 4 March 2016 (Paris: ICOMOS, 2016), 9–11; and Laura Kurgan, "Conflict Urbanism, Aleppo: Mapping Urban Damage," *Architectural Design* 87, no. 1 (2017): 72–77. Several assessments have been carried out concerning damage to the historical areas of Aleppo. The UNESCO and UNITAR 2018 survey covers the area inscribed in the World Heritage List and is based on satellite data. The Aga Khan Trust for Culture 2018 assessment covers the three main historical areas and is based on drone and field analysis.

34. Ross Burns, "Weaponizing Monuments," *International Review of the Red Cross* 99, no. 906 (2017): 937–57; and Rim Lababidi, "The Old City of Aleppo: Situation Analysis," *e-Dialogos: Annual Digital Journal of Research in Conservation and Cultural Heritage* 6 (June 2017): 8–19.

35. Victor Gervais and Saskia van Genugten, eds., *Stabilising the Contemporary Middle East and North Africa: Regional Actors and New Approaches* (London: Palgrave Macmillan, 2020).

36. Directorate General for Antiquities and Museums (DGAM), *The Intervention Plan for Aleppo Ancient City* (Damascus: DGAM, 2018); and DGAM, *State Party Report on the State of Conservation of the Syrian Cultural Heritage Sites* (Damascus: DGAM, 2019), report presented to the 42nd Session of the World Heritage Committee, Baku, Azerbaijan, 2018.

37. As of early 2020, more than 11.1 million people in Syria were still in need of humanitarian assistance, 6.2 million were internally displaced, and an additional 5.6 million had registered with the UNHCR as refugees in nearby countries. See Council on Foreign Relations, "Global Conflict Tracker: Civil War in Syria," 9 April 2021; and Carmit Valensi and Itamar Rabinovich, *Syrian Requiem: The Civil War and Its Aftermath* (Princeton, NJ: Princeton University Press, 2021).

38. Leila Amineddoleh, "The Legal Tools Used before and during Conflict to Avoid Destruction of Cultural Heritage," *Future Anterior* 14, no. 1 (2017): 37–48.

39. Silvia Perini and Emma Cunliffe, *Toward a Protection of Syrian Cultural Heritage* (Girona, Spain: Heritage for Peace, 2014).

40. Directorate-General for Education, Youth, Sport and Culture of the European Commission, "Emergency Safeguarding of the Syrian Cultural Heritage," in *Mapping of Cultural Heritage Actions in European Union Policies, Programmes and Activities* (Brussels: European Commission, August 2017), 33.

41. An important awareness-raising initiative, named #Unite4Heritage, was launched in 2015 by the director-general of UNESCO to promote the involvement of civil society in the protection of heritage and the fight against its deliberate destruction by violent extremist groups. That year, UNESCO's General Conference—the biannual meeting of the organization's member states—adopted the "Strategy for the Reinforcement of UNESCO's Action for the Protection of Culture and the Promotion of Cultural Pluralism in the Event of Armed Conflict." An emergency fund was established to support the strategy.

11

The Lost Heritage of Homs: From the Destruction of Monuments to the Destruction of Meaning

Marwa al-Sabouni

As an architecture student in Syria, I found it difficult to understand the different connotations of the word *heritage*. Not because I thought it was a complicated concept, but because the remnants of our ancient past stood at odds with the fleeting examples of our present. So feeble seemed the present that it could not face the past alone without calling on the future. With this apparent disconnect between the present and past, questions of identity and value seemed more pressing than ever. As "architects of the future," as our professors encouraged us to become, we found little interest in studying the history of our city of Homs.

We were never introduced to our heritage as part of our architecture study; the future had to be designed according to the latest modernist trends taught in Western schools. Homs as a city with a history, and a heritage, was of little if any significance to our architectural imagination: its history, creation, and development were never discussed. Emesa, the ancient name of Homs, was shrouded in mystery, because nothing was left to tell its story. The fact that Emesa was the center of a kingdom that mediated between the Roman Empire and its eastern adversaries was (and to a large extent still is) not relevant to the way we, as local architects, looked at our city. This was mainly because there was no trace left of those earlier cultures: not because of natural processes of erosion, but because of deliberate actions of erasure.

Homs did not make international news until it was destroyed by war; only then did its architecture make any difference. Even while I was at college, focusing on the paradoxes of globalization and localization, the local black basalt buildings of Homs did not seem to me or my peers to have any relevance. It was the war that later damaged those buildings that kindled in me the desire to protect them.

But the question of protection is as wide and vague as the very concept of heritage: how to protect revolves around what we protect and why. The Italian-born Brazilian architect Lina Bo Bardi, who also lived through war, had an understanding of heritage that permeated her work throughout her forty-nine-year career. She refused to look at heritage within the limited frame of Classical Italian churches and sixteenth-century Palladian architecture. Instead, industrial complexes of the 1950s and 1960s were for her structures equally deserving of protection and preservation for their "functional beauty."

When asked, during a lecture in 1989 at the University of São Paulo, about her ideas on preservation and how she reconciled the old and the new, she answered:

> This is what I was talking about when I spoke of the historical present. In architectural practice, there is no such thing as the past. Whatever still exists today, and has not died, is the historical present. What you have to save—or rather not save, but preserve—are the typical features and characteristics of a time that is part of our human heritage. . . . If people thought that everything old hat had to be preserved, the city would soon turn into a museum of junk. On an architectural restoration project, you have to be creative and rigorous in choosing what to preserve. The result is what we call the historical present.[1]

Bo Bardi seems to have rejected the word "heritage" as something only from the past, calling it instead the "historical present." She also summarized the concept within two frameworks encapsulating the values she thought mattered most: survival through time ("what has not died") and exhibiting features related to collective identity ("of a time that is part of our human heritage"). Perhaps examining the products of the past only through the lens of time is what creates a disconnect between what we call "heritage" and the products of our day. This conceptual divide requires creative means of reconciliation.

The disconnect becomes most evident in the aftermath of destruction and wars, because both values, survival and identity, become endangered. Under such threats the questions of what is *valuable* (and holds significance as such) and what is *expressive* (identity) come to the fore and stimulate our efforts to save and preserve remnants of the past. However, when my city was being relentlessly shelled between 2011 and 2015, I asked myself whether there was more to heritage than the threatened existential values of significance and identity. That is, whether there were other values that might call for our concern and care beyond times of crisis. These values are related to a process that precedes destruction. In realizing this, I also came to better understand the relationship between the destruction of war and the destruction of these values.

A decade after that first spark of violence, my city still stands in pretty much the same rubble it was reduced to. According to UN estimates, almost half the city's population had been displaced by December 2013, and most had experienced multiple

displacements during the course of the war. And the material structures of Homs had been reduced to a barely functioning nucleus, with 54 percent of its housing stock lost to destruction, severe losses to infrastructure, more than 60 percent of educational and health facilities no longer functioning, and the partial or complete destruction of twenty-six of its thirty-six neighborhoods. In such a context, the discussion of heritage and historical buildings may sound like a luxury, detached from reality. However, a deeper look demonstrates the opposite.

The Meaning of Heritage

Facing such enormity in human suffering and physical losses, it was strange to realize that certain structures were valued more than others. For instance, when the Roman ruins of the city of Palmyra were destroyed by the Islamic State of Iraq and Syria (ISIS, also known as ISIL or Da'esh) in 2015, including the reduction of the nearly two-thousand-year-old Temple of Baalshamin to rubble (fig. 11.1), the news went viral and the world looked on in shock and horror. Palmyra became the center of the world's attention for months, with a 3D printed replica of Palmyra's Arch of Triumph standing in Trafalgar Square in London, not only as a symbol of solidarity but also as an example of the technological alternative on the table of restoration.

But what about the other half of Palmyra, the living half? This was a modest and modern urban settlement, adjacent to the ancient ruins, housing five hundred thousand people before the war. In the recapture of Palmyra, the town was destroyed and almost

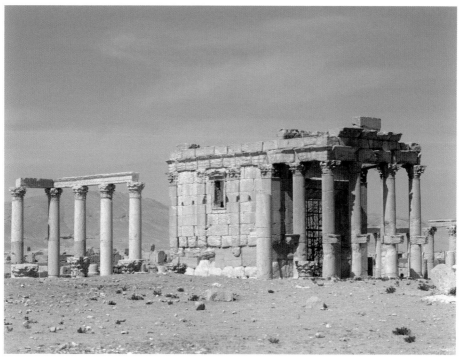

Figure 11.1 The Temple of Baalshamin, one of the most important structures in ancient Palmyra, before its destruction by ISIS in 2015. Image: Prisma Archivo / Alamy Stock Photo

its entire population displaced. Hundreds of families dotted the road between Homs and Damascus, carrying on their backs what little remained of their lives, roaming to safer parts of the country searching for shelter, scattered like the remnants of the world-mourned, historic city of Palmyra. And the world turned away from Homs.

It was no news that the living city of Palmyra was dead. What mattered was the dead Palmyra. The idea of the historical present made no sense to most people: all that mattered was the past. But this also meant that the past meant only so much to very few people: the academic elite. For the people of Palmyra, those who lived their lives marginalized next to the mysterious glory of "those rocks," they meant much less. Why was this?

I tried to answer such questions in my book *The Battle for Home* by addressing the loss of belonging. Our buildings have the power to speak to us through the meanings they embody and the actions they inspire. They can represent us, by being aesthetically pleasing, functionally satisfying, but also by being related to the moral and social necessities of our lives. Our buildings have the potential to help our communities thrive, and they can bring us together—but they can also cause us to drift apart. Ancient Palmyra, set as a theatrical backdrop, isolated as it was next to the populated town, had a kind of centrifugal effect. At best, for most of the town's people, it was a source of income (fig. 11.2).

Perhaps it is easier to understand the loss of meaning in a place so detached in space and time as Palmyra than it is for places that are part of our daily lives and the actions of our people. The majority of Homs's heritage falls into the second category. The loss of

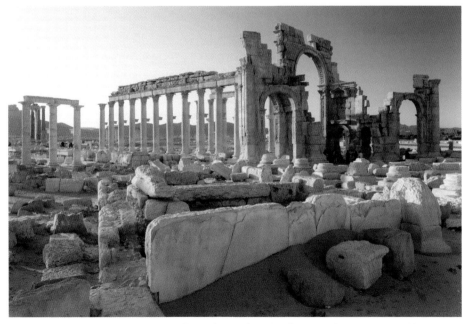

Figure 11.2 Remains of the Great Colonnade at Palmyra. The ruins of ancient Palmyra were one of the prime tourist destinations in Syria before the war and provided a source of employment for those who lived in the area. Image: Luis Dafos / Alamy Stock Photo

this heritage was reported during the war, but the systematic destruction and vandalism that the city's buildings endured long before the war has yet to be discussed. I tell the story in *The Battle for Home*, and make the case for how this process led to the current war. The process of rebuilding in the war's aftermath may also lead to a similar path and an endless cycle of conflict. Because patterns of development focus primarily on short-term goals such as political and economic expedients, heritage, as a carrier of meaning, rarely fits into such interests unless it is used as a propaganda tool benefitting those in power, as it has in the past.

Urban development, especially in the aftermath of war, rarely gains significant media coverage, which places a greater premium on quantity of coverage rather than quality. The language of numbers dominates at the cost of other values and meanings, with heritage reduced to only a number. Risks stem not only from the erasure of memory and the deepening of social wounds by the conflict, but also from the architectural and urban constructs that are built in the aftermath and that fill those voids. *The Battle for Home* explains at length how the French urbanization of Syria transformed our cities into segregated compartments that perpetuated social divisions and led to civil conflict. Therefore, ending the cycle of destruction becomes inherently related to how we preserve meaning and what we can do to defend and strengthen its existence in our built environment. With this is mind, an examination of the creation of the city of Homs may offer insight into how to address this pivotal issue.

The Creation of Homs and the Building of Meaning

Palmyra may be the only internationally famous part of the province of Homs. Nevertheless, Homs is Syria's central province, stretching from the Lebanese mountain slopes in the west to the border with Iraq in the east, and contains its third-largest city. Its varied landscape includes vast arable land and agricultural villages in addition to an arid region to its east (the steppe). The city of Homs, in the western center of the province (and of Syria), has experienced events throughout its history that have dictated its final location. These events include controversies that need to be addressed in order to properly understand the city's cultural and built heritage.

The city is located two to five kilometers from the bed of the Orontes River, an unconventional location, due to the nature of the terrain. Typically, cities are built on or very close to rivers, but this is not the case with Homs, which helps explain its founding and history, and consequently the story of its heritage. The current city lies atop land that used to consist of vast natural swamps, seasonally flooded by the river, making it an unsuitable location for a city. Instead, a small settlement was built on what is called "Homs hill," a mound believed to have been created by those natural conditions, and which dates, according to archaeological research, to the mid-third century BCE. The research findings were controversial, with some arguing that Homs hill was occupied by a small group of nomads and did not constitute an urban settlement, with the real "Homsi" metropolises scattered through different eras, as discussed below. Among these

proposed alternative historical sites for the city are Kadesh, the site of the Battle of Kadesh between the Hittite and Egyptian empires in the thirteenth century BCE. Located almost twenty-four kilometers southwest of Homs, Kadesh disappeared around 1178 BCE. Another development was Qattinah, a settlement fifteen kilometers south of Homs, where a Roman dam created the sixty square-kilometer artificial Lake Homs. To the north, the village of al-Mushrifah (site of the ancient kingdom of Qatanah, eighteen kilometers northeast of Homs) thrived during the third and second centuries BCE; it had been destroyed by 72 BCE. Arethusa (al-Rastan), twenty-five kilometers north of Homs, was built by the Seleucid Empire in the third century BCE. And of course, there was Palmyra much farther away, 150 kilometers to the east. From this perspective, the current city of Homs did not acquire its importance until the Roman era (fig. 11.3).

The second perspective on the archaeological evidence argues that the hill has been a significant settlement since Hellenistic times, and that its dominance culminated during the Roman era. Yet local historians are convinced other circumstances played a more important role in the development of the hill. For instance, Mustfa al-Sufi suggests in *The Establishment of a City's History: From Emesa to Homs* that the building of Qattinah's dam during the Roman period created the right environmental conditions for the establishment of Homs, which had previously been confined to the hill. By draining the river valley of its swamps, the dam made the location habitable (figs. 11.4a, 11.4b).

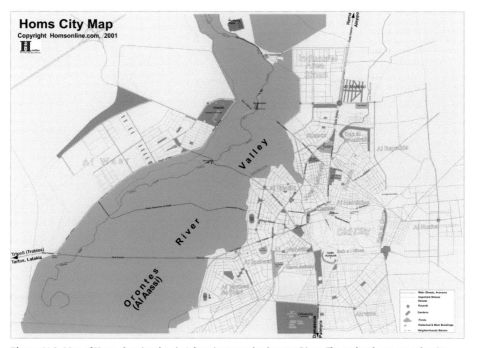

Figure 11.3 Map of Homs showing the city's location near the Orontes River. The orchards separate the city from the Al-Wa'er neighborhood, a newer development built in the 1970s and 1980s. Image: © 2001 Homsonline.com. View map at www.getty.edu/publications/cultural-heritage-mass-atrocities/part-2/11-al -sabouni/#fig-11-3-map.

Figure 11.4a The Hill of Homs, where the ancient city was originally built. Image: Dick Osseman / CC BY-SA 4.0

Figure 11.4b The Hill of Homs showing impacts of the recent war, including signs of structural deterioration on the neglected citadel. Image: Marwa al-Sabouni

The controversy surrounding the historical significance of Homs stems from data collected from aerial photography and geographical scans, along with comparisons of

archaeological findings collected between 1957 and 1959. According to al-Sufi, the basis of the dispute is that, despite the detection of a Hellenistic plan underlying the city and the existence of engraved Greek writings that use the Seleucid dating system, there are no remnants of monuments or buildings that can be attributed to the Seleucid era, and that fact makes any historical judgment of an ancient Homs urban settlement inconclusive.

However, it is agreed that while the city's ancient name of Emesa is pre-Roman, it continued to be used when Homs became a religious center in the first century. The solar deity Elagabalus (in Arabic, al-Gabal, the Mountain) was worshipped there in a great temple of the sun; the ancient city's coinage displayed an image of the temple with a holy basalt stone at the center. It was built by the ruling Sampsigeramids (or Emesene dynasty), an Arab family of priests who ruled after the Seleucid Empire. They made marital relationships with the Romans and ruled the city as a client kingdom.

Figure 11.5 Julia Domna, the famous ancient queen born in Emesa (present-day Homs) and wife of Roman emperor Septimius Severus, who ruled from Rome in the third century CE. Image: Adam Eastland Rome / Alamy Stock Photo

Julia Domna, a Homsi princess and youngest daughter of the high priest of the temple, married the Libyan-born Septimius Severus, and the two ruled from Rome (fig. 11.5). Meanwhile, Homs gained prominence as a religious center with its great temple and expanded well beyond the original hill. The temple long outlived its creators by adopting new religions with new rulers over the centuries, becoming a church and later a mosque. Its remains are incorporated within the walls of the Great Mosque of al-Nuri, which was built (or rather rebuilt) by Nour al-Din al-Zenki in the Mamluk Islamic era, during which it was adjacent to the city wall at one end and the souk, or market, at the other. During the Syrian Civil War, pillars believed to be remnants of the temple became exposed by arms fire (figs. 11.6a, 11.6b, 11.6c).

Figure 11.6a The main courtyard of the Al-Nuri Mosque. The structure is built of black basalt, the local building material of Homs. Image: Marwa al-Sabouni

Figures 11.6b–c The war inflicted great structural damages to the mosque, revealing older pillars from a previous structure buried within its walls. These remnants might be seen as indicative of a unique preservation approach that opted not to tear down, but rather to build on. Image: Marwa al-Sabouni

When I visited the mosque in the aftermath of fighting and first saw the half-exposed pillars, I was overwhelmed by the building's sense of continuity in its development. The basalt slabs of its courtyard surface, its vaults, and its walls were brightened by strips of white limestone around the mosque's doors and windows. In this building, the idea of historical present was so perfectly practiced over millennia: each picking up from where the other had left off, leaving no gaps in time through which meaning might slip. The word *heritage* in such places acquires another layer, belonging to no single past. It becomes an accumulation of experiences, expertise, and expressions.

But Homsis have had little chance to learn about this. "Emesa" and "Julia Domna" were no more than names of local cafés. Today, not much happens in the city. Its economic activity is slow in comparison to that of Damascus and Aleppo, its features are not interesting, and its history is little in evidence. Yet, none of this made sense: the city's location is central, its weather is mild and refreshing, its fields are wide and fertile, and its crops are abundant, as is its history. So why does the city seem to be in constant decline? The answer is multilayered, but the way in which the local government has administered the city's heritage may provide a clue.

Figure 11.7 The mausoleum of Emesa. Its destruction by the city government in 1911, part of a systematic demolition of the city's identity, resulted in a great loss to the history of Homs. Image: C. Watzinger / Public domain

The mausoleum of Emesa, a monument built by the Sampsigeramids in 78–79, was formerly part of the necropolis of Tel Abu Sabun (fig. 11.7). Excavations in the *tel*, or hill, uncovered a total of twenty-two tombs, beginning in August 1936 with the discovery of the Emesa helmet, one of the most exquisite artifacts found at the site. The helmet has sustained much damage since its discovery, first during its initial looting and later by the controversial restoration processes conducted by the French and British. The helmet, along with all other artifacts from the site, including jewelry and statues, has to this day not been returned to Syria: the only remaining aspect of the site is the built structure itself.

The mausoleum of Emesa was part of Homs (and its necropolis) for nearly eighteen centuries, until 1911 when the city government

Figure 11.8 The necropolis of Tel Abu Sabun, now the site of the city's main stadium, built in 1960. Image: Marwa al-Sabouni

dynamited it to make room for an oil depot. The mausoleum, as documented in the drawings and photographs of nineteenth- and twentieth-century orientalists, was a two-story structure, the square base topped with an obelisk whose shape resembled the pyramidical tombs of Palmyra. Each facade was decorated with a row of five columns at the base and another row on the second floor. The building materials—the local black basalt and white limestone mentioned earlier—are a unique feature of Homs's architecture. The greater part of the necropolis had been excavated by 1952 and was reburied to build a municipal stadium (fig. 11.8).

One of the milestones in the making of the city was the creation of the al-Mujahediya irrigation canal by Asad al-Din Shirkuh in the twelfth century, which connected to the Qattinah dam. It irrigated the arable land between the west side of Homs and the river. But, more importantly, it brought water right to the heart of the city for the first time, supplying mosques, hammams (public baths), mills, and all the city's neighborhoods. The canal also protected Homs from the impact of floods that used to wreak havoc on the city (figs. 11.9a, 11.9b).

Waterwheels were built on the canal to raise the level of water where needed. A landmark waterwheel was built in 1712 near what is now considered the city center, in a neighborhood adjacent to the main souk, with numerous mosques and hammams that required water to be lifted to their level. All that remains of the great waterwheel is the name it has given to its locality: al-Naourah (after *noria*, or waterwheel). In its place, French colonial buildings were erected, occupied by clinics and offices on the upper floors and clothing shops at the ground level. Souk al-Naourah, as the neighborhood is called today, has no water anymore, nor a great *noria* (figs. 11.10a, 11.10b, 11.10c).

Figure 11.9a A 2021 photo of the irrigation network running through the city. Municipal decisions to let the water flow are followed by others to restrict it, an on-and-off approach not explained to the public. Image: Marwa al-Sabouni

Figure 11.9b An historic photo of the irrigation canal of al-Mujahediya, a beloved part of the picturesque cityscape that was largely covered by roadways as part of so-called modern planning. Image: Courtesy of Homsstory.com

Figure 11.10a An historic photo of the Naourah (*noria*), or waterwheel, after which the city quarter Souk al-Naourah is named. The only remnant of the waterwheel today is the name of the neighborhood. Image: Wassermühle / dpa Picture Alliance / Alamy Stock Photo

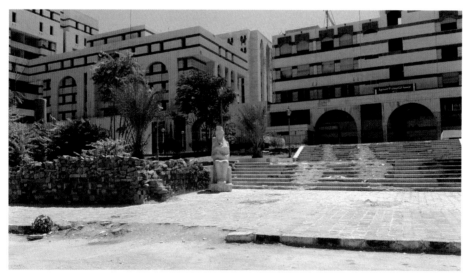

Figure 11.10b The Insurance Building in Souk al-Naourah. Construction of this complex required the demolition of parts of the historic quarter. Image: Marwa al-Sabouni

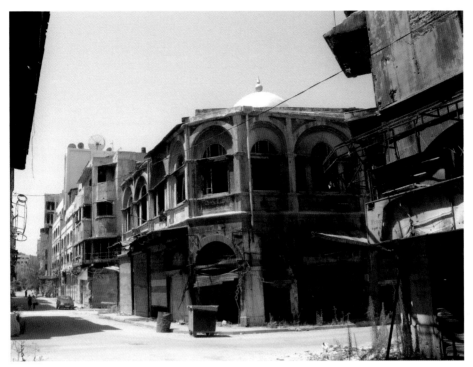

Figure 11.10c Another section of Souk al-Naourah, showing the French-style buildings that used to serve as offices and shops before being destroyed by the recent war. Image: Marwa al-Sabouni

The Destruction of Heritage and the Undermining of Meaning

Homs has been denied many of its treasures over the centuries. The demolition of the mausoleum of Emesa was not the first. John the Baptist's head was allegedly discovered in Homs before it was removed to the Umayyad Mosque in Damascus. The Quran of Uthman, one of the earliest copies written in the time of Uthman, the third Rashidi Khalifa and one of the Prophet Muhammad's companions, was preserved in the citadel's mosque before being taken to Istanbul in the nineteenth century.

In *Homs, My Small Beloved Home*, Abd al-Mueen al-Mallouhi wrote about the systematic destruction of Homs since the 1950s. Even today, after the destruction of more than 60 percent of the city, there are no signs of serious rebuilding or careful preservation. Due to the municipality's methodical demolition of old buildings, the old quarter represents only 6.2 percent of the current city's area, according to UN reports.[2]

Moreover, the selective "rehabilitation" of partially destroyed monuments has exhibited flagrant examples of cultural appropriation and change of visual identity. For instance, Jami al-Arba'een (the Mosque of the Forty), is a small mosque at the northwestern corner of the ancient city wall near what is now the center of Homs. There stands the only remaining defensive tower of the wall's structure. The cylindrical tower, built entirely of basalt, became part of the mosque by creating a connecting stair for the muezzin, who gives the call to prayer. The mosque was built in 1568 as part of a neighborhood of the same name (the Forty) and stands adjacent to an Islamic school and

orphanage built the following year, which remained open until the 1940s. At that time the entire old neighborhood was demolished and replaced with a vast complex of public buildings. More than 80 percent of the complex stands vacant: because it was built to occupy, not to be occupied. The municipality looms over the mosque as the only remaining part of the old neighborhood. Locals recall the accident that prevented the demolition of the mosque: the bulldozers' blades were repeatedly broken at every trial. People took that as a holy sign and demanded preservation.

The current conflict, however, did not spare the mosque from damage. Controversy was stirred when its rectangular window slabs were replaced by pointed-arch windows to resemble Iranian architecture. No protests were enough to prevent it. Even trees and water canals were not spared persistent attack: every now and then, the municipality would send teams to cut down trees that had shaded the city's streets for decades. They had become homes for various species of birds and a dear part of the city's identity in addition to their broader environmental roles. The argument for such interventions (if one is provided) is maintenance!

Why Homs has been so deliberately vandalized and denied significance over the centuries is a mystery to me. To pursue an investigation in this direction would go beyond the scope of this chapter, but one thing remains certain: the power of buildings. Valuable and meaningful buildings can at times be so powerful as to drive political forces to seek their demise for the most ridiculous reasons.

As mentioned, we may value heritage because of both significance and identity. Late nineteenth-century Western intellectuals distinguished between historical significance and cultural significance in the context of postwar historical zoning. I see the question of significance in a slightly different light. For instance, when an object or a structure survives the test of time, it gains a certain historical significance. However, what really distinguishes truly valuable objects or structures is not time alone, but their connections with the concept of "accomplishment." What can be considered an achievement of a certain era is expressed in shapes and forms. Bo Bardi and her colleagues saw this manifest in the shape of factories in the industrial era, whereas ancient Palmyra expressed the peak of its accomplishment in transforming rocks into Corinthian crowns and majestic colonnades. Value also derives from the social status of the owners or users of objects and structures: an object used by a king is considered more valuable than one used by a commoner.

Identity, on the other hand, needs to be understood within the context of cultural significance. This can be explained through the frame of memory, visual or cultural, and in accordance with moral and religious values. Take the basalt of Homs: it holds value for the local people, and it has a cultural significance that makes its architecture appealing. As a product of its natural surroundings, and as a traditional building material, it has become an essential part of Homs's collective visual memory. Moreover, its once-enjoyed religious status in ancient pagan rituals has infused it with a sense of holiness for some time. Although its original reverence disappeared with the

introduction of the monotheistic religions, the use of basalt as a major building material in Homs did not fade away until modern building techniques began to dominate the cityscape.

In fact, this transition toward modernism, whether in urban planning or in architectural forms, was so severe and pervasive that I hardly noticed traditional Homsi architecture, even though I had lived in the city all my life. As mentioned above, demolishing old structures and traditional buildings was (and still is) the goal of all authorities that have taken charge in Homs. This mentality has manifested itself in all Syrian cities, but seems to have had particularly free rein outside Damascus and Aleppo (the focus of Western cultural attention). It was the war that brought the fragments of lost Homsi memory to my attention as layers of cement and cinder block fell off even the more resilient basalt walls. What was disguised as part of modern construction was exposed to its true "bone." It was eye-opening to see how the arrogant modern blocks were pancaked next to dignified, partially destroyed traditional buildings.

Also exposed by the hammer of war was the level of chaos following reconstruction: the remains of half a house in basalt topped with a cinder-block room, connected to a wooden structure, built over cement columns, and so on. I cannot see this in the spirit of "historical present," but rather for what it truly is—*traces* of lost meaning.

Beyond significance and identity, there are nuances in the way people name their cultural surroundings. These fall into three general categories: religious, natural, and folk cultural. I have noticed in most cases that the name is all that is left to indicate the significance and identity of a place or structure. For example, Jourat al-Shayyah is a well-known neighborhood in Homs. Before it was totally destroyed during the war, it was where craft businesses aggregated on the ground floor of adjoining rows of buildings, with the top floors comprising a mix of residences and offices. But the name is strange, meaning "the hole of one who works with wormwood"! The high-density, low-rise, modern neighborhood was still young, existing in a natural trough outside the city wall where limestone used to be burned by using wormwood in order to make quick lime. The mosque of the Shayyah (one who works with wormwood) is another neighborhood landmark. One can see a clear connection between religion, work, and nature in the ways people used language to signify what mattered to them.

Homs used to be Syria's center of Sufism, as indicated by the various places named after notable and famous Sufis. And nature is another key element in how people have related to the built environment, with al-Naourah and Tel Abu Sabun as examples of people's activity around nature. Al-Mrayjah (the Small Meadow) is another example of this kind. Located near the old city wall, it is where harvested wheat used to be stored. In the spring, harvested wheat left the land covered in green grass, inviting the city's residents for picnics and folk singing festivals. Al-Safsafah (the Willow Tree) was another location for folk singing, for those who enjoyed gathering under the big willow that stood in front of the al-Zaafranah Mosque (the Saffron Mosque).

In addition to religion and nature, the people of Homs have taken myth too seriously. Part of the reason for this is the nature of the people, who can be seen as sentimental and imaginative. Homs has always been a place where humor is connected to not only wit and imagination but also eccentric behavior. Jourat al-Arays (the Hole of Brides), before being bomb-flattened during the war, was an informal area with a strange name. Again, the name is related to the topography, as yet another trough that turned into a small lake in winter, hence "hole," but also because some locals believed that ghost brides used to live there, calling on those who passed during the night. Abu Jaras (That of the Bell) is another ghost, a dog ghost this time, who was imagined to be peeking through the city wall, attaching the name of Takat Abu Jaras (the Opening of That of the Bell) to an area in the old city.

As amusing as they are, those folk tales give us insight into heritage as an object of meaning, in contrast to one that becomes a mere trace of something from a forgotten past. Human activity lies at the center of this understanding, around which meaning can be woven. The difference between a museum-quality object and heritage is the soul that only human activity can breathe into it. Nature and religion form both the matter and spirit by which this activity can thrive.

Conclusion: From Meaningful Heritage to an Unmeaningful Trace

In this light, the destruction of nature, religion, and social fabric proves to be the real reason for the physical destruction of heritage buildings, and more importantly it can become a source of their revival. This understanding makes the mysterious disconnect between the past and present less opaque.

"Heritage" translates as *erth* in Arabic, whereas "trace" is *athar*. The two words derive from the same root, but in meaning one is clear and persistent, while the other is obscure and fleeting. More interestingly, we refer to antiquities as *athar*, a plural word, the equivalent of "traces." Modern times must have taught us that if people do not guard traces, if they do not live and work around traces, they will eventually lose them. If we are serious about preserving our heritage, we must leave room for its meaning to grow.

But this cannot be done while our cities are being planned only as dispensable sources for provision, instead of realizing them to be the places of meaning they really are. The example of Homs should be enough to demonstrate that blind destruction—especially when done in the name of building—not only removes those visible buildings but also wipes away the ties embedded in them, which once held people together and to their places.

Today, Homs has been transformed from a dull city to a dead city. The piecemeal efforts toward rebuilding are hindered by the same arbitrariness and ignorance that have plagued it for centuries. Voices that advocate heritage fall on the deaf ears of the public, even before they fall short of the expectations of preservation. These voices do not resonate with the current interests, and they no longer speak a common language with the public. Along with buildings we have lost, we must admit that we have lost the

language in which those buildings spoke to us and we spoke to each other. I do not see a hope for Homs unless we find that meaning again and build back that language.

SUGGESTED READINGS

Talal Akili, *The Great Mosque of Damascus: From Roman Temple to Monument of Islam* (Damascus: Municipal Administration Modernisation Program, 2009).

Diana Darke, *Stealing from the Saracens: How Islamic Architecture Shaped Europe* (London: Hurst, 2020).

Nasser Rabbat, *Mamluk History through Architecture: Monuments, Culture and Politics in Medieval Egypt and Syria* (London: I. B. Tauris, 2010).

Joseph Rosa, Cathrine Veikos, and Sidney Williams, *Albert Frey and Lina Bo Bardi: A Search for Living Architecture* (Munich: Prestel, 2017).

Marwa al-Sabouni, *The Battle for Home: The Vision of a Young Architect in Syria* (London: Thames & Hudson, 2016).

Marwa al-Sabouni, *Building for Hope: Towards an Architecture of Belonging* (London: Thames & Hudson, 2021).

NOTES

1. Sol Camacho, "Retrospective: Lina Bo Bardi," *Architectural Review*, December 2019–January 2020, 30.
2. See, for example, UN-Habitat's June 2014 report, *Neighbourhood Profile: Old City of Homs*, https://unhabitat.org/sites/default/files/download-manager-files/1421063714wpdm_Old%20city%20of%20Homs.pdf.

12

Reconstruction, Who Decides?

Frederick Deknatel

How will reconstruction unfold in Syria, given not only the staggering scale of destruction across the country after a decade of civil war, but also the limited resources and narrow, authoritarian interests of the Syrian government of President Bashar al-Assad? A few token rebuilding projects already underway in Aleppo, Homs, and Damascus provide an initial answer, even if the war still has not ended as of late 2021. Heavily promoted by Syrian authorities and in some cases paid for by their foreign patrons, these projects reflect how the Assad government sees reconstruction as a propaganda tool and vehicle for elite corruption. It is quickly prioritizing what to rebuild, and what not to—projecting an exclusionary vision of "victor's justice" on Assad's terms, while neglecting vast residential neighborhoods once held by opposition forces that the government either cannot rebuild, because it lacks the funds and resources, or will not as a form of collective punishment.

The government's reconstruction agenda relies on co-opting Syria's cultural heritage, so it is no accident that many of these early reconstruction projects involve symbolic sites such as historical mosques. The two most prominent are in Aleppo and Homs, where the medieval Great Umayyad Mosque is in the process of being rebuilt, and the late Ottoman-era Khalid Ibn al-Walid Mosque has been hastily restored. Both mosques have essentially been turned into a stage for Assad's reconstruction message. In contrast to Syrian rebels and other opposition forces that the government has cast as "terrorists" alongside Islamist extremist groups since the earliest days of the war, it promotes Assad as the custodian and even guardian of Syrian culture and history. Although the rebuilding and restoration of both the Great Umayyad Mosque in Aleppo and the Khalid Ibn al-Walid Mosque in Homs have been shrouded in progovernment propaganda, they offer a glimpse of Assad's reconstruction agenda across Syria, with troubling implications for reconstruction in other countries devastated by civil war.

They also make clear that what the Assad government has in mind with reconstruction is limited at best, if it can even be called reconstruction at all. Its aim is

not to fully rebuild Syria and restore its urban landscape and infrastructure to prewar levels, but to use reconstruction as the next stage of the war, consolidating its authority and control of territory and seizing whatever economic and political advantages it can. The reconstruction that has begun in Syria is a warning sign for future conflicts—about self-interested governments and authorities that decide how and where to allocate limited resources, and about the pitfalls of reconstruction unfolding in an environment that is not yet post-conflict.

Assad's Reconstruction Agenda

It was called the "capital of the revolution," but it soon became ground zero for Syria's civil war. Early anti-government protests in Homs, Syria's third-largest city, brought repression and state crackdowns that stoked some of the first armed opposition to Assad's rule. Homs had languished economically for years under the shadow of the capital, Damascus, and Aleppo, Syria's commercial hub in the north, then bore the brunt of the worst violence of the civil war—at least until rebels surrendered after a crippling government siege in 2014, and the fiercest urban warfare shifted to Aleppo. While the battle for Homs had included barrel bombs—crude incendiary devices dropped indiscriminately from government helicopters—along with other bombardments by Syrian forces, the battle for Aleppo included air strikes from Russian jets following Moscow's intervention in the war on Assad's behalf.

When the fighting ended in Homs, the city looked like a wasteland. "Homs is the only city in the whole of blood-soaked Syria that has had its market and center destroyed and completely shut down," architect Marwa al-Sabouni, who witnessed this devastation firsthand, later wrote.[1] Homs was an image of urban destruction reminiscent of World War II, a Dresden for the twenty-first century. A similar fate awaited Aleppo, which fell back into government control in late 2016 following a joint Russian and Syrian blitz. Homs also offered a preview of what would happen to other cities in ruins when they were back under the authority of the Assad government, which was eager to quickly project power and a sense of triumph, most of all through selective and highly symbolic reconstruction projects.

In Homs, this meant the city's main landmark, the Khalid Ibn al-Walid Mosque, built in the late years of the Ottoman Empire in the early twentieth century over the site of a centuries-old mosque and mausoleum dedicated to the Arab military commander who led the Muslim conquest of Syria in the seventh century. It sits on the edge of Homs's historical Old City, which was a fiercely contested front line in the civil war. Several of the mosque's nine signature domes were damaged in the fighting, riddled with huge artillery holes, along with one of its minarets. Like other historical mosques and cultural heritage sites in Syria, the Khalid Ibn al-Walid Mosque itself was covered widely in international media, as a kind of entry point into the Syrian conflict through reports on the damage it had sustained and whether opposition or government forces controlled the site.[2]

In 2017, despite the widespread devastation throughout the city, including to most of its vital infrastructure, Ramzan Kadyrov, the strongman leader of Chechnya who is close to Russian president Vladimir Putin, announced that the Khalid Ibn al-Walid Mosque would promptly be rebuilt, through the apparent goodwill of his opaque quasi charity, the Akhmad Kadyrov Regional Public Foundation. The news was initially announced via Russia's state news agency, TASS: it would fund the reconstruction, along with providing $14 million to rebuild the even more prominent and more extensively damaged Great Umayyad Mosque of Aleppo. The Old City in Aleppo, like the historical center of Homs, was another vicious front line in the civil war; rebels had occupied the medieval, stone-vaulted souks that ran alongside the walls of the Great Mosque, while government soldiers had dug in atop the nearby citadel that looms over the city. In 2013, the Great Mosque's iconic, eleventh-century minaret was toppled—by Assad's own artillery, according to credible accounts on the ground, although the Syrian government insisted that "terrorists," as they called the rebels, deliberately blew it up.

At a reopening ceremony in Homs in early 2019, after the Khalid Ibn al-Walid Mosque had been briskly rebuilt, the city's governor thanked visiting Chechen officials for their largesse and called the mosque the first major reconstruction project in the Old City's Khaldiyeh neighborhood. The rest of that neighborhood, though, has not been as fortunate. Just as damage to the mosque during the battle over Homs had drawn international headlines, so too did this Chechen-funded rehabilitation.[3] During a government-arranged tour of Homs for a group of foreign journalists in 2018, Gareth Browne, a reporter for the *National*, a daily English-language newspaper in the United Arab Emirates, described Syrian authorities as "keen to show off" the rebuilt mosque as a symbol of the city back under government control. They appeared less enthusiastic about the rest of Khaldiyeh, which was still a rubble-strewn ghost town. Brown quoted one anonymous Homs resident, who said of the restored mosque: "There is no one here to pray in it."[4] Although church leaders in Homs, under the eye of government officials, were also eager to show the foreign reporters "renovated chapels and reconstructed altars" in the neighborhood, there was "little mention of reconstruction in the predominantly Sunni areas—where residents are nowhere to be seen and regime flags are slapped on front doors."

This reality did not prevent the Syrian government from promoting the restored mosque as an early sign of Homs's wider reconstruction. The Ministry of Tourism even features it in a video posted online in 2018, one of many propagandistic clips available on YouTube from the ministry. Over a triumphal soundtrack, drone footage shows the Khalid Ibn al-Walid Mosque from above, its reconstructed domes and fresh brickwork standing out starkly amid the surrounding desolate, still-ruined city (fig. 12.1).[5]

The selective and early rebuilding in Homs was a decision made by Syrian authorities backed by their international partners, in Chechnya and by extension Russia, which intervened in the civil war to prop up Assad and occupy strategic parts of the country's Mediterranean coast. It also reflects a wider trend in Syria. In addition to the

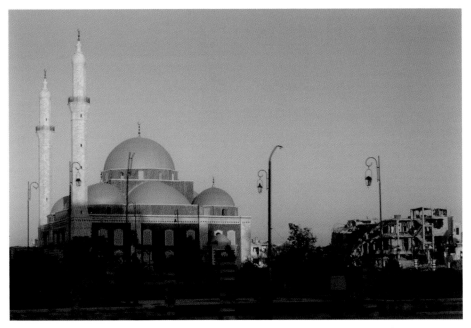

Figure 12.1 The rebuilt Khalid Ibn al-Walid Mosque amid the ruins of the Khaldiyeh neighborhood in Homs's Old City, 15 August 2018. Image: Andrei Borodulin / AFP / Getty Images

propaganda gains of showing off the reconstruction of a well-known mosque damaged in the war—even if it was damaged by Syria's own military, and even if the war is not over—the government can also project authority, not just about what it wants to rebuild, but what it does not. That underscores "a broader truth about Syria's reconstruction framework, namely that it will not rebuild Syria or stimulate recovery," as Syrian architects and urbanists Sawsan Abou Zainedin and Hani Fakhani have argued. Instead, something more overtly political is at play, on the government's own arbitrary terms, whether in the selective reconstruction of religious sites in Homs at the expense of entire war-torn neighborhoods, or in a huge urban redevelopment project in Damascus funded by government insiders and built over expropriated land in the name of "postwar" prosperity. "By transforming the socioeconomic landscape through a reconfiguration of urban space," Abou Zainedin and Fakhani insist, this form of reconstruction "aims to consolidate the regime's authoritarian control."[6]

This is evident throughout Homs, according to researcher Jomana Qaddour, where "the divide between those who support and don't support the Syrian regime is the most notable fracture visible" in the city. "The regime's reconstruction and rehabilitation policies are solidifying this divide," she has observed. "The regime is continuing to deprive former opposition-held quarters, including Bayyada, Waer, and Karam al-Zeitoun, of basic infrastructure, development funding, and services." Meanwhile, it "is rewarding the political elite and minorities it needs to consolidate power," even as "it is leaving behind many Homsis, even poor Alawites who fought on its behalf."[7]

This all adds up to a grim picture of what reconstruction looks like under Assad. As Amr al-Azm, a Syrian anthropologist, archaeologist, and founder of The Day After Initiative, a Syrian civil society organization, told me in 2019, "The regime has two possible areas of interest in reconstruction: One, as a means to reward those areas and individuals that were loyal to it. Two, for the regime's coterie to enrich itself" at the expense of this process. Those former opposition-held neighborhoods in Homs, and ones like them in eastern Aleppo that were destroyed by the Syrian and Russian siege in 2016, will suffer the consequences of that agenda. "The areas that have been most damaged, that most need reconstruction, the areas that were bombed by the regime that produced the refugees in the first place—the regime is not about to go and take all this money and rebuild their homes," Azm added. "It's going to take the money and reward the areas that were loyal to it."[8]

In Aleppo, as in Homs, the Old City has been the focus of hurried reconstruction plans full of blunt symbolism designed to benefit the Assad government, while the most heavily damaged and outlying neighborhoods—which happen to have supported the opposition—have been largely ignored. And like Homs, one reason for that is the aid from Chechnya's Kadyrov Foundation. The $14 million it pledged to rebuild the toppled minaret of Aleppo's Great Umayyad Mosque apparently went to quick use, with a crane erected outside the mosque's battered courtyard, adjacent to where its famous minaret once stood.

"Since the fall of Aleppo in December 2016, the regime has seized both the city and the narrative, attempting to ensure its version of the truth is broadcast loudest," British journalist Diana Darke reported from Aleppo in the spring of 2018. "One example is that the government lays responsibility for Aleppo's destruction firmly at the door of 'the terrorists.'" That was most evident at the Great Umayyad Mosque, where the rebuilding of the toppled minaret had already started and where, Darke wrote, "the truth about what this sacred space witnessed in the war is now being concealed under a cloak of restoration." The young Syrian activists who had safeguarded parts of the mosque's interior with sandbags and other makeshift protection during the height of the civil war were being forgotten, as the authorities proclaimed that they were the ones preserving and restoring Aleppo's heritage and history. No building, perhaps, "could tell us more about the ebb and flow of Syria's war than this once magnificent structure," Darke added. The Syrian military's own construction company—the largest in the country— oversaw the mosque's restoration, rather than cultural heritage experts or the Ministry of Religious Endowments, and orders apparently came straight from the president's office. The military engineer in charge of the project told Darke: "I have no idea why I was chosen for this job. Before this project, I built Aleppo airport."[9]

If the Syrian government was racing to restore the Great Umayyad Mosque in order to project its authority and signal what life meant in Aleppo under Assad's control, it was hardly subtle. Of course, not all symbolism is bad. "Rebuilding the mosque would be a major contribution to the regeneration of Syrian society," as historian Ross Burns, a

former Australian ambassador to Syria and the author of *Aleppo: A History*, told an interviewer. "The Great Mosque is a very important symbol of Aleppo and a point of pride to all Syrians." The rehabilitation and restoration of such cultural heritage sites also brought the promise of jobs for craftspeople, construction workers, and others in cities like Aleppo and Homs—although any prospect of eventually boosting Syria's tourism industry, as Ross suggested, seemed optimistic at best.[10]

As with the media coverage of these sites during the height of the war, their reconstruction provided another entry point for an international audience. The implications, though, have risked being misunderstood or overstated. One story from NBC News declared in mid-2018: "Aleppo's reconstruction is in full swing after years of war."[11] It was not really the case at the time, beyond a few small rebuilding projects and some reopened businesses, such as a soap factory in eastern Aleppo whose roof had been "roughly patched." And it still is not. But as Syrian authorities directed scarce resources to rebuilding or restoring landmarks like Aleppo's Great Umayyad Mosque or the Khalid Ibn al-Walid Mosque in Homs, salutary and sometimes breathless media coverage often followed.

Can a Pariah State Rebuild?

Underpinning this entire situation around reconstruction, however, are the stark political realities in Syria after years of civil war, both on the ground—regarding whether the government or the opposition controls particular territory, and how much damage it sustained in the course of the conflict—and internationally, given that the Syrian government has been under international sanctions for years as a pariah state. The United Nations Development Programme (UNDP) has been engaged in nascent reconstruction projects in Syria, particularly in Homs, where it has overseen the reconstruction—or "rehabilitation," as it says—of the city's covered souk. But it is at pains to distinguish all this from any formal reconstruction, given the sanctions and the position of the UN that it will not support formal reconstruction until a political transition is underway in Syria. The UN calls its small-scale interventions—primarily to restore critical infrastructure like electricity, sewage, and water, or to repair damaged schools and hospitals—"rehabilitation," "recovery," and "community resilience." The United States, for its part, delineates what little reconstruction work it has supported in the northeastern city of Raqqa as "stabilization," after it drove out the extremists of the Islamic State of Iraq and Syria (ISIS, also known as ISIL or Da'esh) by flattening much of the city in air strikes.

"We don't do reconstruction," Moises Venancio, a UNDP adviser for Syria based in New York, told me in 2019. "No one does reconstruction in Syria. It's the international position, but it's also the position adopted by the UN Secretary-General."[12] That assessment was later echoed by a senior humanitarian officer who told the *New Yorker*'s Luke Mogelson: "It's become a collective consensus among donors that we will not do

reconstruction in Syria. 'Reconstruction' is a dirty word. It's political. We don't want to do anything that will eventually benefit the regime."[13]

Whether or not there will be international funding to rebuild Syria is something of a Catch-22. The United States and European countries imposing sanctions on the Assad government have held out the prospect of Western aid as an incentive for negotiations that could end the war, maintaining that they will not fund any major reconstruction unless Assad either gives up power or agrees to a political settlement. But Assad is as entrenched as ever. He has shown little to no sign of yielding to Western pressure or agreeing to reforms in exchange for reconstruction aid, especially after holding onto power at all costs throughout the war. The United Nations keeps a similar position—that it will not support or facilitate physical reconstruction until there is a viable political transition underway. But that is nowhere in sight, as the conflict goes on and several rounds of attempted peace talks have all come up empty. A UNDP official in Damascus, speaking on the condition of anonymity, put the situation bluntly to me in an interview: "Concerning Western players, what you read in the news is what we also see here" in Syria. "There is no appetite [from the Assad government], and there are all the political conditionalities, so nothing is happening."[14]

Nevertheless, as with UNDP's efforts in Homs, this has not precluded the start of some other restoration work, particularly in Aleppo, with the tacit support of international nongovernmental organizations involved in preserving cultural heritage, even if many still lack the necessary funding.[15] Sections of the covered souk in Aleppo are already being rebuilt and restored with funding from the Aga Khan Foundation after the labyrinthine medieval market was gutted by fire early in the civil war and sustained various other forms of damage amid the fighting. "In a process that has so far taken five years," according to the *Guardian*, "650 metres of covered souk has been rebuilt or rehabilitated, out of an original total of 9km." But an architect involved in that project said that rebuilding and restoring the entire souk would take "10 to 20 years, minimum."[16]

It is clear that Syria's government, after years of war and international isolation, cannot afford the ballooning costs of rebuilding the country, estimated at well into the hundreds of billions of dollars. But even if sanctions eased, what vision do Syrian authorities have for the country after a decade of war? "We lost the best of our youth and our infrastructure," Assad told an audience of supporters in Damascus in 2017. "It cost us a lot of money and a lot of sweat, for generations. But in exchange, we won a healthier and more homogeneous society in the true sense."[17] That dark triumphalism has been on display ever since, even though Assad is ruling over a shattered country with pockets still out of his control. When the war began, Syrian soldiers and pro-Assad militias issued a threatening message—"Assad, or we burn the country"—that was often scrawled on the sides of buildings and left as sinister graffiti in besieged towns and cities. The ultimatum in that notorious slogan has now extended into reconstruction. Without the resources to rebuild all of Syria, the government is nevertheless trying to

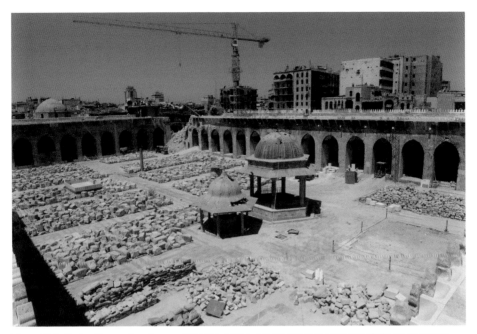

Figure 12.2 Restoration work underway at the Great Umayyad Mosque in the Old City of Aleppo, 14 August 2018. A crane stands over the rubble of the toppled eleventh-century minaret, whose stones have been catalogued and organized in the mosque's courtyard. Image: George Ourfalian / AFP / Getty Images

assert its authority by deciding how to allocate scarce resources, such as aid from friendly allies, into early reconstruction projects that reward its supporters, punish or ignore its opponents, and carry a maximum return on propaganda. It is a form of selective reconstruction by fiat (fig. 12.2).

Who Pays? And Who Can Cash In?

The nature of Assad's authoritarian government has led to this outcome. "Inequality and injustice are at the heart of Syria's reconstruction," scholar Joseph Daher has noted. "The process of rebuilding Syria, which remains very limited, aims to ensure that all power in the country flows from the country's despotic regime and its networks."[18]

For example, take Samer Foz, an accused war profiteer and one of the crony Syrian businessmen close to Assad who has been sanctioned by the United States and the European Union. He has tried to cash in on reconstruction, having already "built his fortune" off the war, according to the *Wall Street Journal*, as he sold vital supplies, including basic foodstuffs, to different parts of the country under the sway of different combatants. Foz is one of the government financiers with a major stake in Marota City, billed as the largest investment project in Syria, which aims to build a collection of luxury high-rises over land in a Damascus neighborhood that was seized during the civil war from Syrians who opposed the government. He owns a steel plant in Homs, promoting it as a key cog in the city's reconstruction, as it has been used to melt down scrap metal and forge it into new rebar. Foz told the *Wall Street Journal* in 2018, somewhat incredulously, "If I don't think about reconstructing my country, who will?"

He wanted "the furnaces of his Homs steel plant to be a cornerstone of Syrian reconstruction even before a political settlement."[19]

In both Aleppo and Homs, reconstruction has begun "unequally," according to Daher, "sometimes in the same city." In heavily bombarded eastern Aleppo, which was under the control of various opposition groups until late 2016, "the government has made no efforts to enhance living conditions or rebuild residential areas," he added. "In such places, the provision of state services has been minimal." Instead, the remaining residents there—if they either stayed throughout the war or have since returned after fleeing the fighting—have had to eke out any attempts at small-scale rebuilding on their own.

In 2019, a UNDP official in Damascus told me that the most noticeable transformation in Aleppo in the year after the government reestablished full control was the small shops that had suddenly opened on a once "spectral" and ruined street in eastern Aleppo, whose businesses had all shuttered during the war. The stores were selling basic construction materials like cement by the bag—"not for big companies," the official said, "but for people" who had returned. They were either refugees or the internally displaced attempting to rebuild their homes themselves. "These returns didn't happen because it's a paradise," the UN official said of Aleppo. "No. It happened because many of these people didn't have any savings anymore to pay the rent somewhere else, or the host communities were also exhausted. They were forced to come back."

Since the UN's interventions have to stop short of anything resembling full-scale reconstruction, given its limited mandate in Syria, UNDP and other UN agencies instead prioritize providing humanitarian assistance to the most vulnerable Syrians, like those in eastern Aleppo. (The UN has nevertheless been criticized for working with the Assad government, since it is the authority on the ground, and even contracting with Syrian entities linked to Assad to deliver aid, which has risked compromising its humanitarian mission in Syria, according to some critics.)[20] When it comes to reconstruction, the UN is also limited by sometimes-byzantine formulas that restrict its activities. For instance, UNDP can rebuild a school or medical clinic partially damaged in the war, but not if its walls are destroyed down to its foundation. It bases such "rehabilitation"—again, not formally considered reconstruction, according to the UN—on some bleak calculations. "The red line is 30 to 40 percent of the initial level" of the building, this UN official explained to me. "So if damage goes beyond 30 to maximum 40 percent of the initial volume of the building, then we consider it reconstruction and we don't intervene."

This official described Aleppo in early 2019 as "completely paralyzed in relation to any kind of reconstruction." Little has changed in the city, it seems, in the years since. There was a rumored master plan for Aleppo's "restoration," as the Syrian government had purportedly described it, but "it is a master plan that nobody has seen; officially it has not been launched." The official described the master plan, which was apparently still being finalized and had not been shared fully with UNDP, revealingly: "It's owned by the government." This sounded even more like reconstruction on Assad's terms.

Whether or not it was part of this mooted master plan, in late 2017 the Syrian government designated fifteen "priority areas" for reconstruction in Aleppo, eight of which were in the western and central parts of the city, which had remained under its control throughout the war. They had therefore sustained far less damage than rebel-held eastern Aleppo, including the Old City, and infrastructure and many public services were still largely intact. That inequity within the city itself was also evident in Homs, where neighborhoods that had either remained under government control or whose residents were considered by the authorities to be sufficiently loyal were identified as priorities for reconstruction, to the neglect of formerly rebel-held areas.

"The government's favoritism of its supporters has been reflected in funding discrepancies," according to Daher. He noted that "the combined value of state investment projects in 2015, for example, reached nearly 30 billion Syrian pounds (around $70 million) for the coastal governorates of Tartous and Latakia, both regime strongholds." But Aleppo, by contrast, "was allocated 500 million Syrian pounds (around $1.2 million), despite being in greater need of restoration." In 2015, Aleppo was still divided between the government-held west of the city and the rebel-held east, but these gaps in funding have persisted as the government reestablished control over the whole city and of more of the country. "Out of 11 billion Syrian pounds (around $22 million) earmarked for repairing and constructing roads across Syria in 2017," Daher reported, "almost half was to be spent in coastal areas, which was less affected by the war but constituted one of its key constituencies." Still, like so many things in Syria, many of these projects "have not yet materialized due to a lack of funding."

Echoes of Beirut?

The warning signs of where this kind of selective reconstruction could lead are next door in Lebanon, especially in Beirut, which, like Aleppo and Homs, was the urban front line of a brutal civil war. When Lebanon's fifteen-year conflict ended in 1990, central Beirut was in ruins. Its reconstruction was not overseen by an authoritarian government like that of Assad but by a single private real estate company, called Solidere, whose largest shareholder was the country's billionaire prime minister, Rafik Hariri. Solidere essentially bought up all of Beirut's heavily damaged historical downtown, displacing many residents and small businesses, and structured the entire area as a single corporation that larger landowners could buy stock in, in exchange for selling their property rights. Solidere then rebuilt the city center for a narrow elite— wealthy Lebanese, as well as investors from the oil-rich Persian Gulf—and with little care or attention to preserving the ancient archaeological ruins, from as far back as the Roman and Phoenician eras, that were under all the rubble and unearthed during reconstruction. The rebuilding introduced new levels of destruction after the war, as "more buildings were torn down during reconstruction than were destroyed by the war, transforming Beirut's war-scarred layers of history from the Roman, Mamluk, Ottoman and French periods into a city without memory."[21]

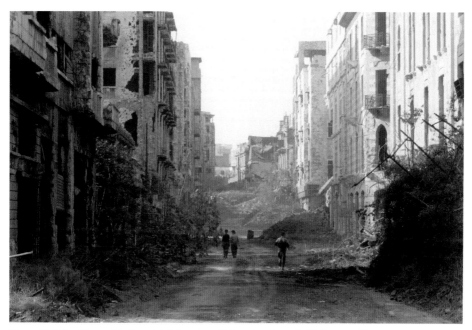

Figure 12.3 Rue Weygand in devastated downtown Beirut after the end of Lebanon's fifteen-year civil war, 23 December 1990. Image: Marc Deville / Gamma Rapho / Getty Images

Solidere restored some Ottoman and French (League of Nations) Mandate-era buildings that had been heavily damaged in the war, but they became, for example, luxury stores and banks. Glittering new towers also went up, some designed by prominent international architects, in what many of Solidere's critics saw as imposing a hollow vision of Dubai on Beirut. "It's a kind of censorship in the middle of the city, a fairy tale," Lebanese architect Bernard Khoury said in an interview in 2006. "It has no relationship to our lives today."[22] Meanwhile, as billions of dollars were invested in Solidere's redevelopment scheme, other decimated areas of Beirut languished, with reconstruction often at the whim of local warlords-turned-politicians (fig. 12.3).

The Syrian government may already have its own version of Solidere in mind—if not in Aleppo and Homs, at least in Damascus, with Marota City, a huge luxury development that is being built over expropriated land on the southwestern edge of the capital by government-aligned entities in the name of reconstruction. There are differences from Beirut, to be sure: most of all, the particular neighborhood in Damascus, Kafr Sousseh, is not the central business district that downtown Beirut had been. The context in Syria is different, too, since the civil war has not ended. Yet researchers Noor Hamadeh and Krystel Bassil have noted "a strikingly close resemblance to the 'Solidere' model" in Marota City, as the project represents similar dynamics and interests at play to those with Solidere in Beirut.[23]

Solidere "led to the systematic violation of property rights, the exclusion of communities, and the profiteering of war criminals," Hamadeh and Bassil write, and Marota City could do much the same. The land for Marota City was acquired coercively

through new laws ostensibly designed to "improve" and redevelop informal areas that had expanded on the outskirts of Damascus before the conflict—and whose residents rose up against the government in the civil war. Human rights observers have warned that those laws, most of all one known as Decree 66, are "not only being used to forcibly dispossess" residents in Damascus, "but also to engineer demographic change."[24] Marota City, according to Hamadeh and Bassil, shows how "the regime is using urban development as a weapon of war to punish and exclude opposition communities."

The Syrian government is also following the investment model of Solidere, forming state-backed holding companies to oversee what are effectively real estate projects dressed up as postwar reconstruction—not just in Marota City but also in an incipient redevelopment scheme in Homs, in the former rebel-held area of Baba Amr. These holding companies have been investment vehicles for the government's inner circle of financiers, including Samer Foz and Assad's cousin, billionaire tycoon Rami Makhlouf, once called "one of the primary centers of corruption in Syria" by the US State Department. Makhlouf, who has also been under US and European sanctions, had a public falling-out with Assad in 2020.

Reconstruction on these terms risks consolidating government control and making anything even resembling postwar reconciliation among Syria's various ethnic and religious communities less and less likely. "I don't think only Aleppo will be punished, but most of the Sunni majority will be punished," exiled Syrian writer Nihad Sirees told me in an interview in 2019, as he predicted that Syrian authorities would ignore the former rebel-held neighborhoods of eastern Aleppo, denying them what little resources are available for reconstruction.[25] Sirees expected reconstruction to be plagued by widespread corruption within the government and among its Russian and Iranian backers. "Rebuilding is like a golden egg," he said. "Everyone sits and is waiting to get it, or to get a good part of it."

Sirees, who is from Aleppo, has chronicled the city's history in his novels, plays, and screenplays, several of which became wildly popular television dramas in Syria and the wider Arab world. An engineer by training, he lived in Aleppo for much of his life, including many years in which he was ostracized by the government and cast as a traitor because of his writing about the history of the ruling Ba'ath Party. The Syrian government started banning his novels in 1998, even though he was one of the most prominent writers in the country. In 2012, with the civil war approaching Aleppo, he had to flee Syria.

"We will talk about rebuilding theoretically, but not realistically, because who knows when the rebuilding will start," Sirees told me. He was skeptical of the government's well-publicized restorations underway in Aleppo's Old City—and of the suggestion that they represented anything like reconstruction. "I don't think that to fix an arch somewhere in the Old City, or a minaret or something, it is not rebuilding. We'll keep talking theoretically until there's a political solution in Syria."

Popular and Grassroots Enterprise

There are nevertheless exceptions to this harsh picture. They reflect wider tensions and realities in Syria today, and in similar contexts where countries are nearing the end of a long civil war or entering a new, post-conflict phase. The Assad government may want to project authority, but its control is still limited in several provinces of Syria. Even in the areas where it has reestablished control, including Aleppo and Homs, it is in many respects weaker today, militarily and economically, because of the war's toll. So, smaller forms of reconstruction will emerge, and already have, at the margins and outside of the control of the state.

In 2014, a young Syrian architect and art historian from Damascus, Khaled Malas, who was then living in Basel, was invited to design a Syrian pavilion at the annual Venice Architecture Biennale.[26] Malas, who is part of an Arab architectural collective called Sigil, used the funds provided by the exhibition to build what he called a "displaced pavilion" in an undisclosed part of southern Syria—later revealed to be in Deraa, the once-quiet town on the Jordanian border where the popular uprising against Assad essentially began with the first protests in March 2011. Malas worked remotely with local activists on the ground there to build a well, which they piped into the local water network. The first project in a series in Syria that Sigil called "Monuments of the Everyday," this wasn't just a public demonstration or architectural experiment; the well provided water for fifteen thousand people whose basic infrastructure had been pummeled by barrel bombs dropped by government forces. After the Venice Biennale, the activists with whom Malas had coordinated built a second well.

"If nothing else, this project is a humble salute to those brave men and women in Syria who are able to maintain a semblance of everyday life for themselves and their communities in the face of death striking at them from multiple directions, including from above," Malas told an interviewer in 2014.[27] The wells are still operating today, in an area that has been outside Assad's control since 2011, governed in part by the local councils and popular committees that formed in the early, more hopeful days of Syria's civil uprising.

Malas was not done. He followed up the wells with a project at the Marrakech Biennale in 2016: a windmill that generated electricity in a building in the devastated Damascus suburb of Ghouta. The building was home to an underground field hospital, so Malas's project, which he and the Sigil collective called "Current Power in Syria," was much more than just another experimental architectural intervention for an international art exhibition or biennale, in this case about "electricity as a nation-building device" over the past century of Syrian history, as Malas later put it.[28] Like the wells, the windmill in Ghouta was practical infrastructure, too, and a small but essential form of reconstruction: it powered a field hospital. For Malas, it also "got him banned from his native Syria."[29]

Malas and Sigil's work has been described as "rural architectures of resistance in Syria," echoing their own description of the windmill as "an act of creative resistance,

one that takes power literally."[30] The writer and critic Kaelen Wilson-Goldie said Malas "uses the codes, production channels, and communication circuits of the art world to build symbolic but useful pieces of infrastructure in Syria."[31] In doing so, she added, Malas "illustrates how communal utilities such as water and power have shaped ideas about nationalism and citizenship. In this sense, the people who built the windmill in the Ghouta are testing out what a sounder, healthier Syrian state could be."

While Malas's wells and windmill are unusual in terms of the international attention they received, given their connections to the global art world, they represent the kind of grassroots rebuilding efforts that many Syrians, by necessity, have already taken up themselves and will keep doing in the years to come. "There will always be some local enterprise," Amr al-Azm told me. "Eventually, some people will make their way back home. Those people will look at their homes and do some clearing themselves. It will all be very localized, on a very individual basis." Such small-scale reconstruction is evident in Aleppo and Homs. In Aleppo, for example, local historians and preservationists formed their own "Friends of Bab al-Nasr" committee to restore one of the damaged medieval gates to the Old City. "We're not rich, but we do have some money to spend on our city," one of its members, Alaa al-Sayed, told the BBC in 2018.[32]

Behind the government's boasts about rebuilding Syria according to its exclusionary vision of "victor's justice"—that "healthier and more homogeneous society in the true sense," as Assad proclaimed—reconstruction on the ground will more often look like something else, something far more modest and limited. "Anything that does get done, maybe the government will send a bulldozer to move rubble out of the way, or to open a street, but it's going to be very piecemeal, very slow, very small scale," Azm said. Reconstruction will ultimately reflect the reality of just how much has been destroyed in Syria, and how weak the government remains, despite its claims to power and authority.

Conclusion

There is an unavoidable tension in discussing reconstruction in the context of Syria— what it really means, and whether what is unfolding now can even be called reconstruction if the civil war has not ended. But in considering the question of who decides, it is clear that the Syrian government will seek credit for any rebuilding projects that it can use to buttress its claims of legitimacy, especially in a city like Aleppo, whose reconstruction might promise new and better international headlines. But Syrians themselves will still determine many other forms of reconstruction, often on a localized and enterprising scale outside the government's authority and remit, whether it is their own modest civic infrastructure or even their own houses.

This question about who shapes reconstruction has been asked before, the most relevant case being neighboring Lebanon, starting in the 1990s when its civil war was finally over. The fact that some of the same dynamics and problems from the rebuilding of Beirut are now evident in Damascus and Homs underscores how quickly reconstruction can be co-opted—by self-interested authorities and elites motivated by

the desire to consolidate political control and seize the economic windfalls, often through corrupt means. This already looks in many cases like "victor's justice" in Syria, but it was more opaque in Lebanon, since there was hardly a single victor in that protracted war. Yet even in more clear-cut, post-conflict scenarios, where war has definitively ended, reconstruction could still be steered in narrow and divisive directions unless there is a more representative government that is responsive to popular will and not tainted by corruption.

Finally, in countries such as Syria, where cultural heritage sites have been damaged in conflict and become an immediate focus of reconstruction or restoration after the fighting, they risk being co-opted. If they are prioritized in reconstruction over housing and basic infrastructure, the question should be asked, Why? Is the rebuilding or restoring of a damaged cultural heritage site—a medieval mosque, perhaps—being done for purely symbolic reasons, and even overt propaganda designed to burnish the reputation or legitimacy of local authorities, especially autocratic ones? Of course, damaged cultural heritage sites may also be deliberately kept as ruins, for their own symbolism. Consider Dresden's Frauenkirche, the eighteenth-century Lutheran church destroyed in the Allied firebombing in 1945, which East German authorities never rebuilt. The rubble was left as a war memorial for fifty years—not only because the communist government could not afford to rebuild it, but because the church's stark ruins sent an intentional message about what American and British bombers had done to the city. Only after reunification did Germany's new government decide to rebuild it; the carefully reconstructed church reopened in 2005, six decades after its destruction.

So far, the fate of some prominent cultural heritage sites in Syria has taken a different course. But given the scale of destruction, many other historical sites across the country will not be rebuilt so quickly, let alone hastily by a government looking to soften its image internationally—it simply lacks the resources. As with Syria's wider reconstruction, the restoration and rebuilding of its cultural heritage sites reflect what the government fundamentally wants to achieve, and project, through reconstruction: that it retains all power and authority, despite ruling over a country shattered by a war of Assad's own making.

SUGGESTED READINGS

Rania Abouzeid, *No Turning Back: Life, Loss, and Hope in Wartime Syria* (New York: W. W. Norton, 2019).

Joseph Daher, *Syria after the Uprisings: The Political Economy of State Resilience* (Chicago: Haymarket Books, 2020).

Samir Kassir, *Beirut*, trans. M. B. DeBevoise (Berkeley: University of California Press, 2010).

Philip S. Khoury and Samir Khalaf, eds., *Recovering Beirut: Urban Design and Post-war Reconstruction* (Leiden, the Netherlands: Brill, 1993).

Lisa Wedeen, *Authoritarian Apprehensions: Ideology, Judgment, and Mourning in Syria* (Chicago: University of Chicago Press, 2018).

Maha Yahya, ed., *Contentious Politics in the Syrian Conflict: Opposition, Representation, and Resistance* (Beirut: Carnegie Middle East Center, 2020).

NOTES

1. Marwa al-Sabouni, *The Battle for Home: The Vision of a Young Architect in Syria* (London: Thames & Hudson, 2016).
2. See, for example, Albert Aji, "Syrian Troops Capture Historic Mosque in Homs," Associated Press, 27 July 2013, https://apnews.com/b713dc88d5d649aca85506197446a600; and "Historic Mosque in Syria's Homs Under Fire as Fighting Rages," *VOA News*, 7 July 2013, https://www.voanews.com/a/historic-mosque-in-syrias-homs-under-fire-as-fighting-rages/1696779.html.
3. See, for example, Nataliya Vasilyeva (Associated Press), "Chechen Religious Leaders Re-open Landmark Mosque in Syria," 21 February 2019, ABC News, https://abcnews.go.com/International/wireStory/chechen-religious-leaders-open-landmark-mosque-syria-61209244; and Michael Jansen, "Restored Mosque in Devastated Old City Gives Syrians Cause to Celebrate," *Irish Times*, 6 April 2019, https://www.irishtimes.com/news/world/middle-east/restored-mosque -in-devastated-old-city-gives-syrians-cause-to-celebrate-1.3851117.
4. Gareth Browne, "An Eerie Silence Prevails in Assad's 'Reconstructed' Homs," *National*, 17 April 2018, https://www.thenational.ae/world/mena/an-eerie-silence-prevails-in-assad-s-reconstructed -homs-1.722506.
5. Syrian Ministry of Tourism, "Homs . . . Portrait of Life," 13 February 2018, YouTube video, 1 min., https://www.youtube.com/watch?v=qA2rAI2XeA0.
6. Sawsan Abou Zainedin and Hani Fakhani, "Syria's Reconstruction between Discriminatory Implementation and Circumscribed Resistance," in *Contentious Politics in the Syrian Conflict: Opposition, Representation, and Resistance*, ed. Maha Yahya (Beirut: Carnegie Middle East Center, 2020), https://carnegie-mec.org/2020/05/15/syria-s-reconstruction-between -discriminatory-implementation-and-circumscribed-resistance-pub-81803.
7. Jomana Qaddour, "Homs, a Divided Incarnation of Syria's Unresolved Conflict," in *Contentious Politics in the Syrian Conflict*, ed. Yahya, https://carnegie-mec.org/2020/05/15/homs-divided -incarnation-of-syria-s-unresolved-conflict-pub-81804.
8. Frederick Deknatel, "What Would Reconstruction Really Mean in Syria?," *Los Angeles Review of Books*, 6 August 2019, https://lareviewofbooks.org/article/what-would-reconstruction-really -mean-in-syria/.
9. Diana Darke, "Is Reconstruction of Aleppo's Grand Mosque Whitewashing History?," *National*, 12 May 2018, https://www.thenationalnews.com/world/mena/is-reconstruction-of-aleppo-s -grand-mosque-whitewashing-history-1.728715.
10. Chris Ray, "Syrians Won't Give Up on the Great Mosque of Aleppo," *Atlas Obscura*, 10 December 2019, https://www.atlasobscura.com/articles/reconstruction-great-mosque-aleppo-syria.
11. Kelly Cobiella and Gabe Joselow, "Aleppo's Reconstruction Is in Full Swing after Years of War," NBC News, 30 August 2018, https://www.nbcnews.com/news/world/syrians-returning-aleppo -confront-hope-hardship-n905231.
12. Moises Venancio, United Nations Development Programme advisor in New York, interview with author, 23 January 2019.
13. Luke Mogelson, "America's Abandonment of Syria," *New Yorker*, 20 April 2020, https://www.newyorker.com/magazine/2020/04/27/americas-abandonment-of-syria.
14. United Nations Development Programme official in Damascus, interview with author, 6 February 2019.

15. Jwanah Qudsi, "US Sanctions Are Strangling the Effort to Rebuild Old Aleppo," *Washington Post*, 10 May 2019, https://www.washingtonpost.com/outlook/us-sanctions-are-strangling-the-effort-to -rebuild-old-aleppo/2019/05/10/747d7856-70f2-11e9-8be0-ca575670e91c_story.html.

16. Rowan Moore, "How Syria's Blasted Landmarks Are Starting to Rise from the Ruins," *Guardian*, 29 August 2020, https://www.theguardian.com/artanddesign/2020/aug/29/how-syrias-blasted -cities-are-rising-from-the-ruins.

17. Ben Hubbard, "Syrian War Drags On, but Assad's Future Looks as Secure as Ever," *New York Times*, 25 September 2017, https://www.nytimes.com/2017/09/25/world/middleeast/syria-assad -war.html.

18. Joseph Daher, "The Paradox of Syria's Reconstruction," *Carnegie Middle East Center*, 4 September 2019, https://carnegie-mec.org/2019/09/04/paradox-of-syria-s-reconstruction-pub -79773.

19. Sune Engel Rasmussen and Nazih Osseiran, "Out of Syria's Chaos, a Tycoon Builds a Fortune," *Wall Street Journal*, 12 August 2018, https://www.wsj.com/articles/out-of-syrias-chaos-a-tycoon -builds-a-fortune-1534100370.

20. Nick Hopkins and Emma Beals, "UN Pays Tens of Millions to Assad Regime under Syria Aid Programme," *Guardian*, 29 August 2016, https://www.theguardian.com/world/2016/aug/29/un -pays-tens-of-millions-to-assad-regime-syria-aid-programme-contracts.

21. Julia Tierney, "Beirut's Lessons for How Not to Rebuild a War-Torn City," *Washington Post*, 12 October 2016, https://www.washingtonpost.com/news/monkey-cage/wp/2016/10/12/beiruts -lessons-for-how-not-to-rebuild-a-war-torn-city/.

22. Nicolai Ouroussoff, "Middle-East Pieces," *New York Times Magazine*, 21 May 2006, https://www .nytimes.com/2006/05/21/magazine/21khoury.html.

23. Noor Hamadeh and Krystel Bassil, "Demolishing Human Rights in the Name of Reconstruction: Lessons Learned from Beirut's Solidere for Syria," Tahrir Institute for Middle East Policy, 16 September 2020, https://timep.org/commentary/analysis/demolishing-human-rights-in-the-name -of-reconstruction-lessons-learned-from-beiruts-solidere-for-syria/.

24. Tom Rollins, "Decree 66: The Blueprint for al-Assad's Reconstruction of Syria?," *New Humanitarian*, 20 April 2017, https://www.thenewhumanitarian.org/fr/node/259390.

25. Nihad Sirees, interview with author, 18 February 2019. See also Deknatel, "What Would Reconstruction Really Mean?"

26. Khaled Malas, "Excavating the Sky," *Jadaliyya*, 29 September 2014, https://www.jadaliyya.com/ Details/31263.

27. Mona Harb, "Exhibiting the War in Syria: Interview with Khaled Malas," *Jadaliyya*, 13 November 2014, https://www.jadaliyya.com/Details/31473/Exhibiting-the-War-in-Syria-Interview-with -Khaled-Malas.

28. Nicholas Korody, "A Well, a Windmill, a Mirror: Sigil's Real and Symbolic Interventions in Syria," *Archinect*, 27 September 2016, https://archinect.com/features/article/149970171/a-well-a -windmill-a-mirror-sigil-s-real-and-symbolic-interventions-in-syria.

29. Hrag Vartanian, "Tracing the Contours of Power at the Marrakech Biennale," *Hyperallergic*, 6 May 2016, https://hyperallergic.com/296474/tracing-the-contours-of-power-at-the-marrakech -biennale/.

30. Jane Lombard Gallery, "Christine Gedeon in Conversation with Hrag Vartanian and Khaled Malas, Jane Lombard Gallery, New York, 28 November 2018," 27 November 2018, Art-agenda, https://www.art-agenda.com/announcements/229375/christine-gedeon-in-conversation-with -hrag-vartanian-and-khaled-malas.

31. Kaelen Wilson-Goldie, "Practical Magic: Can Art Make a Difference in Assad's Syria?," *Bookforum*, April/May 2017, https://www.bookforum.com/print/2401/can-art-make-a-difference -in-assad-s-syria-17557.

32. Lyse Doucet, "Rebuilding Aleppo: Life beyond Syria's Civil War," BBC, 22 January 2018, https://www.bbc.com/news/world-middle-east-42755045.

13

Yemen's Manuscript Culture under Attack

Sabine Schmidtke

In the aftermath of the Ottoman Empire's collapse at the end of World War I, the Yemeni highlands came under the rule of the Zaydi Hamid al-Din dynasty. Imam al-Mutawakkil ʿala llah Yahya Ḥamid al-Din (r. 1904–48) devised an idiosyncratic religio-pedagogical program to advance religion and culture in Yemen while at the same time attempting to shield its citizens from the advancements of modernity. His educational reforms included the foundation in 1926 of a "mosque university" (al-madrasa al-ʿilmiyya) where the country's elite was educated over the next several decades. Moreover, Imam Yahya issued a decree in 1925 announcing the establishment of a public library, al-Khizāna al-Mutawakkiliyya (today Maktabat al-Awqāf), which in many ways constituted a novelty in Yemen. The imam assigned a consecrated location to the library on the premises of the Great Mosque in Sana'a, and he had a new story added for the library along the southern side of the mosque's courtyard. The principal purpose behind the library, as spelled out in the 1925 decree, was to gather what remained of the many historical libraries dispersed all over the country and thus prevent further losses. For this purpose the imam appointed as library officials qualified scholars, who started to build up the collections. The details of this process can be gleaned from the notes that were added to each codex (fig. 13.1). These record the provenance of the individual codices and when each was transferred to the Khizāna, as well as occasional specific regulations for the codex in question. Gradually, registers of the holdings of the newly founded Khizāna were produced, culminating in a catalogue published in 1942/43 (fig. 13.2).[1]

The catalogue, a large folio volume consisting of 344 pages and describing some eight thousand titles of both manuscripts and printed books, is a remarkable piece of work: although the information about each manuscript and printed volume is kept to a minimum, it methodically records the provenance of each item. Taken together, these data allow for an inquiry into the history of the library's manuscript holdings (some four thousand items), dating from the tenth century up until the first decades of the

Figure 13.1 Ms. Ṣanʿāʾ, Maktabat al-Awqāf 2318, pages 1–2, transfer note (upper two lines and margin) for the codex from Ẓafār to Sana'a in Rabīʿ I 1348 (August–September 1929). Image: Courtesy of private collector

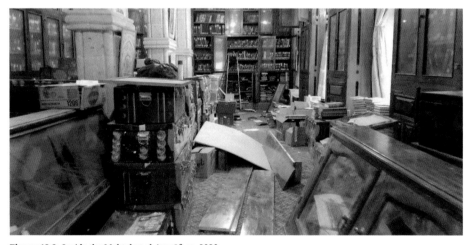

Figure 13.2 Inside the Maktabat al-Awqāf, ca. 2020

twentieth, thus opening a representative window into the history of manuscript production and book culture in Yemen over the course of a millennium.[2]

The oldest layer of manuscripts (constituting 5 percent of the Khizāna's total holdings), some of which were produced during the tenth and eleventh centuries, came from the library of Imam al-Manṣūr bi-llāh ʿAbd Allah b. Hamza (r. 1197–1217), which was situated in his town of residence, Ẓafār, and was one of the oldest extant libraries in

Yemen. Another corpus of particularly precious and old manuscripts originated in the library of the Āl al-Wazīr, a powerful Zaydi family in Yemen, whose members had been engaged in scholarship and politics since the twelfth century; some rose to power while others failed. Time and again their opponents confiscated parts of the family's property, including their books. The codices that are recorded in the 1942/43 catalogue as originating from the library of the Āl al-Wazīr match an inventory of titles confiscated from the al-Wazīr family following the order of the Qāsimī imam al-Mutawakkil ʿala llah Ismaʿil (r. 1644–76), which was written out in 1690 and lists 131 items. According to historical accounts, the library collection of the Āl al-Wazīr, which amounted to some nine hundred codices by the mid-seventeenth century, had been divided between several branches of the family and was at risk of being lost as a result of the dispersal. The inventory was scribbled down on some empty pages of a codex held in the Khizāna—testimony to the care that was taken with books, even in times of conflict, and at the same time an example of the documentary evidence available for the rich and multifaceted history of Yemen's book and library culture, whose story still needs to be written. The fate of other parts of the library of the Āl al-Wazīr remains unknown; a significant portion of the family's books is said to have ended up in Istanbul.[3] Most of what had remained with the family was confiscated and transferred to the Great Mosque after the failed coup d'état in 1948, in which members of the Āl al-Wazīr played a leading role.[4]

Among the largest collections that were incorporated into the Khizāna are the libraries of members of the Qāsimī family, which ruled the country for most of the sixteenth and seventeenth centuries. These members include two grandsons of al-Imam al-Mansur al-Qasim b. Muhammad (1559–1620), the eponymous founder of the dynasty—namely, al-Mahdi li-Din Allah Ahmad b. al-Hasan b. al-Qasim (1620–1681) (10 percent) and Ahmad's older brother Muhammad b. al-Hasan b. al-Qasim (1601–1668), whose private library stands out for its size (31 percent). Some of the leading bureaucrats during the first century of the Qāsimī period (sixteenth century) also had substantial personal libraries, the remains of which were likewise transferred to the Khizāna (21 percent). Imam Yahya also contributed a significant portion of manuscripts from his personal library to the newly founded Khizāna (17 percent).

The imam's concern to salvage what remained of the historical libraries to prevent further losses was certainly justified. Prior to the 1925 decree, numerous codices that had originally belonged to the library of Imam al-Mansur bi-llāh ʿAbd Allah b. Hamza, as well as those libraries founded by members of the Qāsimī dynasty, had been sold and are nowadays preserved in the libraries of Riyadh, Istanbul, Berlin, Leiden, Milan, Vienna, Munich, London, and even Benghazi (figs. 13.3a, 13.3b).[5] Others are today in the possession of private owners in Yemen.

The entries in the catalogue are classified according to twenty-six disciplinary headings,[6] and within each section the titles are arranged in alphabetical order, with printed books and manuscripts listed side by side. While the classification system, as

Figures 13.3a–b Title page and final page of a codex originally in the library of Imam al-Mansur bi-llah ʿAbd Allah b. Hamza. The title page (13.3a) had been glued over, hiding both the title of the book and a note recording that it had been transcribed for the library of Imam al-Mansur bi-llah ʿAbd Allah b. Hamza. The final page (13.3b) has the scribe's colophon, dated Shaʿban 605 (February–March 1209), followed by a note signed by Muḥyi al-Dīn Muhammad b. Ahmad b. ʿAli b. al-Walid al-Qurashi al-Anf (d. 1226) relating that he collated the transcription with a witness of the work from "Iraq" (meaning ʿIraq al-ʿajam, i.e., Iran) and that he finished doing so at the beginning of Shawwal 605 (April–May 1209). Ibn al-Walid, a scholar in his own right, had studied together with ʿAbd Allah b. Hamza and led a project of transcription of manuscripts brought from Iran to Yemen at the request of the imam. Image: Leiden University Libraries, Special Collections, Ms. Or. 8409 / CC BY 4.0

well as other organizational principles applied in the Khizāna, emulated notions of rudimentary library science at the time of its founding, it also reflects the traditional

canon of mainstream Zaydism. Remarkably, several disciplines remain uncovered in the catalogue. There are no headings covering philosophy or Sufism, two strands of thought that were not cherished among the Zaydis. That the exclusion was the result of a conscious decision is corroborated by oral reports, according to which Imam Yahya gave special orders to exclude from the catalogue all categories of holdings that he considered inappropriate or harmful.[7] That works of philosophy did circulate among the Zaydis of Yemen is, however, attested since the twelfth century. The two prominent twelfth-century scholars Qadi Ja'far b. Ahmad b. 'Abd al-Salam al-Buhluli (d. 1177/78) and al-Hasan b. Muhammad al-Rassas (d. 1188), for example, wrote refutations of selected notions of the philosophers, and their respective works testify to their familiarity with some of the relevant primary sources, including perhaps al-Ghazali's *Doctrines of the Philosophers* (*Maqāṣid al-falāsifa*).[8] Moreover, a handwritten inventory of the library of Imam al-Mutawakkil Sharaf al-Din Yahya (d. 1558), a grandson of the renowned Imam al-Mahdi Ahmad b. Yahya b. al-Murtada (d. 1437) and a prominent scholar in his own right, includes a number of philosophical titles, such as two copies of *Doctrines of the Philosophers*, a book on logic by al-Farabi, and a partial copy of Avicenna's *Deliverance* (*K. al-Najāt*). Imam Yahya is also reported to have captured significant quantities of books during his battles against the Isma'ilis in Yemen, including an entire library of four hundred codices that he received as booty in May–June 1905.[9] None of these works are listed in the catalogue, as they were kept during Imam Yahya's lifetime in his personal library.[10] Their later fate and current whereabouts are unknown. Isma'ili missionary propagation (*da'wa*) had been associated with Yemen since the end of the ninth century—that is, since about the time when Imam al-Hadi ila l-Haqq Yahya b. al-Husayn (d. 911) and his followers arrived in Ṣa'da and established a Zaydi state in the northern highlands of Yemen, and the Isma'ilis posed a serious threat to the Zaydis during the Ṣulayḥīd rule over Yemen, which lasted from about the mid-eleventh to the mid-twelfth century. Thereafter, the Isma'īlī *da'wa* moved eastward toward India, although the community continued to be present in small numbers in Yemen. Sufism was also largely detested by the Zaydis,[11] and historical accounts from the Qāsimī era regularly mention repeated attempts to purge the book markets of Sufi works, an indication that such titles did circulate among the Zaydis.

That works pertaining to philosophy, Sufism, and Ismā'īlism are largely missing from the catalogue suggests that Imam Yahya asked them to be left uncatalogued. The 1942/43 catalogue thus testifies both to the long library tradition of Zaydi Yemen and to the continuous efforts to cleanse the curriculum through censorship and destruction and to control the literary canon (fig. 13.4).

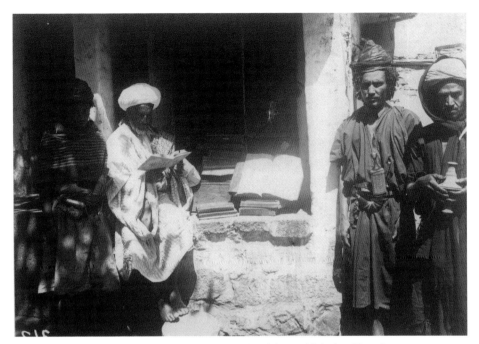

Figure 13.4 Bookshop at Sana'a, Yemen, ca. 1912. Image: Royal Geographic Society / Getty Images

A Millennium of Zaydi Presence in Yemen

Since the ninth century, the Zaydi community has flourished mainly in two regions, the mountainous northern highlands of Yemen and the Caspian region of northern Iran. Over the following centuries, the Zaydis of Yemen remained largely isolated from their coreligionists in Iran as a result of their geographical remoteness and political seclusion. Unlike Yemen, northern Iran was in close proximity to some of the vibrant intellectual centers of the Islamic world between the ninth and eleventh centuries, and Iranian Zaydis were actively involved in the ongoing discussions. The most important among the period's intellectual strands was the Mu'tazila, a school of thought that attributed primary importance to reason in matters of doctrine and that thrived under the Buyids, who ruled over Iran and Iraq. During the tenth century, Abu 'Abd Allah al-Basri (d. 980), who was based in Baghdad, was at the helm of the Bahshamite branch of the movement, and his students included the two brothers and later Zaydi imams Abu l-Husayn Ahmad b. al-Husayn (Imam al-Mu'ayyad bi-llah, d. 1020) and Abu Talib Yahya b. al-Husayn (Imam al-Natiq bi-l-Haqq, d. circa 1033), both prolific scholars. Abu 'Abd Allah al-Basri's successor as the head of the school was 'Abd al-Jabbar al-Hamadhani (d. 1025). The latter enjoyed the patronage of the Buyid vizier al-Ṣṣahib b. 'Abbad, who appointed him chief judge in Rayy (today part of Tehran). 'Abd al-Jabbar also had a fair number of Zaydis among his students, some of whom wrote commentaries on his theological works and composed their own books. Rayy continued to be a center of Zaydi Mu'tazili scholarship, even after the demise of 'Abd al-Jabbar, and we know of a number of prominent Zaydi

scholarly families in the city that flourished during the eleventh and early twelfth centuries.[12]

A rapprochement between the Zaydi communities in Iran and Yemen began in the early twelfth century and eventually resulted in their political unification. This development was accompanied by a transfer of knowledge from northern Iran to Yemen that comprised nearly the entire literary and religious legacy of Caspian Zaydism. The sources—chains of transmission and scribal colophons in manuscript codices, correspondence, and biographical literature, as well as biobibliographies and other historical works—provide detailed information about the mechanisms of this process. Throughout the twelfth century various prolific Zaydi scholars from the Caspian region were invited to come to Yemen: they brought numerous books by Iranian authors and acted as teachers to the Yemeni Zaydi community's spiritual and political leaders, the imams, and other scholars in Yemen. At the same time, Zaydi scholars traveled from Yemen to Iran and Iraq for the purpose of study. The knowledge transfer reached its peak during the reign of the aforementioned Imam al-Mansur bi-llāh ʿAbd Allah b. Hamza. The imam founded a library in Ẓafār, his town of residence, for which he had a wealth of textual sources copied by a team of scholars and scribes.[13]

The imported Basran Muʿtazili literature from Iran served as an ideological backbone in the intra-Zaydi conflict with the local movement of the Muṭarrifiyya, a school of thought within Yemeni Zaydism that had evolved over the tenth and eleventh centuries and is named after Mutarrif b. Shihab b. ʿAmir b. ʿAbbad al-Shihabi (d. after 1067), who played a major role in formulating and systematizing its doctrines. Although the followers of the Muṭarrifiyya claimed to cling fervently to the theological teachings of the aforementioned al-Hadi ila l-Haqq and his sons, they developed a cosmology and natural philosophy of their own. They maintained, for example, that God had created the world out of three or four elements—namely, water, air, wind, and fire—and that it is through the interaction of these constituents of the physical world that change occurs; in other words, they endorsed natural causality rather than God's directly acting upon his creation.

The precise contours of their doctrines cannot be restored at this stage. The conflict between the local Zaydi-Muṭarrifi faction and those Zaydis who adhered to the Bahshamite Muʿtazilite doctrine of northern Iran reached its peak during the reign of Imam al-Mansur bi-llāh ʿAbd Allah b. Hamza, an ardent adherent of the Bahshamite doctrines. He led a relentless, all-out war against the adherents of the Muṭarrifiyya, demolished their abodes,[14] schools, and libraries, and had their entire literary heritage destroyed. Today, we possess only a few original works by Muṭarrifi authors to inform us about the movement's doctrine and its development over time. However, there is a plethora of anti-Muṭarrifi polemics written by mainstream Zaydi authors, a genre that continued to thrive for several centuries after the movement went extinct. These polemics can be used only with great caution as a source for the reconstruction of the thought of the Muṭarrifiyya.[15]

The next important phase of religio-cultural renewal among the Zaydis in Yemen occurred during the Qāsimī era in the sixteenth and seventeenth centuries. Under the rule of the Qāsimīs, the Ottomans, who had conquered Yemen in 1517, were pushed from the country's inland regions, and they eventually withdrew from their last foothold, the coastal town of Mocha, in 1636. Moreover, the Qāsimī imams expanded their territory beyond the traditional Zaydi areas, and during the reign of the third Qāsimī imam, al-Mutawakkil Isma'il (r. 1644–76), most of the country, including lower Yemen and the eastern stretch of Hadramawt, came under Zaydi rule (fig. 13.5).

Economically, the first century of Qāsimī rule was also particularly prosperous, as Yemen maintained a monopoly on the cultivation and export of coffee from 1636 through 1726. The Qāsimī imams, as well as other members of their family, were engaged in fostering a religious and cultural renewal of Zaydism and sought to spread it beyond its traditional boundaries into the newly conquered regions of Yemen, and the

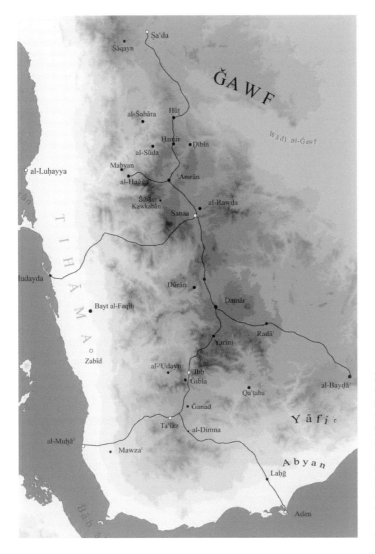

Figure 13.5 Map of Yemen during the seventeenth century, in Tomislav Klarić, "Untersuchungen zur politischen Geschichte der qāsimidischen Dynastie [11./17. Jh.]," PhD diss., University of Göttingen, 2007, fig. 4. View map at www.getty .edu/publications/cultural -heritage-mass-atrocities/part -2/13-schmidtke/#fig-13-5 -map.

prosperity of the period provided them with the material means to do so. There was a significant rise in the production of manuscripts, and many members of the Qāsimī royal family as well as other leading dignitaries and scholars founded new libraries and accumulated significant collections of books, many of which were also imported from other parts of the Islamic world through the Sunni Shafiʿi regions of Yemen as well as through Mecca, which since the beginning of Islam had been an important center for the exchange of books and scholarship during the annual hajj period. At the same time, the Qāsimīs not only promoted scholarship but also carried out censorship by excluding from the canon works that they considered to contravene core Zaydi beliefs and doctrine—most importantly Sufi literature, as well as philosophy and Ismaʿīlī works. Under Qāsimī rule, the confiscation of property and libraries was a common means of combating political enemies within the Zaydi community.[16]

Beyond the Khizāna al-Mutawakkiliyya

The preservation of books, alongside confiscation, censorship, and occasional destruction of books and entire libraries, has continued in Yemen throughout the twentieth century and the first decades of the twenty-first century. In the aftermath of the 1962 revolution and the resulting civil war, thousands of manuscripts from members of the former royal family, from some members of the family of the Prophet Muhammad (sadat), and from collections that were found in combat areas were confiscated and stored in the Maktaba al-Gharbiyya and later in the Dār al-Makhṭūṭāt in Sana'a (fig. 13.6). The latter's holdings were repeatedly catalogued, though it remains uncertain what percentage of the entire collection (which grows continuously through confiscations by state authorities and chance finds) has so far been described.[17]

Additionally, only some of the former rulers' libraries were integrated into the Khizāna al-Mutawakkiliyya under Imam Yahya's rule. Since the Zaydi imams typically made an individual choice regarding where to establish their residences, the holdings of the various rulers' libraries are dispersed all over the country. For example, none of the numerous extant precious manuscripts of the writings of Imam al-Muʾayyad bi-llah Yahya b. Hamza (1270–1348/49) in his own hand can be found today in the Khizāna al-Mutawakkiliyya. Of his major theological summa, the *K. al-Shāmil li-ḥaqāʾiq al-adilla al-ʿaqliyya wa-uṣūl al-masāʾil al-dīniyya*, a work in four volumes, autographs (actual manuscripts written by the original author) of volumes two and four are preserved in Taʿizz and Leiden, respectively. Further, many of the former holdings of the personal library of the aforementioned Imam al-Mutawakkil ʿala llah Sharaf al-Din Yahya are today kept in the library of the Grand Mosque of Dhamar. Only a fraction of such smaller libraries across the country, including countless family libraries, have been catalogued.[18]

The socioreligious and cultural value of the Zaydi literary heritage as preserved in books and libraries for northern Yemen and its people can hardly be overestimated. The principal reason for its importance is the Zaydi notion of political authority, the

Figure 13.6 Inside the Dār al-Makhṭūṭāt, 2009. Image: Sabine Schmidtke

imamate. Although the Zaydis restricted the privilege to claim the imamate to members of the family of Muhammad, the *ahl al-bayt* (preferably descendants of al-Hasan and al-Husayn), they do not insist on a hereditary line of imams. Among the qualifications required of a Zaydi imam, excellent knowledge in religious matters and the capacity to perform *ijtihad* (independent reasoning in legal matters) held top priority. As a result, the Zaydi imams were not only patrons of culture but also prolific scholars themselves, so a significant portion of the Zaydi literary legacy consists of the writings of the imams. Books and libraries therefore qualify as the principal identity marker for Zaydis of Yemen, and this also accounts for the millennium of nearly uninterrupted library history in the country's highlands. The significance of books and libraries in Yemen is also the motivation behind the efforts of private Yemeni nongovernmental organizations and other institutions such as the Imam Zayd b. Ali Cultural Foundation and Markaz al-Badr al-ʿilmi wa-l-thaqafi, which both endeavor to make works by Zaydi imams and scholars available through publication and to digitize private book collections (fig. 13.7).

Figure 13.7 Personnel of the Imam Zayd b. Ali Cultural Foundation, Ṣanʿāʾ, digitizing manuscripts, 2009. Image: Sabine Schmidtke

At the same time, there are several factors that put the library tradition of Yemen at immediate risk today. As elsewhere, books are a commodity in Yemen, and the buying and selling of books and the dispersal of entire libraries following the demise of their owners are common occurrences. Moreover, manuscript culture has persisted in Yemen beyond the turn of the twenty-first century, as is evident from the fact that manuscripts are still being produced in large numbers. As a result, there are interesting encounters between manuscript tradition and technology. Once photocopy machines became available in Yemen, owners of manuscript libraries began to produce copies of individual codices from their collections and often had them bound in the traditional manner. These mechanically produced "new" codices became a novel commodity alongside codices produced by hand, and the same applies to compact discs and other digital media containing scans of large numbers of manuscripts, and often entire libraries, with poor or no documentation as to the provenance of the material and the whereabouts of the physical codices (fig. 13.8).[19]

All this, together with the lack of catalogues for the majority of the numerous public and private libraries in Yemen, makes it impossible to prevent illicit traffic in manuscripts.[20] Throughout much of the second half of the twentieth century and the first decades of the twenty-first, Yemeni authorities have been constantly fighting manuscript dealers, trying to prevent them from smuggling manuscripts out of the country, apparently with only limited success.[21] That such trade continues on a regular basis is attested to by the numerous collections of Yemeni manuscripts offered to libraries in the West during the second half of the twentieth century and occasional

Figure 13.8 Stack of manuscripts in a private library in Yemen, 2019. Image: Imam Zayd bin Ali Cultural Foundation, Sana'a, reproduced with kind permission

reports on social media of manuscripts of Yemeni provenance showing up in museums and private collections in the Persian Gulf region. Another development that has put significant portions of the Zaydi literary tradition at risk is the growing "sunnification" of Zaydism, a trend whose beginnings can be traced back to the fourteenth century. The towering figure in this endeavor was the eighteenth-century Yemeni scholar Muhammad b. ʿAli al-Shawkani (1760–1834), who sought to eliminate the Zaydi-Hādawī tradition—"Hādawī" referring to the founder of the Zaydi state in Yemen, al-Hadi ila l-Haqq—and accordingly revised the traditional works to be included in the curriculum. His program had little impact on the curriculum of the Zaydi elite of Yemen before the revolution, but the situation has changed dramatically since the official abolition of the imamate in 1962. This plus the increasing presence of the so-called *maʿahid al-ʿilmiyya* (Sunni teaching institutions with a distinct anti-Hādawī bias that have spread in Yemen since 1972 with Saudi backing) constitute a major threat to the countless smaller public and private libraries in the country. Many of the private libraries in the north of Yemen were severely damaged, looted, or even destroyed over the course of the twentieth century as a result of political turmoil and wars, and the continuing war today constitutes another imminent threat not only to the local population but also to the cultural heritage of the country, including its many libraries (fig. 13.9).

Conclusion

For Yemen's book culture, it is a curse and a blessing that some of the most precious collections were purchased by European, Ottoman Turkish, and Saudi scholars,

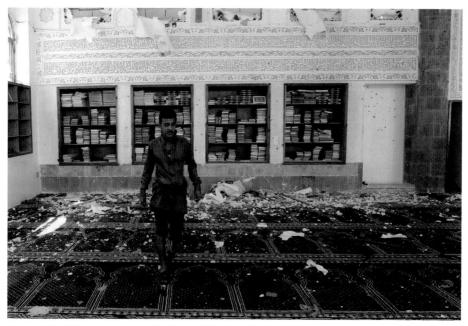

Figure 13.9 A Yemeni man inspects the damage following a bomb explosion at the Badr mosque in southern Sana'a on 20 March 2015. Image: Mohammed Huwais / Getty Images

diplomats, merchants, and travelers during the second half of the nineteenth and the early decades of the twentieth century (and beyond); these manuscripts, numbering between ten and twenty thousand, are nowadays housed in libraries outside of the country. Within Europe, the Glaser collections (today in Berlin, Vienna, and London) and the Caprotti collections (in Munich and Milan) as well as other, smaller collections have served as the basis for Western scholarship on Zaydism since the early twentieth century. Whereas the collections of manuscripts of Yemeni provenance in Turkey, Saudi Arabia, and other countries in the Middle East remain largely unexplored and often even uncatalogued, the majority of European libraries with substantial holdings of Yemeni provenance subscribe to the concept of digital repatriation of those treasures by making their material available through open access, in most cases both through their own digital repositories and under the auspices of collaborative projects such as the Zaydi Manuscript Tradition project.[22] At the same time, the history of libraries in Yemen is largely terra incognita, and no attempt has ever been made to write a critical account of the historical or present-day libraries of Yemen.[23] In view of the lack of a critical mass of reliable catalogues, it is the codices themselves that constitute the most important sources on the historical libraries of Yemen: many contain ample documentary materials, such as ownership statements, purchase notes, scribes' colophons, study notes, and often entire inventories of historical libraries. An analysis of a critical mass of codices could contribute to reconstructing the holdings of individual libraries and their fate over time, which in turn would help curb illicit trafficking and allow for collaborative efforts among scholars in Yemen, the wider Middle East, and beyond to

salvage and study the Zaydi Yemeni manuscript tradition. None of this is possible under current circumstances.

SUGGESTED READINGS

Hassan Ansari and Sabine Schmidtke, eds., *Yemeni Manuscript Cultures in Peril* (Piscataway, NJ: Gorgias Press, 2022).

David Hollenberg, Christoph Rauch, and Sabine Schmidtke, eds., *The Yemeni Manuscript Tradition* (Leiden, the Netherlands: Brill, 2015).

Brinkley Messick, *Sharīʿa Scripts: A Historical Anthropology* (New York: Columbia University Press, 2019).

Sabine Schmidtke, *Traditional Yemeni Scholarship amidst Political Turmoil and War: Muḥammad b. Muḥammad b. Ismāʿīl b. al-Muṭahhar al-Manṣūr (1915–2016) and His Personal Library* (Córdoba: Córdoba University Press, 2018).

Nancy Um, "Yemeni Manuscripts Online: Digitization in an Age of War and Loss," *Manuscript Studies* 5, no. 1 (2021), https://repository.upenn.edu/mss_sims/vol5/iss1/1.

NOTES

1. *Fihrist kutub al-Khizāna al-mutawakkiliyya al-ʿāmira bi-l-Jāmiʿ al-muqaddas bi-Ṣanʿāʾ al-maḥmiyya* (Sanaʾa: Wizārat al-maʿārif, 1942/43).
2. In 1984, another catalogue, describing only the manuscripts of the former al-Khizāna al-Mutawakkiliyya, nowadays Maktabat al-Awqāf, was published: Aḥmad ʿAbd al-Razzāq al-Ruqayḥī et al., *Fihrist makhṭūṭāt maktabat al-Jāmiʿ al-kabīr, Ṣanʿā*, 4 vols. (Sanaʾa: Wizārat al-awqāf wa-l-irshād, 1984). As in the 1942/43 catalogue, the provenance of the individual codices is again indicated, though the information provided seems less reliable overall.
3. See Zaid bin Ali al-Wazir, "The Historic Journey of Banī al-Wazīr's Library," in *Yemeni Manuscript Cultures in Peril*, ed. Hassan Ansari and Sabine Schmidtke (Piscataway, NJ: Gorgias Press, 2022).
4. What is left of the library of another branch of the family is kept today in Hijrat al-Sirr, inaccessible to outsiders. For a partial handlist of the library's holdings, see ʿAbd Allāh Muḥammad al-Ḥibshī, *Fihris makhṭūṭāt baʿḍ al-maktabāt al-khāṣṣa fī al-Yaman* (London: Furqan Foundation, 1994). For the fate of the Āl al-Wazīr during the twentieth century, see Gabriele vom Bruck, *Mirrored Loss: A Yemeni Woman's Life Story* (Oxford: Oxford University Press, 2019).
5. See, e.g., Anne Regourd, "Note sur *Aḫbār al-Zaydiyya bi-al-Yaman* et autres oeuvres du muṭarrifite al-Laḫǧī," *Nouvelles Chroniques du manuscrit au Yémen*, no. 11 (July 2020): 131–46.
6. These include Qurʾanic sciences, exegesis, prophetic traditions, dogmatics, inward sciences and ethics, logic and disputation, legal theory, Hādawī law, Sunni law, law of inheritance, grammar, morphology, eloquence, linguistics, poetry and literature, history, medicine, dream interpretation, astronomy, and agriculture.
7. At present, efforts are underway in Yemen to produce a new catalogue of the holdings of the Maktabat al-Awqāf to include the so-far-uncatalogued manuscripts.
8. See Hassan Ansari, "*Al-Barāhīn al-Ẓāhira al-Jaliyya ʿalā anna l-Wujūd Zāʾid ʿalā l-Māhiyya* by Ḥusām al-Dīn Abū Muḥammad al-Ḥasan b. Muḥammad al-Raṣṣāṣ," in *A Common Rationality: Muʿtazilism in Islam and Judaism*, ed. Camilla Adang, Sabine Schmidtke, and David Sklare (Würzburg, Germany: Ergon, 2007), 337–48; and Hassan Ansari and Sabine Schmidtke, "Sixth/

Twelfth-Century Zaydī Theologians of Yemen Debating Avicennan Philosophy," *Shii Studies Review* 5 (2021): 219–71.

9. See Eugenio Griffini, "Die jüngste ambrosianische Sammlung arabischer Handschriften," *Zeitschrift der Deutschen Morgenländischen Gesellschaft* 69, no. 1–2 (1915): 80. See also Ismail K. Poonawala, "Ismāʿīlī Manuscripts from Yemen," *Journal of Islamic Manuscripts* 5, no. 2–3 (2014): 220–45.

10. Rudolf Strothmann, ed., *Gnosis-Texte der Ismailiten: Arabische Handschrift Ambrosiana H 75* (Göttingen, Germany: Vandenhoeck & Ruprecht, 1943), 10–11.

11. Wilferd Madelung, "Zaydi Attitudes to Sufism," in *Islamic Mysticism Contested: Thirteen Centuries of Controversies and Polemics*, ed. Frederick de Jong and Bernd Radtke (Leiden, the Netherlands: Brill, 1999), 124–44.

12. For an overview of Iranian Zaydism and the reception of Muʿtazilism, see Hassan Ansari, "The Shīʿī Reception of Muʿtazilism (I): Zaydīs," in *The Oxford Handbook of Islamic Theology*, ed. Sabine Schmidtke (Oxford: Oxford University Press, 2016), 181–95.

13. See Hassan Ansari and Sabine Schmidtke, *Studies in Medieval Islamic Intellectual Traditions* (Atlanta: Lockwood Press, 2017), 115–40.

14. For the Yemeni hijra, see Wilferd Madelung, "The Origins of the Yemenite *Hijra*," in *Arabicus Felix: Luminosus Britannicus; Essays in Honour of AFL Beeston on His Eightieth Birthday*, ed. Alan Jones (Reading, UK: Ithaca Press, 1991), 25–44.

15. For details on the reception of Bahshamite doctrine among the Zaydis of Yemen and the conflict with the Muṭarrifiyya, see Hassan Ansari, Sabine Schmidtke, and Jan Thiele, "Zaydī Theology in Yemen," in *The Oxford Handbook of Islamic Theology*, ed. Schmidtke, 473–93.

16. For the history of Yemen under the Qāsimīs, see Tomislav Klarić, "Untersuchungen zur politischen Geschichte der qāsimidischen Dynastie [11./17. Jh.]," PhD diss., University of Göttingen, 2007; and Nancy Um, "1636 and 1726: Yemen after the First Ottoman Era," in *Asia Inside Out*, ed. Eric Tagliacozzo, Helen F. Siu, and Peter C. Perdue (Cambridge, MA: Harvard University Press, 2015), 112–34.

17. For details, see Sabine Schmidtke, "Preserving, Studying, and Democratizing Access to the World Heritage of Islamic Manuscripts: The Zaydī Tradition," *Chroniques du manuscrit au Yémen* 23, no. 4 (2017): 103–66.

18. For details, see Schmidtke, "Preserving, Studying, and Democratizing Access."

19. This is also the case with the online digital Imam Zayd b. Ali Cultural Foundation Library, which contains most of the material previously distributed by the foundation on compact discs and now kept on a website run by the Ministry of Endowments & Religious Affairs of Oman: see Ministry of Endowments & Religious Affairs, "Cultural Foundation Library," https://elibrary .mara.gov.om/mktbtt-muosstt-aliemam-zed-bn-ale-althqafett/mktbtt-muosstt-aliemam-zed-bn -ale-althqafett/.

20. By way of example, see Sabine Schmidtke, "The Intricacies of Capturing the Holdings of a Mosque Library in Yemen: The Library of the Shrine of Imām al-Hādī, Ṣaʿda," *Manuscript Studies* 3, no. 1 (2019): 220–37; and *Traditional Yemeni Scholarship amidst Political Turmoil and War: Muḥammad b. Muḥammad b. Ismāʿīl b. al-Muṭahhar al-Manṣūr (1915–2016) and His Personal Library* (Córdoba: Córdoba University Press, 2018).

21. For examples, see Sabine Schmidtke, "The Zaydi Manuscript Tradition: Virtual Repatriation of Cultural Heritage," *International Journal of Middle East Studies* 50, no. 1 (2018): 124–28.

22. See Valentina Sagaria Rossi and Sabine Schmidtke, "The Zaydi Manuscript Tradition (ZMT) Project: Digitizing the Collections of Yemeni Manuscripts in Italian Libraries," *Comparative Oriental Manuscript Studies (COMSt) Bulletin* 5, no. 1 (2019): 43–60 (with further references).

23. The forthcoming study by Hassan Ansari and Sabine Schmidtke, *Towards a History of Libraries in Yemen*, covers only some aspects of this large field of inquiry.

14

Cultural Heritage at Risk in Mali: The Destruction of Timbuktu's Mausoleums of Saints

Lazare Eloundou Assomo

From January to December 2012, Mali experienced serious threats to its rich cultural heritage. The country's northern region, where two of the four Malian sites inscribed on the UN Educational, Scientific and Cultural Organization (UNESCO) World Heritage List are located, was occupied by armed Islamist groups: Al-Qaeda in the Islamic Maghreb (AQIM), the Movement for Oneness and Jihad in West Africa (MOJWA), and Ansar Dine. The occupied territory reached as far as the Cliff of Bandiagara, an area known as the Land of the Dogons. During the occupation, the armed groups attacked and damaged cultural heritage and cultural expressions intentionally and methodically. They also seized Timbuktu, attacking the city's tangible and intangible heritage with the aim of spreading fear and promoting radical extremism. Fourteen of the city's sixteen mausoleums of the saints inscribed on the World Heritage List were completely destroyed, three mosques were severely damaged, and 4,203 ancient manuscripts were burned. Other tangible cultural heritage was also damaged, such as the El Farouk independence monument, along with many of the basic infrastructure services and houses in the city center.

The government called upon the international community, and UNESCO in particular, for help. Nevertheless, armed groups continued their destruction from 30 June to 2 July 2012, while the thirty-sixth session of UNESCO's World Heritage Committee, composed of representatives from the organization's member states, was being held in Saint Petersburg to raise awareness of the dramatic situation. The international community was shocked by the deliberate destruction of the mausoleums, which was covered widely by international media.

The World Heritage Committee inscribed the two remaining World Heritage Sites on UNESCO's List of World Heritage in Danger and appealed to the international community to assist the Malian government and affected local communities. UNESCO also launched a series of initiatives in response to the calls by Mali and the committee. First was the organization of an international experts meeting, held on 18 February 2013, which resulted in the adoption of a Final Report and Action Plan for the Rehabilitation of Cultural Heritage and the Safeguarding of Ancient Manuscripts in Mali.[1] This enabled planning for the reconstruction of the destroyed mausoleums, the rehabilitation of the Sidi Yahia and Djingareyber Mosques, and the conservation and safeguarding of ancient manuscripts.

UNESCO also launched an awareness-raising campaign regarding the cultural significance of the mausoleums to the social and religious life of Timbuktu's communities. The campaign contributed to the adoption of a series of resolutions by the UN Security Council strongly condemning the destruction of Malian cultural and religious sites and urging the international community to take appropriate actions to ensure the protection of the country's tangible cultural heritage. Among these actions was resolution 2100 of 25 April 2013.[2] This established the United Nations Multidimensional Integrated Stabilization Mission in Mali (MINUSMA) and outlined support for the preservation of cultural sites in partnership with UNESCO. The resolution also recognized the important role played by local populations in facilitating efforts to establish a national dialogue to resolve the Malian conflict. These two aspects of the resolution positioned the reconstruction of the mausoleums in Timbuktu as part of the peacebuilding process from the community level to the local, national, and international levels.

UNESCO also cooperated with the International Criminal Court (ICC) to facilitate the investigation of the intentional destruction of the mausoleums. This resulted in the confirmation of war crime charges against Ahmad al-Faqi al-Mahdi, a member of Ansar Dine, who was sentenced on 27 September 2016 to nine years in prison for intentionally directing attacks against historical monuments and buildings, including nine mausoleums and one mosque in Timbuktu.

Understanding Timbuktu's Cultural Heritage

Timbuktu is said to have been founded toward the end of the Hegira (the Prophet Muhammad's departure from Mecca to Medina in 622) by the Imakcharen Tuareg people, a regional tribal group. With a remarkable geostrategic position at the crossroads between sub-Saharan Africa and North Africa and along the Niger River, the city developed as part of the trans-Saharan trade route, becoming the most prestigious intellectual and scientific center of what is known as the African Middle Ages (1400–1800). Its prestigious Quranic University of Sankoré attracted numerous scholars, explorers, and adventurers, and it became the intellectual measure of West Africa as well as an important center for the propagation of Islam throughout Africa in the

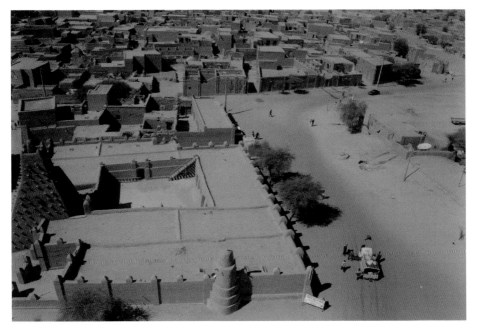

Figure 14.1 Aerial photo of Timbuktu. Image: Serge Negre / © UNESCO

fifteenth and sixteenth centuries. Its three great mosques at Djingareyber, Sankoré, and Sidi Yahia recall Timbuktu's golden age during the fourteenth and fifteenth centuries (fig. 14.1).[3]

Established as a municipality in 1958, Timbuktu covers an area of nearly twenty-one square kilometers.[4] Before its occupation by extremist groups in 2012, it had about 9,500 houses, and a very diverse and cosmopolitan population comprising Songhoï, Tuareg, Bozo, Somono, Moorish, Arab, Bambara, Fulani, and Dogon communities, constituting an estimated 54,500 people. It is located mainly along Niger River wetlands, an area well suited to agriculture.

Timbuktu's old city, also called Medina, with an area of fifty-four hectares, displays a compact, irregular plan, including the Badjindé, Sankoré, Djingareyber, and Sareikena districts, and serves as an administrative center. It evolved around the city's main public square, El Farouk, now located at its entrance. It largely consists of one-to-two-story buildings overlooking narrow streets on one side and interior courtyards on the other. Timbuktu is known for its exceptional earthen architecture, particularly the mosques and mausoleums of saints spread across the city. This architecture has been kept alive for centuries, thanks to recurrent traditional maintenance work by locals, who gather to undertake collective mud replastering.[5] Carried out under the guidance of the masons corporation, this work has an important spiritual and social meaning for the local community.

Crafts and tourism represent the main activities and sources of income of Timbuktu's population, thanks not only to the city's rich and diverse historical and cultural heritage, but also to its dynamic artistic and creative scene. The most prominent crafts are related

to textiles (55 percent of craftspersons before 2012 were tailors and 9 percent embroiderers), jewelry (12 percent), and shoemaking (5 percent); others include carpentry, basketry, forging, tapestry making, and arts and crafts related to the conservation of manuscripts. Before the occupation of the city, more than 50 percent of craft businesses in Northern Mali were located in Timbuktu. And it is estimated that two-thirds of the population made a living in this sector, with each family counting at least one craftsperson. Other economic activities were agriculture, including the growing of rice, millet, sorghum, and wheat, and the breeding of bovines, ovines, goats, and camels, as well as traditional fishing along the Niger. The booming pre-occupation tourism industry also employed, directly or indirectly, more than five hundred people.

In 1988, three of the city's major mosques (Djingareyber, Sidi Yahia, and Sankoré) and sixteen of its saint mausoleums were inscribed on the World Heritage List.[6] These remarkable buildings played a major role in spreading Sufi Islam throughout Africa and are testimony to the golden age of this wealthy, spiritual, and cultural city. The mosques were built between the fourteenth and fifteenth centuries and were restored for the first time in the sixteenth century. The Djingareyber Mosque, the largest in the city and known as the "Friday mosque," constitutes one of Timbuktu's most visible landmarks (fig. 14.2). Although of more modest size, the Sankoré and Sidi Yahia are equally important.

Mausoleums of saints were first built in the thirteenth century by Timbuktu's local communities as a tribute to their ancestors for their exemplary role in the intellectual, social, and religious life of the city. These were initially places for prayer and invocation of ancestors that later became pilgrimage sites for devotees from Mali, North Africa, and

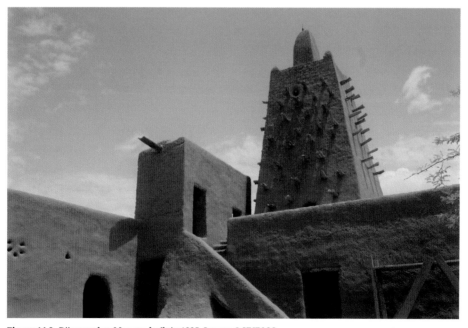

Figure 14.2 Djingareyber Mosque, built in 1325. Image: © UNESCO

the Middle East. Timbuktu is equally famous for its ancient manuscripts, eloquent proof of the city's intellectual, cultural, and scientific development. Estimated to total more than four hundred thousand volumes, they are distributed throughout the city by its public library, the Ahmed Baba Institute.

The importance of the city's cultural heritage was recognized in the Peace and Reconciliation Agreement for Mali, signed on 15 May and 20 June 2015.[7] It includes various measures aimed at promoting better participation of Northern Mali's communities, taking into account their cultural diversity by establishing a special development zone for the North.

The disastrous consequences of the 2012 attacks on cultural heritage also led to a significant decline in Timbuktu's economy. Crafts and tourism, previously comprising the city's greatest source of income, were severely harmed during the occupation, owing to the absence of foreign visitors. The city also faced massive displacement as its population fled the armed groups, aggravating the people's trauma and lowering their standard of living.

The Mausoleums: Cultural Destruction, Trauma, and Response

The UNESCO international expert meeting of 18 February 2013 was instrumental in generating a broader awareness of the strong attachment of Timbuktu's communities to their cultural heritage. The occupiers sought to erase all cultural references that linked its inhabitants to the religious practices of Sufism, which they banned and which the city's population had practiced since the ninth century. The population interpreted these moves by Ansar Dine as punitive, and the destruction of the mausoleums as a direct attack on their cultural identity.

The occupiers attempted to terrorize the population and spread an ideology of violent extremism and radicalization. The communities had considered the mausoleums and mosques as central to their identity, linking them to Timbuktu's world-renowned history, to their ancestors, and to each other. They described mausoleums and ancient manuscripts as the "lungs" of their social life—without them, it would be difficult to recover from the trauma caused by the occupation.

With this understanding, it was agreed that an initial damage assessment mission would be conducted by a joint team of international and Malian experts. This was undertaken between 29 May and 2 June 2013 with the objectives of first evaluating the damage done to the city's cultural heritage and then determining priority actions for its rehabilitation and conservation. Experts from various international organizations as well as from the Malian Ministry of Culture carried out extensive investigations, confirming the destruction of fourteen mausoleums inscribed on the World Heritage List.[8] Also noted was the destruction of the emblematic El Farouk monument and the loss of an estimated 4,203 ancient manuscripts. Importantly, the damage assessment mission concluded that the trauma inflicted on local communities by this heritage destruction was equally consequential (fig. 14.3).

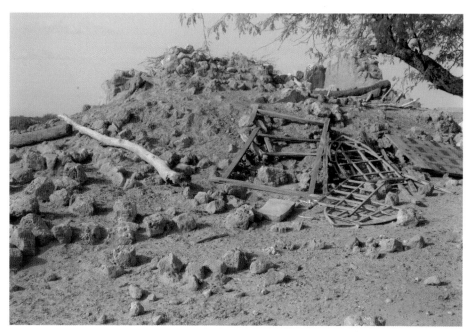

Figure 14.3 Destroyed Alpha Moya mausoleum. Image: © UNESCO

Much work was then carried out, including the collection and consultation of archives, historical information, architectural and archaeological surveys, excavation records, and the compilation of traditional building practices and techniques through consultation with the masons corporation, whose members alone possessed the ancestral knowledge needed to undertake the required mausoleum reconstruction. Understanding the state of thousands of ancient manuscripts was also part of the damage assessment: some three hundred thousand had been removed from the city, mainly to Mali's capital, Bamako, in addition to the more than four thousand known to be missing.

As mentioned, the destruction of cultural heritage and the prohibition on local cultural practices had significantly harmed the large proportion of the local economy based on cultural activities. There were no craft or tourism activities in 2012 or 2013. Craft products available in stores remained unsold, and vandals trashed craftspeople's installations, equipment, and materials. Timbuktu had registered 1,191 day trips and 2,267 overnight stays by international and national tourists in 2011, compared to none in 2012, with all its hotels closed.

Thousands of the city's inhabitants also fled to Bamako or neighboring countries, while others stopped working. An estimated 80 percent of public employees left their positions and 60 percent of craftspeople were displaced. Other activities were interrupted as well, as youth and women fled, as did development actors, as a result of the suspension of public development aid and the consequent shutdown of investment projects.

Many public buildings were damaged, with virtually all schools pillaged or destroyed. It is estimated that at least ninety-four thousand children in the region were unable to attend school during the conflict.[9] In 2013, about 53 percent of primary school teachers were still present, as compared to less than 9 percent of secondary school teachers and 8 percent of those working in vocational and technical education.

The Mausoleums: Reconstruction Strategy

In order to guide the reconstruction process, a series of consultations took place among the main representatives of the local communities and the corporation of traditional masons. These consultations made possible the compilation of traditional building practices and techniques, collected from the masons corporation, who alone possessed the ancestral knowledge necessary to undertake this type of reconstruction. Incorporating the masons into decision-making ensured that the mausoleums would be reconstructed using traditional techniques to preserve the city's architectural integrity. Thanks to data collected during these consultations, knowledge of relevant construction skills was refined, a building site methodology adopted, and a proposal developed to detail the optimal architectural state to be obtained through reconstruction. This data was then incorporated into a reconstruction strategy with local communities at its heart. The strategy was adopted by the Malian government and custodial communities in February 2014, with the latter acting as the official guides for all stages of reconstruction, including the required traditional ritual practices.[10]

Reconstruction was undertaken in two phases. In the first phase, spanning 14 March to 15 May 2014, local masons applied the agreed-upon strategy to the two mausoleums located near the Djingareyber Mosque (Sheik Baber Baba Idjè and Sheik Mahamane al-Fulani mausoleums). This pilot phase refined methodologies for the various steps of reconstruction. It encouraged the consolidation of approaches and methods while also documenting the entire reconstruction process. The second phase corresponded to the reconstruction of the twelve remaining mausoleums between February and September 2015. The mausoleums were sanctified during an inauguration ceremony in Timbuktu on 18 July 2015 in the presence of the then director-general of UNESCO, Irina Bokova. On 4 February 2016, a further consecration ceremony took place—a necessary ritual for the families to fully repossess their mausoleums. According to local religious leaders, such a consecration ceremony was last held for the Timbuktu mausoleums in the eleventh century, as no events of mass destruction had taken place in the intervening millennium. The consecration ceremony was intended to invoke divine mercy and provide the basis for peace, cohesion, and tranquility. It began in the early morning with the sacrifice of cows and the reading of Quranic verses, and concluded with the pronouncement of Al-Fatiha (prayers from the Quran) by the imam of the Djingareyber Mosque. In Timbuktu these religious rites also represent the rejection of intolerance, violent extremism, and religious fundamentalism. This ceremony constituted the last step of Timbuktu's cultural rebirth after the destruction of the mausoleums (fig. 14.4).

Figure 14.4 Reconstructed Sidi Ben Amar mausoleum. Image: © UNESCO

International Justice and Community Reparations

In May 2012, when the first mausoleums of the saints were defaced by Ansar Dine, UNESCO alerted the Malian government to the importance of enforcing the 1954 Hague Convention for the Protection of Cultural Property in the Event of Armed Conflict. Mali had been party to this convention since 1961, making it highly desirable to ratify the convention's 1999 Second Protocol, which would allow for the enforcement of its Chapter 4 provisions on criminal responsibility and jurisdiction. Mali is also a party to the Rome Statute of the ICC. Conforming with its obligations under Article 14 of the statute, the Malian government referred the situation to the court on 13 July 2012. In its letter, the government considered the destruction of mausoleums, mosques, and churches "serious and massive violations of human rights and international humanitarian law." Considering these acts to constitute war crimes under the jurisdiction of the ICC, the government requested that those identified be charged with committing these crimes.

The ICC's Office of the Prosecutor duly opened investigations on 16 January 2013, and the court issued an arrest warrant for Ahmad al-Mahdi on 18 September 2015 "for war crimes of intentionally directing attacks against historic monuments and buildings dedicated to religion, including nine mausoleums and one mosque in Timbuktu, Mali, committed between 30 June 2012 and 10 July 2012."[11] Al-Mahdi was subsequently surrendered to the ICC by the authorities of Niger and formally charged on 24 March 2016. The ICC based the charges partly on UNESCO's explanation that the mausoleums reflected part of Timbuktu's history and the city's role in the expansion of Islam in Africa. In particular, UNESCO considered that the mausoleums "were of great

importance to the people of Timbuktu, who admired them and were attached to them. They reflected their commitment to Islam and played a psychological role to the extent of being perceived as protecting the people of Timbuktu."[12]

Al-Mahdi's trial took place from 22 to 24 August 2016. In a unanimous verdict announced on 27 September, he was found guilty of committing "the war crime of intentionally directing attacks against historic monuments and buildings dedicated to religion, including nine mausoleums and one mosque in Timbuktu, Mali, in June and July 2012."[13] He was sentenced to nine years' imprisonment. It should be noted that al-Mahdi pled guilty to the destruction of the mausoleums and asked for forgiveness from the people of Timbuktu, which was considered by the court as a mitigating factor.

The ICC issued a reparations order on 17 August 2017 to aid in relieving the suffering caused by al-Mahdi's war crimes, enable Timbuktu's communities and the directly impacted families to recover their dignity, and deter the likelihood of future violations. The order concluded that al-Mahdi was liable for €2.7 million in compensation for individual economic losses and collective reparations for the community of Timbuktu.[14] Noting that he was indigent, the court encouraged the ICC's Trust Funds for Victims to aid those impacted with assistance that would complement the reparations award.

Key Lessons Learned

The role that Timbuktu's mausoleums played in the sociocultural and religious life of the community was a vital factor guiding the reconstruction decision. The participation of local communities proved key to ensuring that the mausoleums regained their sacredness after reconstruction was completed. Placing the local community at the heart of the reconstruction process enabled those directly impacted to retake ownership of their mausoleums through a consecration ceremony on 4 February 2016, marking the end of the final phase of reconstruction.

Preservation of the "outstanding universal value" of Timbuktu's cultural heritage and the need for its sustainable conservation were the foundational principles underlying UNESCO's reconstruction efforts. UNESCO was also aware of the importance of the post-reconstruction period and the value of improving and perpetuating the ancestral building traditions that were essential for maintaining the mausoleums. To this end, a Maintenance and Conservation Guide was distributed to the managers of the mausoleums and to the traditional stewards, the masons, and other workers. The guide contains combinations of methods and techniques strongly inspired by ancient building practices and enriched by technical contributions, to facilitate adaptation of this knowledge to conditions of climate change in the Sahel region.

Finally, the sentencing of al-Mahdi to nine years in prison and the recognition—for the first time in the history of international criminal justice—of the intentional destruction of communal cultural heritage as a war crime provides clear recognition that attacks on cultural heritage are now serious crimes under international law and

that perpetrators must and will be held accountable. The verdict signals unequivocally that there is no impunity when cultural heritage is attacked and destroyed.

After the occupation of Timbuktu, it was possible to demonstrate that cultural heritage could play a crucial role in reconstructing a stable and prosperous society. The reconstruction of mausoleums helped the affected communities restore their sense of dignity and autonomy by healing their trauma and wounds, making their lives worth living, and reinforcing their social cohesion. Placing the local communities at the heart of the reconstruction process enabled the creation of a framework of inclusive dialogue. Although the communities of Timbuktu were prevented by Ansar Dine from preserving their specific practices of Islam while maintaining their local beliefs and spirituality, this UNESCO initiative has proven to be fully consistent with all international efforts to support the national peacebuilding process.

SUGGESTED READINGS

Lazare Eloundou and Ishanlosen Odiaua, eds., *African World Heritage: A Remarkable Diversity* (Paris: UNESCO, 2012).

Marina Lostal, *International Cultural Heritage Law in Armed Conflict: Case-Studies of Syria, Libya, Mali, the Invasion of Iraq, and the Buddhas of Bamiyan* (Cambridge: Cambridge University Press, 2017).

Emma Charlene Lubaale, "The First Cultural-Property Conviction at the ICC: An Analysis of the *Al Mahdi* Judgement," *South African Yearbook on International Law* 41, no. 1 (2016): 126–64.

Jadranka Petrovic, "What Next for Endangered Cultural Treasures? The Timbuktu Crisis and the Responsibility to Protect," *New Zealand Journal of Public and International Law* 11, no. 2 (2013): 381–425.

Frédéric Foka Taffo, "Al Mahdi's Case before the International Criminal Court: A Landmark Decision in the Protection of Cultural and Religious Sites," *Conflict Trends*, no. 4 (2016): 42–49.

Sabine von Schorlemer, "Military Intervention, the UN Security Council, and the Role of UNESCO: The Case of Mali," in *Intersections in International Cultural Heritage Law*, ed. Anne-Marie Carstens and Elizabeth Varner (Oxford: Oxford University Press, 2020), 82–103.

NOTES

1. International Experts Meeting for the Safeguarding of Mali's Cultural Heritage, *Final Report and Action Plan for the Rehabilitation of Cultural Heritage and the Safeguarding of Ancient Manuscripts in Mali* (Paris: UNESCO, 2013), https://whc.unesco.org/document/123373.
2. UN Security Council, resolution 2100 (2013), 25 April 2013, https://digitallibrary.un.org/record/748429?ln=en.
3. See the entry for Timbuktu in the UNESCO World Heritage List at https://whc.unesco.org/en/list/119/; and Lazare Eloundou and Ishanlosen Odiaua, eds., *African World Heritage: A Remarkable Diversity* (Paris: UNESCO, 2012), https://unesdoc.unesco.org/ark:/48223/pf0000218276.locale=en.
4. World Bank, *Tombouctou aujourd'hui et demain: Stratégie de développement* (Washington, DC: World Bank, 2017).

5. Ministry of Culture of the Republic of Mali, *Plan de gestion et de conservation de Tombouctou-Mali 2006–2010* (Bamako: Government of Mali, 2006); and *Étude de faisabilité pour la redynamisation du tissu socio-économique de la ville de Tombouctou* (Bamako: Direction Nationale du Patrimonie Cultural, 2006).

6. ICOMOS, *Évaluation ICOMOS du bien proposé: Ville ancienne de Tombouctou*, in *La liste du patrimoine mondial* (Paris: ICOMOS, 1987), #119.

7. "Accord pour la paix et la réconciliation au Mali, issu du processus d'Alger," Bamako, 15 May 2015, https://www.un.org/en/pdfs/EN-ML_150620_Accord-pour-la-paix-et-la-reconciliation-au-Mali_Issu-du-Processus-d'Alger.pdf.

8. Ministry of Culture of the Republic of Mali, *Rapport de mission en vue de l'évaluation du patrimoine culturel malien et des manuscrits anciens* (Bamako: Malian Ministry of Culture, June 2013).

9. UNESCO, *Evaluation de l'impact de la crise sur le secteur de l'éducation, à Tombouctou, Gao et Kidal* (Paris: UNESCO, October 2013).

10. UNESCO and Ministry of Culture of the Republic of Mali, *Stratégie de reconstruction des biens du patrimoine du nord du Mali (Tombouctou, Tombeau des Askia, et autres biens affectés)* (Paris: UNESCO, 2014).

11. The warrant of arrest in the case *The Prosecutor vs. Ahmad Al Faqi Al Mahdi* may be viewed in its original French at https://www.icc-cpi.int/Pages/record.aspx?docNo=ICC-01/12-01/15-1-red.

12. ICC, *Ahmad Al Faqi Al Mahdi*, case no. ICC-01/12-01/15, Judgment and Sentence, 27 September 2016, para. 78.

13. ICC, *Ahmad Al Faqi Al Mahdi*.

14. ICC, *Al Mahdi*, Reparations Order, 17 August 2017.

15

Indigenous Threatened Heritage in Guatemala

Victor Montejo

The history of abuse and destruction of ancient Maya heritage in Guatemala started more than five centuries ago. This long and dark night has persisted as modern Maya continue to struggle for their basic human rights and cultural identity. Between 1960 and 1996 many Guatemalan people, especially its Indigenous population, suffered extreme violence at the hands of the government. They were accused of being subversives and supporters of the guerrilla movement. As a result, the Guatemalan military government unleashed a scorched earth policy that destroyed entire villages and massacred thousands of Indigenous people. According to the 1999 report of the Commission for Historical Clarification, otherwise known as the Truth Commission, more than two hundred thousand people died, one million were displaced internally, and a further thirty thousand were refugees in Mexico and other countries. In 1996, with the signing of the Peace Accords, most refugees returned to Guatemala and rebuilt their abandoned communities or were relocated in new settlements. Unfortunately, the most important of those signed, the Accord on the Identity and Rights of Indigenous Peoples (AIDPI), was not implemented. In other words, the roots of the conflict remained unsolved. It was a peace without justice for the Indigenous population, who continue to endure racist treatment and discrimination.

The Maya have been seen as a backward people reluctant to abandon their traditional way of life and thus opposed to progress. For the Guatemalan ruling class and non-Maya population, they are seen as *indios*—backward, dirty, and savage people. Their cultural identity and link to the ancient past has not been fully recognized, since most Guatemalans argue that Maya civilization is already dead and is seen only as a source of archaeological objects that can be looted or used as sites to attract tourists. This long and intentional process of destruction has been an attempt to eradicate Maya culture and civilization, a process of long-term killing that I have termed *Mayacide*.

In this context, Maya heritage has been threatened, including their traditional dress and their religious practice and ceremonies. Four of the twenty-two Mayan languages are also in danger of extinction.[1] These are prominent examples of the urgent need to protect Maya cultural heritage and to respect the human rights of Indigenous people, as declared in the Guatemalan Constitution. The time has come to treat the country's Indigenous people with respect and to fully recognize them as living inheritors of the ancient Maya culture and civilization. Additionally, the ethics of archaeology must be kept front and center when excavating and handling Maya sites and artifacts in order to finally end the connection between archaeology and colonialism. Considering a living culture as an "archaeological culture" has led to the complicity of museums and colonialism in sustaining the backward position of Indigenous people.[2]

For this purpose, the Maya people should be trained and supported to enable participation in ongoing debates concerning archaeological research and the excavation and handling of Maya remains. To achieve this goal, the international community must apply pressure on nations to comply with existing laws aimed at the protection of cultural heritage.

Historical Background

Maya civilization—the Maya calendar, art, literature, religion, and spirituality—were nearly destroyed during the Spanish conquest and colonization from 1524 to 1821. This destruction occurred not only through the atrocities of war but also through the violent imposition of Christianity on the natives by early missionaries—this genocidal war of conquest, disease, and forced labor dismantled Indigenous Maya populations as they were forcibly separated from their ancient traditions. This is how the Maya hieroglyphic writing system stopped being used and disappeared from memory. Obviously, the native Maya suffered as they watched the destruction of knowledge documented in hieroglyphic books or codices burned by the missionaries. As stated by Bishop Diego de Landa, one of the friars responsible for burning a great number of hieroglyphic books in the Yucatán Peninsula region in 1565: "We found a great number of books in these letters, and since they contained nothing but superstitions and falsehoods of the devil, we burned them all, which they took most grievously, and which gave them great pain."[3]

Those who wanted to maintain the traditional knowledge system were persecuted and tortured to death. By killing the elders who were the last repositories of ancient Maya hieroglyphic writing, the missionaries ensured the extinction of an ancient writing system. In response to these ethnocidal actions, Bishop Bartolomé de las Casas came out in defense of the Indigenous people in the court of Seville, Spain, in 1561, arguing that the war of conquest was inhumane and genocidal.[4] It was during the early colonization of Maya territory that some of the most important hieroglyphic texts to survive destruction were taken to Europe, where they are now housed in museums and

archives. Among these are the three major texts known as the Madrid Codex in Spain, the Paris Codex in France, and the Dresden Codex in Germany.

But it was not until the nineteenth century, when the American explorer John L. Stephens visited the ruins of Quiriguá and published his report in *Incidents of Travel in Central America, Chiapas, and Yucatan* in 1841, that broader interest in the ancient Maya and their cultural heritage caught on. Stephens's account opened the door to and attracted a variety of antiquarians and collectors to Guatemala in the early twentieth century. This army of hungry collectors, as well as Mayanists and other scholars, took away great numbers of artifacts, manuscripts, and other relics of the past. Maya civilization captured the attention of the world as news of the discovery of ancient cities buried in the rain forests of Guatemala, Mexico, Belize, and Honduras spread far and wide, thus exposing Maya cultural heritage to looters and collectors who wanted a piece of this great civilization. Stephens even added to his traveler's account an anecdote describing an arrangement he had made to buy the ruins of Quiriguá for $10,000. His plan was to have them cut into blocks and shipped to New York, where he would rebuild the acquired ruins. Fortunately for the Maya, the owner of the plantation where the ruins were located, hearing that French collectors were paying more, decided not to sell at that time.[5]

Another classic example of the removal of Maya patrimony by collectors and antiquarians was the extraction of the Popol Vuh, the sacred book of the Maya. It was discovered in the attic of the Santo Tomás church in the Guatemalan town of Chichicastenango and transcribed by the parish priest, Francisco Ximénez between 1700 and 1715. By 1860, the manuscript was housed in the national archive in Guatemala City. There, the French collector Abbé Charles-Étienne Brasseur de Bourbourg gained access to it during his research and collecting adventure. The manuscript was smuggled out of the country, surfacing as part of Brasseur de Bourbourg's collection in Europe and translated into French in 1861. The manuscript was later sold at auction to French scholar Alphonse Pinart, who owned it until his death in 1911, after which his widow again placed it up for auction. This time it was purchased by Edward Ayer, an American collector, who brought it back to the United States and placed it at the Newberry Library in Chicago.[6] Other significant Maya manuscripts and codices may have been similarly removed from Guatemala and the Yucatán.

As for Maya artifacts, these are the types of objects that have most commonly been removed from the country. Today one can find them on display in major museums around the world—not to mention a great number of objects kept in private collections or the back rooms of museums. Historically, the Maya have suffered throughout the centuries the destruction of their cultural heritage, both tangible and intangible. This is no accident. For the *ladinos* (non-Maya) of Guatemala, the Maya are considered backward, inferior people who need to be eliminated or assimilated into Western culture. Yet burning books, decimating ancient sites, and killing the adherents of Maya culture are acts of ethnocide and genocide. Starting with the invasion of Guatemala by

the Spaniards in 1524, this slow extermination of a whole civilization amounts to nothing less than Mayacide.

Unprotected Maya Heritage

The false representation of Indigenous people as "savages" has precipitated programs of assimilation that ignore the status of the Maya as inheritors of an ancient civilization. The Maya people are not taken into consideration when it comes to the protection of their cultural rights and heritage. This grotesque violation was evident during the recent armed conflict in Guatemala, which destroyed the social, cultural, and spiritual fabric and context of modern Maya culture; uses of the Mayan languages, traditional dress, and the practice of the Maya calendar by their spiritual leaders were prohibited.[7] According to the report of the Truth Commission in Guatemala, there were more than two hundred thousand Maya killed and millions displaced, some becoming refugees in Mexico and other countries. In other words, the weight of violence and massacre was placed upon Indigenous peoples because they have been considered second-class citizens.[8]

For the living Maya, most aspects of their ancient and modern culture remain unprotected. That is why we must put pressure on states to comply with existing laws protecting cultural heritage. The Guatemalan government likes to glorify the past, promoting Maya heritage for tourism while rejecting and discriminating against the modern Maya population. Similarly, Maya archaeological sites have been in the hands of individuals who show little concern for the protection of the national patrimony. The smuggling of Maya artifacts continues today, but in a more sophisticated way than in the past, sometimes under the control of drug traffickers and organized crime figures. A recent article in the *Los Angeles Times* sounded the alert about a Maya artifact placed on auction in Paris:

> A major, long-lost stone carving of a bird headdress dating from AD 736, made during the classical heyday of the powerful city-state of Piedras Negras in what is today Guatemala, was scheduled to go on the auction block in Paris next week. Long sequestered in a private collection, the magnificent bas-relief carries an estimate of $27,000 to $39,000. The sculpture was almost certainly stolen in the early 1960s from the ancient Maya site. It passed through the inventory of a prominent Los Angeles gallery on its way to Paris. Its illicit history is no secret, yet the sale in France is scheduled to proceed in broad daylight.[9]

The looting and desecration of Maya tombs and archaeological sites have caused much damage to the patrimony and history of Guatemala. Every day, Maya artifacts are illegally smuggled out of Maya sites, with no concerted action by the government to stop the activity. Those objects considered Maya have become desirable for collectors searching for more valuable stone or jade items.[10] During the writing of this chapter, on 9 February 2021, I discovered that another auction was taking place in Paris, with five

Figure 15.1 Polychrome Maya vase sold at Christie's, Live Auction 17456, Lot 129, closed 8 April 2019, https://www.christies.com/en/lot/lot-6196575. Image: Private Collection Photo © Christie's Images / Bridgeman Images

Maya polychrome vases being auctioned (see fig. 15.1).[11] Mexico and Guatemala have initiated legal claims on these objects.

Despite more than a century of research on the Maya, this cultural patrimony is still vulnerable and exposed to destruction, not only by desecrators of Maya tombs but also by development projects carried out without consultation with the culture's inheritors. Maya archaeological sites are exposed and unprotected in the rain forest of northern Guatemala. Once they are uncovered and shown to the public, the sites are invaded not only by archaeologists, but also by new colonists or immigrants to the region who live near these areas and join in the looting. Even the Guatemalan government, through its Ministry of Culture and Sport, has acknowledged its failure to protect Maya sites, stating that "looters and grave diggers operate in archaeological sites in the country, taking

advantage of the lack of vigilance at these sites. They carry out illegal excavations without the required technology, thus causing great destruction to these sites."[12]

Each state has its own laws to protect its cultural heritage, particularly First World countries. But in states such as Guatemala, there is little oversight, and the few programs protecting heritage are underfunded. There is little compliance with the relevant law, since those who deal with archaeological sites know how to manipulate it. That is why the smuggling of pre-Columbian objects has continued, and indeed, during the past twenty years, the theft of colonial art and religious objects has also become more common.

The archaeological patrimony of Guatemala also continues to be smuggled across borders by underground criminal organizations. To prevent the illegal trafficking of archaeological objects, in 1997 the United States and Guatemala created a memorandum concerning "Restrictions on the Import of Archaeological Objects from Pre-Columbian Cultures."[13] The United States has enforced the agreement, but the same should be demanded of each country with which Guatemala has diplomatic relations and agreements.

To this end, the Native American Graves Protection and Repatriation Act (NAGPRA), which protects the rights of Native Americans in the United States, should be extended internationally. All states need to give their Indigenous populations the power and opportunity to control and protect their cultural heritage. Guatemala must have a law for grave protection and repatriation of stolen cultural material and heritage. Most museums, including the National Museum of the American Indian in Washington, DC, are engaged in the repatriation of cultural and sacred objects to Native American communities in the United States that can demonstrate ownership.

Unfortunately, the Maya have been relegated to the role of observers and never given the right to participate in decision-making in relation to their cultural heritage. Throughout the centuries, only the mestizo population in power in Guatemala has had the authority to decide on Indigenous issues. Control over Indigenous patrimony by the state is enforced by the 1970 UNESCO Convention on the Means of Prohibiting and Preventing the Illicit Import, Export and Transfer of Ownership of Cultural Property, which defines "cultural property" in Article 1 as "property, which, on religious or secular grounds, is specifically designated by each State as being of importance for archaeology, prehistory, history, literature, art or science." Leaving governments to identify the relevant cultural heritage means that Indigenous people have been marginalized and sometimes denied access to their cultural and ceremonial centers, as is the case for the Maya *ajq'ijab*, or spiritual leaders.

The pre-Hispanic and colonial cultural heritage of Guatemala is surely of common interest to the entire nation's population. Expressions of cultural production and heritage must be recognized and given the necessary protection against destruction and abandonment. Yet there is a lack of political will within Guatemala to devote economic resources for the protection of cultural heritage. The government's reliance on external

investment and foreign support constitutes a conflict of interest in its adjudication between archaeologists and the living Maya. It is no accident that the smuggling of Maya archaeological objects increased during the civil war.[14] How can a people protect their cultural heritage if they can hardly protect their own lives?

To address these abuses and promote the cultural rights of Indigenous people, an "Agreement on Identity and Rights of Indigenous Peoples" was signed as part of the post–civil war accords between the Guatemalan government and the Guatemalan National Revolutionary Unity (URNG), a guerrilla movement that became a legal political party through the peace process.[15] The agreement was anticipated as one of the most important of the peace accords signed, but it has remained a dead letter. There is no interest or political will for promoting any legislation that could help Indigenous people fight for their rights. Although the constitution recognizes Guatemala as a multicultural nation-state with an Indigenous population of Maya descent, the few relevant laws for the protection of Indigenous culture are not enforced. In some cases, legislation exists, but loopholes allow it to be manipulated. For example, Article 60 of the constitution reads, "Paleontological, archaeological, historical, and artistic assets and values of the country form the cultural heritage of the Nation and are under the protection of the State. Their transfer, export, or alteration, except in cases determined by the law, is prohibited."[16] One clause—"except in cases determined by the law"—is critical. Which law? And who applies it?

The law for protecting cultural heritage in Guatemala must be strengthened. It is also crucial to create new laws pertaining to sacred sites and the freedom of religion for Indigenous people: in the twenty-first century, Indigenous knowledge is still considered a form of witchcraft by some factions of Protestantism. As recently as May 2020, a Maya spiritual guide in northern Guatemala was accused of being a witch and was burned to death for the sin of being a traditional medicine man.[17] We have not come all that far from the criminal actions of the missionaries during the colonization of the Americas.

New Problems at Unprotected Maya Sites

As noted above, the Maya people need to be given more involvement by the state in protecting Maya heritage. The ideology of Indigenismo is founded on the colonialist belief that the Indigenous are not capable of doing things for themselves and need a patron or a savior. When will they be trained and called to be part of the project of protecting and promoting their own Maya heritage? We must recognize that people have different ways of expressing themselves, so we must respect their ways of life, including their arts, writing, languages, literature, manuscripts, and religious iconography. This is to be human, to be creative and diverse in order to survive in this globalized world.

In the context of globalization, a major problem has emerged concerning the great ancient site of El Mirador. This Maya city is now under scrutiny because its head archaeologist, Richard D. Hansen, who for thirty years had a monopoly on research and

decision-making at the site, is negotiating funding from private investors to appropriate it against the will of the Maya people.[18] In the name of science and research, he is working with investors to create a hotel-resort in the Maya biosphere, appropriating Maya culture and negotiating it for private development projects without consulting the Indigenous and Guatemalan population. It has been noted that the Maya biosphere must be untouched for the protection of this vast Maya territory and its archaeological sites.

On this issue, lawyers for Guatemala's National Council of Protected Areas (CONAP) "ruled out construction of any new roads, thereby assuaging one of the major latent fears that had caused distrust among roundtable members for years. The 'no new roads' decision was made public and incorporated into the master plan."[19] But this was far from sufficient: to stop the development project altogether, in 2020, Maya organizations in Guatemala sent an open letter to Hansen "regarding his imperialist and colonial drive to expropriate our Territories and Sacred Sites."[20] The issue is now in the US Congress, where Senate bill S. 3131, also known as the Mirador-Calakmul Basin Maya Security and Conservation Partnership Act, sponsored by Senator James Inhofe of Oklahoma, was introduced in 2019.[21]

According to the North American Congress on Latin America (NACLA), "Hansen's proposal is the latest green land grab in the name of conservation, which does not take into account current efforts in the region to protect the rainforest."[22] Other international organizations have also come forward against Hansen's abusive intrusion, including the Association for the Protection of Latino Cultural Patrimony (APLCP), which demanded that Hansen be expelled from the Society for American Archaeology (SAA).[23] In response, the SAA president sent a letter to Senator Inhofe stating the organization's position on this controversial issue: "We join our archaeologist colleagues in Mexico and Guatemala in strong opposition to the program Senate bill S. 3131 would create."[24]

If allowed to go forward, this megaproject would affect not only ancient archaeological sites, but also the ecological and protected area of the Petén rain forest. Some Guatemalan government officials have supported Hansen, and, as noted above, *ladino* scholars and government officials are not committed to the care of ancient Maya cultural heritage. This is a dangerous new model of colonial economic domination and control that will spread unless we prioritize Maya heritage at the pinnacle of Guatemala's national cultural agenda and empower the Maya as actors in the construction of Guatemalan identity. This would create the framework for a national education program and curricula promoting cultural reaffirmation.

Without such a shift, the continual invasion of the Maya homeland and territories will continue. The government has granted foreign scholars and fortune seekers the right to invade Maya sites, disrespect the dead, and excavate buried cities and monuments. Today, hundreds more sacred cities, buildings, human graves, and other burial sites are being discovered with the aid of new technologies, but then left unprotected. Light Detection and Ranging (LIDAR) technology, for example, while an important tool for revealing sites in the jungle, has created many of these problems

when the mapping of new sites then leaves them unprotected, facilitating the illegal activity of looters and grave robbers. Some looters are locals who make their living by digging up sacred objects and selling them to intermediaries who take them to international black markets.[25]

Maya communities are not consulted or involved in archaeological digs in Guatemala. There are several reasons for this omission. The most traditional Maya are cautious and advocate for the historical values of Maya heritage over its monetary worth. Knowing this, some archaeologists opt not to hire Indigenous people, who might question unethical practices in the field. This also sheds light on why traditional Maya voices are not fully represented in any government institutions that grant licenses permitting access for excavations at these sites. In addition, archaeologists often have total authority at sites, bringing commercial investments to Maya-protected lands and territories against the will of the millions of Maya now voicing concerns. And yet the twenty-two Maya linguistic communities have no formal right to participation in the excavation and handling of archaeological finds. With Maya heritage in the hands of those scholars and collectors with access to the sites and seeking artifacts, there is a lack of checks and balances that might otherwise help prevent the theft of Maya cultural objects. Not surprisingly, artifacts are smuggled across borders and mysteriously appear in museums in cities in the United States and Europe, enlarging their collections of Maya cultural objects and relics.[26]

Maya People and the Protection of Ancient Maya Heritage

A proper economic plan is necessary to help Indigenous people, and Guatemala as a whole, successfully protect its cultural heritage. Indigenous consultants must be made part of the teams at governmental, academic, and international institutions dedicated to making decisions about Maya cultural heritage. Local, trained Indigenous experts should be hired, as they are the living descendants of that ancient civilization. There is, then, a lack of government support for the protection of Maya heritage, particularly at archaeological sites recently under excavation.[27] There is currently no monitoring of excavations or their finds by independent observers and authorities.

The protection of ancient Maya sites and the cultural heritage of the Maya can also be promoted by the *ajq'ij*, or Maya priests. They are the community's spiritual leaders, so their presence and activities may enhance protection and vigilance at ancient Maya centers. In recent decades, as more people have moved closer to archaeological sites, some have become *huecheros* (native looters). If efforts are made to prepare and educate people to participate in archaeological excavation projects, recent migrants may become more sensitive to protecting their cultural patrimony.[28]

Another important effort for the protection of Maya cultural heritage is to request that museums stop buying Maya artifacts. In fact, museums must decolonize their exhibits and repatriate sacred objects to the communities of origin. The Maya need a concerted United Nations effort to halt decades of improper and unmonitored digging,

no matter who is doing it, no matter their credentials. Leaders of the Maya linguistic communities should have a voice in any disturbance of their ancient heritage, as well as on any permitted or proposed excavation site. Additionally, cartels are gaining vast incomes from stealing artifacts, as big-dollar buyers from the United States and other prominent countries are allowed to purchase stolen artifacts with few legal consequences. There is no government watchdog group working on behalf of the Maya to guard, or deny access to, cultural heritage sites for the sake of their protection.

The invention of LIDAR is illuminating, but the Maya now know that people with GPS equipment will walk right over to unknown sites, hidden for millennia, and start digging in prime areas, and no one can stop them. How many hundreds of artifacts have been found in the last thirty years? This ongoing tragedy will continue until all diggings require appropriate monitoring and unauthorized diggings are investigated.

I hope this whole project of gathering information can push states to action. In the case of Guatemala and the Maya, there has been a major cloud around archaeological diggings. How can we better address the theft of artifacts, or even improper removal of these objects by licensed archaeologists, without Maya approval? Why is the Guatemalan government so reluctant to address these thefts? What is the extent of the relationship between the government and the *huecheros*, the local grave looters who continue with illegal diggings and have contacts with traffickers and cartels?[29]

Conclusions

Unfortunately, most Guatemalan *ladinos* do not know the greatness of ancient Maya civilization as their cultural heritage. This lack of knowledge weakens what might otherwise serve as a source of deep pride for the Guatemalan nation. At present, Maya archaeological sites continue to be looted by fortune hunters, including *huecheros* and the drug cartels that have invaded these remote and unprotected lands. Also, the revenues acquired from tourism by the Institute for Guatemalan Tourism (INGUAT) are not distributed to Maya communities, and most tourist businesses are in the hands of the non-Maya, except for those hired as guides at the sites for tourists and visitors. In addition to all this comes the invasion of the rain forest by ranchers and loggers who have threatened the ecosystem and the protected Maya rain forest of El Petén. Great tracts of the rain forest are cut down every year as more people migrate to these areas, invading the territory where the most ancient Maya land and sites are located.

Maya cultural heritage still hidden in the Petén rain forest has benefited from this natural source of protection, remaining undisturbed and secured from illegal excavations. Once a site is "discovered" and digging begins, however, it is exposed to looters, without any oversight of what is being removed—even by archaeologists—due to the absence of a system of proper checks and balances. For example, new LIDAR data showing the immense size of the city of El Mirador have exposed the region to looters, a situation made all the more dangerous by the lack of resources and effective legislation to protect it. There is also a lack of respect for the Indigenous communities living close

to the Maya protected areas, who struggle to maintain their cultural patrimony against newcomers.[30]

As stated at the outset, burning the ancient book of the Maya was akin to incinerating an entire civilization. Burning its knowledge, and thereby erasing a culture or a civilization, is to leave its people naked and devoid of knowledge. In the case of the Maya in 1565, it was not only an ethnic group that was destroyed, but an entire civilization. This was an immense crime, and people have not learned from it as they continue to violate the human and cultural rights of the Indigenous people of Guatemala.

The construction of a major Maya museum in Guatemala to house artifacts, both repatriated and newly discovered, could be a way to rebuild Maya culture in the form of a reparations program. Such a museum could also house the Popol Vuh, if one day it is repatriated to Guatemala to serve as a symbol of unity for all Guatemalans. Yet the failure of many Guatemalans to recognize the greatness of their ancient heritage contributes to their lack of interest in repatriating the stolen treasures now dispersed in museums around the world.

I agree with Simon Adams's assessment that there is widespread agreement among many heritage-associated professionals that "defending cultural heritage [is] not just about preserving statues but also about protecting people."[31] The case of the Maya is a classic example, a conflict that has persisted for centuries and one from which the Maya have not been able to escape, even after more than five hundred years of nightmares and persecution. For the Maya, there must be a strong questioning of the political and ideological role of the state in the construction of an elitist nationalism. After Adams's remarks, Edward Luck went on to say: "It is about a political project, whoever is carrying it out, that wants to identify certain cultures as inferior to others, as getting in the way in the larger nation-building project."[32] The February 1999 report of the Commission for Historical Clarification, entitled *Guatemala: Memory of Silence*, has documented the violations of the state against the Indigenous population that had been silenced for centuries. The recent armed conflict in Guatemala has shown that its Indigenous people are still struggling for full recognition of their rights as human beings, as well as for the protection of their cultural rights and identity as living members of the ancient Maya civilization.

Who finances such criminal actions? National institutions co-opted by corruption, often by outside forces, will not act upon crimes, or will outright ignore them. For this reason, it is important to include Indigenous scholars and trained experts in decision-making about their own cultural heritage, if we wish to protect Indigenous cultural heritage not only from looters, thieves, and organized groups of smugglers, but also from those archaeologists who have been given total freedom to access and decide on ancient Maya heritage, as in the current case involving Richard Hansen. And for this reason, the Native American Graves Protection and Repatriation Act in the United States must be extended to those countries with rich archaeological sites that are subject to

invasion. A law of this kind in Guatemala would help decrease the continued theft of objects from current and future dig sites. Government and university research institutions must have Indigenous scholars to advocate for their Maya communities in the research and excavation of their sites. In this way, their cultural heritage will be afforded greater protections as well as more accurate appraisals in its promotion to the wider world. But these Native scholars need to be critical and to respond to their communities, not to the colonialist agendas established by traditional archaeologists.

Finally, we recognize that Maya resiliency has been fundamental to their ability to survive in the midst of continuous destruction over five centuries: a negation of their cultural identity as descendants of the ancient Maya civilization from which they have been severed for centuries in the attempt to assimilate them into a homogeneous nation-state. While their resiliency is extraordinary, we must not think of them just as victims of the circumstances around them, but as creators and actors in the protection of their cultural heritage in the twenty-first century. Therefore, there is a need to recognize this connection with their ancestors and accord the Maya the privilege of being the living descendants of a great ancient civilization.

SUGGESTED READINGS

Robert M. Carmack, ed., *Harvest of Violence: The Maya Indians and the Guatemalan Crisis* (Oklahoma City: University of Oklahoma Press, 1992).

Patricia A. McAnany, *Maya Cultural Heritage: How Archaeologists and Indigenous Communities Engage the Past* (Lanham, MD: Rowman & Littlefield, 2016).

Rigoberta Menchú, *I, Rigoberta Menchú: An Indian Woman in Guatemala*, 2nd ed., ed. Elisabeth Burgos-Debray, trans. Ann Wright (New York: Verso Books, 2009).

Victor D. Montejo, *Voices from Exile: Violence and Survival in Modern Maya History* (Norman: University of Oklahoma Press, 1999).

Próspero Penados del Barrio (Archbishop of Guatemala), *Guatemala: Never Again!* (New York: Orbis Books, 1999), Recovery of Historical Memory Project (REMHI): The Official Report of the Human Rights Office Archdiocese of Guatemala.

Kay B. Warren, *Indigenous Movements and Their Critics: Pan-Maya Activism in Guatemala* (Princeton, NJ: Princeton University Press, 1998).

NOTES

1. See Academia de las Lenguas Mayas de Guatemala (ALMG), www.almg.org.gt.
2. Dan Hicks et al., "The Brutish Museums: The Benin Bronzes, Colonial Violence and Cultural Restitution," talk given at a webinar conference uploaded by the Hearst Museum of Anthropology, University of California, Berkeley, streamed live on 12 February 2021, YouTube video, 123 mins., https://www.youtube.com/watch?v=Zc-5BnHD8aM&feature=youtu.be.
3. Diego de Landa, *Yucatan before and after the Conquest*, trans. William Gates (New York: Dover, 1978), 83.

4. Bartolomé de Las Casas, *In Defense of the Indians,* trans. Stafford Poole, C. M. (DeKalb: Northern Illinois University Press, 1974).

5. John L. Stephens, *Incidents of Travel in Central America, Chiapas, and Yucatan,* 2 vols. (New York: Harper & Brothers, 1841).

6. Adrian Recinos, *Popol Vuh: The Sacred Book of the Quiché Maya,* trans. Delia Goetz and Sylvanus G. Morley (Norman: University of Oklahoma Press, 1950).

7. See Victor Montejo, *Voices from Exile: Violence and Survival in Modern Maya History* (Norman: University of Oklahoma Press, 1999); and Comisión para el Esclarecimiento Histórico de las Violaciones a los Derechos Humanos y los Hechos de Violencia que Han Causado Sufrimientos a la Población Guatemalteca (Truth Commission), *Guatemala: Memoria del silencio: Las violaciones de los derechos humanos y los hechos de violencia* (Guatemala City: Oficina de Servicios para Proyectos de las Naciones Unidas [UNOPS], 1999).

8. Wikipedia, s.v. "Historical Clarification Commission" (La Comisión para el Esclarecimiento Histórico [CEH]), https://en.wikipedia.org/wiki/Historical_Clarification_Commission.

9. Christopher Knight, "Column: A Looted Maya Sculpture Sparks a Storm Over Its Planned Sale at Auction," *Los Angeles Times,* 11 September 2019, https://www.latimes.com/entertainment-arts/story/2019-09-11/looted-maya-sculpture-millon-auction.

10. Claudia Méndez Villaseñor, "Lo Maya se hizo moda, pero el saqueo comenzó antes, hace 170 años," *El Periódico,* 24 June 2018.

11. Ana Lucía Mendizábal Ruiz, "Piezas mayas guatemaltecas serán subastadas," *El Periódico,* 8 February 2021, https://elperiodico.com.gt/cultura/arte-diseno/2021/02/08/piezas-mayas -guatemaltecas-seran-subastadas/.

12. Ministry of Culture and Sport, Guatemala, "Recompensa: Cien Mil Quetzales (Q.100,00.00)," 2020, https://mcd.gob.gt/q100000-recompensa-piezas-de-arte-robadas/, author's translation.

13. US Department of State, "Guatemala (97-929)—Memorandum of Understanding Concerning the Imposition of Import Restrictions on Archaeological Objects and Material from the Pre-Columbian Cultures of Guatemala," 29 September 1997, https://www.state.gov/97-929.

14. According to Trafficking Culture, an organization that researches the illegal global trafficking of cultural objects, "a spectacular collection of Classic Maya pottery thought to have been systematically looted from Guatemalan sites throughout the 1980s" ended up in an American museum collection. See Donna Yates, "November Collection of Maya Pottery," Trafficking Culture, 21 July 2020, https://traffickingculture.org/encyclopedia/case-studies/november -collection-of-maya-pottery/.

15. https://peacemaker.un.org/sites/peacemaker.un.org/files/GT_950331 _AgreementIdentityAndRightsOfIndigenousPeoples.pdf.

16. *Constitución Nacional de Guatemala* (Guatemala City: Tipografía Nacional de Guatemala, 1985), 22.

17. César Pérez Marroquín and Dony Stewart, "Domingo Choc Che, el hombre que fue linchado señalado de brujería, colaboraba en la investigación sobre plantas medicinales," *Prensa Libre,* 8 June 2020, https://www.prensalibre.com/ciudades/peten/domingo-choc-che-el-hombre-que-fue -linchado-senalado-de-brujeria-colaboraba-en-la-investigacion-sobre-plantas-medicinales.

18. Jeff Abbott, "U.S. Archeologist Seeks to Privatize Maya Historic Sites in the Name of Conservation," NACLA, 27 August 2020, https://nacla.org/guatmala-peten-tourism-hansen.

19. Jeremy Radachowsky and Bayron Castellanos, "Consensus Building Methods for the Management of Natural and Cultural Heritage in the El Mirador Region of Guatemala," in *Consensus Building, Negotiation, and Conflict Resolution for Heritage Place Management,* ed. David Myers, Stacie Nicole Smith, and Gail Ostergren, Proceedings of a Workshop Organized by the Getty Conservation Institute, Los Angeles, California, 1–3 December 2009 (Los Angeles: Getty

Conservation Institute, 2016), 151, https://www.getty.edu/conservation/publications_resources/pdf_publications/pdf/consensus_building.pdf.

20. Tujaal, "Open Letter to Archaeologist, Richard D. Hansen Regarding His Imperialist and Colonial Drive to Expropriate Our Territories and Sacred Sites," 30 June 2020, https://tujaal.org/open-letter-to-archaeologist-richard-d-hansen/.

21. Mirador-Calakmul Basin Maya Security and Conservation Partnership Act of 2019, S. 3131, 116th Cong. [2019–20], https://www.congress.gov/bill/116th-congress/senate-bill/3131.

22. Abbott, "US Archeologist Seeks to Privatize."

23. Association for the Protection of Latino Cultural Patrimony, "Remove Dr. Richard Hansen from the Society for American Archaeology," petition on Change.org, 13 July 2020, https://www.change.org/p/society-for-american-archaeology-remove-dr-richard-hansen-from-the-society-for-american-archaeology.

24. Joe E. Watkins, Society for American Archaeology, letter to the Honorable James M. Inhofe, 13 July 2020, https://documents.saa.org/container/docs/default-source/doc-governmentaffairs/s3131_statement_final.pdf?sfvrsn=dffe78a6_2.

25. Max Radwin, "Black Market for Mayan Artifacts Still Thrives in Guatemala," InSight Crime, 25 February 2020, https://www.insightcrime.org/news/brief/black-market-mayan-ruins/.

26. Julie López, "Narcos: Los nuevos actores en el tráfico de bienes culturales," *Plaza Pública*, 19 October 2016, https://www.plazapublica.com.gt/content/narcos-los-nuevos-actores-en-el-trafico-de-bienes-culturales.

27. Edgar Herlindo Hernández Sánchez, "La Máscara de Río Azul: Un caso de tráfico ilícito del patrimonio cultural de Guatemala," bachelor's thesis, Universidad de San Carlos de Guatemala, Guatemala City, 2008, http://biblioteca.usac.edu.gt/tesis/14/14_0407.pdf.

28. Erik Vance, "Losing Maya Heritage to Looters: Stolen Artifacts Are Making It from the Guatemalan Jungle to Wealthy Black-Market Buyers," *National Geographic*, 10 August 2014, https://www.nationalgeographic.com/culture/article/140808-maya-guatemala-looter-antiquities-archaeology-science.

29. Vance, "Losing Maya Heritage to Looters."

30. López, "Narcos: Los nuevos actores."

31. Simon Adams, contributor to *Cultural Heritage under Siege: Laying the Foundation for a Legal and Political Framework to Protect Cultural Heritage at Risk in Zones of Armed Conflict*, ed. James Cuno and Thomas G. Weiss, Occasional Papers in Cultural Heritage Policy no. 4 (Los Angeles: Getty Publications, 2020), 12, https://www.getty.edu/publications/occasional-papers-4/.

32. Edward C. Luck, contributor, *Cultural Heritage under Siege*, ed. Cuno and Weiss, 15.

PART 3

Cultural Heritage and Populations at Risk

Introduction: Part 3

James Cuno
Thomas G. Weiss

A point of departure for this research project was the compelling need to stop, and hopefully prevent, the destruction of cultural heritage and mass atrocity crimes, which UN member states agreed at the 2005 World Summit under the norm of the responsibility to protect, or R2P (the crimes defined there as genocide, war crimes, crimes against humanity, and ethnic cleansing). Part 3 investigates in-depth the moral repulsion and preoccupation with human suffering that is invariably intertwined with attacks on cultural heritage. Hence, the five chapters in "Cultural Heritage and Populations at Risk" review the many pressing normative, humanitarian, and ethical requirements to halt and prevent mass atrocities.

Chapter 16 is an overview of recent normative efforts in "Cultural Cleansing and Mass Atrocities." Simon Adams, the president and CEO of the Center for Victims of Torture and former executive director of the Global Centre for the Responsibility to Protect, has two distinct yet intertwined themes. He begins with "cultural cleansing," the phrase coined by Irina Bokova, the author of the foreword to this book and the former director-general of the UN Educational, Scientific and Cultural Organization (UNESCO). The term refers to attacks on cultural heritage perpetrated by state and nonstate actors alike, including efforts to erase the history of the people or peoples whose heritage is being damaged or destroyed together with their physical annihilation. While some challenge the link between attacks on cultural heritage and mass atrocities, Adams points to a "disturbing convergence between sustained attacks on cultural heritage and the attempted extermination of entire peoples." In short, there exists a theoretical possibility of separating the protection of people and their cultural heritage, but almost invariably wherever and whenever vulnerable people are the subject of atrocities, their cultural heritage is under attack as well. Using the onslaught against the Hazara population in Afghanistan by state and nonstate forces alike, of many minorities in Iraq by the Islamic State of Iraq and Syria (ISIS), and of the Uyghurs by China, Adams makes a persuasive case that there is an international responsibility to protect vulnerable populations from those seeking to destroy them and their cultural heritage. Neither "cultural cleansing" nor "ethnic cleansing" has an international legal definition, but both capture atrocities together with genocide, war crimes, and crimes against

humanity. His second theme is the responsibility to protect, the emerging norm that seeks to guide international responses to prevent mass atrocities, react to them, or rebuild after failures to do either of those. These same three terms characterize approaches by members of the heritage community—archaeologists, museum curators and directors, and anthropologists—which helps explain why R2P was the point of departure for this research endeavor. Adams echoes Bokova in closing with "an impassioned plea for the protection of civilians to remain at the center of cultural heritage protection."

Part 3 continues with an exploration of the ethical underpinnings of the concerns for people and their cultural heritage. Chapter 17, "Choosing between Human Life and Cultural Heritage in War," contains reflections by Hugo Slim, senior research fellow at the University of Oxford's Institute of Ethics, Law and Armed Conflict in the Blavatnik School of Government; his argument also draws on his years as the head of policy and humanitarian diplomacy at the headquarters of the International Committee of the Red Cross in Geneva. This chapter reinforces one of the central propositions running throughout the book: how difficult it is, analytically or practically, to disentangle the twin imperatives to safeguard human life and cultural heritage, or the inextricable relationship between personhood and property—or in Slim's framing, "humanity is biology and biography." He notes that there are two ways to hurt individuals, "by attacking them and their family, or by attacking what they love in the community to which they belong." He continues by asking why cultural heritage matters at all, and why trade-offs are viewed as so painful. While agreeing that culture is not merely a means for humans to flourish but also an essential value in *being* human, Slim nonetheless argues that, if "hard battlefield choices" are unavoidable, the lives of civilians and friendly combatants trump concerns about cultural heritage. He concludes with suggestions for armed forces, humanitarians, and vulnerable communities about how best to mitigate cultural losses. Like all contributors to this volume, he does not deny that the destruction of cultural heritage is ethically and legally wrong. Yet, Slim holds that under certain circumstances a stark choice may be unavoidable; in that case, do lives or cultural heritage take precedence? His bottom line is that human life must be the priority in such circumstances. His judgment reflects the logic that living beings maintain the potential for cultural reconstruction and renewal; dead ones do not. At the outset of 2022, over eighty million refugees and internally displaced persons are forcibly displaced and suffer not only physically but also from the loss of access to cultural sites left behind. However, Slim concludes that "it is right that they have saved themselves so they can create new things, remember what was lost, and continue to be human."

Chapter 18 continues to explore this uncomfortable reality in "Saving Stones and Saving Lives: A Humanitarian Perspective on Protecting Cultural Heritage in War." Paul H. Wise—professor in child health and society as well as professor of pediatrics and health policy at Stanford University—applies the humanitarian's passion for alleviating unnecessary human pain and the cosmopolitan's appreciation for the inherent value of

cultural heritage. As both suffer during armed conflict, the connection between them has in recent decades been used to justify robust protection not only of human beings but also of cultural heritage. In his words, "the relationship between the destruction of cultural heritage and the destruction of people is as complex as is the meaning of culture and the tragedy of violent death." Wise implores those working within the heritage–humanitarian relationship to move beyond anecdotes and determine empirically the precise impact of the six different mechanisms summarized in his alliterative framework: prelude, provocation, parallelism, protraction, participation, and propaganda.

While the intimate connections between lives and stones seem intuitively correct, he assesses the admittedly inadequate empirical evidence supporting the links. He admits that "the humanitarian justifications for protecting cultural heritage in war are real but complicated." While "the destruction of cultural heritage warrants condemnation regardless of its ultimate linkage to violent attacks on people," he challenges members of the humanitarian and heritage communities to dig deeper. He urges them to pursue in-depth research that goes beyond the narrow disciplines espoused by those who study heritage and those who study humanitarianism. Why? If protecting cultural heritage reduces suffering and death or the duration of war, such protection is not merely a cultural desirability but also a humanitarian imperative. Moreover, the case is all the stronger because heritage destruction also entails psychological costs that also negatively affect health and thus add weight to the humanitarian's appreciation for the extrinsic value of cultural heritage.

Wise points out that even the most basic question—about the precise percentage of heritage destruction (before, during, and after wars) that is associated with mass atrocities—has received scant attention in research by medical personnel, social scientists, and humanists. Debate revolves more around committed conjectures than empirical realities. Wise does not question the value of protecting heritage or the links between such protection and saving human lives, but he demands more than merely asserting that heritage should be protected on humanitarian grounds. It will be necessary to move beyond "a traditional reliance on heritage expertise alone" and toward "new forms of transdisciplinary collaboration involving security, political, health, and humanitarian disciplines." Both strategies and tactics could and should change with more granular data and analysis, which could "lay a more coherent foundation for engaging the heritage protection and humanitarian communities in a unified public advocacy dedicated to saving both stones and lives."

Chapter 19 reflects the academic and policy preoccupations of Jennifer M. Welsh, research chair in global governance and security as well as director of McGill University's Centre for Peace and Security Studies and a former special adviser to the UN Secretary-General on the responsibility to protect. Well versed in the scholarly and practical consequences of the debates about this evolving norm, Welsh seeks a solution to the problem that international law—no matter how adequate or inadequate its

provisions—still mainly applies to states. Yet in recent decades, many atrocities as well as the destruction of substantial cultural heritage have resulted from attacks by nonstate actors. Welsh's essay, "Engaging Nonstate Armed Groups in the Protection of Cultural Heritage," explores the admittedly limited means to persuade nonstate armed groups (NSAGs) of the necessity to take seriously international norms and respect the provisions of international humanitarian and human rights law.

However, engagement with NSAGs is controversial and often blocked within intergovernmental deliberations because of "the long-standing reluctance of states to undertake actions or commitments that they believe might legitimize such entities, or challenge the authority of existing governments." She puts forward a five-part typology that distinguishes types of NSAGs by their differences in political objectives, organizational types, community embeddedness, ideology, and the nature of their internal political and military wings. Welsh argues that identifying variations in criminal behavior toward cultural heritage is a prerequisite for tailoring policy measures to discourage destructive and encourage constructive behavior. She probes the "why" and "how" of attacks on cultural heritage that are deliberate and public.

Deterring what often constitutes theater to be consumed by susceptible audiences demands different approaches for countering destruction from those designed to prevent collateral damage or poorly informed and executed military actions. One size certainly does not fit all because there are two categories of NSAGs—those that deliberately destroy cultural heritage and those that respect it. So, incentives could work to persuade the latter to sign pledges to respect international law and, perhaps more importantly, norms (work pioneered by Geneva Call). While NSAGs have not participated in the elaboration of the formal rules governing the protection of cultural heritage, "some of them acknowledge the importance of the *values* underpinning the legal regime." Welsh thus aims to identify processes that can engender restraint—that is, to discover the sources of authority, belief, and influence—within NSAGs that can be used to steer them toward respecting cultural heritage rather than intentionally flouting international obligations.

The final topic of part 3 is chapter 20, "After the Dust Settles: Transitional Justice and Identity in the Aftermath of Cultural Destruction." The authors are Philippe Sands, professor of law at University College London, and Ashrutha Rai, a doctoral candidate at the University of Cambridge and previously a judicial fellow at the International Court of Justice in The Hague. Beginning in the 1990s and following the negotiated end of many armed conflicts and the start of substantially new government regimes, a series of intense experiments began in a variety of contexts to ensure some nonjudicial accountability and redress for victims of abuse and atrocities. Sands and Rai peer obliquely through the prism of international law to explore the potential of transitional justice—pioneered to address atrocities in the aftermath of wars or significant repression of basic human rights—to examine its applicability for safeguarding cultural heritage. The authors analyze the details of this conflict-management device in cases as

varied as the former Yugoslavia, Sierra Leone, East Timor, and Rwanda. Seeing little consistency in theory or practice, they seek to identify the legitimate but not strictly judicial responses to massive violations of rights that also could be relevant for protecting cultural heritage. Transitional justice does not emphasize the letter of international law but rather the more immediate and practical solutions for communities that have suffered both heritage loss and mass atrocities. It seeks to circumscribe "fractious questions of ownership in favor of practical solutions for embedded communities."

The delicate challenge for Sands and Rai is to avoid the easy path of ignoring cultural cleansing while not exacerbating the fragile equilibrium of a country in transition. Thus, conviction and punishment are not the only paths to a measure of justice. "An attempt to move past traumatic episodes requires inquiry into the nature of cultural ownership," which the authors admit is a fraught undertaking. While international cultural heritage law emphasizes the decontextualized protection of cultural sites and property, Sands and Rai argue that framing the dilemma accurately has two requirements: understanding the numerous fractious claims to "ownership" that range from individuals and distinct groups (local, regional, national) to all of humankind; and finessing the internationalist versus nationalist divide for such claims. International heritage law does not distinguish varied affective experiences and senses of loss, yet any successful reconstruction following war, violence, and mass atrocities molds and is molded by the identities of those with simultaneous claims to ownership. As the authors point out, "the distinct aims of both transitional justice and international cultural heritage law are ultimately oriented toward and best achieved through a peace that is sustainable and effective over the long term." Sustainable peace "calls for an approach to cultural heritage that is responsive to the simultaneous narratives, multiple identities, and unpredictable associations that link people with culture."

16

Cultural Cleansing and Mass Atrocities

Simon Adams

Raphael Lemkin was personally responsible for the creation of the term "genocide." As a Polish-Jewish refugee during World War II, Lemkin was painfully aware of how Nazi Germany demolished the cultural underpinnings of Jewish life in occupied Europe. For Lemkin the killing of a people "in a spiritual and cultural sense" was linked to their destruction in a physical sense. It is understandable, therefore, that his conception of genocide included the "desecration and destruction of cultural symbols, destruction of cultural leadership, destruction of cultural centers, prohibition of cultural activities" and forced conversion to an alien religion or way of life. The intentional eradication of a people's "traditions, monuments, archives, libraries, and churches" amounted to the destruction of "the shrines of a nation's soul." Regrettably, opposition from some member states of the early United Nations saw Lemkin's ideas regarding culture discarded in the final version of the Genocide Convention that was adopted in December 1948.[1]

This is not to say that the connection between culture, conflict, persecution, and atrocities was completely ignored. The 1954 Hague Convention for the Protection of Cultural Property in the Event of Armed Conflict highlights that "damage to cultural property belonging to any people whatsoever means damage to the cultural heritage of all [hu]mankind." Cultural heritage is protected under the convention and is part of customary international humanitarian law (rules 38–41). Jurisprudence was further advanced at various international criminal tribunals and via the International Criminal Court (ICC), which has jurisdiction over genocide, crimes against humanity, and war crimes. According to Article 8 of the 1998 Rome Statute, which established the ICC, war crimes may include "intentionally directing attacks against buildings dedicated to religion, education, art, science or charitable purposes, historic monuments" and other civilian objects. As a result, as James Cuno and Thomas G. Weiss argue in the

introduction to this volume, "there are sufficient international legal tools to protect immovable cultural heritage should UN member states decide to do so."

On the political front, while indifference and inaction were the norm during the Cold War, in the aftermath of the 1994 genocide in Rwanda and following the July 1995 genocide at Srebrenica in Bosnia, UN member states struggled to come to terms with their failure to live up to the post-Holocaust promise of "never again." At the UN's 2005 World Summit, the assembled heads of state and government adopted the principle of the responsibility to protect (R2P). The new idea was perhaps best encapsulated by Ramesh Thakur, who wrote that R2P was a rejection of a past diplomatic history of both "institutionalized indifference and unilateral interference" when it comes to mass atrocity crimes.[2]

The moral and political basis of R2P is that all human beings have a right to be protected from genocide, war crimes, ethnic cleansing, and crimes against humanity. The responsibility to protect people from these crimes falls, first and foremost, upon their sovereign government. Secondly, the international community—meaning not just state powers, but also intergovernmental organizations and global civil society—has an obligation to assist any state that is struggling to uphold its protective responsibilities. Finally, if a government proves manifestly unable or unwilling to exercise its responsibility to protect, then the UN Security Council is obligated to act.[3]

Since 2006, R2P has been invoked in sixty resolutions of the UN Human Rights Council and over eighty Security Council resolutions. The emerging norm has helped protect populations from atrocities in the Central African Republic, Democratic Republic of the Congo, Côte d'Ivoire, and many other countries.[4] However, the failure of the Security Council to end atrocities and hold perpetrators accountable in Syria or Myanmar exposed its inability to consistently uphold the new norm even when a crisis has the attention of the entire world.

Moreover, throughout the world, wherever and whenever vulnerable populations face mass atrocity crimes, there are often also targeted attacks on their cultural heritage. In Myanmar, for example, the targeting of cultural property was an early warning sign that the authorities were moving from a policy of discrimination and segregation of the country's Rohingya community toward a policy of systematic destruction.

The Rohingya—a mainly Muslim ethnic minority group in a predominantly Buddhist country—had been persecuted for decades. Following a military coup in 1962, political power was increasingly concentrated in the hands of the Bamar Buddhist majority, with other significant ethnic groups largely marginalized. The country's 1982 Citizenship Law did not even recognize the approximately one million Rohingya—living mainly in Rakhine State, bordering Bangladesh—as one of the country's 135 official "national races." Although the Rohingya constituted 1 percent of Myanmar's population, most were rendered stateless.

Despite a gradual move away from military rule after 2011, anti-Muslim and anti-Rohingya sentiment intensified.[5] New discriminatory laws restricted their freedom of movement and access to employment and education. In 2014 the Rohingya were prohibited from self-identifying on the national census, the first to take place in the country since 1983. The so-called Protection of Race and Religion laws, which were passed in 2015 and place harsh restrictions on women and non-Buddhists, further constrained fundamental religious freedoms as well as reproductive and marital rights. The conditions under which the Rohingya minority were forced to live in Myanmar came to resemble a uniquely Southeast Asian form of apartheid.

Following an attack by Rohingya militants on several remote border posts in October 2016, a four-month "counterinsurgency" campaign by Myanmar's security forces led to mass killings and other atrocities. Over a period of several weeks the security forces also burned down at least twenty-five mosques and other Rohingya cultural buildings in six villages across Rakhine State. According to local residents, this included an "ancient mosque" in Dar Gyi Zar.[6]

Partly due to the weak international response to these attacks, in late 2017 Myanmar's military launched new so-called clearance operations. These involved more mass killings and the forced displacement of over 750,000 Rohingya, as well as the burning of more than three hundred villages across Rakhine State. Mosques, graveyards, and other physical manifestations of Rohingya culture were destroyed. Fortify Rights, a regional human rights organization, collected testimonies from survivors. According to its cofounder and head, Matthew Smith, "in many cases, mosques were one of the military's first targets during the 'clearance operations,' sending a frightful message to Rohingya residents."[7] Afterward, the charred remains of hundreds of Rohingya cultural sites were deliberately bulldozed and buried, as noted in the historic genocide case eventually brought against Myanmar at the International Court of Justice in 2019.

Places of worship, cemeteries, historical monuments, libraries, museums, and other cultural spaces are the means by which a living culture is transmitted from one generation to the next. While armed extremist groups are perhaps the most notorious contemporary perpetrators of attacks on cultural heritage, powerful governments and rogue states also continue to commit acts of "cultural cleansing." The following three brief case studies examine differing international responses to attacks on cultural heritage and vulnerable populations over the past two decades.

The Taliban and the Hazaras

On 26 February 2001 Mullah Mohamed Omar, the supreme leader of the Taliban—the armed extremist group which had become the rulers of Afghanistan—declared that "all statues and non-Islamic shrines located in the different parts of the Islamic Emirate of Afghanistan must be destroyed."[8] The order included two magnificent giant Buddhas carved into the face of a cliff in Bamiyan, in Afghanistan's central highlands along the

ancient Silk Road. Both of the Buddhas had been created during the sixth century and were an internationally renowned symbol of Afghanistan's syncretic history.

Despite diplomatic pleas from the United Nations, the Organisation of the Islamic Conference (now the Organisation of Islamic Cooperation), and an international delegation of esteemed Muslim scholars, the Taliban proceeded with the demolition of the Buddhas at the start of March. Although this action was part of a wider Taliban campaign against "idolatry," it was the blowing up of the Buddhas (which was filmed) that got the world's attention. Indeed, the spectacular destruction at Bamiyan was perhaps the Taliban's most notorious crime, resulting in an outpouring of diplomatic opprobrium. The director-general of the UN Educational, Scientific and Cultural Organization (UNESCO), Koïchiro Matsuura, denounced "the cold and calculated destruction of cultural properties which were the heritage of the Afghan people, and, indeed, of the whole of humanity." He also welcomed the fact that the International Criminal Tribunal for the former Yugoslavia (ICTY) had included attacks on the World Heritage Site at Dubrovnik, Croatia, in recent indictments against suspected war criminals. Matsuura drew an explicit link with Bamiyan, arguing that the ICTY indictments "[show] the international community can take action to protect cultural property and apply sanctions for its protection."[9]

The destruction of the Bamiyan Buddhas was condemned around the world. But it was not nearly as widely reported that this constituted part of an ongoing campaign of atrocities targeting the ethnic Hazara community living in the Bamiyan Valley. The Taliban are Sunni extremists whose core constituency has always been within the country's largest ethnic group, the Pashtun. The Hazaras are physically and linguistically distinct, predominantly Shia, and their origin story is that they are the descendants of Mongol soldiers left behind by Genghis Khan. An ethnic group of approximately two million people, the Hazaras formed around 10 percent of the population of Afghanistan in 2001 and have experienced a long history of poverty and persecution, including atrocities in the late nineteenth century. The Hazaras were also considered the cultural custodians of the ancient Buddhas.

The Hazaras were also integral to the armed resistance to the Taliban. As a result, when the latter overran the northern city of Mazar i-Sharif on 8 August 1998, they conducted door-to-door searches for Hazara men and boys, massacring at least two thousand. Witnesses described a "killing frenzy," and there were also widespread reports of sexual violence directed at Hazara women and girls. The city's new Taliban governor, Mullah Manon Niazi, publicly called on the Hazaras to convert to Sunni Islam or perish. Another senior Taliban commander, Maulawi Mohammed Hanif, called for the extermination of all Hazaras within the group's zone of control.[10]

When the Bamiyan Valley fell to the Taliban the following month, Hazara homes were demolished and summary executions conducted, while graveyards and other physical manifestations of Hazara culture were destroyed. Bamiyan, the provincial capital at the feet of the towering Buddhas, was largely depopulated. Another major

massacre of Hazara civilians, conducted over a period of several days, was documented in Yakaolang district during January 2001. Hazara community leaders later claimed that as many as fifteen thousand may have been killed in these various atrocities and many survivors described the Taliban systematically demolishing Hazara mosques using bulldozers and explosives. When the Taliban were finally overthrown in late 2001 and people started excavating the mass graves, many Hazaras drew a link between these crimes and the destruction of the giant Buddhas. In the words of local midwife Marzia Mohammadi, the "Buddhas had eyes like ours, and the Taliban destroyed them like they tried to destroy us. They wanted to kill our culture, erase us from this valley."[11]

The Taliban's destruction of the Bamiyan Buddhas was intended as a spectacle, a reprisal, and also as a cultural palimpsest. But in 2001 there was no international tribunal for Afghanistan, and the ICC had not yet been established. Nor was there any international consensus on how to confront rogue state actors, like the Taliban, who were perpetrating atrocities. Regrettably, by focusing so intently on the shocking destruction of the Buddhas, some diplomats may have also inadvertently fed into one of the Taliban's key propaganda points—namely, that the outside world cared more about the fate of ancient statues than the Afghan people.

It took 9/11 and the US military intervention in Afghanistan to finally halt the Taliban's campaign to eradicate the Hazaras. However, while the Bamiyan Valley was recognized as a UNESCO World Heritage Site in 2003, the Hazara people remained vulnerable and underprotected, as they do to this day. A resurgent Taliban continued to sporadically attack Hazara civilians, while other armed extremist groups operating in Afghanistan and Pakistan continue to bomb Hazara cultural events and gatherings, in acts that may amount to crimes against humanity under international law.[12]

The Islamic State and the Yezidis

During 2014, just over a decade after the destruction at Bamiyan and nine years after the adoption of R2P at the UN World Summit, another armed extremist group, the Islamic State of Iraq and Syria (ISIS, also known as ISIL or Da'esh), swept across the Nineveh Plain in northern Iraq, seizing towns and villages. Iraq's second largest city, Mosul, fell on 10 June and shortly afterward ISIS declared the extensive lands it now occupied to constitute a "caliphate."

At its peak in 2015, the group had at least thirty thousand fighters on a territory in western Iraq and eastern Syria that was larger than England, ruling over ten million people. ISIS's caliphate also included several thousand significant archaeological sites from some of humanity's earliest civilizations. In all territory it occupied the group systematically destroyed "deviant" aspects of Iraq and Syria's cultural heritage. In the Mosul Museum statues from ancient Mesopotamia were demolished with sledgehammers. At Nimrud the ruins of an ancient Assyrian city were bulldozed. And at Palmyra in Syria Roman ruins that were a recognized UNESCO World Heritage Site were partially destroyed.[13]

ISIS was not the only armed force in the Levant that was destroying the region's cultural inheritance. Between 2011 and 2015 five of the six World Heritage Sites in Syria suffered significant damage during the country's bitter civil war. But ISIS's assault on cultural heritage was uniquely focused. When the then director-general of UNESCO, Irina Bokova, described these acts as a policy of "cultural cleansing," ISIS could not contain its outrage. In a video, one of its leaders declared: "Some of the infidel organizations say the destruction of these alleged artifacts is a war crime. We will destroy your artifacts and idols anywhere and Islamic State will rule your lands."[14] For Bokova, what made ISIS's cultural cleansing exceptional was not just its scale, but the fact that it "combines the destruction of monuments and the persecution of people." Surveying a world where vulnerable populations were subjected to atrocities, Bokova's conclusion was that culture was now "at the front line of modern conflict."[15]

On those front lines in northern Iraq, ISIS systematically desecrated and destroyed sixty-eight Yezidi temples and shrines.[16] While these acts may seem to pale in comparison to some of ISIS's other atrocities, they represented a systematic attempt to erase Yezidi identity, history, and memory. Although ISIS also carried out sectarian attacks against the Shia population and targeted Iraq's endangered Christian communities, the threat they posed to the Yezidis was truly existential.

A small ethno-religious group encompassing approximately four hundred thousand people (or roughly 2 percent of the country's population) and concentrated in communities around Mount Sinjar, the Yezidis were one of Iraq's most vulnerable minorities. The ancient Yezidi religious tradition is monotheistic and although it incorporates influences from Christianity and Islam, it predates both. Although Yezidis are Kurdish-speaking and are considered by some to be ethnic Kurds, to be a Yezidi you must be born of Yezidi parents and cannot convert. The occluded nature of many Yezidi communities has led to their marginalization and persecution throughout history, including under the Ottoman Empire.

Drawing on long-established myths and prejudices, ISIS considered the Yezidis to be polytheists. They "referred to the Yazidi as *mushirkin*, 'those who commit the sin of idolatry/paganism.'"[17] As a result, when ISIS overran the Sinjar region in early August 2014, the Yezidis became the focus of atrocities intended for their eradication.

During their three-year armed occupation, ISIS carried out mass executions of Yezidi men and boys, and the enslavement of more than five thousand women and girls. Yezidis were subjected to targeted killings, forced religious conversion, and the transferring of children (as slaves or child soldiers) to persons outside the community. Such acts, carried out as policy by ISIS, constituted genocide. Or as a UN commission of inquiry report later put it, drawing directly from Article 2 of the Genocide Convention, ISIS "intended to destroy the Yazidis of Sinjar, composing the majority of the world's Yazidi population, in whole or in part."[18]

The corresponding cultural destruction inflicted by ISIS was also catastrophic. In the twin villages of Bashiqa–Bahzani all thirty-eight significant Yezidi shrines and temples

were systematically destroyed using explosives and bulldozers. This included two shrines that were at least seven hundred years old, as well as the desecration of tombstones dating back to the thirteenth century. At the shrine of Sheikh Mand, near Mount Sinjar, ISIS executed fourteen elderly villagers inside the shrine before blowing it up. Ceremonies and rituals performed at all these shrines and temples, with elders transmitting traditions from one generation to the next, are essential to the survival of the Yezidi faith. ISIS's motivation, in the words of one Yezidi survivor, was "to erase everything that connected us to our culture and heritage."[19]

The international reaction to this campaign of atrocities was grounded in international law. In February 2015, UN Security Council resolution 2199 condemned the "targeted destruction" of cultural heritage in Syria and Iraq, including religious sites and objects, by ISIS and other extremist groups. The Security Council also imposed international sanctions. Then in September 2016 Ahmad al-Faqi al-Mahdi, a member of an armed group in Mali, was found guilty at the ICC of a war crime for his role in the deliberate destruction of the UNESCO World Heritage Site at Timbuktu. In March the following year the Security Council adopted resolution 2347, deploring the destruction of humanity's cultural heritage and noting that the ICC had "for the first time convicted a defendant for the war crimes of intentionally directing attacks against religious buildings and historic monuments and buildings."

The historic resolution stressed that states "have the primary responsibility in protecting their cultural heritage" in conformity with international law. But were states prepared to act accordingly? Following the fall of Mosul, the Iraqi government pleaded for military assistance. On 9 August 2014 the United States launched air strikes on ISIS fighters who were besieging thousands of Yezidis on Mount Sinjar, protecting them from what President Barack Obama described as "a potential act of genocide." Rita Izsák-Ndiaye, the UN special rapporteur on minority issues, also called for "all possible measures" to "be taken urgently to avoid a mass atrocity and potential genocide within days or hours."[20] The skies over northern Iraq eventually became congested with foreign fighter planes as Australia, Belgium, Denmark, France, Jordan, the Netherlands, and the United Kingdom all responded to these pleas, conducting air strikes as part of an international anti-ISIS coalition.

Because the group was not a formal part of the international system and lacked even the limited diplomatic recognition temporarily achieved by the Taliban, their "caliphate" was less susceptible to measures that did not involve the use of force, like sanctions or an arms embargo, than a normal state. However, ISIS did trade on the illicit fringes of the regional economy, relying on the sale of black-market oil and looted antiquities. International sanctions cut off 75 percent of ISIS's revenue, but the fact that the group proudly rejected the norms and laws of modern diplomacy and was committed to global military expansion meant that there were very few nonmilitary tools that could be deployed against them.[21]

On the ground in Iraq, the anti-ISIS struggle was led by the Iraqi army, Shia militias, and various Kurdish forces. By October 2017 Mosul had been retaken and the amount of land held by ISIS was just one quarter of its peak of around 90,800 square kilometers (56,400 square miles) in January 2015. With the final fall of the Syrian village of Baghuz in March 2019, ISIS's "caliphate" was no more.[22]

If the campaign against ISIS was a successful example of international military intervention to halt atrocities, it did not feel that way to the Yezidi survivors who returned to broken communities. Thousands of women and girls also remained enslaved by fleeing ISIS forces. But partly in response to a relentless campaign by Yezidi advocates, during September 2017 the Security Council authorized the establishment of the UN Investigative Team to Promote Accountability for Crimes Committed by Da'esh/ISIL (UNITAD). As of the time of writing, however, not a single ISIS perpetrator has been held legally accountable in Iraq for inciting and organizing atrocity crimes against the Yezidis, including the systematic destruction of their cultural heritage.

Nevertheless, UNESCO did launch a campaign to rebuild some of the cultural monuments of northern Iraq and "revive the spirit of Mosul." Initial funding came from the United Arab Emirates among other donors. Hungary's government, meanwhile, offered to rebuild some Christian churches on the Nineveh Plain. And in Sinjar, an Iranian-backed Shia militia rebuilt the Sayyida Zaynab shrine. Surveying these developments, during 2019 a local Yezidi activist, Falah Hasan Issa, complained that no destroyed Yezidi shrines in Sinjar had been rebuilt. By contrast, "There was only one Shia shrine, and they reconstructed it." Khurto Hajji Ismail, or Baba Sheikh, then head of the Yezidi faith, insisted that "if they do not rebuild the shrines which were destroyed" by ISIS "the existence of the Yazidis in these areas will be forgotten."[23] Despite the defeat of ISIS, and the recent reconstruction of some Yezidi temples and shrines, culture remains a battlefield across northern Iraq.

China and the Uyghurs

Although the Taliban were a state power between 1996 and 2001, and ISIS's seizure of vast expanses of Iraq and Syria between 2014 and 2017 meant they took on the functions of an occupying military power, neither enjoyed widespread international diplomatic recognition. The People's Republic of China, by contrast, is a superpower with the second largest economy in the world, nuclear weapons, and a permanent seat on the UN Security Council.

In recent years the Chinese government has come under scrutiny for its policies in the Xinjiang Uyghur Autonomous Region (XUAR). Although minority ethnic groups that are predominantly Muslim account for less than 2 percent of the total population of China, the approximately ten million Uyghurs who live in XUAR form a majority of the population in the vast western region.

Following intercommunal riots in 2008 and 2009 and a number of terrorist attacks, President Xi Jinping visited XUAR in April 2014, where he met with local officials and

called for "absolutely no mercy" to be shown in the "struggle against terrorism, infiltration and separatism."[24] In March 2017 the government introduced harsh new regulations aimed at the "de-extremification" of the Uyghurs and other Turkic Muslim populations whose religious identity and cultural independence allegedly made them susceptible to violent extremism.

China's crackdown has resulted in pervasive surveillance in Xinjiang as well as severe restrictions on religious practice. New regulations prohibit "abnormal" (long) beards and ban face coverings in public. The authorities closely monitor Uyghur social gatherings and install tracking devices on all vehicles. Forced sterilization and other coercive policies also caused a 60 percent decline in births in the Uyghur-majority regions of Khotan and Kashgar between 2015 and 2018. In August 2018 the corapporteur on China for the UN Committee on the Elimination of Racial Discrimination described XUAR as having become a "no-rights zone" where Uyghurs were persecuted for "nothing more than their ethno-religious identity."[25]

Notoriously, the government has also detained approximately one million ethnic Uyghurs (10 percent of the population) in reeducation camps and other "vocational training" or "de-extremification" facilities. There are reports that the government has also removed nearly half a million Uyghur children from their families, placing many in state-run boarding schools. While the government claims it is targeting extremists and terrorists, information from a leaked government database revealed that over three hundred Uyghur detainees in Karakax County were sent to the camps simply for participating in ordinary acts of religious devotion, such as fasting. Research also revealed that formerly detained Uyghurs were often working in factories under "conditions that strongly suggest forced labor." Human rights organizations have described these violations and abuses as potentially constituting crimes against humanity and genocide under international law.[26]

As part of this campaign, the authorities have also engaged in the widespread destruction of Uyghur cultural heritage. Using satellite imagery, researchers noted that of ninety-one significant Uyghur religious sites in XUAR that they examined, "31 mosques and two major shrines, including the Imam Asim complex and another site, suffered significant structural damage between 2016 and 2018. Of those, 15 mosques and both shrines appear to have been completely or almost completely razed. The rest of the damaged mosques had gatehouses, domes, and minarets removed."[27]

The Imam Asim shrine is a renowned pilgrimage site on the edge of the Taklamakan desert and is more than a thousand years old. The area is now under constant police surveillance and Uyghur pilgrims are discouraged from visiting. Another investigation claimed that the Sultanim cemetery in southwestern Khotan, which was also more than a thousand years old, had been "flattened" and part of the cemetery "appears to now be a parking lot."[28]

In 2012 an internationally renowned Uyghur scholar, Rahile Dawut, argued that without access to the Imam Asim and Jafari Sadiq shrines, the Uyghur people "would no

longer have a personal, cultural or spiritual history," and that after "a few years we would not have a memory of why we live here or where we belong." Dawut disappeared in 2017 and is now presumed to be in a detention facility. Since then, the campaign of destruction has only accelerated. One diaspora organization claims that satellite imagery and witness testimony indicate that possibly as many as ten thousand Uyghur cultural sites may have now been damaged or destroyed.[29]

Beyond Xinjiang, a process of cultural intervention is also underway in Linxia Hui Autonomous Prefecture, another Muslim-majority region in Gansu Province. Linxia is home to about 1.1 million Muslims, most of whom are ethnically Hui. It is now officially recommended that the roofs of all mosques in the region have clear "Chinese characteristics," such as upturned eaves. Domes and minarets that mimic Arabian or Turkish designs are actively discouraged. While the government's policies toward the Hui are not nearly as repressive as those against the Uyghurs, a number of Hui living in Xinjiang were also sent to the detention camps for "de-extremification."[30] The XUAR authorities have confirmed the destruction of some Uyghur cultural sites for allegedly violating building codes. However, the government's overall response to criticism of its policies regarding Uyghurs and other Turkic Muslims has been denial and obfuscation.[31]

Given its position as a veto-wielding permanent member of the UN Security Council, it was always going to be difficult for states to diplomatically confront China about its treatment of the Uyghurs. Certainly, no one has proposed military intervention. The counterterrorism narrative has also been extremely useful for Beijing, garnering diplomatic support from a number of states that have used similar arguments to justify their own human rights abuses. The importance of Chinese trade and fear of diplomatic reprisals have also inhibited action.

Perhaps this helps explain why so few Muslim-majority countries are prepared to publicly raise concerns despite increasing evidence of what may amount to genocide and crimes against humanity. For example, when asked about the situation in Xinjiang, Prince Mohammed bin Salman of Saudi Arabia defended China's right to "take anti-terrorism and de-extremism measures to safeguard national security." On the multilateral front, during July 2019 a group of twenty-two states sent a letter to the president of the UN Human Rights Council urging China to end the mass detention and persecution of the Uyghurs. In response, thirty-seven states sent a joint letter to the council's president defending China's policies. The signatories included a number of influential Muslim-majority countries which lauded China for "providing care to its Muslim citizens."[32]

Similarly, on 29 October 2019 the United Kingdom delivered a statement on behalf of twenty-three states at the Third Committee of the UN General Assembly, which oversees social, humanitarian, and cultural issues, urging China to respect freedom of religion and "allow the Office of the UN High Commissioner for Human Rights and UN Special Procedures immediate unfettered, meaningful access to Xinjiang." In response, fifty-four

states, including Pakistan, with the second-largest Muslim population in the world, commended "China's remarkable achievements in the field of human rights." The counterstatement was later proudly displayed on the website of China's permanent mission to the United Nations.[33]

Nevertheless, the Xinjiang issue has definitely had a detrimental impact on China's international reputation. It has also led to increased diplomatic pressure. On 26 June 2020, a group of fifty UN special procedure mandate holders—virtually all of the independent human rights experts with thematic or country-specific perspectives—called for the creation of a UN mechanism to monitor the grave human rights situation in Xinjiang. In early 2021 the parliaments of Canada and the Netherlands recognized that the scale and scope of Uyghur persecution may amount to genocide under international law. The Canadian, British, and US governments have also banned products from China that rely on supply chains which potentially exploit Uyghur forced labor. The two biggest Muslim organizations in Indonesia, the world's most populous Muslim country, have publicly called for an end to Uyghur persecution, and global awareness of the issue continues to grow.[34]

Bahram Sintash, a Uyghur diaspora activist whose father is in a detention camp, has argued that it is "clear that China's objective is to kill our identity. But if we can save our culture, China cannot win."[35] By continuing to insist that Beijing has a responsibility to protect all its diverse populations, civil society organizations and concerned governments can hopefully end the climate of impunity surrounding China's Uyghur policy.

Protecting People by Protecting Culture

It is possible to destroy immovable cultural heritage without committing atrocities against the surrounding population. Similarly, it is possible to commit atrocities against a population without desecrating or demolishing the objects, structures, and monuments that are central to their cultural continuity. However, throughout history there has often been a disturbing convergence between sustained attacks on cultural heritage and the attempted extermination of entire peoples. As the three brief cases above show, and as Irina Bokova repeatedly argued as head of UNESCO, in "today's new conflicts, those two dimensions cannot be separated." As a result, "there is no need to choose between saving lives and preserving cultural heritage: the two are inseparable."[36]

Such cultural cleansing can take many forms. The Taliban and ISIS blew up statues and temples, and systematically targeted and killed minority populations whose existence offended them. By contrast, China's ongoing persecution of the Uyghurs does not involve massacres: the campaign is perpetrated by mass detention and by slowly erasing their unique cultural heritage. But international efforts to constrain China reveal the limits of diplomacy. The world may have advanced legally and normatively since the destruction of the Bamiyan Buddhas in 2001, but it is still painfully

inconsistent when it comes to preventing and halting atrocity crimes, especially when they are perpetrated by a global superpower. If, on the other hand, cultural cleansing is perpetrated by a nonstate armed group or a rogue state then there is a better chance of a robust response. But states simply must get better at translating early warning into practical action, especially given that attacks on cultural heritage can provide a disturbing portent of future harm. Diplomatic responses and policy tools must be carefully calibrated to fit the unique circumstances of each case.

In some cases, as with the Bamiyan Buddhas in 2001, protecting particularly impressive cultural monuments may initially appear a more prudent option. For example, partly in response to ISIS's cultural cleansing across the Levant, in March 2017 the G7 group of the world's largest economies (minus China) agreed to create a new peacekeeping force to protect World Heritage Sites from plunder and destruction.[37] Although this noble initiative was lauded by many, military intervention should always be a measure of last resort. Supporters of the plan also need to ensure they inoculate themselves against the accusation that they are more determined to protect ancient statues than living people.

That, after all, was the whole point of Bokova's "cultural cleansing" argument. It was an impassioned plea for the protection of civilians to remain at the center of cultural heritage protection. And it was a reminder that by protecting humanity's cultural inheritance, we can also help protect populations who face the threat of the mass grave or the concentration camp today.

SUGGESTED READINGS

Simon Adams, *Mass Atrocities, the Responsibility to Protect and the Future of Human Rights: "If Not Now, When?"* (New York: Routledge, 2021).

Alex J. Bellamy and Edward C. Luck, *The Responsibility to Protect: From Promise to Practice* (Medford, MA: Polity Press, 2018).

Irina Bokova, "Culture on the Front Line of New Wars," *Brown Journal of World Affairs* 22, no. 1 (2015): 289–96.

Global Centre for the Responsibility to Protect, "Protecting Cultural Heritage," https://www.globalr2p .org/cultural-heritage/.

Edward C. Luck, *Cultural Genocide and the Protection of Cultural Heritage*, Occasional Papers in Cultural Heritage Policy no. 2 (Los Angeles: Getty Publications, 2018), https://www.getty.edu/ publications/occasional-papers-2/.

Nick Waters, "Are Historic Mosques in Xinjiang Being Destroyed?," Bellingcat, 5 April 2019, https:// www.bellingcat.com/news/rest-of-world/2019/04/05/are-historic-mosques-in-xinjiang-being -destroyed/.

NOTES

1. Its full name is the Convention on the Prevention and Punishment of the Crime of Genocide. See Donald Bloxham and A. Dirk Moses, eds., *The Oxford Handbook of Genocide Studies* (New York: Oxford University Press, 2010), 305; Donna-Lee Frieze, ed., *Totally Unofficial: The Autobiography of Raphael Lemkin* (New Haven, CT: Yale University Press, 2013), 172; and Edward C. Luck, *Cultural Genocide and the Protection of Cultural Heritage*, Occasional Papers in Cultural Heritage Policy no. 2 (Los Angeles: Getty Publications, 2018), 17–26, https://www.getty.edu/publications/occasional-papers-2/.

2. Ramesh Thakur, *Reviewing the Responsibility to Protect: Origins, Implementation and Controversies* (New York: Routledge, 2019), 5, 122; and UN, *2005 World Summit Outcome*, UN doc. A/RES/60/1, https://documents-dds-ny.un.org/doc/UNDOC/GEN/N05/487/60/PDF/N0548760.pdf.

3. Alex J. Bellamy and Edward C. Luck, *The Responsibility to Protect: From Promise to Practice* (Medford, MA: Polity Press, 2018), 32–36.

4. Global Centre for the Responsibility to Protect, "UN Security Council Resolutions and Presidential Statements Referencing R2P," 8 April 2021, https://www.globalr2p.org/resources/un-security-council-resolutions-and-presidential-statements-referencing-r2p/.

5. Francis Wade, *Myanmar's Enemy Within: Buddhist Violence and the Making of a Muslim "Other"* (London: Zed Books, 2017).

6. Fortify Rights, *They Gave Them Long Swords: Preparations for Genocide and Crimes against Humanity against Rohingya Muslims in Rakhine State, Myanmar* (Fortify Rights: July 2018), 156, https://www.fortifyrights.org/downloads/Fortify_Rights_Long_Swords_July_2018.pdf.

7. Author email correspondence with Matthew Smith, 14 April 2020; and Ronan Lee and José Antonio González Zarandona, "Heritage Destruction in Myanmar's Rakhine State: Legal and Illegal Iconoclasm," *International Journal of Heritage Studies* 26, no. 5 (2020): 519–38.

8. Christian Manhart, "UNESCO's Activities for the Safeguarding of Bamiyan," in *After the Destruction of Giant Buddha Statues in Bamiyan (Afghanistan) in 2001: UNESCO's Emergency Activity for the Recovering and Rehabilitation of Cliff and Niches*, ed. Claudio Margottini (Berlin: Springer-Verlag, 2014), 38.

9. *Irish Times*, "UN Condemns Destruction of Afghan Buddhas," 12 March 2001, https://www.irishtimes.com/news/un-condemns-destruction-of-afghan-buddhas-1.377208; and UN, "Daily Press Briefing by the Office of the Spokesman for the Secretary-General," 13 March 2001, https://www.un.org/press/en/2001/db031301.doc.htm. See also UNESCO, *Convention Concerning the Protection of the World Cultural and Natural Heritage*, Report of the UNESCO World Heritage Committee, 25th Session (Helsinki, 11–16 December 2001), doc. no. WHC-01/CONF.208/24, Paris, 8 February 2002, 8–13.

10. Human Rights Watch, "Afghanistan: The Massacre in Mazar I-Sharif," November 1998, https://www.hrw.org/legacy/reports98/afghan/Afrepor0.htm; Kenneth J. Cooper, "Taliban Massacre Based on Ethnicity," *Washington Post*, 28 November 1998; Justin Huggler, "UN Urged to Put Taliban Chiefs on Trial for 'Ethnic Cleansing,'" *Independent*, 1 December 2001; and Michael Sheridan, "How the Taliban Slaughters Thousands of People," *Sunday Times*, 1 November 1998.

11. Aryn Baker, "Should Buddhas Blasted by the Taliban Be Rebuilt?," *Time*, 26 June 2008; Paul Salopek, "Minority Afghans Tell Taliban Atrocities," *Chicago Tribune*, 26 November 2001; Brian Murphy, "Afghans Begin to Dig Up Taliban Atrocities," Associated Press (AP), 9 February 2002; and Rory Carroll, "Pits Reveal Evidence of Massacre by Taliban," *Guardian*, 7 April 2002.

12. Ahmad Shula, "Report: Afghanistan's Shia Hazara Suffer Latest Atrocity," *Human Rights Watch*, 13 October 2016; and Global Centre for the Responsibility to Protect, "Populations at Risk: Afghanistan," 15 May 2020, https://www.globalr2p.org/countries/afghanistan/.

13. Benjamin Isakhan and Jose Antonio Gonzalez Zarandona, "Erasing History: Why Islamic State Is Blowing Up Ancient Artefacts," *The Conversation*, 4 June 2017, http://theconversation.com/

erasing-history-why-islamic-state-is-blowing-up-ancient-artefacts-78667; and Laurence Bindner and Gabriel Poirot, *ISIS Financing: 2015* (Center for the Analysis of Terrorism: May 2016), 19–20, https://cat-int.org/wp-content/uploads/2016/06/ISIS-Financing-2015-Report.pdf.

14. Irina Bokova, "Culture on the Front Line of New Wars," *Brown Journal of World Affairs* 22, no. 1 (2015): 289; Hugh Eakin, "Use Force to Stop ISIS' Destruction of Art and History," *New York Times*, 3 April 2015; and Isakhan and Gonzalez Zarandona, "Erasing History."

15. Bokova, "Culture on the Front Line of New Wars," 289–90.

16. RASHID International, Endangered Archaeology in the Middle East and North Africa (Eamena), and Yazda, *Destroying the Soul of the Yazidis: Cultural Heritage Destruction during the Islamic State's Genocide against the Yazidis* (Munich: RASHID International, 2019), 20, 53.

17. UN Assistance Mission for Iraq (UNAMI) and Office of the High Commissioner for Human Rights (OHCHR), *Unearthing Atrocities: Mass Graves in Territory Formerly Controlled by ISIL* (UNAMI/OHCHR, 6 November 2018), 8, https://www.ohchr.org/Documents/Countries/IQ/UNAMI_Report_on_Mass_Graves4Nov2018_EN.pdf.

18. Independent International Commission of Inquiry on the Syrian Arab Republic, *"They Came to Destroy": ISIS Crimes against the Yazidis*, UN doc. A/HRC/32/CRP.2, 15 June 2016, 1, 20–31, https://www.ohchr.org/Documents/HRBodies/HRCouncil/CoISyria/A_HRC_32_CRP.2_en.pdf.

19. RASHID International, Eamena, and Yazda, *Destroying the Soul of the Yazidis*, 34–35; and Benjamin Isakhan and Sofya Shahab, "The Islamic State's Destruction of Yezidi Heritage: Responses, Resilience and Reconstruction after Genocide," *Journal of Social Archaeology* 20, no. 1 (2020): 12–14.

20. The White House (Office of the Press Secretary), "Statement by the President," 7 August 2014, https://www.whitehouse.gov/the-press-office/2014/08/07/statement-president; and UN News, "Northern Iraq: UN Rights Experts Urge Action to Avoid Mass Atrocity, Potential Genocide," 12 August 2014, https://news.un.org/en/story/2014/08/474982-northern-iraq-un-rights-experts-urge-action-avoid-mass-atrocity-potential.

21. *Economist*, "The Caliphate Cracks," 21 March 2015.

22. Jason Burke, "Rise and Fall of ISIS: Its Dream of a Caliphate Is Over, So What Now?," *Guardian*, 21 October 2017, https://www.theguardian.com/world/2017/oct/21/isis-caliphate-islamic-state-raqqa-iraq-islamist; and Seth G. Jones et al., *Rolling Back the Islamic State* (Santa Monica, CA: RAND Corporation, 2017), https://www.rand.org/pubs/research_reports/RR1912.html.

23. Lizzie Porter, "Why an Iran-Backed Paramilitary Group Has Rebuilt a Shrine in a Ruined Iraqi City," *Atlantic Council*, 19 August 2019, https://www.atlanticcouncil.org/blogs/iransource/why-an-iran-backed-paramilitary-group-has-rebuilt-a-shrine-in-a-ruined-iraqi-city/; Lauren Green, "Hungary Leading the Way in Helping Persecuted Christians," Fox News, 27 February 2020, https://www.foxnews.com/faith-values/hungary-leading-way-helping-persecuted-christians; UNESCO, "Revive the Spirit of Mosul," https://en.unesco.org/fieldoffice/baghdad/revivemosul; and RASHID International, Eamena, and Yazda, *Destroying the Soul of the Yazidis*, 19.

24. Austin Ramzy and Chris Buckley, "'Absolutely No Mercy': Leaked Files Expose How China Organized Mass Detentions of Muslims," *New York Times*, 16 November 2019.

25. OHCHR, "Committee on the Elimination of Racial Discrimination Reviews the Report of China," 13 August 2018, https://www.ohchr.org/EN/NewsEvents/Pages/DisplayNews.aspx?NewsID=23452&LangID=E; and AP, "China Cuts Uighur Births with IUDs, Abortion, Sterilization," 29 June 2020, https://apnews.com/article/269b3de1af34e17c1941a514f78d764c.

26. Dake King, "Leaked Data Shows China's Uighurs Detained Due to Religion," AP, 17 February 2020; Vicky Xiuzhong Xu, *Uyghurs for Sale: "Re-education," Forced Labour and Surveillance beyond Xinjiang* (Canberra: Australian Strategic Policy Institute, 2020), Policy Brief Report no. 26; and "Joint NGO Open Letter of Concern to Governments on Crimes against Humanity and Genocide against Uyghurs in China," 14 January 2021, https://www.globalr2p.org/publications/

joint-ngo-open-letter-of-concern-to-governments-on-crimes-against-humanity-and-genocide
-against-uyghurs-in-china/.

27. Lily Kuo, "Revealed: New Evidence of China's Mission to Raze the Mosques of Xinjiang,"
 Guardian, 6 May 2019, https://www.theguardian.com/world/2019/may/07/revealed-new-evidence
 -of-chinas-mission-to-raze-the-mosques-of-xinjiang; and Nick Waters, "Are Historic Mosques in
 Xinjiang Being Destroyed?," Bellingcat, 5 April 2019, https://www.bellingcat.com/news/rest-of
 -world/2019/04/05/are-historic-mosques-in-xinjiang-being-destroyed/.

28. Matt Rivers, "More than 100 Uyghur Graveyards Demolished by Chinese Authorities, Satellite
 Images Show," CNN, 2 January 2020, https://www.cnn.com/2020/01/02/asia/xinjiang-uyghur
 -graveyards-china-intl-hnk/index.html.

29. Chris Buckley and Austin Ramzy, "Star Scholar Disappears as Crackdown Engulfs Western
 China," *New York Times*, 10 August 2018; Asim Kashgarian, "US: China Targets Uighur Mosques
 to Eradicate Minority's Faith," VOA News, 1 December 2019, https://www.voanews.com/
 extremism-watch/us-china-targets-uighur-mosques-eradicate-minorits-faith; and Kuo,
 "Revealed: New Evidence of China's Mission."

30. *Economist*, "Out with the Arab-Style," 28 September 2019; Gerry Shih, "'Boiling Us Like Frogs':
 China's Clampdown on Muslims Creeps into the Heartland, Finds New Targets," *Washington
 Post*, 20 September 2019; and Gene A. Bunin, "Xinjiang's Hui Muslims Were Swept into Camps
 alongside Uighurs," *Foreign Policy*, 10 February 2020.

31. State Council Information Office of the People's Republic of China, *Historical Matters Concerning
 Xinjiang* (Beijing: Foreign Languages Press, July 2019), 20–24; and *The Fight against Terrorism
 and Extremism and Human Rights Protection in Xinjiang* (Beijing: Foreign Languages Press,
 March 2019).

32. Jane Perlez, "China Wants the World to Stay Silent on Muslim Camps. It's Succeeding," *New York
 Times*, 25 September 2019; and Mohammed bin Salman, "Saudi Crown Prince Defends China's
 Right to Fight 'Terrorism,'" Al-Jazeera, 23 February 2019, https://www.aljazeera.com/news/2019/
 02/saudi-crown-prince-defends-china-fight-terrorism-190223104647149.html.

33. *Middle East Monitor*, "Egypt Praises China's 'Remarkable Rights Achievements' Despite Uyghur
 Crackdown," 31 October 2019, https://www.middleeastmonitor.com/20191031-egypt-praises
 -chinas-remarkable-rights-achievements-despite-uyghur-crackdown/; and Permanent Mission of
 the People's Republic of China to the UN, "Belarus Made Joint Statement on Behalf of 54
 Countries in Firm Support of China's Counter-Terrorism and Deradicalization Measures in
 Xinjiang," 29 October 2019, http://chnun.chinamission.org.cn/eng/hyyfy/t1711896.htm.

34. BenarNews, "Indonesian Muslim Groups Urge China to Stop Violating Uyghur Rights," Radio
 Free Asia, 16 December 2019, https://www.rfa.org/english/news/uyghur/indonesia-china
 -12162019201026.html.

35. Bahram Sintash, "China Is Trying to Destroy Uighur Culture. We're Trying to Save It,"
 Washington Post, 18 March 2019.

36. Bokova, "Culture on the Front Line of New Wars," 294.

37. Reuters, "Italy Wins G7 Backing for UN Peacekeeping Force for Culture," 31 March 2017.

17

Choosing between Human Life and Cultural Heritage in War

Hugo Slim

One of the most devastating ways to hurt and erase a people in war is to destroy the places and artifacts that are most precious to them as a group. These may be sacred spaces where they meet to celebrate new life, pray together, experience transcendence, or bury their dead. They may be ancient market squares where families have traded with one another for centuries through good times and bad. They may also be works of architecture, art, and craft so beautiful that they exemplify the very best the community can achieve, heartfelt proof that as a people, past and present, they have reached moments that are truly sublime.

To lose these things is deeply tragic. To have them deliberately and sadistically destroyed in front of you is profoundly wounding to that part of us where we feel more as a group than as an individual: our collective sense of self. Such attacks feel like an attempt to eradicate our group's identity and joy, destroying who "we are." This kind of collective heritage destruction has been part of war since records began. Many forms of war have had the specific purpose of destroying a people or rendering them so humiliated and subjugated that they would cease to be a political threat.[1] A good way to do this is to destroy things precious to them.

Being human is about being a singular person and a community. "Life alone is only half a life," as Jonathan Sacks observed.[2] It is rare to find a person who feels complete and truly human without also feeling plural as part of a group, or sharing in an imagined community around them. This is why there are always two main ways to harm someone: by attacking them and their family, or by attacking what they love in the community to which they belong. Both hurt terribly.

Hard Battlefield Choices

If both life and heritage are important, then should soldiers prioritize human lives or beautiful buildings when they are faced with such a choice in a hard-fought battle?

Deliberate and premeditated destruction of cultural heritage in war for genocidal, ideological, or propagandistic reasons is ethically and legally wrong. This chapter does not debate such violations, which are immoral and catastrophic cultural vandalism. But deliberate ideological destruction is not the only situation in which cultural heritage is attacked and lost forever in war. The chapter focuses instead on hard choices that arise for civilians and combatants alike when a legitimate fight comes to areas rich in cultural heritage and it becomes impossible not to lose it in some way as the fight intensifies, as has recently been the case in the battles of Mosul in Iraq, Marawi in the Philippines, and many others.

In these conditions, soldiers and civilians may feel responsibility, and even guilt, for the loss of cultural heritage when they decide to flee to save their lives, abandoning it to likely destruction. Should they instead perhaps stay on and die alongside a heritage that is so important to them? Should they attempt to rescue or protect some of it somehow? Or are they right to flee and prioritize their lives? To let go of the heritage of many generations to save one generation inevitably engenders moral doubt in those who abandon what is precious because the human impulse to preserve runs as deep as the impulse to destroy.

For military forces, state or nonstate, hard battlefield choices arise because the protection of civilians, troops, and cultural heritage are all given importance in the ethics and laws of war. Military forces often encounter cultural heritage when fighting desperately to protect their own civilians, while also trying to limit the number of deaths among their own troops in the process. In defending their civilians from attack, should military forces be ready to accept the collateral destruction of some of their cultural heritage against attackers who do not care about this heritage and position their forces among it? Or should they limit their fire to protect their heritage and so invite greater fire upon their people and their own troops? Some defenders may feel the need to fight to the end in places which are most important to them, risking massive destruction in the process and dying with their heritage in an ultimately meaningful way. Would it be better to surrender to a vicious foe to avoid the destruction of their heritage?

Similarly, should attacking military forces inhibit their onslaught against a ruthless enemy because the latter's forces are held up within an area rich in cultural heritage in which they continue to impose harsh treatment and significant suffering on an occupied population? Is it better to save parts of a medieval town or release thousands of men from inhuman detention and women from forced marriage and sexual slavery? On some battlefields, attackers may feel a pressing military necessity to target combatants inside or around important cultural heritage and so destroy large parts of it. Instead, should they prolong the fight, extend people's suffering and risk more lives among their own troops as they carefully avoid damage to cultural heritage and delay victory?

In these situations, when soldiers are faced with saving people or a medieval temple, the ethics embedded in the laws of war, which say that human life and human culture

are equally valuable, are severely tested. And while both life and heritage are held to be valuable, the law itself gives no answer as to which should be given priority in the face of military necessity. A hard choice, therefore, has to be made between the preservation of human life and human culture. If we cannot save both, which shall we save?

With this choice in mind, I want to think beyond the ideal prescriptions of the laws of war, and their insistence that both human life and cultural heritage are ultimately important, to nonideal times when lawful or unlawful destruction of cultural heritage seems inevitable or is already underway. Considering this choice ethically may help to think it through in a way that helps guide fleeing civilians and military forces attacking or defending amid cultural heritage.

What follows examines two aspects of this hard choice between blood and bricks. In the first section the reasons cultural heritage matters are explored, and therefore why these are hard choices to make. after all, important buildings are not equivalent in survivalist terms to what the Geneva Conventions call "objects indispensable to the survival of the civilian population," such as water installations, food supplies, businesses, and arable land. This is because our humanity is so deeply vested in our cultural heritage that it has ontological and not just instrumental value. The second section looks at whether we should prioritize life or heritage. I argue that human life should always trump cultural heritage in extremis, even though it is always important to mitigate cultural losses in two ways: by letting some individuals stay with their cultural heritage if they wish; and by trying very hard to save some part of peoples' heritage during or after the fight, while primarily prioritizing human life.

Humanity Is Biology and Biography

The principle of humanity, which drives humanitarian norms and action, is a fundamental value in the laws of war that guides the conduct of armed conflict. The most widely recognized meaning of humanity in armed conflict, violence, and humanitarian action is the formal definition of the International Red Cross and Red Crescent Movement. This defines the principle of humanity as follows: "To prevent and alleviate human suffering wherever it may be found. Its purpose is to protect life and health and to ensure respect for the human being."[3] This Red Cross Red Crescent definition has been taken up by the United Nations and integrated into many of its policies and resolutions on armed conflict, disasters, and humanitarian action.[4] It is noticeable for identifying life, health, and being as the integral ingredients of humanity.

The laws of war, and the ethics implicit within them, place significant emphasis on the importance of protecting cultural heritage as well as human life. The way the laws are written seems to give human lives and cultural heritage ethical parity. A bomber pilot should avoid destroying both as much as she or he can. In emphasizing parity between life and culture, the law declares that cultural heritage is a vital part of human life, and that certain artifacts that we make with our hands and our machines are essential to being human.

Without our things of beauty, our cultural buildings, our homes, our books of learning, our ideals, our gods, our religious artifacts, our games, our clothes, our manners, and our art, we are biology deprived of biography, and so significantly less human or dehumanized. Being human is not simply a process of blood flow and breathing. It is also about being a particular person with a life of one's own that is lived with others in a shared sense of meaning and custom that are represented in things made around us and ideas believed between us.[5] These things we have in common and the individual lives we have made with them by living in certain houses, eating certain foods, being happy in certain places, and praying in beautiful buildings give us a sense of a biography that complements our breathing lungs and beating hearts.

How shall we explain this ontological and biographical value in cultural heritage? How is it that we feel our bricks and artifacts to be such a deep part of *being* human, running through us in the same way as our blood? There seem to be three main ways to explain this: arguments of dependence, identity, and universalism.

The first argument hinges on our *dependence* on cultural heritage in all its forms. Like the provision of healthcare, food, and water, the law insists that a group's cultural heritage is a valuable public good on which people depend to be fully human and socially alive. Our ability to meet together in sacred and significant places, or treasure certain artifacts made and handed down by ancestors, affirms our sense of being alive. This argument relies on the idea that being together and being part of some shared meaning are necessary for us as human beings. Sharing common space, mixing with familiar faces, and enjoying traditional music and arts are good for us. The shared bricks, stories, music, and textiles of our cultural heritage help us to be human. Without these things, we suffer. So the argument runs: as we depend on food and water for our physical health, we depend on human culture for much of our emotional and mental health. Culture is essential to our life and health, and protecting it shows a respect for the human being demanded by the principle of humanity.

The second argument goes deeper to focus on *identity*, on our profound identification with our cultural heritage. Our cultural assets do not just give us creative refreshment and social life as an emotional public good, they are woven into the very fabric of our particular identity as a human being. In some significant sense, we *are* our culture in a way that we are not food and water. Although each of us is biologically 60 percent water and we all need water to live, we do not actually live as water or identify as water. But in a more literal sense I am what I believe, and I am the group to which I belong and the things that I hold dear. I am a Muslim if I cherish my copy of the Quran as a sacred text and answer the call of the Muazzan from an ancient minaret. I am a Christian if I pray with others in a church in front of an altar with an ornate silver cross. I am a Gujarati woman if I weave and wear Gujarati textiles as my mother and grandmother taught me to do. I am a devout democrat if I treasure and respect the great libraries of Enlightenment thought and the secular parliament buildings where my national politics

is enacted. We are the things we treasure and believe because our identity is represented, nurtured, and confirmed in our places and our art.

Beyond the dependency claim of social refreshment and the essentialist claim of cultural identity, the ideology around cultural heritage goes further still in a third argument of *universalism*. Many champions of cultural heritage insist that culturally distinct works of human hands and the social meaning invested in them are valuable to the whole world, and not just the group that made them and uses them. This global added value in cultural heritage is in line with the maximal universalist ideology of humanity itself, which insists that every human life is important to us all and that one person's death diminishes everyone.[6]

The idea here is that whatever humans believe and make in any part of the world, and in any time in history, informs a universal ontology in all humans alive today and those who will come after us. Every civilization embodies some truth about human life and experience in its culture and so every culture informs us universally about who we are. This is why the destruction of synagogues across Europe, churches in Dresden, Buddha statues in Afghanistan, classical Greek and Roman ruins in Iraq and Syria, and mosques in Rakhine State, Myanmar, are deemed crimes against humanity. As human beings, the maximal humanity argument says that we have our particular identity as human beings but also a common meta-identity as human beings. This meta-identity can also be hurt and damaged by the destruction of cultural heritage, which, in a sense, belongs to us all as part of the richness of being human. This argument is analogous to the universal claim about the destruction of the environment, which is similarly understood as a particularly local public good as well as a universal one.

What about Bad Bricks and Evil Art?

These seem to be the three main arguments for why cultural heritage is a humanitarian matter and which produce the legal standard for protecting cultural heritage. Ethically, however, it is not this simple, and they all come with one major qualification: there is still a complication around what we should define as cultural heritage that is morally worthy of protection. Should anything which a group of humans assert as culture be protected in war? Or should we recognize that bad humans produce bad cultural heritage that does not merit protection in armed conflict? And, if we think there is an ethical boundary between good and bad human culture, how would we decide this border and reduce legal protection accordingly?

Not all cultural practices embodied in the spaces and artifacts of human culture are respectful of the principle of humanity. Cultural heritage can be used to produce ideologies and practices that are dehumanizing. These inhumane practices may be directed toward women if they are produced in patriarchal cultural sites, against young men if they are sites of induction into wanton violence, or against groups and nations defined in these sites as enemy others worthy of destruction.

There is significant moral ambiguity in cultural heritage, and we might not want to celebrate and protect it all as intrinsically humanizing. For example, would we feel it right if young men from the Hitler Youth or the Interahamwe in Rwanda had insisted that we respect their club houses and the flags and uniforms in which they were first schooled in ethnic nationalism and genocidal thinking, and so protect these sites from attack because they are key spaces of their culture and vital symbols of their particular human identity? Or, as another example, is everything good and worthy of protection in the sacred spaces in which male elites routinely discriminate against women or sexually abuse children? Cultural heritage cannot be simplistically championed as humanizing and good just because it is beautiful and old, or important to some people.

There is obviously good and bad cultural heritage. Most human spaces and many human artifacts embody the ambivalence of our humanity. Does this mean it is ethical to withdraw the protective rule from some forms of cultural heritage and even wipe them from the face of the earth? It seems clear that certain forms of cultural heritage property do not deserve protection from attack and the protective threshold in armed conflict can legitimately be reduced when fighting near or inside them. But their tragic value as human cultural history must still be recognized and a remnant of them should be protected where possible so that, ultimately, the people who were made to suffer in and by these spaces can help define the later ethics of these sites. Much cultural heritage around the world has value as bad sites. Places like the slave forts in Ghana or the death camp at Auschwitz in Poland are rightly preserved to function as remembrance and "dark tourism."[7]

Why Life Comes First

The arguments above constitute an ethical case for protecting cultural heritage, albeit one that is qualified by the humanizing or dehumanizing role played by cultural sites. This section looks at how we should deal with the apparent ethical parity between human life and cultural heritage—blood and bricks—that is presumed in international humanitarian law.

The law insists it is right to protect both human life and cultural heritage in the conduct of hostilities, but this may not be possible in certain instances of war and does not resolve which should take precedence. Even so, when the progress of a war throws up a choice between blood and bricks, it is clear that human life should trump cultural heritage as the more important object of protection. It is always better to save lives instead of buildings or paintings when both cannot be saved. There is one main reason for this, and it should always operate with three mitigating conditions or strategies (discussed in the next section).

The reason to prioritize human life is simple and can be made essentially and consequentially. Essentially, in any comparison between the value of a work of art and a human being, the human is in the great majority of cases inherently more valuable. Rushing into a burning building, a firefighter would not expect to hear his senior officer

cry: "Save the Rembrandt not the child." If he did hear such an order, we would all think him right to ignore it. To save the child seems reasonably and emotionally right. Failing to protect a Rembrandt would be a tragedy to some but failing to save the child in favor of a Rembrandt would be a crime.

If, however, a firefighter were rushing into a burning bunker in Berlin in 1945, we would understand if he were placed in more explicit moral confusion by the order: "Save the Rembrandt not Magda Goebbels." We might morally understand if he came out with the Rembrandt, but we might also think it wrong. Survivors of the Nazi regime and her own six children whom she had murdered had greater justice claims on Magda Goebbels than other people had cultural and aesthetic claims on the Rembrandt. The essential value of buildings and artwork is less than human life—good and bad. Their loss is great but to prioritize human life above them is not a crime. This is because, although cultural heritage is a part of us, the potential of our lives and the importance of our ethics mean more to us than a cultural heritage which we can carry within us anyway and realize anew in a different place.

This last point forms the basis of the consequentialist reason for prioritizing human life over cultural heritage. In the long run, it is better to have a remnant of a human community than it is to have the remains of buildings without people, or precious Qurans and icons without their owners and their prayers. If saved, human beings can create and build again. If dead, they cannot. In extremis, therefore, a life-saving ark filled with human life, which still carries culture and creativity within it, must always be prioritized over a cargo of artifacts or sites marked with buildings bereft of the humans who gave them meaning. Cultural heritage is irreplaceable, but it is renewable. Armenians who survived the Ottoman genocide against them have created new community and art. European Jews who escaped from Nazism have built new synagogues, consecrated new cemeteries, written new texts, and continued to raise Jewish children. Yezidis and Rwandans who have saved themselves or been rescued by others are doing the same. This is why people must always be allowed to flee and why defenders and attackers may sometimes be permitted to fight over and destroy cultural heritage if military necessity requires it.

Three Ways to Mitigate Cultural Loss

There are, however, three important qualifications that should be applied to mitigate the loss or destruction of cultural heritage which arises when a primary ethical commitment is made to protect human life over human heritage. These can be carried out by armed forces, humanitarian agencies, and communities themselves. The first is an obligation to discount the lives of enemy combatants who pose a direct threat to cultural heritage and, where possible, to use additional force against them to limit the damage they can do. The second is to respect the decision of some people to stay in a cultural site rather than to evacuate or flee. The third is an obligation to rescue and preserve some remnant from the loss.

The first mitigating strategy is for military forces to change their calculation of proportionate force in targeting enemy troops that are intent on, or very likely to, destroy cultural heritage. The enemy's willingness to violate this ethical and legal norm justifies a lessening of restraint and a significant increase in the use of force against them to limit cultural destruction. In such situations, more massive force seems reasonable against any part of the enemy's operation if this can undermine enemy capacity to destroy cultural heritage. Scaling up attacks against enemy units within cultural heritage sites creates the obvious dilemma of destroying what you seek to preserve, but there may well be other units, infrastructure, and supply lines on which these units depend which can be attacked more fiercely to disempower those in the sites themselves. Within the sites, it may well be justifiable to accept severe heritage damage in one place to reduce it in many others. Just as an adjustment of proportionality would be obligatory to stop enemy forces from deliberately targeting civilians or torturing thousands of detainees, so too would it be to stop them from destroying extensive cultural heritage.

The second kind of mitigation involves letting certain people stay on in cultural sites and not coercing their rescue or retreat. Identification with cultural heritage may be so intense in some people that they refuse to leave places, buildings, and artifacts behind. Such people are often cultural professionals of various kinds who feel a deep affinity with cultural objects and sites, and experience a deep obligation to remain. These people may be religious leaders, museum curators, or cultural devotees of different sorts. Their commitment to staying in these places may be for good reasons. Perhaps they want to stay so they can continue to carry out various rites demanded by the sites and seasons of a place, or to try to defend the sites with dialogue in a way that sees their heritage still honored under a new government. Finally, they may simply wish to die with the site and so accompany it into occupation or destruction in the same way that captains have conventionally felt a duty to go down with their sinking ship. Such consent to stay on, if it is informed consent, should be respected as a conscious commitment to live out one's identity and cultural heritage, which, for some people, can transcend the value of their life.

The third obligation to mitigate the tragedy of cultural destruction is to preserve something of the heritage immediately around the time of its damage and ultimately when peace makes some form of conservation possible. In the 1992 preface to his classic Holocaust text, *Man's Search for Meaning*, Viktor Frankl tells the story of how he visited his parents in Vienna in 1941 to tell them he had received a US visa and so could flee Nazism even though they could not. They were delighted for him, but he then records how he changed his mind:

> It was then I noticed a piece of marble lying on a table at home. When I asked my father about it, he explained that he had found it on the site where the National Socialists had burned down the largest Viennese synagogue. He had taken a piece

home because it was part of the tablets on which the Ten Commandments were inscribed. One gilded Hebrew letter was engraved on the piece; my father explained that the letter stood for one of the Commandments. I asked, "Which one is it?" He answered, "Honour thy father and thy mother that thy days may be long upon the land." At that moment I decided to stay with my father and mother upon the land, and to let the American visa lapse.[8]

This moment shows two important things that help make the case for salvaging and preserving whatever one can from the destruction of cultural heritage. First, it shows how people feel it is so vital to gather remnants of their cultural heritage destroyed in war, no matter how small and no matter the risks. It is a humanitarian act to rescue such remains after destruction and loss, just as it is a humanitarian duty to protect it in the first place in armed conflict.

Second, Frankl's story shows how such remnants point the way for survivors and enable cultural continuity and renewal: even small remains of cultural heritage work ontologically to remind us who we are. In this case, the fragment pointed Frankl to meet his religious obligation as a son by staying, not fleeing. As a result, Frankl, his parents, and his entire family were sent to death camps; only he and a sister survived. Even though the fragment is lost, it always remained with Frankl in his mind as a prompt of what is good and an explanation of the terrible path his choice involved. One can also imagine that if he had instead made the decision to take up his visa and leave for the United States, the fragment would have led him to establish some memorial to his parents in his new life, so renewing and remembering his cultural commitments in a new place, as he eventually does in the preface and his remarkable book.

Life as the Possibility of Cultural Renewal
This principle of potential cultural renewal is equally striking in the stories of two famously beautiful and culturally important European cities. One of the richest cultural sites in the world today was founded in the fifth century by thousands of internally displaced persons (IDPs) fleeing the Germanic invasions of northern Italy. Running from their invaders and their cultural heritage, they hid in marshlands bordering the Adriatic, where their conquerors decided not to follow. Here, they huddled together and, over many years, building on small islands and around lagoons, they slowly became a people of the sea. Their city is Venice.

Similarly, in England in the late twelfth century a group of scholars decided they could no longer tolerate the endemic urban violence and unlawful reprisals that plagued medieval Oxford: its murders, robbery, rape, and arbitrary hangings. They decided to flee, arguably displaced, carrying as many manuscripts as they could. Heading northeast, they settled by the River Cam and founded Cambridge University.

These two stories carry hope in the same way that all fleeing people carry hope and a deep identification with the cultural sites and spaces they have left behind. Millions of

people are fleeing war today and enduring exile in new places as IDPs and refugees (the latter defined as crossing an international border). It is deeply tragic that they have lost their ancient place in the world because of war and violence, and many have had their cultural heritage destroyed. But it is right that they have saved themselves so they can create new things, remember what was lost, and continue to be human.

SUGGESTED READINGS

Jonathan Cuénoud and Benjamin Charlier, "Cultural Heritage under Attack," *Humanitarian Law and Policy* (blog), ICRC, 18 February 2021, https://blogs.icrc.org/law-and-policy/2021/02/18/cultural-heritage-under-attack/.

Christiane Johannot-Gradis, "Protecting the Past for the Future: How Does Law Protect Tangible and Intangible Cultural Heritage in Armed Conflict?," *International Review of the Red Cross* 97, no. 900 (2016): 1253–75, https://international-review.icrc.org/articles/protecting-past-future-how-does-law-protect-tangible-and-intangible-cultural-heritage.

Joris D. Kila and James A. Zeidler, eds., *Cultural Heritage in the Crosshairs: Protecting Cultural Property during Conflict* (Boston: Brill, 2013).

Hugo Slim, *Humanitarian Ethics: The Morality of Aid in War and Disaster* (New York: Oxford University Press, 2015).

NOTES

1. Hugo Slim, *Killing Civilians: Method, Madness and Morality in War* (New York: Oxford University Press, 2008).
2. Jonathan Sacks, *To Heal a Fractured World: The Ethics of Responsibility* (London: Bloomsbury, 2005), 3.
3. International Federation of Red Cross and Red Crescent Societies, "The Seven Fundamental Principles," https://www.ifrc.org/fundamental-principles.
4. See UN General Assembly, "Strengthening of the Coordination of Humanitarian Emergency Assistance of the United Nations," UN doc. A/RES/46/182, 19 December 1991, Art. 2, and many subsequent resolutions by the UN Security Council.
5. Hugo Slim, *Humanitarian Ethics: A Guide to the Morality of Aid in War and Disaster* (New York: Oxford University Press, 2015), 46–49.
6. Bruce Mazlish, *The Idea of Humanity in a Global Era* (New York: Palgrave Macmillan, 2009).
7. Annette Becker, "Dark Tourism: The 'Heritagization' of Sites of Suffering with an Emphasis on Memorials of the Genocide Perpetrated against the Tutsi of Rwanda," *International Review of the Red Cross* 101, no. 910 (2019): 317–31.
8. Viktor Frankl, *Man's Search for Meaning* (London: Rider, 2004), 13. The book was originally published in 1946.

18

Saving Stones and Saving Lives: A Humanitarian Perspective on Protecting Cultural Heritage in War

Paul H. Wise

This chapter examines the relationship between saving people and saving the things they love. The humanitarian imperative to save lives in war is rooted in high ideals and a long history of nuanced, moral reasoning.[1] This imperative, however, must operate in real-world settings of extreme risk, purposeful killing, and unspeakable cruelty. Both saints and generals have pondered this stark juxtaposition and struggled to craft humane but pragmatic principles that permit war while attempting to constrain its barbarity. After the horrors of World War II, a global consensus emerged in what these principles should express and the practical strategies that should be implemented to achieve these humanitarian goals.[2] A global legal and normative infrastructure consisting of the Geneva Conventions, international humanitarian law more broadly, and principles of humanitarian practice was created to give operational form to these humanitarian intentions. This infrastructure has provided both legal legitimacy and practical guidance to an array of international agencies and nongovernmental organizations dedicated to humanitarian protection and service provision in areas of violent conflict.[3]

In settings of violent conflict, cultural heritage, when valued, becomes vulnerable to attack. As is true for the protection of people, the protection of cultural heritage has drawn upon a long history of moral argument and practical experience to advocate for strong international protections.[4] But mobilizing international action to protect cultural heritage—"saving stones"—has encountered greater ambivalence, and at times explicit resistance, than have humanitarian strategies directed at "saving people." In response, advocates for heritage protection have argued that the protection of cultural heritage is in fact inseparable from the protection of people and, further, that protecting cultural

heritage can result in saved lives.[5] In essence, this logic attempts to transform the protection of heritage from a cultural obligation into a humanitarian imperative.

At its core, the argument that the protection of heritage can save lives is an empirical proposition. Is it true, and if so, how and when? While there are important theoretical issues to consider, in the end the practical utility of advancing heritage protection on humanitarian grounds will depend on empirical evidence and pragmatic experiences in actual war settings. This chapter provides an overview of the nature and scope of this evidence and outlines a basic framework for understanding the mechanisms by which the destruction of cultural heritage can potentially shape humanitarian outcomes in different war settings. This overview is based on a preliminary examination of available reports and databases on heritage destruction together with those that document conflict-related casualties and political violence around the world. The primary task involves the integration of data and insights from disciplines that have not adequately sought collaboration or shared understanding. Consequently, this discussion represents an effort to construct a kind of disciplinary bridge that appreciates the beauty and value of cultural heritage while respecting the humanitarian metrics of lives ruined and lost.

Linking Cultural Heritage and Humanitarian Protections: The Empirical Challenge
One in four countries are currently involved in violent conflict, with some seventy million people forcibly displaced, more than at any time since World War II. Civilian populations are being targeted by relentless aerial bombardment as well as ruthless ground assaults by national militaries and a proliferating number of armed nonstate actors. Hospitals and health workers have been targeted, with almost two hundred killed and a thousand injured in the last year. An estimated eight hundred million people go hungry, the majority in countries wracked by violent conflict. Sixty percent of the population is affected by acute hunger in Yemen, a country that has been plagued by the worst cholera epidemic in recorded history. These figures sketch only the broad outlines of the current humanitarian challenge, a challenge addressed by two general, humanitarian strategies: protecting noncombatants from attack and responding with care and succor to the needs of noncombatants when protection fails.

The destruction of human life through *direct* exposure to combat operations, from injuries generated by bombs and bullets, has long been the dominant humanitarian concern. However, war also generates death and illness through the destruction of the essentials of human survival, including shelter, food, water, sanitation, and healthcare. These *indirect* effects of war have existed whenever and wherever wars have been fought. Indeed, estimates of mortality associated with recent violent conflicts have revealed that deaths resulting from indirect effects almost always dwarf deaths due to direct effects.[6]

Among the earliest protections for cultural objects in war were provisions in the Lieber Code, developed by the former soldier and international lawyer Francis Lieber for use by Union forces during the American Civil War.[7] A series of efforts to regulate

the conduct of war during the late nineteenth and early twentieth centuries included protections for a variety of valued cultural objects, including religious, charitable, and educational institutions, and historical monuments. However, these provisions were not justified on the basis of their relationship to saving lives. An explicit connection between heritage and humanitarian concerns was made by Raphael Lemkin, who first proposed the concept of "genocide." As early as 1933, Lemkin included the destruction of culture as one of the eight dimensions of genocide, with each component "targeting a different aspect of a group's existence."[8] After World War II, the global commitment to preventing genocide took legal form in the 1948 Convention on the Prevention and Punishment of the Crime of Genocide. However, while protections for cultural heritage were included at the drafting stage, they were ultimately rejected as formal provisions in the final convention. The reasons for the omission of cultural genocide as a criminalized act were complex but, in some measure, reflected the preoccupation with protecting lives and the dismissal of heritage's relevance to this objective. The protection of cultural heritage was also omitted in the 1949 Geneva Conventions, again largely because it was not deemed as serious as other violations related to human life. Subsequent international agreements, including the 1954 Hague Convention for the Protection of Cultural Property in the Event of Armed Conflict and the two 1977 Additional Protocols to the Geneva Conventions, explicitly provided for the protection of cultural heritage. While inconsistencies in their ratification and interpretation have somewhat undermined their effective implementation, it is significant that these agreements emphasize the universal value of cultural heritage and not any particular linkage to attacks on people.

More recently, the connection between humanitarian and cultural protections has been vigorously argued as a basis for "the adaptation of humanitarian norms and tools for heritage," including the potential use of force as embodied in the responsibility to protect protocols adopted by the United Nations in 2005.[9] These arguments have been resisted on the basis that this strategy would equate heritage with lives, and potentially put soldiers in harm's way to protect "things." More broadly, arguments for the application of humanitarian protections to heritage have utilized a complex mix of empirical study and metaphor, such as the adoption of "cultural cleansing" as a heritage counterpart to the crime of ethnic cleansing.[10]

The assertion that the destruction of cultural heritage can deepen the pain inflicted on a community undergoing violent attack is undeniable. However, arguments that justify more aggressive protections for cultural heritage have attempted to evade the "equating lives and things" refutation by contending that heritage protections will in fact save lives. There is much at stake if this contention is true, as it could help justify a cascade of aggressive heritage protections, including the use of force.

Mapping the Connection between Humanitarian and Heritage Protection
The complexity of the relationship between humanitarian and heritage protections may be best explored by examining the strategic and tactical utility of heritage destruction,

how combatants employ "patterns of violence" in their struggle for power. This approach treats the destruction of cultural heritage within a broader security context, a perspective that recognizes the role of such destruction within an array, or "repertoire," of violent strategies and tactics.[11]

Prelude

On 9 November 1938, senior elements of the Nazi government unleashed a flood of violent attacks against what remained of Jewish life in Germany. Over the next forty-eight hours, members of the Nazi *Sturmabteilung* (stormtrooper) paramilitary group and their police and civilian allies looted and destroyed more than one thousand synagogues and countless Jewish-owned shops in cities and towns across the country. This series of attacks, which came to be known as Kristallnacht, or the "Night of Broken Glass," was portrayed by Adolf Hitler's government as a spontaneous outburst of resentment by the German people but was in reality a well-organized campaign designed to not only destroy but also desecrate cultural objects and architecture held dear by Jews throughout Germany.[12]

While Kristallnacht was in itself a calamitous assault on a vulnerable community, its enduring presence in the deliberation of heritage and war is related to its foreshadowing of the Holocaust. Indeed, Kristallnacht has been characterized as a rehearsal or at least a *prelude* to the Nazi extermination campaign against European Jewry, the "Final Solution" to be formally articulated at the Wannsee Conference in suburban Berlin in January 1942.[13] In this manner, Kristallnacht has become the archetypal example of the predictive power of heritage destruction to foretell future violent assaults on specific communities of people. The portrayal of heritage destruction as a precursive indicator is perhaps best captured in the words of the German poet and writer Heinrich Heine (1797–1856): "Where they have burned books, they will end in burning human beings."[14] Edward Luck underscored the importance of this relationship and turned explicitly to Raphael Lemkin, who shaped the modern understanding of genocide, as stating "physical and biological genocide are always preceded by cultural genocide or by an attack on the symbols of the group or by violent interference with religious or cultural activities."[15]

The case that destroyed heritage serves as a critical prelude to destroyed people is, after all, an empirical argument, a proposition that has, somewhat surprisingly, received scant empirical analysis. While the Heine quote is often invoked as a definitive truth, it originates not from a careful historical analysis but from his play *Almansor*, the line uttered by a Muslim character lamenting Christian Spain's burning of the Quran.[16]

There are actually three empirical questions embedded in the prelude humanitarian argument.[17] First, the basic issue is whether the destruction of cultural heritage is in fact followed by attacks on people. This is the predictive value of the relationship. It is based on whether a destructive heritage event during some semblance of peace is indeed followed by large-scale, violent attacks on people. Prelude implies that violent

attacks were not occurring simultaneously, or in parallel, with the destruction of heritage. Therefore, this predictive value can be considered as the portion of heritage destruction events that are in fact associated with subsequent violent attacks on people sometime in the future.

A preliminary analysis of available heritage destruction and conflict datasets suggests that prelude appears to be a relatively rare phenomenon. It should be noted that Kristallnacht, while an oft-cited example of prelude, did in fact include violent attacks on people. At least ninety-one Jews were killed, thousands beaten, and thirty thousand people were arrested and transported to concentration camps. Its characterization as prelude, however, rests on the catastrophic scale of violence and death that was to be unleashed over the following six and a half years. Interestingly, no one was prosecuted specifically for their role in perpetrating the violence of Kristallnacht [18]

Second, it is not clear the extent to which attacks on people are commonly foreshadowed by attacks on heritage. This is the converse of the predictive argument as it relates to the attributable capability of the relationship, the portion of all attacks on people that are foreshadowed by attacks on heritage. This shifted conditional perspective is important for humanitarians. If the prelude relationship were quite rare among the dozens of current conflicts around the world, the arguments for heritage protection on humanitarian grounds would be weakened. In other words, the prelude linkage by itself may account for such a small portion of all the attacks on people that prelude is rendered a somewhat peripheral humanitarian issue. It should be noted in this context that none of the most prominent quantitative efforts to predict violent atrocities include the previous destruction of cultural heritage as a meaningful element in their models.

Third, it also is unclear whether protecting heritage in conflict would result in a substantially reduced risk to people. This is the preventive, as opposed to the predictive, capability of the prelude argument, which faces a challenging empirical requirement as it implies that the destruction of cultural heritage contributes causally rather than serving only as an indicator of subsequent attacks on people. It also suggests that even if the linkage is causal, it must be sufficiently causal to reduce attacks on people if interrupted. More fundamentally, it is a difficult proposition to prove as the counterfactual (for example would the Holocaust have not occurred if Kristallnacht had been prevented) is not amenable to empirical analysis.

Provocation

Cultural heritage can be attacked as a way to provoke violence against people. Both intended and unintended (collateral) damage to an important cultural object may result in violent opposition to the party responsible for the attack. Standard counterinsurgency doctrine recognizes this relationship and cautions against the use of force in proximity to important cultural objects. Heritage can also be attacked to

undermine the legitimacy of a government or other party claiming jurisdiction over the cultural objects or site. These attacks can also be used to intensify tensions between political or ethnic groups and generate retributive violence in an effort to instigate civil discord and even civil war. The 2006 attack on the al-Askari Mosque in Samarra, Iraq, a revered Shia shrine, was likely carried out by al-Qaeda in Iraq or another radical Sunni group in order to incite a cycle of violence.[19] Indeed, the attack was immediately followed by days of retributive violence against Sunni communities and mosques. One source reported that 168 Sunni mosques were attacked, and ten Sunni imams were killed in the forty-eight hours after the al-Askari bombing. Over the next two weeks, sectarian violence flared dramatically across the country, deepening political divisions and undermining the central government's ability to govern. Similarly, in 1992, Hindu nationalists demolished the Babri Masjid mosque in Ayodhya, Uttar Pradesh, India, an attack that appeared to be designed to intensify sectarian tensions and was in fact followed by weeks of intercommunal violence.[20]

Parallelism

Heritage destruction as prelude is far less common than heritage destruction occurring simultaneously or in *parallel* with assaults on people. The following provide a brief sample of the hundreds of instances of the deliberate destruction of heritage during active attacks on people. The Stari Most (Old Bridge), which stood over the Neretva River in the Bosnian city of Mostar for 427 years, was targeted and destroyed by Croat paramilitary forces in 1993.[21] The Great Umayyad Mosque of Aleppo, dating back to the eighth century and the purported resting place of Zechariah, the father of John the Baptist, was seriously damaged during fighting between Syrian government forces and rebel groups in 2013. Although responsibility for the destruction remains contested, there is substantial evidence that the mosque's towering minaret was demolished deliberately during the government's assault on the city. And the Great Mosque of al-Nuri, famous for its leaning minaret, was destroyed intentionally during the Battle of Mosul, Iraq in 2017, one of the largest urban battles since Stalingrad.

These parallel assaults often occur as part of sieges, such as in Mostar or Sarajevo, where sites of cultural importance were targeted to undermine the will of city inhabitants to resist. In other settings the destruction of cultural heritage can occur after a belligerent party has recently captured territory previously held by a victimized ethnic group. Some of the most notorious attacks conducted by the Islamic State of Iraq and Syria (ISIS, also known as ISIL or Da'esh) on heritage sites in Iraq and Syria, including in Mosul and Palmyra, occurred soon after it seized control, but not in the midst of active combat. There was nothing precursive or foreshadowing about these events; they were merely one component of the ISIS portfolio of violence, propaganda, and social control.[22]

Even in the context of explicit genocidal or ethnic cleansing strategies, the linkage of heritage destruction and attacks on people is most commonly parallel in nature. In 2014,

ISIS drove government security forces from much of northern Iraq, including Sinjar, the traditional home of the Yezidi minority. Almost immediately, thousands of Yezidis were killed while tens of thousands fled, many seeking refuge on the upper plateau of Mount Sinjar. Without adequate shelter, food, or water, hundreds of Yezidis would perish before humanitarian provisions were airdropped and a supply corridor opened by Kurdish Peshmerga forces. As the attacks on Yezidi villages progressed, ISIS purposefully destroyed at least twenty-six holy sites, including the shrines of Sheikh Hassan, Malak Fakhraddin, and Sheikh Abdul Qader.[23] In one instance, ISIS killed fourteen Yezidi elders inside the shrine of Sheikh Mand in the foothills of Mount Sinjar and then demolished the shrine, burying the remains of the elders in the rubble. A recent review of the destruction of Rohingya communities and heritage in Myanmar's Rakhine State concluded that these attacks were also largely parallel in nature.[24]

During the ethnic cleansing campaigns of the Bosnian War (1992–95), Serb forces and paramilitaries committed grievous violence against Bosnian Muslims and Croats, including the killing of civilians, rape, torture, and the destruction of civilian, public, and cultural property.[25] However, most of the destruction of Bosniak mosques and other heritage sites occurred in areas that had recently come under Serb control but were somewhat distant from the frontlines. These attacks against heritage were not prelude but rather a component of ongoing Serb efforts to eradicate Bosniak communities and erase any trace of their historical presence.[26] Again, as was the case for much of the heritage destruction in Iraq and Syria, the linkage between heritage destruction and humanitarian atrocity in Bosnia was profound but was not based on any precursive association. Rather, it was due to a simultaneous onslaught targeting both a people and their culture.

Protraction

A community's vulnerability to conflict is shaped not only by the intensity of the violence but also how long it lasts. Some of the deadliest wars in human history have been those that have been prolonged over many years. This has been primarily due to indirect effects, resulting from the destruction of the essentials of life, including shelter, food, healthcare, and the unraveling of community-based social protections.

Wars require financing. Prolonged conflict will extend the need for resources and therefore the threat to any objects with monetary value. Consequently, the protection of valuable cultural objects could reduce the resource base of warring parties, which, in turn, could reduce the threat to people. Luck labeled this protective stance the "counterterrorism" lens for heritage protection.[27] However, this concern extends beyond counterterrorism: both state militaries and armed nonstate actors engage heavily in a range of these illicit economies and benefit substantially from prolonged conflict.[28] Indeed, in many conflicts, greed becomes a more important motivation than political grievance. In these circumstances, the effective protection of heritage could be

a meaningful way to diminish the incentives for continued fighting, thereby resulting in a reduced threat to people and their way of life.

Propaganda

The destruction of cultural heritage can target norms as well as communities of people. Humanitarian protections have depended on an infrastructure of international norms and legal frameworks that were largely constructed after World War II and backed by Western power.[29] While attacks on cultural heritage have most often targeted specific ethnicities or other selected groups, some can be directed at the broad global conventions and institutions that support this humanitarian infrastructure. These types of attacks are directed at a global audience and are usually staged as a kind of perverse political theater. They often exploit new forms of dissemination technologies, including social media.[30] The intentional destruction of the two monumental Buddha statues at Bamiyan, Afghanistan, in 2001, while part of a larger Taliban campaign of heritage destruction, was videotaped and displayed globally. The destruction of heritage sites in Palmyra by ISIS was purposefully portrayed in social media over several months in 2015.[31]

These highly public acts of "symbolic terrorism" or "iconoclastic" propaganda are generally strategic in nature and intended to breach long-held international humanitarian norms. These norms have been essential to the construction of a global framework for protecting noncombatants since World War II, rooted in an array of legal conventions and multilateral institutions.[32] The implementation of international humanitarian law and the safe provision of humanitarian services in areas of conflict have relied on these norms and collective global order, and any assault on them can undermine essential protections for populations under threat.

Universalist arguments for protecting major sites of cultural heritage have turned on heritage's "intrinsic value and importance to humanity" and not on any alleged relationship to lost lives. But it is precisely the universal value attached to specific cultural heritage sites that makes them attractive targets for spectacular, public destruction. A hunger for antinormative statements can, therefore, make inseparable the destruction of cultural heritage inseparable from that of people. The relationship is not one of prelude, provocation, or protraction but one of propaganda. The greater the universal value of the targeted heritage, the greater its value in the language of iconoclastic challenge—a challenge to international norms essential to the protection of both heritage and lives.

Implications

This discussion does not question the value of cultural heritage nor the importance of protecting it in war. Indeed, the destruction of cultural heritage warrants condemnation regardless of its ultimate linkage to violent attacks on people. This discussion's focus on the utility of greater empirical evidence is also not blind to the profound human cost of

cultural loss nor morally agnostic to its intentional destruction. Rather, the discussion merely demands more from the argument that cultural heritage should be protected on humanitarian grounds. The justifications for protecting such heritage from violence are varied and have evolved over time. Of concern here is only one of these justifications: that protecting cultural heritage will result in saved human lives. This is fundamentally a humanitarian argument, which, to date, has been based on the interpretation of history, the detailed analysis of selected case studies, and the construction of a humane logic. However, this chapter has underscored the complexity of this humanitarian argument and the urgent need to provide greater empirical insight into its nature and mechanisms of action.

The relationship between the destruction of cultural heritage and the destruction of people is as complex as is the meaning of culture and the tragedy of violent death. Consequently, this relationship can take different forms, a heterogeneity that deserves greater respect in crafting humanitarian justifications for aggressive heritage protection. Heritage destruction as prelude has served as the archetypal motif for protective advocacy and under certain circumstances could provide a potential opportunity to prevent subsequent attacks on people. However, prelude appears to be a relatively rare phenomenon and while always an important concern, does not appear to be an appropriate basis for a broad, general policy of enhanced heritage protection.

Provocation attacks on cultural heritage can also provide humanitarian grounds for protecting heritage sites and objects. These kinds of attacks are explicitly intended to generate violence against targeted communities, and therefore should provoke strong preventive action in certain security settings. The precise nature of these settings warrants urgent, empirical examination, however, as not all or even most conflict environments provide the conditions for meaningful preventive intervention based on provocation concerns. Nevertheless, in conflict situations characterized by sharp ethnic or sectarian divisions, heritage sites strongly affiliated with one of the groups could be particularly vulnerable to attack. Under such conditions, strong heritage protections could diminish the risk for provocative attacks, which, consequently, could save lives.

It appears that the most common risk to cultural heritage in war is the simultaneous, parallel assault on people and their culture, but here again there can be some diversity in how this parallel character can play out. In some settings, such as urban sieges, heritage sites can be targeted for their cultural significance while surrounding residential neighborhoods are being bombarded. Heritage sites that fall within recently captured territory can also be extremely vulnerable even if simultaneous attacks on people are occurring some distance away. This parallel pattern of assault tends to characterize the linkage of ethnic and cultural cleansing. The intent is not just the forced dispossession of territory through killing and intimidation, but the erasure of any vestige of presence through the systematic destruction of beloved heritage and cultural identity.[33] Parallel patterns of assault can also make difficult the attribution of responsibility, much less intent, of attacks on cultural heritage. In addition, arguments

for the active protection of heritage, particularly involving the use of force, should take note of the central importance of parallel threats, as they do not easily justify a specific focus on heritage protection for humanitarian protection. Rather, parallelism recognizes that the threat to heritage is commonly intertwined with the threat to people, a reality that underscores the pragmatic linkage of heritage protection to international humanitarian law and intervention protocols directed at saving people. This linked posture conforms to some moral arguments as well as providing a basis for a common protective framework and advocacy.[34]

Human health is not only defined by biology but also by social engagement. Indeed, assaults on the fabric of social life and the perception of injustice can affect both physical and mental health. This recognition calls into question the traditional tendency to confine the humanitarian relevance of heritage destruction to direct, violent attacks on people. Rather, it suggests that the destruction of cultural heritage, if this heritage is truly valued enough, could have indirect effects expressed in patterns of human health and disease. In fact, the relationship between social engagement and health outcomes has been one of the most active arenas of recent medical research. Issues of identity, stress, and social networks have been linked to a variety of medical conditions, including mental health, chronic diseases such as diabetes and high blood pressure, and adverse health behaviors and addictions. Humiliation has long been recognized by both psychologists and political scientists as a powerful driver of mental health as well as of rebellion.[35] Dignity has evolved from a largely religious or philosophical concept to what has become a central social and political process that defines both human rights and human health.[36] Resilience, while traditionally defined by individual health and personality characteristics, has more recently been tied to social relations and community-based engagement.[37] This growing body of evidence has documented the complex processes by which physical health is influenced by a person's sense of belonging, being part of a defined community, and the practical ability to participate in community activities and rituals. Community engagement does not only convey meaning to one's life, it can also alter the physiology and ultimately the length of one's life.

The recognition that the destruction of cultural heritage can alter the social determinants of health blurs some traditional distinctions that have been employed to assess the legitimacy of heritage protection. In their cogent, moral dissection of arguments advocating the use of force to protect cultural heritage, Helen Frowe and Derek Matravers distinguish between extrinsic and intrinsic justifications for defending cultural heritage.[38] Extrinsic arguments are based on protecting heritage for some instrumental purpose, such as saving lives. Intrinsic justifications hold that heritage should be protected because of its essential value to people and community life regardless of any subsequent effects. While helpful in distinguishing different moral characteristics, this dichotomy is blurred if one recognizes that these "intrinsic" elements can be expressed extrinsically as human illness and preventable death. This

epidemiology underscores the importance of protecting cultural heritage on humanitarian grounds, as both extrinsic and intrinsic justifications become instrumental in nature. What distinguishes them pragmatically are the nature and timing of their impact, what humanitarians label the direct and indirect effects of conflict, both of which are ultimately articulated in human health and well-being.

There is an urgent need to strengthen the justifications for heritage protection through purposeful empirical analysis, a mandate that requires both new analytic strategies and new kinds of data. At its most basic level, an understanding of the linkage between heritage destruction and the health of people entails the documentation of a temporal relationship—namely, how the two phenomena are situated in time. It also requires an understanding of a spatial relationship—how the phenomena are related geographically. This implies a commitment to seek data regarding not only violent assault and homicide but also on the full spectrum of outcomes, including morbidity and mortality from nonviolent causes.

These considerations must be addressed by sufficiently comprehensive datasets or combinations of datasets to permit intensely cross-disciplinary analysis. There exist datasets with information on the destruction of cultural heritage in certain conflict areas, as well as ones that track violent assaults on groups of people. The task is to technically integrate them in a manner that respects the distinct disciplinary assumptions and variable limitations that always shape empirical data collection. At a more fundamental level, this task requires intense transdisciplinary engagement, a requirement that has never come easily to the examination of cultural heritage protections in war.

Any empirical analysis of the relationship between the destruction of cultural heritage and war's effects on people must overcome the long-standing disciplinary boundaries between those who study heritage and those who study humanitarian effects. This implies an integrative task that requires the development of a community of collaborators from diverse fields, a community committed to crafting new, shared methodologies and a common, creole, analytic language. This integrative challenge will also require the engagement of those responsible for the pragmatic implementation of both heritage and humanitarian protections in real conflict environments.

The primary conclusion of this discussion is that the humanitarian justifications for protecting cultural heritage in war are real but complicated. Some complications can alter the legitimacy of humanitarian claims for heritage protection in areas of violent conflict. Consequently, traditional advocacy for heritage protection must evolve in two ways. First, far greater empirical detail is needed to identify under what political and security conditions heritage protection would actually reduce humanitarian need. This analytic challenge will not easily be met by a traditional reliance on heritage expertise alone. Rather, it will require new forms of transdisciplinary collaboration involving security, political, health, and humanitarian disciplines. Second, a strong transdisciplinary approach would also lay a more coherent foundation for engaging the

heritage protection and humanitarian communities in a unified public advocacy dedicated to saving both stones and lives.

SUGGESTED READINGS

Michael Barnett, *Empire of Humanity: A History of Humanitarianism* (Ithaca, NY: Cornell University Press, 2011).

Drew Gilpin Faust, *This Republic of Suffering: Death and the American Civil War* (New York: Vintage, 2008).

Christopher Merrill, *The Old Bridge: The Third Balkan War and the Age of the Refugee* (Minneapolis: Milkweed Editions, 1995).

Philippe Sands, *East West Street: On the Origins of Genocide and Crimes against Humanity* (New York: Knopf, 2018).

Hugo Slim, *Humanitarian Ethics* (Oxford: Oxford University Press, 2015).

NOTES

1. Michael Barnett, *Empire of Humanity: A History of Humanitarianism* (Ithaca, NY: Cornell University Press, 2011).
2. Jean Pictet, "The Fundamental Principles of the Red Cross: Commentary," International Committee of the Red Cross, 1 January 1979, https://www.icrc.org/en/doc/resources/documents/misc/fundamental-principles-commentary-010179.htm.
3. Hugo Slim, *Humanitarian Ethics* (Oxford: Oxford University Press, 2015).
4. Johan Brosché et al., "Heritage under Attack: Motives for Targeting Cultural Property during Armed Conflict," *International Journal of Heritage Studies* 23, no. 3 (2016): 1–12.
5. Thomas G. Weiss and Nina Connelly, "Protecting Cultural Heritage in War Zones," *Third World Quarterly* 40, no. 1 (2019): 1–17.
6. Paul H. Wise, "The Epidemiologic Challenge to the Conduct of Just War: Confronting Indirect Civilian Casualties of War," *Daedalus* 146, no. 1 (2017): 139–54.
7. Francis Lieber, Instructions for the Government of Armies of the United States in the Field, General Orders No. 100, Adjutant General's Office, 24 April 1863. For text, see Yale Law School, "General Orders No. 100: The Lieber Code," The Avalon Project, https://avalon.law.yale.edu/19th_century/lieber.asp.
8. Patty Gerstenblith, "The Destruction of Cultural Heritage: A Crime against Property or a Crime against People?," *John Marshall Review of Intellectual Property Law* 15, no. 3 (2016): 337–89.
9. Weiss and Connelly, "Protecting Cultural Heritage in War Zones," 2; and James Cuno and Thomas G. Weiss, eds., *Cultural Heritage under Siege: Laying the Foundation for a Legal and Political Framework to Protect Cultural Heritage at Risk in Zones of Armed Conflict*, Occasional Papers in Cultural Heritage Policy no. 4 (Los Angeles: Getty Publications, 2020), https://www.getty.edu/publications/occasional-papers-4/.
10. Irina Bokova, "Culture on the Front Line of New Wars," *Brown Journal of World Affairs* 22, no. 1 (2015): 289.
11. Francisco Gutiérrez-Sanín and Elisabeth Jean Wood, "What Should We Mean by 'Pattern of Political Violence'? Repertoire, Targeting, Frequency, and Technique," *Perspectives on Politics* 15, no. 1 (2017): 20–41.
12. Martin Gilbert, *Kristallnacht: Prelude to Destruction* (New York: HarperCollins, 2006).

13. Robert Bevan, *The Destruction of Memory: Architecture at War*, 2nd ed. (London: Reaktion, 2016).

14. Heinrich Heine, *Almansor: Eine Tragödie* (Berlin: Hofenberg, 2015).

15. Edward C. Luck, *Cultural Genocide and the Protection of Cultural Heritage*, Occasional Papers in Cultural Heritage Policy no. 2 (Los Angeles: Getty Publications, 2018), https://www.getty.edu/publications/occasional-papers-2/.

16. Stephen J. Whitfield, "Where They Burn Books . . . ," *Modern Judaism* 22, no. 3 (2002): 213–33.

17. Helen Frowe and Derek Matravers, *Conflict and Cultural Heritage: A Moral Analysis of the Challenges of Heritage Protection*, Occasional Papers in Cultural Heritage Policy no. 3 (Los Angeles: Getty Publications, 2019), https://www.getty.edu/publications/occasional-papers-3/.

18. Daniel Siemens, *Stormtroopers: A New History of Hitler's Brownshirts* (New Haven, CT: Yale University Press, 2017).

19. Benjamin Isakhan, "Heritage Destruction and Spikes in Violence: The Case of Iraq," in *Cultural Heritage in the Crosshairs*, ed. Joris D. Kila and James A. Zeidler (Boston: Brill, 2013).

20. Amaria Atta et al., "Is Bharat (India) a Secular or a Religious State?," *Journal of the Research Society of Pakistan* 56, no. 2 (2019): 353–61.

21. Christopher Merrill, *The Old Bridge: The Third Balkan War and the Age of the Refugee* (Minneapolis: Milkweed Editions, 1995); and Helen Walasek, *Bosnia and the Destruction of Cultural Heritage* (Oxford: Routledge, 2018).

22. Matthew Clapperton, David Martin Jones, and M. L. R. Smith, "Iconoclasm and Strategic Thought: Islamic State and Cultural Heritage in Iraq and Syria," *International Affairs* 93, no. 5 (2017): 1205–31.

23. Benjamin Isakhan and Sofya Shahab, "The Islamic State's Destruction of Yezidi Heritage: Responses, Resilience and Reconstruction after Genocide," *Journal of Social Archaeology* 20, no. 1 (2020): 3–25.

24. Ronan Lee and José Antonio González Zarandona, "Heritage Destruction in Myanmar's Rakhine State: Legal and Illegal Iconoclasm," *International Journal of Heritage Studies* 26, no. 5 (2020): 519–38.

25. Merrill, *The Old Bridge*; and Adam Lindhagen, "War on Memory: International Law and the Destruction of Cultural Property in Armed Conflict 1979–2018," master's thesis, University of Oslo, 2018, https://www.duo.uio.no/handle/10852/64519.

26. UN Security Council, Final Report of the Commission of Experts Established Pursuant to Security Council Resolution 780 (1992), UN doc. S/1994/674, 27 May 1994.

27. Luck, *Cultural Genocide and the Protection of Cultural Heritage*.

28. Vanda Felbab-Brown, Harold Trinkunas, and Shadi Hamid, *Militants, Criminals, and Warlords* (Washington, DC: Brookings, 2018).

29. Barnett, *Empire of Humanity*.

30. José Antonio González Zarandona, César Albarrán-Torres, and Benjamin Isakhan, "Digitally Mediated Iconoclasm: The Islamic State and the War on Cultural Heritage," *International Journal of Heritage Studies* 24, no. 6 (2018): 649–71.

31. Claire Smith et al., "The Islamic State's Symbolic War: Da'esh's Socially Mediated Terrorism as a Threat to Cultural Heritage," *Journal of Social Archaeology* 16, no. 2 (2016): 164–88.

32. Timothy William Waters, "The Persecution of Stones: War Crimes, Law's Autonomy and the Co-optation of Cultural Heritage," *Chicago Journal of International Law* 20, no. 1 (2019): 62–97.

33. Weiss and Connelly, "Protecting Cultural Heritage in War Zones."

34. Frowe and Matravers, *Conflict and Cultural Heritage*.

35. Brian K. Barber et al., "Long-Term Exposure to Political Violence: The Particular Injury of Persistent Humiliation," *Social Science & Medicine* 156 (2016): 154–66.

36. Nora Jacobson, "A Taxonomy of Dignity: A Grounded Theory Study," *BMC International Health and Human Rights* 9, no. 1 (2009): 1–9; and Francis Fukuyama, *Identity: The Demand for Dignity and the Politics of Resentment* (New York: Farrar, Straus and Giroux, 2018).

37. Wouter Poortinga, "Community Resilience and Health: The Role of Bonding, Bridging, and Linking Aspects of Social Capital," *Health & Place* 18, no. 2 (2012): 286–95.

38. Frowe and Matravers, *Conflict and Cultural Heritage*.

19

Engaging Nonstate Armed Groups in the Protection of Cultural Heritage

Jennifer M. Welsh

Many of the core norms that seek to regulate the conduct of belligerents in armed conflict, or of the perpetrators of atrocity crimes, originally focused on the behavior of sovereign states. It is states and their representatives, after all, that make and enforce international law, and thus it is their rights and responsibilities that are of primary concern. But in addition, national governments have long resisted any moves that might empower actors seeking to challenge state authority or the domestic political status quo. As a result, the laws of war, from their earliest incarnation, sought to set boundaries around those who can legitimately fight by insisting that only sovereigns have the "right authority" to wage war.[1] It was not until the adoption of the Additional Protocols in 1977 that nonstate actors fighting in civil wars incurred obligations to comply with the Geneva Conventions—a delay due in large part to states' reluctance to legitimize such entities.

Over time, however, the legal and normative backdrop to armed conflict has evolved to include a broader set of actors, as a result of both the changing nature of war and the development of international criminal law. This chapter concentrates on a particular set of actors, nonstate armed groups (NSAGs), as a critical "constituency" for any endeavor that seeks to enhance the protection of cultural heritage in contemporary situations of violent conflict. It examines the growing literature from political science and civil war studies on the motives, structure, and behavior of NSAGs, and draws out implications for those seeking to develop strategies to limit the destruction of cultural property. The discussion reveals that while both law and practice have evolved in ways that acknowledge the importance of understanding and, in some cases, engaging with nonstate armed groups, the long-standing reluctance of states to undertake actions or commitments that they believe might legitimize such entities, or challenge the authority

of existing governments, remains a formidable constraint. This reluctance also extends to state-based organizations, such as the United Nations and its agencies.

Conflict data reveal that the incidence and nature of armed conflict have changed significantly over the last two decades. While for much of the post-1945 period the phenomenon of interstate war has been on a steady decline, the same cannot be said for wars within states. Between 2001 and 2016, for example, the number of non-international armed conflicts more than doubled, from fewer than thirty to more than seventy.[2] Moreover, research organized by the International Committee of the Red Cross (ICRC) indicates that today's armed conflicts are characterized by a proliferation of NSAGs, with more such groups emerging in the last decade than the previous seven decades combined.[3] An increasing number are also highly decentralized and enter into constantly shifting alliances at the local, national, or international level,[4] thereby defying analysts' attempts to categorize the shape of many of today's armed conflicts. Only one-third of contemporary wars are fought between two belligerent parties, while close to half feature between three and nine opposing forces and just over 20 percent have more than ten parties to the conflict.[5] Two years chosen from the decade-long conflicts in Libya and Syria convey the way in which conflict actors are fragmenting in twenty-first-century conflict landscapes: in 2011, roughly 230 armed groups were fighting just in and around Misrata and in 2014 over one thousand armed groups were engaged in hostilities in Syria.[6]

Many of these decentralized NSAGs emerged from the 2011 Arab Spring popular protests, the insurgencies in Iraq, Syria, Ukraine, and Afghanistan, and among self-proclaimed jihadi groups in Africa, South Asia, and the Middle East. In 2017, approximately 40 percent of states experiencing armed conflict were confronting jihadi groups, as new recruits filled their ranks for a variety of motives, including humiliation, perceived injustices, and corruption.[7] Within these contexts, armed groups have perpetrated exceptionally brutal forms of violence and destruction that place inordinate stress on the existing frameworks for regulating armed conflict.[8]

Sovereign states, however, also bear a share of the responsibility for the erosion of norms of conduct in war and the ethic of restraint that underpins them. In response to the threat posed by NSAGs, some state representatives have proclaimed the desire to see fighters from the Islamic State of Iraq and Syria (ISIS, also known as ISIL or Da'esh) killed rather than detained or prosecuted, thus departing from long-standing international law on the treatment of captured or surrendered fighters.[9] In addition, some powerful states are increasingly "outsourcing" warfare to human or technological "surrogates" to keep their distance from the battlefield and lessen the domestic costs of direct involvement.[10] This has translated into logistical, training, intelligence, advisory, and air support to direct parties to a conflict, which—though often directed at state military forces—can flow to private security companies, nonstate armed groups, militias, or even community vigilantes. These various forms of outsourcing amplify the trend toward diluted responsibility for battlefield conduct, as state sponsors evade

accountability for their proxies' actions, despite the ongoing legal obligation of the former to ensure respect for international humanitarian law (IHL).[11]

The discussion of these issues in the chapter proceeds as follows. The first section explains how the category of NSAG must be further disaggregated, given the significant differences in the central purposes of such groups, the types of authority and hierarchy within their organizational structures, and the range of their ideological commitments. The next section shows that while some NSAGs have brazenly challenged the legal and normative framework designed to protect populations and cultural heritage in situations of violent conflict, others have proved crucial to the safety and preservation of cultural property. The third section demonstrates that NSAGs and their individual members do not operate in a legal vacuum, but rather are bound in meaningful ways by a considerable range of obligations under international humanitarian law, international criminal law, and the legal instruments relating specifically to cultural heritage. The next section, drawing on the ICRC's *Roots of Restraint in War* project and report, argues that rather than formulating one general recipe to address the challenges posed by NSAGs, we should situate such groups on a spectrum, and employ a deeper understanding of the variation in their structures and behavior to inform the development of tailored strategies aimed at protecting cultural heritage. The chapter concludes with a discussion of the challenges confronting efforts to engage with NSAGs, including the effects of counterterrorism policies that have affected the willingness of both states and nongovernmental organizations (NGOs) to enter into a dialogue with such groups. Although existing law does not itself prohibit contact or dialogue, counterterrorism measures have had the indirect effect of limiting efforts to engage NSAGs on issues related to the protection of populations and, by extension, could limit the strategies of those seeking to protect cultural heritage.

Deconstructing the Category of NSAG

As a first step to understanding how NSAGs (and their sponsors) might challenge the protection of cultural heritage, and how such challenges could be mitigated, it is crucial to unpack this category and identify its many variants. Here I adopt NGO Geneva Call's definition of an NSAG as "any organized group with a basic structure of command operating outside state control that uses force to achieve its political or allegedly political objectives."[12] Note that in order to distinguish NSAGs from drug cartels or criminal gangs, we need to move beyond the general criterion of any actor that challenges the state's monopoly on the use of legitimate violence, to include the strategic use of violence for *political* ends.

Similarly, in differentiating NSAGs, we might begin by recognizing the various types of political objectives that shape their behavior. These can range from the push for particular government reforms (e.g., the Revolutionary Armed Forces of Colombia, or FARC), to secession and new state creation (e.g., the Liberation Tigers of Tamil Eelam in Sri Lanka), to regime overthrow (e.g., the Houthis in Yemen), to the creation of a new

territorial and political order (e.g., the case of ISIS). As I suggest below, the more concrete the overall political objective, the more likely an NSAG is to engage with other actors if such engagement contributes to achieving its overarching goals.[13] Entities oriented toward independent statehood, for example, are particularly concerned with recognition by the international community and thus often demonstrate openness to political negotiation and compliance with international humanitarian law.[14] Conversely, the lack of a clear political objective can frustrate attempts at political dialogue with NSAGs and often intensifies the nature of the violence used by and against them.

A second feature of NSAGs is variation in the nature of the relationship between their political and military wings, with some groups having parallel organizations (e.g., Sinn Féin and the Irish Republican Army in Northern Ireland), others featuring political and military branches within the same organization (e.g., the Sudan People's Liberation Movement/Army, SPLM/A, in South Sudan), and others having fully integrated politico-military structures (e.g., the Farabundo Martí National Liberation Front in El Salvador). Those NSAGs with separate political and military structures have been found to be less violent toward civilians, more likely to comply with international humanitarian law, and more open to political negotiation.[15]

The third axis along which NSAGs vary is organizational type. Some groups have state-like features, with clear command structures and a leadership that exercises effective control over the rank and file, particularly through indoctrination, training, and the exercise of military discipline. Many anticolonial and secessionist movements have organized themselves in this hierarchical fashion precisely in order to demonstrate their approximation to sovereign states.[16] Most NSAGs, however, are either divided into competing factions or participate in loose coalitions with ambiguous lines of command and weak control by the "center."[17] Common rules of behavior in this context are either inconsistent or nonexistent, and subcommanders frequently exercise considerable authority and discretion. Indeed, some NSAGs consciously embrace fragmentation and rely on loosely allied self-managing units in order to strengthen their resilience and protect themselves from decisive attacks on their core organization.[18] This is particularly true for al-Qaeda, which consists of more than forty distinct groups, each with its own structure and history, and—despite sharing a common identity—exhibiting significant variation in the patterns of violence and behavior vis-à-vis external actors.[19]

The degree to which NSAGs are "vertically integrated"[20] or horizontally organized is thus a critical factor affecting an individual combatant's understanding of and respect for norms of restraint. But analysts have pried open the black box of the NSAG even further, to examine the potential differences between leaders and followers. Research on leaders, for example, has explored whether they are simply instrumentalizing conflict to access power or resources and whether they are playing a "game" of survival—in which case they are likely to be resistant to efforts at negotiation.[21] Research on followers has sought to determine which individuals are most likely to

fight, the factors that enable their mobilization into armed groups,[22] and how specific modes of recruitment may be connected to the way in which NSAGs treat civilian populations. The findings indicate that NSAGs that are made up mainly of "consumers"—those who pursue economic gain—are much more likely to mistreat civilian populations and use indiscriminate violence than those consisting of individuals more invested in a particular political cause.[23]

A fourth differentiating feature of NSAGs is their level of community embeddedness—i.e., whether their strength and longevity are dependent on a local community, or whether they are largely self-sustaining. At one end of the spectrum is ISIS, which has relied heavily on foreign fighters and extra-community sources of funding, or the Lord's Resistance Army of central Africa, which does not attempt to hold territory or establish deep connections to local communities. This contrasts with those NSAGs that draw their support from a particular sector of the community and hence try to enhance their legitimacy by providing social services and other governance functions to that population.[24] The extent of this "rebel governance" has been shown to influence the nature of NSAG–civilian relations, with some groups having either predatory or parasitic relationships with local populations, and others more symbiotic and constructive ties.[25] At the far end of the spectrum are NSAGs explicitly formed to defend community interests, such as South Sudan's Titweng, Gelweng, and Gojam armed cattle-keeping groups. Overall, the degree of community embeddedness can have a significant impact on the propensity of NSAGs to resort to lethal violence against civilians and the destruction of civilian infrastructure.

The presence and strength of ideology is a fifth differentiating factor among NSAGs, as ideologies can both motivate and justify behavior. Although much of the early scholarship on the microfoundations of civil conflict downplayed the role of ideology as a driver for violence against civilians or civilian infrastructure,[26] in favor of economic or other instrumental motives for violence, more recent political science research has reasserted the significance of ideology.[27] More specifically, we now understand how ideology can impact both the deeper structural context and more immediate situational incentives facing members of armed groups, and thus exerts both indirect and direct effects. It can socialize combatants into a cohesive collective that is better able to execute difficult orders and prevent individual "defection," and it can directly define the normative commitments of combatants which shape their interpretation of their context and influence their actions and responses.[28] In brief, ideas help members of NSAGs determine who is a friend and who is an enemy, who and what gets protected, and against whom or what violence can be used.[29]

For violent extremists, such as those that have operated in Syria, Iraq, and Afghanistan, "atrocity-justifying ideologies" can provide a powerful resource for individuals in leadership positions within NSAGs, as well as for those who carry out their orders.[30] These exclusionary ideologies justify the targeting or even extermination of members of particular groups—along with key symbols of their culture. In fact, there

is mounting evidence that we can only account for the variation in belligerents' proclivity to engage in mass killing and other atrocities by analyzing these preexisting negative attitudes and beliefs toward a targeted group.[31]

Ideology is therefore a particularly crucial element for discerning the "why" and "how" of attacks on cultural heritage, since such acts do not always take the form of collateral damage from poorly executed military strikes, but rather represent a subcategory of conflict behavior that is both deliberate *and* public. Extreme forms of violence or destruction present a puzzle for many analysts of civil conflict, as they frequently entail costs for perpetrators—in terms of lost credibility or retaliation—or provoke moral outrage that fuels resistance. In explaining why belligerents nonetheless engage in time-consuming and costly displays of "extra-lethal" violence or "extreme atrocity,"[32] scholars have argued that certain wartime behaviors are "performative": they are designed to produce particular effects for both local and international audiences, such as enhancing the power and prestige of perpetrators[33] or proving loyalty to the group.[34] Understood in this way, the public displays of extreme violence (such as beheadings or crucifixion) that constitute ISIS's "global spectacle" are neither instances of random brutality nor exceptional evil, but rather strategic practices aimed at unsettling audiences through the transgression of prevailing norms and forcing them to confront the reality of a new political order.[35]

In sum, NSAGs differ considerably in their core purposes, the relationship between their military and political leadership, their organizational structure, their degree of community embeddedness, and the nature of their ideological commitment. These factors in turn influence how NSAGs engage strategically and tactically with legal and normative frameworks for regulating conduct in war. Some groups consciously attempt to adhere to principles of international humanitarian law, such as those that have signed pledges brokered by Geneva Call,[36] while others, such as ISIS, intentionally flout international legal obligations—either for the ideological reasons suggested above or to coerce opponents or populations under their control. All five of the dimensions discussed here should also be understood as fluid and dynamic. The nature and behavior of NSAGs can shift across both space—the geography of a conflict—and time— the lifespan of a conflict. When considering whether and how to engage with NSAGs, it is therefore essential not only to develop a tailored approach, depending on the type of actor, but also to regularly reassess these factors and how they might be shaping behavior.

The Engagement of NSAGs with Cultural Heritage

It has been a convenient diversionary tactic of many national governments to depict NSAGs as the primary perpetrators of war crimes and therefore as *the* key problem when it comes to such atrocities. During my tenure as special adviser to the UN Secretary-General on the responsibility to protect, I was frequently encouraged by state diplomats to focus on understanding and addressing the challenge posed by these "bad

actors." Yet it is worth remembering that states themselves are still responsible for many violations of IHL. Moreover, even when concentrating exclusively on NSAGs, we should resist the temptation to categorize all as potential perpetrators, particularly when it comes to attacks on cultural heritage.

Instead, following the analysis conducted by Geneva Call, two broad categories of NSAG can be identified: those which destroy such heritage as a matter of policy and deliberate method of warfare, which the organization refers to as the "destructive trend"; and those which have demonstrated appreciation for cultural heritage and in some cases have taken conscious actions to protect it—the "non-destructive trend." In the latter case, particular military tactics or ignorance of obligations under IHL may still expose cultural heritage to incidental damage.[37]

The destructive acts of those in the first category, such as ISIS or radical Islamists in the Sahel, are most often ideologically motivated and justified on religious grounds. Attacks on statues, shrines, or temples are driven by the conviction that the worshipping of these objects is idolatrous or impious, and that prevailing religious or cultural beliefs which are heretical must be erased in favor of a more perfect or "true" interpretation of Islam. To borrow from the words of Irina Bokova, the former director-general of the UN Educational, Scientific and Cultural Organization (UNESCO), the destruction of mosques, mausoleums, and tombs is part of a larger campaign of "cultural cleansing," in which alternative or diverse cultural beliefs and practices are denied.[38] But as suggested above, such attacks can also be theatrical and aimed at alternative audiences: the international community and potential recruits. For the former, the destruction of cultural heritage—as in Mosul in Iraq or Palmyra in Syria—represents an "act of defiance" against the outside world that calls into question the power and authority of the international community and its norms and principles.[39] For the latter audience, the demolition of high-profile monuments is a means of proving strength and success, which serves as a magnet for prospective fighters. Finally, some violations of the rules and norms surrounding the protection of cultural heritage stem more directly from economic incentives. In conflict contexts from Iraq to Somalia, looting and trading in antiquities are key sources of revenue for NSAGs to prolong their fighting. Even if valuable objects themselves are not destroyed, illegal excavations can result in destruction of their "contextual background."[40]

Turning to the non-destructive trend, there are many striking examples in which NSAGs have either expressly committed to be bound by laws and norms relating to the protection of cultural heritage and thus willingly agreed to restrain their actions, or in which members of such groups have established special departments or procedures to catalogue and safeguard antiquities and have secured sites with armed guards or reinforcements such as sandbags. In Sudan in the 1980s, for example, the high command of the SPLM/A issued a directive to its rank and file to respect cultural property (including religious monuments), while in the Philippines, members of the National Democratic Front agreed with the government in Manila to be bound by IHL—

including provisions on historical monuments, cultural objects, and places of worship. Kurdish Peshmerga fighting in Iraq were also trained in the need to protect cultural heritage and were given a "Guide to Mosul Heritage" prior to their military operations. In Libya, the Free Libyan Army (the precursor to the country's National Transition Council) took steps to protect the National Museum of Tripoli during the fighting that followed the fall of Muammar Gaddafi. In a similar way, the commanders of the Free Syrian Army have deployed personnel and established protective measures for key archaeological sites as well as the Great Umayyad Mosque of Aleppo.

These examples indicate how some NSAGs are potentially part of the *solution* to protecting cultural heritage. At the same time, a general recognition of the values underpinning the regime of protection on the part of armed group members often proves insufficient. Cultural sites have suffered collateral damage when they are situated in strategic military locations (as was the case for some valuable sites in Aleppo), or when NSAGs fail to fulfill the obligation to take precautions to protect cultural heritage. In addition, many of the interviews conducted by Geneva Call for its study of attacks on cultural heritage revealed a lack of clarity on the part of armed groups as to when and whether sites could be used for military purposes and how to operationalize the principle of military necessity. To take just one illustration: the Crac des Chevaliers, a medieval Crusader fortress near Homs in Syria, was used as a military base by NSAGs in the summer of 2013 but then quickly became a target of government-led bombardment. Finally, discussions with NSAGs indicate that some are simply unaware of the Blue Shield emblem used to denote cultural heritage, as established by the 1954 Hague Convention for the Protection of Cultural Property in the Event of Armed Conflict, or are unsure of the obligations associated with it.

The discussion above suggests that some NSAGs are and will remain key culprits in attacks on cultural heritage, particularly if they are ideologically motivated to engage in "extreme atrocity" or are indifferent to the alienating effects of their actions on local and international audiences. But it also points to the potential to enhance the respect of some NSAGs for rules and norms protecting cultural heritage through different strategies of engagement (discussed further below). This is particularly true for those NSAGs fighting for the rights of national, ethnic, and religious minorities—and which are therefore likely to be aware of the symbolic value of cultural heritage—as well as groups seeking international recognition for their claims. Political scientists such as Hyeran Jo have identified a subset of rebel groups that exhibit a greater tendency to comply with the laws of war, either because their local norms are consistent with global norms or because compliance is instrumentally valuable in enhancing the legitimacy of their armed struggle. These "legitimacy-seeking" NSAGs, who make strategic calculations in the context of a larger political environment, are thus more open to the overtures of humanitarian organizations or other international agents of international law as they seek to encourage restraint and respect for IHL.[41]

The Responsibilities and Obligations of NSAGs

Although NSAGs are frequently depicted as being outside the boundaries of the international community, they do not operate beyond the reach of the law. They are bound by a considerable range of relevant obligations under existing IHL, and individual members of such groups can be subject to international criminal law in cases where they commit international crimes. The discussion in this section addresses the law of armed conflict before analyzing the legal regime protecting cultural heritage.

Common Article 3 of the Geneva Conventions binds all parties to a non-international armed conflict to refrain from using violence against individuals taking no active part in hostilities. Additional Protocol II also requires NSAGs to respect and protect civilian populations, and contains specific rules relating to the protection of cultural objects. While the protocol has traditionally applied only to situations in which such groups control territory, many of its provisions are now recognized to form part of customary international law and are thus also applicable where NSAGs are not in full control.[42] More generally, many aspects of IHL applicable to international armed conflict, as a matter of treaty law, are now also considered to apply in non-international armed conflict and therefore also to NSAGs as a matter of customary law—regardless of whether such groups control territory. This includes aspects of the Geneva Conventions that relate to prohibitions on the destruction of cultural property.[43]

In addition, while international human rights law is still relatively limited with respect to NSAGs, given that it is focused on obligations of the *state* toward individuals within its jurisdiction, developments in international criminal law—particularly the broadening of the scope of crimes against humanity and war crimes to include acts committed in non-international armed conflict—have provided possibilities for establishing individual criminal responsibility for members of such groups.[44] In the context of Syria, the 2016 report of the Independent International Commission of Inquiry, established by the UN Human Rights Council, therefore emphasized the need for all groups to be held accountable for violations of IHL that amounted to war crimes.[45] This includes, for example, those offenses specified in Articles 8.2.c and 8.2.e of the Rome Statute of the International Criminal Court (ICC), which apply to conflicts "not of an international character." These steps and others have helped to address what was previously a notable imbalance in the impunity enjoyed by nonstate and state actors. It is now the gravity of the crime, rather than the requirement of statehood, that has become crucial for criminal accountability.[46] It should also be noted that international criminal law establishes the responsibility of individual members of nonstate armed groups for international crimes committed outside the context of armed conflict (and thus outside the ambit of IHL), including genocide and crimes against humanity.

In situations where international criminal law cannot be applied or where the protection of populations requires more than general compliance with Common Article 3, the task of establishing responsibility is more complex. Agreement to restrain behavior and assume responsibilities will then depend on the consent and compliance

of members of NSAGs themselves,[47] a fact that has fostered the attempts by Geneva Call to encourage NSAGs to sign its public pledges, called "Deeds of Commitment," to follow the principles of IHL. Skeptics of this approach might argue that by attributing responsibilities to NSAGs, the international community is headed down a slippery slope of not only legitimizing such actors but also endowing them with state-like attributes—a move that some states with secessionist movements strongly resist. But organizations like Geneva Call insist that this further step is not implied. Its engagement with NSAGs is directed at setting expectations for behavior with respect to a population and civilian infrastructure over which an NSAG exercises a measure of control, rather than passing judgment on the rightness or wrongness of that control.[48]

On first sight, the legal framework regarding the protection of cultural heritage appears to apply more explicitly and directly to NSAGs than does the general legal regime for armed conflict. Article 19 of the 1954 Hague Convention enunciates core obligations for all parties in non-international armed conflict—state and nonstate— while Article 4 outlines those relating to the prohibition of the use of cultural property in ways that might expose it to damage; the prohibition of acts of hostility or reprisal against cultural property; and the obligation to take precautionary measures to prohibit, prevent or cease acts of theft, misappropriation, or vandalism.

Nevertheless, when digging a bit deeper, one finds structural asymmetries in the convention which result in more limited provisions for nonstate than for state parties. For example, Article 7's provisions on training and safeguarding measures apply only to states, and there are no mechanisms for the exchange of information between warring parties with respect to the location of cultural property. The latter gap places NSAGs at a distinct disadvantage vis-à-vis national governments in terms of compliance, since knowing "the location of cultural property is a prerequisite to ensuring respect for its integrity." Similarly, Article 28 is ambiguous as to whether NSAGs have the same obligations as state parties when it comes to prosecuting individuals that have breached the convention. Finally, Article 23 stipulates that only state parties can call upon UNESCO for "technical assistance" in organizing the protection of their cultural property. This has created a "unidirectional" means of communication between NSAGs and UNESCO that exposes the former to difficulty when they require specialist advice or assistance, as was the case in Mali in 2012–13, for example, with respect to the protection of rare manuscripts.[49]

The 1999 Second Protocol to the Hague Convention reaffirms the application of its rules to non-international armed conflict and contains a number of "enhanced protection" obligations that are directly relevant to NSAGs.[50] Most notably, unlike the Additional Protocols to the Geneva Conventions, this one applies to all such groups even if they do not control a portion of a state party's territory or if the conflict only involves NSAGs. Furthermore, Article 15.1 of the Second Protocol identifies a subset of conduct in violation of its rules that gives rise to universal criminal jurisdiction; as a result, a member of an NSAG that has allegedly committed such acts can be prosecuted or

extradited by the state party on the territory of which the individual in question is situated.[51] Article 15.2 extends the principle of command responsibility to the leaders of NSAGs, by enabling them to be held criminally responsible for the failure to exercise control over criminal actions that they knew, or had reason to know, were being committed by forces under their control. Nonetheless, some of the asymmetries established in the 1954 convention have echoes in the more recent protocol, including the lack of an explicit right for NSAGs to request technical assistance from UNESCO, and the lack of access for NSAGs to a special fund established by the protocol to assist with undertaking safeguarding measures for cultural property (Articles 29 and 32).

Beyond the 1954 convention and 1999 Second Protocol, other hard and soft law instruments relate to the protection of cultural property and heritage and create varying obligations for NSAGs. In addition, as noted above, significant advances in international criminal law, through the jurisprudence of the International Criminal Tribunal for the former Yugoslavia (ICTY) and the ICC's Rome Statute, now establish that attacks by members of NSAGs on cultural heritage can constitute a war crime (in both non-international and international armed conflicts); can be considered a crime against humanity when they amount to "persecution" against an identifiable group; or can be deemed to demonstrate the intent to commit genocide.[52] Lastly, it is worth underscoring the moves taken by the UN Security Council to request that all parties to conflicts—state and nonstate—halt damage to cultural heritage (e.g., resolution 2056 in relation to Mali[53]) or take proactive steps to protect cultural property (e.g., resolution 2139 in regard to Syria).

This overview of the legal framework suggests that the primary challenge in protecting cultural heritage is not the creation of new rules to regulate the behavior of NSAGs, but rather ensuring compliance with already existing obligations. While ideally some of the imbalance between state and nonstate rights and obligations should be rectified—much in the same way that lawyers are pressing for harmonization in the rules applying to international and non-international armed conflict[54]—the more urgent task is to develop strategies and tactics for encouraging and enabling NSAGs to adopt safeguarding measures and exercise restraint in their belligerent conduct.

Understanding Sources and Possibilities for Restraint

The discussion thus far has highlighted two main openings for engagement with NSAGs with respect to the protection of cultural heritage: the fact that not all NSAGs are alike and that some have strong motivations for modifying destructive behavior; and that such groups can be held accountable for breaches of international humanitarian law and their individual members for violations of international criminal law. For almost two decades, the ICRC has built on these insights to intensify its efforts to persuade belligerents to comply with the legal and normative regime regulating armed conflict. The first ICRC-sponsored study on this theme, *The Roots of Behaviour in War*,[55] explored the social and psychological processes that condition the behavior of fighters during

armed conflict, including the pressures of group conformity. The findings of this initial wave of research led the ICRC to expand its focus from boosting awareness of the law to ensuring that it was better integrated into the inner workings of armed forces and armed groups, including through doctrine, training, and measures for sanctioning breaches of legal frameworks. But despite the merits of this "integrated approach," the ICRC continued to pursue modifications in levels of violence through the lens of legal obligation, without sufficient attention to more local norms or values that underpin the behavior of conflict parties and to the degree of variation in levels of restraint exhibited by belligerents. Moreover, while the integrated approach had some traction in conflict parties with a vertical or hierarchical structure, it struggled to address the increasingly horizontal and decentralized structure of many NSAGs.[56]

The most recent research sponsored by the ICRC has therefore focused more squarely on how restraint is, or could be, generated in different types of armed actors.[57] In so doing, it builds on a new wave of conflict studies that goes beyond describing and explaining different types or "repertoires" of violence in war and instead treats restraint as the "outcome of interest."[58] While to date this scholarship has mostly considered state forces and has not yet generated a parsimonious causal explanation for how restraint is achieved,[59] the ICRC's *Roots of Restraint in War* project and report have more closely examined the *process* of engendering restraint, with the hope of providing more policy-relevant and actionable insights.

More specifically, the project advances an analytical framework centered on processes of socialization, whereby a "culture of restraint" is generated and maintained through the instilling of social norms. Drawing on research on different types of socialization,[60] the report emphasizes the need to move from situations in which norms are adopted by actors on the basis of instrumental calculation (to secure reward or avoid punishment) or in order to conform to group expectations, toward a situation in which norms become part of a belligerent's identity and are seen as the "right thing to do." Though IHL remains vital in setting standards for behavior, it is only by encouraging individual combatants to internalize the values underpinning law, through socialization, that restraint becomes more enduring.[61]

Two of the five axes of variation in NSAGs outlined earlier are the starting point for determining how norms conducive to restraint can be formed and reinforced: organizational structure and community embeddedness. A core finding of the ICRC's research is that different configurations of these two variables suggest different approaches and points of access for most effectively promoting restraint.[62] Furthermore, whether the conflict party is a state or nonstate actor will determine which influences shape an individual combatant's understanding of, and respect for, norms of restraint. Although individuals might adhere to certain norms for a range of religious, cultural, or personal reasons (which exist independently from or prior to their membership in an armed group), organizational structure will help pinpoint which of the following sources of restraint will be most influential: commanders, group

ideologies and institutions, peer groups, or external pressures. For example, though hierarchical armed groups might be amenable to top-down training approaches led by commanders, decentralized armed groups often do not have written codes of conduct and individual subcommanders exercise significant authority, often through forms of charismatic leadership.

In this latter context, research shows that restraint among the members of NSAGs is more likely to be influenced by societal actors or "community notables" *external* to the group itself, including, in some cases, business elites or religious leaders.[63] External actors can thus draw on religious, social, or even economic authority to sway the behavior of combatants; yet, as the authority and status of local actors fluctuate, so too does their influence. As the cases of Mali and South Sudan highlight, multiple social and religious authorities can even compete for control over armed groups' use of violence. This may present more entry points for dialogue about behavior, but it may also dilute the impact of any single influence on the armed group. Actors seeking to influence armed groups must therefore consider the growing complexity of alliances among NSAGs—with groups composed of "networks of networks"—and should identify and engage with key "nodes" that have the greatest leverage in promoting either violence or restraint.[64]

While for the ICRC the key norms of restraint to encourage are those ideas and practices that regulate behavior with respect to noncombatant immunity, theoretically it is possible to imagine a wider set of ideas and practices related to the protection of cultural heritage. Five other important implications flow from the ICRC's research:

1. Most obviously, a detailed understanding of the inner workings of armed groups is a key prerequisite for identifying the sources of authority, beliefs, and influence that can steer the behavior of NSAG members toward restraint. In short, as expert analysts note, "there is no one-size-fits-all approach, as behavior is also shaped by values, traditions, ideology, and communities' attitudes on acceptable behavior";[65]

2. Relatedly, understanding local viewpoints and values will be particularly important for the promotion of restraint, and therefore necessitates deeper and more sustained dialogue with communities themselves. Here it is crucial to remember that civilians living in communities are not passive actors, but can often influence armed-group behavior in favor of violence or restraint;[66]

3. Training manuals on engagement with armed groups may also need to be rewritten, since they are heavily skewed toward rational actor models and currently identify leverage points based on assumptions about militants' economic or political interests;[67]

4. The *Roots of Restraint* research highlights the importance of analyzing patterns of violence and destruction over time—type, method, target, and frequency—to enable a better understanding of where and when restraint is being exercised,

what sources of influence might be shaping armed group actions, and when violence and destruction are explicitly ordered by group leaders, as opposed to opportunistic behavior practiced by only a few local commanders or fighters.[68] Identifying the decisionmakers behind patterns of violence and destruction will assist local or international actors as they try to target the optimal leaders with whom to engage; and

5. The ICRC's findings indicate that the set of actors tasked with encouraging restraint will need to broaden. Although international humanitarian organizations can still play essential roles in promoting restraint in some cases (as in the integrated approach), the changing nature of armed conflicts and of NSAGs suggests the need to mobilize new societal actors to the cause of limiting violence.[69] Once again, the organizational structure of an armed group will provide important clues to the sources of influence on the behavior of its members.

Conclusion: Challenges in Engaging with NSAGs

The research conducted by the ICRC and Geneva Call illustrates that while NSAGs have not taken part in elaborating the formal rules that regulate armed conflict, including those that protect cultural heritage, some of them acknowledge the importance of the *values* underpinning the legal regime. And even in the toughest cases—extremist groups motivated by ideology—there have been documented cases of disagreement within NSAGs about the legitimacy of targeting particular religious symbols.[70] This suggests that although efforts to shape the behavior of NSAGs are inherently difficult, there are opportunities to both enhance awareness of international standards relating to cultural property and encourage forms of behavior likely to protect cultural heritage. Specialized agencies and humanitarian organizations should therefore leverage such opportunities, but so too should states which exercise a degree of control over nonstate armed groups and which are indirectly responsible for their destructive behavior.

To date, however, only a few specialized organizations have sought to engage directly with NSAGs to promote respect for cultural heritage. These include Heritage for Peace as well as the Smithsonian Institution. For its part, UNESCO has exhibited caution with respect to dialogue with NSAGs in light of Article 1.3 of its constitution, which forbids the organization from intervening in matters which are essentially within member states' domestic jurisdiction. Generally speaking, UNESCO interprets contact with NSAGs to be a breach of this obligation and limits its contact to recognized governments. Article 19.3 of the Hague Convention does permit UNESCO to "offer its services" to parties to a non-international armed conflict—both state and nonstate—and expressly states that such contact does not affect the legal status of NSAGs. But in practice instances of engagement between UNESCO and such actors have been rare,[71] and most commonly consist of calls by the organization's director-general for all parties to respect legal obligations in relation to cultural heritage or to help facilitate

agreements with them to create "cultural protection zones."[72] In February 2016, UNESCO entered into a memorandum of understanding with the ICRC to strengthen cooperation with respect to the protection of cultural heritage, but there was no explicit mention of NSAGs. Although the ICRC regularly engages with all conflict parties to serve its mission, UNESCO's approach—as an intergovernmental organization—reflects the long-standing concerns of governments about legitimating nonstate armed actors.

Counterterrorism measures undertaken in the wake of 9/11 have further complicated dialogue with NSAGs that have been designated as terrorist organizations. Sanctions regimes authorized by the European Union and UN Security Council, for example, prohibit making economic resources available to such groups—whether directly or indirectly. Criminal measures adopted by certain states are broader in scope and can thus extend to other forms of material support. However, the legal instruments do not prohibit mere contact with NSAGs for humanitarian purposes, despite a widespread misperception that engagement with designated entities is somehow "outlawed." In fact, a restriction on contact would conflict with existing principles of IHL and particularly Common Article 3, which expressly foresees the possibility for humanitarian actors to offer services to both states and NSAGs. The funding arrangements of donors with humanitarian NGOs often replicate the restrictions outlined in sanctions regimes, but these too only regulate the provision of funds and do not preclude contact or dialogue.[73]

Yet, as hinted above, various donors and humanitarian organizations are reading into the law tighter restrictions on engagement with NSAGs than exist, and thus unnecessarily curtailing their operations. Of course, humanitarian actors can and often do set more onerous standards over and above the law for reasons related to reputation or risk tolerance. For example, where they work in areas under the control of NSAGs, they may set guidelines addressing various aspects of their engagement with group members, including visibility at public events or use of organizational logos.[74] But it is crucial in any agenda that seeks to encourage restraint in the behavior of NSAGs that legal restrictions—with which humanitarian NGOs must comply—are carefully distinguished from political and policy choices.

Furthermore, it remains the case that certain governments, and their armed forces, are broadly interpreting their own domestic terrorism legislation in ways that constrain or intimidate humanitarian organizations. The Nigerian Army, for example, has threatened international NGOs with closure of their offices if their staff makes overtures to Boko Haram.[75] More generally, humanitarian organizations such as Médecins Sans Frontières have underscored the negative effects of counterterrorism policy in their attempts to offer humanitarian relief in armed conflict contexts, given the practical impossibility of avoiding all contact with NSAGs active in or in control of territory where humanitarian operations are taking place.[76] Similarly, organizations such as Civilians in Conflict, the ICRC, and Geneva Call face ongoing challenges in implementing their civilian protection programs given the need to negotiate access to civilian

populations and to engage with NSAGs to encourage restraint. In the context of cultural heritage, the work of the Smithsonian has also been constrained, as contact with entities that the US government has identified as terrorist organizations is prohibited.

Any concerted strategy to leverage the opportunities that exist for encouraging NSAGs to protect cultural heritage must therefore address barriers to dialogue through both practical measures and a broader political shift on the part of international organizations and national governments. This entails a willingness to discuss long-cherished principles such as noninterference in the domestic affairs of states and the extent of the "right of initiative" on the part of actors such as UNESCO, as well as the courage to challenge governments' refrain that engagement with NSAGs implies legitimation. It also calls for states to demonstrate greater *political* will to ensure that humanitarian action and contact with NSAGs are not impeded by national or multilateral counterterrorism strategies—as called for by the UN General Assembly in 2016.[77] Above all, it requires a deeper recognition that NSAGs are not always the core problem and might instead form a crucial part of the solution to ensuring the survival of cultural heritage for future generations.

SUGGESTED READINGS

Simone Molin Friis, "'Behead, Burn, Crucify, Crush': Theorizing the Islamic State's Public Displays of Violence," *European Journal of International Relations* 24, no. 2 (2018): 243–67.

Lee Ann Fujii, "The Puzzle of Extra-Lethal Violence," *Perspectives on Politics* 11, no. 2 (2013): 410–26.

Geneva Call, *Culture under Fire: Armed Non-state Actors and Cultural Heritage in Wartime* (Geneva: Geneva Call, October 2018), https://genevacall.org/wp-content/uploads/2017/10/Cultural_Heritage _Study_Final.pdf.

Hyeran Jo, *Compliant Rebels: Rebel Groups and International Law in World Politics* (Cambridge: Cambridge University Press, 2015).

Brian McQuinn, Fiona Terry, Oliver Kaplan, and Francisco Gutiérrez-Sanin, "Promoting Restraint in War," *International Interactions* 47, no. 5 (2021): 795–824.

Jessica A. Stanton, *Violence and Restraint in War* (Cambridge: Cambridge University Press, 2016).

NOTES

1. Claire Vergerio, "Alberico Gentili's *De iure belli*: An Absolutist's Attempt to Reconcile the *jus gentium* and the Reason of State Tradition," *Journal of the History of International Law* 19, no. 4 (2017): 429–66.
2. Thérése Pettersson, Stina Högbladh, and Magnus Öberg, "Organized Violence, 1989–2018 and Peace Agreements," *Journal of Peace Research* 56, no. 4 (2019): 589–603.
3. ICRC, *Professional Standards for Protection Work Carried Out by Humanitarian and Human Rights Actors in Armed Conflict and Other Situations of Violence*, 3rd ed. (Geneva: ICRC, 2018), 28–32.
4. Jay Benson et al., *Reassessing Rebellion: Exploring Recent Trends in Civil War Dynamics* (Broomfield, CO: One Earth Future, March 2019), http://dx.doi.org/10.18289/OEF.2019.035.

5. ICRC, *Professional Standards for Protection Work*, 28–32.

6. Brian McQuinn, "Assessing (In)security After the Arab Spring," *PS, Political Science and Politics* 46, no. 4 (2013): 716–20; and Carter Center, *Syria: Countrywide Conflict Report No. 5* (Atlanta: Carter Center, February 2015), https://www.cartercenter.org/resources/pdfs/peace/conflict _resolution/syria-conflict/NationwideUpdate-Feb-28-2015.pdf.

7. Scott Atran, Hammad Sheikh, and Angel Gómez, "Devoted Actors Sacrifice for Close Comrades and Sacred Cause," *Proceedings of the National Academy of Sciences* 111, no. 50 (2014): 17702–3.

8. Brian McQuinn et al., "Promoting Restraint in War," *International Interactions* 47, no. 5 (2021): 795–824.

9. Anne Barnard, "Red Cross Warns of 'Dehumanizing' Rhetoric in ISIS Fight," *New York Times*, 26 October 2017, https://www.nytimes.com/2017/10/26/world/middleeast/red-cross-islamic-state .html.

10. Andreas Krieg and Jean-Marc Rickli, "Surrogate Warfare: The Act of War in the 21st Century?," *Defence Studies* 18, no. 2 (2018): 113–30.

11. McQuinn et al., "Promoting Restraint in War."

12. Anki Sjöberg, *Armed Non-state Actors and Landmines, Volume III: Towards a Holistic Approach to Armed Non-state Actors?* (Geneva: Geneva Call, 2007), 3, https://www.ruig-gian.org/ressources/ NSA_Landmines_Volume_III.pdf?ID=226&FILE=/ressources/NSA_Landmines_Volume_III.pdf.

13. Alex J. Bellamy, "Non-state Armed Groups and the Responsibility to Protect," discussion paper for seminar Fulfilling the Responsibility to Protect: The Threat of Non-state Armed Groups and Their Increased Role in Perpetrating Atrocity Crimes, Brussels, 22 March 2016.

14. Hyeran Jo, *Compliant Rebels: Rebel Groups and International Law in World Politics* (Cambridge: Cambridge University Press, 2015); and Tanisha M. Fazal, *Wars of Law: Unintended Consequences in the Regulation of Armed Conflict* (Ithaca, NY: Cornell University Press, 2018).

15. Jessica A. Stanton, "Regulating Militias: Governments, Militias, and Civilian Targeting in Civil War," *Journal of Conflict Resolution* 59, no. 5 (2015): 899–923.

16. Nina Caspersen, "Democracy, Nationalism and (Lack of) Sovereignty," *Nations and Nationalism* 17, no. 2 (2011): 337–56.

17. Kathleen Cunningham, *Inside the Politics of Self-Determination* (Oxford: Oxford University Press, 2014); and Lee JM Seymour, Kristin M. Bakke, and Kathleen Gallagher Cunningham, "E Pluribus Unum, Ex Uno Plures: Competition, Violence, and Fragmentation in Ethnopolitical Movements," *Journal of Peace Research* 53, no. 1 (2016): 3–18.

18. Bellamy, "Non-state Armed Groups and the Responsibility to Protect"; and Ivan Briscoe, *Non-conventional Armed Violence and Non-state Actors: Challenges for Mediation and Humanitarian Action* (Oslo: Norwegian Peacebuilding Resource Centre, May 2013).

19. ICRC, *Professional Standards for Protection Work*, 28–32.

20. McQuinn et al., "Promoting Restraint in War."

21. Hein E. Goemans, *War and Punishment: The Causes of War Termination and the First World War* (Princeton, NJ: Princeton University Press, 2000).

22. Macartan Humphreys and Jeremy M. Weinstein, "Handling and Manhandling Civilians in Civil War," *American Political Science Review* 100, no. 3 (2006): 429–47.

23. Humphreys and Weinstein.

24. Claire Metelits, *Inside Insurgency: Violence, Civilians, and Revolutionary Group Behavior* (New York: New York University Press, 2009); and Zachariah C. Mampilly, *Rebel Rulers: Insurgent Governance and Civilian Life during War* (Ithaca, NY: Cornell University Press, 2011).

25. Robin T. Naylor, "The Insurgent Economy: Black Market Operations of Guerrilla Groups," *Crime, Law and Social Change* 20 (July 1993): 13–51.

26. Elisabeth J. Wood, "Rape during War Is Not Inevitable: Variation in Wartime Sexual Violence," in *Understanding and Proving International Sex Crimes*, ed. Morten Bergsmo, Elisabeth J. Wood,

and Alf B. Skre (Beijing: Torkel Opsahl Academic EPublisher, 2012), 389–420; and Jeremy M. Weinstein, *Inside Rebellion: The Politics of Insurgent Violence* (Cambridge: Cambridge University Press, 2007).

27. Jonathan L. Maynard, "Ideology and Armed Conflict," *Journal of Peace Research* 56, no. 5 (2019): 635–49.

28. Francisco G. Sanín and Elisabeth J. Wood, "Ideology in Civil War: Instrumental Adoption and Beyond," *Journal of Peace Research* 51, no. 2 (2014): 213–26.

29. Marie-Joëlle Zahar, "Is All the News Bad News for Peace? Economic Agendas in the Lebanese Civil War," *International Journal* 54, no. 1 (2001): 115–28.

30. Jonathan L. Maynard, "Preventing Mass Atrocities: Ideological Strategies and Interventions," *Politics and Governance* 3, no. 3 (2015): 67–84.

31. Omar McDoom, "Radicalization as Cause and Consequence of Violence in Genocides and Mass Killings," *Violence: An International Journal* (December 2019), http://eprints.lse.ac.uk/103206/.

32. Lee Ann Fujii, "The Puzzle of Extra-Lethal Violence," *Perspectives on Politics* 11, no. 2 (2013): 410–26; and Marek Brzezinski, "Extreme Atrocity in Armed Conflict: Cross-National Evidence," paper presented to the Centre for International Peace and Security Studies, McGill University, Montreal, 4 December 2020.

33. Lee Ann Fujii, "The Puzzle of Extra-Lethal Violence"; and "'Talk of the Town': Explaining Pathways to Participation in Violent Display," *Journal of Peace Research* 54, no. 5 (2017): 661–73.

34. Dara K. Cohen, "The Ties That Bind: How Armed Groups Use Violence to Socialize Fighters," *Journal of Peace Research* 54, no. 5 (2017): 701–14.

35. Simone Molin Friis, "'Behead, Burn, Crucify, Crush': Theorizing the Islamic State's Public Displays of Violence," *European Journal of International Relations* 24, no. 2 (2018): 243–67.

36. See the discussion of deeds of commitment at Geneva Call, "How We Work," https://www.genevacall.org/how-we-work.

37. Geneva Call, *Culture under Fire: Armed Non-state Actors and Cultural Heritage in Wartime* (Geneva: Geneva Call, October 2018), https://genevacall.org/wp-content/uploads/2017/10/Cultural_Heritage_Study_Final.pdf.

38. Geneva Call, *Culture under Fire*, 32.

39. Friis, "'Behead, Burn, Crucify, Crush.'"

40. Geneva Call, *Culture under Fire*.

41. Jo, *Compliant Rebels*.

42. Jean-Marie Henckaerts and Louise Doswald-Beck, *Customary International Humanitarian Law Vol. 1: Rules* (Cambridge: Cambridge University Press, 2005).

43. See ICRC, "Database on Customary IHL," Rules 38–41, https://ihl-databases.icrc.org/customary-ihl/eng/docs/.

44. William Schabas, "Punishment of Non-state Actors in Non-international Armed Conflict," *Fordham International Law Journal* 26, no. 4 (2002): 907–33.

45. UN Human Rights Council, *Report of the Independent International Commission of Inquiry on the Syrian Arab Republic*, UN doc. A/HRC/33/55, 11 August 2016, https://undocs.org/A/HRC/33/55.

46. Clare Frances Moran, *Beyond the State: The Future of International Criminal Law*, ICD Brief 7, International Crimes Database (September 2014), http://www.internationalcrimesdatabase.org/upload/documents/20141002T145950-ICD%20Brief%20-%20Moran.pdf.

47. Marco Sassòli, "Taking Armed Groups Seriously: Ways to Improve Their Compliance with International Humanitarian Law," *Journal of International Humanitarian Legal Studies* 1, no. 1 (2010): 5–51.

48. Jennifer Welsh, "The Responsibility to Protect and Non-state Actors," in *The Grey Zone: Civilian Protection between Human Rights and the Laws of War*, ed. Mark Lattimer and Philippe Sands (Oxford: Hart Publishing, 2018).

49. Geneva Call, *Culture under Fire*, 15.

50. Geneva Call, *Culture under Fire*, 16.

51. This right to prosecute can be activated even if the offense was committed in another state or if the individual committing the offense is not one of the prosecuting state's nationals. See 1999 Second Protocol to the 1954 Hague Convention, Art. 16.1.

52. Geneva Call, *Culture under Fire*, 21–22. There are some obvious limitations to the reach of ICC prosecution, which have particular relevance for situations involving NSAGs. According to the Rome Statute, only individuals that are nationals of a state over which the court has jurisdiction, or that have allegedly committed a crime on such a state's territory, can be prosecuted. This did not prevent the ICC from playing a role in Mali, with respect to the high-profile case of Ahmad al-Mahdi, but it has limited the possibilities for prosecution with respect to the destruction of cultural property in Iraq and Syria, which are not parties to the statute. In addition, the ICC's jurisdiction is activated only in situations where the "most serious" international crimes are committed, which may not be the case in some instances where cultural heritage is attacked.

53. This resolution is particularly significant, given that the 1972 Convention Concerning the Protection of the World Cultural and Natural Heritage only addresses states.

54. Sarah Cleveland, "Harmonizing Standards in Armed Conflict," *EJIL Talk!* (blog), *European Journal of International Law*, 8 September 2014, https://www.ejiltalk.org/harmonizing-standards-in-armed-conflict/.

55. Daniel Muñoz-Rojas and Jean-Jacques Frésard, *The Roots of Behaviour in War: Understanding and Preventing IHL Violations* (Geneva: ICRC, 2004), https://www.icrc.org/en/publication/0853-roots-behaviour-war-understanding-and-preventing-ihl-violations.

56. McQuinn et al., "Promoting Restraint in War."

57. ICRC, *Professional Standards for Protection Work*, 28–32.

58. McQuinn et al., "Promoting Restraint in War."

59. Jessica A. Stanton, *Violence and Restraint in War* (Cambridge: Cambridge University Press, 2016); Andrew M. Bell, "Military Culture and the Sources of Battlefield Restraint: Examining the Ugandan Civil Wars," *Security Studies* 25, no. 3 (2016): 488–518; Elisabeth J. Wood, "Armed Groups and Sexual Violence: When Is Wartime Rape Rare?," *Politics & Society* 37, no. 1 (2009): 131–61; Amelia H. Green, *The Commander's Dilemma: Violence and Restraint in Wartime* (Ithaca, NY: Cornell University Press, 2018); and Oliver Kaplan, "Nudging Armed Groups: How Civilians Transmit Norms of Protection," *Stability: International Journal of Security and Development* 2, no. 3 (2013): 62.

60. Jeffrey T. Checkel, "Socialization and Violence: Introduction and Framework," *Journal of Peace Research* 54, no. 5 (2017): 592–605.

61. ICRC, *Professional Standards for Protection Work*, 28–32.

62. Fiona Terry and Brian McQuinn, *The Roots of Restraint in War* (Geneva: ICRC, 2018).

63. ICRC, *Professional Standards for Protection Work*, 28–32.

64. McQuinn et al., "Promoting Restraint in War."

65. McQuinn et al., "Promoting Restraint in War."

66. Oliver Kaplan, "Shootings and Shamans: Local Civilian Authority Structures and Civil War Violence in Colombia," draft of paper, 25 July 2012, http://dx.doi.org/10.2139/ssrn.2102751.

67. Gilles Carbonnier, *Humanitarian Economics: War, Disaster and the Global Aid Market* (London: Hurst, 2015), 20.

68. ICRC, *Professional Standards for Protection Work*, 28–32.

69. McQuinn et al., "Promoting Restraint in War."

70. See, for example, the analysis of Ansar Dine's actions in Mali, in Geneva Call, *Culture under Fire*, 49–50.

71. Examples include the UNESCO director-general's contact in 2001 with Mullah Omar over Taliban threats to destroy the Buddhas of Bamiyan in Afghanistan, and in 2004 with the SPLA over the fate of Garamba National Park in the Democratic Republic of the Congo, along the border with South Sudan.

72. Geneva Call, *Culture under Fire*, 55.

73. The only case in which contact with a designated entity is legally prohibited is in the funding agreement of one donor, the United States Agency for International Development (USAID), in relation to its operations in Gaza. This provision was motivated by a political rather than counterterrorism-related objective: to deny visibility or legitimacy to Hamas. See USAID West Bank/Gaza, "Contact Policy for the Palestinian Authority," Notice No. 2006-WBG-17, 26 April 2006. I am grateful to Emanuela-Chiara Gillard for pointing me to this source.

74. Emanuela-Chiara Gillard, "Humanitarian Action in Gaza: Covid-19 as a Catalyst for Alleviating Counterterrorism-Related Restrictions?" Expert Opinion, commissioned by the Norwegian Refugee Council, May 2021, http://bit.ly/GillardEO2021.

75. In this case, the army alleged that humanitarian organizations were "aiding and abetting terrorism" by supplying food and drugs, and not merely engaging in contact. See Lucy Lamble, "Nigerian Army Orders Closure of Aid Agency for 'Aiding Terrorism,'" *Guardian*, 19 September 2019, https://www.theguardian.com/global-development/2019/sep/20/nigerian-army-orders -closure-of-aid-agency-for-aiding-terrorism.

76. Bertrand Perrochet, "Is Counter-Terrorism Killing Humanitarian Action in Nigeria?," Médecins Sans Frontières, 22 November 2019, https://www.msf.org/counter-terrorism-killing -humanitarian-action-nigeria.

77. UN General Assembly, *The United Nations Global Counter-Terrorism Strategy Review*, UN doc. A/ RES/70/291, 1 July 2016.

20

After the Dust Settles: Transitional Justice and Identity in the Aftermath of Cultural Destruction

Philippe Sands

Ashrutha Rai

The question of ownership of cultural heritage has long been contentious. The identity of groups and the feelings of their members are often associated with monuments and other cultural objects. The accompanying traditions, histories, and customs are considered emblematic of a group's culture, perhaps even that of multiple groups. Yet cultural heritage has also come to be seen as a common heritage of humankind, belonging to everyone and no one in particular. The tension between these rival conceptions of belonging and ownership can have far-reaching ramifications in the interplay between law and politics. Often it is circumstance and perspective that determine the relative legitimacy of competing claims, providing only temporary or incomplete answers to the enduring question of ownership.

This is particularly apparent when cultural heritage is destroyed in an armed conflict or during a period of significant repression of human rights. Such destruction frequently occurs with the specific intent of intensifying the material and psychological harm to victim communities. An attempt to move past traumatic episodes requires inquiry into the nature of cultural ownership, as efforts at recovery will invariably require the involvement of the most affected stakeholders, whether at the local, national, or international level.

These attempts at post-conflict recovery have, since the 1990s, become increasingly internationalized. This seems inevitable in a society transitioning out of a period of armed conflict or repression, since it is likely to find itself facing atrocities on so great a scale that its own justice system is unable to address the legacy.[1] Under the rubric of

"transitional justice," international organizations and local authorities tend to work together to create judicial and nonjudicial mechanisms "including tribunals, truth commissions, memorial projects, reparations and the like to address past wrongs, vindicate the dignity of victims and provide justice in times of transition."[2]

This conception of "justice" for a post-atrocity society has evolved over the years. "Justice, in transitional justice . . . has long meant retributive or criminal justice," as characterized by the push toward the development and use of international criminal tribunals to address mass atrocities in the 1990s.[3] Nevertheless, the success of less conventional mechanisms, such as the South African and East Timorese truth commissions, has led to a growing place for the idea of restorative justice—of "reestablishing social peace through the repair of relationships."[4] Whether focused on the past through formal criminal proceedings or on the present through informal conciliation and community building, these complementary visions of transitional justice are ultimately focused on preventing the recurrence of violence and creating a sustainable peace.

However, there is little theoretical or practical consistency in the approaches taken toward achieving this vision of transitional justice. Numerous factors may influence the choice of approaches, such as the particular circumstances of the affected society or international political will and mobilization.[5] But these approaches and the mechanisms of their implementation are not mutually exclusive. While each mechanism may address some aspects of the atrocities committed, a combination may address the needs of a society or conflict. For instance, transitional justice efforts that were undertaken in the aftermath of the eleven-year civil war in Sierra Leone included a hybrid criminal tribunal based on international and domestic law, a consequence of the conflict having been ended by government forces working with UN peacekeepers as well as British military involvement. A truth commission was also set up at the insistence of civil society and as a guarantee of accountability due to the likelihood of amnesties. Additionally, a human rights commission was created, institutional reform of the security agencies was carried out by the UN and the British Commonwealth Community Safety and Security Project, and UN-funded reparations programs offered monetary compensation and emergency medical and educational services to affected populations.[6] Other, longer-term efforts included strengthening the media and civil society with the help of international nongovernmental organizations.[7]

Increasingly, cultural rights are addressed by transitional justice strategies, and there is a growing recognition of the specific needs of societies that have faced the destruction of cultural heritage. This chapter uses the framework of transitional justice and its approaches to cultural destruction to deepen the understanding of cultural ownership and belonging in relation to heritage. The discourse on what justice means in the context of cultural destruction is deepened by the recognition of how the cultural identity of individuals and groups molds, and is molded by, intentional destruction and projects of reconstruction. Ultimately, it allows a more holistic understanding of the link

between cultural heritage and identity—a link organically felt by groups and individuals, but also normatively conceptualized by law- and policymakers in addressing and redressing threats to culture.

Cultural Heritage as a Transitional Justice Strategy

Where intentional cultural destruction has been a characteristic of an armed conflict or repression, some transitional justice mechanisms have addressed aspects of cultural heritage or cultural rights in formulating their strategies for the recovery of these damaged societies. The reasons for doing so are manifold. Recognizing the occurrence of past atrocities, including, among others, cultural destruction, may be an essential first step for establishing the factual record. This is often necessary to restore the dignity of victims and establish accountability for perpetrators—key objectives of retributive as well as restorative justice.

Further, where cultural destruction has been deliberately perpetrated with the intent to erode social cohesion among a targeted group, such recognition can assist in rebuilding that cohesion by delineating the space where there existed cultural markers upon which the group's identity was based. Significantly, in a psychological sense, recognition may offer a grant of legitimacy to the group and its identity, and also a narrative of cultural loss upon which social identity and cohesion may be rebuilt.[8]

For instance, East Timor's Commission for Reception, Truth and Reconciliation made specific note of the fact that "Indonesian practice in such areas as education, health and land rights violated the norms and integrity of East Timorese culture" and was in breach of the 1966 International Covenant on Economic, Social and Cultural Rights.[9] The truth commission and other post-conflict trust-building initiatives also reverted to reliance on Timorese intangible cultural heritage, in the form of traditional communal meetings, to initiate dialogue for both information and reconciliation.[10]

In recent years international criminal justice has also institutionalized the practice, dating back to the International Military Tribunal at Nuremberg, of recording and recognizing harm caused to cultural heritage as a crime.[11] The foundational instruments of tribunals such as the International Criminal Tribunal for the former Yugoslavia (ICTY) and the International Criminal Court (ICC) explicitly authorize prosecutions for "seizure of, destruction or wilful damage done to . . . historic monuments and works of art," and for "intentionally directing attacks against buildings dedicated to . . . art . . . or . . . historic monuments."[12] In its judgments, the ICTY frequently noted the nature and extent of cultural destruction, and in some cases its irreversibility—with the symbolism of such recognition forming an integral part of the justice sought. In *Prosecutor v. Jokić*, the ICTY noted that while the World Heritage Site of "the Old Town of Dubrovnik was . . . an especially important part of the world cultural heritage," it was also "a 'living city' . . . and the existence of its population was intimately intertwined with its ancient heritage. Residential buildings within the city also formed part of the World Cultural Heritage site and were thus protected. Restoration of

buildings of this kind, when possible, can never return the buildings to their state prior to the attack."[13]

In some cases, addressing cultural crimes through restoration of cultural heritage may be useful to recreate a degree of normality in the wider region, and defuse tensions between formerly hostile factions, preventing cycles of violence. It has been observed that "in the Balkans and after the civil war in Spain, refugees and displaced people did not return to their former towns and villages until rebuilding of significant heritage sites occurred, even if this was many years later," and that engagement with heritage limits the emigration of victim communities, even during peace.[14]

Alternatively, tangible or intangible memorialization of loss permits state-sanctioned public displays of grief and anger, as well as constituting a widely accessible marker of group identity based on cultural loss. Again, this may vitiate the urge for social cohesion and catharsis through retributive cycles of violence.[15] In Rwanda, for instance, "places of education, healing and faith became places of butchery . . . because genocide embodies the inversion of human values." Sacred sites were defaced as massacres were carried out within, such as the church at Kibeho famed for its Marian apparitions. This site has since been reconsecrated and now functions as both a church and a memorial, with only a curtain separating the preserved skulls and bones of the genocide victims from view.[16] Such restored cultural heritage—and memorialization of past atrocities or past cultural losses—may serve also as sites of touristic interest and memory, bringing economic activity and investment to reduce the likelihood of instability, aiding the transition to a more lasting peace.[17]

Even in conflicts or repression without an element of explicit cultural loss, cultural heritage—which may be essential to the formation of narratives and self-identity—can be instrumentalized to reshape hostile group identities or to change the course of historical narratives that would otherwise foment violence. As part of its restorative goals and as an aspect of strategies to achieve long-term peace and stability, transitional justice pays attention to cultural matters such as historical accounts in education and memorialization of atrocities, even where there was no overt destruction of cultural heritage.[18] The report of the UN special rapporteur in the field of cultural rights on "memorialization processes" notes that "cultural rights have an important role to play in transitional justice and reconciliation strategies," and "the ways in which narratives are memorialized have consequences far beyond the sole issue of reparations," since "entire cultural and symbolic landscapes are designed through memorials and museums reflecting, but also shaping negatively or positively, social interactions and people's self-identities, as well as their perception of other social groups."[19]

Shaping cultural memory is particularly important in working toward nonrecurrence, a shared goal of retributive and restorative approaches to transitional justice. However, due consideration for multiple narratives, including local and nonofficial ones, as well as a clarity of purpose that emphasizes a peaceful and final

resolution, may be necessary in ensuring that such memorialization does not itself become a source of fresh tensions.[20]

The inclusion of cultural heritage within transitional justice approaches thus offers a strategic use of the power of cultural identity to rebuild or reshape a society's conception of itself. Such narratives, if offered with sensitivity and inclusivity toward those affected by mass atrocities, can be important in transitioning to a sustainable peace.

At Cross-Purposes: Transitional Justice and International Cultural Heritage Law

By incorporating cultural heritage within its range of strategies, transitional justice draws attention to internal conflicts in the international law, and international conceptions, of "cultural heritage." The tension between the terminology of "cultural heritage" and "cultural property" is itself long standing in international law. One understanding is that it is a proxy for a deeper tension between competing notions of cultural ownership: on one hand that of ownership by the international community of states (or others), as exemplified by the use of phrases such as "cultural heritage of all [hu]mankind" in the main cultural heritage treaties;[21] and on the other the conception of ownership by the individual state within whose current geographical boundaries the tangible manifestations of culture may lie.[22]

Elements of the cultural nationalist model persist in the international law concerning cultural heritage, for instance treaties permitting only the territorial state to designate "their cultural property" as worth protecting from looting[23] or armed conflict.[24] Nevertheless, this tension has largely been resolved in favor of the cultural internationalist model with the postwar creation of the UN Educational, Scientific and Cultural Organization (UNESCO). The adoption of its 1972 Convention Concerning the Protection of the World Cultural and Natural Heritage—which speaks of "world heritage of mankind as a whole" and establishes intergovernmental committees and funds for its protection—is sometimes seen as the high-water mark of this vision.[25]

Transitional justice, meanwhile, does not see the protection and restoration of cultural heritage as an end in itself, but as a means toward another end—that of reviving post-conflict or post-repression societies and protecting them from future atrocities. It skirts the internationalist–nationalist divide and tends to be focused on the communities (and geography) directly affected by conflict or repression: victim groups who remain in the geographical vicinity of the atrocities and those forcibly displaced by the atrocities, as well as new inhabitants of the geographical area.

While it is the dynamic between international and national actors that may give rise to these transitional justice mechanisms, the mechanisms themselves are considered to function with the best interests of the victims as their guiding rationale.[26] This victim-centric focus is often made evident in the functioning of these bodies. For instance, even though prosecution for the destruction of cultural property fell within the express terms of the ICTY statute, the tribunal acknowledged the harm caused to victim communities

by this crime in multiple cases. In *Prosecutor v. Strugar*, while noting that the "offence of damage to cultural property (Article 3 (d))" had occurred and that "such property is, by definition, of . . . great importance to the cultural heritage of every people," the tribunal highlighted that "even though the victim of the offence at issue is to be understood broadly as a 'people,' rather than any particular individual, the offence can be said to involve grave consequences for the victim."[27]

This approach differs significantly from the rules of international law relating to tangible cultural heritage. These tend to function within the internationalist paradigm, with the best interests of the property constituting cultural heritage as their guiding rationale, rather than the holistic interests of associated communities. This can, at times, put the two approaches in conflict. For instance, from a transitional justice perspective the listing of the Cape Floral Region in South Africa as a World Heritage Site has been criticized for decontextualizing and providing value-neutral heritage status to a property which includes a colonial botanical garden and an apartheid-era hedge used to physically and visually separate the colonists' settlement areas from the local population. While the UNESCO listing guarantees a certain standard of conservation, and a stream of tourist revenue, the international law structures in place do not appear to embrace a connection with the negative cultural memories associated with the site.[28]

The differentiating factor lies in the recognition of cultural embeddedness. The focus in international cultural heritage law on the internationalist–nationalist dichotomy is an extension of traditional international law's overwhelming emphasis on the state. This tends to overshadow the third and most proximate layer of cultural ownership and belonging—that of the community (or communities) in which the cultural heritage is embedded.[29] Such embeddedness may come about through the interweaving of tangible sites and objects with intangible cultural heritage or community life, forming a living culture. Such interweaving may itself be the consequence of perceived or actual historical continuity, or even of mere geographical proximity. The crucial distinction is whether individual and group identity, as well as social cohesion, are inextricably connected to the tangible cultural heritage or whether they can survive the loss.

The destruction at the Palmyra site in Syria, for instance, had a global resonance, as one of the oldest archaeological marvels of humanity. In many ways, it was the archetypal UNESCO World Heritage Site, seen to stand at the "crossroads of several civilizations."[30] It also spurred transnational interest in Western countries, not only among archaeologists and classicists but even the public, in no small part due to its Greco-Roman roots and perceived historical connection with Western civilization. Technologically advanced reconstructions have been created and exhibited in New York, London, Luxembourg, and Washington, DC.[31]

Meanwhile, the Syrian state has concertedly deployed Palmyra within its national narrative as a marker of collective identity, with the monuments featuring on banknotes. Syrian refugees have rebuilt miniature models from memory,[32] and the government has announced on several occasions an intention to rebuild the site.[33] But

Palmyra also served for many generations as a backdrop to everyday life for local communities who lived in nearby settlements, including a bustling tourist town. For them, the loss is felt viscerally as not only that of their houses and livelihoods, but also of the landscape they know as home.[34] Felt as deeply is the impact of its loss on the family of Khaled al-Asaad, Palmyra's former head of antiquities. Al-Asaad's son and son-in-law, both archaeologists, fled the city with over 400 antiquities loaded on trucks, but al-Asaad, who had stayed behind to safeguard the remaining structures, was killed. His daughter, named Zenobia after the last queen of Palmyra, describes a childhood spent amid the ruins—but also states emphatically that she cannot conceive of ever returning.[35] The vernacular of international cultural heritage law, however, is incapable of distinguishing between these varied affective experiences of cultural loss, and its dual categorization as the international and national elides the multiplicity of global and local experiences.

That international law should fall short in accounting for the embeddedness of culture in communities is no surprise, given the primacy of the state in its worldview. In a case involving a disputed temple on the Thai–Cambodian border, for instance, Judge Antônio Augusto Cançado Trindade of the International Court of Justice highlighted the disjuncture between international human rights law's claims of universalized protection for peoples and their cultural heritage on the one hand, and international law's inherent deference to statehood on the other. Observing that the armed hostilities leading to the case had erupted due to Thailand's opposition to Cambodia's unilateral inscription of the temple on the UNESCO World Heritage List, the judge noted that "despite the wealth of information placed before it by the Parties concerning the fate and the need of protection of people in territory, the Court repeatedly insisted on respect for 'sovereignty' and 'territorial integrity.'"[36] Therefore the principal judicial organ of the United Nations created a provisional demilitarized zone for the latter reason, rather than for the protection of "the populations that live thereon, as well as the set of monuments found therein."[37] This abstraction undermined an understanding that international law norms such as "territorial sovereignty [ought] to be exercised to secure the safety of local populations . . . in cooperation with the other State concerned, as parties to the World Heritage Convention, for the preservation of the Temple at issue as part of the world heritage . . . and to the (cultural) benefit of humankind."[38]

Transitional justice, by contrast, is far more concerned with embeddedness in assessing harm caused to cultural heritage, and by extension to a people. This extends from assessing whether an instance of cultural destruction falls within the scope of crimes suffered by an individual or group, to determining to whom reparations are due and to formulating reconstruction or memorialization strategies for restoring community life. In its reparations order in *Prosecutor v. Al Mahdi*, for example, the ICC invited expert submissions to determine who might constitute the "victims" of the cultural crimes in question—the destruction of Timbuktu's heritage mosques and mausoleums—and thus toward whom reparations should be directed. It concluded that

although the international community and the national community of Mali were victims within the understanding of international cultural heritage law, the reparations would only be directed toward those most directly affected—the guardian families and faithful local inhabitants. It was considered "self-evident that the community of Timbuktu suffered disproportionately more harm as a result of the attack on the Protected Buildings."[39]

The transitional justice approach to redressing cultural destruction may thus, at first sight, appear to fulfill Cançado Trindade's ideal of "bringing territory, people and human values together."[40] However, it can also at times privilege embeddedness to the exclusion of certain kinds of cultural heritage and, by extension, the cultural rights of concerned groups.

Places without People: Embeddedness as the Cause of Exclusion

Transitional justice's focus on embeddedness may not always guarantee enhanced protection for the cultural rights of individuals and groups. In some instances, a perceived lack of embedded interests, disinterest, or contestation may lead transitional justice approaches to overlook the protection of local cultural heritage in favor of what are considered the more pressing needs of victim communities. Such a calculus does not necessarily factor in the cost to groups who may be less embedded, yet still have a vested interest in the cultural heritage and associated cultural rights.

One example is the division of Cypriot heritage sites in Nicosia and Famagusta, on either side of the UN buffer zone and Green Line. This physical separation has split the region's cultural identities and caused these heritage sites to lack embeddedness in either of the two mutually exclusive communities created. The collective memories they embody are either disjunctive with the monoethnic identities now sought to be created or, in cases where the local population consists of newly "resettled" groups from mainland Turkey, disconnected from them. This has led to their neglect by the communities on either side of the divide,[41] while transitional justice approaches to the conflict have left the issue unaddressed as well.[42] In fact, a decontextualized focus on cultural heritage as an end in itself may have better preserved memories of a historically contiguous past for Cypriots on either side, as well as for the peoples of the greater Mediterranean region.

Similarly, the reconstruction of the Bamiyan Buddhas in Afghanistan has suffered from a perceived lack of connection with the national and local community. Although their destruction in 2001 galvanized international attention and led to UNESCO's seminal Declaration Concerning the Intentional Destruction of Cultural Heritage in 2003,[43] repeated assurances of reconstruction by the Afghan government have come to naught. In the ICC's *Al Mahdi* case, expert submissions noted that the Buddhas had neither function nor meaning in modern Afghan life, and their destruction had "little or no impact on the modern Afghan community."[44] Consequently, this cultural reconstruction was of low priority in an ongoing conflict.

Nevertheless, this left transnational cultural claims to the heritage unaddressed, as the Buddhist community in countries such as Sri Lanka, Thailand, and Japan had been negatively affected by the destruction and had expressed deep interest in supporting reconstruction.[45] Afghans in the immediate geographical vicinity of the Buddhas too had expressed their sense of dislocation at the sudden erasure of a dramatic facet of their home landscape, not to mention the loss of livelihoods through the drying up of tourism. One of the locals forced to assist the Taliban in its destruction described them as having been "a source of pride for all Bamiyan," and that destroying them had been "like taking an axe to [his] own house"; having to continue living within sight of the ruins was said to be deeply affecting.[46]

In fact, one perspective on transitional justice considers even the reconstruction of Palmyra unnecessary insofar as the best interests of local communities are concerned.[47] Admittedly, there is little historical continuity between the modern communities and the Palmyrene Semitic and Greco-Roman civilizations. It could be argued that social cohesion might be better served through privileging the reconstruction of such small-scale heritage sites in Syria as the Mar Elian monastery, or the traditional jasmine-covered courtyard houses of Aleppo, in the physical structures of which a greater degree of local identity was vested.[48] However, such an approach would negatively affect the cultural rights of the larger Syrian national community as well as the international community, while undermining the impact of geographical proximity in fostering embeddedness among the local communities. The reliance of Syrian refugees on the iconography of Palmyra in commemorative art projects is testament to the impact of its physical presence on their memories of home and self, even without more characteristic features of embeddedness.[49] It may even be developing new meaning for the Syrian diaspora as a symbol of their losses, creating a deeper bond than that which existed before the conflict.

Conserving culture for the sake of culture may even have unexpected outcomes for local communities and consequently for transitional justice. Cultural heritage can carry meaning(s) across both time and space. Even where continuity with historical heritage has been broken, there are instances where this link has been reestablished, during or after the changes wrought by conflict. Conservation strategies for cultural heritage sometimes posit the involvement of the local community in heritage management as being more likely to ensure the effective conservation of heritage in the long term. This may have the additional benefit of binding in the local communities, through livelihood and a sense of ownership, even where such links did not earlier exist.[50] This recreated embeddedness can aid in the healing and social cohesion of these societies, which forms one of the primary goals of any transitional justice approach.

For instance, in Mexico's Chiapas state, home to Maya ruins and one of the largest Indigenous populations in the country, it has been noted that "the existence of a cultural break or discontinuity after the Conquest between the Indigenous communities and [archaeological] sites was usually taken for granted, given that many of the

archaeological sites had already been abandoned for a long time when the Spanish arrived in the sixteenth century."[51] Archaeological management of these sites remained unaffected by the Zapatista armed rebellion in the region. In the aftermath of the conflict, there was a "re-appraisal of Indigenous traditions and beliefs, and a consequent resurgence of pride in different communities."[52] Indigenous communities began to identify as "Maya," and reestablished a sense of cultural ownership over ancient Maya sites such as the World Heritage Site of Palenque. They began taking a more active part in their management and benefited economically from a burst of post-conflict tourism and commercial activity in relation to these sites—to the mutual benefit of the cultural heritage and the transitional communities.[53]

This is not to say that transitional justice should privilege heritage protection over the immediate needs of local communities, if hard choices are necessary. To choose stones over people could be considered as running counter to the pluralistic but ultimately humanitarian visions of justice. Yet, an overemphasis on the local and immediate insofar as multifaceted questions of cultural heritage and identity are concerned may risk failing to redress the full spectrum of cultural damage wrought. It can fall short of the restorative ideal of transitional justice by delegitimizing claims of cultural loss and identity that may fall beyond the bounds of an externally-imposed vision of the "local."[54] From the perspective of international cultural heritage law, this can eventually denude the heritage itself of a layer of associated cultural value since it is the varied cultural meanings ascribed to immovable sites that makes them "cultural heritage."[55]

Conclusion

In a society that is transitioning out of mass atrocities, the distinct aims of both transitional justice and international cultural heritage law are ultimately oriented toward and best achieved through a peace that is sustainable and effective over the long term. Such a peace, premised on not only ending but also preempting violence, calls for an approach to cultural heritage that is responsive to the simultaneous narratives, multiple identities, and unpredictable associations that link people with culture. Neither transitional justice nor international cultural heritage law provides easy or immediate solutions in this regard. Both frameworks have their own set of goals and concomitant priorities that influence how they confront the interlinking of cultural heritage with identity and, by extension, the cultural rights of individuals and groups. While neither framework can entirely encapsulate these multilayered associations, each works within its paradigm to safeguard different aspects of these structures of cultural meaning.

The challenge for the independent but connected trajectories is that privileging one frame of reference in relation to cultural heritage at threat may wipe out the parallel claim of another. In contrast, a contextually flexible approach that recognizes and gives due weight to the many concentric and overlapping (and sometimes conflicting) circles of cultural interest, ownership, and belonging might offer a means of addressing the

dynamic challenges of preserving cultural heritage at risk and the troubled past of associated communities, while working toward a peaceful future.

SUGGESTED READINGS

Oumar Ba, "Who Are the Victims of Crimes against Cultural Heritage?," *Human Rights Quarterly* 41, no. 3 (2019): 578–95.

Patty Gerstenblith, "The Destruction of Cultural Heritage: A Crime against Property or a Crime against People?," *John Marshall Review of Intellectual Property Law* 15, no. 336 (2016): 336–93.

Wendy Lambourne, "Transitional Justice and Peacebuilding After Mass Violence," *International Journal of Transitional Justice* 3, no. 1 (2009): 28–48.

Lucas Lixinski, "Cultural Heritage Law and Transitional Justice: Lessons from South Africa," *International Journal of Transitional Justice* 9, no. 2 (2015): 278–96.

Marina Lostal, *International Cultural Heritage Law in Armed Conflict: Case-Studies of Syria, Libya, Mali, the Invasion of Iraq, and the Buddhas of Bamiyan* (Cambridge: Cambridge University Press, 2017).

NOTES

1. Working Group on Transitional Justice and SDG16+, *On Solid Ground: Building Sustainable Peace and Development After Massive Human Rights Violations* (New York: International Center for Transitional Justice, May 2019), 4, 6.
2. Susanne Buckley-Zistel et al., "Transitional Justice Theories: An Introduction," in *Transitional Justice Theories*, ed. Susanne Buckley-Zistel et al. (London: Routledge, 2014), 1.
3. Christalla Yakinthou, *Transitional Justice in Cyprus: Challenges and Opportunities* (Berlin: Berghof Foundation and SeeD, 2017), Security Dialogue Project, background paper, 20.
4. Yakinthou, *Transitional Justice in Cyprus*, 21.
5. Buckley-Zistel et al., "Transitional Justice Theories," 1.
6. Mohamed Gibril Sesay and Mohamed Suma, *Transitional Justice and DDR: The Case of Sierra Leone* (New York: International Center for Transitional Justice, 2009), 15–17.
7. Mohamad Suma and Cristián Correa, *Report and Proposals for the Implementation of Reparations in Sierra Leone* (New York: International Center for Transitional Justice, 2009), 6, 10–12.
8. Lucas Lixinski, "Cultural Heritage Law and Transitional Justice: Lessons from South Africa," *International Journal of Transitional Justice* 9, no. 2 (2015): 278, 296.
9. Commission for Reception Truth and Reconciliation in East Timor (CAVR), *Chega! Final Report of the Commission for Reception, Truth and Reconciliation in Timor-Leste* (Dili, East Timor: CAVR, 2005), ch. 7.9, para. 12, https://www.etan.org/etanpdf/2006/CAVR/07.9-Economic-and-Social-Rights.pdf; and UN General Assembly, International Covenant on Economic, Social and Cultural Rights, 16 December 1966.
10. Luiz Vieira, *The CAVR and the 2006 Displacement Crisis in Timor-Leste: Reflections on Truth-Telling, Dialogue, and Durable Solutions* (New York: International Center for Transitional Justice, 2012), 11.
11. International Military Tribunal, *Göring and Others*, Judgment and Sentence (Nuremberg Judgment), 1 October 1946, in Trial of the Major War Criminals before the International Military Tribunal, Nuremberg, 14 November 1945–1 October 1946, 117.

12. UN Security Council, Statute of the International Tribunal for the Prosecution of Persons Responsible for Serious Violations of International Humanitarian Law Committed in the Territory of the Former Yugoslavia since 1991, UN doc. S/25704 at 36, Annex (1993), 3 May 1993 (adopted by the Security Council on 25 May 1993, UN doc. S/RES/827), Art. 3.d; and Rome Statute of the International Criminal Court, circulated as doc. no. A/CONF.183/9, 17 July 1998, Art. 8.2.b.ix.

13. ICTY, *Prosecutor v. Jokić*, Judgment, case no. IT-01-42/1-S, 18 March 2004, paras. 51–52.

14. Marina Lostal and Emma Cunliffe, "Cultural Heritage That Heals: Factoring in Cultural Heritage Discourses in the Syrian Peacebuilding Process," *The Historic Environment: Policy & Practice* 7, nos. 2–3 (2016): 3.

15. Thomas G. Weiss and Nina Connelly, *Cultural Cleansing and Mass Atrocities: Protecting Cultural Heritage in Armed Conflict Zones*, Occasional Papers in Cultural Heritage Policy no. 1 (Los Angeles: Getty Publications, 2017), 13, https://www.getty.edu/publications/occasional-papers-1/.

16. Annette Becker, "Dark Tourism: The 'Heritagization' of Sites of Suffering, with an Emphasis on Memorials of the Genocide Perpetrated against the Tutsi of Rwanda," *International Review of the Red Cross* 101, no. 910 (2019): 325.

17. Becker, "Dark Tourism," 326–27.

18. UN Human Rights Council, *Report of the Special Rapporteur in the Field of Cultural Rights, Farida Shaheed: Memorialization Processes*, UN doc. A/HRC/25/49, 23 January 2014, 3–5; and Lixinski, "Cultural Heritage Law and Transitional Justice," 285.

19. UN Human Rights Council, *Report of the Special Rapporteur*, 4.

20. UN Human Rights Council, *Report of the Special Rapporteur*, 9.

21. Convention for the Protection of Cultural Property in the Event of Armed Conflict with Regulations for the Execution of the Convention (1954 Hague Convention), 14 May 1954, Preamble.

22. John Henry Merryman, "Two Ways of Thinking about Cultural Property," *American Journal of International Law* 80, no. 4 (1986): 831; and Marina Lostal, *International Cultural Heritage Law in Armed Conflict: Case-Studies of Syria, Libya, Mali, the Invasion of Iraq, and the Buddhas of Bamiyan* (Cambridge: Cambridge University Press, 2017), 60.

23. Convention on the Means of Prohibiting and Preventing the Illicit Import, Export and Transfer of Ownership of Cultural Property, 14 November 1970, Art. 5.

24. 1954 Hague Convention, Art. 3.

25. Craig Forrest, "Cultural Heritage as the Common Heritage of Humankind: A Critical Re-evaluation," *Comparative and International Law Journal of Southern Africa* 40, no. 1 (2007): 124, 129; and Convention Concerning the Protection of the World Cultural and Natural Heritage, 16 November 1972, Preamble, and Arts. 8, 15.

26. Simon Robins, "Towards Victim-Centred Transitional Justice: Understanding the Needs of Families of the Disappeared in Postconflict Nepal," *International Journal of Transitional Justice* 5, no. 1 (2011): 77.

27. ICTY, *Prosecutor v. Strugar*, Judgment, case no. IT-01-42-T, 31 January 2005, para. 232.

28. Lixinski, "Cultural Heritage Law and Transitional Justice," 289.

29. The exception to this is the UNESCO Convention for the Safeguarding of the Intangible Cultural Heritage, 17 October 2003, Arts. 2.1, 11, 14, 15.

30. UNESCO, "Site of Palmyra" (World Heritage List, 1980), https://whc.unesco.org/en/list/23/.

31. Institute for Digital Archaeology, "Triumphal Arch in the News," http://digitalarchaeology.org.uk/media; and Vanessa H. Larson, "At the Sackler Gallery, Take a Virtual-Reality Tour of Cities Ravaged by ISIS and War," *Washington Post*, 5 March 2020, https://www.washingtonpost.com/goingoutguide/museums/at-the-sackler-gallery-take-a-virtual-reality-tour-of-cities-ravaged-by-isis/2020/03/04/593250c4-58e8-11ea-9b35-def5a027d470_story.html.

32. Charlie Dunmore, "How Art Is Helping Syrian Refugees Keep Their Culture Alive," *Guardian*, 2 March 2016, https://www.theguardian.com/global-development-professionals-network/2016/mar/02/art-helping-syrian-refugees-keep-culture-alive.

33. Kareem Shaheen and Emma Graham-Harrison, "Palmyra Will Rise Again: We Have to Send a Message to Terrorists," *Guardian*, 26 March 2016, https://www.theguardian.com/world/2016/mar/26/palmyra-restoration-isis-syria.

34. Ruth Maclean, "Desecrated but Still Majestic: Inside Palmyra after Second ISIS Occupation," *Guardian*, 9 March 2017, https://www.theguardian.com/world/2017/mar/09/inside-palmyra-syria-after-second-isis-islamic-state-occupation.

35. Kanishk Tharoor and Maryam Maruf, "Museum of Lost Objects: The Temple of Bel," BBC, 1 March 2016, https://www.bbc.com/news/magazine-35688943.

36. ICJ, "Request for Interpretation of the Judgment of 15 June 1962 in the Case Concerning the *Temple of Preah Vihear (Cambodia v. Thailand)* (Cambodia v. Thailand), Request for the Indication of Provisional Measures, Order of 18 July 2011, Separate Opinion of Judge Cançado Trindade," para. 97.

37. ICJ, "Request for Interpretation of the Judgment of 15 June 1962 in the Case Concerning the *Temple of Preah Vihear (Cambodia v. Thailand)* (Cambodia v. Thailand), Judgment of 11 November 2013, Separate Opinion of Judge Cançado Trindade," para. 30.

38. ICJ, *Temple of Preah Vihear*, para. 12.

39. ICC, *Prosecutor v. Ahmed Al Faqi Al Mahdi*, Reparations Order, case no. ICC-01/12-01/15, 17 August 2017, paras. 52–56.

40. ICJ, "Request for Interpretation, Judgment of 11 November 2013, Separate Opinion of Judge Cançado Trindade," para. 33.

41. Carlos Jaramillo, "Memory and Transitional Justice: Toward a New Platform for Cultural Heritage in Post-war Cyprus," *Santander Art and Culture Law Review* 1, no. 2 (2015): 199, 205, 207, 209, 213.

42. See Yakinthou, "Transitional Justice in Cyprus," 17–18, 20–21.

43. UNESCO Declaration Concerning the Intentional Destruction of Cultural Heritage, doc. no. 32/C Res., 17 October 2003, 62.

44. ICC, *Prosecutor v. Al Mahdi*, Application by Queen's University Belfast Human Rights Centre and the Redress Trust for Leave to Submit Observations Pursuant to Article 75(3) of the Statute and Rule 103 of the Rules, 2 December 2016, para. 44.

45. ICC, *Prosecutor v. Al Mahdi*.

46. BBC, "The Day I Blew Up the Bamiyan Buddhas," 16 March 2016.

47. Michael D. Danti et al., *ASOR Cultural Heritage Initiatives: Planning for Safeguarding Heritage Sites in Syria and Iraq—Weekly Report 87–88, March 30–April 12, 2016)*, 2.

48. Emma Loosley, "Re: Destruction of Dayr Mar Elian ssh-Sharqi, Qaryatayn, Syria by IS in August 2015," Submission to OHCHR [Office of the UN High Commissioner for Human Rights] Study on Intentional Destruction of Cultural Heritage, https://www.ohchr.org/Documents/Issues/CulturalRights/DestructionHeritage/NGOS/E.Loosley.pdf; and BBC Radio 4, "Return to Aleppo," *Museum of Lost Objects*, 28 July 2017, https://www.bbc.co.uk/programmes/b08zmf1l.

49. Humam Alsalim and Rami Bakhos, "Cultural Beheading," http://www.studentshow.com/gallery/26282319/Cultural-Beheading; and Dunmore, "How Art Is Helping Syrian Refugees."

50. See UNESCO, "World Heritage, Sustainable Development and Community Involvement," https://whc.unesco.org/en/sdci/.

51. Valerie Magar, "Armed Conflict and Culture Change in Chiapas, Mexico," in *Cultural Heritage in Post-war Recovery*, ed. Nicholas Stanley-Price, ICCROM Conservation Studies 6 (Rome: International Centre for the Study of the Preservation and Restoration of Cultural Property, ICCROM, 2007), 83.

52. Magar, "Armed Conflict and Culture Change in Chiapas, Mexico," 82.

53. Magar, "Armed Conflict and Culture Change in Chiapas, Mexico," 83–84.

54. See Adam Kochanski, "The 'Local Turn' in Transitional Justice: Curb the Enthusiasm," *International Studies Review* 22, no. 1 (2020): 27.

55. Laurajane Smith, *Uses of Heritage* (London: Routledge, 2006), 3.

PART 4

Cultural Heritage and International Law

Introduction: Part 4

James Cuno

Thomas G. Weiss

The earlier chapters in this book have provided much of the historical and social scientific foundation that undergirds the largely legal endeavors to protect cultural heritage since the nineteenth century. Both hard and soft legal measures figure in the six distinct perspectives found in part 4's chapters, which detail the main sources of public international law as they apply to cultural heritage and mass atrocities.

It begins with a comprehensive overview in chapter 21, "Protecting Cultural Heritage: The Ties between People and Places." Patty Gerstenblith, a distinguished professor at DePaul University's College of Law, applies her analytical skills and policy experience in national and international capacities to the legal instruments that circumscribe this volume's overall emphasis on the links between assaults on cultural heritage and mass atrocities (under the rubrics of genocide, crimes against humanity, and war crimes). Among her many insights is the crucial importance of moving from a preoccupation with cultural heritage as "objects" (or property owned by a specific entity) to their interpretation as a basic human right. Gerstenblith examines the relevance of the emerging norm of the responsibility to protect (R2P) for the protection of cultural heritage; from the perspective of legitimacy and feasibility, she evaluates military intervention, criminal responsibility, involvement of nonstate actors, and safeguarding heritage. One part of the three-pronged responsibility that originally framed R2P is the crucial importance of reconstruction, which is applicable to cultural heritage in particular, and post-conflict economies in general. To be successful, such efforts should reflect the necessity for cooperation and understanding from and genuine participation by local communities, a theme that reinforces the experience depicted in several of the cases examined earlier in this volume. In her view, the activities and projects of international organizations and outside donors can be problematic because almost invariably they are administered from the top down rather than the bottom up. She stresses the critical inputs from those who have experienced, and perhaps continue to experience, the effects of catastrophic heritage destruction. Indeed, she argues, attempts to address the aftermath of cultural heritage destruction must successfully juggle local, regional, national, and international perspectives. Gerstenblith concludes emphatically: "Only such a multifaceted approach is likely to succeed."

The authors of chapter 22, "International Humanitarian Law and the Protection of Cultural Property," are Benjamin Charlier, senior legal advisor on international humanitarian law at the International Committee of the Red Cross, and Tural Mustafayev, associate program specialist for culture and emergencies at the UN Educational, Scientific and Cultural Organization (UNESCO). This team of policy analysts with strong legal training spells out the comprehensive nature of the codified provisions of international humanitarian law since the first sketches of the Lieber Code were drafted during the US Civil War. They note that deliberate destruction and collateral damage in recent armed conflicts have attracted increasing academic scrutiny as well as public attention. They caution against overlooking less well-known and less visible sites and monuments, such as local cemeteries and architecturally unexceptional places of worship. While not attracting the widespread media coverage that can trigger international attention and action, such heritage is crucial to the lives of ethnic, religious, and cultural groups worldwide; they too merit international concern. Charlier and Mustafayev are clear about the rationale: "there is an inherent link between the protection of cultural property during armed conflict and the protection of human beings," and this protection is "a humanitarian imperative." They also join others in stressing the need for more ratifications of existing treaties and for political pressure to foster their implementation. Like the other legal and nonlegal voices in this volume's chorus, they counsel steering away from additional efforts to fine tune elements of the law because "a comprehensive framework exists under international law, both treaty and customary." Charlier and Mustafayev conclude on a positive note in looking toward the future: "As a side effect of publicized intentional destruction of cultural sites and looting of artifacts in recent armed conflicts, public sensitivity to this issue is also arguably higher today than ever before. In our view, this creates an unprecedented opportunity ready to be capitalized on."

The authors of chapter 23, "International Human Rights Law and Cultural Heritage," are two scholars with substantial practical experience: Marc-André Renold, professor of art and cultural heritage law and director at the University of Geneva's Art-Law Centre, and Alessandro Chechi, a senior researcher there. They explore the synergy between human rights law and the protection of cultural heritage—that is, how international human rights law has contributed to the growth of international cultural heritage law, and vice versa. The discourse of "cultural property" and "cultural heritage" is fluid and evolving. The semantics are less consequential than ongoing efforts to prevent the erasure of memory and history. The authors note that over time the law has become enriched by the actions of such international organizations as UNESCO, which has integrated human rights as essential elements of cultural heritage protection in its normative discussions and operational projects. The authors also argue that the application of international human rights law is at least as pertinent as international humanitarian law for the effective protection of cultural heritage. "Belligerents target cultural heritage for reasons other than the destruction of the object: to destroy the

morale of the enemy, annihilate the communal identity of those for whom it has special significance, and undermine their (cultural) survival." The authors also point out that much localized destruction does not necessarily occur in armed conflicts but rather in the mistreatment by central governments of local communities such as the Uyghurs and Yezidis. Renold and Chechi point to the possible traction for enhancing the effective protection of cultural heritage afforded by the international goal setting and monitoring of the Sustainable Development Goals. The key is to make human rights a more integral part of the implementation of the UN's 2030 Development Agenda because they were insufficiently spelled out and emphasized in this international agreement negotiated in 2015.

The previous three chapters discussed the "hard" features of international humanitarian and human rights law agreed to by state parties, whereas chapter 24 continues with what are often referred to as the "soft" sources of international law. While they are not codified in black-and-white, these sources nonetheless affect the policies and actions of states. "Customs, General Principles, and the Intentional Destruction of Cultural Property" is the contribution by Francesco Francioni, one of the most authoritative commentators in this arena. He has worked for governments and international organizations and as a distinguished scholar (currently, professor emeritus at the European University Institute in Florence and professor of International Cultural Heritage Law at the LUISS University in Rome). Francioni argues that "in the past half century, international law on the protection of cultural heritage has undergone a spectacular development at the level of standard-setting." The cosmopolitan appreciation of and respect for the beliefs and practices of others provide the very foundations for customary international law as it applies to cultural heritage. Components of custom are often contested sources of law; however, they are not so in this case because so many experts agree about the nature of authoritative sources for this subject, and so many states have articulated their support for them and acted accordingly. As such, these voices provide ample evidence of the general obligations binding all sovereign members of the international community of states and acknowledged by them to prevent and avoid the destruction of cultural heritage. Francioni argues that the specific character of the customary norm or general principle of the obligation to avoid and prevent destruction of cultural heritage may imply that it preempts treaty law within some states' legal systems. As such, he sees custom and general principles as helpful tools to combat the nationalism and intolerance that threaten the universality of both cultural heritage and public international law.

The biggest difference between domestic and international law, for cultural heritage or other topics, is recognized to be the virtually total lack of enforcement capacity and inadequate compliance mechanisms for the numerous provisions of even "hard" international law. Chapter 25, "Prosecuting Heritage Destruction," is by Joseph Powderly, associate professor of public international law at Leiden University. He explores this gap and the fledgling but nonetheless consequential efforts to bridge it, as

well as various experiments with international criminal justice mechanisms, most specifically through the relatively recent actions by the International Criminal Court (ICC). While not yet a quarter-century old and with a single verdict related to the war crime of destroying cultural heritage, there still is evident and ample potential for its future application in the prosecution of cultural heritage as a possible crime against humanity as well as a recognized war crime. As for all public international law, precedents are essential considerations, and here Powderly states unequivocally: "The prohibition of the intentional, wanton destruction of tangible cultural heritage has an unimpeachable pedigree as one of the founding principles of the law of armed conflict." His historical overview prior to the contemporary ICC deliberations in The Hague begins with nineteenth-century precedents of the Lieber Code—"Abraham Lincoln's laudable, if admittedly naïve, attempt to limit the ravages of the American Civil War"—and the Hague Conventions. It continues with the League of Nations, the UN War Crimes Commission during and immediately after World War II, the postwar Nuremberg and Tokyo tribunals, and the International Criminal Tribunal for the former Yugoslavia. His essay provides the necessary context of international law's evolution as we think about the future trajectory of improved accountability for cultural heritage destruction, or how best to punish some criminals as well as to deter would-be iconoclasts in our era, the cultural aggressors acting in tandem with perpetrators of mass atrocities. While the ICC is a "cause for optimism," Powderly recognizes that "the future of accountability for heritage destruction must be before domestic courts" in order to attenuate this "stain on the very notion of humanity."

The final essay in part 4 is chapter 26, "Fighting Terrorist Attacks against World Heritage and Global Cultural Heritage Governance." The subject is explored by Sabine von Schorlemer, UNESCO chair in international relations and chair of international law, European Union law, and international relations at Technical University Dresden. The link between the destruction of cultural heritage and the plague of international terrorism explains the UN Security Council's growing interest and decisions. This relationship gathered momentum after the attacks on the United States of 9/11. The interest by many states in the topic of combatting terrorism reflects the vandalizing and looting of cultural heritage as a source of finance for nonstate actors. Ironically, despite decades of deliberations, neither the UN's General Assembly nor Security Council has an agreed definition of the term—captured by the adage that "my terrorist is your freedom fighter." In addition, the applicability of international law to nonstate actors is extremely limited. Nonetheless, concrete actions to combat the manifestations of terrorism and attacks on cultural heritage seem possible when the politics are right, when they form part of a security–cultural heritage nexus or a complex cross-sectoral problem to be addressed. As such, identifying the destruction of cultural heritage as a "threat to international peace and security" elevates the issue and provides the basis in the UN Charter for decisions by the world organization's most powerful entity. The "securitization" of heritage destruction by the Security Council has the advantage of

pushing important states to consider acting vigorously rather than remaining on the sidelines. Thus, there is the potential to transform the international legal tools created originally to protect cultural heritage from looting into instruments to combat terrorism more broadly. However, von Schorlemer also points to the downside—namely, that the "terrorist" label provides governments with a blank check for repression of dissidents of all stripes. That said, she still finds room for optimism in the shift from a state- to a "people-centered" approach to preventing heritage destruction.

21

Protecting Cultural Heritage: The Ties between People and Places

Patty Gerstenblith

In May 2015, members of the Islamic State of Iraq and Syria (ISIS, also known as ISIL or Da'esh) moved toward the Greco-Roman site of Palmyra, located in central-western Syria. Palmyra was denominated a World Heritage Site in 1980 by the UN Educational, Scientific and Cultural Organization (UNESCO) and placed on its List of World Heritage Sites in Danger in 2013, along with Syria's five other World Heritage Sites. The threat to Palmyra's ancient architectural elements was immediately recognized and their subsequent destruction condemned by the world cultural heritage community. ISIS's move against Palmyra was preceded by many atrocities, including murder and rape, as well as destructive activities at other cultural sites, particularly in northwestern Iraq, such as the ruins of the Neo-Assyrian cities of Nineveh, Nimrud, and Khorsabad, and the shrine of Nebi Yunus in Mosul. The outrage and helplessness of the international community seemed only to reinforce the desire of ISIS to inflict as much damage and in as public a way as possible to sites that were recognized for their great historical, cultural, and artistic significance. The largely ineffective outrage of the international heritage community has a venerable history going back to at least the mid-1990s, when it stood by helplessly as Croatian forces destroyed the Stari Most (Old Bridge) in Mostar in 1993 during the Balkan conflict and when the Taliban destroyed the Bamiyan Buddhas in Afghanistan in 2001. The suggestion that troops should be sent to intervene and protect these sites raises numerous and probably insurmountable problems.

This chapter examines the destruction of cultural heritage through the lens of human rights and then turns to the applicability of the responsibility to protect (R2P), analyzing in particular the feasibility of applying its third pillar in the attempt to preserve immovable heritage. The analysis links immovable cultural heritage to the people who live amid that heritage and the different communities to whom the heritage has

meaning and value. The UN's special rapporteur in the field of cultural rights has noted the difficulty of defining community within the context of cultural rights: "The term 'community' is too often assumed to suggest homogeneity, exclusivity, structure and formality. Such a construction is embraced not only by some outside observers not willing to recognize plurality and dynamism within groups, but also by often self-proclaimed 'representatives' of the concerned groups—or presumed groups—themselves."[1]

In the current context, the term "community" can refer to three distinct groups. First is the international or global community, which has an interest in the universal value of heritage. Second is the national or regional community, represented primarily by the state, which often wields the greatest power to determine the fate of heritage. And third is the local community, which consists of the people who live amid the heritage, who may be the descendants of those who produced the heritage, who may have the greatest spiritual, religious, and cultural affinity to the heritage, and who are also often in the best position to protect it.[2] The value of heritage needs to be recognized and heritage itself needs to be protected at four levels: the local, national, regional, and international.

Historical Background

In the 1790s, during the French Revolution, the Catholic priest Henri Grégoire coined the term "vandalism" to describe the destruction of cultural property, explaining that he "created the word to destroy the thing." As Joseph Sax commented, "Grégoire made cultural policy a litmus test of civilized values, and located it in the ideological geography of the French Revolution. The nation decides what it will be as it stands before its artistic, historical, and scientific monuments, hammer in hand."[3]

The Polish lawyer Raphael Lemkin later used the term "vandalism" to describe what we today might refer to as "cultural genocide." In 1933, he included cultural genocide as one of the eight dimensions of the crime of genocide: political, social, cultural, economic, biological, physical, religious, and moral, "each targeting a different aspect of a group's existence."[4] Lemkin described two acts, barbarism and vandalism, to be added to the list of acts against the law of nations. In his work "Acts of Vandalism" he wrote:

> An attack targeting a collectivity can also take the form of systematic and organized destruction of the art and cultural heritage in which the unique genius and achievement of a collectivity are revealed in fields of science, arts and literature. The contribution of any particular collectivity to world culture as a whole forms the wealth of all of humanity, even while exhibiting unique characteristics.

> Thus, the destruction of a work of art of any nation must be regarded as acts of vandalism directed against world culture. The author [of the crime] causes not only the immediate irrevocable losses of the destroyed work as property and as the culture of the collectivity directly concerned (whose unique genius contributed to the

creation of this work); it is also all humanity which experiences a loss by this act of vandalism.[5]

Cultural genocide was included in the first draft of what became the 1948 Convention on the Prevention and Punishment of the Crime of Genocide. Its elements included systematic destruction of historical or religious monuments or their diversion to alien uses and destruction or dispersion of documents and objects of historical, artistic, or religious value, and of objects used in religious worship.[6] Cultural genocide was ultimately omitted from the convention due to the objections of settler states, which were concerned that the granting of cultural rights would undermine their sovereignty.[7]

Nonetheless, the concept has seen a resurgence, particularly where cultural sites are targeted because of their identification with a religious or ethnic minority group. For example, the International Criminal Tribunal for the former Yugoslavia (ICTY) used the intentional targeting of mosques and other structures devoted to religious uses as a basis for establishing the genocidal intent of the Bosnian Serb leadership against the Bosnian Muslim population during the Balkan civil war of the 1990s.[8] In 2016, former US secretary of state John Kerry linked commission of genocide by ISIS with its destruction of religious sites of minority religious and ethnic groups, including Christians, Yezidis, and Shiite Muslims in northern Iraq and Syria, and its attempt "to erase thousands of years of cultural heritage by destroying churches, monasteries and ancient monuments."[9]

Human Rights and the Destruction of Cultural Heritage

Some commentators and legal scholars, particularly in the United States, consider the preservation of cultural objects or sites as the paramount value to be honored. For example, the late John Henry Merryman centered his work on the object itself and emphasized preservation, integrity, and distribution of (or access to) the physical or tangible embodiments of heritage as the preeminent considerations.[10] This associates the tangible object or site with a universal heritage that is of importance to all people, thereby challenging the idea of a definitive connection between tangible cultural heritage and the people who identify with it, their descendants, and also the people among whom the heritage had been located before its often violent extraction. It also undermines the claims of states and communities to a right of repatriation or restitution, other than in very limited circumstances, such as the object's use as part of an ongoing religious tradition, as judged from a Western outsider perspective.[11] The value of access in Merryman's conception seems otherwise limited to the type of access gained through display of cultural objects in museums.[12]

This approach denies a broader and more fundamental connection between living local communities and the heritage in their midst.[13] A human rights approach to cultural heritage requires us to move away from an object-centered cultural property policy and toward a human-centered perspective, recognizing that people and tangible

heritage are inextricably connected. Viewing cultural heritage through the lens of human rights assists us in reaching a more integrated understanding of the role that cultural heritage plays in the lives of human beings—the local community that lives amid the heritage, and the regional and national communities, as well as the world community.

Cultural heritage destruction is a war crime and is sometimes categorized as a crime against humanity when the destruction targets a particular ethnic, racial, or religious group with discriminatory intent.[14] The association of heritage sites with human values, identity, beliefs, and artistic endeavor turns what would simply be a crime against property into a crime against people, whether from a local, regional, or global perspective.[15] Cultural heritage often also serves as a link between diverse religious and ethnic communities, as did the bridge at Mostar, the site of Palmyra, the Mar Elian monastery near al-Qaryatayn, also in Syria, and the shrine of Nebi Yunus in Mosul.[16] Destruction of cultural heritage devastates both the cohesiveness and the diversity of multicultural, multiethnic populations.

The significance and uses of heritage deepen with the human dimension bestowed by local inhabitants over centuries. Salam al-Kuntar, a Syrian refugee scholar, has recounted her grandparents' life amid the ruins of Palmyra, where successive generations lived and where the pagan temple of Bel had evolved first into a Byzantine church, then into a mosque and a center of village life before the local population was expelled to allow Palmyra's reconstruction as an ancient site:[17] "When lamenting the masonry and sculpture destroyed by the Islamic State, we can easily overlook this shifting human story. We too readily consign antiquities to the remote province of the past. But they can remain meaningful in surprising and ordinary ways. 'This is the meaning of heritage,' Ms. Kuntar said. 'It's not only architecture or artifacts that represent history; it's these memories and the ancestral connection to place.'"[18]

Several sources of law now link cultural heritage to human rights. Legal instruments include the 1948 Universal Declaration of Human Rights, the 1966 International Covenant on Economic, Social and Cultural Rights, the 1966 International Covenant on Civil and Political Rights, and the 2007 United Nations Declaration on the Rights of Indigenous People.[19] The former special rapporteur in the field of cultural rights for the UN Human Rights Council, Karima Bennoune, also listed cultural heritage destruction among the threats to cultural rights. As she noted: "Cultural heritage is significant in the present, both as a message from the past and as a pathway to the future. Viewed from a human rights perspective, it is important not only in itself, but also in relation to its human dimension, in particular its significance for individuals and groups and their identity and development processes. Cultural heritage is to be understood as the resources enabling the cultural identification and development processes of individuals and groups which they, implicitly or explicitly, wish to transmit to future generations."[20]

The International Court of Justice (ICJ), for example, linked human rights and cultural heritage in *Cambodia v. Thailand*, a dispute concerning which country had

sovereignty over the Temple of Preah Vihear and sparked in its most recent iteration by inscription of the temple on the World Heritage List.[21] The border dispute had resulted in the loss of human life and endangered the historical structure. The court viewed the temple as having religious and cultural significance for all the people in the region and, as a site of continuing religious significance, the local people had a right of free access. In referring to both the temple's status as a World Heritage Site and as a religious and spiritual center for the local people, the ICJ acknowledged both the local and global significance of the site.[22] Judge Antônio Augusto Cançado Trindade argued, in particular, for the prevention of spiritual damage, drawing together the issues of territoriality, preservation of life, and the cultural and spiritual heritage dimensions. As he later described the ICJ's opinion, the court "encompassed the human rights to life and to personal integrity, as well as cultural and spiritual world heritage. . . . The Court's order went 'well beyond State territorial sovereignty, *bringing territory, people and human values together*,' well in keeping with the *jus gentium* of our times."[23] His opinion that the preservation of cultural heritage plays an important role in the spiritual and cultural lives of the local community who live amid the heritage leads to a melding of human values and cultural heritage preservation.

Atrocity Crimes and the Responsibility to Protect

The term "atrocity crimes" encompasses three legally defined international crimes, genocide, crimes against humanity, and war crimes, as well as a fourth offense, ethnic cleansing.[24] Preventing atrocity crimes protects human life and avoids "psychosocial and psychological damages and trauma."[25] Preventing such crimes also contributes to national, regional, and global peace and stability. Preserving cultural heritage does not directly contribute to preserving human life, although its destruction is often viewed as a precursor to genocide. However, cultural heritage clearly has both psychological and societal benefits through the formation of identity and the connection of people to the historical structures and cultural landscapes through which they access tradition, folklore, and religious experiences.[26] Destruction of cultural heritage is an action that makes ending conflict more difficult, while its protection helps to preserve peace, encourage stability, assist with reconciliation, and reduce tensions among formerly warring factions during post-conflict stabilization.

Articles 4.1 and 4.2 of the 1954 Hague Convention for the Protection of Cultural Property in the Event of Armed Conflict prohibit the intentional targeting of cultural property unless excused by imperative military necessity. Article 19 includes armed conflicts not of an international character in the core obligation to respect cultural property. Based on its wording, this obligation is interpreted to extend to nonstate actors, such as ISIS.[27] Article 15 of its 1999 Second Protocol explicitly requires state parties to criminalize grave violations of the Hague Convention, including intentional destruction. The statute of the ICTY established intentional destruction of cultural heritage as a distinct crime, citing the Hague Convention as evidence of customary

international law. While the 1949 Geneva Conventions do not discuss cultural property protection, the 1977 Additional Protocols prohibit acts of hostility directed against historical monuments, works of art, and places of worship in both international (Protocol I, Article 53) and non-international armed conflict (Protocol II, Article 16), but these provisions are subordinate to the 1954 Hague Convention because the latter law specifically focuses on the issue of cultural heritage.[28] The 1998 Rome Statute of the International Criminal Court (ICC) criminalizes as a war crime the intentional destruction of cultural property in both international and non-international armed conflict.[29] When the destruction of cultural heritage is part of a broader attack on a civilian population or is motivated by a discriminatory intent, it may also constitute a crime against humanity.[30]

According to the UN *Framework of Analysis for Atrocity Crimes* and some commentators, the obligation to ensure respect found in Common Article 1 of the Geneva Conventions imposes on all state parties, including those that are not directly involved in a conflict, "an obligation to prevent violations of international humanitarian law,"[31] thus establishing the basis for R2P, set out in the UN *2005 World Summit Outcome* document.[32] As further formulated in the 2009 report *Implementing the Responsibility to Protect*, the emerging norm encompasses three pillars.[33] In pillar one, each state bears primary responsibility for protecting its population from genocide, war crimes, ethnic cleansing, and crimes against humanity. In pillar two, the international community commits to assist states in fulfilling this responsibility by building capacity and assisting states before crises and conflicts occur. And finally, in pillar three, the international community has a responsibility to respond collectively using diplomatic, humanitarian, and other peaceful means through the United Nations when a state fails to protect its population. If peaceful means are inadequate and national authorities are manifestly failing to fulfill their responsibilities to protect their populations, then collective action may be taken by the Security Council under Chapter VII of the UN Charter, which permits military enforcement. The limitations set by R2P on an individual state's action outside its own territorial borders restrict what can be done by states to protect or prevent destruction of tangible heritage, particularly immovable heritage, even during times of crisis. While the desire to engage in such interventionist protective activity has a superficial appeal, it would fall outside both the applicable law and applicable norms with respect to cultural heritage protection.

In November 2015, the UNESCO Expert Meeting on the "Responsibility to Protect" as Applied to the Protection of Cultural Heritage in Armed Conflict described R2P as "not a legally binding obligation but a political concept, even if relevant obligations did exist under various bodies of international law."[34] Nonetheless, given the status of destruction of cultural heritage as a war crime and sometimes a crime against humanity, a consensus has developed that such destruction fits within the R2P norm.[35] Statements in various international legal documents indicate the interests of the international community in the preservation of cultural heritage across territorial

boundaries and that these may supersede some concerns with territorial sovereignty: the 1954 Hague Convention (in the preamble), the 1972 Convention Concerning the Protection of the World Cultural and Natural Heritage, Additional Protocols I and II to the Geneva Conventions, the statute of the ICTY (Article 3.d), and the 2003 UNESCO Declaration Concerning the Intentional Destruction of Cultural Heritage.[36] Whether protection of cultural heritage extends to pillar three of R2P, allowing for interventionist measures, is a different issue and one around which a positive consensus has not yet developed.

In considering the contours of the application of R2P to cultural heritage preservation, the expert group raised the concern of balancing protection of physical structures and sites with the protection of civilians. As their report commented, "the ultimate objective of protecting cultural heritage was the protection of the living culture of populations and humanity, of human rights and dignity, and of the interests of past and future generations."[37] This specifically links the tangible heritage with the intangible heritage of the populations that utilize or live amid heritage sites, thus emphasizing that the goal is to protect people. The report also reiterated that intentional destruction and misappropriation of cultural heritage can aggravate armed conflict, make achieving peace more difficult, hinder post-conflict reconciliation, and may also be a harbinger of other atrocity crimes including genocide.[38]

Incorporating Cultural Heritage Protection into R2P

In considering the specific ways in which R2P can be brought to bear on cultural heritage preservation, this section will focus on pillar three: the responsibility of the international community to respond collectively when a state fails to protect its population. It presents four proposals that will enable a more robust application of R2P to preserving cultural heritage within pillar three.

There are many actions that a third-party state may take to ensure respect for international humanitarian law. States often engage in protests and may engage in unilateral or collective measures to prevent violations. These include imposing economic sanctions,[39] such as a trade embargo, arms embargo, travel ban, and expulsion of diplomats. Many of these actions were taken by states during the Syrian conflict in an attempt to quell the massive human rights violations,[40] although most were not effective. States, intergovernmental organizations (IGOs) such as UNESCO and the UN more broadly, and nongovernmental organizations (NGOs), such as the Blue Shield and its constituent national committees, engaged in extensive protest against the destructive actions of the parties to the Syrian conflict. But, ironically, it is possible that such protests motivated ISIS to increase its destruction of cultural heritage as a performative act to garner world attention and to demonstrate the impotence of international institutions.[41] In line with UN Security Council resolutions 2199 and 2347, and pursuant to the 1970 UNESCO Convention on the Means of Prohibiting and Preventing the Illicit Import, Export and Transfer of Ownership of Cultural Property,

states adopted measures to prevent trade in antiquities looted from Iraq and Syria, as the looting provided funding for the conflict and terrorism while destroying archaeological sites and historical and religious structures.[42] Other measures that can be taken to protect cultural heritage in different forms include documentation of the damage done to cultural property and collections of movable cultural objects.

The first proposal presented here concerns military intervention. The most difficult question in applying R2P to the protection of cultural heritage is whether military intervention, invoking the use of lethal force, would be justified on the grounds that the state has failed in its obligation to prevent the war crime of the intentional destruction of cultural heritage. Some have argued that it would be justified,[43] others that it is not.[44] Military intervention, as a "blue helmet" option of using a UN force, was the first element of James Cuno's five-point proposal for protecting cultural heritage in Syria and Iraq.[45] Even if the possibility of military intervention to preserve cultural heritage were to be accepted as an application of R2P, such action can only be taken legitimately with Security Council authorization and is unlikely to succeed.[46]

As Helen Frowe and Derek Matravers argue, military intervention should not be undertaken solely to secure protection of cultural heritage, even though we can recognize the intertwined nature of people and heritage.[47] Often such intervention endangers human life, both of the intervenors and of innocent civilians who live amid the heritage. Sometimes we ignore the local populations, such as those living near the ancient site of Palmyra, and thereby discount the collateral harm that may be done to them. Heritage preservation may also not justify the killing of those attacking heritage unless such preservation is deemed likely to avert a greater harm such as genocide, further armed conflict, or terrorism.[48]

From a practical perspective, preservation of immovable heritage would require the long-term stationing of troops at cultural sites, magnifying the threat to life and failing the requirement that such intervention be reasonably likely to succeed.[49] While people and movable cultural objects can be preserved by moving them to safety, it is not possible to move heritage sites without destroying them. This would leave only the option of prolonged military intervention with increased risk of loss of life to save immovable cultural heritage while a political resolution to the armed conflict is found. Military intervention to protect cultural heritage should therefore be undertaken only as part of a larger strategy to take and hold territory or to protect civilian lives; to take territory on a temporary basis, perhaps while movable heritage is moved to a secure location; in conjunction with efforts to preserve human life or prevent serious injury to people where the protection of heritage is instrumental, rather than the only goal; or as part of peacekeeping efforts.

Security Council resolution 2100 condemned the destruction of cultural and historical heritage in Mali and established the Multidimensional Integrated Stabilization Mission in Mali (MINUSMA) for the purposes of peacekeeping and political stabilization. The mission's mandate included cultural preservation by "assist[ing] the transitional

authorities of Mali, as necessary and feasible, in protecting from attack the cultural and historical sites in Mali, in collaboration with UNESCO."[50] Cultural heritage preservation was thus put on a par with several other humanitarian and civil protection goals, including humanitarian assistance and promotion and protection of human rights, but clearly within the peacekeeping function of the stabilization force. Unfortunately, this part of the MINUSMA mandate was removed in its 2018 renewal, perhaps due to lack of capacity by the peacekeeping forces.

To be successful, such forces must include those who are knowledgeable about cultural heritage preservation and peacekeepers must be trained in the importance of cultural heritage for local populations, protection and emergency conservation of both movable and immovable heritage, and the need to avoid looting or purchasing looted or stolen cultural objects. Such training would be most appropriately carried out under the auspices of the Blue Shield, which has trained Fijian and Irish armed forces, which only deploy as peacekeepers, and has conducted such training with the UN Interim Force in Lebanon (UNIFIL) in the south of the country.[51] The US Committee of the Blue Shield, the Smithsonian Institution, and the University of Pennsylvania provided pocket guides on international law and heritage preservation to US, Iraqi, and Kurdish troops before the offenses to retake Mosul and later Raqqa from ISIS.[52] There are other examples of intermediary actions that could be taken short of military intervention. UNESCO and Italy entered into an agreement in 2016 to create a task force of experts that could be deployed to assist with conservation of cultural heritage during crises.[53] To some extent similar functions are being undertaken through NGOs such as the International Alliance for the Protection of Heritage in Conflict Areas (ALIPH), the Smithsonian Cultural Rescue Initiative, the International Council of Museums (ICOM), and Blue Shield International.

The second proposal to enable a more effective application of R2P within pillar three involves the criminalization of intentional destruction. While it is too complex a subject to be treated here in detail,[54] the crime of intentional destruction of cultural heritage was incorporated into the Rome Statute,[55] the ICTY statute, the Second Protocol to the 1954 Hague Convention, and the 2001 Cambodian Law on the Establishment of the Extraordinary Chambers in the Courts of Cambodia for the Prosecution of Crimes Committed during the Democratic Kampuchea.[56] In 2016, the ICC secured a conviction in its first case for intentional destruction in Mali (that of Ahmad al-Mahdi) and is in the process of prosecuting a second (al-Hassan Ag Abdoul Aziz).[57] However, ICC jurisdiction, like that of other international tribunals, is limited, for the most part, temporally to post-ratification conduct and territorially to ratifying states. In addition, the ICC recently gave the term "attack" that appears in the relevant provisions of the Rome Statute a narrow interpretation in the *Ntaganda* case, which may further limit the applicability of the Rome Statute.[58]

A state's failure to prosecute cultural heritage destruction could be viewed as another reason for other states or the Security Council to invoke R2P to ensure punishment for such crimes.[59] A more modern understanding of cultural heritage also

needs to be used in formulating the elements of the crime under international law. These elements should encompass tangible and intangible, movable and immovable heritage, and sacred and cultural landscapes, the latter of which would implicate environmental issues. The status of intentional destruction of cultural heritage, when accompanied by the requisite discriminatory or persecutorial intent, as a crime against humanity would allow the prosecution of such destruction outside the context of armed conflict.[60]

The third proposal is the development of a more effective coordination with nonstate armed groups. The NGO Geneva Call concluded, based on a study conducted in Syria, Iraq, and Mali, that IGOs, UNESCO in particular, were reluctant to engage with or provide assistance to even those nonstate actors that expressed willingness to preserve cultural heritage. While it is apparent that ISIS would not have been an appropriate partner, other nonstate armed groups, particularly those affiliated with the Free Syrian Army, undertook measures to protect heritage but were greatly in need of training, education, and supplies to effectuate this goal. These groups found UNESCO to be unresponsive to their requests,[61] even though Articles 19.3 and 19.4 of the 1954 Hague Convention anticipate that UNESCO would render this sort of assistance and explicitly state that this type of cooperation does not change the legal status of nonstate actors.

IGOs such as UNESCO are too beholden to or bound by the wishes of their member states: it is almost certain that a member state will oppose cooperation of any sort with a nonstate armed group operating within its territory even if the goal is observance of international humanitarian law. UNESCO needs to commit in advance of any conflict to working with those nonstate armed groups willing and interested in preserving heritage. Such cooperation is the necessary corollary if international humanitarian law is to hold them to the legal requirements that apply to states, as is increasingly occurring. Examples include the above-referenced ICC prosecutions of Ahmad al-Mahdi and al-Hassan for destruction of cultural heritage in Mali, as well as the unsuccessful 2015–19 prosecution of Bosco Ntaganda for intentional destruction of cultural heritage in the Democratic Republic of the Congo, although he was convicted on other counts. NGOs such as Blue Shield and Geneva Call are alternative intermediaries that can offer assistance to nonstate armed groups in heritage preservation when IGOs cannot or will not do so. But their efforts should be supported, not criticized or hampered.

The fourth and last proposal concerns refuges for heritage protection. Movable heritage can, by its nature, often be moved for safekeeping.[62] Although it is an element of the First Protocol of the 1954 Hague Convention, the notion of safe havens understandably triggers connotations of the "universal" museum. Prominent European museums benefited from the plunder and expropriation of cultural objects, such as the Benin bronzes and ivories, during periods of colonialism and armed conflict. The offer of such museums to serve as safe havens for movable cultural objects might appear to be a reincarnation of the same idea in a new guise. As Thomas G. Weiss and Nina Connelly note, "the use of safe havens will depend on trust,"[63] a sentiment that may be

in short supply based on history, rhetoric, and conduct by many museums. Nonetheless, a more robust international system would, at times, benefit the people and countries to whom the heritage belongs. In addition to the practical difficulties of funding and safe movement of heritage possibly through zones of conflict, the domestic laws of states that might be the recipients and guardians of such heritage are for the most part inadequate, posing obstacles of bureaucracy and concerns with immunity from seizure or legal process.

In 2008, the International Law Association (ILA) proposed "Guidelines for the Establishment and Conduct of Safe Havens for Cultural Materials," which established standards for legislation to be adopted by individual states.[64] On 24 March 2017, in resolution 2347, Article 16, the Security Council encouraged states to create a network of safe havens within their own territory as another means of protecting cultural heritage. Switzerland enacted legislation in 2014 which, while helpful, poses practical obstacles such as requiring a treaty between Switzerland and the depositor country, something that could likely not be done in a period of crisis.[65] Alessandro Chechi points out that the Swiss legislation departs from the ILA guidelines, in particular by not requiring storage and display in accord with the laws and traditions of the state of origin.[66]

In 2016, the United States enacted legislation to provide refuge with an automatic grant of immunity from seizure for objects entering its territory, but this legislation is limited to cultural property from Syria.[67] At the same time, the Association of Art Museum Directors adopted guidelines which track but do not follow the US legislation, in particular because they are not restricted to cultural property from Syria.[68] A provision in the 2021 US National Defense Authorization Act creates automatic immunity from seizure for cultural objects legally exported from Afghanistan and imported into the United States pursuant to a loan agreement with an educational or other charitable institution. This provision also expands the purposes for which immunity from seizure may be granted.[69]

France,[70] the United Kingdom, Italy, Germany, and China have all considered or enacted legislation to effectuate the idea of refuges, but enacted legislation seems not to be comprehensive or sufficiently responsive to practical impediments.[71] In other states, complying with existing immunity from seizure legislation and return guarantees often poses significant obstacles by limiting the amount of time that an object can be in the country or by requiring that the object be on display. Other questions that need to be answered include: Who may request safe haven? To whom and when should objects be returned, particularly if the identity of the original owner has changed? What event or threat triggers the safe haven provisions? Is a formal agreement or treaty required? May the cultural objects be studied, displayed or conserved? Do the objects receive immunity from seizure? And must UNESCO approve the granting of safe haven or be otherwise involved? Economic sanctions and travel restrictions may pose other obstacles to effective assistance. States that are willing to provide refuges need to develop new and more flexible legislative solutions. The export and corresponding

import of cultural objects may also be hampered by the very provisions of conventions, such as the 1970 UNESCO convention, that require legal export. This may prove to be unpopular or impractical, but countries may also want to consider adding provisions to their domestic legislation that would allow easier export in case of crisis situations.

A hypothetical scenario (based on facts) illustrates some of the challenges.[72] In 2015 and 2016, Syrian government forces attacked the Maarat al-Numan Museum, one of the foremost repositories for late Roman and Byzantine mosaics, in the Idlib region. Museum professionals were trained to protect the mosaics in situ, as well as in aspects of the law of armed conflict for protecting cultural heritage. However, if a faction of the Free Syrian Army or a civilian group had wanted to arrange transport of those mosaics out of the country, would it have been possible to arrange safe haven in another country and would UNESCO or other IGOs, probably over the protest of the Syrian government, have assisted? Under current circumstances, an arrangement for a safe haven would likely not have been feasible. Yet, in the end, government forces repeatedly attacked the museum, and the full extent of damage remains unknown.

Conclusion

Much of the preceding discussion illustrates the limited applicability of R2P to the preservation of immovable cultural heritage during armed conflict. But any actions taken via R2P are more likely to be successful if done with the consent and for the benefit of the local communities that live amid the heritage. Too much of the rhetoric surrounding recent destruction during conflict, as in Syria, Iraq, and Mali, demonstrates a top-down approach by IGOs, while at the same time these organizations have limited the assistance they are willing to provide because of political pressure from member states over the role of nonstate armed groups.

The threats posed by such groups constitute one of the most significant obstacles faced by international humanitarian law. Conflicts are increasingly conducted between different nonstate armed groups or between them and states. The 1899 and 1907 Hague conventions and regulations on the conduct of warfare[73] did not recognize the role of nonstate armed groups for historical and geopolitical reasons. Some of the difficulties posed by legal instruments and their interpretation as applied to non-international armed conflict and nonstate armed groups have remained as "artifacts" of these earlier conventions, in particular with respect to the definition of "occupied territory," a key term in the 1954 Hague Convention and its two protocols. However, now, more than a hundred years later, there is a growing recognition that nonstate armed groups must be subjected to the same international legal obligations as states and they must be punished when they fail to comply. Most recent conventions, beginning with the 1954 Hague Convention, implicitly recognize the role of nonstate armed groups through the explicit application of their provisions to non-international armed conflict, although perhaps not as extensively as required by current conflicts,[74] and recent prosecutions by the ICC reflect that recognition.

As Fatou Bensouda, the ICC chief prosecutor at the time, stated in the *Al Mahdi* case[75] and was reiterated in the assessment of reparations for the destruction in Timbuktu,[76] the impact of cultural heritage destruction must be evaluated from the local, national, regional, and international perspectives. While international conventions and overarching legal principles benefit the international community and, for the most part, we tend to universalize the value of our shared global heritage, the local community must also participate in and derive benefit from the protection of this heritage if the goal of preservation is to be achieved. Only such a multifaceted approach is likely to succeed.

SUGGESTED READINGS

Kevin Chamberlain, *War and Cultural Heritage: A Commentary on the Hague Convention 1954 and Its Two Protocols,* 2nd ed. (Builth Wells, UK: Institute of Art and Law, 2013).

Francesco Francioni, "Beyond State Sovereignty: The Protection of Cultural Heritage as a Shared Interest of Humanity," *Michigan Journal of International Law* 25, no. 4 (2004): 1209–28.

Patty Gerstenblith, "The Destruction of Cultural Heritage: A Crime against Property or a Crime against People?," *John Marshall Review of Intellectual Property Law* 15, no. 336 (2016) 336–93.

Federico Lenzerini, "Terrorism, Conflicts and the Responsibility to Protect Cultural Heritage," *International Spectator* 51, no. 2 (2016): 70–85.

Polina Levina Mahnad, "Protecting Cultural Property in Syria: New Opportunities for States to Enhance Compliance with International Law?," *International Review of the Red Cross* 99 (2019): 1037–74.

Stephennie Mulder, "Imagining Localities of Antiquity in Islamic Societies," *International Journal of Islamic Architecture* 6, no. 2 (2017): 229–54.

Joseph L. Sax, "Heritage Preservation as a Public Duty: The Abbé Grégoire and the Origins of an Idea," *Michigan Law Review* 88, no. 5 (1989–90): 1142–69.

NOTES

1. Karima Bennoune, *Report of the Special Rapporteur in the Field of Cultural Rights*, Human Rights Council, UN doc. A/HRC/31/59, 3 February 2016, Art. 2.A.14, p. 5, https://digitallibrary.un.org/record/831612?ln=en.

2. Lucas Lixinski, *International Heritage Law for Communities: Exclusion and Re-imagination* (Oxford: Oxford University Press, 2019), 94–105. A more amorphous fourth set of "communities" at times has a role in preserving cultural heritage. Such communities often consist of a group of experts or scholars. Terms such as the "preservation community," "museum community," "scholarly community," "expert community," and "archaeological community" may be used. Their interests may be seen as transcending national boundaries. In a few instances, they are given a specific role, as with the International Council on Monuments and Sites and the World Conservation Union, which serve as technical advisors to UNESCO's World Heritage Committee in recommending which cultural and natural sites qualify for inscription on the World Heritage List. See UNESCO, "World Heritage List Nominations," para. 3, http://whc.unesco.org/en/nominations; and Lixinski, *International Heritage Law for Communities*, 71–75.

3. Joseph L. Sax, "Heritage Preservation as a Public Duty: The Abbé Grégoire and the Origins of an Idea," *Michigan Law Review* 88, no. 5 (1989–90): 1161.

4. David Nersessian, "Rethinking Cultural Genocide under International Law," Human Rights Dialogue: Cultural Rights, Carnegie Council for Ethics in International Affairs, 22 April 2005, https://www.carnegiecouncil.org/publications/archive/dialogue/2_12/section_1/5139; and Elisa Novic, *The Concept of Cultural Genocide* (Oxford: Oxford University Press, 2016), 18–22. See also Edward C. Luck, *Cultural Genocide and the Protection of Cultural Heritage*, Occasional Papers in Cultural Heritage Policy no. 2 (Los Angeles: Getty Publications, 2018), 17–22, https://www.getty .edu/publications/occasional-papers-2.

5. Raphael Lemkin, "Acts Constituting a General (Transnational) Danger Considered as Offences against the Law of Nations," Additional Explications to the Special Report Presented to the 5th Conference for the Unification of Penal Law in Madrid, 14–20 October 1933, www .preventgenocide.org/lemkin/madrid1933-english.htm.

6. Hirad Abtahi and Philippa Webb, *The Genocide Convention: The Travaux Préparatoires* (Leiden, the Netherlands: Brill Nijhoff, 2008), 234–36. See also Roger O'Keefe, "Protection of Cultural Property under International Criminal Law," *Melbourne Journal of International Law* 11, no. 2 (2010): 386.

7. Abtahi and Webb, *The Genocide Convention*, 163–67, 726–31; and Lawrence Davidson, *Cultural Genocide* (New Brunswick, NJ: Rutgers University Press, 2012), 127–30.

8. O'Keefe, "Protection of Cultural Property," 388–89.

9. Matthew Rosenberg, "Citing Atrocities, John Kerry Calls ISIS Actions Genocide," *New York Times*, 18 March 2016. See also John Kerry, "Remarks on Daesh and Genocide," US Department of State, 17 March 2016, https://2009-2017.state.gov/secretary/remarks/2016/03/254782.htm.

10. John Henry Merryman, "The Nation and the Object," *International Journal of Cultural Property* 3, no. 1 (1994): 64.

11. Merryman, "The Nation and the Object," 69.

12. Merryman, "The Nation and the Object," asserted that the object should be "optimally accessible to scholars (for study) and to the public (for education and enjoyment)" (64). In further considering the question of the relevant public, he concluded that "to the object-oriented person the number of interested viewers, regardless of their nationality, is the significant figure" (74 n. 14). However, this fails to account for the disparities in practical access that result from the ability to travel.

13. See, e.g., Lucas Lixinski, "A Third Way of Thinking about Cultural Property," *Brooklyn Journal of International Law* 44, no. 2 (2019): 564.

14. Karolina Wierczynska and Andrzej Jakubowski, "Individual Responsibility for Deliberate Destruction of Cultural Heritage: Contextualizing the ICC Judgment in the *Al-Mahdi* Case," *Chinese Journal of International Law* 16, no. 4 (2017): 708; and Federico Lenzerini, "Terrorism, Conflicts and the Responsibility to Protect Cultural Heritage," *International Spectator* 51, no. 2 (2016): 74–75.

15. Wierczynska and Jakubowski, "Individual Responsibility for Deliberate Destruction," 711–13.

16. Wendy M. K. Shaw, "In Situ: The Contraindications of World Heritage," *International Journal of Islamic Architecture* 6, no. 2 (2017): 341.

17. Stephennie Mulder, "Imagining Localities of Antiquity in Islamic Societies," *International Journal of Islamic Architecture* 6, no. 2 (2017): 229.

18. Kanishk Tharoor, "Life among the Ruins," *New York Times*, 20 March 2016.

19. Luck, *Cultural Genocide*, 26–27; and Francesco Francioni, "Beyond State Sovereignty: The Protection of Cultural Heritage as a Shared Interest of Humanity," *Michigan Journal of International Law* 25, no. 4 (2004): 1212–13.

20. Bennoune, *Report of the Special Rapporteur*, 11 (internal citations omitted).

21. ICJ, "Request for Interpretation of the Judgment of 15 June 1962 in the Case Concerning the *Temple of Preah Vihear (Cambodia v. Thailand)* (Cambodia v. Thailand), Summary of the Order of 18 July 2011, Separate Opinion of Judge Cançado Trindade," paras. 20–26, https://www.icj-cij.org/en/case/151/orders; and, in the same case, "Judgment of 11 November 2013, Separate Opinion of Judge Cançado Trindade," paras. 30–33, https://www.icj-cij.org/en/case/151/judgments. See also Alessandro Chechi, "The 2013 Judgment of the ICJ in the *Temple of Preah Vihear* Case and the Protection of World Cultural Heritage Sites in Wartime," *Asian Journal of International Law* 6 (2016): 358–59.

22. ICJ, "Request for Interpretation, Cambodia v. Thailand, Provisional Measures, Order of 18 July 2011," para. 106, https://www.icj-cij.org/en/case/151/provisional-measures; and Chechi, "The 2013 Judgment of the ICJ," 368.

23. ICJ, "Request for Interpretation, Cambodia v. Thailand, Judgment of 11 November 2013," para. 33 (italics in original; omitting internal citations).

24. UN, *Framework of Analysis for Atrocity Crimes: A Tool for Prevention* (New York: United Nations, 2014), 1.

25. UN, *Framework of Analysis for Atrocity Crimes*, 2.

26. Thomas G. Weiss and Nina Connelly, *Cultural Cleansing and Mass Atrocities: Protecting Cultural Heritage in Armed Conflict Zones*, Occasional Papers in Cultural Heritage Policy no. 1 (Los Angeles: Getty Publications, 2017), 13–14, https://www.getty.edu/publications/occasional-papers-1/.

27. Kevin Chamberlain, *War and Cultural Heritage: A Commentary on the Hague Convention 1954 and Its Two Protocols*, 2nd ed. (Builth Wells, UK: Institute of Art and Law, 2013), 52–55.

28. See Roger O'Keefe, *The Protection of Cultural Property in Armed Conflict* (Cambridge: Cambridge University Press, 2006), 207–18, 230–32.

29. Rome Statute of the International Criminal Court, circulated as doc. no. A/Conf. 183/9, 17 July 1998, Art. 8.2.b.ix (applying to international armed conflict) and Art. 8.2.e.iv (non-international armed conflict).

30. Polina Levina Mahnad, "Protecting Cultural Property in Syria: New Opportunities for States to Enhance Compliance with International Law?' *International Review of the Red Cross* 99 (2019): 1056–59; and Lenzerini, "Terrorism, Conflicts and the Responsibility to Protect," 78.

31. UN, *Framework of Analysis*, 3. See also Mahnad, "Protecting Cultural Property in Syria," 1046–47; and Knut Dörmann and José Serralvo, "Common Article 1 to the Geneva Conventions and the Obligation to Prevent International Humanitarian Law Violations," *International Review of the Red Cross* 96, nos. 895/6 (2014): 707, 708–9, 723–25. The International Court of Justice in *Case Concerning Application of the Convention on the Prevention and Punishment of the Crime of Genocide (Bosnia and Herzegovina v. Serbia and Montenegro)* held that the Genocide Convention imposes an obligation on third states to prevent genocide, stating that "every State with a 'capacity to influence effectively the action of persons likely to commit, or already committing genocide,' even if outside its own borders, is under the obligation to 'employ all means reasonably available to them, so as to prevent genocide so far as possible.'" See UN, *Framework of Analysis*, 3, quoting ICJ, *Case Concerning Application*, Judgment, 26 February 2007, para. 430, https://www.icj-cij.org/public/files/case-related/91/091-20070226-JUD-01-00-EN.pdf.

32. UN, *2005 World Summit Outcome*, UN doc. A/RES/60/1, 24 October 2005, paras. 138–39.

33. UN Secretary-General, *Implementing the Responsibility to Protect*, UN doc. A/63/677, 12 January 2009, https://www.un.org/ruleoflaw/blog/document/report-of-the-secretary-general-implementing-the-responsibility-to-protect/.

34. UNESCO Expert Meeting on the "'Responsibility to Protect' as Applied to the Protection of Cultural Heritage in Armed Conflict," *Final Report*, 26–27 November 2015, Art. 3.8, p. 2, https://www.unesco.org/new/fileadmin/MULTIMEDIA/HQ/CLT/pdf/R2P-FinalReport-EN.pdf.

35. Lenzerini, "Terrorism, Conflicts and the Responsibility to Protect," 80.

36. Chechi, "The 2013 Judgment of the ICJ," 363–65.

37. UNESCO Expert Meeting, *Final Report*, Art. 3.11.a, p. 3.

38. UNESCO Expert Meeting. For more discussion of the role of post-conflict reconstruction in achieving reconciliation, see Patty Gerstenblith, "Toward a Human-Rights Based Approach as an Element in Post-Conflict Cultural Heritage Reconstruction," in *Heritage Destruction, Human Rights and International Law*, ed. Joe Powderly and Amy Strecker (Leiden, the Netherlands: Brill Nijhoff, forthcoming).

39. Francioni, "Beyond State Sovereignty," 1215, discussing that the Second Protocol to the 1954 Hague Convention, Art. 31, envisions the possibility of enforcing state responsibilities through sanctions.

40. Dörmann and Serralvo, "Common Article 1 to the Geneva Conventions," 721.

41. Different motivations have been attributed to ISIS for the destruction of cultural heritage. See Cristopher W. Jones, "Understanding ISIS's Destruction of Antiquities as a Rejection of Nationalism," *Journal of Eastern Mediterranean Archaeology and Heritage Studies* 6 (2018): 31; Shaw, "In Situ: The Contraindications of World Heritage," 339; and Miroslav Melcak and Ondrej Beránek, "ISIS's Destruction of Mosul's Historical Monuments: Between Media Spectacle and Religious Doctrine," *International Journal of Islamic Architecture* 6, no. 2 (2017): 389.

42. Mahnad, "Protecting Cultural Property in Syria," 1048.

43. Weiss and Connelly, *Cultural Cleansing and Mass Atrocities*, 38.

44. Helen Frowe and Derek Matravers, *Conflict and Cultural Heritage: A Moral Analysis of the Challenges of Heritage Protection*, Occasional Papers in Cultural Heritage Policy no. 3 (Los Angeles: Getty Publications, 2019), https://www.getty.edu/publications/occasional-papers-3/.

45. James Cuno, "The Responsibility to Protect the World's Cultural Heritage," *Brown Journal of World Affairs* 23, no. 1 (2016): 106.

46. Lenzerini, "Terrorism, Conflicts and the Responsibility to Protect," 81–82. But see UN Security Council, French draft resolution, UN doc. S/2014/348, 22 May 2014; and "Recent Draft Resolution," *Harvard Law Review* 128 (2015): 1057–58, which discusses vetoes by Russia and China of a referral of the situation in Syria by the Security Council to the ICC.

47. Frowe and Matravers, *Conflict and Cultural Heritage*, 14–17.

48. Frowe and Matravers, *Conflict and Cultural Heritage*, 11–13.

49. Weiss and Connelly, *Cultural Cleansing and Mass Atrocities*, 38.

50. UN Security Council, UN doc. S/RES/2100, 25 April 2013, para. 16.f, https://digitallibrary.un.org/record/748429?ln=en.

51. UN Peacekeeping, "Action Plan to Preserve Heritage Sites during Conflict," 12 April 2019, https://peacekeeping.un.org/en/action-plan-to-preserve-heritage-sites-during-conflict.

52. Smithsonian, "Training Aids," https://culturalrescue.si.edu/what-we-do/resilience/training-aids/.

53. UNESCO, "Italy Creates a UNESCO Emergency Task Force for Culture," 15 February 2016, https://en.unesco.org/news/italy-creates-unesco-emergency-task-force-culture-1.

54. See O'Keefe, *The Protection of Cultural Property*; and Ana Filipa Vrdoljak, "The Criminalisation of the Intentional Destruction of Cultural Heritage," in *Forging a Socio-legal Approach to Environmental Harm: Global Perspectives*, ed. Tiffany Bergin and Emanuela Orlando (New York: Routledge, 2017), 237–67.

55. See Wierczynska and Jakubowski, "Individual Responsibility for Deliberate Destruction," 701–3.

56. Caroline Ehlert, *Prosecuting the Destruction of Cultural Property in International Criminal Law* (Leiden, the Netherlands: Brill Nijhoff, 2013), 180–85, 200; and Jiří Toman, *Cultural Property in War: Improvement in Protection* (Paris: UNESCO, 2009), 795.

57. ICC, *Prosecutor v. Ahmad Al Faqi Al Mahdi*, Judgment and Sentence, doc. no. ICC-01/12-01/15-171, 27 September 2016; and ICC, *Prosecutor v. Al Hassan Ag Abdoul Aziz Ag Mohamed Ag Mahmoud*, case no. ICC-01/12-01/18.

58. See ICC, *Prosecutor v. Bosco Ntaganda*, Judgment, case no. ICC-01/04-02/06, 8 July 2019, paras. 1145–68. The defendant was acquitted on this charge because the destruction was not part of an attack carried out during the "actual conduct of hostilities" (para. 1142), a required element of the crime under the Rome Statute. His conviction was confirmed on appeal on 30 March 2021.

59. Federico Lenzerini, "Intentional Destruction of Cultural Heritage," in *The Oxford Handbook of International Cultural Heritage Law*, ed. Federico Lenzerini and Ana Filipa Vrdoljak (Oxford: Oxford University Press, 2020), 96–98.

60. See Novic, *The Concept of Cultural Genocide*, 154–68, for a discussion of the crime of cultural persecution.

61. Marina Lostal, Kristin Hausler, and Pascal Bongard, "Armed Non-state Actors and Cultural Heritage in Armed Conflict," *International Journal of Cultural Property* 24, no. 4 (2017): 418–22.

62. Nikolaus Thaddäus Paumgartner and Raphael Zingg, "The Rise of Safe Havens for Threatened Cultural Heritage," *International Journal of Cultural Property* 25, no. 3 (2018): 323–46; and Alessandro Chechi, "Rescuing Cultural Heritage from War and Terrorism: A View from Switzerland," *Santander Art and Culture Law Review* 2 (2015): 88–91, discussing Swiss implementation of the First Protocol of the 1954 Hague Convention and adoption of procedures for establishing safe havens for cultural property.

63. Weiss and Connelly, *Cultural Cleansing and Mass Atrocities*, 36–37.

64. See International Law Association, Resolution No. 2/2008, Annex: Guidelines for the Establishment and Conduct of Safe Havens as Adopted by the International Law Association at Its 73rd Conference Held in Rio de Janiero [sic], Brazil, 17–21 August 2008, Art. 4.b and Art. 4.e; and Paumgartner and Zingg, "The Rise of Safe Havens," 326–27.

65. Swiss Federal Council, Loi fédérale sur la protection des biens culturels en cas de conflit armé, de castastrophe ou de situation d'urgence (LPBC), doc. no. RO 2014 3545, 20 June 2014, Art. 12, www.admin.ch/opc/fr/official-compilation/2014/3545.pdf. See also Chechi, "Rescuing Cultural Heritage," 86–91.

66. Chechi, "Rescuing Cultural Heritage from War and Terrorism," 92–93.

67. US Congress, Protect and Preserve International Cultural Property Act, Public Law 114–151, 9 May 2016, https://www.congress.gov/bill/114th-congress/house-bill/1493?r=67.

68. Association of Art Museum Directors, "AAMD Protocols for Safe Havens for Works of Cultural Significance from Countries in Crisis," 1 October 2015, https://aamd.org/document/aamd -protocols-for-safe-havens-for-works-of-cultural-significance-from-countries-in-crisis.

69. US Congress, National Defense Authorization Act for Fiscal Year 2021, Public Law No. 116–283, Section 1216, https://www.congress.gov/bill/116th-congress/house-bill/6395.

70. Government of France, Code du Patrimoine, Art. L111–11, 7 July 2016, https://www.legifrance .gouv.fr/codes/article_lc/LEGIARTI000032857167/. A *décret d'application*, which details the specific procedures, still needs to be issued.

71. Paumgartner and Zingg, "The Rise of Safe Havens," 327–29.

72. Syrians for Heritage, "A Statement from the Idlib Antiquities Center about the Maarat Al Numan Museum from the End of 2012 to the Beginning of 2020," 2 February 2020, https:// syriansforheritage.org/?p=3218; and Salam al-Quntar and Brian I. Daniels, "Responses to the Destruction of Syrian Cultural Heritage: A Critical Review of Current Efforts," *International Journal of Islamic Architecture* 5, no. 2 (2016): 389–91.

73. Convention (II) with Respect to the Laws and Customs of War on Land and Its Annex: Regulations Concerning the Laws and Customs of War on Land, The Hague, 29 July 1899, https:// ihl-databases.icrc.org/ihl/INTRO/150; and Convention (IV) Respecting the Laws and Customs of

War on Land and Its Annex: Regulations Concerning the Laws and Customs of War on Land, The Hague, 18 October 1907, https://ihl-databases.icrc.org/ihl/INTRO/195.

74. See, e.g., Chamberlain, *War and Cultural Heritage*, 53–54.

75. ICC, "Statement of the Prosecutor of the International Criminal Court, Fatou Bensouda, at the Opening of the Confirmation of Charges Hearing in the Case against Mr Ahmad Al-Faqi Al Mahdi," 1 March 2016, www.icc-cpi.int/en_menus/icc/press%20and%20media/press%20releases/Pages/otp-stat-01-03-16.aspx.

76. ICC, *Prosecutor v. Ahmad Al Faqi Al Mahdi*, case no. ICC-01/12-01/15, Reparations Phase, Brief by Ms. Karima Bennoune, 27 April 2017, 14–15, 18–22, www.icc-cpi.int/RelatedRecords/CR2017_05022.pdf.

22

International Humanitarian Law and the Protection of Cultural Property

Benjamin Charlier

Tural Mustafayev

From entire libraries burned to the ground during World War II to the more recent calculated and demonstrative destruction of archaeological sites in Syria, the deliberate attacks against historical monuments in Mali, Libya, and Yemen, or the looting of invaluable artifacts from museums in Iraq, the deleterious effects of war on cultural property are well documented. History has long shown there is an inherent link between the protection of cultural property during armed conflict and the protection of human beings, giving this protection a humanitarian imperative. A comprehensive corpus of international law has been developed since the 1950s to regulate the protection of cultural property against the devastating effects of war. Not only does this corpus establish a set of legal obligations addressed to states in peacetime and to parties to armed conflict—several of which have been crystallized into customary law— it also sets up normative and institutional mechanisms with a view to enhancing its effectiveness.

Certain aspects of the applicable legal framework could be improved. Nevertheless, this chapter argues that international humanitarian law (IHL) provides a solid system of protection for tangible cultural heritage in the event of armed conflict. The key to effectively reinforcing such protection lies in strengthening the implementation of the established conventional and customary rules rather than focusing on ways to alter existing imperfections. In this context, the authors present the key features of some of the existing mechanisms established to ensure compliance with the relevant norms and assess their relevance.

For the purposes of IHL, "cultural property" must be understood as a specific legal concept, which differs from that of "cultural heritage." The latter, which exists in a

variety of international standard-setting instruments, is generally intended to be broader in scope than the notion of cultural property, as it also encompasses all the intangible aspects of cultural life.[1] In contrast, while there is no agreed definition of cultural property under international law, one common feature of the definitions provided in IHL treaties is the fact that the notion of protected cultural property is limited to material objects. While the safeguarding of diverse cultural practices and expressions are enshrined in important international human rights law instruments—which are applicable at all times, including in wartime—and in the 2003 Convention for the Safeguarding of the Intangible Cultural Heritage, and the 2005 Convention on the Protection and Promotion of the Diversity of Cultural Expressions, the legal framework discussed in this chapter refers exclusively to the concept of "cultural property."

The Law of Armed Conflict and Its Primary Sources

International humanitarian law—also referred to as the law of armed conflict or the law of war—is the body of law that seeks to alleviate the human suffering inherently caused by war. It does so by limiting the means (weapons) and methods (tactics) of warfare that parties to an armed conflict can resort to, and by protecting persons who do not, or no longer, participate in hostilities (civilians and military placed hors de combat alike).

IHL rules, irrespective of the treaties in which they are codified, share three key features. First, they are the result of a constant compromise between the principle of humanity and the military necessity imposed by the realities of warfare. Accepting that war necessarily entails armed violence is an essential component of IHL, as it ensures that this body of law must be taken seriously by the belligerent parties. However, since the whole raison d'être of IHL is to preserve a minimum level of humanity during wartime, the concept of military necessity also entails that unavoidable violence during such time must be limited to what is strictly necessary to achieve the only legitimate aim of the belligerent parties: to weaken the military capacities of the enemy. As a matter of principle, any use of force that goes beyond that objective is prohibited under IHL.

Second, rather than adjudicating the legality of the resort to force between the belligerent parties (*jus ad bellum*), the purpose of IHL is exclusively to provide those parties with a set of binding rules that will preserve a minimum of humanity during the chaos of war. Third, IHL rules impose direct obligations exclusively on the belligerent parties, rather than on the civilian population. Whether any category of organized armed carriers (national armed forces, nonstate armed groups, or any other organized armed entity, such as regional military organizations and peacekeeping forces) can be classified as a belligerent party under IHL is a question of facts that must be assessed on a case-by-case basis.

By its very nature, IHL applies to armed conflict, whether of an international character (opposing two or more states) or non-international (opposing one or more states to one or more nonstate armed groups, or between such groups only).[2] The notion of "armed conflict" is a legal concept that corresponds to relatively well-established

criteria.[3] Since not all situations of armed violence fall under this concept, adequately classifying the situation at stake will always be a necessary preliminary step before considering the applicability of any IHL instrument, including those related to the protection of cultural property.

The most prominent instruments of contemporary IHL are the four Geneva Conventions adopted in 1949, in the aftermath of World War II, and the two Additional Protocols (AP I and AP II) of 1977, the latter of which apply to situations of international armed conflict (IAC) and non-international armed conflict (NIAC), respectively.[4] Many other treaties also apply to situations of armed conflict and therefore encompass in full or in part some of its core elements.[5]

In addition to treaty law, the importance of custom as a law-creating source of obligations under IHL cannot be underestimated. Rules of customary IHL—including those that relate to the protection of cultural property—derive from the general practice accepted as law and are legally binding to belligerent parties irrespective of treaty ratification. By filling some of the gaps left under treaty law, they undeniably play a key role in the protection afforded to victims of armed conflict.[6]

The Protection of Cultural Property under IHL

Under IHL rules, cultural property is protected in two ways. First, because it is civilian in nature, the general protection afforded by IHL to all civilian objects applies. Parties to a conflict are bound to respect at all times the core principles regulating the conduct of hostilities which are laid out in AP I and are undisputedly part of customary international law. These include the principle of distinction (which prohibits direct attacks against any target that does not meet the definition of a legitimate military objective); the principle of proportionality (which requires that the effects of attacks on the civilian population and on civilian objects, including of cultural value, must not be excessive in relation to the concrete and direct military advantage sought); and the principle of precaution (which requires the attacking and defending parties to take various precautionary measures to limit the consequences of the hostilities on protected persons and objects).

Second, in addition to these provisions, due to the special character and important value of this category of civilian objects, several international instruments provide for a more specific system of protection for cultural property. The list of these conventional instruments starts with the 1863 Instructions for the Government of Armies of the United States in the Field (the "Lieber Code") and subsequently the Hague Convention (II) of 1899 and (IV) of 1907 and their annexed regulations, which codified at the time the "Laws and Customs of War on Land" and laid out the foundation of the modern protection of cultural property during armed conflict by prohibiting unnecessary destruction and seizure of cultural property during wartime, including in occupied territories.[7]

The cornerstone of this system of protection is undoubtedly articulated in the Hague Convention for the Protection of Cultural Property in the Event of Armed Conflict and the Regulations for the Execution of the Convention, adopted on 14 May 1954 in the aftermath of the extensive destruction of large urban centers during World War II, and in the convention's two protocols (1954 and 1999). As a direct response to the massive looting of artwork that took place during the war, the First Protocol deals with the prevention of the exportation of movable cultural property from occupied territories and with restitution. The Second Protocol, adopted more than forty years after the convention, critically reinforces the latter's protection system by addressing some of its important shortcomings. Due to the comprehensive nature of both the convention and the Second Protocol, specific focus will be given to these instruments in the analysis below.

Last, in addition to the already mentioned core principles related to the conduct of hostilities, the two 1977 Additional Protocols to the four Geneva Conventions also contain specific provisions on the protection of cultural property. For example, Article 53 of AP I and Article 16 of AP II prohibit belligerent parties from "commit[ting] any acts of hostility directed against the historic monuments, works of art or places of worship which constitute the cultural or spiritual heritage of peoples; and to use such objects in support of the military effort." Since these provisions explicitly apply without prejudice to the provisions of the 1954 Hague Convention, their main purpose is to confirm both the relevance of the core elements of the protection system already laid out in the Hague Convention and to give them prevalence over the text of the Additional Protocols in case of conflict between these instruments.

The Core Features of the 1954 Hague Convention and Its Second Protocol
Under the 1954 Hague Convention, protected "cultural property" is defined as "movable or immovable property of great importance to the cultural heritage of every people." The first article of the convention provides a large, nonexhaustive list of objects, sites, monuments, and buildings (i.e., tangible heritage) that fit that definition, adding that the protection afforded by the convention also extends to "buildings whose main and effective purpose is to preserve or exhibit . . . movable cultural property," such as museums or large libraries and refuges intended to shelter, in the event of armed conflict, movable cultural property, and to "centres containing a large amount of cultural property."[8]

This definition, which is proper to the convention and its protocols, gives latitude to each state party to decide what falls under the threshold of "great importance to the cultural heritage of every people."[9] This is naturally first and foremost true for the state within which the concerned movable or immovable cultural properties is located. But unless that state communicates the list of such protected properties to other states or clearly marks them with the Blue Shield distinctive emblem (neither of which is compulsory under the convention), in the event of an armed conflict the responsibility

to define which objects are protected will also fall in practice on the shoulders of the opposing party, which can potentially be problematic.[10]

Replicating some of the wording used in the Geneva Conventions, the Hague Convention applies to the protection of cultural property in the event of international armed conflict, which includes belligerent occupation arising between two or more of the state parties, even if the state of war has not been recognized by some of them. More interestingly, in case of NIAC, the provisions that pertain to the "respect" of cultural property apply, as a minimum, to each party to the conflict. These rules, which serve to protect cultural property during active hostilities, are consequently equally binding on state armed forces and nonstate armed groups. This is somewhat remarkable at a time when Common Article 3 of the Geneva Conventions was the only provision in the conventions that applied to NIAC, reflecting the fact that these situations were essentially considered by states as a domestic affair.[11] Common Article 3 remains the only universally binding treaty provision governing all NIAC.

The obligation to protect cultural property under the 1954 Hague Convention is articulated around a twofold complementary approach: state parties to the treaty must commit to both "safeguard" and "respect" cultural property, which respectively sets obligations for peacetime measures and in time of armed conflict. In peacetime, states must take preparatory "safeguarding" measures against the foreseeable effects of armed conflict on cultural property as they consider appropriate. Examples of such measures are not provided but, as later listed in the Second Protocol, include the preparation of inventories or the adoption of emergency plans for protection against fire or structural collapse; the preparation for the removal of movable cultural property; or the provision for adequate in situ protection of such property. The objective of these preventive measures is evidently to ensure that the authorities in charge of the protection of valuable cultural property are prepared in the event of armed conflict.

Other important preventive peacetime measures foreseen by the 1954 Hague Convention include considering the marking of protected cultural property with the distinctive Blue Shield emblem, adapting military regulations in compliance with the convention, and establishing military services or personnel specialized in the protection of cultural property (modeled on World War II's "Monuments Men").

When an armed conflict erupts, belligerent parties must refrain from using cultural property in ways that are likely to result in destruction or damage (for instance by using a cultural site for military purposes) or carrying out any acts of hostility against them. Only in case of *imperative military necessity* can these obligations be waived. It is easy to understand why the vagueness and the inherently subjective nature of this concept, which is neither defined in the convention nor in any other IHL treaty, has created major difficulties for those in charge of applying it on the battlefield and why, consequently, clarifying the scope of this notion became one of the key stakes during the drafting of the 1999 Second Protocol. In fact, adequately circumscribing the concept of military necessity under IHL is as necessary as it is challenging.

As mentioned, allowing the belligerent parties to integrate the necessities of war into their military operations constitutes one of the key pillars of the law of armed conflict, ensuring that the warring parties do not discard its applicability due to the perception that respecting the rules would be militarily unrealistic. At the same time, not setting clear limits to the concept of military necessity would simply defeat the purpose of incorporating it into law. This is equally true for the part of IHL that specifically protects cultural property, the focus of which lies on the protection of cultural property rather than human lives. It is therefore not surprising that attempts to find that balance in relation to how protected cultural objects might permissibly be harmed in the course of hostilities, despite their value for all humankind, led to intense negotiations prior to the adoption of the 1954 Hague Convention.

In addition to this general layer of protection, the convention introduced a system of "special protection" for a limited number of immovable objects of "very great importance," providing they meet a number of specific criteria (one of which is inscription on an international register to that effect, briefly discussed below). The idea behind this system was to provide protected objects with a higher degree of immunity against harmful acts by imposing a stricter application of the concept of military necessity to the belligerent parties than the one applicable to objects under general protection. Harmful acts against these more legally protected objects are temporarily permissible only in "exceptional cases of unavoidable military necessity" and when specifically authorized by a high-ranking commanding officer. Despite best intentions, here again reliance on an inherently subjective and undefined concept proved to be a difficult flaw to overcome. It was finally addressed in 1999 with the adoption of the Second Protocol.

In addition to these prohibitions, "respecting" cultural property in time of armed conflict also implies the unconditional obligation (no waiver is permitted) to protect cultural property against theft, pillage, misappropriation, and vandalism. It also requires refraining not only from requisitioning movable cultural property situated in the territory of another state but also from carrying out acts of reprisal against any protected cultural property.

But all these rules cannot be effectively applied if they are not incorporated into domestic and criminal law. To some extent, domestic (and international) criminal law provides an enforcement capability for IHL. By keeping people individually accountable for their serious violations of the rules applicable in time of conflict, criminal law arguably plays an important role in ensuring compliance.

Similarly to the Geneva Conventions, the 1954 Hague Convention follows this path, by imposing on state parties a broadly framed obligation to take all necessary steps to prosecute and punish perpetrators of crimes under the 1954 Hague Convention within their own domestic legal system (including by amending their national laws and regulations to that effect, if necessary). It was expected that by leaving significant discretionary power to states as to how to process the provision within their domestic

legal frameworks, its implementation would naturally be made easier. However, in contrast to the Geneva Conventions, the lack of a clear list of offenses requiring a criminal sanction, and the absence of explicit jurisdictional grounds on which alleged perpetrators could be either tried or extradited, proved to be major impediments to the effectiveness of the provision, which was later corrected by the Second Protocol, significantly advancing the international legal protection of cultural property.

The importance of the Second Protocol in relation to the system of protection put in place by the 1954 Hague Convention cannot be overemphasized. Despite the undeniable progress that the convention represented at the time, its effectiveness was called into question in the 1990s in the aftermath of the Persian Gulf and Balkan Wars, which highlighted a number of weaknesses and gaps preventing it from fully delivering on its intended ambitions. The protocol was a timely instrument that critically improved the system put in place by the convention, including by clarifying the somewhat vague and subjective notion of military necessity, which can now only be invoked if a relevant property technically corresponds to the legal meaning of a "military objective," against which attacks are permitted under certain conditions as a matter of principle under IHL. The concept of military objective has been explicitly defined in AP I and is now indisputedly part of customary IHL, corresponding to "objects which by their nature, location, purpose or use make an effective contribution to military action and whose total or partial destruction, capture or neutralization, in the circumstances ruling at the time, offers a definite military advantage." Unless a cultural property meets both criteria, and providing that all other applicable conditions are met, it can neither be used in support of military action nor be the object of an attack.[12]

The Second Protocol also drastically improved the system of criminal repression of offenses committed against protected cultural property in three ways. First, it defines the five acts that, when committed in breach of the convention or protocol, must be considered as criminal offenses under the domestic law of each state party.[13] Second, it establishes the jurisdictional basis that state parties must apply for the prosecution of these offenses and imposes a duty to establish universal jurisdiction—i.e., jurisdiction over alleged perpetrators irrespective of their nationality and place of the offense—over the three of the five offenses seen as the most serious.[14] Third, by equally applying the advanced sanctions regime to IAC and NIAC, it provides a potentially powerful tool to ensure accountability for crimes committed against protected cultural property in NIAC, which goes considerably beyond the prescriptions of other applicable international instruments.[15]

The Second Protocol also replaced the system of special protection, which never really functioned, with a new and improved system of "enhanced protection," whose main purpose is to complement the prohibition on direct attacks against protected cultural property with an absolute prohibition for the holder of such property to use it for military action and, consequently, to put it at risk by turning it into a military objective. Finally, the protocol established an important new supervisory mechanism,

the Committee for the Protection of Cultural Property in the Event of Armed Conflict, whose role is examined below.

Normative and Institutional Mechanisms

From peacetime measures to wartime obligations, in the context of international and non-international conflict, the multiple layers of treaty and custom that apply to the protection of cultural property undeniably constitute a comprehensive system of protection under IHL. But beyond that, many other treaties also contribute to limiting the number and scope of potential consequential gaps in the protective legal arsenal available in the event of armed conflict. These include the 1970 Convention on the Means of Prohibiting and Preventing the Illicit Import, Export and Transfer of Ownership of Cultural Property; the 1995 International Institute for the Unification of Private Law (UNIDROIT) Convention on Stolen or Illegally Exported Cultural Objects; and to some extent the 2003 Convention for the Safeguarding of Intangible Heritage and the 1972 Convention Concerning the Protection of the World Cultural and Natural Heritage.

But rules governing the protection of cultural property do not exist in a vacuum. A mere isolated analysis of such rules, no matter how comprehensive, is not enough to understand the state of protection of cultural property under international law since many other factors shape the effectiveness of these rules in practice. They can be grouped into two broad categories: normative and institutional mechanisms.

Normative mechanisms are arrangements embedded in treaties—in this context, those related to the protection of culture—with the objective of supporting implementation of law. These mechanisms do not regulate the conduct of hostilities or entail domestic policy obligations as such. Rather, their rationale is to anticipate challenges to effective state implementation of provisions within the relevant treaty and to serve as tools to limit foreseen difficulties. Examples of normative mechanisms include mediation or conciliation procedures devised to settle potential disputes between states that may arise regarding the protection of cultural property. The creation of national periodic reporting mechanisms also offers states a tool to model best practices as well as encourage other nations to apply similar initiatives when relevant. The compilation of international lists of cultural property provides yet another example of normative mechanisms. Such lists identify the most valuable cultural property to be protected in the course of an armed conflict. By increasing the international visibility of these cultural sites, such lists significantly reinforce their protection.

Institutional mechanisms or bodies are also important components of today's international system for the protection of cultural property. Supervisory or advisory in nature, such arrangements monitor the application of and compliance with treaties or assist in their implementation. Some of these are treaty-based statutory governing bodies, such as intergovernmental committees, while others are based on domestic arrangements or derive from the work of international organizations and entities

mandated to work for the protection of cultural property in armed conflict. International governmental and nongovernmental organizations also fall under this category.

International Lists of Cultural Property as Normative Mechanisms
The difficulty of identifying protected cultural property in times of armed hostility and the necessity to preserve, at minimum, sites that are of the "greatest importance for humanity," or posess an "outstanding universal value," paved the way for the creation of international lists of cultural sites. These have been established under their respective treaties in the field of culture and are notable examples of useful normative mechanisms. They participate in providing a higher level of protection to a limited number of cultural properties, whose recognized cultural value is measured by way of specific methodology and based on established criteria.

The idea of special protection for a select number of cultural properties originated in the Draft International Convention for the Protection of Historic Buildings and Works of Art in Time of War prepared by the International Museums Office in 1938. It was later integrated into the 1954 Hague Convention as a separate chapter titled "Special Protection," laying the foundation for the creation of the first international list of protected cultural property, the International Register of Cultural Property under Special Protection. Stato della Città del Vaticano (Vatican City State) became the first cultural site inscribed on the international list, on 18 January 1960.

However, states have demonstrated a lack of interest in the system, resulting from a combination of: the difficulty of meeting the eligibility criteria for special protection under the 1954 Hague Convention—namely, that the concerned property must be situated at an "adequate distance" from large industrial centers or from important military objectives; the perceived politicization of the registration process; and the limited protection that it ultimately offered in practice. As a result, by 1994, only nine cultural properties had been inscribed on the register. As mentioned, the system was replaced in 1999 by the adoption of the mechanism of "enhanced protection" under the Second Protocol, which included the creation of the International List of Cultural Property under Enhanced Protection. Since it became operational in 2010, and despite ongoing discussions on how best to establish clear evaluation procedures for inscription on the list, the number of registered cultural properties keeps growing; as of mid-2022, it contained seventeen sites, all immovable cultural property.[16] By ensuring the uncontested visibility of important cultural properties and their protected status, and with both easier inscription criteria and an effective post-inscription monitoring mechanism, the enhanced protection list has the potential to become an instrumental mechanism of protection for cultural property in the future.

There is also the World Heritage List, the most widely recognized compilation of cultural and natural sites. Established under the 1972 convention, it compiles over eleven hundred cultural and natural sites having so-called outstanding universal value.

Unlike the lists established by the 1954 Hague Convention and its Second Protocol, the World Heritage List was not devised to provide special immunity for cultural sites in time of armed conflict. But its wider acceptance as an international inventory of cultural and natural sites of universal value de facto transformed it into a global reference list. This is illustrated by the importance given it by the International Criminal Tribunal for the former Yugoslavia (ICTY) in a case related to the shelling of the Old City of Dubrovnik in 1991 and by the International Criminal Court in a case related to the destruction of the mausoleums in Timbuktu in 2012. Both the ICTY and the ICC considered that the presence of the targeted cultural property on the World Heritage List added to the gravity of the offense.[17]

The full potential of the international lists of cultural property, as normative mechanisms, remains untapped. But for now, beyond the role that they play in improving the identification of protected sites in time of armed conflict, the lists already exert a recognized influence in galvanizing international support and attention when these sites are at risk.[18]

Supervisory and Advisory Institutional Mechanisms

Statutory bodies are institutional mechanisms created under the respective treaties and are usually intergovernmental. The World Heritage Committee and the Committee for the Protection of Cultural Property in the Event of Armed Conflict are prominent examples; both are charged with broad mandates to discuss questions and adopt strategic policy orientations related to the preservation of cultural heritage and, as such, play an important role in operationalizing the text of their affiliated treaties.

The initiative to establish a permanent supervisory body entrusted with monitoring the implementation of the 1954 Hague Convention had already been discussed during the diplomatic conference that led to its adoption. Although this option was temporarily abandoned, the value of creating such a permanent body resurfaced during the process leading to the adoption of the 1999 Second Protocol and became one of its key elements. The Committee for the Protection of Cultural Property in the Event of Armed Conflict, established by the protocol, is modeled on the World Heritage Committee.[19] It is composed of representatives of twelve state parties to the protocol, who are elected for a four-year mandate, and is primarily tasked with monitoring and supervising its implementation.[20] Since 2006, meeting annually under the auspices of the United Nations Educational, Scientific and Cultural Organization (UNESCO), the committee has proved instrumental in some important areas of protection for cultural property by disseminating good practices related to the implementation of safeguarding measures; creating a platform for international cooperation; granting enhanced protection to seventeen cultural sites; and actively promoting this system on an ongoing basis. However, its ability to discharge effectively its mandate is undoubtedly hampered by the scope of the political considerations that sometimes surface during committee meetings—namely, a focus on procedural matters rather than on potentially more

pressing substantive operational actions, and a reluctance to become an international platform for the debate of alleged serious violations of the Second Protocol.

National IHL committees, which exist in one form or another in more than a hundred countries, represent another example of valuable mechanisms to assist and advise government authorities on ways to comply with IHL and the protection of cultural property. Although states are not required under international law to establish such advisory bodies, and there is no standard model for their composition, status, or mandate, experience has clearly demonstrated the instrumental nature of their work for the effective implementation of IHL obligations at the domestic level.[21] As acknowledged in 2016 at the fourth universal meeting of these committees in Geneva, "given their interdisciplinary approach and the nature of their mandate, they can play an important role in setting up those policies, strategies and action plans that are required at national level to protect cultural property (including ratification of/ accession to relevant international instruments and enactment of comprehensive domestic legislation/regulations)."[22] In other words, these committees are generally well positioned to deploy the most important preventive measures and policies and to propose relevant courses of action.

Intergovernmental and nongovernmental organizations, as well as other international entities, also play an important role. Within their respective field of expertise and mandates, many organizations contribute to the implementation of a protective legal framework, including UNESCO, the International Committee of the Red Cross (ICRC), the Blue Shield International, the International Council of Museums (ICOM), the International Council on Monuments and Sites (ICOMOS), the International Centre for the Study of the Preservation and Restoration of Cultural Property (ICCROM), the International Council on Archives (ICA), the International Federation of Library Associations and Institutions (IFLA), and the International Alliance for the Protection of Heritage in Conflict Areas (ALIPH). Their work includes activities such as humanitarian diplomacy, support for ratification of international instruments, support for the domestic implementation of those treaties, advocacy and awareness-raising in case of violations of the law, capacity building and training initiatives, development of international standards, and post-conflict restoration programs. While recognizing that these organizations are an integral part of the international system of protection of cultural property, and that support by states for their work is a key component of this system, maximizing the impact of their work by ensuring proper coordination of their action still represents an arduous challenge.

Conclusion

As the means and methods of warfare change, constantly querying the strength of rules governing the protection of cultural property is not only inevitable but necessary. However, revisiting the effectiveness of these rules must be conducted in a holistic

manner. A focus on the relevance of the existing legal framework must be combined with an interest in strengthening its implementation on the ground.

In this vein, existing international humanitarian law arguably provides for a comprehensive set of rules when it comes to protecting cultural property from the effects of armed conflict. Not only does it restrict the behavior of the warring parties in the course of hostilities, but also purports to prepare for the protection of valuable cultural property in peacetime. While small normative gaps exist within the framework, looking for ways to exploit some of the untapped potential of existing implementation mechanisms is one of the key challenges to cultural property protection in a time of armed conflict.

Among other things, effective and sustainable monitoring mechanisms, supervised by competent intergovernmental bodies, must be established or reinforced; clear procedures and strong incentives must be developed for the inscription of cultural properties on international lists; and international assistance and capacity-building activities must continue to be offered to states in order to both assist them in better complying with the law and to restore destroyed cultural property and sites. Support for multilateral institutions must be galvanized to coordinate all these processes. Effective responses to protect cultural property requires not only all important international actors to find ways to optimize the collective impact of their actions, but to also make the most of relevant practices and policies—approaches that some states have already put in place in order to assist others in aligning their actions accordingly. Finally, while international coordination is important, giving a role and space to local actors is equally crucial, since national responders are often in the strongest position to deliver rapid, culturally appropriate, and sustainable humanitarian assistance to their own communities. In other words, in this field probably more than in any other, both the preventive and the humanitarian response to the lack of protection of cultural property should be as international as necessary and as local as possible.

Overall, the international system of protection of cultural property in time of armed conflict is better equipped today than at any time in history. As a side effect of publicized intentional destruction of cultural sites and looting of artifacts in recent armed conflicts, public sensitivity to this issue is also arguably higher today than ever before. In our view, this creates an unprecedented opportunity.

SUGGESTED READINGS

Kevin Chamberlain, *War and Cultural Heritage: An Analysis of the 1954 Convention for the Protection of Cultural Property in the Event of Armed Conflict and Its Two Protocols*, 2nd ed. (Builth Wells, UK: Institute of Art and Law, 2012).

Francesco Francioni and Ana Filipa Vrdoljak, eds., *The Oxford Handbook of International Cultural Heritage Law* (Oxford: Oxford University Press, 2020).

Marina Lostal, *International Cultural Heritage Law in Armed Conflict: Case-Studies of Syria, Libya, Mali, the Invasion of Iraq, and the Buddhas of Bamiyan* (Cambridge: Cambridge University Press, 2017).

Roger O'Keefe, *The Protection of Cultural Property in Armed Conflict* (Cambridge: Cambridge University Press, 2006).

"Protection of Cultural Property in Armed Conflict," special issue, *International Review of the Red Cross*, no. 854 (June 2004), https://international-review.icrc.org/reviews/irrc-no-854-protection -cultural-property-armed-conflict.

NOTES

1. However, the distinction between the concepts of "cultural heritage" and "cultural property" is not absolute. The 1972 Convention Concerning the Protection of the World Cultural and Natural Heritage uses the term "cultural heritage" to refer to tangible objects.
2. Some aspects of IHL nevertheless apply during peacetime, such as the preventive measures intended to prepare the situation before any war erupts: e.g., training and dissemination obligations, adapting domestic legislation and military doctrine in accordance with IHL obligations, and marking protected buildings, sites, and objects with a distinctive emblem.
3. The constitutive elements of the concept of "armed conflict," which is technically not defined in treaty law, have essentially been defined by the jurisprudence of the ICTY in *Dusko Tadić*, case no. IT-94-1-T, Judgment, 7 May 1997. For an explanation of how this notion should be understood, see, among many other sources, the following opinion paper: International Committee of the Red Cross, "How Is the Term 'Armed Conflict' Defined in International Humanitarian Law?," March 2008, https://www.icrc.org/en/doc/assets/files/other/opinion-paper -armed-conflict.pdf.
4. The Third Additional Protocol to the Geneva Conventions (8 December 2005) exclusively relates to the adoption and recognition of an additional distinctive emblem, the Red Crystal; it may be used for the same purposes and has the same legal status as the Red Cross and the Red Crescent emblems.
5. This is the case for many treaties and other legal instruments that regulate the use of weapons, that apply to naval warfare or to the regulation of the use of mercenaries, and, as explained in this chapter, for treaties related to the protection of cultural property in the event of armed conflict.
6. After a ten-year study mandated by the International Conference of the Red Cross and Red Crescent Movement in 1995, the ICRC published a list of 161 rules of customary IHL, four of which specifically apply to the protection of cultural property. The study, which compiles relevant national and international practice related to each identified rule, is updated on an ongoing basis. See ICRC, "IHL Database: Customary IHL," https://ihl-databases.icrc.org/ customary-ihl/eng/docs/home.
7. See Regulations to the 1907 (IV) Hague Convention, Art. 27, 56. The 1907 (IX) Hague Convention concerning bombardment by naval forces in time of war also contains a provision on the protection of cultural property (Art. 5).
8. 1954 Hague Convention, Art. 1.
9. Within the limits imposed by good faith and by the ordinary meaning of words, as imposed under international law. See Vienna Convention on the Law of Treaties, 23 May 1969, Art. 26, 31.
10. At the same time, in situations where the enemy has clearly demonstrated its intention not to respect the protective rules imposed by IHL, sharing inventories or the GPS coordinates of protected objects (including cultural property, hospitals, objects indispensable to the survival of

the civilian population such as power stations or dams) or marking them with a distinctive emblem can in fact put these objects at higher risk. In such exceptional—although not hypothetical—circumstances, where there is indication that the marking of the objects would in fact defeat its intended purpose, the concerned belligerent party must carefully assess the relevance of not marking them and of the alternative protective measures that it will put in place. This can potentially be even more problematic when the marking of specific categories of protected cultural property is compulsory under treaty law, as is the case for buildings and items under the categories of "special" and "enhanced" protection.

11. NIAC, which is by far the most prevalent form of contemporary warfare, is much less regulated under treaty law than IAC. Not only is Article 3 common to the four 1949 Geneva Conventions the only provision in the conventions that deals with situations of NIAC, but there is a major discrepancy between the level of detail laid out in AP I (102 articles) and the rudimentary provisions of AP II (twenty-eight articles).

12. Even when imperative military necessity can successfully be invoked, the attacking party is still bound by the core principles guiding the conduct of hostilities under IHL. This means that before launching an attack against any legitimate military objective (including against cultural property that has lost its protection), the attacking party must take a series of precautionary measures intended to limit the effects of the attack on the civilian population and on civilian objects, and keep them proportionate to the direct and concrete military advantage anticipated by the operation. The attacking party must also cancel or suspend the attack if it becomes apparent that the target is in fact protected under IHL or that collateral damage to protected persons and objects will be disproportionate. These obligations, which are deeply rooted in customary IHL, have been specifically adapted to the protection of cultural property in Arts. 7, 8 of the 1999 Second Protocol.

13. These acts are: "(a) Making cultural property under enhanced protection the object of attack; (b) Using cultural property under enhanced protection or its immediate surroundings in support of military action; (c) Extensive destruction or appropriation of any protected cultural property; (d) Making any protected cultural property the object of attack; (e) Theft, pillage, misappropriation of or vandalism directed against protected cultural property." See Second Protocol, Art. 15.

14. It is, however, necessary that the alleged offender be apprehended on the territory of the prosecuting state.

15. Beyond the fact that the sanctions regime in the 1999 Second Protocol goes beyond the prescription in AP I, Art. 85 (which only applies to IAC), neither Article 3 common to the Geneva Conventions nor AP II contain provisions on the repression of war crimes in NIAC. The Second Protocol undeniably also goes beyond the prescription of the Rome Statute, which not only distinguishes crimes committed in IAC from those committed in NIAC but more importantly criminalizes neither offenses committed against movable cultural property nor the use of protected cultural property for military purposes. See Rome Statute of the International Criminal Court, Arts. 8.2.b.ix, 8.2.e.iv.

16. See the International List of Cultural Property under Enhanced Protection: UNESCO, "Armed Conflict and Heritage: Enhanced Protection," http://www.unesco.org/new/en/culture/themes/armed-conflict-and-heritage/lists/enhanced-protection/.

17. In the *Al Mahdi* case, the ICC stated that the attack against objects of the World Heritage Site "appears to be of particular gravity as their destruction does not only affect the direct victims of the crimes, namely the faithful and inhabitants of Timbuktu, but also people throughout Mali and the international community." See ICC, *Prosecutor v. Ahmad Al Faqi Al Mahdi*, case no. ICC-01/12-01/15, Judgement and Sentence, 27 September 2016, para. 80, https://www.icc-cpi.int/CourtRecords/CR2016_07244.PDF.

18. It must be noted that inscribed cultural sites may also attract the attention of warring parties, which may make them vulnerable to damage or destruction. The capture of the site of Palmyra in Syria and its use by the Islamic State of Iraq and Syria (ISIS, also known as ISIL or Da'esh) to attract public attention is well known.

19. Patrick Boylan, *Review of the Convention for the Protection of Cultural Property for the Protection in the Event of Armed Conflict (The Hague Convention of 1954)* (Paris: UNESCO, 1993).

20. Art. 27 of the Second Protocol lists the functions of the Committee for the Protection of Cultural Property in the Event of Armed Conflict. These include granting, suspending, or canceling enhanced protection for cultural property and maintaining the List of Cultural Property under Enhanced Protection; monitoring and supervising the implementation of the Second Protocol; and considering requests for international assistance.

21. Although each is adapted to the specificities of its own state, national IHL committees or similar bodies are generally composed of representatives of different ministries interested in IHL matters (such as defense, justice, foreign affairs, internal affairs, health, and the office of the chief executive), with sometimes the addition of representatives from the legislature, the judiciary, universities, nongovernmental organizations, and national Red Cross or Red Crescent societies.

22. Universal Meeting of National Committees and Similar Bodies on International Humanitarian Law, *Enhancing Protection in Armed Conflict through Domestic Law and Policy: Conference Overview, Geneva, Switzerland, 30 November–2 December 2016* (Geneva: ICRC, 2016), 13, https://www.icrc.org/en/publication/enhancing-protection-armed-conflict-through-domestic-law-and-policy.

23

International Human Rights Law and Cultural Heritage

Marc-André Renold

Alessandro Chechi

The tangible dimension of any movable and immovable cultural object is completed and accompanied by an intangible human dimension, which relates to the symbolic, spiritual, or historical values embodied in such objects. Such values—which are independent of any aesthetic or monetary significance—are assigned to cultural heritage by its makers and those who identify with these objects.[1] In other words, culture is understood, protected, and promoted not only for its physical manifestations but for the relationship of culture to people, individually or in groups, and the diversity of the relationships being protected and promoted.[2]

This intrinsic link between cultural objects and human beings explains why mass atrocity crimes committed in the context of contemporary armed conflict are often accompanied by the destruction and looting of the tangible heritage of the enemy—monuments, buildings, sites, archaeological materials, and sacred artifacts connected to the history, literature, art, or science of the target people.[3] Belligerents target cultural heritage for reasons other than the destruction of the object: to destroy the morale of the enemy; annihilate the communal identity of those for whom it has special significance; and undermine their (cultural) survival.[4] It follows that the issue of cultural heritage protection cannot be treated in isolation from human rights.[5]

The aim of this chapter is to explore the interconnections between human rights and cultural heritage.[6] This chapter first examines the ways in which international human rights law has contributed to the growth and maturity of international cultural heritage law as its own distinct field of international law.[7] It then discusses how cultural heritage has increasingly been integrated into human rights treaties. Finally, it provides an appraisal of the mutual interactions of the two fields.

The Human Rights Dimension of UNESCO Instruments

International cultural heritage law has concerned itself predominantly with the preservation of the integrity of tangible objects. This is not surprising since the development of this branch of law can be connected to the effort to protect cultural heritage items in time of armed conflict, i.e., when damage and destruction of culture's tangible elements can result either from intentional, direct acts of hostility or use for military purposes, or as combat-related collateral damage. Only in recent times have instruments adopted under the auspices of the United Nations Educational, Scientific and Cultural Organization (UNESCO) recognized the connection between cultural heritage, its makers, and the people who identify with it. By exploring the contribution of international human rights law to the development of international cultural heritage law, this essay demonstrates the distinct human rights approach of UNESCO's instruments, in which human rights are positioned as important elements of cultural heritage protection.

The Convention for the Protection of Cultural Property in the Event of Armed Conflict was adopted by UNESCO in 1954. It introduced for the first time the notion of "cultural property" in an international legal context.[8] According to Article 1, this term includes movable and immovable property "of great importance to the cultural heritage of every people, such as monuments of architecture, art or history . . . archaeological sites; groups of buildings . . . works of art; manuscripts, books and other objects of artistic, historical or archaeological interest."[9] This new concept was supposed to serve as a category of objects worth protecting because of their inherent value rather than because of their vulnerable character.[10]

However, when applied to objects of cultural value, the term causes significant problems. First, the term "property" is generally used to indicate material things subject to private ownership rights of a predominantly economic nature. Second, it emphasizes control in the form of an ability to alienate, exploit, dispose of, and exclude others from using or benefiting from an object (known as the "right to property" or the "right to destroy," or *jus utendi et abutendi*). Third, it entails an important contradiction between the exclusive owner's rights and the application of specific protective rules that might curtail such rights. And fourth, it clears the way for the "commodification" of cultural objects, i.e., the attribution of market value.[11]

The term "cultural property" has been superseded by the concept of "cultural heritage," which was originally developed with the 1972 Convention Concerning the Protection of the World Cultural and Natural Heritage (WHC), and later the 2001 Convention on the Protection of the Underwater Cultural Heritage. Specifically, the WHC brings together the safeguarding of the human-made environment of exceptional importance, on the one hand, and of the most extraordinary natural resources, on the other, as essential elements of the "human environment." The WHC is thereby one of the signals of the dawn of international environmental law—following the Stockholm Declaration of the United Nations Conference on the Human Environment in 1972—and

of the international community's engagement for preventing the loss or degradation of natural and built heritage. It is for these reasons that the WHC brought about the shift from "cultural property" to the more complex concept of "cultural heritage," and transformed the protection of cultural heritage items into a collective interest.[12] Accordingly, the term "cultural heritage" is today used in legal parlance to embrace any manifestation of artistic and creative processes having a public or private dimension. As such, cultural heritage conveys an understanding that is broader than that of "cultural property" (or "cultural objects" or "cultural goods") used to indicate tangible movable assets. In addition, the term "cultural heritage" emphasizes that the values inherent in cultural heritage expressions—which are given to them by the individual or the people who created them, or for whom they were created, or whose particular identity and history they share—must be transmitted from one generation to the next with the duty to preserve.[13]

Furthermore, the introduction of the term "cultural heritage" has increasingly extended international protection to intangible forms of cultural expression through a new generation of UNESCO instruments which explicitly emphasize the relationship between human rights and cultural heritage. These include the 2001 Universal Declaration on Cultural Diversity, the 2003 Declaration Concerning the Intentional Destruction of Cultural Heritage, the 2003 Convention for the Safeguarding of the Intangible Cultural Heritage, and the 2005 Convention on the Protection and Promotion of the Diversity of Cultural Expressions.

The Universal Declaration on Cultural Diversity contains multiple references to the imperative of human rights protection. For instance, its preamble affirms a commitment to the "full implementation of human rights" and proclaims that "the defence of cultural diversity is an ethical imperative" (Article 4) and "cultural rights are an integral part of human rights" (Article 5).

The Declaration Concerning the Intentional Destruction of Cultural Heritage was adopted by the UNESCO General Conference as a reaction to the demolition of two Buddha statues in the Bamiyan Valley, Afghanistan, which dated from the pre-Islamic era, perpetrated by the Taliban in 2001. As is well known, the Buddhas of Bamiyan were destroyed for ideological reasons.[14] The preamble to the declaration states that "cultural heritage is an important component of the cultural identity of communities, groups and individuals . . . so that its intentional destruction may have adverse consequences on human dignity and human rights." More importantly, Principle 9 of the declaration links human rights to the duty incumbent upon every state to protect the cultural heritage of significant importance for humanity situated within its territory: "States recognize the need to respect international rules related to the criminalization of gross violations of human rights and international humanitarian law, in particular, when intentional destruction of cultural heritage is linked to those violations."

The Convention for the Safeguarding of the Intangible Cultural Heritage is the first legally binding international instrument to focus on the intangible cultural heritage of

communities, groups, and individuals. It defines "intangible cultural heritage" as "the practices, representations, expressions, knowledge, skills . . . that communities, groups and, in some cases, individuals recognize as part of their cultural heritage. This intangible cultural heritage, transmitted from generation to generation, is constantly recreated by communities and groups in response to their environment, their interaction with nature and their history, and provides them with a sense of identity and continuity, thus promoting respect for cultural diversity and human creativity." This definition includes music, literature, dance, mythology, rituals, handicrafts, and other cultural manifestations and establishes a direct connection between intangible heritage and the identity of individuals and communities who create and maintain it.

Therefore, the novelty of the intangible heritage regime lies in the protection of cultural objects not as endowed with their own intrinsic value, but because of their association with a community which sees the safeguarding of its living culture as part of its human rights claim to maintain and develop its identity as a social body beyond the biological life of its members. The 2003 convention therefore denotes a confluence of cultural heritage law with human rights law and the law on the protection of minorities and Indigenous peoples.[15]

The Convention on the Protection and Promotion of the Diversity of Cultural Expressions focuses on the plurality of cultures and cultural diversity as constituting the "common heritage of humanity."[16] But it also emphasizes that protection of cultural diversity hinges on the protection of the rights of each individual, and not merely on the preservation of the tangible manifestations that express their culture.

In sum, the scope of the international legal framework has changed dramatically since the establishment of UNESCO in 1945. Initially, it was concerned with the preservation of the integrity of tangible objects in times of armed conflict. Then, in response to environmental concerns, protection was extended to sites of cultural and natural importance. More recently, intangible heritage was included in the concept of cultural heritage. Accordingly, today the international legal framework covers not only all types of cultural expressions, but also—as demonstrated in the next section—the human rights associated with them.

Finally, the influence of international human rights law is discernible in treaty clauses which proclaim that "harmful traditional practices" (such as female genital mutilation, polygamy, female infanticide, child [forced] marriage, and honor killings)[17] are not worthy of protection under cultural heritage law.[18] For instance, Article 4 of the 2001 declaration states that "no one may invoke cultural diversity to infringe upon human rights guaranteed by international law." Article 2.1 of the 2003 convention provides that "for the purposes of this Convention, consideration will be given solely to such intangible cultural heritage as is compatible with existing international human rights instruments." Similarly, Article 2.1 of the 2005 convention affirms that "no one may invoke the provisions of this Convention in order to infringe human rights and fundamental freedoms." All in all, these provisions indicate that the imperative of

cultural heritage protection should not be used to uphold violent or discriminatory practices, even if an individual consents to a cultural practice, and even if the group to which that individual belongs believes that such a practice is valid.[19] Put differently, the protection of cultural heritage assumes the observance of human rights values and the repudiation of any violent, abusive, and discriminatory practice.

The Cultural Dimension of International Human Rights Law

Preoccupation with the protection of cultural heritage has progressively influenced the interpretation and implementation of international human rights treaties. The most relevant are the 1965 Convention on the Elimination of All Forms of Racial Discrimination (Article 5.e.vi), the 1966 International Covenant on Economic, Social and Cultural Rights (ICESCR), the 1966 International Covenant on Civil and Political Rights (ICCPR), the 1981 Convention on the Elimination of All Forms of Discrimination against Women (CEDAW, Article 13.c), the 1981 African Charter on Human and Peoples' Rights (Article 17.2), the 1988 Additional Protocol to the American Convention on Human Rights in the Area of Economic, Social and Cultural Rights (Article 14.1.a), and the 1990 Convention on the Protection of the Rights of All Migrant Workers and Members of their Families (Articles 43.1.g and 45.1.d).

Despite the existence of provisions for cultural rights in a wide range of treaties and a number of studies undertaken by UNESCO,[20] the meaning of such rights (and of the corresponding state obligations) have long remained unexplored when compared to civil, political, economic, and social rights in terms of their scope, legal content, enforceability, and justiciability.[21] One reason for this is that culture was frequently addressed in the context of other rights, such as the right to practice religion or freedom of expression.[22] Another reason is that the Committee on Economic, Social and Cultural Rights (CESCR), the body of independent experts that monitors implementation of the ICESCR under the authority of the UN Economic and Social Council (ECOSOC), was established only in 1985—i.e., nearly twenty years after the adoption of the covenant. Moreover, as demonstrated, the existence of the human dimension of cultural heritage has been acknowledged only in recent times.[23] As such, human rights bodies have explored the concepts of culture and cultural heritage from a human rights perspective in recent years. The findings of these bodies are now examined.

In the ICESCR, the most comprehensive treaty on the protection of cultural rights, Part III outlines the substantive rights to be protected: to education (Articles 13–14); to participate in cultural life (Article 15.1.a); to enjoy the benefits of scientific progress and its applications (Article 15.1.b); to benefit from the protection of the moral and material interests resulting from any scientific, literary or artistic production of which the person is the author (Article 15.1.c); and the freedom for scientific research and creative activity (Article 15.3).

Article 15.1.a, on the right to participate in cultural life, contains a very general and vague assertion. Neither a literal interpretation nor the consultation of its *travaux*

préparatoires, or drafting history, are of assistance in understanding the exact meaning of the provision.[24] The normative content of this right was fleshed out by the CESCR in General Comment No. 21 of 2009.[25] At the outset, the CESCR affirmed that "cultural rights are an integral part of human rights and, like other rights, are universal, indivisible and interdependent." It also made clear that cultural rights may be exercised by "a person (a) as an individual, (b) in association with others, or (c) within a community or group." It follows that the right to participate in cultural life belongs to all individuals, regardless of the bond of citizenship. The committee also confirmed that the rights related to cultural heritage cannot be invoked to infringe upon other human rights,[26] and it elaborated on the terms "culture" and "participation."

According to the CESCR, the term "culture" reflects "a living process, historical, dynamic and evolving," one that encompasses "all manifestations of human existence," such as "ways of life, language, oral and written literature, music and song, non-verbal communication, religion or belief systems, rites and ceremonies, sport and games, methods of production or technology, natural and man-made environments, food, clothing . . . and the arts, customs and traditions" that are essential to individuals and communities to "express their humanity and the meaning they give to their existence, and build their world view representing their encounter with the external forces affecting their lives."[27] These statements indicate that: the CESCR considered culture in its broadest form as a dynamic process apart from its material side;[28] individuals and communities are regarded as rights holders; and the right to take part in cultural life is not limited to the enjoyment of what is considered to be of outstanding value to humanity or the "national culture" (i.e., the culture of the dominant group). Rather, such a right is understood as encompassing what is of significance for individuals and communities (their own culture or the "the cultural heritage and the creation of other individuals and communities").[29]

Also in General Comment No. 21, the notion of participation was interpreted by the committee to include participation in, access to, and contribution to cultural life. From a passive perspective, taking part in cultural life means having access to it (and to information about it) and enjoying its benefits without any form of discrimination. From this perspective, to take part implies that the cultural heritage that is related to cultural life is protected and preserved, and that everyone, including individuals belonging to nondominant groups, has the right to access monuments, cultural spaces, and art objects in museums and similar institutions. From an active perspective, taking part in cultural life means having the right to choose and change a cultural affiliation, and to freely contribute to cultural life by means of creative activities and by participating in the identification, interpretation, protection, and development of cultural heritage meaningful to them, and in decision-making processes concerning the design and implementation of policies and programs.[30]

General Comment No. 21 also confirmed that states retain the primary responsibility for the promotion of cultural rights and the protection of cultural heritage. The concept

of human rights assumes the existence of state duties. Without these obligations human rights would be meaningless. Depending on the situation, ICESCR state parties are under a negative obligation to refrain from interference with the exercise of cultural practices and with access to cultural objects, and under a positive obligation to take measures to guarantee participation in, access to, and enjoyment of cultural heritage. All in all, the CESCR endeavored to articulate the obligation of state parties to ensure the protection of tangible and intangible cultural heritage within their jurisdiction, including the cultural heritage of minorities and Indigenous peoples, and the right to take part in cultural life as a freedom as opposed to mere opportunities to engage in cultural activities.[31] In effect, the preservation of monuments, sites, and artifacts of archaeological, historical, religious, or aesthetic value can be regarded as instrumental in safeguarding the rights and identity of the individuals and communities who created them, or for whom they were created, or whose identity and history they are bound up with. Indeed, it is pointless to pursue the preservation of cultural heritage items for their own sake and not for the sake of the people for whom they have special meaning.

Over the years, the Human Rights Committee (HRC), which is charged with overseeing state compliance with the ICCPR, has developed an important body of practice on the cultural rights of minorities based on ICCPR Article 27, which provides: "In those States in which ethnic, religious or linguistic minorities exist, persons belonging to such minorities shall not be denied the right, in community with the other members of their group, to enjoy their own culture, to profess and practise their own religion, or to use their own language."[32] The article's reach can be delineated as follows.

First, the HRC has endorsed a broad and dynamic interpretation of "culture." In General Comment No. 23, it defined culture as a dynamic concept, one that includes the way of life of a given community,[33] or one through which the group expresses its cultural distinctiveness.[34] This definition allows that, for example, modern equipment or techniques may be used for handicraft, music performances, or traditional activities such as fishing and hunting, without making these activities any less worthy of protection.

Second, the HRC has repeatedly affirmed that the right of Article 27 can only be realized meaningfully when exercised "in community" (though the article also speaks about the rights of "persons" belonging to minorities).[35] In addition, in order to identify the minorities who are the subjects of Article 27 (and the persons belonging to such minorities) a subjective element is required—namely, the existence of a connection with a common past and common traditions. This element bears a strong parallel with the purposes of cultural heritage as having meaning for those who identify with it as their own.[36] Accordingly, the enjoyment of rights under the ICCPR does not depend on a formal bond of citizenship between the members of a group and a state, but on the display of stable characteristics by a group, which distinguishes it from the rest of the population.[37] In this sense it must be stressed that cultural rights and minority rights

are different in terms of their application, because while the former are afforded to all, the latter are only afforded to recognized minorities.

Third, although the right contained in Article 27 is negatively conferred ("shall not be denied the right"), in addition to the requirement that states not interfere with the ability of minorities to enjoy their own culture, they are obliged to act proactively on behalf of rights holders to protect their identity as well as the tangible religious or historical property that is indispensable to them. States are also required to take measures to ensure the continued access of minority communities to their heritage along with the ability to create and maintain it.[38]

Although Article 27 does not specifically refer to Indigenous peoples, the HRC has not hesitated to extend to them the protection afforded by this rule.[39] However, today the rights of Indigenous peoples are enshrined in the 2007 United Nations Declaration on the Rights of Indigenous Peoples (UNDRIP). It recognizes the legal personality of Indigenous peoples and contains far-reaching guarantees concerning their rights to self-determination (Articles 3–5). But the protection of these prerogatives may be substantially impaired by the very nature of the UNDRIP, which lacks binding force. Concerning the material scope, the UNDRIP is the first human rights instrument to contain explicit references to cultural heritage. This should not be surprising since it was adopted a few years after that of UNESCO's new generation instruments—namely, the 2001 Universal Declaration on Cultural Diversity and the 2003 Convention for the Safeguarding of the Intangible Cultural Heritage. Notably, Article 31 of the UNDRIP reads: "Indigenous peoples have the right to maintain, control, protect and develop their cultural heritage, traditional knowledge and traditional cultural expressions, as well as the manifestations of their sciences, technologies and cultures, including human and genetic resources, seeds, medicines, knowledge of the properties of fauna and flora, oral traditions, literatures, designs, sports and traditional games and visual and performing arts. They also have the right to maintain, control, protect and develop their intellectual property over such cultural heritage, traditional knowledge, and traditional cultural expressions." As such, UNDRIP acknowledges Indigenous peoples' holistic conceptualization of cultural heritage, which covers land, immovable and movable heritage, and tangible and intangible elements, and assumes a symbiotic relationship between these elements. For Indigenous peoples, cultural heritage includes everything that belongs to their distinct identity, not only the things regarded as the creative production of human thought and craftsmanship (such as songs, stories, and artworks), but also human remains, the natural features of the landscape, and species of plants and animals.[40] This means that the idea of cultural heritage embodied in UNDRIP is antagonistic to the idea of the public heritage of a nation.[41] More importantly, UNDRIP acknowledges the human dimension of Indigenous cultural heritage.

Appraisal

The legal instruments on cultural heritage adopted by UNESCO display a clear human rights approach, whereby human rights are considered as important elements of cultural heritage protection. By fostering the safeguarding of intangible cultural heritage, cultural identity, and cultural diversity, the most recent UNESCO instruments place human rights issues more directly at the forefront of cultural heritage protection than was previously the case.[42] These legal tools place greater emphasis on the importance of the promotion and protection of cultural heritage as a fundamental element for the construction and expression of the cultural identity of individuals and communities, and for fostering cultural diversity. In other words, a shift has taken place from protecting cultural objects for humankind as a whole to safeguarding cultural heritage for communities. One reason for this evolution resides in the ongoing or dormant interethnic and interreligious conflicts that plague many states where discrimination against, and persecution of, individuals within ethnic or religious communities are common. The international community is engaged in promoting cultural diversity (rather than suppressing cultural, ethnic, or religious differences) in order to address the root causes of such conflicts and to ensure peace and human rights for all.[43]

However, human rights concerns can also be found (albeit sometimes implicitly) in UNESCO conventions on tangible cultural heritage. This is demonstrated by the reference to "people" (and not states) in the 1954 Convention for the Protection of Cultural Property in the Event of Armed Conflict, by the involvement of local communities in the process leading up to the inscription of sites on the World Heritage List under the WHC and in the subsequent management of such sites, and by articles referring to the objects belonging to tribal or Indigenous communities in the 1995 Convention on Stolen or Illegally Exported Cultural Objects.[44] In addition, the latest version of the WHC operational guidelines proclaim for the first time that state parties "are encouraged to adopt a human-rights based approach, and ensure gender-balanced participation of a wide variety of stakeholders and rights-holders, including . . . local communities, Indigenous peoples . . . and other interested parties and partners in the identification, nomination, management and protection processes of World Heritage properties."[45] Similarly, the latest version of the operational guidelines for the implementation of the 1970 UNESCO Convention on the Means of Prohibiting and Preventing the Illicit Import, Export and Transfer of Ownership of Cultural Property affirms that the "loss, through theft, damage, clandestine excavations, illicit transfer or trade, of its invaluable and exceptional contents constitutes an impoverishment of the cultural heritage of all nations and peoples of the world and infringes upon the fundamental human rights to culture and development."[46] The symbiosis between cultural heritage and human rights is emphasized in order to reiterate the detrimental effects of the illicit trafficking in cultural property (theft, clandestine excavation, illicit export), and to facilitate the restitution of cultural objects.[47]

Furthermore, the above overview also demonstrates that cultural rights are now recognized as forming part of the catalogue of human rights. This is due to the exponential expansion of the understanding of culture and cultural heritage, on the one hand, and deeper interpretations of human rights norms, on the other.[48]

However, while the link between human rights and cultural heritage is generally recognized today, respect, protection, and the fulfillment of cultural rights are not yet sufficiently achieved. The main reason is that human rights and cultural heritage instruments preserve states' sovereign powers. In particular, the UNESCO treaties remain classical international treaties in the sense that they mainly have a horizontal character as agreements between states creating mutual rights and obligations.[49] As such they do not provide for clear substantive rights to cultural heritage for individuals and communities.[50] As a result, states retain a wide margin of discretion with respect to the fulfillment of the obligations set out in existing treaties regarding the selection, recognition, and protection of the cultural heritage and cultural rights of communities and individuals.

To this must also be added that many ICESCR contracting states not only fail to adopt adequate measures to remove the obstacles inhibiting or limiting access to a community's own and other cultures, but also to preserve and protect the tangible cultural heritage situated on their territory.[51] In addition, the rights of Indigenous peoples set out in the UNDRIP are often curtailed by states. For instance, regarding the "cultural, intellectual, religious and spiritual property taken without their free, prior and informed consent or in violation of their laws, traditions and customs," Article 11.2 affirms that "States shall provide redress through effective mechanisms, which may include restitution, developed in conjunction with Indigenous peoples." Moreover, Article 12 provides that "States shall seek to enable the access and/or repatriation of ceremonial objects and human remains in their possession through fair, transparent and effective mechanisms developed in conjunction with Indigenous peoples concerned." This means that the restitution of the objects important to Indigenous peoples does not constitute an autonomous right but, rather, one of the outcomes of the negotiation between a state and the community concerned.

Further, human rights enforcement procedures often prove ineffective for individuals and communities.[52] Whether international compliance mechanisms and remedies are available and whether they are directly accessible by individuals and groups will depend on the treaties (or their optional protocols) to which the state in question is party, and on the rule on exhaustion of local remedies (where relevant). The protection of cultural rights also needs transparent and effective accountability mechanisms to ensure that they are respected, protected, and fulfilled, and that victims can obtain redress. Such redress could take several forms, including investigation into gross and systematic violations, damages to victims, restitution, satisfaction, and guarantees of nonrepetition.[53] In terms of the powers of these institutions, the three regional human rights courts—the European Court of Human Rights, the Inter-American

Court of Human Rights, and the African Court of Human and Peoples' Rights—are each vested with jurisdiction authoritatively to determine a state's breach of the treaty in question and to award or order one or more forms of reparation. In contrast, treaty monitoring bodies such as the HRC and the CESCR have no power to declare a state in breach of treaty, let alone make binding orders for reparation or adopt provisional measures.[54] The monitoring systems of the ICCPR and ICESCR are fully in the hands of states.[55] Nevertheless, it may well be that domestic courts are available to victims. In many states, treaty-based human rights guarantees are self-executing in national law or have been enacted into national law by the legislature. Provided that the applicable rules on standing are satisfied, this enables individuals and groups to enforce these rights through domestic courts.[56]

Conclusion

The synergy between the international legal frameworks developed to ensure the protection of human rights and cultural heritage is essential to prevent the intentional destruction and looting of cultural heritage associated with mass atrocities committed in the context of contemporary armed conflict by belligerents belonging to a state's armed forces or to nonstate armed groups. In other words, such legal frameworks are mutually supportive to the extent that the protection of cultural heritage and the rights associated with it may indirectly protect human beings. We also argue that the adoption of a human rights approach to cultural heritage is required to address the root causes of the crimes under consideration—namely, extremism in its diverse forms. Although essential to the prevention of acts of deliberate destruction of cultural heritage accompanying large-scale killings and other heinous violations, the human rights approach under consideration would also be crucial for the promotion of human rights after the end of hostilities in the context of peacebuilding processes.

Given that fundamentalist ideologies are the cause of attacks against individual rights and freedoms as well as against cultural heritage, education on human rights and the values of tangible and intangible cultural heritage should be deployed to prevent and fight the spread of such dangerous ideas.[57] Efforts in education should be fostered because cultural heritage and human rights can only be protected and fulfilled if they are known and understood by people, from the professionals having responsibilities in the field (lawyers, judges, and law-enforcement officers) to the laymen and laywomen living in the vicinity of the relevant heritage.[58] Through human rights education, cultural rights can become "empowering rights." As posited by Janusz Symonides, "without their recognition and observance, without implementation of the right to cultural identity, to education, to creativity or to information, neither may human dignity be guaranteed nor other human rights fully implemented. Without the recognition of cultural rights, cultural plurality and diversity, fully democratic societies cannot function properly."[59]

The importance of promoting and developing human rights education is underlined in many documents. Apart from UNESCO conventions[60] and human rights treaties,[61] the constitution of UNESCO contains multiple references to the idea of human rights education, as it provides that: "since wars begin in the minds of men, it is in the minds of men that the defences of peace must be constructed"; "the wide diffusion of culture, and the education of humanity for justice and liberty and peace are indispensable to the dignity of man and constitute a sacred duty which all the nations must fulfil in a spirit of mutual assistance and concern"; and "a peace based exclusively upon the political and economic arrangements of governments would not be a peace which could secure the unanimous, lasting and sincere support of the peoples of the world, and that the peace must therefore be founded, if it is not to fail, upon the intellectual and moral solidarity of mankind." Arguably, such "intellectual and moral solidarity of [hu]mankind" includes awareness and respect for cultural heritage, the rights associated with it, and the diversity of its expressions.[62]

SUGGESTED READINGS

Janet Blake, *International Cultural Heritage Law* (Oxford: Oxford University Press, 2015).

Francesco Francioni and Ana Filipa Vrdoljak, eds., *The Oxford Handbook of International Cultural Heritage Law* (Oxford: Oxford University Press, 2020).

Federico Lenzerini, *The Culturalization of Human Rights Law* (Oxford: Oxford University Press, 2014).

Roger O'Keefe, *The Protection of Cultural Property in Armed Conflict* (Cambridge: Cambridge University Press, 2006).

Riccardo Pavoni, "International Legal Protection of Cultural Heritage in Armed Conflict: Achievements and Developments," *Studi Senesi* 132, no. 2 (2020): 335–57.

NOTES

1. Yvonne Donders, "Cultural Heritage and Human Rights," in *The Oxford Handbook of International Cultural Heritage Law*, ed. Francesco Francioni and Ana Filipa Vrdoljak (Oxford: Oxford University Press, 2020), 385.
2. Ana Filipa Vrdoljak, "Introduction," in *The Cultural Dimension of Human Rights*, ed. Ana Filipa Vrdoljak (Oxford: Oxford University Press, 2013), 1. See also Roger O'Keefe, "Tangible Cultural Heritage and International Human Rights Law," in *Realising Cultural Heritage Law: Festschrift for Patrick O'Keefe*, ed. Lyndel V. Prott, Ruth Redmond-Cooper, and Stephen Urice (Builth Wells, UK: Institute of Art and Law, 2013), 95.
3. This chapter focuses on atrocities committed during armed conflict and their deleterious impact on cultural heritage. However, egregious violations of cultural heritage and cultural rights also occur in time of peace. This is testified by the systematic persecution of Tibetans, Uyghurs, and other Muslim minorities in China, which is accompanied by the destruction of their heritage.
4. Farida Shaheed, *Report of the Independent Expert in the Field of Cultural Rights*, Human Rights Council, UN doc. A/HRC/17/38, 21 March 2001, para. 18.
5. Francesco Francioni, "Beyond State Sovereignty: The Protection of Cultural Heritage as a Shared Interest of Humanity," *Michigan Journal of International Law* 25, no. 4 (2004): 1221.

6. Sarah Joseph, "Art and Human Rights Law," in *Research Handbook on Art and Law*, ed. Jani McCutcheon and Fiona McGaughey (Cheltenham, UK: Edward Elgar, 2020), 389.

7. On the question of whether international cultural heritage law constitutes a subsection of public international law, see Ana Filipa Vrdoljak and Francesco Francioni, "Introduction," in *Oxford Handbook on International Cultural Heritage Law*, ed. Francioni and Vrdoljak, 9.

8. The term "cultural property" was also used in the 1970 UNESCO Convention on the Means of Prohibiting and Preventing the Illicit Import, Export and Transfer of Ownership of Cultural Property.

9. Earlier treaties did not contain a precise term. Movable and immovable cultural objects were identified based on their use. For instance, the Regulations Respecting the Laws and Customs of War on Land Annexed to Hague Convention (IV) Respecting the Laws and Customs of War on Land of 1907, Art. 56 refers to "property of municipalities [and] . . . of institutions dedicated to religion, charity and education, the arts and sciences . . . historic monuments, works of art and science."

10. Francesco Francioni, "A Dynamic Evolution of Concept and Scope: From Cultural Property to Cultural Heritage," in *Standard-Setting in UNESCO: Normative Action in Education, Science and Culture*, ed. Abdulqawi A. Yusuf (Leiden, the Netherlands: Martinus Nijhoff and UNESCO, 2007), 225.

11. Lyndel V. Prott and Patrick O'Keefe, "'Cultural Heritage' or 'Cultural Property'?," *International Journal of Cultural Property* 1, no. 2 (1992): 311.

12. Francesco Francioni, "World Cultural Heritage," in *Oxford Handbook on International Cultural Heritage Law*, ed. Francioni and Vrdoljak, 250–51.

13. Prott and O'Keefe, "'Cultural Heritage' or 'Cultural Property'?," 307, 311.

14. Kristy Campion, "Blast through the Past: Terrorist Attacks on Art and Antiquities as a Reconquest of the Modern Jihadi Identity," *Perspectives on Terrorism* 11, no. 1 (2017): 28.

15. Francesco Francioni, "Public and Private in the International Protection of Global Cultural Goods," *European Journal of International Law* 23, no. 3 (2012): 726.

16. Preamble, para. 2.

17. Harmful traditional practices can be defined as any pattern of conduct that: is regarded by the members of a given community as forming part of their culture; is deeply rooted in the idiosyncratic sociocultural and/or religious customs according to which certain vulnerable groups (i.e., women and girls) are inferior; is perceived as having beneficial effects for the victims of such practices, their families, and the wider community; entails physical or mental harm or suffering, threats of such acts, coercion, and other deprivations of liberty, which often reach the threshold of torture or cruel, inhuman, and degrading treatment; is imposed on women and children by family members, traditional and religious leaders, and/or their community, regardless of whether the victim provides, or is able to provide, full, free, and informed consent; or is maintained by social norms, i.e., informal rules that create a sense of obligation that conditions the behavior of community members.

18. See Alessandro Chechi, "When Culture and Human Rights Collide: The Long Road to the Elimination of Gender-Based Harmful Traditional Practices," *Rivista Ordine internazionale e diritti umani* (2020): 839–62.

19. Alexandra Xanthaki, "Multiculturalism and International Law: Discussing Universal Standards," *Human Rights Quarterly* 32, no. 1 (2010): 43.

20. Since 1952, UNESCO has organized several expert meetings on cultural rights.

21. See Janusz Symonides, "Cultural Rights: A Neglected Category of Human Rights," *International Social Science Journal* 50, no. 158 (December 1998): 559–72.

22. Pok Yin S. Chow, "Culture as Collective Memories: An Emerging Concept in International Law and Discourse on Cultural Rights," *Human Rights Law Review* 14, no. 4 (2014): 617.

23. Vanessa Tünsmeyer, "Bridging the Gap between International Human Rights and International Cultural Heritage Law Instruments: A Functions Approach," in *Intersections in International Cultural Heritage Law*, ed. Anne-Marie Carstens and Elizabeth Varner (Oxford: Oxford University Press, 2020), 321.

24. Laura Pineschi, "Cultural Diversity as a Human Right? General Comment No. 21 of the Committee on Economic, Social and Cultural Rights," in *Cultural Heritage, Cultural Rights, Cultural Diversity: New Developments in International Law*, ed. Silvia Borelli and Federico Lenzerini (Leiden, the Netherlands: Martinus Nijhoff, 2012), 29–53.

25. ECOSOC, "General Comment No. 21: Right of Everyone to Take Part in Cultural Life (art. 15, para. 1a, of the International Covenant on Economic, Social and Cultural Rights)," UN doc. E/C.12/GC/21, 21 December 2009, https://digitallibrary.un.org/record/679354?ln=en.

26. ECOSOC, "General Comment No. 21," paras. 1, 9, 17–20, 64.

27. ECOSOC, "General Comment No. 21," paras. 11–13.

28. Donders, "Cultural Heritage and Human Rights," 391.

29. ECOSOC, "General Comment No. 21," para. 15b.

30. Donders, "Cultural Heritage and Human Rights," 392.

31. ECOSOC, "General Comment No. 21," paras. 6, 44–59, 54.b.

32. https://treaties.un.org/doc/publication/unts/Volume%20999/volume-999-i-14668-english.pdf.

33. Human Rights Committee, "General Comment No. 23: The Rights of Minorities (Art. 27)," UN doc. CCPR/C/21/Rev.1/Add.5, 26 April 1994, paras. 7, 9.

34. See Chow, "Culture as Collective Memories," 632–35, for discussion of a case decided by the Human Rights Committee, *JGA Diergaardt et al. v. Namibia* (Communication No. 760/1997), UN doc. CCPR/C/69/D/760/1997, 25 July 2000.

35. See the Human Rights Committee cases *Ilmari Länsman and others v. Finland* (Communication No. 511/1992), 14 October 1993, and *Bernard Ominayak, Chief of the Lubicon Lake Band v. Canada* (Communication No. 167/1984), 26 March 1990. See also Human Rights Committee, "General Comment No. 23," para. 6.2.

36. Janet Blake, *International Cultural Heritage Law* (Oxford: Oxford University Press, 2015), 292.

37. Human Rights Committee, "General Comment No. 23," para. 6.2.

38. Human Rights Committee, "General Comment No. 23," paras. 6.1, 6.2. See also Blake, *International Cultural Heritage Law*, 292.

39. Human Rights Committee, "General Comment No. 23," paras. 3.2, 7.

40. Ana Filipa Vrdoljak, "Human Rights and Cultural Heritage in International Law," in *International Law for Common Goods*, ed. Federico Lenzerini and Ana Filipa Vrdoljak (Oxford: Hart Publishing, 2014), 158.

41. Francioni, "Public and Private in the International Protection," 722.

42. Blake, *International Cultural Heritage Law*, 271.

43. Vrdoljak, "Human Rights and Cultural Heritage," 139.

44. See Articles 3.8 and 5.3d. The convention was adopted on 24 June 1995 by the International Institute for the Unification of Private Law (UNIDROIT) upon request of UNESCO.

45. UNESCO, *Operational Guidelines for the Implementation of the World Heritage Convention*, doc. no. WHC.19/01, 10 July 2019, para. 12.

46. UNESCO, *Operational Guidelines for the Implementation of the Convention on the Means of Prohibiting and Preventing the Illicit Import, Export and Transfer of Ownership of Cultural Property (UNESCO, Paris, 1970)* (Paris: UNESCO, May 2015).

47. Ana Filipa Vrdoljak, "Human Rights and Illicit Trade in Cultural Objects," in *Cultural Heritage, Cultural Rights, Cultural Diversity. New Developments in International Law*, ed. Silvia Borelli and Federico Lenzerini (Leiden, the Netherlands: Martinus Nijhoff, 2012), 124.

48. Vrdoljak, "Human Rights and Cultural Heritage," 140.

49. Tünsmeyer, "Bridging the Gap," 319–20.

50. Donders, "Cultural Heritage and Human Rights," 383; and Tünsmeyer, 321.

51. O'Keefe, "Tangible Cultural Heritage," 91.

52. Blake, *International Cultural Heritage Law*, 311.

53. Manisuli Ssenyonjo, *Economic, Social and Cultural Rights in International Law* (Oxford: Hart, 2009), 403.

54. O'Keefe, "Tangible Cultural Heritage," 88.

55. Donders, "Cultural Heritage and Human Rights," 383.

56. O'Keefe, "Tangible Cultural Heritage," 88–89.

57. The adoption of a human rights approach centered on educational programs was advocated by former UN special rapporteur Karima Bennoune. See *Report of the Special Rapporteur in the Field of Cultural Rights*, Human Rights Council, UN doc. A/HRC/31/59, 3 February 2016; and *Report of the Special Rapporteur in the Field of Cultural Rights*, General Assembly, UN doc. A/71/ 317, 9 August 2016, paras. 55, 78.

58. Janusz Symonides, "UNESCO's Contribution to the Progressive Development of Human Rights," in *Max Planck Yearbook of United Nations Law* 5, ed. Jochen A. Frowein, Rüdiger Wolfrum, and Christiane E. Philipp (Boston: Brill, 2001), 307–40.

59. Symonides, "UNESCO's Contribution to the Progressive Development of Human Rights," 340.

60. See the 2001 Universal Declaration on Cultural Diversity, Art. 5; the 2003 Convention for the Safeguarding of the Intangible Cultural Heritage, Art. 2.3, 14; and the 2005 Convention on the Protection and Promotion of the Diversity of Cultural Expressions, Art. 10.

61. See the 1989 Convention on the Rights of the Child, Art. 28–29; the 1981 CEDAW, Art. 10; the 1998 Declaration on the Right and Responsibility of Individuals, Groups and Organs of Society to Promote and Protect Universally Recognized Human Rights and Fundamental Freedoms, Art. 15–16; and the 2011 UN Declaration on Human Rights Education and Training.

62. Ana Filipa Vrdoljak, "Cultural Heritage, Transitional Justice, and Rule of Law," in *The Oxford Handbook of International Cultural Heritage Law*, ed. Francesco Francioni and Ana Filipa Vrdoljak (Oxford: Oxford University Press, 2020), 173.

24

Customs, General Principles, and the Intentional Destruction of Cultural Property

Francesco Francioni

At a time when terrorists destroy temples and monuments declared the patrimony of humanity, and angry crowds tear down statues memorializing controversial symbols of the past, we may well ask, What does international law have to say with regard to this phenomenon? To answer this question one must remember that in the past half century, international law on the protection of cultural heritage has undergone a spectacular development at the level of standard-setting. UNESCO has promoted the adoption of treaty regimes for the prevention of cultural destruction in time of war, of illicit traffic in cultural property, for the protection of world cultural heritage and underwater cultural heritage, for the safeguarding of intangible cultural heritage, and for the protection and promotion of cultural diversity.[1] But the obligations undertaken by states in this field are still predominantly treaty-based, i.e., they are founded on consent expressed by states in their acts of ratification or accession to relevant treaties. As such, they are binding only for the states parties to these treaties and place no obligations on third parties. If we look at the most relevant international instrument for the prevention of cultural property destruction, the 1954 Hague Convention for the Protection of Cultural Property in the Event of Armed Conflict, it is in force for 133 states, a fairly high number of contracting parties, considering also that they include major military powers, and, after the United Kingdom's accession in 2017, all five permanent members of the UN Security Council (the so-called P5).

Yet, a significant number of states are still not bound by this convention. Besides, the much more stringent Second Protocol to the 1954 Hague Convention, adopted in 1999[2] to fill certain gaps and improve the convention's effectiveness, is in force for only eighty-three parties and, of the P5, it has only been ratified by France and the United

Kingdom. Therefore, a good number of states remain outside the most advanced international regime for the prohibition and suppression of cultural property destruction in time of war. As for the prohibition of intentional destruction of cultural property in peacetime, no treaty exists. The only instrument is the "soft law" 2003 Declaration Concerning the Intentional Destruction of Cultural Heritage, which was adopted by the General Conference—the biannual meeting of member states—of the UN Educational, Scientific and Cultural Organization (UNESCO) in the wake of the 2001 destruction of the Buddhas of Bamiyan in Afghanistan by the Taliban.[3] This situation makes it necessary to inquire whether, besides treaty obligations in force for state parties, international law contains general norms and principles prohibiting the destruction of cultural heritage, which are binding on all states independently of their consent to be bound.

The relevance and timeliness of this question become more apparent when we think that even for the states bound by the 1954 Hague Convention and its protocols, and by other relevant treaties on the subject, the obligations undertaken have no retroactive effect. Thus, situations and disputes concerning destruction of cultural property that arose before the entry into force of those international instruments remain beyond the reach of such instruments.

In addition, the recognition of the character of customary norm or general principle of the obligation to avoid and prevent destruction of cultural heritage can place such norm and general principle on a position of hierarchical superiority over treaty law within the domestic legal system of some states, thus enhancing the effectiveness of their enforcement at the level of domestic law.[4]

Identifying Customary Cultural Heritage Law and the Contribution of the International Court of Justice

How do we determine the existence of customary norms or general principles that would establish a general prohibition of the intentional destruction of cultural heritage? Do we take into account the practice of all states, including those that have already accepted a treaty obligation to prevent and avoid such destruction? Or do we limit our investigation only to the practice of those that are not bound by treaty obligations, on the assumption that only their behavior is relevant to the finding of a practice and of a sense of legal obligation that does not depend on the consent expressed in a treaty?

A formalistic approach to the first question would suggest following the latter option since only the behavior of nonparties can disclose a sense of legal obligation that does not depend on treaties. However, this approach would be inappropriate in the context of cultural heritage and wrong from a methodological point of view. Multilateral treaties in this field have a very high number of state parties, which has the effect of shrinking the scope of the potentially relevant practice of nonparties.[5] The proof of a widespread practice by non–treaty parties would become extremely difficult and perhaps misleading.[6]

Additionally, it would be illogical and counterproductive to limit the investigation over the existence of general norms or principles of international law to the sole group of states that are not bound by treaties relevant to the destruction or dispersion of cultural heritage. Such a restrictive approach would deprive us of the benefit of considering the possibility that state parties may also comply with the obligation to prevent and avoid destruction of cultural heritage by virtue of an *opinio iuris*, that is, evidence that the practice derives from a felt sense of legal obligation beyond the terms of any applicable treaty. Besides, such a narrow approach would prevent the consideration of the unavoidable interaction between treaty parties and nonparties, and of the possibility that norms of customary international law or general principles prohibiting destruction of cultural heritage may have emerged by way of abstraction from existing treaties.

With these general observations in mind, the following discussion begins by examining, first, the existence of norms of customary international law, and then the relevance of general principles of law in the field of cultural heritage protection against acts of deliberate destruction. Customary norms of international law are created by the combination of *diuturnitas*—a widespread and consistent practice—and *opinio iuris*. This dual structure of custom has been confirmed in the jurisprudence of the International Court of Justice (ICJ)[7] and in the ongoing work of the International Law Commission on the Identification of Customary International Law.[8] Requiring both elements obviously makes it more difficult to determine the existence of a binding rule of customary international law. This becomes clear especially in the field of cultural heritage, where manifestations of state practice and expressions of legal obligation are far from abundant.

The ICJ, whose case law represents the most authoritative source of evidence for the existence of customary norms, has had few opportunities to address questions of cultural heritage from the point of view of "general international law" (which refers to the combination of customary international law and general principles). In the case of *Temple of Preah Vihear (Cambodia v. Thailand)*, decided first in 1962 and again in 2013 on a request for interpretation, the court ruled that Thailand had an obligation to respect Cambodia's sovereignty over the area of the temple; to return to Cambodia parts of the cultural heritage removed from the monument during the period of its military occupation of the site; to ensure cooperation at bilateral and multilateral levels to safeguard the important cultural and religious value of the temple; and "not to 'take any deliberate measures which might damage directly or indirectly' such heritage."[9] These statements imply a general sense of duty to respect cultural heritage of great importance, but fall short of a specific recognition of a customary norm prohibiting the intentional destruction of cultural heritage. Another case brought before the ICJ, *Liechtenstein v. Germany* (2005), for the restitution of cultural property expropriated by a third country after World War II, never went beyond the phase of preliminary objections, with the court declaring its lack of jurisdiction.[10]

In the *Genocide* case (2007), the ICJ was confronted with the question of whether the documented destruction by Serbia of religious, historical, and cultural monuments and sites within Bosnia and Herzegovina during the Bosnian War (1992–95) could be considered part of the criminal enterprise of genocide. The court concluded that the intentional destruction of cultural property "does not fall within the category of acts of genocide set out in Article II of the [1948 Genocide] Convention." However, in the same paragraph, the ICJ also recognized that "the elimination of all traces of the cultural or religious presence of a group" may be "contrary to other legal norms." The judgment does not clarify what kind of legal norms the court had in mind, whether treaty norms or customary rules, for example. And this is quite understandable since the court's jurisdiction in the case was grounded in the Genocide Convention and could not, therefore, extend to the application of "other legal norms," however significant those on cultural destruction could have been as a matter of applicable law.

Nevertheless, this precedent provides an explicit recognition that systematic "destruction of historical, cultural, and religious heritage" can be "contrary to" international "legal norms," which certainly may include rules of customary international law.[11] In the subsequent *Genocide* case (Croatia v. Serbia), decided in 2013, the ICJ confirmed the legal opinion in the 2007 case that destruction of cultural heritage in the context of armed conflict falls outside the definition of genocide under the convention. At the same time, the judgment contains the following important statement: "The Court recalls, however, that it may take account of attacks on cultural and religious property in order to establish an intent to destroy the group physically."[12] The reference to intent echoes the jurisprudence of the International Criminal Tribunal for the former Yugoslavia (ICTY), which had already recognized the intentional destruction of cultural heritage as the indicator of the special intent, *dolus specialis*, as an element of the crime of genocide.[13] By implication, if intentional destruction of cultural property can be evidence of *dolus specialis* in relation to genocide, the destruction itself must constitute a prohibited act under international law.

In its recent jurisprudence, the ICJ has also had occasion to address the obligation of states to respect and protect forms of cultural heritage related to ways of life, social structures, and socioeconomic processes, which today fall within the broad category of "intangible cultural heritage." Two examples are the case concerning *Navigational and Related Rights* between Costa Rica and Nicaragua (2009), and the *Frontier Dispute* between Burkina Faso and Niger (2013). In the first, the court, in assessing the sovereign rights of the parties over the San Juan river, recognized that the exercise of these rights should not entail the destruction of the cultural rights of the local Indigenous communities to have access to the river resources, and affirmed the obligation of the riparian state to respect those communities' traditional practices of resource utilization along the river as a form of subsistence economy.[14] In the second case, the ICJ was confronted with a classic case of frontier delimitation. While the judgment was ultimately based on the application of the traditional principle of *uti possidetis*[15]—

respect for the territorial demarcation drawn at the time of independence—a strong call for the integration of this territorial principle with a more modern approach based on respect for the local traditions and the cultural practices of the population was made in the separate opinion of Judge Antônio Augusto Cançado Trindade and in the declaration of Judge Mohamed Bennouna.[16]

The jurisprudence of the International Court of Justice shows a clear tendency to take into account the value of cultural heritage for the purpose of interpreting other norms or principles of international law applicable to the case. However, we cannot say that such jurisprudence offers conclusive evidence of the existence of a customary norm prohibiting the destruction of cultural heritage even in the limited context of armed conflict. We need to look at other manifestations of the practice to establish the existence of customary norms.

The Customary Law Prohibition of Intentional Destruction of Cultural Heritage in the Context of Armed Conflict

Arbitration as a means of settling cultural heritage disputes is quite rare, but it is here that we find one of the most important manifestations of the explicit recognition of a customary norm prohibiting the destruction of cultural heritage: in the 2004 ruling of the Eritrea–Ethiopia Claims Commission on the "Stela of Matara." The stela, an ancient obelisk of great historical and cultural importance for both Eritrea and Ethiopia, was felled by explosives during the military occupation of the surrounding area by Ethiopian forces. Based on evidence provided by Eritrea, including proof of the presence of an Ethiopian military contingent in the vicinity of the monument the night it was toppled, the commission reached the following conclusion: "The felling of the stela was a violation of customary international humanitarian law. While the 1954 Hague Convention on the Protection of Cultural Property was not applicable, as neither Eritrea nor Ethiopia was a Party to it, deliberate destruction of historic monuments was prohibited by Article 56 of the Hague Regulations, which prohibition is part of customary law. Moreover, as civilian property in occupied territory, the stela's destruction was prohibited by Article 53 of the Geneva Convention IV and by Article 52 of Protocol I."[17]

This is a typical example of determination of the existence of a rule of customary international law by a process of abstraction from well-settled treaty rules, in this case pertaining to the law of armed conflict and humanitarian law. This is a perfectly valid method of customary law reconstruction. It is regrettable, however, that the commission in this case did not go beyond mere treaty practice in its search for a customary legal basis of the obligation to avoid destruction of cultural property. By 2004, the year of the commission's decision, other important manifestations of state practice had emerged to support such a general obligation. Suffice it to mention the unanimous reaction of condemnation by the international community of the deliberate destruction of the great Buddhas of Bamiyan in 2001.[18] This reaction left little doubt about the conviction that

such egregious, discriminatory destruction, in defiance of appeals by UNESCO, the broader UN, and the international community as a whole, was not only morally and politically condemnable, but also wrongful under international legal standards.

The best proof of this conviction was the organization under the auspices of UNESCO of a diplomatic effort aimed at drafting a normative instrument prohibiting the intentional destruction of cultural heritage in time of war and in time of peace. This instrument took the form of the UNESCO Declaration Concerning the Intentional Destruction of Cultural Heritage, which was adopted by the organization's General Conference on 17 October 2003.[19] Article 2 defines international destruction as: "an act intended to destroy in whole or in part cultural heritage thus compromising its integrity, in a manner that constitutes a violation of international law or an unjustifiable offence to the principles of humanity and dictates of public conscience." Article 6 further provides that "a State that intentionally destroys or intentionally fails to take appropriate measures to prohibit, prevent, stop, and punish any intentional destruction of cultural heritage of great importance for humanity . . . bears the responsibility for such destruction, to the extent provided for by international law."

The declaration was adopted by acclamation. No participating state attached reservations or restrictive understandings to its text. The General Conference comprised at the time of its adoption nearly all recognized states, including the United States and the United Kingdom, which had rejoined UNESCO after their previous withdrawal. Even if the declaration remains formally a soft law instrument, it is difficult to dismiss its value as evidence of a widespread *opinio iuris* about the existence of an international obligation to avoid and prevent intentional destruction of cultural heritage of great importance for humanity in a context of conflict or terrorism.

Other important elements of international practice support the existence of such a customary norm. They can be found in the case law of international criminal tribunals and in the practice of United Nations organs. In the *Tadić* case, the ICTY stated that: "The emergence of international rules governing civil strife has occurred at two different levels: at the level of customary law and at that of treaty law. . . . The interplay between the two sets of rules is such that some treaty rules have gradually become *part of customary international law*. This . . . also applies to Article 19 of the Hague Convention for the Protection of Cultural Property in the Event of Armed Conflict."[20] Article 19 concerns the obligations of the parties to a non-international armed conflict to abide as a minimum by "the provisions of the . . . Convention which relate to respect for cultural property." Thus, the *Tadić* judgment would confirm the customary law character of the prohibition to destroy cultural heritage in armed conflict, including non-international conflict.

As far as the practice of UN organs is concerned, a 1999 "bulletin" from the secretary-general concerning the obligations of UN forces to respect the rules of international humanitarian law delineated the following obligation: "In its area of operation, the United Nations forces shall not use such cultural property, monuments of art,

architecture or history, archaeological sites, works of art, places of worship and museums and libraries which constitute the cultural or spiritual heritage of peoples or their immediate surroundings for purposes which might expose them to destruction or damage."[21] The General Assembly adopted a resolution in 2015, *Saving the Cultural Heritage of Iraq*, which unambiguously condemned the intentional destruction of cultural heritage by the Islamic State of Iraq and the Levant (ISIL, also known as ISIS or Da'esh) and affirmed that "the destruction of cultural heritage, which is representative of the diversity of human culture, erases the collective memories of a nation, destabilizes communities and threatens their cultural identity, and emphasiz[ed] the importance of cultural diversity and pluralism as well as freedom of religion and belief for achieving peace, stability, reconciliation and social cohesion."[22] The UN Human Rights Council has also addressed the enormity of the atrocities committed by ISIL and related nonstate armed groups in Iraq, and included in a 2014 resolution a specific paragraph concerning the intentional destruction of cultural heritage.[23]

But the most conclusive evidence about the existence of a general prohibition of intentional destruction of cultural property in the context of armed conflict and terrorism comes from the practice of the Security Council. Over the past twenty years this practice has shown a growing concern with the international security implications of the intentional destruction of cultural heritage. It started with resolution 1485 of 22 May 2003 (paragraph 7) concerning the rampant destruction and dispersion of Iraqi cultural heritage in the chaos that followed the US-led invasion. It continued with a series of resolutions linking the willful destruction of cultural heritage to terrorism and threats to the peace, including resolution 2170 of 15 August 2014 (preamble), and it culminated with resolution 2347 of 24 March 2017, which is entirely dedicated to the prescription of measures to be taken in order to prevent the destruction of cultural heritage as well as the dispersion and illegal commerce of looted cultural property.

In resolution 2347 (paragraph 1), the Security Council: "*Deplores and condemns* the unlawful destruction of cultural heritage, inter alia the destruction of religious sites and artefacts, as well as looting and smuggling of cultural property from archaeological sites, museums, libraries, archives and other sites, in the context of armed conflicts. . . . *Affirms* that directing unlawful attacks against sites and buildings dedicated to religion, education, art, science or charitable purposes, or historic monuments may constitute, under certain circumstances and pursuant to international law, a war crime and that perpetrators of such attacks must be brought to justice."

The practice examined above includes treaties of almost universal application, arbitral awards, decisions of international tribunals, soft law (including the 2003 UNESCO declaration), the verbal practice of UN organs, and Security Council binding decisions under Chapter VII of the UN Charter, which permit military enforcement. All these elements concur in forming a solid legal basis for the identification of a customary law establishing an obligation to abstain from and prevent the intentional destruction of cultural heritage in the context of armed conflict and terrorism. This obligation has two

corollaries: the responsibility of the state for breach of such primary obligation, as ruled in *Stela of Matara*, and the international criminal responsibility of the individual perpetrator of the crime of cultural destruction. This second aspect, already well developed in the case law of the ICTY, is now confirmed by recent decisions of the International Criminal Court (ICC) in the *Al Mahdi* case, in which the court found that the extensive destruction of cultural heritage in Mali during the 2012 internal armed conflict constituted in itself a war crime.[24]

Destruction and Dispersion by Looting and Illicit Transfer from Territories under Military Occupation

Besides the customary rule prohibiting intentional destruction in the context of armed conflict, does customary international law prohibit indirect forms of destruction by looting, dispersion, and illicit transfer of cultural property from occupied territories? This question has been addressed by treaty for over a century, starting with the regulations attached to the 1907 Hague Convention on Land Warfare (Articles 46 and 47) and the restitution practice of peace treaties after World War I,[25] up to the First Protocol to the 1954 Hague Convention and the 1970 UNESCO Convention on the Means of Prohibiting and Preventing the Illicit Import, Export and Transfer of Ownership of Cultural Property (Article 11). To these one needs to add the important Declaration of St. James's Palace on Punishment for War Crimes, also known as the London Declaration, issued by the Allied Powers in 1943 with the intent of notifying their determination to nullify and reverse, under a general presumption of duress, all acts of transfer of property, including cultural property, which occurred in the territories occupied by Nazi Germany and its allies.

However, it needs to be determined whether this practice constitutes evidence of a general rule grounded in customary law. In the past a skeptical view has been expressed by a number of legal scholars,[26] but this interpretation has become untenable in light of the great acceleration that international practice has undergone in this field in the past twenty years. First, a more robust international reaction to the scourge of illicit excavation and looting of cultural objects in occupied territories has developed, hand in hand with the increasing sense of indignation and condemnation of such acts as a perverse component of foreign occupation, and sometimes of ethnic conflict and ethnic cleansing. This is shown by the response to the well-documented atrocities of the Yugoslav wars of the 1990s and to the abominable criminal enterprise of ISIS and related nonstate armed groups in the occupied territories of Iraq and Syria.

Second, the number of states that have ratified or acceded to the First Protocol to the 1954 Hague Convention has increased significantly since 2000 to include many important source and market countries of cultural heritage, such as China, the United Kingdom, Canada, Japan, Italy, the Netherlands, and Germany, thus supporting the presumption of a sense of obligation of a general character.

Third, the practice of domestic courts now tends to enforce the international prohibition of appropriation of cultural objects in occupied territories and the obligation to return them, even in the absence of specific treaty obligations. An important example of this practice is provided by the decision to return to the Church of Cyprus the wall paintings of the Byzantine Fresco Chapel in Houston, Texas. These rare medieval frescoes had been looted in the town of Lysl in Northern Cyprus in the aftermath of the Turkish invasion of the island in 1974 and later purchased and imported into the United States by the Menil Foundation. By a voluntary agreement concluded in March 2012 between the foundation and the Church of Cyprus, the frescoes were returned to the original owner after meticulous restoration and public exhibition in Houston for several years. Other important precedents, supporting the *opinio iuris* that cultural property looted in foreign countries must be returned to the original owner, are the decision of US courts in *Elicofon*[27] and *Church of Cyprus and the Republic of Cyprus v. Goldberg*.[28] The latter concerned the determination of title over ancient mosaics stolen from a religious monument in Northern Cyprus in circumstances similar to those of the Byzantine Fresco Chapel. In both cases the illegally transferred cultural objects were returned to the country of origin in the absence of any specific treaty obligation, since the United States was not a party to the First Protocol to the 1954 Hague Convention.

The evidence provided by treaty and judicial practice is corroborated by the already mentioned practice of Security Council resolutions[29] requiring UN member state cooperation to stop and counter illicit trafficking in cultural property originating from conflict areas. This duty of cooperation is cast in general terms, which presupposes a general obligation to return looted objects. In the already cited resolution 2347 (paragraph 8), the Security Council: "*Requests* Member States to take appropriate steps to prevent and counter the illicit trade and trafficking in cultural property and other items of archaeological, historical, cultural, rare scientific, and religious importance originating from a context of armed conflict."

This discussion has so far identified evidence of the existence of two customary law obligations: to prevent and avoid destruction of cultural property, and to prevent and suppress illicit transfer of cultural property from territories under military occupation. These customary norms apply in the event of armed conflict, including non-international armed conflict and related acts of terrorism, and military occupation of a foreign territory. But are these obligations also applicable in peacetime?

The 2003 UNESCO declaration covers the protection of cultural heritage in connection with peacetime activities.[30] But this soft law instrument cannot provide by itself a legal basis for the finding of a customary rule prohibiting in general terms the destruction of cultural heritage in peacetime. The legislative history of the declaration demonstrates that the great majority of UNESCO member states opposed mandatory language in this respect,[31] for fear it could limit their sovereign right to pursue forms of economic and social development even at the cost of cultural heritage destruction. This

may be regrettable, because much of the destruction of cultural heritage occurs in peacetime,[32] and development projects and private and public works often lead to the deliberate destruction of precious cultural heritage. Prominent examples include the destruction of the five-hundred-year-old Great Wall of Beijing under Mao Zedong, and the extensive destruction of the medieval centers of numerous European cities in the name of modern urban renewal.

Furthermore, the looting and dispersion of cultural heritage in peacetime are among the most insidious and pervasive forms of cultural heritage destruction. It is unknown whether the *Nativity with St. Francis and St. Lawrence* by Caravaggio, an irreplaceable masterpiece stolen from an oratory in Palermo in 1979, most likely by organized crime, has been destroyed or simply kept in a bank vault or secret deposit. Its disappearance is equivalent to destruction. The *Nativity* was one of only about seventy paintings created by one of the greatest artists of all times.

But the fact that there is no evidence of a specific rule of customary international law prohibiting the destruction of cultural heritage in peacetime does not mean that no such obligations arise, independently of or against the consent of states. Obligations in this field may arise, directly or indirectly, from the category of general principles, a source of international law that operates independently of customary rules. It is to the examination of this category of sources of international law that we turn in the remainder of the chapter.

The Role of "General Principles"

The 1945 Statute of the International Court of Justice places "general principles of law" among the sources of nonconsensual obligations of international law (Article 38.1.c). General principles may, therefore, be the applicable law in disputes concerning the destruction of cultural heritage. However, their nature and scope remains a contested subject in the theory of international law. Legal positivism has always looked with suspicion upon general principles as a source of true international legal obligations and has relegated them to a purely subsidiary function of filling gaps in the law by the interpretative activity of the judge.[33] By contrast, some champions of legal realism have placed the category of general principles at the top of the hierarchy of international norms, as a direct expression of the collective will and legal conscience of the world community.[34] A more moderate orientation admits the operation of general principles in international law but only as far as they are derived from general concepts of justice and reasonableness universally recognized in domestic legal systems.[35] Other contemporary tendencies link general principles to a certain revival of natural law and to the growing relevance of "values" such as respect for human rights, for the global environment, for peace, and for the cultural heritage of humankind.[36] On similar values rests the position of the contemporary proponents of an "international constitutionalism."[37]

These theoretical orientations are not mutually exclusive. Each contains an aspect of the truth in the sense that general principles may assume a different nature and different functions as sources of international law, as interpretative criteria, and as tools for bending the law to just and equitable decisions in concrete cases, as well as autonomous sources of international obligations. Relevant here is that general principles of law can be the direct expressions of values autonomously recognized by the international community. At the same time, they can also be the result of a transposition onto the international legal order of general concepts of justice, logic, and reasonableness historically developed in domestic private and public law.

Keeping in mind this multifaceted nature of general principles, we can try to identify a typology according to their different substantive content, origins, and functions performed in relation to the protection of cultural heritage against acts of deliberate destruction. Certain general principles developed in different fields of international law may be applicable to the field of cultural heritage and have the effect of creating an obligation to avoid and prevent its destruction. Some of these principles may even belong to the category of *jus cogens* (international legal norms that are peremptory and prevail over all other legal rules). This is the case with the following five principles.

First is the prohibition of the threat or use of force. Enshrined in the UN Charter (Article 2.4), it was also recognized by the ICJ in the *Nicaragua* case[38] as a general principle of international law binding outside and beyond the formal operation of the UN Charter as a treaty. This principle becomes relevant to the intentional destruction of cultural heritage when the use of force includes, as has happened in numerous recent conflicts, deliberate attacks on historical and cultural sites. Its relevance becomes all the more evident at a time when the Security Council has started to consider assaults on cultural heritage as elements of a threat to peace and international security under Article 39 of the UN Charter. Even if it is unlikely that such acts of cultural destruction can be considered entirely separate from other conduct amounting in itself to a breach of the peace or a threat to the peace—such as armed aggression, international terrorism, and massive violations of human rights and humanitarian law—intentional destruction of cultural heritage is increasingly acquiring distinct relevance in the role of the Security Council in countering terrorism and forms of violence and intolerance directed against cultural heritage.

This is evident in the already examined resolution 2347 of 2017 and even more so in resolution 2100 of 2013 authorizing the deployment of the UN Multidimensional Integrated Stabilization Mission in Mali (MINUSMA).[39] Adopted under Chapter VII of the UN Charter, resolution 2100 provides the first example of a post-conflict peace mission to which the Security Council has conferred a specific function to protect cultural heritage from deliberate attack.[40] The general principle prohibiting the threat of force can therefore become a pertinent legal parameter to determine the illegality of attacks on cultural property in peacetime, in the sense that such attacks may constitute an

aspect of a threat to the peace and, in post-conflict situations, an element of peacekeeping missions by the UN or regional organizations.

Second, self-determination has been recognized as a general principle of international law by the ICJ in its advisory opinions on *South West Africa*,[41] *Western Sahara*,[42] *The Wall in Occupied Palestinian Territories*,[43] and most recently in the 2019 opinion on *Chagos Archipelago*.[44] This principle can be relevant to the destruction of cultural heritage to the extent that participation of people in cultural life, in the enjoyment and enactment of their cultural heritage, can be a constitutive element of their right to self-determination. This right is impaired by the destruction of cultural heritage.[45]

Third, individual criminal responsibility is a well-established principle of international law, applying to grave breaches of human rights and of international humanitarian law. The principle is now applicable to the field of international cultural heritage law so as to cover grave offenses against cultural heritage, and especially the intentional destruction of objects or sites of great importance for humanity, under the rubric of war crimes and crimes against humanity. Besides the case law of the ICTY examined above, we must recall the judgment of the ICC that for the first time has applied this principle to the crime of wanton destruction of cultural heritage in the 2016 *Al Mahdi* case.

Fourth, elementary considerations of humanity have evolved within the corpus of international humanitarian law and from the Martens Clause contained in the preamble of the 1907 Convention (IV) on the Laws and Customs of War. It was reaffirmed as a principle of general application by the ICJ in 1949 in the *Corfu Channel* case (United Kingdom v. Albania), and it was incorporated in the 2003 UNESCO declaration. Its role in relation to cultural heritage becomes especially relevant in all those cases in which its destruction is part of a criminal enterprise of persecution of a cultural minority and of a pattern of gross and systematic violations of human rights.[46]

Fifth is the principle that cultural heritage forms part of the heritage of humanity. It entails the conceptualization of cultural heritage as part of the collective interest of humanity to the protection of the infinite variety of its cultural expressions and their transmission to future generations. The first articulation of this principle can be traced to an 1803 Canadian military case, *The Marquis de Somerueles*,[47] and, later, it can be found in the preamble of the 1954 Hague Convention, whose second paragraph reads: "Being convinced that damage to cultural property belonging to any peoples whatsoever means damage to the cultural heritage of mankind, since each people makes its contribution to the culture of the world."

This innovative idea of cultural property as part of the cultural heritage of humanity did not develop in a vacuum. It is rooted in the more general political philosophy and constitutional objectives underlying the UN efforts at rebuilding the bases of human civilization in 1945, after the war and the catastrophe of genocide. We can recall that the preamble of the UNESCO Constitution warned that: "A peace based exclusively upon the

political and economic arrangements of governments would not be a peace which would secure the unanimous, lasting and sincere support of the peoples of the world, and that peace must therefore be founded, if it is not to fail, on the intellectual and moral solidarity of mankind."

Principles of Progressive Realization

Cultural heritage law, like other areas of international law, such as environmental protection, has seen the emergence of general principles that we can define as norms "of progressive realization" because they set goals and standards of gradual achievement without prescribing a mandatory course of action for states. One such principle is that of sustainable development proclaimed in the 1992 Rio Declaration on Environment and Development and recently incorporated in the Sustainable Development Goals adopted by the UN General Assembly in 2015. It has a multidimensional character, applying to the environment, to the social and economic sphere, and with increasingly compelling evidence also to the compatibility of development with the cultural fabric of a society and with the respect for cultural heritage, both tangible and intangible, that contributes to the social cohesion and sense of identity of every community. This cultural dimension of sustainable development becomes all the more important today, when much of the destruction of cultural heritage happens in the name of economic development and modernization, without much consideration for the adverse long-term effects of the loss of memory and sense of historical roots of the affected communities.

The other principle of progressive realization that can have a direct relevance for the protection of cultural heritage against acts of intentional destruction is that underlying the responsibility to protect (R2P), which was elaborated and proclaimed by the United Nations with the aim of preventing, stopping, and remedying mass atrocities and egregious violations of human rights and humanitarian law.[48] Today, R2P has become extremely important for the protection of cultural heritage because violent attacks on cultural heritage tend to be the forerunner or inseparable complement of assaults on people and of grave breaches of human rights and humanitarian law. This is amply demonstrated by the rich jurisprudence of the ICTY and by the recognition that such attacks can constitute evidence of the specific intent to commit a crime of genocide.

But R2P is increasingly relevant also for the purpose of a progressive interpretation of the concepts of "threat to the peace" and "breach of the peace." Article 39 of the UN Charter confers upon the Security Council the power to "determine the existence of any threat to the peace, breach of the peace, or act of aggression" as a condition for adopting mandatory measures under Chapter VII. If the purpose of R2P is to involve the Security Council in the prevention and suppression of mass atrocities, then deliberate attacks on cultural heritage can be a relevant indicator of serious violations of human rights and humanitarian law capable of endangering international peace and security. As the practice of the United Nations over the past fifty years has produced a progressive

expansion of the concepts of threat to and breach of the peace, by including domestic (non-international) situations revealing systematic patterns of gross violations of human rights,[49] so assaults on cultural heritage by nonstate armed groups and so-called rogue states today are becoming an element in the determination of a threat to international peace and security under Article 39, thus triggering the application of R2P.[50]

Conclusions

The foregoing analysis has identified customary norms and general principles of international law that create general obligations to prevent and avoid the deliberate destruction of cultural heritage. These obligations are binding on all states and go beyond the limited scope of applicable treaties. The examination of the practice of states, intergovernmental bodies, judicial organs, and domestic courts has made possible the identification of two customary norms of general application: one that prohibits the intentional destruction of cultural property in the context of armed conflict and terrorism, and one prohibiting looting and the illicit transfer of cultural property from territories under military occupation. The latter norm has a direct relevance for intentional destruction because looting and illicit transfer inevitably result in dispersion and destruction of cultural heritage.

At the same time, no corresponding customary norms can be found today in relation to the destruction of cultural heritage in peacetime and in isolation from situations of armed conflict or terrorism, with which mass atrocities are normally associated. This is regrettable because much destruction of cultural heritage of great importance occurs in peacetime and in the pursuit of an ill-conceived idea of economic development. This gap in the law can be filled by recourse to a wide range of general principles that can be applied to the prevention and suppression of willful destruction of cultural heritage in the context of both conflict and peacetime. These principles and the two customary norms may provide interpretative criteria and true sources of law in the adjudication of disputes between states which are not bound by existing treaty norms, or in relation to situations that fall outside the temporal scope of application of relevant treaties. More important, the evolutive and dynamic nature of customary norms and general principles developed in this field may help overcome the sectorialization and fragmentation of treaty law by helping the harmonization and systemic integration of cultural heritage law with other strands of international law, such as humanitarian law, human rights law, and environmental law, as well as trade and economic law.

Custom and general principles can thus be the wellspring of a progressive development of international cultural heritage law. At the same time they can enhance its coherence with other fields of international law at a time when cultural conflicts, rising nationalism, and intolerance appear to pose the main threats to the value of the universality of cultural heritage and of international law.

SUGGESTED READINGS

Janet Blake, *International Cultural Heritage Law* (Oxford: Oxford University Press, 2015).

Francesco Francioni, "Beyond State Sovereignty: The Protection of Cultural Heritage as a Shared Interest of Humanity," *Michigan Journal of International Law* 25, no. 4 (2004): 1209–28.

Francesco Francioni and Federico Lenzerini, "The Destruction of the Buddhas of Bamiyan and International Law," *European Journal of International Law* 14, no. 4 (2003): 619–51.

Federico Lenzerini, "Intentional Destruction of Cultural Heritage," in *The Oxford Handbook of International Cultural Heritage Law*, ed. Francesco Francioni and Ana Filipa Vrdoljak (Oxford: Oxford University Press, 2020), 75–100.

James A. R. Nafziger, "The Responsibility to Protect Cultural Heritage and Prevent Cultural Genocide," in *The Oxford Handbook of International Cultural Heritage Law*, ed. Francesco Francioni and Ana Filipa Vrdoljak (Oxford: Oxford University Press, 2020), 121–44.

Roger O'Keefe, *The Protection of Cultural Property in Armed Conflict* (Cambridge: Cambridge University Press, 2006).

"Symposium: The Human Dimension of International Cultural Heritage Law," special issue, *European Journal of International law* 22, no. 1 (2011).

Ana Filipa Vrdoljak, ed., *The Cultural Dimension of Human Rights* (Oxford: Oxford University Press, 2013).

NOTES

1. See Convention for the Protection of Cultural Property in the Event of Armed Conflict, 14 May 1954 (1954 Hague Convention), https://ihl-databases.icrc.org/ihl/INTRO/400; Convention on the Means of Prohibiting and Preventing the Illicit Import, Export and Transfer of Ownership of Cultural Property, 14 November 1970, https://en.unesco.org/fighttrafficking/1970; Convention Concerning the Protection of the World Cultural and Natural Heritage, 16 November 1972, https://whc.unesco.org/en/conventiontext/; Convention on the Protection of Underwater Cultural Heritage, 2 November 2001, https://en.unesco.org/underwater-heritage/2001; Convention for the Safeguarding of the Intangible Cultural Heritage, 17 October 2003, https://ich.unesco.org/en/convention; and Convention on the Protection and Promotion of the Diversity of Cultural Expressions, 20 October 2005, https://en.unesco.org/creativity/convention.
2. 26 March 1999, https://ihl-databases.icrc.org/ihl/INTRO/590.
3. See Francesco Francioni and Federico Lenzerini, "The Destruction of the Buddhas of Bamiyan and International Law," *European Journal of International Law* 14, no. 4 (2003): 619–51.
4. This is the case in the constitutional system of Italy (the republican constitution adopted in 1947, Art. 10, para. 1), Germany (the *Grundgesetz*, or Basic Law, adopted in 1949, Art. 25), and many other states that give constitutional status to customary international law.
5. In the case of the World Heritage Convention, which now numbers 194 state parties that have accepted cooperation to prevent and avoid the destruction and deterioration of cultural (and natural) heritage of outstanding universal value located in their territory, there would be no available practice. The Convention on the Means of Prohibiting and Preventing the Illicit Import, Export and Transfer of Ownership of Cultural Property counts 141 parties, and the Convention on the Safeguarding of Intangible Cultural Heritage is now in force for 180 states. The only multilateral conventions that still suffer from a low number of ratifications are the Convention on the Protection of Underwater Cultural Heritage, with only seventy-one, and the 1995

UNIDROIT Convention on Stolen or Illegally Exported Cultural Objects, in force for fifty-three states.

6. This problem was pointed out for the first time by Richard Baxter, who observed in 1970 that "the proof of a consistent pattern of conduct by nonparties becomes more difficult as the number of parties to the instrument increases. The number of participants in the process of creating customary law may become so small that the evidence of that practice may be minimal or altogether lacking." See Richard R. Baxter, *Treaties and Custom* (Recueil des Cours no. 129) (Leiden, the Netherlands: Martinus Nijhoff, 1970), 25, 64.

7. See, in particular, ICJ, *North Sea Continental Shelf Cases (Federal Republic of Germany v. Denmark, Federal Republic of Germany v. Netherlands)*, Judgment, 20 February 1969, https://www .icj-cij.org/public/files/case-related/52/052-19690220-JUD-01-00-EN.pdf; and the more recent case, *Jurisdictional Immunities of the State (Germany v. Italy: Greece Intervening)*, Judgment, 3 February 2012, https://www.icj-cij.org/public/files/case-related/143/143-20120203-JUD-01-00-EN .pdf.

8. See International Law Commission, Draft Conclusions on Identification of Customary International Law, *Yearbook of the International Law Commission 2018*, vol. 2, part 2, Conclusion 2. For a general overview, see Sean Murphy, "The Identification of Customary International Law and Other Topics: The Sixty-Seventh Session of the International Law Commission," *American Journal of International Law* 109, no. 4 (2015): 822; and "Anniversary Commemoration and Work of the International Law Commission's Seventieth Session," *American Journal of International Law* 113, no. 1 (2019): 94.

9. ICJ, "Request for Interpretation of the Judgment of 15 June 1962 in the Case Concerning the *Temple of Preah Vihear (Cambodia v. Thailand),*" Judgment, 11 November 2013, para. 106, https:// www.icj-cij.org/en/case/151.

10. ICJ, *Certain Property (Liechtenstein v. Germany)*, Preliminary Objections, Judgment, 10 February 2005, https://www.icj-cij.org/public/files/case-related/123/123-20050210-JUD-01-00-EN.pdf.

11. ICJ, *Application of the Convention on the Prevention and Punishment of the Crime of Genocide (Bosnia and Herzegovina v. Serbia)*, Judgment, 26 February 2007, para. 344, https://www.icj-cij .org/public/files/case-related/91/091-20070226-JUD-01-00-EN.pdf.

12. ICJ, *Application of the Convention on the Prevention and Punishment of the Crime of Genocide (Croatia v. Serbia)*, Judgment, 3 February 2015, para. 390, https://www.icj-cij.org/public/files/case -related/118/118-20150203-JUD-01-00-EN.pdf.

13. ICTY, *Krstić*, case no. IT-98-33-T, Trial Judgment, 2 August 2001, para. 580, https://www.icty.org/x/ cases/krstic/tjug/en/krs-tj010802e.pdf. See also the dissenting opinion of Judge Shahabuddeen in the appeal: ICTY, *Krstić*, case no. IT-98-33-A, Appeal Judgment, 19 April 2004, Section 8, https:// www.icty.org/x/cases/krstic/acjug/en/krs-aj040419e.pdf.

14. ICJ, *Dispute Regarding Navigational and Related Rights (Costa Rica v. Nicaragua)*, Judgment, 13 July 2009, paras. 134–144, https://www.icj-cij.org/public/files/case-related/133/133-20090713-JUD -01-00-EN.pdf.

15. ICJ, *Frontier Dispute (Burkina Faso v. Niger)*, Judgment, 16 April 2013, https://www.icj-cij.org/ public/files/case-related/149/149-20130416-JUD-01-00-EN.pdf.

16. The separate opinion of Judge Cançado Trindade expressly recognizes that "cultural and spiritual heritage appears more closely related to a human context rather than to the traditional State-centric context; it appears to transcend the purely inter-State dimension, that the Court is used to." See ICJ, *Frontier Dispute*, Judgment, 16 April 2013, Separate Dissenting Opinion of Judge Cançado Trindade, para. 91, https://www.icj-cij.org/public/files/case-related/149/149-20130416 -JUD-01-02-EN.pdf. The declaration by Judge Bennouna contains the following statement: "the frontier, as predicated on the Westphalian model, is far removed from the cultural heritage of this region of the world," and then he added "it is for the Parties to rediscover this heritage by

deepening, as encouraged by the Court, their cooperation." See *Frontier Dispute*, Judgment, 16 April 2013, Declaration of Judge Bennouna, 56, https://www.icj-cij.org/public/files/case-related/149/149-20130416-JUD-01-01-EN.pdf.

17. Eritrea–Ethiopia Claims Commission, "Partial Award: Central Front—Eritrea Claims 2, 4, 6, 7, 8 & 22," 28 April 2004, para. 113, https://legal.un.org/riaa/cases/vol_XXVI/115-153.pdf.

18. See Francioni and Lenzerini, "Destruction of the Buddhas"; and "The Obligation to Protect and Avoid Destruction of Cultural Heritage: From Bamiyan to Iraq," *Art and Cultural Heritage: Law, Policy and Practice*, ed. Barbara Hoffman (Cambridge: Cambridge University Press, 2006), 28.

19. For the text of the document see UNESCO, http://portal.unesco.org/en/ev.php-URL_ID=17718&URL_DO=DO_TOPIC&URL_SECTION=201.html.

20. ICTY, *Tadić*, case no. IT-94-1-T, Decision on the Defence Motion for Interlocutory Appeal on Jurisdiction, 2 October 1995, para. 98 (emphasis added), https://www.icty.org/x/cases/tadic/acdec/en/51002.htm.

21. Kofi Annan, "Secretary-General's Bulletin: Observance by United Nations Forces of International Humanitarian Law," UN doc. ST/SGB/1999/13, 6 August 1999, para. 6.6.

22. UN General Assembly, "Saving the Cultural Heritage of Iraq," UN doc. A/RES/69/281, 9 June 2015, 2.

23. "Deeply concerned also by . . . the rampant destruction of monuments, shrines, churches, mosques, and other places of worship, archaeological sites, and cultural heritage sites." See Human Rights Council, "The Human Rights Situation in Iraq in the Light of Abuses Committed by the So-Called Islamic State in Iraq and the Levant and Associated Groups," UN doc. A/HRC/RES/S-22/1, 3 September 2014, preamble.

24. ICC, *Ahmad Al Faqi Al Mahdi*, case no. ICC-01/12-01/15, Judgment and Sentence, 27 September 2016, https://www.icc-cpi.int/Pages/record.aspx?docNo=ICC-01/12-01/15-171. In 2017, the ICC charged al-Mahdi with the obligation to pay a reparation of €2.7 million for the damage caused to the cultural heritage of Mali: see ICC, *Al Mahdi*, Reparations Order, 17 August 2017, https://www.icc-cpi.int/CourtRecords/CR2017_05117.PDF.

25. For extensive examination of this practice, see Andrzej Jakubowski, *State Succession in Cultural Property* (Oxford: Oxford University Press, 2015), 53.

26. See, for instance, Antonio F. Panzera, *La tutela internazionale dei beni culturali in tempo di guerra* (Turin: G. Giappichelli, 1993), 16, 46; and Guido Carducci, "L'obligation de restitution des biens culturels et des objets d'art en cas de conflit armé," *Revue générale de droit international public* 2 (2000): 290–357.

27. US District Court for the Eastern District of New York, *Kunstsammlungen zu Weimar v. Elicofon* (536 F. Supp. 829, EDNY 1982), 15 June 1981, concerning works by Albrecht Dürer that had been stolen in Germany in 1945.

28. US Federal Court of Appeal, 7th Circuit, *Autocephalous Greek-Orthodox Church of Cyprus v. Goldberg & Feldman Fine Arts, Inc.* (917 F. 2d 278, 7th Cir. 1990), 24 October 1990.

29. See US Federal Court of Appeal, 7th Circuit, Sect. 3.

30. Section 4 of the declaration applies to peacetime activities and establishes a duty of protection of cultural heritage in accordance with standards laid down in UNESCO recommendations and treaties, including the 1972 World Heritage Convention.

31. The present author was a member of the group of experts charged with the task of drafting the declaration. For a thorough analysis of the process of "softening" the duty to avoid and prevent destruction of cultural heritage from the stage of experts drafting to the stage of diplomatic negotiations, see Federico Lenzerini, "The UNESCO Declaration Concerning the Intentional Destruction of Cultural Heritage: One Step Forward and Two Steps Back," *Italian Yearbook of International Law* 13, no. 1 (2003): 131–45.

32. For a thorough analysis of the cases of destruction of cultural heritage in peacetime, with a distinction between legitimate aims of economic development and manifestations of fundamentalist intolerance, see Kanchana Wangkeo, "Monumental Challenges: The Lawfulness of Destroying Cultural Heritage during Peacetime," *Yale Journal of International Law* 28 (2003): 185–274.

33. The most compelling elaboration of this theory can be found in Dionisio Anzilotti, *Corso di diritto internazionale* (Rome: Athenaeum, 1928), 107. For a comprehensive, historical reconstruction of the emergence and development of the category of general principles, see I. Imogen Saunders, *General Principles as a Source of International Law* (Oxford: Oxford University Press, 2021).

34. See Rolando Quadri, "Cours général de droit international public," *Recueil des Cours* no. 3, 1964; and *Diritto internazionale pubblico* (Napoli: Liguori, 1968), 119.

35. Hersh Lauterpacht, *Private Law Sources and Analogies in International Law: With Special Reference to International Arbitration* (Cambridge: Cambridge University Press, 1927), 215; and Michel Virally, "The Sources of International Law," in *Manual of Public International Law*, ed. M. Sorensen (London: St. Martin's, 1968), 116–74.

36. See Allen Buchanan, *Justice, Legitimacy, and Self-determination: Moral Foundations of International Law* (Oxford: Oxford University Press, 2007); and Lon Fuller, *The Morality of Law* (New Haven, CT: Yale University Press, 1969).

37. Jan Klabbers, Anne Peters, and Geir Ulfstein, *The Constitutionalization of International Law* (Oxford: Oxford University Press, 2011).

38. ICJ, *Military and Paramilitary Activities in and against Nicaragua (Nicaragua v. United States of America)*, Judgment, 26 November 1986, https://www.icj-cij.org/public/files/case-related/70/070 -19841126-JUD-01-00-EN.pdf.

39. UN doc. S/RES/2100, 25 April 2013. The MINUSMA mandate was extended in Security Council resolution 2423, UN doc. S/RES/212423, 28 June 2018.

40. The effectiveness of the MINUSMA resolution with regard to the protection of cultural heritage remains untested, especially since it is unclear how the specialized personnel competent for the conservation and protection of cultural heritage can be integrated into the security forces and how their safety can be guaranteed in the absence of full demilitarization of the relevant areas and of sufficient institutional control. For an in-depth analysis of these problems, see Laura Pineschi, "Tutela internazionale del patrimonio culturale e missioni di pace delle Nazioni Unite: un binomio possibile? Il caso MINUSMA," *Rivista di diritto internazionale* 101 (2018): 5–57.

41. ICJ, *Legal Consequences for States of the Continued Presence of South Africa in Namibia (South West Africa) notwithstanding Security Council Resolution 276 (1970)*, Advisory Opinion, 21 June 1971, https://www.icj-cij.org/public/files/case-related/53/053-19710621-ADV-01-00-EN.pdf.

42. ICJ, *Western Sahara*, Advisory Opinion, 16 October 1975, para. 88, https://www.icj-cij.org/public/ files/case-related/61/061-19751016-ADV-01-00-EN.pdf.

43. ICJ, *Legal Consequences of the Construction of a Wall in the Occupied Palestinian Territory*, Advisory Opinion, 9 July 2004, para. 88, https://www.icj-cij.org/public/files/case-related/131/131 -20040709-ADV-01-00-EN.pdf.

44. ICJ, *Legal Consequences of the Separation of the Chagos Archipelago from Mauritius in 1965*, Advisory Opinion, 25 February 2019 (revised 4 March 2019), https://www.icj-cij.org/public/files/ case-related/169/169-20190225-ADV-01-00-EN.pdf.

45. See Federico Lenzerini, "Intentional Destruction of Cultural Heritage," in *The Oxford Handbook of International Cultural Heritage Law*, ed. Francesco Francioni and Ana Filipa Vrdoljak (Oxford: Oxford University Press, 2020), 75–100. The UN Declaration on the Rights of Indigenous Peoples, UN doc. A/Res/61/295, 13 September, 2007, recognizes the culture and cultural rights of Indigenous peoples as the foundation of their right of self-determination.

46. See the 2003 UNESCO Declaration Concerning the Intentional Destruction of Cultural Heritage (preamble), and the Human Rights Council resolution on the linkage between wanton destruction of cultural heritage and human rights atrocities. See Human Rights Council, "Human Rights Situation in Iraq." See also Karima Bennoune, *Report of the Special Rapporteur in the Field of Cultural Rights*, General Assembly, UN doc. A/HRC/31/59, 3 February 2016.

47. Court of the Vice Admiralty, Nova Scotia, Canada, 1803. Cited in John Henry Merryman and Albert E. Elsen, *Law, Ethics and the Visual Arts*, 4th ed. (New York: Kluwer Law International, 2002), 10.

48. This principle was formally adopted in the UN's *2005 World Summit Outcome*, UN doc. A/RES/60/1, 24 October 2005, paras. 138–39. For a discussion of the effectiveness and limits of this principle, see two articles in a special issue on R2P of the *International Spectator: Italian Journal of International Affairs*: Jennifer Welsh, "The Responsibility to Protect at Ten: Glass Half Empty or Half Full?," *International Spectator* 51, no. 2 (2016): 1–9; and Federico Lenzerini, "Terrorism, Conflicts and the Responsibility to Protect Cultural Heritage," *International Spectator* 51, no. 2 (2016): 70–85.

49. For an analysis of this practice, see Benedetto Conforti and Carlo Focarelli, *The Law and Practice of the United Nations* (Leiden, the Netherlands: Martinus Nijhoff, 2016), 219.

50. This point was recognized in the document adopted by a high-level meeting organized at the United Nations, at the initiative of the Italian mission, on 21 September 2017, on the theme of "Our Responsibility to Protect Cultural Heritage from Terrorism and Mass Atrocities." See http://www.unesco.org/new/en/social-and-human-sciences/themes/sv/news/our_responsibility_to_protect_cultural_heritage_from_terrori/. This document follows the UNESCO recommendation on the "Responsibility to Protect Cultural Heritage," adopted by an expert meeting of 26–27 November 2015.

25

Prosecuting Heritage Destruction

Joseph Powderly

On the opening of the case against Ahmad al-Faqi al-Mahdi for his role in the destruction of mausoleums in Timbuktu, Mali, the then chief prosecutor of the International Criminal Court (ICC), Fatou Bensouda, reflected on the importance of pursuing international criminal accountability for heritage destruction. In her view, the case against al-Mahdi was historic "in view of the destructive rage that marks our times, in which humanity's common heritage is subject to repeated and planned ravages." She concluded that heritage destruction is "a crime that impoverishes us all and damages universal values we are bound to protect."[1] The protection and realization of universal values sit at the very heart of the purposive foundations of international criminal law. Since the inception of the notion of international criminal accountability, the courts and tribunals that have been tasked with its delivery have recognized that acts that threaten and destroy the heritage of peoples cannot be left unpunished. The prosecution of heritage destruction before international criminal courts and tribunals, from the International Military Tribunal at Nuremberg (IMT) in 1945–46 to the present day ICC, has made an important contribution to ending impunity for heritage destruction, and has significantly advanced the development of international law in this area.

This chapter offers an account of the history of international criminal legal efforts to prosecute heritage destruction. In doing so, it reflects on significant jurisprudential milestones, and the manner in which the law in this area has evolved from the post–World War I era through to the contemporary developments before the ICC, in order to demonstrate the significance of this body of jurisprudence and its future potential.

The Origins of International Criminal Accountability for Heritage Destruction

The prohibition of the intentional, wanton destruction of tangible cultural heritage has an unimpeachable pedigree as one of the founding principles of the law of armed

conflict. The Lieber Code of 1863, the Union Army and President Abraham Lincoln's laudable, if admittedly naïve, attempt to limit the ravages of the American Civil War, precipitated a paradigm shift away from the mere moral condemnation of the destruction and appropriation of cultural property toward express legal proscription. Article 35 of the code is unambiguous: "Classical works of art, libraries, scientific collections, or precious instruments . . . must be secured against all avoidable injury, even when they are contained in fortified places whilst besieged or bombarded." The prescriptive, deterrent objective of the code is reflected in Article 44, which makes clear that the intent was not only to prohibit such conduct, but to actively ascribe a penal basis for individual responsibility.[2]

While law and practice often offer disparate narratives—there is little to suggest that any member of the Union Army was in fact punished for cultural heritage destruction—the influence of the Lieber Code on efforts aimed at codifying the laws of armed conflict at the level of international law can hardly be underestimated. However, it was not until the adoption of the Hague Conventions and annexed regulations of 1899 and 1907 (the "Hague Rules"), that the protection of tangible cultural heritage in armed conflict was codified in the form of binding international rules.[3] While Articles 27 and 56 of the 1907 Hague Convention (IV) regulations provide for minimum protections for immovable cultural objects (subject to considerations of military necessity) in the context of the conduct of hostilities and situations of occupation respectively, the question of the specific applicability of individual criminal responsibility remained ambiguous, not to say controversial. Article 56 adopted verbatim the text of Article 8 of the 1874 Brussels Declaration to the effect that all acts of seizure, destruction, or willful damage, "be made the subject of legal proceedings," but the suggestion that this implied the imposition of individual criminal responsibility was contestable.[4]

The opaque threat of criminal sanction contained in the Hague Rules clearly did little to curtail the rampant destruction of cultural heritage characteristic of World War I. Wanton destruction of precious cultural heritage sites exemplified by the infamous burning of the library of the Catholic University of Louvain and the razing of the Cloth Hall at Ypres, both in Belgium, and the bombardment of the cathedral in Rheims, France, were contemporaneously held up as emblems of the indiscriminate barbarity of German military tactics and have since been etched in historical memory. In the aftermath of the burning of Louvain, the British prime minister, Herbert Asquith, referred to it as "the greatest crime committed against civilization and culture since the Thirty Years' War—a shameless holocaust of irreparable treasures lit up by blind barbarian vengeance."[5] However, mere condemnation is a poor alternative to criminal accountability, a fact not lost on the Allied powers, who, in the context of the plenary meeting of the Preliminary Peace Conference convened in Paris in January 1919, established the Commission on the Responsibility of the Authors of the War and on Enforcement of Penalties.

The wide-ranging mandate of the commission included ascertaining "the facts as to breaches of the laws and customs of war" and determination of "the constitution and procedure of a tribunal appropriate for the trial of these offences." What we witness in the mandate of the commission is the first meaningful elaboration of the very idea of international criminal justice, and in particular that violations of the laws and customs of war entail individual criminal responsibility prosecutable before a dedicated international tribunal. Sub-Commission III was tasked with drafting a list of offenses for which, in its view, individual criminal responsibility should be sought. The subcommission returned a list of some thirty-two offenses, constituting the first effort aimed at elaborating what in common legal parlance are referred to as "war crimes." Included in the subcommission's list was the offense of "wanton destruction of religious, charitable, educational, and historic buildings and monuments."[6] The express focus of the offense on immovable cultural heritage is consistent with those references contained in the Hague Rules, the Brussels Declaration, and the Lieber Code.

The final text of the 1919 Treaty of Versailles included a number of provisions relating to individual criminal responsibility generally. However, the promise of the treaty in this area would never be fulfilled. The purported demand of the Allied powers for criminal accountability would rapidly wane in the face of the political and economic pragmatism invited by pan-European postwar social instability. The compromise (and largely symbolic) proceedings in 1921 that would come to be known as the Leipzig War Crimes Trials would be remembered as a combination of farce, parody, and tragedy rather than a landmark moment in the history of international criminal justice.[7] Ultimately, of the twelve trials completed, none addressed charges relating to the destruction of cultural heritage. While the trials stand as a precedent that international criminal justice would much rather forget, they, alongside the Treaty of Versailles, nonetheless set down the principle that violations of the laws and customs of war carry individual criminal responsibility enforceable both domestically and before internationally constituted courts and tribunals. Such a principle would be central to the establishment of the International Military Tribunal at Nuremberg (IMT) in the immediate aftermath of World War II.

Prelude to Nuremberg: The UNWCC and Crimes against Cultural Heritage
Before discussing the advances in accountability for looting and destruction of cultural heritage brought about by the *Trial of the Major War Criminals* before the IMT, it is worth considering the associated but parallel activities of the United Nations War Crimes Commission (UNWCC). The UNWCC's determination to unravel and offer clarity on key questions relating to individual criminal responsibility for international crimes has until relatively recently only been accounted for in the footnotes of the history of international criminal justice. The true contribution of the UNWCC was gradually revealed once its extensive archive, controlled by the US government, was made available to researchers in 2011.[8]

Established in October 1943 on the initiative of seventeen Allied states, the UNWCC was envisaged as a means by which to assist states in the preparation of cases involving the commission of war crimes. As such, the UNWCC was viewed as complimentary to domestic legal processes, and took on an important advisory function wherein it made, "recommendations to member Governments on questions of law and procedure in order to carry out the objects of the Allied nations."[9] From the archive, it is evident that the UNWCC was actively involved in compiling case files and lists of possible suspects relating to the commission of crimes against cultural heritage. These activities focused predominately on the large-scale looting of cultural objects by German forces across occupied Europe. The archives reveal that the UNWCC actively cooperated and collaborated with Allied efforts to safeguard cultural monuments and sites, and to identify, track down, and return looted cultural objects. For example, it exchanged information with the Monuments, Fine Arts, and Archives (MFAA) program, which fell under the authority of the Civil Affairs and Military Governments sections of the Allied Armies.

More significant from a prosecutorial perspective is the UNWCC's interaction with the Inter-Allied Commission on the Protection and Restitution of Cultural Material, known as the Vaucher Commission, after its chairman Professor Paul Vaucher, the cultural attaché to the French Embassy in London. The commission was established in April 1944 by the Conference of Allied Ministers of Education—the precursor to the UN Educational, Scientific and Cultural Organization (UNESCO). The primary objectives of the Vaucher Commission were: i) "to collect from all available sources the fullest possible information as to the damage, destruction, and looting of monuments, works of art and cultural material of all sorts in the occupied countries,"; ii) "to act as a pool for all such information,"; and iii) "to offer its services in any other useful capacity to such military or civil authorities as may now or hereafter be concerned with the public administration of any liberated territory or of any enemy territory which may be occupied by Allied Forces." In its work, the commission focused on the compilation of extensive indexes documenting sites subject to looting or to the destruction of cultural material, and indexes listing objects looted or disappeared. However, of particular relevance for the UNWCC was the commission's index of individuals suspected of having been involved in the looting or destruction of cultural property across occupied Europe. While the Vaucher Commission was only operational for some eighteen months—its final report was submitted in December 1945—it nonetheless succeeded in gathering copious amounts of valuable information with direct relevance to the prosecution of cases involving the looting and destruction of cultural heritage. For instance, its final report documents that it circulated some "2,000 confidential dossiers relating to looters" to military authorities and other relevant bodies.[10]

The minutes of the Vaucher Commission reveal that it welcomed a delegation from the UNWCC in March 1945, which met to discuss the modalities of potential cooperation between the two bodies. Cecil Hirst, then chair of the UNWCC, had previously met with

Vaucher Commission secretary C. P. Harvey on two occasions. During these meetings Hirst explained that the UNWCC was "inclined to widen the scope of its activities, and was taking an increased interest in crimes against artistic property." He was particularly eager to be granted access to the information compiled by the Vaucher Commission, especially its list of suspects. The minutes reveal that several members of the commission were wary at the prospect of handing over swathes of material to the UNWCC, as it might have resulted in the cherry-picking of information and suspects.[11]

Despite misgivings, the Vaucher Commission agreed to assist the UNWCC and to open its files. To this end, in April 1945, Wing-Commander Llewellyn-Jones selected forty cases from the commission's trove of material, all of which pertained to the looting of cultural objects in occupied Poland.[12] Of these, four were selected by Llewellyn-Jones as test cases. In the months after the selection of the test cases, the minutes reveal the eagerness of the membership of the Vaucher Commission to be further informed of the progress and status of the cases. However, neither the archives of the commission nor those of the UNWCC reveal what ultimately happened to them.[13] Sadly, the trail runs cold on this fascinating collaboration.

It will be some time before we have a clear picture of the full extent of the impact of the work of the UNWCC on the prosecution of crimes against tangible cultural heritage. Prior to the opening of its archives, most insights into its work were gleaned from the series of law reports it published between 1947 and 1949. Referred to as the *Law Reports of the Trial of War Criminals*, they set out in fifteen volumes to summarize a selection of the cases prosecuted in domestic jurisdictions that were driven by, and which benefitted from, the work of the UNWCC.[14] Most notable from the perspective of the prosecution of crimes against cultural heritage is the trial of Arthur Greiser before the Supreme National Tribunal of Poland. Greiser was the former Gauleiter and *Reichsstatthelter* (regional Nazi leader and governor) of the Wartheland, the part of occupied Poland incorporated formally into Germany during the war. His indictment was seminal because it laid charges relating to the widespread destruction of Polish heritage undertaken as part of, and in tandem with, a campaign of genocide and persecution.[15] The indictment also charged Greiser with involvement in the conception and implementation of so-called denationalization policies, the purpose of which was the eradication of individual and collective identity and the imposition of a homogenized, assimilated, "German" society on the occupied population.[16] The case addressed the destruction of both tangible and intangible cultural heritage and had an impact on early conceptualizations of the notion of cultural genocide, illustrating for the first time the unmistakable link between acts of heritage destruction and genocidal intent.

The UNWCC's role in forging accountability efforts for crimes against culture constitutes something of a hidden history. More prominent in orthodox accounts of the evolution of international criminal law in this sphere is the legacy of the IMT and its prosecution of, among others, Alfred Rosenberg, the architect and overseer of the Third Reich's systematic crimes against culture.

Nuremberg, Rosenberg, and Crimes against Culture

Under Article 6.b of the London Charter, which established the IMT, the tribunal had jurisdiction over violations of the laws and customs of war, part of which was "the plunder of public or private property, wanton destruction of cities, towns or villages, or devastation not justified by military necessity."[17] The primary focus of the evidence relating to the looting and destruction of cultural sites and objects centered on Alfred Rosenberg, who among other roles oversaw the *"Einsatzstab* Rosenberg" (Special Staff Rosenberg).[18] The US prosecution team at Nuremberg presented the *Einsatzstab* as "an organization which planned and directed the looting of cultural treasures of nearly all Europe."[19]

The sheer scale of looting defied accurate quantification and description with the prosecution relying on estimates drawn from seized German records. In an effort to give the judges a sense of both the scale of the looting and the cultural value of the objects stolen, the prosecution selected a number of images from the carefully compiled catalogues maintained by the *Einsatzstab* Rosenberg, sharing them with the courtroom via projector. The prosecution displayed thirteen images, ranging from Vecchio's *Portrait of a Woman*, and Reynolds's *Portrait of Lady Spencer*, to *The Three Graces* by Rubens, as well as a selection of jewelry, a silver-inlaid Louis XIV cabinet, and a Gobelin tapestry.[20]

Notably, the IMT proceedings placed a much greater focus on the looting of cultural objects compared with evidence relating to the destruction of cultural property and sites. The consequences of the Nazi pursuit of total war in the wanton destruction of cities and the devastation of public and private property are certainly accounted for, as are policies relating to denationalization and Germanization, but there is little specificity to the prosecution case or the final judgment with regard to the destruction of monuments or the destruction of buildings and sites of cultural value,[21] and as a consequence neither is an especially rich source of legal guidance in this area.

While the judgment may be lacking in elemental specificity, it is certainly not lacking in principle. Indeed, this was recognized during the drafting of the 1954 Hague Convention for the Protection of Cultural Property in the Event of Armed Conflict, with the *travaux préparatoires*, or drafting history, noting that the IMT had "introduced the principle of punishing attacks on the cultural heritage of a nation into positive international law."[22] In expressing this principle, the Nuremberg judgment established a precedent that would be instrumental in the prosecution of crimes against cultural heritage before the International Criminal Tribunal for the former Yugoslavia (ICTY) and ultimately the ICC.

The ICTY: The Foregrounding of Heritage Destruction in International Prosecutions

In the years following the conclusion of the IMT proceedings, the momentum created by this historic advance in international law precipitated the drafting and adoption of a

series of instruments that placed ever-increasing emphasis on notions of human dignity, fundamental human rights, and the pursuit of individual criminal responsibility for international crimes. Nevertheless, it was inevitable that the optimism of the law's postwar progressive development would gradually dissipate in the context of the intractability and consequent inertia of the Cold War. For the next fifty years international criminal accountability became an occasional domestic spectacle rather than a pillar of the international legal order. However, with the Cold War shackles completely removed after the December 1991 implosion of the Soviet Union, the early 1990s represented a moment in which the legacy of Nuremberg could be revived.

The breakup of Yugoslavia, which started in 1990, sparked a protracted and brutal interethnic conflict characterized by harrowing numbers of civilian casualties, ethnic cleansing, and the wanton destruction of public and private property, including in particular the deliberate targeting of cultural sites by all parties to the conflict. The response of the international community took several forms, but central was the determination that international criminal justice could play a role in the restoration of peace.

To this end, the UN Security Council, invoking its powers under Chapter VII of the UN Charter, established the ICTY in May 1993 through resolution 827. Under its statute, the ICTY had jurisdiction with respect to war crimes, crimes against humanity, and genocide committed on the territory of the former Yugoslavia since 1 January 1991. Most importantly for present purposes, under Article 3.d of its statute the tribunal was expressly granted jurisdiction to prosecute crimes against tangible cultural heritage as a violation of the laws and customs of war. The wording of the article provides for the prosecution of conduct relating to the "seizure of, destruction or wilful damage done to institutions dedicated to religion, charity and education, the arts and sciences, historic monuments and works of art and science."

The ICTY's jurisdiction to prosecute crimes against cultural heritage was not limited to the terms of Article 3.d. The complex interethnic character of the various conflicts that raged on the territory of the former Yugoslavia demanded that prosecutions reflect the underlying motivations and specific intent that drove perpetrators to systematically destroy cultural heritage. Throughout the period of the conflicts, from 1991 to 1999, heritage destruction in Croatia, Bosnia and Herzegovina, Serbia, and the latter's own breakaway territory of Kosovo was not the result of recklessness or the disproportionate use of force; it was the consequence of concerted campaigns of ethnic cleansing, persecution, and genocide. The foundation to the destruction of cultural heritage was the pursuit of ethnic homogeneity and the complete elimination of the "other." In short, the situation encompassed both ethnic *and* cultural cleansing.[23] Article 3.d of the statute was not equipped to encapsulate this reality, rather it was for Articles 4 and 5, which addressed genocide and crimes against humanity, respectively, to account for the persecutory and at times genocidal intent that characterized the destruction of cultural heritage in the former Yugoslavia.

Over the course of almost twenty-five years, the ICTY also developed an extensive and diverse body of jurisprudence addressing individual criminal responsibility for the destruction of tangible cultural heritage. Charges addressing the destruction of cultural heritage as a war crime under Article 3.d were frequently connected with related charges of persecution as a crime against humanity. This strategy reflected the relationship between the intentional destruction of cultural heritage and associated systematic attacks against civilian populations. While a full account of the ICTY's jurisprudential legacy can hardly be captured in this short contribution, a number of seminal cases demand attention.[24]

The destruction of cultural heritage was not the sole focus in any one case at the ICTY, but in a number of cases heritage destruction featured more prominently. Perhaps most significant is the *Strugar* case, which dealt with criminal responsibility for the shelling of the Old Town of Dubrovnik, a UNESCO World Heritage Site in Croatia. Pavle Strugar, the commander of a unit of the Yugoslav People's Army (JNA), argued that the Old Town constituted a legitimate military target and that the shelling was consistent with his understanding of the notion of military necessity since it was his belief that Croatian forces were using it as a defensive stronghold. The Trial Chamber was not persuaded. In finding him guilty and sentencing him to eight years imprisonment, the Trial Chamber interpreted the elements of the offense under Article 3.d. The court determined that the protection of cultural heritage applies equally to international and non-international armed conflicts, and that the article reflected customary international law. The judgment identified three elements to the offense under Article 3.d: "(i) damage or destruction to property which constitutes the cultural or spiritual heritage of peoples; (ii) the damaged or destroyed property was not used for military purposes at the time when the acts of hostility directed against these objects took place; and (iii) the act was carried out with the intent to damage or destroy the property in question."[25]

In a series of cases the ICTY expounded not only on the elements of the offense falling within the scope of Article 3.d, but advanced much further in offering reflections on the normative values that motivate accountability for heritage destruction in international criminal law. For example, in the *Hadžihasanović and Kubura* case, dealing with the destruction of religious buildings, the tribunal emphasized that, in assessing the gravity of the alleged offense, the spiritual value of property protected under the article should be a paramount consideration over and above the material damage inflicted.[26] In other instances, the ICTY highlighted the intrinsic value of property protected under the article.[27]

A significant feature of the tribunal's jurisprudence is its recognition of the intersectionality of heritage destruction with the crime against humanity of persecution. The latter is complex and multilayered, but at the heart of it is the denial of fundamental human rights on discriminatory grounds. In the *Tadić* case, the Trial Chamber held that persecution under Article 5.h provided broad coverage, "including acts mentioned elsewhere in the Statute as well as acts which, although not in and of themselves

inhumane, are considered inhumane because of the discriminatory grounds on which they are taken." The tribunal emphasized that "what is necessary is some form of discrimination that is intended to be and results in an infringement of an individual's fundamental rights."[28]

The first recognition that the targeting and destruction of religious and cultural heritage could be classified as persecution came in the *Blaškić* case. The Trial Chamber determined that "persecution may take forms other than injury to the human person, in particular those acts rendered serious not by their apparent cruelty but by the discrimination they seek to instil within humankind." Included within this understanding was the "confiscation or destruction of private dwellings or businesses, symbolic buildings or means of subsistence."[29]

This opened the door for further development of the law in the *Kordić and Čerkez* case, in which the accused were charged with multiple counts relating to "the destruction and plunder of Bosnian Muslim property and the destruction of institutions dedicated to religion or education." Reflecting on whether attacks on religious cultural property fell within the scope of persecution, the tribunal stated: "This act, when perpetrated with the requisite discriminatory intent, amounts to an attack on the very religious identity of a people. As such it manifests a nearly pure expression of the notion of 'crimes against humanity,' for all of humanity is indeed injured by the destruction of a unique religious culture and its concomitant cultural objects. The Trial Chamber therefore finds that the destruction and willful damage of institutions dedicated to Muslim religion or education, coupled with the requisite discriminatory intent, may amount to an act of persecution."[30]

This categorically emphasizes the intersectionality of attacks on cultural heritage with campaigns of ethnic cleansing. It is also arguably the closest international criminal law has come to encapsulating within a single prosecutable offense acts contemplated by Raphael Lemkin—who first proposed the concept of genocide—to fall within the scope of the notion of "cultural genocide," which he referred to as "vandalism." In prosecuting heritage destruction as persecution, the ICTY was in a position to comprehensively set out the context within which attacks on cultural heritage were carried out.[31] Such attacks are rarely isolated incidents of destruction, but rather fall within a widespread pattern of related conduct that is systematically directed at the eradication of significant markers of the religious and cultural identity of a distinct group.

The absence of cultural genocide from the 1948 Genocide Convention has been much lamented and commented upon. While international criminal law does not expressly contemplate accountability for cultural genocide, evidence of heritage destruction was used to great effect by the ICTY as a means of establishing the specific intent required of the crime of genocide; that is, the intent to destroy the protected group in whole or in part. The utility of evidence of heritage destruction in this regard was clearly endorsed in the *Tolimir* case, where the tribunal stated that: "Although an attack on cultural or

religious property or symbols of a group would not constitute a genocidal act, such an attack may nevertheless be considered evidence of an intent to physically destroy the group."[32] This position has been endorsed in the jurisprudence of the International Court of Justice, which has cited ICTY jurisprudence approvingly on the matter.[33]

The ICTY deserves due recognition for foregrounding the destruction of cultural property in many of its most high-profile cases. The following section considers the extent to which the ICC has embraced this legacy and whether it is well placed or not to further the law as it relates to the destruction of cultural heritage.

The ICC and *Al Mahdi*: The Trajectory of Accountability for Heritage Destruction
Since its establishment in 2002, the ICC has struggled under the weight of utopian expectations. The unfortunate reality is that in the more than twenty years since the conclusion of the 1998 Rome Statute that gave birth to the ICC, there have only been rare successes amid a plethora of failures and missed opportunities. One of the more unexpected success stories relates to the efforts of the Office of the Prosecutor to pursue charges relating to heritage destruction. Under Article 8 of the Rome Statute, the court has jurisdiction to prosecute the war crime of "intentionally directing attacks against buildings dedicated to religion, education, art, science or charitable purposes, historic monuments, hospitals and places where the sick and wounded are collected provided they are not military objectives." This provision is applicable both in non-international and international armed conflicts under Articles 8.2.b.ix and 8.2.e.iv, respectively. Harking back to the terms of Article 27 of the regulations annexed to Hague Convention (IV) of 1907, the provision mixes the protection of immovable cultural property with other types of protected property. The emphasis is clearly on civilian use rather than the cultural value of the protected property,[34] and the scope of the provision is further limited by the exclusion of movable cultural objects.

Whereas Article 3.d of the ICTY statute referred to "damage or destruction" done to cultural property, the equivalent offense under the Rome Statute refers to "intentionally directing attacks." An attack under international humanitarian law (also known as the laws of war) is quite particular, and refers to combat action, whether in offense or defense. This means that in the language of international humanitarian law, attacks occur during a specific phase of an armed conflict—during the conduct of hostilities. This would suggest that in order for an offense under Article 8.2.b.ix or 8.2.e.iv to be prosecutable, the cultural property must be intentionally attacked during the conduct of hostilities, and not in other phases of the armed conflict such as situations of occupation, or where territory or objects have fallen into the hands of one of the parties. If the provision is strictly construed, as is required by Article 22 of the Rome Statute, the scope of protection afforded to immovable cultural heritage is significantly reduced.

The opportunity to explore the interpretation to be given to heritage protection under Article 8 came in the *Al Mahdi* case, which arose in the context of the Office of the Prosecutor's investigation into crimes allegedly committed in the context of the internal

armed conflict that was waged in Mali in 2012 and 2013. The conflict was sparked by an Islamist uprising in the north of the country in January 2012 that culminated in large areas, including the city of Timbuktu, falling under the control of an alliance of Islamist groups. Ansar Dine, a Salafist (ultraconservative Muslim) group, was a prominent member of this alliance, and, along with al-Qaeda in the Islamic Maghreb (AQIM), controlled Timbuktu between April 2012 and its liberation by French and Malian government forces in January 2013. During the short-lived occupation of the city, a fundamentalist, strictly conservative system of sharia law was enforced. From April to September 2012, Ahmad al-Faqi al-Mahdi acted as the head of the Hesbah, or morality brigade.[35]

Famed as a historically significant center of Islamic learning and culture, Timbuktu was inscribed on the UNESCO World Heritage List in 1988. The city is renowned for its unique Islamic architecture, including mosques, madrasas, and mausoleums. In June 2012, the leadership of Ansar Dine proclaimed that any construction over a tomb was contrary to sharia law and must be destroyed. As the leader of the Hesbah, al-Mahdi was instructed to destroy the mausoleums of saints located in Timbuktu's cemeteries. Consequently, between 30 June and 11 July 2012, al-Mahdi, alongside a number of coperpetrators, attacked and destroyed nine of the most revered mausoleums in the city, as well as the legendary door of the Sidi Yahia mosque.

In January 2013, the ICC Office of the Prosecutor formally opened an investigation into the situation in Mali, noting that there was "a reasonable basis to believe that war crimes of attacking protected objects pursuant to Article 8.2.e.iv were committed at least in Timbuktu."[36] In September 2015, an arrest warrant was issued under seal against al-Mahdi, who had fled and was at that time in custody in neighboring Niger. He was swiftly surrendered into the custody of the ICC, where he faced one charge of attacking protected objects under the aforementioned article. That the case focused exclusively on his role in the destruction of religious and cultural heritage was a significant statement on the part of the Office of the Prosecutor: as noted in the context of the ICTY, up to this point charges relating to crimes against cultural heritage had been laid alongside other offenses entailing the infliction of physical harm—an international criminal case had never been constructed purely around the destruction of cultural heritage. The decision was criticized by several human rights organizations, highlighting that, as head of the Hesbah, al-Mahdi could and should be held responsible for a variety of other crimes, including widespread gender-based violence.

In a statement issued shortly after he was handed into the custody of the court, Chief Prosecutor Bensouda remarked that:

> The people of Mali deserve justice for the attacks against their cities, their beliefs and their communities. Let there be no mistake: the charges we have brought against Ahmad Al Faqi Al Mahdi involve the most serious crimes; they are about the destruction of irreplaceable historic monuments, and they are about a callous assault

on the dignity and identity of entire populations and their religious and historical roots. The inhabitants of Northern Mali, the main victims of these attacks, deserve to see justice done. . . . No longer should such reprehensible conduct go unpunished. It is rightly said that 'cultural heritage is the mirror of humanity.' Such attacks affect humanity as a whole. We must stand up to the destruction and defacing of our common heritage.[37]

There is much to unpack in this statement. Most strikingly, Bensouda emphasized the anthropocentric character of the charges, thereby implicitly rejecting suggestions that crimes against cultural heritage are not of the same gravity as offenses that involve the infliction of physical harm. The charges are presented as attacks on dignity and individual and collective identity, rather than as the infliction of material damage. This language underlines the universal cultural value of the mausoleums rather than their practical value to the local population.

It was hoped that the case would allow the ICC judges to carefully unravel the extent of the protection afforded to cultural heritage under the Rome Statute. However, such hopes were significantly dented by al-Mahdi's decision to plead guilty to the charge: instead of a lengthy set of proceedings, all that was required was a brief outline of the evidence supporting the charge, and confirmation that his guilty plea was free and fully informed. One question that needed to be addressed, however, was whether the fact that the mausoleums were destroyed outside of the conduct of the hostilities phase of the conflict had any impact on the applicability of Article 8.2.e.iv to al-Mahdi's conduct. The Trial Chamber chose to elide the strictures of international humanitarian law, stating that: "The element of 'direct[ing] an attack' encompasses any acts of violence against protected objects and [the Chamber] will not make a distinction as to whether it was carried out in the conduct of hostilities or after the object had fallen under the control of the armed group. . . . This reflects the special status of religious, cultural, historical and similar objects, and the Chamber should not change this status by making distinctions not found in the language of the Statute."[38]

This interpretation led one prominent commentator to provocatively proclaim that al-Mahdi had been convicted "of a crime he did not commit."[39] From a purely international humanitarian law perspective, there is much to be said for this conclusion. How the notion of "attack" is to be interpreted for the purposes of war crimes under the Rome Statute continues to be a source of some confusion: Should it be strictly construed in line with international humanitarian law, or should it be given a broader, more liberal understanding? It was hoped that the issue would be resolved by the appeals chamber in the *Ntaganda* case, but while the court appeared to disavow the *Al Mahdi* approach, significant ambiguity and uncertainty remain.[40]

In determining al-Mahdi's sentence, the Trial Chamber embarked on an assessment of the gravity of the crime. In doing so, they rejected any notion that there was an immediate and obvious equivalence between all crimes under the statute, stating that,

"even if inherently grave, crimes against property are generally of lesser gravity than crimes against persons." Due recognition was given to the "symbolic and emotional value" attached to the destroyed mausoleums, their status as UNESCO World Heritage Sites, and the fact that they were destroyed for religious motives.[41] Having taken all aggravating and mitigating factors into account (including his admission of guilt and statement of remorse), al-Mahdi was sentenced to nine years.

Under Article 75 of the Rome Statute, the ICC has the power to award reparations in the form of restitution, compensation, or rehabilitation to victims of crimes. Following al-Mahdi's conviction, the court set about determining the appropriate reparations to be awarded, permitting experts to submit their opinion on how it should conceptualize and quantify the harm that resulted from his actions and how this should be reflected in the reparations order.

In this order of 17 August 2017, reflecting on the importance of tangible and intangible cultural heritage, the court stated that "cultural heritage is considered internationally important regardless of its location and origin" and that "cultural heritage is important not only in itself, but also in relation to its human dimension." The court also recognized that heritage destruction constitutes "an irreplaceable loss that negates humanity."[42] With respect to the victims of al-Mahdi's actions, it determined that harm was inflicted on the community of Timbuktu, the people of Mali, and the international community; thus it was conceptualized as occurring on the local, national, and international levels. Al-Mahdi's actions resulted in material damage, economic loss, moral harm in the form of "mental pain and anguish," the "disruption of culture," and emotional distress. Having considered multiple factors, the court determined that he was liable for €2.12 million for the economic loss that resulted from his actions. Furthermore, individual and collective reparations totaling €483,000 were awarded for the moral harm inflicted.

With respect to the harm suffered by the national and international communities, the court chose to award symbolic reparations in the form of €1 to the state of Mali and UNESCO. In total, al-Mahdi was held personally liable for reparations of €2.7 million, though he is not in a position, nor is he likely to be in the future, to fulfill the reparations order. Consequently, the Court's Trust Fund for Victims has stepped in to ensure that in time, through fund raising and voluntary contributions from states, the reparations will be appropriately fulfilled.

The *Al Mahdi* case has undoubtedly made an important contribution in terms of sharpening international criminal law's relevance to ongoing efforts aimed at accountability for heritage destruction. Prosecuted during a period in which the world was outraged at the intentional, wanton, and ideologically driven destruction of cultural heritage by the Islamic State of Iraq and Syria (ISIS, also known as ISIL or Da'esh), the case's timeliness marked the possibility of international accountability and stood as a warning to potential perpetrators that a reckoning may be at hand.

In the immediate aftermath of the case, there was a brief period in which efforts were made to build on the momentum created by the positive reception to al-Mahdi's conviction. A memorandum of understanding was signed by the Office of the Prosecutor and UNESCO formalizing their cooperative relationship. More recently, in the final days of her term of office as chief prosecutor, Bensouda published a dedicated *Policy on Cultural Heritage*. This commits the Office of the Prosecutor, among other things, to integrate the investigation and prosecution of heritage destruction (in all of its forms) into the heart of its activities.[43] This is an important step in the right direction, which it is hoped will be taken up, developed, and implemented by Chief Prosecutor Karim Khan during his term of office.

Clearly, *Al Mahdi* constitutes a positive development deserving of recognition. However, it also stands as something of a missed opportunity. While on the one hand the decision to focus the case on a single charge of heritage destruction highlighted the role of international criminal law in this area, it failed to fully account for and present the broader context in which the destruction of the mausoleums took place. The charge against al-Mahdi did not make clear that his actions were part of a broader campaign of persecution in which the fundamental rights of the people of Timbuktu were denied. In this respect, the case appeared to deviate from the important advances made in the jurisprudence of the ICTY.

The decision not to charge him with the crime against humanity of persecution, or any other offense, was necessarily a conscious one. It is entirely conceivable that limiting the charges against al-Mahdi was a purely pragmatic decision on the part of the Office of the Prosecutor, which viewed the case as a stepping-stone to prosecuting further cases arising from the situation in Mali. The commencement in 2020 of proceedings against al-Mahdi's acolyte and former chief of Ansar Dine's Islamic police, al-Hassan Ag Abdoul Aziz, tends to lend credence to this conclusion. In contrast with the former, al-Hassan is on trial for multiple counts of war crimes and crimes against humanity, including the destruction of the mausoleums. Most significantly, he is facing charges of religious and gender-based persecution as a crime against humanity under Article 7 of the Rome Statute. Central to these charges is evidence relating not only to the destruction of the mausoleums, but also evidence that addresses the wider policies of Ansar Dine that targeted the cultural heritage of the people of Timbuktu. In this respect, the Office of the Prosecutor is arguing that Ansar Dine's persecution of the city's civilian population included the denial of access to and participation in traditional forms of worship (including forms of prayer and religious festivals), singing and even listening to music, dress (including wearing amulets and talismans), and the imposition of a system of single-sex education based on the group's Salafist ideology.[44]

The case has the potential to be of seminal importance in the history of international criminal law. In addition to opening space for the prosecution of intangible cultural heritage destruction, thus broadening international criminal law's appreciation of cultural heritage's implicit diversity, it is also the first case in the history of international

criminal law to address gender-based persecution.[45] In constructing a charge of religious and gender-based persecution around evidence of the destruction of tangible and intangible cultural heritage, the Office of the Prosecutor is recognizing the inherent intersectionality of heritage destruction with different forms of discrimination. The narrative of the case presents the religious persecution as occurring against the civilian population of Timbuktu who did not subscribe to Ansar Dine's ideology. However, the inclusion of gender-based persecution represents how women and girls in Timbuktu were also persecuted on account of their gender and nonconformity with the group's brutally misogynistic rule: they were doubly persecuted, and the destruction of tangible and intangible cultural heritage was central to both forms of persecution.

The *Al Mahdi* and *Al Hassan* cases allow for reasonable optimism that, like the ICTY, the ICC is on the road to constructing an important legacy with respect to accountability for heritage destruction. However, given the pace of proceedings, the limited capacity of the court, and increasing state ambivalence with respect to international criminal justice mechanisms, it would be naïve to expect the ICC to carry the weight of delivering global accountability for heritage destruction. It certainly has a role to play in ending impunity for heritage destruction, but this must be considered as but one element of the global response to this issue.

Conclusion

Since the concept of individual criminal responsibility for the commission of international crimes took root over a century ago, international criminal law has played an important role in documenting and holding to account those most responsible for cultural heritage destruction. The resulting jurisprudence has led to the progressive development of the law and has been a notable component in the emergence of the distinct body of international cultural heritage law. From Nuremberg to the ICC, international criminal law has recognized that the harm inflicted by heritage destruction is far from purely material, but rather exists on a spectrum of harm that has a profound impact on the spiritual and mental well-being of people on an individual and collective level. Numerous seminal cases have highlighted the link between heritage destruction and crimes against humanity, and while states have rejected the notion of cultural genocide, evidence of heritage destruction has been used as a means of proving genocidal intent. Perhaps most significantly, the prosecution of heritage destruction before international criminal courts has underlined the universal values that are eroded when heritage is targeted. Heritage destruction is an affront to the dignity and identity of those most immediately affected by it and constitutes a stain on the very notion of humanity.

With the burgeoning case law of the ICC, there is cause for optimism that international criminal justice can continue to pursue accountability for heritage destruction. However, it is imperative that international criminal justice be seen as a subsidiary, rather than as a primary, means of accountability. The cases prosecuted by

international criminal courts should be used as a source of guidance and inspiration to states to ensure that legislation is in place to allow for the prosecution of heritage destruction before domestic courts: the future of accountability for heritage destruction must be before domestic courts in accordance with the Second Protocol to the 1954 Hague Convention. International prosecutions can show the way, but it is for states to follow if there is to be meaningful accountability for the scourge that is cultural heritage destruction.

SUGGESTED READINGS

Serge Brammertz, Kevin C. Hughes, Alison Kipp, and William B. Tomljanovich, "Attacks against Cultural Heritage as a Weapon of War: Prosecutions at the ICTY," *Journal of International Criminal Justice* 14, no. 5 (2016): 1143–74.

Micaela Frulli, "The Criminalization of Offences against Cultural Heritage in Times of Armed Conflict: The Quest for Consistency," *European Journal of International Law* 22, no. 1 (2011): 203–17.

ICC, Office of the Prosecutor, *Policy on Cultural Heritage* (The Hague: ICC, June 2021), https://www.icc-cpi.int/itemsDocuments/20210614-otp-policy-cultural-heritage-eng.pdf.

Ana Filipa Vrdoljak, "Cultural Heritage in Human Rights and Humanitarian Law," in *International Humanitarian Law and International Human Rights Law*, ed. Orna Ben-Nephtali (Oxford: Oxford University Press, 2011), 250–302.

Karolina Wierczyńska and Andrzej Jakubowski, "Individual Criminal Responsibility for Deliberate Destruction of Cultural Heritage: Contextualizing the ICC Judgment in the *Al-Mahdi* Case," *Chinese Journal of International Law* 16, no. 4 (2017): 695–721.

NOTES

1. ICC, "Statement of the Prosecutor of the International Criminal Court, Fatou Bensouda, at the Opening of Trial in the Case against Mr. Ahmad Al-Faqi Al Mahdi," 22 August 2016, https://www.icc-cpi.int/Pages/item.aspx?name=otp-stat-al-mahdi-160822.
2. Francis Lieber, "Instructions for the Government of Armies of the United States in the Field," General Orders No. 100, Adjutant General's Office, 24 April 1863, Arts. 35, 44.
3. Convention (II) with Respect to the Laws and Customs of War on Land and Its Annex: Regulations Concerning the Laws and Customs of War on Land, The Hague, 29 July 1899; and Convention (IV) Respecting the Laws and Customs of War on Land and Its Annex: Regulations Concerning the Laws and Customs of War on Land, The Hague, 18 October 1907.
4. Its full name is the Project of an International Declaration Concerning the Laws and Customs of War, Brussels, 27 August 1874.
5. Asquith made this remark in private correspondence. See Michael Brock and Eleanor Brock, eds., *Asquith: Letters to Venetia Stanley* (Oxford: Oxford University Press, 1985), quoted in Alan Kramer, *Dynamic of Destruction: Culture and Mass Killing in the First World War* (Oxford: Oxford University Press, 2007), 14.
6. See "Commission on the Responsibility of the Authors of the War and on Enforcement of Penalties," *American Journal of International Law* 14, no. 1 (1920): 95, 115.
7. See Matthias Neuner, "When Justice Is Left to the Losers: The Leipzig War Crimes Trials," in *Historical Origins of International Criminal Law: Volume I*, ed. Morten Bergsmo, Cheah Wui Ling, and Yi Ping (Brussels: Torkel Opsahl Academic EPublisher, 2014), 333–77.

8. For an account of the obstacles that had to be negotiated in order to gain access to the archives of the UNWCC, see Dan Plesch, *Human Rights after Hitler: The Lost History of Prosecuting Axis War Crimes* (Washington, DC: Georgetown University Press, 2017).

9. Plesch, *Human Rights After Hitler*.

10. Commission for the Protection and Restitution of Cultural Material, *Final Report*, doc. no. AME/148, 15 December 1945, British National Archives Reference T 209/5/1, 2.

11. See Conference of Allied Ministers of Education, Commission for Protection and Restitution of Cultural Material, "Draft Minutes of the 15th Meeting of the Commission," 2 March 1945, US National Archives Microfilm Publication M1944, roll 154.

12. UNWCC, Committee I, "Looting of Art Treasures and Report of the Vaucher Committee: Report by Wing Commander Jones and Discussion in Committee I," 24 April 1945, https://www.legal-tools.org/doc/0c6110/pdf.

13. Conference of Allied Ministers of Education, Commission for Protection and Restitution of Cultural Material, "Draft Minutes of the 17th Meeting of the Commission," 8 June 1945, US National Archives Microfilm Publication M1944, roll 154, 2.

14. All fifteen volumes can be accessed through the Library of Congress: Military Legal Resources, "Law Reports of Trials of War Criminals," https://www.loc.gov/rr/frd/Military_Law/law-reports-trials-war-criminals.html.

15. See Mark Drumbl, "Germans Are the Lords and Poles Are the Servants: The Trial of Arthur Greiser in Poland, 1946," in *The Hidden Histories of War Crimes Trials*, ed. Kevin Heller and Gerry Simpson (Oxford: Oxford University Press, 2013), 411.

16. See UNWCC, "Trial of Gauleiter Artur Greiser, Supreme National Tribunal of Poland, 21st June–7th July 1946," in *Law Reports of Trials of War Criminals: Volume XIII* (London: His Majesty's Stationery Office, 1949), 71.

17. Charter of the International Military Tribunal (London Charter), 8 August 1945, Art. 6.b.

18. Rosenberg was by no means the only defendant to face charges relating to looting and destruction; indeed, it was alleged that he was joined in the conspiracy by Nuremberg codefendants Hermann Göring, Wilhelm Keitel, and Hans Frank.

19. IMT, "Blue Series," 4:81 (18 December 1945), https://www.loc.gov/rr/frd/Military_Law/pdf/NT_Vol-IV.pdf.

20. See IMT, 91. The Soviet prosecution case included extensive evidence of heritage destruction throughout Soviet territory. This was presented in various forms, including that of a documentary specifically created for the proceedings. For a general overview of the Soviet role at Nuremberg, see Francine Hirsch, *Soviet Judgment at Nuremberg* (Oxford: Oxford University Press, 2020).

21. This is most likely due to the prosecution's desire to avoid accusations of hypocrisy given the widespread evidence and notoriety of the indiscriminate Allied destruction of German towns and cities.

22. Quoted in Ana Filipa Vrdoljak, "Cultural Heritage in Human Rights and Humanitarian Law," in *International Humanitarian Law and International Human Rights Law*, ed. Orna Ben-Nephtali (Oxford: Oxford University Press, 2011), 272–73.

23. Council of Europe, Committee on Culture and Education, *War Damage to the Cultural Heritage in Croatia and Bosnia–Herzegovina*, information report, doc. no. 7431, 1995.

24. Council of Europe, para. 1157.

25. Council of Europe, paras. 229, 312. See ICTY, *Pavle Strugar*, case no. IT-01-42-T, Judgment, 31 January 2005, https://www.icty.org/x/cases/strugar/tjug/en/str-tj050131e.pdf.

26. ICTY, *Hadžihasanović and Kubura*, case no. IT-01-47-T, Judgment, 15 March 2006, para. 63, https://www.icty.org/x/cases/hadzihasanovic_kubura/tjug/en/had-judg060315e.pdf.

27. ICTY, *Prlić et al.*, case no. IT-04-74-T, Judgment, Volume 2 of 6, doc. no. D2165-1567/78692 BIS, 29 May 2013, para. 1282, https://www.icty.org/x/cases/prlic/tjug/en/130529-2.pdf.

28. ICTY, *Tadić*, case no. IT-95-1-T, Opinion and Judgment, 7 May 1997, paras. 715, 697, https://www.icty.org/x/cases/tadic/tjug/en/tad-tsj70507JT2-e.pdf.

29. ICTY, *Blaškić*, case no. IT-95-14-T, Judgment, 3 March 2000, para. 227, https://www.icty.org/x/cases/blaskic/tjug/en/bla-tj000303e.pdf.

30. ICTY, *Kordić and Čerkez*, case no. IT-95-14/2-T, Judgment, 26 February 2001, paras. 6, 207, https://www.icty.org/x/cases/kordic_cerkez/tjug/en/kor-tj010226e.pdf.

31. Serge Brammertz et al., "Attacks against Cultural Heritage as a Weapon of War: Prosecutions at the ICTY," *Journal of International Criminal Justice* 14, no. 5 (2016): 1161.

32. ICTY, *Tolimir*, case no. IT-05-88/2-T, Judgment, 12 December 2012, para. 746, https://www.icty.org/x/cases/tolimir/tjug/en/121212.pdf. See also ICTY, *Krstić*, case no. IT-98-33-A, Appeal Judgment, 19 April 2004, para. 25, https://www.icty.org/x/cases/krstic/acjug/en/krs-aj040419e.pdf.

33. ICJ, *Application of the Convention on the Prevention and Punishment of the Crime of Genocide (Bosnia and Herzegovina v. Serbia)*, Judgment, 26 February 2007, para. 344, https://www.icj-cij.org/public/files/case-related/91/091-20070226-JUD-01-00-EN.pdf; and ICJ, *Application of the Convention on the Prevention and Punishment of the Crime of Genocide (Croatia v. Serbia)*, Judgment, 3 February 2015, paras. 386–99, https://www.icj-cij.org/public/files/case-related/118/118-20150203-JUD-01-00-EN.pdf.

34. Micaela Frulli, "The Criminalization of Offences against Cultural Heritage in Times of Armed Conflict: The Quest for Consistency," *European Journal of International Law* 22, no. 1 (2011): 211.

35. ICC, *Al Mahdi*, case no. ICC-01/12-01/15, Judgment and Sentence, 27 September 2016, para. 33, https://www.icc-cpi.int/Pages/record.aspx?docNo=ICC-01/12-01/15-171.

36. ICC, Office of the Prosecutor, *Situation in Mali: Article 53(1) Report*, 16 January 2013, para. 113.

37. ICC, Office of the Prosecutor, "Statement of the Prosecutor of the International Criminal Court, Fatou Bensouda, Following the Transfer of the First Suspect in the Mali Investigation," 26 September 2015, https://www.icc-cpi.int/pages/item.aspx?name=otp-stat-26-09-2015.

38. ICC, *Al Mahdi*, Judgment and Sentence, para. 15.

39. See William Schabas, "Al Mahdi Has Been Convicted of a Crime He Did Not Commit," *Case Western Reserve Journal of International Law* 49, no. 1 (2017): 75.

40. See Ori Pomson, "Ntaganda Appeals Chamber Judgment Divided on Meaning of 'Attack,'" *Articles of War*, 12 May 2021, https://lieber.westpoint.edu/ntaganda-appeals-chamber-judgment-divided-meaning-attack/.

41. ICC, *Al Mahdi*, Judgment and Sentence, paras. 77, 79–81.

42. ICC, *Al Mahdi*, Reparations Order, 17 August 2017, paras. 15, 16, 22, https://www.icc-cpi.int/CourtRecords/CR2017_05117.PDF.

43. ICC, Office of the Prosecutor, *Policy on Cultural Heritage* (The Hague: ICC, June 2021), para. 20, https://www.icc-cpi.int/itemsDocuments/20210614-otp-policy-cultural-heritage-eng.pdf.

44. ICC, *Al Hassan Ag Abdoul Aziz Ag Mohamed Ag Mahmoud*, case no. ICC-01/12-01/18, Rectificatif à la décision relative à la confirmation des charges portées contre Al Hassan Ag Abdoul Aziz Ag Mohamed Ag Mahmoud, 13 November 2019, para. 683.

45. Rosemary Grey et al., "Gender-Based Persecution as a Crime against Humanity: The Road Ahead," *Journal of International Criminal Justice* 17, no. 5 (2019): 957.

26

Fighting Terrorist Attacks against World Heritage and Global Cultural Heritage Governance

Sabine von Schorlemer

Over the past few years, cultural heritage without military significance has increasingly become a target of systematic and intentional attacks by nonstate armed groups.[1] The attractiveness of the world's cultural heritage as target for terrorists in the twenty-first century is reflected in just a few prominent examples: the intentional destruction of the Buddha statues of Bamiyan by the Taliban in Afghanistan in 2001, the attacks by militant Islamist group Ansar Dine against world heritage in Mali in 2012, and the rage of the Islamic State of Iraq and Syria (ISIS, also known as ISIL or Da'esh) against monuments and archaeological sites in Syria and Iraq over the last ten years.

In many countries, weak governance fuels violence and terrorism, and hence a strategic targeting of civilian objects, including cultural heritage. As terrorist groups often strive intensively for media attention and seek iconic targets, the attribution of "world heritage" status to a monument or a site, that is, their inscription on the World Heritage List[2] of the United Nations Educational, Scientific and Cultural Organization (UNESCO) may even provoke them to destroy it.[3] The former UN special rapporteur in the field of cultural rights, Karima Bennoune, warned that "fundamentalists often seek to erase the culture of others . . . and stamp out cultural diversity."[4]

The UNESCO World Heritage Committee has undertaken various efforts to raise international awareness and mobilize support for the protection of world heritage, including by inscribing sites that have been wantonly attacked and damaged on the List of World Heritage in Danger (e.g., Timbuktu and the Tomb of Askia in Mali, and six World Heritage Sites in Syria) and by working closely with international actors.[5] Dealing with counterterrorism measures in order to protect World Heritage Sites registered on the basis of the 1972 Convention Concerning the Protection of the World Cultural and

Natural Heritage is clearly within UNESCO's mandate as a UN specialized agency: the UNESCO Constitution sets forth that the organization has the task of ensuring "the conservation and protection of the world's inheritance of books, works of art and monuments of history and science" (Article 1.2.c). However, when reaching out to its member states, UNESCO has to respect that its constitution prohibits the organization "from intervening in matters which are essentially within their [member states'] domestic jurisdiction" (Article 1.3).

The Notion of "Terrorism"

To fight terrorist attacks on a global scale, the UN Security Council has included several groups, individuals, undertakings, and entities responsible for the above-mentioned atrocities (henceforth, "terrorist groups") on its antiterrorism sanctions lists,[6] subjecting them to asset freezes, travel bans, and arms embargoes.

Furthermore, various UN bodies have tabled proposals with the objective of providing a comprehensive, universally agreed definition of "terrorism." Interestingly, the draft Comprehensive Convention on International Terrorism views damage to a place of public use as an "offence," including cultural places that are accessible or open to the public.[7] Still, negotiations on the draft are deadlocked and the international community of states has thus far been unable to agree on a universally binding definition of terrorism. This is seen as compromising ex ante any legal elaboration regarding the possible consequences of attacks on cultural heritage perpetrated within the context of terrorist campaigns.[8]

Irrespective of a binding legal definition, the wanton devastation of monuments and archaeological sites is often related to what may be seen as the nucleus of terrorism: deliberate violent action directed against civilians and civilian objects. Among other targets, it is motivated by a political, social, or religious cause, spreads fear among communities, and aims at maximum impact on people (shock, trauma, and intimidation).[9]

As James Cuno and Thomas G. Weiss have argued, attacks on cultural heritage and attacks on civilian populations are profoundly connected, and the protection of people and the protection of heritage are also "intimately intertwined."[10] When terrorist attacks on cultural heritage in Iraq and Syria perpetrated by ISIS reached an unprecedented level of destruction, UNESCO director-general Irina Bokova called what was happening "cultural cleansing."[11] Although not a legal term, "cultural cleansing" is increasingly used by UNESCO to refer to systematic and intentional attacks on cultural heritage and diversity, such as those perpetrated by ISIS.[12] The expression evokes ethnic cleansing as a major threat to local communities, populations, and other stakeholders, and reminds us of the urgent need for a universal defense of human rights and cultural heritage.

Fighting terrorist attacks directed against cultural heritage needs to be inclusive in legal terms and beyond. Against this backdrop, this chapter examines the extent to

which global cultural heritage governance can support intergovernmental efforts to fight terrorism, thereby improving cultural heritage protection and developing its international legal regime.

State-Centered Approaches to Combating Terrorist Attacks against Cultural Heritage

For decades, the UN's fight against terrorism has had a clear intergovernmental focus, primarily obliging UN member states to take measures against terrorist attacks. Generally, the Security Council's resolutions address UN member states in their operative paragraphs. For example, in the face of ISIS's willful attacks, resolution 2199 in 2015 established a ban on trade in antiquities illegally removed from Iraq since 6 August 1990 and from Syria since 15 March 2011, recognizing that the illicit trafficking of antiquities is a source of income for terrorist groups. In a similar vein, resolution 2462 in 2019 adopted under Chapter VII of the UN Charter, which permits military enforcement, encouraged member states to improve efforts to identify cases of trafficking in cultural property that finance terrorism (paragraph 25). Other resolutions demonstrate a similar focus on UN member states in their intergovernmental relations.

Intergovernmental fora have been increasingly used to fight terrorism. As Weiss has observed, "wanton non-state destruction facilitates . . . conversations in intergovernmental fora, including those about counterterrorism."[13] The UNESCO Declaration Concerning the Intentional Destruction of Cultural Heritage, adopted by the General Conference—the biannual meeting of UNESCO's member states—on 17 October 2003,[14] may serve as an example. Adopted in the aftermath of the destruction of the Bamiyan Buddhas in Afghanistan in 2001, the declaration drew attention to the vulnerability of cultural heritage and the need for a global defense against terrorist attacks. States should take "all appropriate measures to prevent, avoid, stop and suppress acts of intentional destruction of cultural heritage, wherever such heritage is located" (paragraph 3.1). States failing to take appropriate measures should be responsible for such destruction (section 4).

A fresh impetus stems from resolution 2347, adopted in 2017, the first thematic resolution of the Security Council to focus exclusively on matters of cultural heritage. It addresses the practice by terrorist groups of intentionally destroying cultural heritage and plundering cultural property, recognizing that the protection of cultural heritage in conflict is inextricably linked to the fight against terrorism. Resolution 2347 explicitly addresses the common interest and obligation of the international community (including nonstate actors) to protect cultural heritage.[15] It goes beyond the traditional state-centered approach and thus deserves further scrutiny as terrorism is a complex societal phenomenon, rendering the struggle against it a challenging long-term project that needs to address all stakeholders—not only state organs—on a global scale.

The Perceived "Implementation Gap"

Generally, armed nonstate actors have to comply with obligations under existing international humanitarian law. This is clearly stated as a general rule for non-international armed conflict in Common Article 3 of the four Geneva Conventions of 1949, and—specifically with regard to the protection of cultural property—also in Article 16 of the 1999 Second Protocol to the 1954 Convention for the Protection of Cultural Property in the Event of Armed Conflict.[16]

The problematic question is how to combat intentional attacks by nonstate (terrorist) actors who are not willing to obey the rules and who even ignore their legal obligations. In these cases—such as the attacks by ISIS against world heritage in Syria and Iraq or by Ansar Dine in Mali—an implementation gap exists, i.e., a discrepancy between legal rules and their compliance.

Still, not all armed groups are prone to conduct acts of terrorism when they start fighting against governments—many rebel groups strive for democracy and freedom of speech, as could be seen, for example, at the beginning of the uprising in Syria (as part of the so-called Arab Spring). From an international legal perspective, it is important to note therefore that not all armed nonstate actors are terrorists per se. Automatically labeling them as "terrorists" risks their having little or no incentive to apply international humanitarian law norms, including the 1954 Hague Convention and its Second Protocol.[17] In addition, dealing with nonstate armed groups as *hostes humani generis* ("enemies of humanity" in international law) leaves them in a legal gray zone, creating the false impression that armed groups inhabit a lawless world.[18]

In cases when nonstate actors take up arms, their willingness to obey international law, including rules on cultural heritage protection, should be encouraged. Often rebel groups do not have sufficient knowledge of the rules with which they are supposed to comply. Thus there is "a need to better understand how these groups view cultural heritage" and to engage them "toward compliance with international standards applicable in armed conflicts for its protection."[19] Doubtlessly, combating terrorism requires a greater dissemination of knowledge of international law. This is of particular importance for better compliance with cultural heritage protection rules by state and nonstate actors alike.

Fighting terrorist attacks against world heritage requires a broader approach, going beyond classic state-centered instruments adopted in intergovernmental fora. This leads us to look at multifaceted global governance instruments, which include, as the Commission on Global Governance highlighted in its report *Our Global Neighbourhood*, "informal arrangements that people and institutions either have agreed to or perceive to be in their interest."[20]

Special Arrangements with Nonstate Armed Groups: Geneva Call

Special arrangements of a rather informal character may be helpful complementary instruments in dealing with violence from nonstate armed groups when it comes to

attacks on cultural property. Common Article 3(2) of the four Geneva Conventions states that the parties to a conflict "should further endeavour to bring into force, by means of special agreements, all or part of the other provisions of the present Convention." This is a way to expand the rule of law. In order to reassure governments that no "upgrading" of rebel groups' legal status will take place through international recognition, Common Article 3(2) emphasizes that the application of the provision "shall not affect the legal status of the Parties to the conflict."

Improved information, better transparency, and participation of armed nonstate actors is part of the governance agenda pursued by Geneva Call, a Swiss nongovernmental organization promoting respect for international humanitarian law. The organization is recognized as a forum for humanitarian engagement with armed nonstate actors.[21]

For example, Geneva Call conducted pilot trainings on the protection of cultural heritage with commanders of the Free Syrian Army in Geneva in December 2015 and June 2017.[22] Moreover, so-called deeds of commitment with rebel groups are used to promote compliance in specific fields of international humanitarian law. Initiated by Geneva Call and supported by the Canton of Geneva as custodian, deeds of commitment currently exist in areas such as land mines, the protection of children, and the prohibition of sexual violence.

In order to fight terrorist acts against cultural property and to promote the rule of law, a newly drafted "deed of commitment on cultural heritage protection" signed by nonstate armed groups might be a useful instrument with obvious advantages. Along the lines of Article 4.1 of the 1954 Hague Convention, a future pledge could comprise the duty to respect cultural property by refraining from any use of the property and its immediate surroundings likely to expose it to destruction or damage in the event of armed conflict, and by refraining from any act of hostility directed against it.

As most signatories to such deeds of commitment take measures—direct orders, training, or sanctions against noncomplying group members—to fulfill their protection obligations, these new types of agreements could help improve participatory global governance on behalf of cultural heritage protection. By signing such a deed, group members generally express "their adherence to specific humanitarian norms and to be held accountable for their pledge."[23] It can be observed that most signatories to deeds of commitment have abided by their monitoring obligations, for example, by reporting to Geneva Call or allowing for field missions.[24]

A deed of commitment is a special agreement reflecting international standards and opens up space for the application of international law. This ought to be reconsidered when it comes to the defense of cultural heritage against nonstate armed groups. Deeds of commitment initiated by Geneva Call addressing such groups could be an option in cases of armed conflict of a non-international character—i.e., typical situations when rebel groups take up arms.

The Relevance of Global Cultural Heritage Governance

In parallel to efforts to bring about greater respect for international humanitarian law, the conviction is growing that improved global governance can play an essential role in sustaining peace and security. *Our Global Neighbourhood* viewed governance as "a continuing process through which conflicting or diverse interests may be accommodated and cooperative action may be taken."[25] The concept of global governance is comprehensive, as it establishes important principles to guide international political, social, and economic activities. Generally, it may also include a cultural dimension. For example, the Council of the European Union—a legislative body that consists of European Union (EU) member-state cabinet ministers—on 25 November 2014 adopted a declaration, a "conclusion" in EU parlance, called Participatory Governance of Cultural Heritage, which emphasized that there is an "increased recognition at international level of a people centred and culture-based approach to foster . . . the importance of transparent, participatory and informed systems of governance for culture."[26] Seen in this light, transparency and the bottom-up participation of stakeholders (local communities, nonstate actors, and civilians) are becoming major factors in protecting cultural heritage from direct attacks.

An inclusive, people-centered emphasis is also reflected in the research work on global governance by the Committee on Participation in Global Cultural Heritage Governance of the International Law Association. Here, "global cultural heritage governance" is viewed as "a set of multilevel mechanisms linking various actors to help ensure a just, participatory management of cultural issues for the benefit of communities, locally, regionally and globally."[27] Within such a concept of "multilevel cultural heritage governance," as the committee's chair pointed out, the aim is to link legally binding international obligations for the protection of cultural heritage with voluntary policy commitments, "thus calling for the convergence of objectives of various international actors to promote interstate cooperation and the participation of non-State actors."[28]

Against this backdrop, it seems worth analyzing the extent to which global governance principles providing some guiding force in a complex environment can be furthered. The discussion now moves on to look at the law and policies of UNESCO, and its institutions and instruments responsible for the protection of cultural heritage in the face of terrorist attacks.

Strategy for the Reinforcement of UNESCO's Action for the Protection of Culture and the Promotion of Cultural Pluralism in the Event of Armed Conflict

Global cultural heritage governance is not yet a key notion with regard to UNESCO. The organization's cultural heritage framework has remained largely untouched by the global governance approaches that have emerged in international relations in recent years and which are already predominantly used outside the cultural sector. This is about to alter in the light of new challenges.

UNESCO has begun to demonstrate leadership in shaping innovative heritage and cultural governance.[29] In November 2015, the thirty-eighth General Conference of UNESCO adopted the Strategy for the Reinforcement of UNESCO's Action for the Protection of Culture and the Promotion of Cultural Pluralism in the Event of Armed Conflict, which was revised in 2017.[30] The strategy was a reaction to unprecedented challenges resulting from mass atrocities and intentional cultural heritage attacks, stressing that "terrorism" is a threat to cultural heritage.

The overall aim of the new strategy is to set forth ways to reinforce UNESCO's protection of cultural heritage, and the promotion of cultural diversity and pluralism. In a broad vision, the document emphasizes the "fundamental role of local communities in acting as bearers and custodians of cultural heritage and living expressions belonging to different periods of history." It also underlines that a critical element of UNESCO's preventive action will be "raising their awareness on threats facing culture in conflict and on the importance of its protection and promotion as an element of resilience for peaceful co-existence in multilateral societies."

The strategy also emphasizes how to prevent attacks on cultural heritage and diversity during conflict. UNESCO will need to strengthen not only authorities, but also relevant civil society actors in anticipating threats, preventing illicit trafficking of cultural property, developing contingency plans, and implementing protective measures for enhanced security at cultural heritage sites and museums.

Thus, for the first time, with a view to better respond to crisis situations, UNESCO highlighted the participation of people as an important element in global cultural heritage governance, acknowledging that "participation and access to culture and its living expressions, including intangible heritage, can help strengthen people's resilience and sustain their efforts to live through and overcome crisis." In addition, better information and raising of awareness, especially among young people, were stressed as equally important components of global cultural heritage governance.[31] In this respect, UNESCO pledged to develop communication and outreach material with a focus on the core values of cultural pluralism and diversity, as well as on cultural heritage safeguarding to counter hate speech and the narrative of violent extremists.[32]

By including people and communities, stressing the importance of their intangible heritage and cultural expressions, and—in particular—by placing special emphasis on awareness raising and the resilience of people, the new UNESCO strategy clearly went beyond its former rather state-oriented, conservational approach as reflected in the aforementioned 2003 Declaration Concerning the Intentional Destruction of Cultural Heritage. Obviously the new dimension of mass atrocities, in particular those committed by ISIS against people and cultural treasures, led UNESCO to reevaluate its strategic planning in a dynamic way and to thereby strengthen elements of global cultural heritage governance.

Challenges for World Cultural Heritage in the Twenty-First Century: The Phenomenon of Socially Mediated Terrorism

New global governance concepts that may complement state efforts to fight terrorism are needed as the quality of acts directly targeting cultural heritage has changed in recent years. Clearly, social and networked media are used to augment the impact of such acts with the aim of causing physical as well as emotional or psychological suffering that extends beyond the immediate public.[33]

Acts of radical, assertive media presentation of cultural heritage destruction are a phenomenon of the twenty-first century: while during the Balkan Wars in the 1990s willful destructions of cultural property took place, the "triumphs" were not celebrated in the media in a comparable way. When, for example, members of the Islamist rebel group Ansar Dine, under the leadership of Ahmad al-Mahdi, partly destroyed the UNESCO World Heritage Site of Timbuktu in July 2012, they demonstrated their "victory" online, and their YouTube videos went viral.

Also, the "Islamic State's counter-heritage campaign" in Syria and Iraq took place as a "media performance on a global scale."[34] The high-tech and systematic use of networked social media (e.g., YouTube, Facebook, Twitter, and Instagram), using a variety of platforms and accounts, and generating a high number of posted messages (as many as ninety thousand per day),[35] was a key component of ISIS's performative strategies. Videos and photographic imagery were staging "performances," e.g., by deliberately choosing, in a calculated way, ancient statues instead of smaller antiquities.[36]

When ISIS disseminated images of violent acts through a range of online and social media, this augmented "the time-tested tactic of shock and awe—a military strategy of rapid dominance in which the deployment of power aims to destroy an adversary's will to resist."[37] Thus, for ISIS, social media has proven effective as a terrorist medium for not only intimidating local populations but also for provoking fear further away from the direct war zone.[38] Moreover, young people may be recruited easily by terrorist groups especially when they become fascinated by terrorist propaganda in social media and prone to hate speech.

As a result, media-oriented terrorist activities have become widespread in the twenty-first century. The "ubiquity of [social] media" is thus a huge challenge,[39] making it necessary for the UN to reach out to people and communities and try to win people's hearts and minds against extremism. Therefore, the fight against terrorism nowadays is being challenged to take these new developments into consideration.

As the G20 leaders stated at a summit meeting in 2017, counterterrorism action must be part of a comprehensive approach which includes countering terrorist propaganda as well as combating radicalization and recruitment.[40] These objectives are reflected in new global governance instruments developed by UNESCO, discussed next.

Countering Terrorist Attacks: UNESCO's People-Centered Approach to Preventing Extremism

In its October 2015 session, the UNESCO executive board expressed concern about the "worldwide challenge of increased recruitment and radicalization to violent extremism of youth on social media, in communities, and in schools."[41] Recalling the UN Global Counter-Terrorism Strategy adopted in 2006 by the UN General Assembly, which encouraged UNESCO to "play a key role" in addressing conditions conducive to the spread of terrorism,[42] the executive board decided to develop new educational resources in order to facilitate the prevention of violent extremism through education. Hence, the "E" in UNESCO deserves enhanced attention when it comes to countering direct targeting in the future. This should also comprise "incentives in long-term projects to make people understand that they have something to lose, to educate them and have them internalize changed norms," as Hartwig Fischer has put it.[43]

Against this backdrop, the right to education is crucial in preventing extremism: it is a fundamental right enshrined in the 1948 Universal Declaration of Human Rights and several other international human rights instruments. The right to education is perceived by UNESCO as an "empowering right" aiming at equality of opportunity and universal access to quality education.[44] In particular, children should be prepared for a "responsible life in a free society in the spirit of understanding, peace, tolerance, equality of sexes, and friendship among all peoples, ethnic, national, and religious groups."[45]

UNESCO has demonstrated its willingness to support member states in this endeavor by establishing strategic partnerships for the creation of a global network of policymakers, experts, practitioners, research institutes, media, and other stakeholders to use educational strategies to prevent violent extremism.[46] In addition, efforts for training and capacity building should be made, including of educators, policymakers, parents, and youth.[47] To this end, in 2016 UNESCO released *A Teacher's Guide on the Prevention of Violent Extremism*, which provides practical advice on when and how to discuss violent extremism and radicalization in classrooms.[48]

With *Preventing Violent Extremism through Education: A Guide for Policy-makers* in 2017, UNESCO has begun to address education policymakers, school staff, and educators at large.[49] At the organizational level, joint activities and cooperation between the different sectors, or program areas, of UNESCO, including the Culture Sector, and headquarters and field offices have also been developed. Among other activities, UNESCO also assists countries within the framework of *Global Citizenship Education* in delivering education programs that strengthen young people's resilience to violent extremist messaging and foster a positive sense of identity and belonging. Furthermore, UNESCO mobilizes stakeholders to create social media and online coalitions for the prevention of violent extremism in order to prevent and respond to violent extremism and radicalization on the Internet.[50] Strong financial support is required for these

endeavors in order to restrain the spread of extremism that may lead to terrorist attacks on people and civilian objects.

Through another bottom-up initiative, the #Unite4Heritage campaign,[51] UNESCO strove to engage young people in the protection of all forms of heritage in order to foster more fair, inclusive, and peaceful societies. The global campaign was launched on 28 March 2015 and aimed to create a global movement of mostly young people to protect heritage under threat by sharing stories, knowledge, and experiences about heritage and culture.[52] The inspiration behind such a participatory method for the safeguarding of cultural heritage was simple, yet convincing: based on the ideas of cultural diversity, tolerance, and understanding, the campaign aimed at establishing alternative value-based narratives in contrast to extremists' narratives, which depreciate cultural heritage of foreign influence. This relates to a reframing of heritage protection "to mean winning the peace and hearts and minds, about creating a counternarrative to ISIS."[53]

By "showing a commitment to helping local efforts to address both the root causes of problems and their more immediate triggers, broader international efforts gain added credibility," as the International Commission on Intervention and State Sovereignty (ICISS) set forth regarding the "responsibility to protect."[54] Despite the fact that the #Unite4Heritage campaign initially faced some problems in becoming a major social network platform, taken together the measures are good examples of soft power at the grassroots level, helping to prevent the abuse of social media related to terrorist attacks and to strengthen the resilience of local communities. People's participation in changing narratives used by terrorist groups is a crucial element in strengthening the universal defense of cultural heritage.

Reconstruction of World Heritage and New Concepts of Global Governance

Due to an increasing number of wanton attacks in the twenty-first century, reconstruction of cultural heritage sites in post-conflict periods has gained considerable importance. UNESCO practice reflects an increasing willingness on the part of the international community to react to terrorist attacks by rebuilding cultural heritage and restoring cultural life. For example, the Revive the Spirit of Mosul initiative, launched by UNESCO in 2018, focuses on the rehabilitation and reconstruction of damaged or destroyed cultural heritage, the rehabilitation of the education system, and the revitalization of cultural life. The initiative envisions the reconstruction of the Al-Nuri Mosque in Mosul, Iraq, and its minaret, as well as two churches; it is funded, inter alia, by the United Arab Emirates.[55] In an earlier project, the UN Development Programme (UNDP) donated some $90,000 to protect heritage sites in the Old City of Mosul from further damage.[56]

Historically, reconstruction of cultural heritage has been a sign of perseverance, unity, and resilience as it helps communities express and uphold their identity.[57] Still, reconstruction of damaged monuments and sites is complex and often controversial. Since the nineteenth century, heritage conservation professionals have traditionally

been opposed to reconstructing ancient monuments. Moreover, the 1964 International Charter for the Conservation and Restoration of Monuments and Sites (the Venice Charter) largely excluded the option of reconstruction and even insisted that restoration end when guesswork begins.[58]

A materials-based reconstruction doctrine is part of the Operational Guidelines to the 1972 World Heritage Convention, supported by the International Council on Monuments and Sites (ICOMOS).[59] When a World Heritage Site of outstanding universal value or part of one is completely destroyed and its original building materials lost, authenticity must be analyzed in every single case.[60]

In the early years, the World Heritage Committee—which selects sites for inclusion on UNESCO's heritage lists—opposed reconstructions of world heritage. However, a growing number of terrorist attacks in recent years have resulted in heavier losses to the world's cultural heritage. The visible way that these attacks were celebrated as a defeat of universal values, have led the committee and UNESCO to shift their attitudes "towards the reconstruction of damaged or destroyed sites, in the face of traditional opposition."[61]

As world heritage has increasingly become a victim of heavy armed attacks by terrorist groups, reconstruction apparently turned into a more realistic option for UNESCO. While reconstruction projects at World Heritage Sites need always to address the "outstanding universal value" of each site, socioeconomic questions as well as the needs of the local communities may also be addressed "within the context of a larger vision for recovery."[62]

Despite the strict exigencies regarding "authenticity," UNESCO nowadays opts for a rather pragmatic approach when it comes to rebuilding World Heritage Sites that have been destroyed by terrorist groups (e.g., in Syria, Iraq, Afghanistan, Yemen, and Mali). Thus, in the aftermath of terrorist attacks causing shock and trauma, a more people-centered cultural governance approach is gaining ground.

Rebuilding cultural heritage in a post-conflict phase enables the international community to make contact with different parts of the local population. In the words of Luis Monreal, "you need to work with the community to explain what the final result will be,"[63] thereby ideally promoting trust and cohesion in politically divided societies. The Thematic Paper for the UN Secretary General's 2020 Report on Sustaining Peace and Peacebuilding emphasized that building peace is about "putting in place the institutions and trust that will strengthen the social contract and carry people forward into a peaceful future."[64] Consequently, reconstruction is viewed as a means for building the confidence of individuals and groups in times of crisis, thus supporting the transition process to recovery.

The destruction of fourteen Sufi mausoleums at the Timbuktu World Heritage Site in Mali in 2012 marked the beginning of this "shift," prompting UNESCO to lead a comprehensive reconstruction process which was largely completed in 2015. Notably, it was the broadened use of intangible attributes that made a stronger case for

reconstruction. Christina Cameron rightly observed that community and intangible values were evoked only after the destruction of the tombs, even though they are not mentioned in the statement of outstanding universal value made at the time of inscription on the World Heritage List.[65] In fact, arguments in favor of reconstruction resided largely in the local community: traditional building techniques were transmitted from elders to a new generation of builders and the projects brought together the whole community.[66] For that reason, the reconstruction of the mausoleums took place in close cooperation with local families and masons, with UNESCO also offering training courses for stone masons since then.

The involvement of the local community in the reconstruction of the tombs proved essential for the reconciliation process and as a source of strength for the Malian people.[67] When Irina Bokova inaugurated the reconstruction work done by UNESCO in July 2015, she declared this to be the "response to extremism" and at the same time "an example of the successful integration of culture in peace building."[68]

The position of the World Heritage Committee adopted in the light of the horrific terrorist attacks against the tombs in Mali was at first characterized as an "ad hoc decision-making by the WHC" that "appears to be leading to new approaches."[69] Meanwhile, there is no doubt that this innovative approach became an integral part of UNESCO's activities. UNESCO's Strategy for the Reinforcement of UNESCO's Action for the Protection of Culture and the Promotion of Cultural Pluralism in the Event of Armed Conflict mentions the importance of collecting systematic, reliable, and verified data on built, movable, but also on intangible heritage, in order to prepare the recovery phase and to support national authorities in assessing and planning recovery (paragraph 24).

Still, experts from the Global South tell us that when the international community turns its attention to a damaged heritage site and international organizations bring professional standards, expertise, and funds, the site starts to change as it becomes placed within a different paradigm.[70] It is of tremendous importance, therefore, to not only listen to local people, but to also give them a voice in the decision-making process of rebuilding.

Another rather difficult ethical point pertains to the question of balancing different priorities, e.g., when local communities wish to rebuild "their" religious sites (cemeteries, churches, mosques, synagogues) instead of reconstructing ancient monuments and archaeological sites of outstanding universal value which the international community sees as important. As Weiss has rightly put it: "It is not just the most famous sites."[71] To address these problems, further research on participatory global cultural heritage governance in post-conflict peacebuilding is needed.[72]

Conclusion

Global cultural heritage governance is inextricably linked to universal values. In a statement on "Global Governance for the 21st Century," Irina Bokova argued convincingly that universal values and human rights are key to enhanced global

governance as supported by UNESCO: "All cultures are different, but humanity stands united around human rights and fundamental freedoms. These are universal, even if they are not always universally accepted. Supporting societies in this respect is one of the key tasks of global governance today."[73]

Strengthening global cultural heritage governance has brought about a stronger collective commitment regarding the preservation of cultural heritage of humankind. The deliberate eradication of iconic world cultural heritage by terrorist groups has forged a new consensus within the international community regarding the need to fight terrorist action. In the wave of terrorist attacks on world heritage that we have witnessed in the last two decades, reactions among UN member states have become more comprehensive, focusing also on the participation of local communities in the effort to protect cultural heritage. Seen in this light, expanding global cultural heritage governance is a fruitful avenue for combating terrorist attacks against cultural heritage, not only because such improved global governance may play a role in sustainable peacebuilding, but also because it supports more resilient patterns in societies all over the world.

Still, although gains in global cultural heritage governance are neither to be achieved easily nor in a linear fashion, they are a worthy investment for sustaining peace and preventing future crises.[74] We need reliable efforts and solid funding for governance support, human rights, and the rule of law.

SUGGESTED READINGS

Irina Bokova, *UNESCO's Response to the Rise of Violent Extremism: A Decade of Building International Momentum in the Struggle to Protect Cultural Heritage*, Occasional Papers in Cultural Heritage Policy no. 5 (Los Angeles: Getty Publications, 2021), https://www.getty.edu/publications/occasional-papers-5/.

James Cuno and Thomas G. Weiss, eds., *Cultural Heritage under Siege: Laying the Foundation for a Legal and Political Framework to Protect Cultural Heritage at Risk in Zones of Armed Conflict*, Occasional Papers in Cultural Heritage Policy no. 4 (Los Angeles: Getty Publications, 2020), https://www.getty.edu/publications/occasional-papers-4/.

Francesco Francioni with the assistance of Federico Lenzerini, eds., *The 1972 World Heritage Convention: A Commentary* (Oxford: Oxford University Press, 2011).

Wolfgang Schneider and Daniel Gad, eds., *Good Governance for Cultural Policy: An African-European Research about Arts and Development* (Frankfurt am Main: Peter Lang, 2014).

Sabine von Schorlemer, "Cultural Heritage Protection as a Security Issue in the 21st Century: Recent Developments," *Indonesian Journal of International Law* 16, no. 1 (2018): 28–60.

Sabine von Schorlemer, "Military Intervention, the UN Security Council, and the Role of UNESCO: The Case of Mali," in *Intersections in International Cultural Heritage Law*, ed. Anne-Marie Carstens and Elizabeth Varner (Oxford: Oxford University Press, 2020), 82–103.

Claire Smith, Heather Burke, Cherrie de Leiuen, and Gary Jackson, "The Islamic State's Symbolic War: Da'esh's Socially Mediated Terrorism as a Threat to Cultural Heritage," *Journal of Social Archaeology* 16, no. 2 (2016): 164–88.

NOTES

The author wishes to express her gratitude to Jessica Nagamichi for her research and valuable support in working on the manuscript.

1. Kristin Hausler, "Culture under Attack: The Destruction of Cultural Heritage by Non-State Armed Groups," *Santander Art and Culture Law Review* 2, no. 1 (2015): 117–46; and Andrew Clapham, "Focusing on Armed Non-State Actors," in *The Oxford Handbook of International Law in Armed Conflict*, ed. Andrew Clapham and Paola Gaeta (Oxford: Oxford University Press, 2014), 766–810.
2. See Convention Concerning the Protection of the World Cultural and Natural Heritage, 16 November 1972, Art. 11.
3. Bruno S. Frey and Lasse Steiner, "World Heritage List: Does it Make Sense?," *International Journal of Cultural Policy* 17, no. 5 (2011): 564.
4. UN Human Rights Council, *Report of the Special Rapporteur in the Field of Cultural Rights*, UN doc. A/HRC/34/56, 16 January 2017, para. 5.
5. Irina Bokova, *UNESCO's Response to the Rise of Violent Extremism: A Decade of Building International Momentum in the Struggle to Protect Cultural Heritage*, Occasional Papers in Cultural Heritage Policy no. 5 (Los Angeles: Getty Publications, 2021), 16–20, https://www.getty .edu/publications/occasional-papers-5/.
6. See Security Council, United Nations Security Council Consolidated List, https://www.un.org/ securitycouncil/content/un-sc-consolidated-list.
7. UN General Assembly, Letter Dated 3 August 2005 from the Chairman of the Sixth Committee Addressed to the President of the General Assembly, UN doc. A/59/894, 12 August 2005, Appendix II, Arts. 1.4, 2.1.b.
8. Federico Lenzerini, "Terrorism, Conflicts and the Responsibility to Protect Cultural Heritage," *The International Spectator* 51, no. 2 (2016): 77.
9. UN Office on Drugs and Crime, *Module 1: Introduction to International Terrorism*, Education for Justice University Module Series on Counter-Terrorism, August 2018, https://www.unodc.org/ documents/e4j/18-04932_CT_Mod_01_ebook_FINALpdf.pdf. See also Sabine von Schorlemer, "Cultural Heritage Protection as a Security Issue in the 21st Century: Recent Developments," *Indonesian Journal of International Law* 16, no. 1 (2018): 30–33.
10. James Cuno and Thomas G. Weiss, "Introduction," in *Cultural Heritage under Siege: Laying the Foundation for a Legal and Political Framework to Protect Cultural Heritage at Risk in Zones of Armed Conflict*, Occasional Papers in Cultural Heritage Policy no. 4 (Los Angeles: Getty Publications, 2020), 6, https://www.getty.edu/publications/occasional-papers-4/.
11. UNESCO, "Director-General Denounces Cultural Cleansing during Visit to Iraq," 4 November 2014, https://en.unesco.org/news/director-general-denounces-cultural-cleansing-during-visit -iraq.
12. UNESCO, "Reinforcement of UNESCO's Action for the Protection of Culture and the Promotion of Cultural Pluralism in the Event of Armed Conflict," doc. no. 38/C/49, 2 November 2015, para. 6, n. 2.
13. Cuno and Weiss, "Introduction," in *Cultural Heritage under Siege*, 7.
14. UNESCO, "UNESCO Declaration Concerning the Intentional Destruction of Cultural Heritage," doc. no. 32 C/Resolution 33, 17 October 2003.

15. For details, see Andrzej Jakubowski, "Resolution 2347: Mainstreaming the Protection of Cultural Heritage at the Global Level," *Questions of International Law: Zoom-in* 48 (2018): 21–44.

16. Dieter Fleck, *The Handbook of International Humanitarian Law* (Oxford: Oxford University Press, 2021), 650–51.

17. Clapham, "Focusing on Armed Non-State Actors," 768.

18. Clapham, "Focusing on Armed Non-State Actors," 769. See also Sabine von Schorlemer, "Human Rights: Substantive and Institutional Implications of the War against Terrorism," *European Journal of International Law* 14, no. 2 (2003): 265–82.

19. Marina Lostal, Kristin Hausler, and Pascal Bongard, "Armed Non-State Actors and Cultural Heritage in Armed Conflict," *International Journal of Cultural Property* 24, no. 4 (2017): 409.

20. Commission on Global Governance, *Our Global Neighbourhood* (Oxford: Oxford University Press, 1995), 4.

21. Fleck, *The Handbook of International Humanitarian Law*, 651.

22. Lostal, Hausler, and Bongard, "Armed Non-State Actors," 418.

23. Pascal Bongard, "Engaging Armed Non-State Actors on Humanitarian Norms: Reflections on Geneva Call's Experience," *Humanitarian Exchange* 58 (July 2013): 9.

24. Bongard, "Engaging Armed Non-State Actors on Humanitarian Norms,"11.

25. Commission on Global Governance, *Our Global Neighbourhood*, 4.

26. Council of the European Union, Council Conclusions on Participatory Governance of Cultural Heritage, doc. no. 2014/C 463/01 (OJ C 463, 23.12.2014), 23 December 2014, para. 4.

27. International Law Association, "Proposal to the Executive Council of the International Law Association (ILA) for the Establishment of a Committee on 'Participation in Global Cultural Heritage Governance,'" 31 August 2017, 2, https://www.ila-hq.org/index.php/committees.

28. Jakubowski, "Resolution 2347," 43.

29. Christine M. Merkel, "Towards a Better Governance of Culture for Development: Mobilising Tacit Knowledge in and through UNESCO," in *Good Governance for Cultural Policy*, ed. Schneider and Gad, 63.

30. UNESCO, "Reinforcement of UNESCO's Action for the Protection of Culture and the Promotion of Cultural Pluralism in the Event of Armed Conflict," doc. no. 38/C/49, 2 November 2015; and revision, Annex I, Addendum Concerning Emergencies Associated with Disasters Caused by Natural and Human-Induced Hazards, doc. no. 39/C/57, 24 October 2017.

31. Bokova, *UNESCO's Response to the Rise of Violent Extremism*, 21–23.

32. For the specific quotes from the strategy, see UNESCO, "Reinforcement of UNESCO's Action," paras. 1, 10, 20, 22, 32.

33. Claire Smith et al., "The Islamic State's Symbolic War: Da'esh's Socially Mediated Terrorism as a Threat to Cultural Heritage," *Journal of Social Archaeology* 16, no. 2 (2016): 173.

34. Ömür Harmanşah, "ISIS, Heritage, and the Spectacles of Destruction in the Global Media," *Near Eastern Archaeology* 78, no. 3 (2015): 171.

35. Smith et al., "The Islamic State's Symbolic War," 172.

36. Harmanşah, "ISIS, Heritage, and the Spectacles of Destruction," 175.

37. Quoted in Smith et al., "The Islamic State's Symbolic War," 174, referring to Harlan Ullman and James Wade, *Shock and Awe: Achieving Rapid Dominance* (Washington, DC: The National Defense University, 1996).

38. Jytte Klausen, "Tweeting the Jihad: Social Media Networks of Western Foreign Fighters in Syria and Iraq," *Studies in Conflict & Terrorism* 38, no. 1 (2015): 20.

39. Cuno and Weiss, "Introduction," in *Cultural Heritage under Siege*, 7.

40. G20 Germany 2017, "The Hamburg G20 Leaders' Statement on Countering Terrorism," July 2017, para. 17, http://www.bundesregierung.de/breg-de/impressum/the-hamburg-g20-leaders -statement-on-countering-terrorism-750874.

41. UNESCO, "UNESCO's Role in Promoting Education as a Tool to Prevent Violent Extremism," doc. no. 197 EX/46, 7 October 2015, para. 2.

42. UN General Assembly, The United Nations Global Counter-Terrorism Strategy, UN doc. A/RES/60/288, 8 September 2006, Annex: Plan of Action, para. I.3.

43. Hartwig Fischer, "Next Steps and Concluding Remarks," in *Cultural Heritage under Siege*, ed. Cuno and Weiss, 74.

44. UNESCO, "Right to Education," https://en.unesco.org/themes/right-to-education.

45. Convention on the Rights of the Child, 20 November 1989, Art. 29.

46. UNESCO, "UNESCO's Role in Promoting Education as a Tool to Prevent Violent Extremism," para. 17.f.

47. UNESCO, "UNESCO's Role in Promoting Education as a Tool to Prevent Violent Extremism," para. 17.g.

48. UNESCO, *A Teacher's Guide on the Prevention of Violent Extremism* (Paris: UNESCO, 2016), https://unesdoc.unesco.org/ark:/48223/pf0000244676.

49. UNESCO, *Preventing Violent Extremism through Education: A Guide for Policy-makers* (Paris: UNESCO, 2017), https://en.unesco.org/sites/default/files/policymakr.pdf.

50. UNESCO, *Preventing Violent Extremism through Education*, 12.

51. UNESCO, "#Unite4Heritage," https://www.unite4heritage.org.

52. UNESCO, "#Unite4Heritage Campaign Launched by UNESCO Director-General in Baghdad," 28 March 2015, https://whc.unesco.org/en/news/1254; and Bokova, *UNESCO's Response to the Rise of Violent Extremism*, 21.

53. Benjamin Isakhan, "Social and Cultural Costs," in *Cultural Heritage under Siege*, ed. Cuno and Weiss, 66.

54. ICISS, *The Responsibility to Protect* (Ottawa: International Development Research Centre, 2001), 19.

55. UNESCO, "Commitment to the Reconstruction of Mosul Reaffirmed," 11 September 2019, https://en.unesco.org/news/commitment-reconstruction-mosul-reaffirmed; and Hadani Ditmars, "UNESCO's Plan to 'Revive Spirit' of Devastated Mosul Gets under Way," *Art Newspaper*, 15 June 2020, https://www.theartnewspaper.com/news/unesco-plan-to-revive-spirit-of-devastated-mosul-gets-under-way.

56. UNESCO, "Initial Framework for Reconstruction of Mosul," 2018, https://en.unesco.org/fieldoffice/baghdad/initialframeworkmosul.

57. See Deutsches Archäologisches Institut, "Resilienz: Vom Umgang mit Krisen," *Archäologie Weltweit* 1 (August 2020).

58. ICOMOS, International Charter for the Conservation and Restoration of Monuments and Sites (The Venice Charter 1964), adopted 1965, https://www.icomos.org/charters/venice_e.pdf.

59. UNESCO (Intergovernmental Committee for the Protection of the World Cultural and Natural Heritage), "Operational Guidelines for the Implementation of the World Heritage Convention," doc. no. WHC.21/01, 31 July 2021, para. 86. See also the so-called Nara Document on Authenticity of 1994, which is annexed to the operational guidelines.

60. Birgitta Ringbeck, *Management Plans for World Heritage Sites: A Practical Guide* (Bonn: German Commission for UNESCO, 2008), 17–18.

61. Christina Cameron, "Reconstruction: Changing Attitudes," *The UNESCO Courier* 2 (July–September 2017): 56.

62. Mechtild Rössler, "Editorial," *World Heritage* 86 (January 2018): 5.

63. Luis Monreal, "Cultural Heritage at Risk," in *Cultural Heritage under Siege*, ed. Cuno and Weiss, 26.

64. UNDP, Governance for Peace: Strengthening Inclusive, Just and Peaceful Societies Resilient to Future Crises, Thematic Paper for the UN Secretary General's 2020 Report on Sustaining Peace

and Peacebuilding, undated, para. 1, https://un.org/peacebuilding/sites/www.un.org
.peacebuilding/files/undp.pdf.

65. Cameron, "Reconstruction: Changing Attitudes," 58. See also Sabine von Schorlemer, "Military
Intervention, the UN Security Council, and the Role of UNESCO: The Case of Mali," in
Intersections in International Cultural Heritage Law, ed. Anne-Marie Carstens and Elizabeth
Varner (Oxford: Oxford University Press, 2020), 98–101.

66. Cameron, "Reconstruction: Changing Attitudes," 58.

67. Cameron, "Reconstruction: Changing Attitudes," 58.

68. UNESCO, "Director-General Praises the People of Timbuktu for the Reconstruction of the City's
Mausoleums," 19 July 2015, https://whc.unesco.org/en/news/1324.

69. Cameron, "Reconstruction: Changing Attitudes," 59.

70. Kavita Singh, "Social and Cultural Costs," in *Cultural Heritage under Siege*, ed. Cuno and Weiss,
52.

71. Thomas G. Weiss, "Military Perspectives and Costs: War, Occupation, and Intervention," in
Cultural Heritage under Siege, ed. Cuno and Weiss, 33.

72. European External Action Service (EEAS), "Concept on Cultural Heritage in Conflict and Crises. A
Component for Peace and Security in European Union's External Action," doc. no. 9962/21, 18
June 2021.

73. Irina Bokova, Global Governance for the 21st Century: The UNESCO Angle, doc. no. ERI.2011/WS/
4, 11 April 2011, 13.

74. UNDP, Governance for Peace, paras. 14, 34.

PART 5

Cultural Heritage and Military Perspectives

Introduction: Part 5

James Cuno

Thomas G. Weiss

Part 5 comprises six chapters with differing interpretations of the pertinence and applicability of military perspectives to the topic of cultural heritage protection. In many ways, regular and irregular armed forces alike have been the perpetrators of destruction of cultural heritage through direct targeting and collateral damage during warfare. But the most responsible militaries have also been advocates for better rules to govern the protection of cultural heritage—just as they were among the most enthusiastic supporters of and catalysts for other provisions of the laws of war, or international humanitarian law. In addition, the uses and regulation of military force for human protection purposes have provided the basis for a dominant, albeit contested, theme in contemporary debates, the responsibility to protect (R2P).

The first three chapters are in-depth explorations of cultural heritage from the vantage point of the US military at key historical junctures. Chapter 27, "Protecting Cultural Heritage on the Battlefield: The Hard Case of Religion," analyzes decisions about European religious sites during World War II. The author is Ron E. Hassner, professor of political science at the University of California, Berkeley. He begins with General (later President) Dwight D. Eisenhower's comment that "nothing can stand against the argument of military necessity," but that too often indifference to cultural heritage or laziness has led to rationalizations "of military convenience or even personal convenience." Hassner explores the hard case of religion in relation to the destruction and protection of cultural heritage in the European theater during the war—"hard," in his view, because the stakes were so high and no one could readily afford to demonstrate restraint in the midst of all-out war. The meaning for local populations of such damage is straightforward: they see a lack of respect and desecration of culture-defining entities and practices. Moreover, the difficulties of avoiding destruction from the perspective of military planners are acute because so many of the most important sacred shrines are in strategic urban areas, or are surrounded by civilians who are protected by the laws of war. Stressing the significance of both World War II's Roberts Commission and the "Monuments Men," Hassner points to the short-term, utilitarian logic of protection and the longer-term concern regarding the Allied legacy for post-conflict reconstruction in Europe. He concludes by pointing to

the conditions under which the protection of immovable cultural heritage is likely to produce military restraint—especially the favorable views by opposing military forces and by civilians living near immovable sites. An additional factor in explaining restraint is the extent to which particular sites of religious heritage appeal to a large international audience concerned about the civilians near them. This concern is especially significant when public support for armed conflicts reflects a component of winning "hearts and minds."

Chapter 28, "From Kyoto to Baghdad to Tehran: Leadership, Law, and the Protection of Cultural Heritage," is by the distinguished professor and analyst of military affairs and political science Scott D. Sagan of Stanford University. The intersection between the logics of morality and strategy is his point of departure for exploring why the laws of war, also called "international humanitarian law," are not merely pieces of paper when interpreted properly by the right leadership. Sagan begins his account with US president Harry Truman's 1945 decision to replace Kyoto, the ancient Japanese capital, with Nagasaki as the favored target for the second nuclear bomb. He fast-forwards to the more recent cases of the 1991 Gulf War, the 2003 looting of the Iraq Museum in Baghdad, and the 2020 threat by then US president Donald Trump against Iranian cultural heritage sites. While appreciating the "complex balancing act" between the principles of proportionality and precaution, Sagan's key lesson from these cases is that protecting cultural heritage matters not only when it helps win battles and wars (as a "force multiplier") but even when it does not. He applies this generalization to all countries and not merely the United States. It also means that the ratification of existing international law is essential even if, or perhaps because, treaties provide standards and guidelines; they do not constitute strict, rigid rules. As a result, his powerful concluding plea resonates loudly: "We should follow the law because it reflects who we are, or at least who we aspire to be." At the same time, like other scholars and researchers, he recommends gathering more and better data because we "would benefit from more empirical research on the conditions under which protecting cultural heritage helps win conflicts and promotes peace afterward, and under which this strategic logic is compelling." In short, in the complex process of applying not only legal and ethical but also military reasoning, Sagan believes that people matter, that international humanitarian law matters, and that cultural heritage matters.

The third presentation of military perspectives emanates from two faculty members at the US Military Academy, West Point: Ruth Margolies Beitler, professor of comparative politics, and Dexter W. Dugan, a major and assistant professor of international affairs. Chapter 29, "Practicing the Art of War While Protecting Cultural Heritage," brings to bear recent US military practice as well as institutional deliberations, particularly regarding the lengthy and controversial invasions and occupations of Afghanistan and Iraq. These contemporary cases complement the older historical examples in the preceding two chapters. Both Afghanistan and Iraq illustrate well how "significant twenty-first century challenges have complicated cultural heritage

protection during military operations." Of note are two complications that circumscribe the protection of cultural heritage during military operations; both reflect technological developments and often lead to "increased resentment and frustration when sites are not protected or become . . . 'collateral damage.'" First, social media provide not only real-time viewing but also increase the propaganda impact of any destruction of cultural heritage—especially by non-Muslim (that is, US military) forces in the two cases under discussion. Second, precision munitions reduce the tolerance for collateral damage of any magnitude whether military necessity requires it or not. The US Army's evolving practices are reflected in formal rules and doctrine that aim to protect, or at least not unduly harm, cultural heritage—a tactic that has an intrinsic as well as consequentialist value in improving relations with civilian populations. Beitler and Dugan conclude with recommendations—training, education, partnerships with experts, and better intelligence gathering and information—to ensure that military forces are viewed by local populations as protecting and respecting, or at least not harming, their cultural heritage. They argue that there has been little to no systematic study of the impact of occupations on the preservation of cultural heritage. They conclude that "future research on the ramifications of long-term occupations on cultural heritage protection will benefit the field."

Part 5 continues with chapter 30, "Peace Operations and the Protection of Cultural Heritage." Richard Gowan, the UN director of the International Crisis Group in New York, is a recognized authority on the United Nations and especially its practices of traditional peacekeeping as well as more robust peace operations. While peacekeeping was not in the UN Charter, it is generally viewed as a legitimate invention of the world organization, deploying outside military forces under UN command and control with authorization from the UN Security Council. Continual adaptation has characterized the evolution of peace operations since the 1950s, which includes the emphasis in Gowan's essay on the inclusion of the protection of Mali's cultural heritage as part of the "people-centered approach" in the mandate of the United Nations Multidimensional Integrated Stabilization Mission in Mali (MINUSMA).

In addition, he examines the impact of NATO's Kosovo Force, which had, and continues to have, heritage-protection activities. While outside forces can view these actions as distractions, especially with resources so limited and demands so overwhelming, Gowan argues that they should be reframed as integral to protecting people, fostering political settlements, and reknitting the fabric of societies. The protection of cultural heritage as a more routine part of mandates for international peace forces would include removing hazards, suppressing looting, and deterring politically motivated attacks. If such actions improve relations with the local community, how could such protection be considered a distraction for peacekeepers? Yet as Gowan points out, the first-time experiment in a UN peace operation in Mali has been on "an unfortunate hiatus since 2017." The following year the UN secretary-general criticized the proliferation of mandates with many additional tasks, viewing the

latter as distractions or "baubles weighing down a Christmas tree." A better question is, Could heritage protection produce a virtuous circle, a different kind of "force multiplier"? The key to protecting cultural heritage during and after armed conflicts is political—indeed, it is impossible to disentangle heritage protection from the broader reasons that justify the deployment of peacekeepers. Thus, negotiators should find incentives and prioritize persuading local and national leaders of the essential need for protection because the most decisive factor in success is local buy-in. Gowan concludes with the appeal of cultural heritage protection: "A UN official with absolutely no cultural sensitivities should be able to see that heritage sites are significant factors in her or his political and security work. An architectural historian or archaeologist with no interest in mediation or military patrols should, conversely, see the potential utility of working with the UN or NATO."

Chapter 31 also moves beyond mere military forces to examine "the necessity for dialogue and action integrating the heritage, military, and humanitarian sectors," which is the subtitle for "Protecting Cultural Property in Armed Conflict." As human beings are the focus for all normative, legal, and military interpretations of events, a distinctive additional civilian perspective is that of "humanitarians." The author, Peter G. Stone, is the UN Educational, Scientific and Cultural Organization (UNESCO) Chair in Cultural Property Protection and Peace at Newcastle University's School of Arts and Cultures. His perspective reflects the training courses he has organized in Europe and his practical applied policy experience as the former vice president and current president of the Blue Shield, a nongovernmental organization that fosters awareness of and respect for cultural property protection. The history of efforts to safeguard heritage is, perhaps unexpectedly for newcomers to the field, a lengthy one. They include those by the founding fathers of international law (Hugo Grotius) and of military strategy (Carl von Clausewitz), but the post–Cold War era has witnessed a growing visibility of the issue and efforts to formulate more specific policies and undertake more concrete protective actions. Stone's point of departure is "the indivisible link between the protection of people and their cultural property." He analyzes numerous threats—lack of planning and awareness, collateral damage, direct targeting, looting, reuse of sites, neglect, and development—during times of war and peace. He argues that successful protection must move beyond the confines of the heritage community and become integral to political, humanitarian, and military thinking. Stone recognizes the long-run horizon for his work, "an extremely ambitious project that will not be delivered in my lifetime." He also acknowledges that effective "cultural property protection in armed conflict will never be achieved by the heritage sector's simply shouting that it must be taken seriously," but rather when all relevant parties recognize the pertinence and traction of cultural heritage protection for the realization of their values and objectives.

Part 5 concludes with chapter 32 by independent journalist and author Hugh Eakin, who explores a stage in conflict management and resolution that most mediators and activists pursue indefatigably—namely, "When Peace Breaks Out." Even if safeguarding

cultural heritage is successful in the midst of our focus on wars and terrorism, it will be of little value without appropriate strategies once armed combat or violence eases. Eakin argues that this subsequent period has attracted far too little analytical or policy attention. As such, it not only presents an opportunity but also exposes new threats, which are captured in his subtitle "The Peril and Promise of 'Afterwar.'" If a central objective is successful heritage preservation, care must be taken because international and civil wars can be followed by a brutal and destructive peace. While the impulse to destroy the cultural heritage of an enemy is seemingly a universal and ancient tactic, "equally old may be the impulse to preserve, an impulse that has often transcended confessional and ethnic boundaries." The challenge is to ensure that peace accords foster the latter impulse. Eakin points to numerous contemporary cases that have resulted in global outrage against the wanton destruction of cultural heritage. That, in turn, has led to a growing awareness of this challenge along with the exploration of measures to protect cultural heritage from combatants and interveners alike. The steepest challenge, according to Eakin, is to convert the opportunities for short-term protection into longer-term preservation. His fieldwork across numerous crises leads to some optimism: "Such destructive acts might be prevented with the right kind of international pressure." Yet over the longer term, heritage survival (either protection or reconstruction) depends on local governments and local populations—especially for sites that do not reflect their own ethnic or religious identities. In cases ranging from Cyprus and Syria to Kosovo, Mali, and Azerbaijan, Eakin concludes that monuments were spared "because they speak to the people that live around them."

27

Protecting Cultural Heritage on the Battlefield: The Hard Case of Religion

Ron E. Hassner

Arguments about the protection of cultural assets in wartime are often made in the abstract, drawing on theoretical insights from ethics, international law, and just war theory. How do these principles fare when tested on the battlefield?

General Dwight D. Eisenhower stated the case bluntly in the winter of 1943–44. US forces, fighting their way north along the Italian peninsula, had become bogged down at the foot of the abbey of Monte Cassino, the oldest monastery in the Western world. The abbey was, in the words of General Harold Alexander, situated on "one of the strongest natural defensive positions in the whole of Europe."[1] It held a central position in the Gustav Line, the German system of high-ground defensive positions that stretched across Italy and controlled the main route from Naples to Rome. Artillery was raining down on Allied troops from the vicinity of the abbey, leading commanders to suspect that the Germans were using the ancient shrine as an observation post, perhaps even as a base of operations. For example, an intelligence report of the 34th Infantry Division of the US Army stated that "enemy artillery was provided with exceptional observation on the high ground all along the line, and particularly by the use as an observation post of the Abbey de Monte Cassino, from which the entire valley to the east is clearly visible. Orders preventing our firing on this historical monument increased enormously the value of this point to the enemy."[2] In actuality, German observers were not using the abbey to direct artillery, but US forces could not know, and could perhaps not even conceive of, that restraint.

Responding to desperate requests from commanders in the field that the abbey be bombed, Eisenhower responded: "If we have to choose between destroying a famous building and sacrificing our own men, then our men's lives count infinitely more and the buildings must go." But he continued: "The choice is not always so clear-cut as that.

In many cases the monuments can be spared without any detriment to operational needs. Nothing can stand against the argument of military necessity. That is an accepted principle. But the phrase 'military necessity' is sometimes used where it would be more truthful to speak of military convenience or even personal convenience. I do not want it to cloak slackness or indifference."[3]

As shown below, these deliberations led Allied forces to hesitate for three months before finally deciding to bomb Monte Cassino. That delay came at a great human cost. Meanwhile, the Germans, equally concerned with the status of this holy site, refrained from accessing the abbey or its grounds, contrary to the Allies' suspicions. When Allied command determined that the abbey was to be bombed, the Germans exploited images of the destroyed shrine, and the testimony of the monks who fled the destruction, for propaganda purposes.

The challenge of protecting religious sites at times of war provides a unique opportunity for exploring the broader question of protecting cultural artifacts. I propose that sacred sites are a hard case, especially in the context of a conflict such as World War II, for multiple reasons. For one, they are particularly valuable, and not just in the eyes of local constituencies. Significant religious sites are revered by regional or even global audiences. Yet they also pose unique challenges to military decisionmakers. Some are located in city centers, encumbering urban warfare or bombing campaigns. Others are formidable structures that can be exploited by opposing military forces or by insurgents. As the Monte Cassino case shows, the historical record regarding the protection of these sites is decidedly mixed. Their religious status provokes deliberation and hesitation, though not always restraint. Their destruction has significant implications for the conduct of counterinsurgencies and military occupations, especially when occupying forces seek the goodwill and cooperation of local populations.

The Nature of Sacred Places

For religious practitioners, geography is not uniform. Salvation can more easily be obtained at locations where the sacred breaks through into the human realm and becomes accessible. Sacred shrines perform this function and, as a result, become religious centers. They are places with a divine presence at which worshippers can expect blessings, healing, forgiveness, and spiritual merit. At the same time, religious practitioners seek to protect that sacred presence by circumscribing access to holy places and behavior within them. A transgression of these rules, or any damage to the structure itself, is tantamount to desecration.

The most important sacred shrines are often large, ornate, and architecturally vulnerable monuments, located in city centers, that teem with worshippers. Because they have physical properties, they are susceptible to harm.[4] In twentieth-century wars, soldiers tried to minimize damage to sacred sites and to the worshippers in their vicinity. This respect for religious sites is reflected in, and bolstered by, Article 27 of the 1907 Hague Convention, which required armies "to spare, as far as possible, buildings

dedicated to religion, art, science, or charitable purposes, historic monuments, hospitals, and places where the sick and wounded are collected, provided they are not being used at the time for military purposes."[5]

But this convention treats religious heritage sites as one category of structures among many that deserve protection. Why should we expect combatants to afford them unique treatment? In other words, what is religious about protecting sacred space? The answer is twofold. First, damage to sacred sites often provokes a broader audience, and it may do so to a greater extent than damage to other types of monuments and public buildings. With the exception of particularly ancient or artistically valuable structures, most public buildings and monuments are valued by local communities only. Religious sites tend to broaden and deepen that audience. Not only are they revered by global communities of faith, but the rules governing their desecration are crisp and unambiguous.

Second, their vulnerability compounds many of the specific reasons that make "secular" structures susceptible to risk: public structures, like hospitals and schools, are sensitive because civilians tend to congregate in them. Cultural assets are sensitive due to their artistic and historical value. Government buildings and historical monuments have nationalist appeal. Religious centers exhibit all these characteristics together: they have historical, artistic, and nationalist appeal, and they also attract noncombatants in large numbers. Indeed, sacred sites in many religious traditions have the official status of "sanctuaries," places protected from even the most legitimate sources of violence. If museums, universities, and theaters are deserving of discrimination at times of war, churches are deserving a fortiori. As I show below, one of the implications of this logic during World War II was that the Allied committees that sought to protect "cultural treasures" focused the lion's share of their attention on churches.

Monte Cassino

Allied commanders, hampered by orders to avoid targeting German facilities near Monte Cassino in a manner that might accidentally harm the abbey, came to see the structure as the primary obstacle to their advance on Rome.[6] Major General Howard Kippenberger, the leader of the New Zealand forces, stated that "it was impossible to ask troops to storm a hill surmounted by an intact building such as this."[7] Lieutenant General Bernard Freyberg relayed to Lieutenant General Mark Clark that "it was unfair to assign to any military commander the mission of taking the hill and at the same time not grant permission to bomb the monastery." He told the American chief of staff, General Alfred Gruenther, "I want it bombed. . . . The other targets are unimportant, but this one is vital."[8]

Despite these pleas, Allied command refused to issue the order to bomb the abbey due in large part to pressure from the Vatican. Alexander informed Clark in early November 1943 of the "urgent importance of preservation from bombing" of the abbey. Clark responded with a promise: "Every effort will continue to be made to avoid

damaging the Abbey in spite of the fact that it occupies commanding terrain which might well serve as an excellent observation post for the enemy."[9]

By February 1944, however, the Allied situation had turned desperate. A breakthrough at Cassino could have provided the desperately needed relief for the stalled Allied beachhead at Anzio in late January. Casualties from fighting at the base of the unharmed abbey already exceeded ten thousand troops.[10] Even Eisenhower was now convinced that the Germans were exploiting the Allied reluctance to take action against the abbey. In a subsequent statement about the protection of Europe's cultural heritage, Eisenhower recalled how at Cassino "the enemy relied on our emotional attachments to shield his defense."[11]

Amazingly, the Germans had done no such thing. The German commander in chief in Italy, Field Marshall Albert Kesselring, had given his personal assurance to the abbot of Monte Cassino that the structure would not be used for military purposes and ordered German troops to stay away from the abbey.[12] German soldiers, aided by monks, drew a circle of three hundred meters from the walls of the monastery, establishing an exclusion zone that soldiers were forbidden to enter. Several military policemen were stationed at the abbey entrance to enforce the order. The monks monitored the exclusion zone and reported violations to the Vatican, which issued formal complaints to the German embassy. German troops also assisted in evacuating to safety nearly eighty monks, as well as many of the abbey's treasures and relics, prior to the start of the US offensive.[13]

On 15 February, after three months of deliberations, Alexander finally issued the order to bomb the abbey. Leaflets in Italian and English were dropped over the monastery, offering a warning and justification for the assault: "Italian friends, BEWARE! We have until now been especially careful to avoid shelling the Monte Cassino Monastery. The Germans have known how to benefit from this. But now the fighting has swept closer and closer to its sacred precincts. The time has come when we must train our guns on the monastery itself."[14] Allied pilots with religious scruples were invited to recuse themselves from participating in the operation but none accepted the invitation.[15] Amid the cheers of Allied soldiers, 250 bombers dropped six hundred tons of high explosive on the abbey, followed by shelling from howitzers. The assault continued for three days. The *New York Times* called it the "worst aerial and artillery assault ever directed against a single building."[16] It reduced the beautiful thousand-year-old abbey to rubble.[17] General Harold Alexander encapsulated the Allied dilemma in his recollections after the war, as indicated by the Right Reverend Dom Rudesind Brookes: "Giving the order to bomb the abbey had been the most difficult decision he had ever had to make but [he] had finally decided that men's lives must come before stones however holy" (fig. 27.1).[18]

The bombing shocked observers throughout Europe. Vatican secretary of state Luigi Maglione told the American envoy to the Vatican that the bombing was "a colossal blunder . . . a piece of a gross stupidity." British and American public opinion now

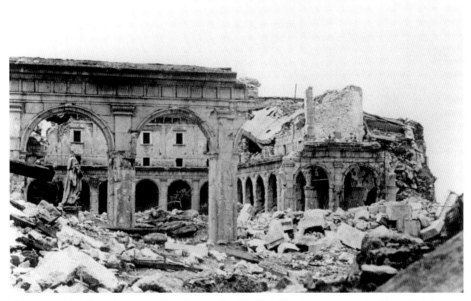

Figure 27.1 The Abbey of Monte Cassino, destroyed by Allied bombing in 1944. Image: Sueddeutsche Zeitung Photo / Alamy Stock Photo

rallied against a possible bombing of Rome. The German Propaganda Office in Rome had taken photographs of the abbey prior to the attack so that, "in case it was destroyed, they could use the pictures to show the barbarity of the Anglo-Americans."[19] At the insistence of German propaganda minister Joseph Goebbels, the abbot was brought to a transmitting station to broadcast his condemnation of Allied behavior, and at the request of German foreign minister Joachim von Ribbentrop, he was pressured into signing a written statement testifying to German respect for the monastery and its inhabitants. These statements were reproduced and plastered around Rome, and German diplomats abroad were instructed to exploit them to the best of their abilities.[20] German radio followed up with propaganda that accused the Allies of targeting Italy's patrimony: "The U.S. and Britain no longer even try to hide their anticultural intentions, but quite openly propagate in their newspapers the destruction of all cultural monuments."[21] A diarist recorded: "All Rome is thickly placarded today with posters showing photographs of the ruins of Monte Cassino with monks and refugee civilians, and reproductions of handwritten signed statements by the Abbot and his administrator. This is certainly a trump card in the German propaganda game."[22] The outcry was so great it led some in the diplomatic corps to speculate that the German army had somehow tricked the Allies into bombing the abbey in order to reap the propaganda rewards.[23]

In summary, the sacred status of Monte Cassino did not influence the "bottom line"— the abbey was bombed. But it shaped the timing of the attack and the content of the deliberations that preceded it, with tangible effects on the Allied ability to forge their way to Rome. Allied officers and soldiers, Catholic and non-Catholic alike, supported the

bombing with enthusiasm. It was senior Allied decisionmakers who hesitated to destroy the abbey, realizing the harm that such an act would cause to relations with the Vatican, European perceptions of Allied intentions, and support for the war on the home front. The outrage provoked by the bombing, in turn, undermined efforts to persuade Italians to cease fighting and to greet the Allies as welcome liberators. Efforts to undo the reputational damage from Cassino by safeguarding religious and cultural sites would have an enduring effect on Allied targeting policy throughout the liberation of Europe.

The Roberts Commission

Several months prior to the bombing of Monte Cassino, in response to extensive cultural damage caused by military operations in North Africa and in preparation for the invasion of Italy, the American government had started forming an official committee to safeguard these treasures: the American Commission for the Protection and Salvage of Artistic and Historic Monuments in War Areas. It was known as the "Roberts Commission" after its chair, Associate Supreme Court Justice Owen J. Roberts.[24] Its operatives on the ground in European war zones, the Monuments, Fine Arts, and Archives (MFAA) Section of the Civil Affairs and Military Government Sections of the Allied Armies, were colloquially known as "the Monuments Men." The Roberts Commission and its Monuments Men faced three difficult tasks: to identify cultural treasures and monuments so that these could be kept out of harm's way during Allied operations, to document any damage that did occur, and to unearth and repatriate looted treasures after the war. The items to be protected ranged from museums and palaces to paintings, statues, and archives. But the single largest category of protected treasures was religious: cathedrals, churches, and sacred objects. The committee was formed too late to impact decisions at Monte Cassino but, in subsequent months, its work would have a significant effect on the protection of Europe's religious heritage.

To do so, the Roberts Commission, based in Washington, DC, had to first identify and locate the monuments, structures, and treasures that needed salvaging. Commission members established a master index of monuments by sending thousands of questionnaires to art scholars and educational institutions and by scouring popular guidebooks and libraries. Experts compiled this information into authoritative lists and ranked monuments by priority by conferring one, two, or three stars to the most significant structures. Lists for the eight most important countries were accompanied by handbooks that provided commanders and soldiers with historical background and instructions on respecting and preserving monuments.[25] These lists and handbooks were then forwarded to a second working group, tasked with locating the monuments on 786 maps, supplied by the Army Map Service. Since the greatest danger to monuments was from the air, the commission also asked the US Air Force (then called the US Army Air Forces) to fly special reconnaissance missions over major Italian and French cities so that it could identify and outline key monuments on reconnaissance photographs. These photo-maps were used in planning strategic bombing campaigns.[26]

A survey of the monuments listed in these handbooks and atlases sheds light on the significance of churches among the commission's priorities. Churches appeared as the first category in the commission's definition of cultural treasures (followed by palaces, monuments, and cultural institutions) and as the first category listed in each handbook and atlas.[27] Of the 5,466 sites that the commission identified as particularly valuable, more than 40 percent (2,269 in all) were churches, monasteries, or other religious shrines, the single largest category by far. By comparison, the handbooks listed only 583 museums worthy of protection, amounting to only 10 percent of all sites.

To persuade military decisionmakers to act on these motivations, the commission offered a short-term utilitarian logic and a long-term concern with the Allied legacy after the end of the war. Both views were first expressed in one of the founding documents of the commission, a pamphlet written in the summer of 1942 by art conservation specialist George Stout entitled *Protection of Monuments: A Proposal for Consideration*. Stout used surprisingly religious language in his vision of the committee and its purpose: "To safeguard these things will show respect for the beliefs and customs of all men and will bear witness that these things belong not only to a particular people but also to the heritage of mankind. To safeguard these things is part of the responsibility that lies on the governments of the United Nations. These monuments are not merely pretty things, not merely signs of man's creative power. They are expressions of faith, and they stand for man's struggle to relate himself to his past and to his God."[28]

Robert E. Sherwood, the director of overseas operations in the US government's Office of War Information, urged that the commission's efforts be made public in order to counter Axis propaganda and to "reassure the world" that Americans were not "vandals and ignorant of European culture."[29] Commission members emphasized their role in protecting the US Army from the blame for careless destruction.[30] But they also stressed the long-term contribution of their efforts to America's legacy: "It is a record of which we shall all be proud as Americans and that record should be available for future historians."[31]

In its handbooks, the commission highlighted the positive influence that respect for monuments would have on the US Army's ability to effectively control occupied territories. Several handbooks make an explicit connection between preservation efforts, their positive effects on "the morale of the population," and the army's efforts in "enlisting their cooperation."[32] The commissioners thus conceived of their task as part and parcel of what we would today call a "hearts and minds" campaign. After the war, the commission's final report cited its activities in France as an example: "The most important general aspect of MFA&A [MFAA] work in France is the most intangible, the exhibition of good will on the part of the military authority towards an aspect of French national life and sentiment of which the French themselves are especially conscious. The French have been given a feeling that their national possessions and sentiments are not a matter of indifference to us."[33]

The Roberts Commission's spectacular success in tracking and recovering looted art in the final years of World War II is the stuff of legends. But was the commission able to influence the conduct of the war itself? At the most fundamental level, the lists and maps it drafted provided pilots with the information necessary for avoiding historical, cultural, and religious structures. Allied pilots were not always interested in or capable of taking advantage of that information but, in the absence of the commission, they would have caused extensive damage even in those cases in which they wished to preserve monuments from destruction (fig. 27.2).

The Allied bombing of Rome is instructive in this regard: much as pilots took tremendous care to avoid bombing the four major basilicas in the city, following a promise from US president Franklin Roosevelt to the pope, they were unaware of the presence of other Vatican properties in their flight paths.[34] The unintentional damage caused to the Basilica of San Lorenzo, a "minor basilica" but nonetheless a treasured Vatican property, caused significant outrage among Catholics worldwide. Unlike the sparsely indexed maps that these pilots had used, the list of monuments drafted by the Roberts Commission would ultimately identify 210 sites of significance in Rome, of which 23 were categorized as "highly significant." Most of these were churches, and they included the Basilica of San Lorenzo, but the commission's list arrived too late: it was completed on 29 July, ten days after the city had been bombed.[35]

The bombing of Florence in March 1944 offers a clear contrast to the Rome debacle. Prior to the attack, members of the commission pinpointed fifty-eight of Florence's most important monuments, half of which were churches, on an aerial reconnaissance photograph.[36] To convince Prime Minister Winston Churchill to authorize the attack, British air marshal John Slessor reassured the Air Ministry that only the most experienced American air crews would be used and that Florence's famous cathedral, the Duomo, would not be hit.[37] The detailed briefing of the air crews was documented by a film crew from the US Army Signal Corps in order to show that all necessary precautions had been taken. Bomb runs skirted the Duomo altogether.

The Roberts Commission could not prevent the destruction of Pisa, caused in large part by retreating German artillery. Lieutenant General Clark, deeply concerned over the adverse publicity caused by the destruction, responded quickly to requests from local Monuments Men and rushed engineers, military personnel, and fresco specialists from Florence and Rome to salvage what they could in Pisa. This was the most significant contribution of the Monuments Men to salvaging Europe's cultural heritage: documenting damage, preventing further deterioration (by preventing soldiers from billeting in protected structures, for example), and initiating emergency repairs where needed. The US Army did its part by providing the Roberts Commission with reconnaissance photographs, taken after bombings, so that its experts could assess the scope of destruction in preparation for the arrival of the Monuments Men.[38]

Throughout the war the commission also played an important advocacy role, striving to counter arguments about military necessity with claims about the pragmatic value of

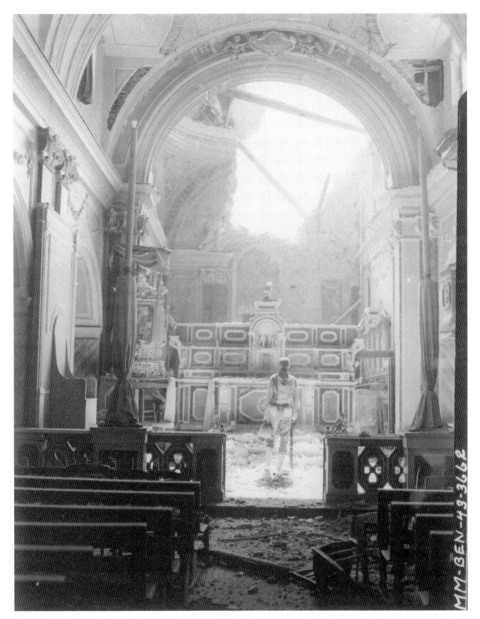

Figure 27.2 Private Paul Oglesby of the US 30th Infantry Regiment stands amid the bomb-blasted remains of the roof of Santa Maria degli Angeli in the southern Apennine town of Acerno, Italy, September 1943. Image: Courtesy National Archives, photo no. 531181 (NWDNS-111-SC-188691)

protecting monuments. One such exchange has been captured in the minutes of a meeting between representatives of the US Department of War and members of the commission, chaired by Justice Roberts himself, on 8 October 1943. Major General John H. Hilldring, chief of the Civil Affairs Division, struck the main theme of the meeting, the moral hazard of declaring certain sites off-limits due to their cultural value: "We have a most important project and that is to beat the German Army. . . . If we said we wouldn't bomb art objects, we would be giving the enemy an advantage. . . . Every time you tell a

fellow you aren't going to bomb something, they are apt to put an ammunition dump there." Roberts Commission member Archibald MacLeish presented the counterargument: "To win this war under terms and conditions which make our victory harmful to ourselves would hardly be to win it . . . I don't think that it is starry eyed but realistic and of military importance."[39]

It is hard to tell just how much of the preservation of Europe's churches can be attributed to the efforts of the Roberts Commission and the Monuments Men as opposed to military considerations and the vagaries of war. The final report of the commission, composed after the war, conceded this point: "It is difficult to estimate how far the comparative immunity of the greater cathedrals of France from damage was due to the efforts of the Allied Air Forces based on information supplied by SHAEF [Supreme Headquarters Allied Expeditionary Force] but certainly such information was sought by the air staff and supplied."[40] Where the fighting was fiercest, as in Normandy, the US Army was able to make few concessions to sacred sites. The damage to sacred places was heaviest in Britain and Germany, where most of the destruction was the result of massive night bombing from high altitude by the Luftwaffe and the Royal Air Force.

Given the scale of destruction across Europe, more churches survived World War II than might have been expected. Where bomber doctrine permitted accurate targeting, as in US daylight campaigns over Italy and France, and where troops advanced more rapidly, the desire to protect churches influenced the use of force. In many cases, the decision to spare holy sites came at some military cost. Nowhere did the Allies target churches intentionally, despite the advantages that such attacks might have provided. The scale of the damage depended primarily on the speed of the Allied advance and the amount of resistance put up by the Axis, which in turn depended on the terrain and on the proximity of cities to axis of attack.[41]

Where units were able to exercise some caution, the care with which they treated sacred sites depended on the religious, cultural, and political significance of those sites. The more important the church, the more likely decisionmakers were to tolerate risks to spare the structure and the more likely it was that experts would be able to guide combatants on how to protect the site. Even where the ultimate decision was to destroy a shrine, as at Cassino, the sacred character of the target affected deliberations and the manner and timing of the attack.

Conclusion

The protection and preservation of sacred places during World War II offers an interesting test for the ability of armed forces to exercise restraint under extreme conditions. On the one hand, this is an easy case: religious sites are among the most culturally sensitive civilian assets and both parties to this conflict to some extent shared a respect for Christian holy places. On the other hand, this was a conflict of extreme significance and high-intensity violence in which neither side could afford to show much restraint. What broader lessons might this case study entail?

The first lesson is that, even under the most extreme of circumstances, decisionmakers have tried to protect sacred sites. There are pragmatic reasons to do so, and these arguments are often incorporated into deliberations about the use of force. The conclusion from those deliberations is not always restraint. But only rarely is it reckless destruction. The historical, social, national, and emotional appeal of religious structures plays into the calculations of military decisionmakers and leads to delayed action, possibly a willingness to adopt risky tactics, perhaps even an increased acceptance of higher casualties, and a desire to mitigate or repair the damage caused to these assets. How great a restraint or risk decisionmakers are willing to accept depends on a long list of factors, including the technology employed in the fighting (for example, the accuracy of weapons), the speed and intensity of military campaigns, the value of the location occupied by a shrine, and the accuracy of the information about sacred sites available to decisionmakers.

The second lesson is that, among these factors, one of the most crucial is the nature of the audience observing the damage and desecration. The greater the audience that values the sacred site, the more cautiously it will be treated in the course of war. This is why holy places pose such an acute challenge to leaders: often their audience is neither local nor regional, but global. Roosevelt worried about Monte Cassino and the bombing of Rome not only because of the effects on Catholics in Italy or Europe more broadly but also because he worried about the perceptions of Catholics in the United States, a core constituency in the ensuing presidential election. Along similar lines, US military engagements in the vicinity of mosques in Iraq and Afghanistan in the last two decades risked offending not only local Muslims but also observers throughout the entire Middle East and, indeed, across the world (fig. 27.3).

Third, the religious identity of the participants matters. Observers are likely to be more tolerant of damage to shrines caused by combatants who share their religious identity than by outsiders. This explains why, for example, the presence of armed insurgents in Iraqi mosques caused less outrage than the presence of the US troops pursuing them: even though the insurgents were responsible for drawing the fighting to the mosques, they were Muslim, while their American opponents were perceived as Christians. Thus, troops are likely to display particular restraint when operating in a "foreign" religious environment. They may blunder, due to lack of information about the centrality or vulnerability of local shrines. But they are likely to realize that their legitimacy is precarious: any damage or offense will be interpreted uncharitably by observers precisely because they are religious outsiders.

Fourth, the intention of the combatant matters. Constraint is most likely in conflicts that include a "hearts and minds" component, where military leaders have good reasons to value the support of the local and regional population. Especially in situations in which leaders envision a prolonged occupation, as in Iraq and Afghanistan, or in situations in which leaders require the cooperation of local communities in the ensuing war effort, as in Italy in the 1940s, they will go to some effort to protect religious sites.

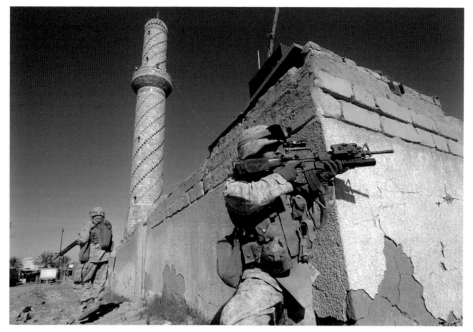

Figure 27.3 US Marines take up position on the perimeter of a mosque while patrolling in the central Iraqi city of Yusufiyah, December 2004. Image: Odd Andersen / AFP via Getty Images

The fifth and final lesson is that opponents will take advantage of that hesitation. Thus, any reluctance to target sacred heritage sites in wartime will provoke a moral hazard. At the very least, the enemy will use sacred sites as sanctuaries from violence, hiding their wounded, weapons, supplies, and even combatants there. At worst, they will try to provoke attacks on sacred heritage sites by using them as bases of operation, placing sniper nests in church towers or minarets, or seeking refuge from hot pursuit in temples and mosques.[42] As often in war, acting with restraint imposes costs on one's own units and provides some advantage to opponents. The challenge for decisionmakers is to strike a balance between those tactical considerations and the broader strategic costs of damaging holy places.

SUGGESTED READINGS

Robert M. Edsel, *Saving Italy: The Race to Rescue a Nation's Treasures from the Nazis* (New York: W. W. Norton, 2013).

Sumit Ganguly and C. Christine Fair, eds., *Treading on Sacred Ground* (Oxford: Oxford University Press, 2008).

David Hapgood and David Richardson, *Monte Cassino* (New York: Congdon and Weed, 1984).

Ron E. Hassner, *Religion on the Battlefield* (Ithaca, NY: Cornell University Press, 2016).

Ron E. Hassner, *War on Sacred Grounds* (Ithaca, NY: Cornell University Press, 2009).

NOTES

1. Robert M. Edsel, *Saving Italy: The Race to Rescue a Nation's Treasures from the Nazis* (New York: W. W. Norton, 2013), 97; John North, ed., *The Memoirs of Field-Marshal Earl Alexander of Tunis: 1940–1945* (London: Cassell, 2000), 90.

2. David Hapgood and David Richardson, *Monte Cassino* (New York: Congdon and Weed, 1984), 167, citing *Records of II Corps and 34th Division, Fifth Army History* (College Park, MD: National Archives and Records Administration), Part IV, 92.

3. Hapgood and Richardson, *Monte Cassino*, 158–59; and Matthew Parker, *Monte Cassino: The Hardest-Fought Battle of World War II* (New York: Doubleday, 2004), 161.

4. For an exploration of these instances, see Ron E. Hassner, *War on Sacred Grounds* (Ithaca, NY: Cornell University Press, 2009).

5. Convention (IV) Respecting the Laws and Customs of War on Land and its Annex: Regulations Concerning the Laws and Customs of War on Land, The Hague, 18 October 1907, Art. 27.

6. Hapgood and Richardson, *Monte Cassino*, 110, 139; Edsel, *Saving Italy*, 45–46; and Lynn H. Nicholas, *The Rape of Europa: The Fate of Europe's Treasures in the Third Reich and the Second World War* (New York: Alfred A. Knopf, 1994), 240.

7. Edsel, *Saving Italy*, 45–47, citing Fred Majdalany, *The Battle of Cassino* (Boston: Houghton Mifflin, 1957), 122.

8. Parker, *Monte Cassino*, 163.

9. Hapgood and Richardson, *Monte Cassino*, 30, 53, 63–64, citing F. Jones, "Report on the Events Leading to the Bombing of the Abbey of Monte Cassino on 15 February 1944," Public Record Office, London (now The National Archives, Kew) 1949, 49.

10. In those five weeks, the British Corps lost four thousand men among their three divisions. The French Corps suffered 2,500 casualties. The US 36th Infantry Division lost two thousand and the 34th Infantry Division lost around 2,200 men. See Majdalany, *The Battle of Cassino*, 103–4; and North, ed., *The Memoirs of Field-Marshal Earl Alexander of Tunis*, 90.

11. Edsel, *Saving Italy*, 63–64.

12. Hapgood and Richardson, *Monte Cassino*, 76–77, citing Howard McGraw Smyth, "German Use of the Abbey of Monte Cassino Prior to Allied Aerial Bombardment of 15 February 1944," undated memorandum, Office of the Chief of Military History, US Army, 5.

13. Parker, *Monte Cassino*, 37; David Fraser, *Wars and Shadows: Memoirs of General Sir David Fraser* (London: Allen Lane, 2002), 184–85; and Hapgood and Richardson, *Monte Cassino*, 36–58, 73–94, 108, 222, 238.

14. Hapgood and Richardson, *Monte Cassino*, 191; Majdalany, *The Battle of Cassino*, 148; and Parker, *Monte Cassino*, 166.

15. Hapgood and Richardson, *Monte Cassino*, 199.

16. Parker, *Monte Cassino*, 172.

17. Hapgood and Richardson, *Monte Cassino*, 211.

18. Tom Johnstone and James Hagerty, *The Cross on the Sword: Catholic Chaplains in the Forces* (London: Geoffrey Chapman, 1996), 216, citing Rt. Rev. Dom. Rudesind Brookes, *Father Dolly: The Guardsman Monk* (London: Henry Melland, 1983), 155.

19. Hapgood and Richardson, *Monte Cassino*, 81, 169, 227.

20. Hapgood and Richardson, *Monte Cassino*, 213, 221–24; and Majdalany, *The Battle of Cassino*, 158.

21. Edsel, *Saving Italy*, 109; and Hapgood and Richardson, *Monte Cassino*, 181.

22. Majdalany, *The Battle of Cassino*, 181.

23. Hapgood and Richardson, *Monte Cassino*, 81, 169.

24. Similar commissions functioned, on a smaller scale, in Britain, France, and Belgium. The most significant of these was the British Committee for the Preservation and Restitution of Works of Art, Archives, and Other Material in Enemy Hands, also known as the MacMillan Committee.

The primary focus of these committees, unlike that of the Roberts Commission, was on restitution and reparation. See Edsel, *Saving Italy*, 78, 114–15, 142–44; and *Report of the American Commission for the Protection and Salvage of Artistic and Historic Monuments in War Areas* (Washington, DC: United States Government Historical Reports on War Administration, 1946), 92 (henceforth *REAC*).

25. *REAC*, 34.

26. William L. M. Burke, "Full Draft Text for the Office of War Information," Records of the American Commission for the Protection and Salvage of Artistic and Historical Monuments in War Areas (henceforth "RAC"), Miscellaneous Records, National Archives and Records Administration, doc. no. NARA M1944, 26 May 1945, 14–15, 26; *REAC*, 19–20; Edsel, *Saving Italy*, 61, 104; and Ronald Schaffer, *Wings of Judgment: American Bombing in World War II* (New York: Oxford University Press, 1985), 48.

27. "Minutes of a Special Meeting of the American Commission for the Protection and Salvage of Artistic and Historic Monuments in Europe," 8 October 1943, 16, RAC.

28. Robert M. Edsel, *The Monuments Men: Allied Heroes, Nazi Thieves, and the Greatest Treasure Hunt in History* (New York: Center Street, 2009), 23.

29. "Minutes of a Special Meeting," 10, RAC.

30. "Outline of the Commission's Accomplishments and Future Activities for the House Committee on Appropriations," undated, 3, RAC.

31. "Remarks by David E. Finley, Vice Chairman of RC [Roberts Commission] at Hearing of the Appropriations Committee, House of Representatives," 6 September 1945, 3, RAC.

32. "Introduction" to "Greece" list, undated, 2, RAC; "Introduction" to "Hungary" lists, undated, 2, RAC; *Civil Affairs Handbook*, "France," Section 17C: "Cultural Institutions Central and Southern France," xiv–xv, RAC; and *Civil Affairs Handbook*, "The Netherlands," Section 17: "Cultural Institutions," 1, RAC.

33. *REAC*, 123, citing unnamed MFAA report of January 1945.

34. This operation and the deliberations that preceded it are discussed at length in Ron E. Hassner, *Religion on the Battlefield* (Ithaca, NY: Cornell University Press, 2016), 63–72.

35. "Report of Activities to November 1943," 243, RAC.

36. Colonel Henry C. Newton, "Field Report: Florence," 13 June 1944, 16, RAC.

37. Richard Overy, *The Bombers and the Bombed: Allied Air War over Europe: 1940–1945* (New York: Viking, 2014), citing British National Archives, doc. no. AIR 19/215, Slessor to Air Ministry, 29 February 1944.

38. Edsel, *Saving Italy*, 104–9, 179–81, 202.

39. "Minutes of a Special Meeting," RAC.

40. *REAC*, 98–99.

41. Edsel, *The Monuments Men*, 260; and Burke, "Full Draft Text for the Office of War Information," 16.

42. Ron E. Hassner, "Fighting Insurgency on Sacred Ground," *Washington Quarterly* 29, no. 2 (2006): 149–66; and Sumit Ganguly and C. Christine Fair, eds., *Treading on Sacred Ground* (Oxford: Oxford University Press, 2008).

28

From Kyoto to Baghdad to Tehran: Leadership, Law, and the Protection of Cultural Heritage

Scott D. Sagan

In July 1945, at the end of World War II, US secretary of war Henry Stimson persuaded President Harry Truman to remove Kyoto, the ancient capital of Japan, from the top of the target list for the dropping of the atomic bomb. In 1991, during the Gulf War, US Central Command developed an extensive "no-attack" list of cultural, religious, and historical sites that were off-limits for military targeting. In March 2003, after the invasion of Iraq, it became clear that such no-attack lists were not enough, when considerable looting took place at the Iraq Museum in Baghdad. Yet in response to widespread criticism of the US military for failing to prevent the looting, Secretary of Defense Donald Rumsfeld displayed little concern about the incident. In January 2020, President Donald Trump tweeted a threat to target Iranian cultural heritage sites, but Secretary of Defense Mark Esper promptly announced that US armed forces would follow the laws of armed conflict in any retaliatory attack against Iran.

These events took place in different eras with different international legal regimes in place regarding rules and standards for cultural heritage protection in war. But the contrasting statements and behavior also provide insights into the complex process by which ethical and legal reasoning and strategic imperatives interact to impact military decision-making. The history of these incidents illustrates why it is easier to prioritize protection of cultural heritage when it is deemed to make a positive contribution to winning the war and sustaining the peace. But that is not always the case, and trade-offs between cultural protection and military force protection are common. The legal principles of proportionality and precaution must always be followed so that soldiers take risks and properly weigh the harm of cultural heritage destruction against the importance of destroying a legitimate target. Unfortunately, this complex balancing act

is made more difficult when an adversary's military forces hide near or within cultural heritage sites. Nevertheless, the history also illuminates how legal constraints can take on a life of their own, influencing operational decisions even when individual political leaders are not particularly concerned about following international law.

The Role of Law in Cultural Heritage Protection

The historical case studies examined here illuminate four main arguments. First, the relationship between the ethical and legal requirements to protect cultural heritage and the strategic incentives to win wars is complex and contested. There are two central logics for protecting cultural heritage in war, a moral one and a strategic one. The moral logic emphasizes the intrinsic value of cultural heritage to humankind and argues that protecting cultural heritage is simply the right thing to do; the strategic logic, in contrast, maintains that protecting an adversary's cultural heritage helps win wars. Under the moral logic argument, there can be tensions and trade-offs between cultural heritage protection and destroying legitimate targets that create "military advantage." Such calculations often force the US military, following the laws of armed conflict, to weigh the intended positive contributions of an operation against a specific target to eventual victory against the incidental harm to cultural heritage sites. Under the strategic logic argument, such trade-offs do not exist: protection of cultural heritage contributes to eventual victory both by encouraging local populations to support the protectors and by contributing to postwar stability and reconstruction. Laurie Rush has claimed, for example, that cultural heritage protection is "a force multiplier"—that is, protection of cultural sites makes individual military operations more effective in achieving the broader goals of war, and the US military should therefore be "protecting the past to secure the future."[1] These two logics can coexist inside leaders' calculations, and there is strong historical evidence in the protection-of-Kyoto case in 1945 that Secretary Stimson used the strategic rationale for cultural heritage protection in order to more effectively persuade President Truman.

Second, the history demonstrates that laws protecting cultural heritage matter and that the United States has increasingly sought to comply with existing law. Like other countries, the United States tends to only ratify treaties that it believes serve its interests. This helps explain why it did not ratify the 1954 Hague Convention for the Protection of Cultural Property in the Event of Armed Conflict (hereafter the 1954 Hague Convention) until 2009, after the Baghdad looting incident and other destruction of cultural property in Iraq encouraged a reassessment of US policy. International law, however, whether through a ratified treaty or acceptance as customary international law, can constrain states, often in unanticipated ways. As Laura Ford Savarese and John Fabian Witt argue, the laws of armed conflict create "entailments": "What makes law strategically valuable is that it entails consequences beyond the control of the parties that invoke it."[2] Laws can create formal obligations, to be sure, but their existence also

shapes expectations, makes violations more costly, and enables critics of policies to mobilize more effectively.

In this sense, the laws regarding cultural heritage protection are not different from other laws of armed conflict. The laws prohibiting torture of prisoners, for example, have not ended the practice of torture. However, they have increased the incentives for humane treatment, created opportunities for reciprocity, and increased the probability of punishment for violators of the law.[3] The laws protecting cultural heritage in war do not guarantee compliance, but they increase focus on protection and create extra political costs for violation in ways that the US government does not always anticipate.

Third, the history shows that laws regarding cultural heritage protection still require constant interpretation by junior and senior military officers. In this regard as well, they are similar to other laws of armed conflict. To use a common legal theory analogy, the laws of armed conflict generally provide "standards" rather than "rules" to guide decision-making. A standard is like a law telling a driver "do not drive recklessly," while a rule is like a law telling a driver "do not drive above 60 miles per hour." In Additional Protocol I to the 1949 Geneva Conventions, the principles of proportionality (do not engage in attacks that kill disproportionate numbers of civilians) and precaution (take feasible precautions to avoid noncombatant deaths) are standards requiring much interpretation, while the principle of distinction (do not intentionally target civilians) is closer to a rule. The 1954 Hague Convention should be thought of as setting standards more often than rules. With the exception of the strict red line rule to refrain "from any act of hostility, directed against such [cultural] property," the treaty's guidelines still require complex, situation-dependent interpretation by battlefield commanders and military lawyers.[4] Examples of this can be seen in the history of the 1990–91 Gulf War.

Fourth, top-level leadership matters. The historical case studies described here demonstrate how different US presidents and secretaries of defense hold wide-ranging views about the importance of the laws of armed conflict. While some leaders are deeply concerned about these laws, others are not. If Henry Stimson, for example, had not been the secretary of war in 1945, the city of Kyoto would almost certainly have been destroyed. If Rumsfeld had not been secretary of defense in 2003, it is possible that the Iraq Museum would not have been looted. The history, however, also reveals one entailment of the laws of armed conflict: professional military and civilian leaders are trained and incentivized to follow the laws of armed conflict, and this can increase the probability of compliance, even when some top political leaders do not care. This is clear in the 2020 incident when Secretary of Defense Esper refused to target Iranian cultural sites despite President Trump's threats to do exactly that.

Sparing Kyoto

The decision to drop the atomic bomb on Hiroshima has been the subject of exhaustive research. What is less well understood is the complex, even convoluted, process by which Kyoto was taken off the top of the target list, which led to the bombing of

Nagasaki. Michael Gordin calls the sparing of Kyoto "the solitary instance of moral restraint dictating target choice on behalf of any belligerent in World War II."[5] Gordin's argument, however, ignores the many instances of Allied bombing decisions taking into account protection of cultural heritage in Europe, a phenomenon well documented by Ron Hassner.[6] Gordin's argument also underplays the strategic element of the rationale behind Stimson's insistence that Kyoto be removed from the target list. It is impossible to disentangle or weigh the relative importance of moral and strategic motives in Stimson's mind.[7] But it is clear that both motives existed, and that Stimson employed the two arguments as necessary in his efforts to spare Kyoto.

When the Target Committee, which included Robert Oppenheimer and Major General Leslie Groves, met in Los Alamos, they considered destroying cultural heritage as a positive act, one that would reduce the Japanese civilian population's support for continuing the war. Committee meeting minutes suggest that the planners believed that destruction of Kyoto and the Imperial Palace in Tokyo would contribute to military victory:

> Kyoto: This target is an urban industrial area with a population of 1,000,000. It is the former capital of Japan and many people and industries are now being moved there as other areas are being destroyed. From the psychological point of view there is the advantage that Kyoto is an intellectual center for Japan and the people there are more apt to appreciate the significance of such a weapon as the gadget. . . .
> Hiroshima has the advantage of being such a size and with possible focusing from nearby mountains that a large fraction of the city may be destroyed. The Emperor's palace in Tokyo has a greater fame than any other target but is of least strategic value (fig. 28.1).[8]

Military logic supported attacking Kyoto because of the increasing amount of military industry coming into the city, its location surrounded by mountains, and its large population. Indeed, Kyoto was well over twice the size of Hiroshima or any other city that had not yet been subjected to the firebombing campaign of the US Army Air Forces (as the US Air Force was then known). Simply put, if Kyoto was attacked, more Japanese people would be killed. This appealed to General Groves: as he later put it, "I particularly wanted Kyoto as a target because . . . it was large enough in area for us to gain complete knowledge of the effect of an atomic bomb."[9]

Groves's account of Stimson's opposition is revealing: "The reason for his objection was that Kyoto was the ancient capital of Japan, a historical city, and one that was of great religious significance to the Japanese." Groves noticed that Stimson's position then evolved to emphasize the strategic rationale: "In the course of our conversation he gradually developed the view that the decision should be governed by the historical position that the United States would occupy after the war."[10] Stimson stressed his moral reasoning for sparing Kyoto in his postwar memoirs: "With President Truman's

Figure 28.1 Target map of Kyoto, June 1945. Image: Alex Wellerstein, "The Kyoto Misconception," *Restricted Data: The Nuclear Secrecy Blog*, 8 August 2014, http://blog.nuclearsecrecy.com/2014/08/08/kyoto-misconception/. View map at www.getty.edu/publications/cultural-heritage-mass-atrocities/part-5/28-sagan/#fig-28-1-map.

warm support I struck off the list of suggested targets the city of Kyoto. Although it was a target of considerable military importance, it had been the ancient capital of Japan and was a shrine of Japanese art and culture. We determined that it should be spared."[11]

But it was the "strategic" rationale for sparing Kyoto that Stimson emphasized as being effective in his crucial discussions with Truman at the Allied leaders' Potsdam Conference in Germany in July–August 1945. As Stimson recorded in his diary: "We had a few words more about the S-1 program, and I again gave him my reasons for

eliminating one of the proposed targets. He again reiterated with the utmost emphasis his own concurring belief on that subject, and he was particularly emphatic in agreeing with my suggestion that if elimination was not done, the bitterness which would be caused by such a wanton act might make it impossible during the long post-war period to reconcile the Japanese to us in that area rather than to the Russians."[12] Truman's diary entry is also revealing: "I have told the Sec. of War, Mr. Stimson to use it so that military objectives and soldiers and sailors are the target and not women and children. Even if the Japs are savages, ruthless, merciless, and fanatic, we as the leader of the world for the common welfare cannot drop this terrible bomb on the old Capitol [Kyoto] or the new [Tokyo]. He and I are in accord."[13]

Stimson's use of the strategic rationale for sparing Kyoto helped persuade Truman to support his efforts against the military planners led by Groves. This decision saved the lives of many thousands of Japanese civilians, since Kyoto's population was significantly larger than that of Nagasaki, the city that replaced it on the target list. But saving Japanese lives was not Stimson's objective—this was saving Kyoto's cultural treasures. The evidence is clear that Truman's eventual decision to spare Emperor Hirohito from war crimes trials helped negotiate surrender and end the war, and aided the US in maintaining peace and stability during the occupation of Japan.[14] It is not clear, however, that sparing Kyoto had similarly important strategic effects.

The 1954 Hague Convention

The 1954 Hague Convention was a response to the massive cultural heritage destruction that occurred during World War II. In brief, Article 1 defines cultural property as "(a) movable or immovable property of great importance to every people . . . (b) buildings whose main and effective purpose is to preserve or exhibit the movable cultural property . . . [and] (c) centers containing a large amount of cultural property."[15] Article 3 requires that states protect cultural heritage within their own territory, and, to that effect, Article 4 requires that states not place military objects in locations that would endanger cultural heritage sites. Article 4 additionally requires states to refrain from targeting cultural heritage in "any act of hostility," to prevent its damage by way of looting or vandalism, and to not target cultural heritage, even in an act of reprisal.

As mentioned, the United States did not ratify the convention until 2009, and its instrument of ratification included important qualifying declarations, outlining the US government's interpretation of a "military necessity exception": attacks on cultural heritage sites are permitted, provided they are "proportionate" and "required by military necessity and notwithstanding possible collateral damage to such property."[16] The US Department of Defense's 2016 *Law of War Manual* affirms this military necessity waiver. Nevertheless, the manual also cautions commanders to remember that "the requirement that military necessity imperatively require[s] such acts should not be confused with convenience or be used to cloak slackness or indifference to the preservation of cultural property."[17] This follows General Dwight Eisenhower's famous

World War II warning that "'military necessity' is sometimes used where it would be more truthful to speak of military convenience or even personal convenience."[18] The manual also insists that even when a waiver of the protection of cultural heritage may be warranted as a matter of law, decisionmakers may still refrain from harming cultural heritage for broader strategic or policy reasons. It is important and worrisome to note that while the manual also cites Stimson's decision to spare Kyoto as an example of an appropriate restraint toward cultural heritage, it claims that by today's standards, an attack on Kyoto could still have been justified under the military necessity exception.[19]

The 1990–91 Gulf War and 2003 Invasion of Iraq

Although in 1990 the United States was not yet a party to the 1954 Hague Convention, its armed forces were trained to adhere to some of the convention's principles, suggesting that the US military accepted many provisions as reflecting customary international law and thus legally constraining its plans and operations.[20] The effects of the laws of armed conflict regarding cultural heritage protection were direct and significant during the 1990–91 Gulf War. The after-action report by the Department of Defense to Congress particularly highlighted the importance of "off-limits target lists" and the proportionality principle applied to legitimate military targets: "Planners were aware that each bomb carried a potential moral and political impact, and that Iraq has a rich cultural and religious heritage dating back several thousand years. . . . Targeting policies, therefore, scrupulously avoided damage to mosques, religious shrines, and archaeological sites, as well as to civilian facilities and the civilian population. . . . When targeting officers calculated the probability of collateral damage as too high, the target was not attacked" (fig. 28.2).[21]

Perhaps the most widely discussed example of adherence to cultural heritage protection rules influencing a US targeting decision was when the Iraqi Air Force placed

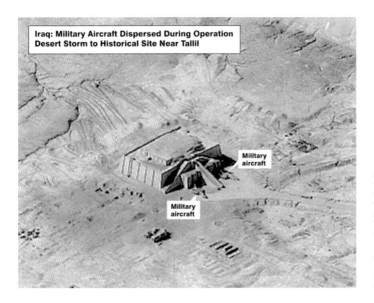

Figure 28.2 Iraqi military aircraft stationed near the Temple of Ur. Image: US Department of Defense, *Conduct of the Persian Gulf War: Final Report to Congress* (April 1992), https://apps.dtic .mil/dtic/tr/fulltext/u2/ a249270.pdf, 133.

two fighter aircraft immediately outside the Temple of Ur. The Iraqis apparently anticipated that the United States would refrain from attacking, or that if they did, the destruction of the temple would create a propaganda victory for Iraq. According to the Department of Defense report, US forces chose not to attack the aircraft because the military advantage of destroying them was deemed insufficient to justify the risk to the temple, rather than the legal advice they received that Iraq would be responsible for any collateral damage to it. Thus, it was the proportionality rule that created the constraint. According to the report: "While the law of war permits the attack of the two fighter aircraft, with Iraq bearing responsibility for any damage to the temple, Commander-in-Chief, Central Command (CINCCENT) elected not to attack the aircraft on the basis of respect for cultural property and the belief that positioning of the aircraft adjacent to Ur (without servicing equipment or a runway nearby) effectively had placed each out of action, thereby limiting the value of their destruction by Coalition air forces when weighed against the risk of damage to the temple."[22]

This example is widely cited as an effort by President Saddam Hussein to practice "lawfare," using US and international respect for the laws of armed conflict and cultural heritage protection to shelter his armed forces or, if attacked, weaken US domestic and coalition support for the war. It is also an example, however, of the subtle power of law's entailments, since the United States had signed the treaty and was thereby obliged to refrain from acts that would defeat its purpose, even though the United States had not ratified it. Most importantly, the law encouraged commanders to assess proportionality and take a broader perspective on the effects of attacks.[23] Patty Gerstenblith notes that in 1991 "no archaeological, cultural, or historic site was intentionally targeted," though many sites were unintentionally damaged, including the brickwork at the Temple of Ur through "rocket or shell fire."[24]

The United States is also widely perceived to have been constrained in direct attacks on cultural sites in the 2003 invasion of Iraq, but that campaign raised an important new question about the priority that should be given to active measures to protect cultural heritage from local looters. After Saddam Hussein's government fell in Baghdad, Iraqi citizens began looting the ousted leader's residences, government agencies, and, most dramatically, the Iraq Museum, ultimately stealing thousands of antiquities, many of which remain missing to this day.[25] Chairman of the Joint Chiefs of Staff General Richard Myers defended the failure of the United States to stop the pillaging as the result of an overriding need to focus energy on subduing the paramilitary groups throughout Baghdad that remained loyal to the deposed government.[26] In response to growing condemnation as press coverage of the Iraq Museum increased, Secretary of Defense Rumsfeld seemed resigned to the inevitability of looting: "Freedom's untidy. . . . Stuff happens."[27]

In 2003 the United States was still not a state party to the 1954 Hague Convention. Accordingly, military manuals at the time did not specifically require personnel to protect Iraq's cultural heritage during the initial conflict or ensuing occupation, and

only placed prohibitions on looting by US military forces, deliberate targeting of cultural sites, or the use of cultural sites for military purposes.[28] Inclusion of these prohibitions indicated only a limited acceptance at the operational level of the convention's principles. A military policy that lacked affirmative requirements to protect cultural heritage paved the way for the looting and destruction of the Iraq Museum and other important cultural sites in Baghdad. Patty Gerstenblith's conclusion is highly critical: "Looting of government buildings by the local populace was tacitly permitted by the lack of intervention of coalition forces."[29]

As a result of the ensuing global outcry, according to Matthew Thurlow, many officials in the US government learned that "intentionally destroying cultural sites is often conflated with negligently failing to prevent their destruction."[30] This political controversy encouraged the United States to finally ratify the convention in 2009.[31] The Department of Defense manual was later updated to require military commanders "to take reasonable measures to prevent or stop any form of theft, pillage, or misappropriation of, and any acts of vandalism directed against, cultural property" during occupation.[32]

In October 2019, the Pentagon signaled a willingness to allocate greater energy toward cultural heritage protection when it announced that the army was training a group of commissioned officers of the US Army Reserve to "provide a scholarly liaison for military commanders and the local authorities to help secure the cultural heritage of the regions involved and rebuild civil society in war and disaster zones."[33] More specifically, the group was assigned to help the government fulfill its obligations as a party to the convention by providing lists of sites to avoid in air strikes and ground operations and locations where the military should try to forestall looting.

Trump's 2020 Threat to Iran

On 4 January 2020, one day after the United States had killed Major General Qassim Suleimani, the commander of Iran's Islamic Revolutionary Guard Corps, President Trump tweeted out a threat to destroy Iranian cultural heritage: "Let this serve as a WARNING that if Iran strikes any Americans, or American assets, we have targeted 52 Iranian sites (representing the 52 American hostages taken by Iran many years ago), some at a very high level & important to Iran & the Iranian culture, and those targets, and Iran itself, WILL BE HIT VERY FAST AND VERY HARD. The USA wants no more threats!"[34]

Trump's tweet reflected the president's strong vengeful proclivities. The threat to target Iranian cultural sites is one of many examples of his disregard for the laws of armed conflict. During the 2016 US presidential election campaign, for example, Trump had accused the administration of President Barack Obama of fighting "a very politically correct war" against terrorists and said that he instead would "take out their families."[35] In November 2019, he granted clemency to three US service members convicted or accused of deliberately killing noncombatants.[36] In this light, it is not surprising that

after facing criticism for his threat to attack cultural sites, Trump doubled down the next day: "They're allowed to kill our people. They're allowed to torture and maim our people. They're allowed to use roadside bombs and blow up our people. And we're not allowed to touch their cultural site? It doesn't work that way."[37]

However, Trump's threats to attack cultural heritage sites were criticized by a number of Democratic members of Congress as threats to commit "a war crime."[38] In addition, Republican senators, including staunch Trump allies Mitch McConnell and Lindsey Graham, respectively characterized targeting cultural sites as "inappropriate" and something that both is "not lawful" and "undercuts what we're trying to do."[39] In this incident, the laws of armed conflict created more political opposition than otherwise would have existed.

Secretary of State Mike Pompeo tried to reassure the public by stating: "The American people should know that every target that we strike will be a lawful target."[40] The following exchange between Secretary of Defense Esper, Chairman of the Joint Chiefs of Staff General Mark A. Milley, and the Pentagon press corps perhaps best reveals the constraining power of the law. Question: "The president has twice now, not hypothetical, said he is willing to strike cultural sites. Truly cultural sites not with weapons that makes them military targets. So straight-up could you both say whether you are willing to target cultural sites?" Milley: "We will follow the laws of armed conflict." Question: "And that means no because targeting a cultural site is a war crime?" Milley: "That's, that's the laws of armed conflict."[41]

Trump finally backed away from the threat, but not without complaints about the constraints: "They are allowed to kill our people. They are allowed to maim our people. They are allowed to blow up everything that we have, and there's nothing that stops them. And we are, according to various laws, supposed to be very careful with their cultural heritage. And you know what, if that's what the law is, I like to obey the law."[42]

What should we make of this incident? We do not know whether a target list presented to the president included a cultural site that was being used by the Iranians for military purposes. But we do know that, with the exception of such military use by the enemy, direct targeting of cultural heritage sites would be illegal. The best contemporary legal analysis was by Mark Nevitt, a retired US Navy Judge Advocate General's Corp (JAG) officer and professor at the US Naval Academy, who noted that targeting Iranian cultural sites would violate international law (the 1954 Hague Convention), US domestic law (18 US Code Section 2441), and US military law and guidance (outlined in the 2016 *Law of War Manual*). Nevitt concluded that "there is simply no legal gray area or colorable argument to the contrary. This 'legal trifecta' provides for strong protections of cultural sites around the world in both peacetime and across the spectrum of armed conflict."[43] Unless there was specific intelligence that Iran was using a protected cultural site as a military facility (for example, by placing aircraft next to a temple or mosque), any officer who received an order to attack a cultural site would be obligated to disobey.[44] There was no evidence that such intelligence existed,

however, when Trump issued his threat, which helps explain why the secretary of defense was so quick to clarify the Pentagon's position and contradict the president.

Conclusions: The Past and Future of Cultural Protection

Global norms have moved a great distance, from accepting plunder to promoting protection. When viewed from a great distance, the arc of history may well bend toward justice. But from a closer perspective, that arc looks more like a roller-coaster ride, with successes mixed with failures to protect cultural heritage and different reactions to those failures.[45] The arc of history only bends toward justice if we make it do so.

This historical review has focused on the United States, but the lessons apply to all states. In general, democracies are more likely to comply with the international treaties that they have signed and ratified.[46] This is a reminder, therefore, of the importance of getting all states, democracies and nondemocracies alike, to ratify treaties that seek to protect cultural heritage in conflict. But because these treaties usually create standards of appropriate behavior—not specific rules to govern how to make trade-offs between acts that improve military advantage and constraints that protect cultural heritage—the international community needs to be constantly vigilant to identify not only clear violations of law, but also poor interpretations of norms or implementation of laws that lead to unnecessary cultural heritage destruction.

The 1954 Hague Convention created entailments that encouraged the United States, despite not originally ratifying the treaty, to adjust its behavior over time. This phenomenon was neither linear nor inevitable. It was subject to backtracking, leadership pressures, and errors in wartime decision-making. For American political and military leaders in the crucible of war, both strategic and moral considerations were at play, considerations that sometimes reinforced each other and sometimes created tensions.

In many situations, protecting cultural heritage in war may contribute to victory and enhance the prospects of postwar reconstruction. But we lack empirical evidence about how often and to what degree this is true. Indeed, the evidence for the "strategic logic" regarding cultural heritage protection is quite anecdotal compared to the rigorous empirical social science research about the strategic effects of "force protection," torture of prisoners, and collateral damage to civilians.[47] The international community would benefit from more empirical research on the conditions under which protecting cultural heritage helps win conflicts and promotes peace afterward, and under which this strategic logic is compelling.

It is important that more governments recognize that protection of cultural heritage can be a force multiplier in some contexts, reducing the animosity of foreign civilians and increasing the prospects for peaceful settlements and post-conflict stability. But it is also important for the United States and other governments to take great care to protect cultural heritage not only when it contributes to winning the war and sustaining the peace, but even when it does not. And we should protect cultural heritage even when

we do not expect reciprocity. Ultimately, we should protect cultural heritage in war because it is the right thing to do. As Jennifer M. O'Connor, the chief legal officer in the US Department of Defense, argued in 2016: "We comply with the law of war because it is the law. . . . We will treat everyone lawfully and humanely, even when our foes do not do the same. We follow the law because it reflects our core values, the very principles that we are fighting to protect and preserve—in short, it reflects who we are."[48] O'Connor was referring to the laws of armed conflict regarding protection of noncombatants, but the sentiment holds true about protection of cultural heritage as well. We should follow the law because it reflects who we are, or at least who we aspire to be.

SUGGESTED READINGS

Joseph H. Felter and Jacob N. Shapiro, "Limiting Civilian Casualties as Part of a Winning Strategy: The Case of Courageous Restraint," *Daedalus* 146, no. 1 (2017): 44–58, https://doi.org/10.1162/DAED_a _00421.

Patty Gerstenblith, "From Bamiyan to Baghdad: Warfare and the Preservation of Cultural Heritage at the Beginning of the 21st Century," *Georgetown Journal of International Law* 37, no. 2 (2006): 245–351.

Katherine E. McKinney, Scott D. Sagan, and Allen S. Weiner, "Why the Atomic Bombing of Hiroshima Would Be Illegal Today," *Bulletin of the Atomic Scientists* 76, no. 4 (2020): 157–65.

Wayne Sandholtz, *Prohibiting Plunder: How Norms Change* (New York: Oxford University Press, 2007).

Laura Ford Savarese and John Fabian Witt, "Strategy & Entailments: The Enduring Role of Law in the U.S. Armed Forces," *Daedalus* 146, no. 1 (2017): 11–23.

NOTES

1. Laurie W. Rush, "Cultural Property Protection as a Force Multiplier in Stability Operations," *Military Review* (March–April 2012): 36. Also see Laurie W. Rush and Matthew F. Bogdanos, "Protecting the Past to Secure the Future: The Strategic Value of Heritage Training," *Joint Force Quarterly* 53, no. 2 (2009): 126–27; and Thomas G. Weiss and Nina Connelly, *Cultural Cleansing and Mass Atrocities: Protecting Cultural Heritage in Armed Conflict Zones*, Occasional Papers in Cultural Heritage Policy no. 1 (Los Angeles: Getty Publications, 2017), 14, https://www.getty.edu/publications/occasional-papers-1/.
2. Laura Ford Savarese and John Fabian Witt, "Strategy & Entailments: The Enduring Role of Law in the U.S. Armed Forces," *Daedalus* 146, no. 1 (2017): 11.
3. James D. Morrow, *Order within Anarchy* (Cambridge: Cambridge University Press, 2014); and Geoffrey P. R. Wallace, *Life and Death in Captivity* (Ithaca, NY: Cornell University Press, 2015).
4. Hague Convention for the Protection of Cultural Property in the Event of Armed Conflict, 1954, Art. 4.1.
5. Michael D. Gordin, *Five Days in August: How World War II Became a Nuclear War* (Princeton, NJ: Princeton University Press, 2007), 45.
6. Ron E. Hassner, *Religion on the Battlefield* (Ithaca, NY: Cornell University Press, 2016).
7. See Sean L. Malloy, *Atomic Tragedy: Henry L. Stimson and the Decision to Use the Bomb against Japan* (Ithaca, NY: Cornell University Press, 2008), 120–42.

8. US Army, "Summary of Target Committee Meetings on 10 and 11 May 1945," Memorandum from Major J. A. Derry and Dr. N. F. Ramsey to General L. R. Groves, 12 May 1945, RG 77, MED Records, Top Secret Documents, File no. 5d (copy from microfilm), National Security Archive, Washington, DC, https://nsarchive2.gwu.edu/NSAEBB/NSAEBB162/6.pdf.

9. As quoted in McGeorge Bundy, *Danger and Survival: Choices about the Bomb in the First Fifty Years* (New York: Random House, 1988), 78.

10. Bundy, *Danger and Survival*, 78.

11. Henry L. Stimson and McGeorge Bundy, *On Active Services in Peace and War* (New York: Harper & Brothers, 1948).

12. US Department of State, Office of the Historian, "Foreign Relations of the United States: Diplomatic Papers, the Conference of Berlin (the Potsdam Conference), 1945, Volume II," No. 1310 n. 3, https://history.state.gov/historicaldocuments/frus1945Berlinv02/d1310. For an excellent analysis, see Alex Wellerstein, "The Kyoto Misconception: What Truman Knew, and Didn't Know, about Hiroshima," in *The Age of Hiroshima*, ed. Michael D. Gordin and G. John Ikenberry (Princeton, NJ: Princeton University Press, 2020), 34–55.

13. David McCullough, *Truman* (New York: Simon & Schuster, 1992), 592.

14. See Katherine E. McKinney, Scott D. Sagan, and Allen S. Weiner, "Why the Atomic Bombing of Hiroshima Would Be Illegal Today," *Bulletin of the Atomic Scientists* 76, no. 4 (2020): 157–65; and John W. Dower, *Embracing Defeat: Japan in the Wake of World War II* (New York: W. W. Norton, 1999).

15. 1954 Hague Convention, Art. 1.

16. UNESCO: Legal Instruments, "Ratification by the United States of America of the Convention for the Protection of Cultural Property in the Event of Armed Conflict (The Hague, 14 May 1954)," 23 March 2009, http://portal.unesco.org/en/ev.php-URL_ID=44905&URL_DO=DO_TOPIC&URL _SECTION=201.html. On the negotiation of the treaty and the controversy around the military necessity waiver, see Wayne Sandholtz, *Prohibiting Plunder: How Norms Change* (New York: Oxford University Press, 2007), 180–86.

17. US Department of Defense, *Department of Defense Law of War Manual* (Washington, DC: General Counsel of the Department of Defense, June 2015, updated December 2016), 298–99 (para. 5.18.3.1, Imperative Military Necessity Waiver), https://dod.defense.gov/Portals/1/Documents/ pubs/DoD%20Law%20of%20War%20Manual%20-%20June%202015%20Updated%20Dec %202016.pdf?ver=2016-12-13-172036-190.

18. Quoted in US Department of Defense, *Department of Defense Law of War Manual*, 55 n.30 (para. 2.2.2.2). Original source: General Dwight D. Eisenhower, Commander-in-Chief, US Army, "Memorandum Regarding the Protection of Historical Monuments in Italy," 29 December 1943, X Whiteman's Digest, 438 (para. 13).

19. US Department of Defense, *Department of Defense Law of War Manual*, 301 n.618 (para. 5.18.5.1).

20. Federation of American Scientists, "Putting Noncombatants at Risk: Saddam's Use of 'Human Shields,'" January 2003, https://fas.org/irp/cia/product/iraq_human_shields/index.html; and David A. Meyer, "The 1954 Hague Cultural Property Convention and Its Emergence into Customary International Law," *Boston University International Law Journal* 11, no. 2 (1993): 349–89.

21. US Department of Defense, *Conduct of the Persian Gulf War: Final Report to Congress—Chapters I through VIII* (Washington, DC: Department of Defense, April 1992), https://apps.dtic.mil/dtic/tr/ fulltext/u2/a249270.pdf, 132–33.

22. US Department of Defense, *Conduct of the Persian Gulf War: Final Report to Congress—Appendix on the Role of the Law of War* (Washington, DC: Department of Defense, April 1992). For the text, see *International Legal Materials* 31, no. 3 (1992): 626, www.jstor.org/stable/20693692.

23. See W. Hays Parks, "The Gulf War: A Practitioner's View," *Penn State International Law Review* 10, no. 3 (1992): 393–423; and Meyer, "The 1954 Hague Cultural Property Convention," 376–77.

24. Patty Gerstenblith, "From Bamiyan to Baghdad: Warfare and the Preservation of Cultural Heritage at the Beginning of the 21st Century," *Georgetown Journal of International Law* 37, no. 2 (2006): 280.

25. Matthew Bogdanos, "The Casualties of War: The Truth about the Iraq Museum," *American Journal of Archaeology* 109, no. 3 (2005): 477–526.

26. James Cogbill, "Protection of Arts and Antiquities during Wartime: Examining the Past and Preparing for the Future," *Military Review* (January–February 2008): 33; and Douglas Jehl and Elizabeth Becker, "Experts' Pleas to the Pentagon Didn't Save Museum," *New York Times*, 16 April 2003, https://www.nytimes.com/2003/04/16/world/a-nation-at-war-the-looting-experts-pleas -to-pentagon-didn-t-save-museum.html.

27. Sean Loughlin, "Rumsfeld on Looting in Iraq: 'Stuff Happens,'" CNN, 12 April 2003, https://www .cnn.com/2003/US/04/11/sprj.irq.pentagon/.

28. Matthew D. Thurlow, "Protecting Cultural Property in Iraq: How American Military Policy Comports with International Law," *Yale Human Rights and Development Law Journal* 8, no. 1 (2005): 172, 175.

29. Gerstenblith, "From Bamiyan to Baghdad," 288.

30. Thurlow, "Protecting Cultural Property in Iraq," 179.

31. Patty Gerstenblith, "The Destruction of Cultural Heritage: A Crime against Property or a Crime against People?," *John Marshall Review of Intellectual Property Law* 15, no. 3 (2016): 355.

32. US Department of Defense, *Department of Defense Law of War Manual*, para. 11.19.

33. Ralph Blumenthal and Tom Mashberg, "The Army Is Looking for a Few Good Art Experts," *New York Times*, 21 October 2019, https://www.nytimes.com/2019/10/21/arts/design/new-monuments -men.html.

34. Donald Trump (@realDonald Trump, 4 January 2020), https://www.thetrumparchive.com/ ?searchbox=%22some+at+a+very+high+level%22.

35. Tom Lobianco, "Donald Trump on Terrorists: 'Take Out Their Families,'" CNN, 3 December 2015, https://www.cnn.com/2015/12/02/politics/donald-trump-terrorists-families/.

36. See Scott D. Sagan and Benjamin A. Valentino, "Do Americans Approve of Trump's Pardons of Court-Marshalled Military Officers?," *Washington Post*, 16 December 2019, https://www .washingtonpost.com/politics/2019/12/16/do-americans-approve-trumps-pardons-court -martialed-military-officers/.

37. Maggie Haberman, "Trump Threatens Iranian Cultural Sites, and Warns of Sanctions on Iraq," *New York Times*, 5 January 2020, https://www.nytimes.com/2020/01/05/us/politics/trump-iran -cultural-sites.html.

38. Rick Noack, "The Disturbing History behind Trump's Threat to Target Iranian Cultural Sites," *Washington Post*, 6 January 2020, https://www.washingtonpost.com/world/2020/01/06/disturbing -history-behind-trumps-idea-target-iranian-cultural-sites/; and Elizabeth Warren, "You are threatening to commit war crimes. We are not at war with Iran. The American people do not want a war with Iran. This is a democracy. You do not get to start a war with Iran, and your threats put our troops and diplomats at greater risk. Stop," @ewarren, 4 January 2020, https:// twitter.com/ewarren/status/1213665218020171777.

39. Alexander Bolton, "McConnell: 'Not Appropriate' to Target Iranian Cultural Sites," *The Hill*, 7 January 2020, https://thehill.com/homenews/senate/477187-mcconnell-not-appropriate-to-target -iranian-cultural-sites; and Jordan Carney, "Graham Says He Warned Trump against Targeting Iranian Cultural Sites," *The Hill*, 6 January 2020, https://thehill.com/homenews/senate/477031 -graham-says-he-warned-trump-against-targeting-iranian-culture-sites.

40. Conor Finnegan and Adia Robinson, "World Is Safer Because of Iranian Commander's Death: Secretary of State Mike Pompeo," ABC News, 5 January 2020, https://abcnews.go.com/Politics/world-safer-iranian-commanders-death-secretary-state-mike/story?id=68056187.

41. US Department of Defense, "Press Gaggle with Secretary of Defense Dr. Mark T. Esper and Chairman of the Joint Chiefs of Staff General Mark A. Milley," Transcript, 6 January 2020, https://www.defense.gov/Newsroom/Transcripts/Transcript/Article/2051321/press-gaggle-with-secretary-of-defense-dr-mark-t-esper-and-chairman-of-the-join/. Both Pompeo and Esper are graduates of West Point.

42. Quint Forgey, "'I Like to Obey the Law': Trump Backs Off Threat to Target Iranian Cultural Sites," *Politico*, 7 January 2020, https://www.politico.com/news/2020/01/07/pompeo-us-abide-laws-of-war-targeting-cultural-sites-095525.

43. Mark Nevitt, "Trump's Threat to Target Iranian Cultural Sites: Illegal Under International, Domestic and Military Law," Just Security, 8 January 2020, https://www.justsecurity.org/67961/trumps-threat-to-target-iranian-cultural-sites-illegal-under-international-domestic-and-military-law/.

44. Nevitt, "Trump's Threat."

45. On the "cycle of norm change," see Sandholtz, *Prohibiting Plunder*, 1–29, 261–78.

46. Beth A. Simmons, "Treaty Compliance and Violation," *Annual Review of Political Science* 13, no. 1 (2010): 273–96.

47. For examples see Joseph H. Felter and Jacob N. Shapiro, "Limiting Civilian Casualties as Part of a Winning Strategy: The Case of Courageous Restraint," *Daedalus* 146, no. 1 (2017): 44–58; Ron E. Hassner, "What Do We Know about Interrogational Torture?," *International Journal of Intelligence and Counter-Intelligence* 33, no. 1 (2020): 4–42; Asfandyar Mir, "What Explains Counterterrorism Effectiveness? Evidence from the US Drone War in Pakistan," *International Security* 43, no. 2 (2018): 45–83; and Janina Dill, "Distinction, Necessity, and Proportionality: Afghan Civilians' Attitudes toward Wartime Harm," *Ethics and International Affairs* 33, no. 3 (2019): 315–42.

48. Jennifer M. O'Connor, "Applying the Law of Targeting to the Modern Battlefield," Just Security, 28 November 2016, https://www.justsecurity.org/34977/applying-law-targeting-modern-battlefield-full-speech-dod-general-counsel-jennifer-oconnor/.

29

Practicing the Art of War While Protecting Cultural Heritage: A Military Perspective

Ruth Margolies Beitler

Dexter W. Dugan

While serving in Afghanistan in 2006, a special forces officer briefed Lieutenant General Karl Eikenberry, commander of Combined Forces Command–Afghanistan, about a night raid that his unit was going to conduct. Although Eikenberry did not have operational control of the mission, other units coordinated with him. The special forces unit wanted to capture a Taliban bombmaker responsible for the death of at least two members of their team. When the military located the bombmaker in a village, the unit prepared for a midnight attack. Eikenberry disagreed with this approach, contending that the operation would traumatize the village by raiding at midnight, having loud Blackhawk helicopters circling overhead, and disrespecting the culture by violating women's privacy rules during the search. Even if the bombmaker was captured, the general contended, the exact threat would be replicated in a month, so he suggested apprehending him on the road and not in a village. According to Eikenberry, this anecdote reflects the imperative that "tactics be put in the larger context."[1]

That context is one of protecting cultural heritage while engaged in military operations. Protecting cultural heritage sites has crucial strategic implications due to the symbolic and economic interconnections between cultural sites, artifacts, and populations. These inextricable links can incite populations to participate in actions against military forces when cultural sites are harmed. The US Armed Forces have long recognized the instrumental and moral value of protecting cultural heritage when conducting military operations abroad, yet two factors in recent decades have complicated this task. First, the changing context of modern war has presented new

dilemmas for US military commanders charged with safeguarding cultural heritage. The ever-widening access to digital communications and social media increases the risk that even seemingly minor and unintended harm to cultural heritage can quickly rouse local, regional, and international reactions. Second, the employment of twenty-first-century precision munitions reduces tolerance for collateral damage. Coupled with social media's potential elevation of tactical errors to strategic consequences, such expectations foster host nation resentment of foreign soldiers perceived as insensitive to their most prized cultural beliefs.

Although the law of armed conflict defines cultural property and delineates what armed forces may lawfully target, the US military also needs to be mindful of the broader definition of cultural heritage, the symbolism and economic value of cultural artifacts, and the disconnect between perception and legality. For example, in certain circumstances a mosque may legally be targeted, yet its damage or destruction can evoke reactions that have strategic consequences. Additionally, while an external military force, like that of the United States, might not be involved in damaging cultural heritage, during conflict it may be perceived by the host nation as required to protect cultural sites from attack. Here we define the boundaries of cultural heritage broadly to include cultural artifacts, property, and norms that may not be internationally or legally recognized but carry the potential to ignite passions if damaged or disrespected. This expanded definition is more relevant to practitioners in the fields of diplomacy, development, and defense.

Understanding the ramifications of protecting cultural heritage necessitates critical education and training in cultural awareness. This need, as President Franklin D. Roosevelt understood during World War II, was met by the creation of the US Army's Monuments, Fine Arts, and Archives (MFAA) Section within the Civil Affairs branch; members of the MFAA were more famously known as the "Monuments Men." In 2019, the army revitalized a new generation of Monuments Men, who were credentialed cultural heritage experts trained in military and civil governance. Although promising, these heritage and preservation specialists cannot replace critical cultural heritage awareness training for the mass formations of soldiers, who must be able to identify and preserve cultural heritage during combat operations. The efficacy of this training and that of the heritage and preservation specialist program depend on the US Army's strategic outlook for cultural heritage protection. If limited to a property-based perspective of liability mitigation, the army will not induce institutional change to prioritize the heritage preservation of host nations. However, if it expands its perspective to protect heritage that includes a host nation's intangible traditions and ways of life, the United States will likely significantly improve diplomatic relations with such states.

The chapter explores the modern challenges of protecting cultural heritage sites during military operations and assesses the US Army's current practices and capabilities in this endeavor. It concentrates on recent military operations in Iraq and Afghanistan,

dealing mostly with counterinsurgency operations, in order to explore recent challenges to protecting cultural heritage sites during military operations, particularly the dramatic increases in the speed and proliferation of information and communications technologies. While the discussion focuses on one type of operation, the protection of cultural heritage and cultural awareness are relevant across the spectrum of armed conflict. The chapter concludes with a discussion of various means that the military can employ to ensure the priority of cultural heritage protection.[2]

Twenty-First-Century Challenges

The pervasiveness of social media, the transformation of conflict which includes terrorism, and the use of precision munitions have had substantial effects on cultural heritage and its protection. Since 2001, the United States has been involved in wars that include battling nonstate armed groups, mostly in the Middle East and Central Asia. In both Iraq and Afghanistan such groups have used social media to document the destruction of cultural heritage. Whether it is destroyed as part of a terrorist group's strategy or inadvertently by foreign forces, the ramifications are similar. Although the demolition of cultural heritage has a long history, "what is new is the opportunity that the media revolution provides for the increased impact of destruction, both locally and globally."[3]

Adversaries have used the destruction of cultural heritage as a mechanism of communication. According to David Rapoport, the first wave of modern terrorism during the period of the "anarchists" in the 1880s reflected a novel way to communicate and mobilize people to action.[4] Terrorist groups destroy cultural heritage to expunge the identity of perceived enemies, recruit new followers, illustrate their power, and sow fear throughout the population. During armed conflict, some actors perceive the destruction of their adversary's tangible history and symbolism as connected with military success; in many cases, "conflicts are aimed specifically at the material and symbolic manifestations of ethnic, ethno-national, ideological or religious beliefs."[5] Erasing identities, especially in conflicts where the combatants possess a zero-sum attitude toward each other, serves as part of a group's strategy to communicate their ideology to their followers.

A key challenge for foreign militaries with regard to the protection of cultural heritage is that social media facilitates the immediate dissemination of an armed group's message to its intended audiences. With the changing nature of warfare, "information is a commodity receptive to weaponization, and the information environment has become vital to the success of military operations."[6] The videos of the destruction of cultural heritage by the Islamic State of Iraq and Syria (ISIS, also known as ISIL or Da'esh) have been among their most popular posts, as evidenced by the number of views.[7] The filming and dissemination of beheadings and other extremist acts multiplies an armed group's audience exponentially and imparts its political message. New technology, particularly the video component of communication,

becomes part of the group's strategy of global propaganda.[8] In Iraq, ISIS encouraged the filming of cultural heritage destruction and scripted these demolitions with militants reciting the Quran in front of "idolatrous" sites, while negating any connection those groups have to the cultural identities of those living in the "caliphate."[9]

The rapid circulation of messages has created a dangerous environment for foreign militaries or peacekeepers in a host country. Coupled with the inflammatory videos of a site's destruction, social media includes commentary and explanation of an event from the group's perspective, without regard for facts. Insurgents and terrorist groups mold views concerning the destruction of cultural heritage sites by using blogs encouraging interaction and the development of groups with similar views. Social media creates virtual communities that champion causes and foster allegiances outside national boundaries.[10] The destruction of the Bamiyan Buddhas in Afghanistan in February 2001 illustrates the magnified impact of modern communication on cultural heritage destruction. The Taliban's manipulation of the media by encouraging the photographing and documentation of the demolition reflect its profound understanding of social media's value in achieving its strategic objectives, including global propaganda and recruitment.

The ability of groups to manipulate messages through social media with strategic consequences impacts the efficacy of foreign forces and creates diplomatic tensions in a host country. Governments often perceive foreign forces as protectors of cultural sites and blame them for their destruction, even when foreign forces are not involved. Similar reactions occur when US munitions miss an intended target and inadvertently destroy a cultural site—cell phones capture the devastation and photographic evidence circulates the globe instantaneously. Such an event is no less impactful than when a terrorist or insurgent group destroys cultural heritage. More importantly, networked communication permits individuals to process events and express diverse opinions when sharing the incident through Facebook, Twitter, and other social media platforms. This contrasts with mass communication, which distributes information through central sources, such as state-owned media, that represents news from a particular perspective and where the flow of information is unidirectional.[11]

For foreign forces, even when military manuals set rules for cultural heritage protection, uncertainty and confusion in military operations lead to mistakes. Due to the rapidity with which the ramifications of these errors are captured by social media, outside forces often lack time to ameliorate the fallout. In 2003, the Iraq Museum in Baghdad was looted forty-eight hours after the United States toppled Saddam Hussein's government. Although some Iraqis pushed the Americans to protect the museum during the looting, the initial reaction by US troops was tepid and only occurred after an archaeologist found American marines in a nearby street and brought them to the museum.[12] Its looting reflects the issue of moral hazard. Unlike signatories to the 1954 Hague Convention which had also ratified it and are thereby obliged to protect cultural heritage, the United States, as a signatory only, lacked the pressure of enforcement. Yet

the absence of a robust response to the looting ignited Iraqi anger, amplifying the feeling by the local population that the United States had a responsibility to protect cultural heritage after invading. Significant outcry within the international community underscored the understanding that cultural heritage protection is interconnected with international human rights, as the destruction of cultural heritage is often intertwined with identity destruction.[13]

The impact of social media on US military operations has been significant. When General Eikenberry arrived in Afghanistan in 2002 as the US security coordinator, cell phones were a "luxury item" among the local population. However, when he returned in 2005 and then in 2009 as ambassador, they seemed ubiquitous. He also observed that "no matter where you are, even in the most remote region, there is access to social media." The Taliban's familiarity and deftness with social media continued to grow, posing significant trials for the US military. To combat this phenomenon, Eikenberry contends that commanders must maintain a profound understanding of how US military actions impact the local population, along with a clear recognition that cultural heritage encompasses intangibles such as cultural norms. For example, the US military used dogs to conduct searches, but in Islam dogs have a negative connotation. Additionally, the military conducted searches within family compounds, unwittingly violating female privacy rules. Eikenberry argues that despite any progress made, it only takes "certain camera shots to send you back on your heels."[14]

There are other examples where the US military unintentionally disturbed a culturally significant site. In 2013, according to Lieutenant Kyle Staron, who served as an Afghan National Police development engineer, the US military was overseeing contractors' construction of police stations in Kabul when excavators found a long-forgotten cemetery. Almost immediately, townspeople arrived on the scene and appeared upset by the discovery. They wanted compensation for damaging the cemetery, a request that was frustrating to the US military since, according to Staron, most of the local population had been unaware of the burial site's existence. The military lacked a mechanism to distribute petty cash to manage problems on the ground, but fortunately the local contractor agreed to move the bodies and paid for lunch for the local bystanders at a cost of two hundred dollars. The contractor also paid the imam to consecrate the site where the bodies were relocated. Staron believed that in this case, had social media been more prevalent in the village, "we would have seen a much more dramatic episode in finding those bodies, which would have made the project much more complicated."[15]

Interconnected with the difficulty that increased social media use has posed for US forces with regard to cultural heritage protection, the use of precision munitions has also proven challenging. The US Department of Defense defines a precision munition as a "guided weapon intended to destroy a point target and minimize collateral damage."[16] Diminishing damage to cultural heritage and decreasing the number of civilian casualties provide a critical consequentialist argument for the benefits of such weapons.

For example, during the bombing of Libya by the North Atlantic Treaty Organization (NATO) in 2011, coalition forces used precision munitions to destroy a radar installation that sat atop an ancient Roman fortification without damaging the ruin.

According to Eikenberry, a perception exists that using precision missiles should negate the possibility of ever hitting cultural heritage. Consequently, resentment increases when collateral damage does occur during their use. Although precision weapons have somewhat ameliorated the issue of collateral damage, their implementation remains problematic for cultural heritage. Colonel Andrew Scott DeJesse argues that although the weapons might have "struck targets cleanly" in Iraq, the military must consider second and third order effects of the strikes. For example, during the 2003 invasion, missiles hit the correct targets while also exploding water pipes which flooded adjacent buildings containing cultural heritage. Furthermore, when war was pending, to protect cultural heritage from potential strikes, items were moved and not always carefully tracked. They tended to be destroyed when hidden in government buildings which were targeted during the war. DeJesse's bottom line is that "precision munitions do not negate destruction of cultural heritage property."[17]

The US Army and Cultural Heritage Protection

The destruction of cultural heritage during military operations, whether as intentional acts or collateral damage, has occurred throughout history, with examples from Carthage in 149–146 BCE to numerous cases during World War II.[18] During the latter, President Roosevelt recognized the significance of cultural heritage protection and created the Commission for the Protection of Cultural Treasures in War Areas with military officers, who were subject-matter experts, serving as advisors to commanders in the field.[19] They became members of the MFAA, tasked with creating lists of monuments, works of art, and other cultural heritage to protect during military operations. However, within the US Department of Defense, protecting cultural heritage lacked an institutionalized process and remained a voluntary endeavor until recently.[20]

The US military recognizes the challenges posed by the destruction of cultural heritage, the ramifications of which have been heightened and exacerbated by social media. The US Army's current practices are incorporated in its formal doctrine, roles, and the capabilities developed recently to preserve cultural heritage during military operations.

The US Army's Civil Affairs branch is responsible for executing the mission of cultural heritage preservation with the overall responsibility to improve the army's relationship with local populations and institutions.[21] Deployed soldiers work directly with local government and civilian populations to support activities from providing humanitarian aid to improving the quality of governance.[22] Their efforts in both mitigating the effects of conflict and providing intelligence through civil reconnaissance have made lasting impacts in Afghanistan, Iraq, and Syria. Civil Affairs forces have coordinated with private telecommunications companies in Afghanistan to provide

mobile services and counter improvised explosive devices (IEDs) in Iraq through local networking that has provided critical intelligence.[23]

In 2015, Civil Affairs created the "military government specialist" role to bolster the government capabilities of host nations.[24] The role is designed for experts recruited as US Army Reserve officers to consult with host nation government officials. "Heritage and preservation specialist" is one of the eighteen specializations within this role, along with others such as "energy," "commerce and trade," and "transportation."[25] Although these concentrations should contribute to significant improvements in state capacities for the host nation, the reality of this role conveys a different message.

The US Army has been recruiting experts into their ranks rather than relying on civilian experts from the private sector or other government agencies such as the Department of State.[26] However, demand for these positions has not materialized. Instead of commissioning experts as "military government specialists," recruiters resolved to "getting what they could." A second grade teacher would be recruited as the education specialist, for example, while a local town police officer would be hired as a law and border enforcement specialist, a role reserved for US Army experts who consult with host state officials to better enforce the rule of law.[27] Much of the misguided recruitment for military government specialists to include heritage and preservation specialists is due to the army's lack of resourcing and lack of interest within Civil Affairs. As the branch is comprised of 90 percent reservists, it has had difficulty maintaining strategic and operational relevance with active duty units in theater. Civil Affairs elements are attached to most major deployed formations, yet US Army commanders are not trained to leverage these assets. The Civil Affairs primary staff officer position at each echelon, responsible for advising the commander on all Civil Affairs capabilities, is frequently vacant in deployed units.[28]

Upon assuming the mantle in 2019, Colonel DeJesse, the director of the military government specialist program, has sought to revalidate the military government specialist role, particularly that of cultural heritage and preservation specialists. An accomplished painter, DeJesse redesigned the heritage and preservation specialist program to develop interdisciplinary experts who are academically credentialed in fields related to cultural heritage and also trained in military and civil governance. Branding officers in the specialization as the "new Monuments Men," the program's inception in October 2019 was praised by the media.[29]

Despite the program's public debut, it may be some time before there are major impacts from these new Monuments Men. As of this writing, there are only about twenty credentialed and fully qualified heritage preservation specialists, with another twenty currently in training.[30] A spring 2020 conference to develop doctrine for the redefined military government specialist program was canceled due to the COVID-19 pandemic, further hampering the program's momentum.[31] Even when the new Monuments Men reach a critical mass where expertise can be reliably and consistently leveraged in the field, they might confront challenges similar to those of other Civil

Affairs officers. Their relevance may be questioned by commanders who prioritize lethal force and training local police over Civil Affairs efforts in local governance and cultural heritage preservation.[32] Commanders may also be unaware of the expertise in their formations as they lack the Civil Affairs primary staff officer to inform them about such assets.

If some commanders may be uninformed as to their unit's expertise regarding cultural heritage protection, how can soldiers be equipped to prevent mistakes involving cultural heritage protection? Lower echelon leaders in the US Army are highly skilled in small group tactics and are trained to accept risk and take disciplined initiative while following the commander's intent for accomplishing the mission.[33] This increased initiative fosters agility and adaptability, with forces capable of maneuvering the battlespace within set parameters without having to seek permission for every action. Although this has been a tactical advantage during combat, smaller units may encounter ambiguous situations involving cultural heritage sites and artifacts. Without access to heritage and preservation specialists or any Civil Affairs assets, these soldiers may unknowingly desecrate sites or otherwise unintentionally provoke significant distress among the local population.

There have been numerous widely publicized incidents involving the US Army's failure to preserve cultural heritage during combat operations. With sufficient training to develop a basic understanding of heritage preservation and its significance to the local population, army units might have reconsidered the building of US bases on ancient citadels in Afghanistan, despite the strategic vantage points they offered.[34] Training requires more than simple awareness, as many cultural heritage sites are far less obvious than citadels, mosques, and libraries. For example, if soldiers are informed that a pile of stone in Afghanistan may signify a cemetery, they might avoid parking vehicles or setting up camp upon a sacred burial site.[35]

Beyond awareness and identification, the military has overlooked a psychological issue that necessitates cultural heritage training. American-born citizens are often unaware of the relative youth of their country and culture. The embedded psychological attachment a local population has to traditions spanning centuries can be an alien concept for many Americans.[36] Exploring the profound connection between the people and symbols of cultural heritage will help soldiers and commanders understand the behavior and values of local communities. This heightened understanding of social behavior will improve not only diplomatic ties but will ultimately enhance force effectiveness through better integration with the host nation populace.

Unfortunately, awareness of the US Army's role in cultural heritage protection is severely lacking throughout the military. Even within Civil Affairs, soldiers often are not cognizant that their branch is responsible for cultural heritage protection.[37] During the weeks prior to deployment, soldiers may receive perfunctory guidance about cultural heritage awareness as part of their training in rules of engagement.[38] Although mandatory training outside of the immediate mission set may be enforced, soldiers

understandably do not prioritize it and are seldom afforded the luxury to reflect on what they have learned.

The US Army maintains numerous training schools that could provide a more deliberate learning experience in cultural heritage protection, but the necessary courses are nonexistent. The Special Warfare Center, which trains all special forces, Civil Affairs, and psychological operations soldiers, does not conduct any training in cultural heritage protection.[39] The Combined Arms Center, responsible for the US Army's doctrine and training in combat and occupation, also neglects this topic.[40] Much of the reason for the absence of institutionalized training in cultural heritage protection lies with the US Army's Training and Doctrine Command (TRADOC). There is no Civil Affairs general officer present at TRADOC to generate interest in heritage preservation training as there is for various other doctrine and training centers.[41] If commanders receive any relevant training, it would be designed by the active-duty Judge Advocate General proponent, which has a legal stake in cultural heritage protection. This would provide only a legal context for mitigating damage to cultural heritage, explored later in this section. Without proper advocacy, TRADOC leadership will continue to neglect systemic training for heritage preservation.

Eventually, if TRADOC does consider implementing heritage preservation training, the US Army could generate army-wide interest to a greater breadth of army leaders, rather than limiting it to Civil Affairs or predeployment training. Creating a common core course in cultural heritage within the Intermediate Level Education curriculum, which all Majors must complete, would contribute to generating this universal interest.[42] Including a similar core course in precommand training for future brigade and division commanders would also help this endeavor.

Although implementing the Immediate Level Education and precommand curricula could develop a universal appreciation and respect for cultural heritage across the military, a first step may be as simple as furnishing full-length manuals to leaders and soldiers upon deployment, such as the graphic training aid "Civil Affairs Arts, Monuments, and Archives Guide."[43] Initial research indicates that soldiers believe a full-length manual would be helpful during deployment and would read one if provided. More importantly, although a soldier's prior deployment experience generally increases their cultural heritage awareness, experience alone does not necessarily expand knowledge or efficacy of cultural heritage protection. However, according to the research, all deployed personnel significantly improved in awareness, knowledge, and comfort regarding cultural heritage protection after reading the training manual, regardless of prior deployment experience. Possessing a full-length manual during deployment would allow soldiers to refer to information that they have found difficult to retain, such as how to recover cultural heritage or set up a temporary position at a cultural site.[44]

A key challenge for cultural heritage protection is that proposing training and knowledge resources is moot if senior army leader interests are incompatible.

Understanding the strategic value of cultural heritage protection is critical for the military to prioritize this issue. A candid response from an army leader for the justification of protecting cultural heritage is often to avoid legal prosecution.[45] This reasoning, coupled with the predicted ire of the local population, has been the calculus when considering target locations that include cultural heritage.

The focus of the US Army to simply "mitigate" cultural heritage damage during combat operations undermines the psychological significance of cultural heritage. As discussed, the substantial psychological connection local people associate with ancient cultural traditions fundamentally shapes their identity, norms, and ways of life. A focus on cultural heritage should not rest on the superficial context of mitigating property damage. The context for its preservation should be expanded to encompass local norms and institutions, since understanding the deeper implications of cultural heritage allows the United States to better explain and potentially predict host nation behavior.[46] More importantly, preserving and rebuilding cultural heritage in conflict-ridden states may help to restore stability.[47] While cooperating with a host nation, preserving local mechanisms for the maintenance of the rule of law has also led to greater stability than installing a western liberal democratic ideal for the rule of law. For example, in Afghanistan, utilizing the *jirga* or tribal council proved more effective than foreign imposed measures.

The US Army has had some success implementing proactive measures to protect and rebuild cultural heritage. During a joint exercise with Honduras in the summer of 2017, US Civil Affairs soldiers learned that Honduran brigades were committed to cultural heritage site protection during interdiction missions intended to mitigate drug, weapons, and human smuggling. US soldiers improved their awareness of cultural heritage protection to work with their Honduran counterparts. Consequently, military relations between the United States and states throughout Central and South America were markedly improved.[48] Similarly, in Afghanistan in 2008, the US Department of State coordinated with the German and Afghan governments to restore the famous Herat Citadel.[49] With a three-million-dollar investment from the US Ambassador's Fund for Cultural Preservation, tourism returned to the citadel after thirty-five years of disrepair.[50]

The milestone commitment to restoring the Herat Citadel reflects a positive direction for the United States in proactive cultural heritage protection. That investment was the cost equivalent of deploying three US Army soldiers to Afghanistan for one year, a small amount compared with the strategic benefits.[51]

The Way Forward

Protections for cultural heritage can be improved by increased training and education, augmented partnerships with the host country and subject-matter experts, and enhanced information operations to counter terrorist group messaging. The training of US military personnel to protect cultural heritage is complicated by varying levels of

both understanding and commitment. To serve as a force multiplier by generating goodwill, cultural heritage protection should be planned prior to any military action. Although no guarantee, proper planning can diminish potential backlash, domestic instability, and international criticism.[52] Additionally, empirical evidence exists that failure to prevent looting of cultural artifacts can have strategic ramifications when those artifacts are sold to finance terrorist activities, although the amount of funding procured by the terrorist groups is in question.[53]

To foster commitment to cultural heritage protection, working effectively in another culture requires cultural knowledge and skills, and cross-cultural competence.[54] According to Montgomery McFate, "cultural knowledge of adversaries should be considered a national security priority."[55] With regard to cultural heritage protection, knowledge of the cultures of both friends and foes is critical if the military is to retain support during operations in other countries and project a keen recognition of cultural heritage's significance. Eikenberry emphasizes that military commanders must comprehend the cultural environment in which they operate. Recognizing that "culture does equal politics and politics equal culture," the military must ensure that tactical decisions are informed by military, political, and cultural information.

Cultural knowledge, however, is insufficient for US military personnel to internalize the importance of cultural heritage to a local population. They also need to develop cross-cultural competence, which, even if lacking an in-depth knowledge of another culture, helps foster "the ability to quickly and accurately comprehend, then appropriately and effectively engage individuals from distinct cultural backgrounds to achieve the desired effect."[56] Interconnected with cross-cultural competence is that military leaders must develop critical thinking skills to anticipate fallout from implemented actions.[57]

Developing this competence takes time and, where possible, should be done during training prior to one becoming an officer. At the US Military Academy at West Point, the Conflict and Human Security Studies program places cadets with nongovernmental organizations (NGOs) in developing countries during the summer months to enhance their ability to work effectively in other cultures. An objective of the program is to develop officers who can convey to their soldiers the strategic ramifications of discounting and disrespecting the norms, values, and behaviors of other cultures.

Coupled with developing cross-cultural competence, Laurie Rush recommends bolstering the relationship between host-country personnel and the military. General Stanley McChrystal stresses empathy and a long-term approach with the host country as well, warning against what he calls the "airport syndrome" of nearsighted priorities that could result from short deployment rotations.[58] To accomplish this, it is critical for the US military to learn which local cultural protections are available and with which key personnel to partner.[59] DeJesse emphasizes that partnering with local experts, such as those in museums, is the best training for soldiers and necessary for greater understanding of what a culture values.[60] Additionally, enhanced training should allow

commanders on the ground decision-making authority to bypass certain bureaucratic processes to save cultural heritage, which often is time sensitive.[61] Eikenberry underscores the requirement of building a database over time that details cultural heritage locations of mosques, cemeteries, and even the location of a village elder's home. His bottom line is that commanders must know which locations, if searched or attacked, could provoke an explosive reaction.[62]

Similarly, Rush stresses the necessity of a broader interpretation of cultural heritage by recognizing that local communities value cultural heritage that might be absent from lists. A commander's failure to understand the significance of such formally unrecognized heritage "could very well be interpreted as an act of hostility and provoke violent retribution." In addition, military commanders must acknowledge that the local population, not external powers, ascribes value to cultural heritage. Continuing with this concept of broader interpretation of cultural heritage, Rush advances an example of vineyards in Iraq and Afghanistan, which have important symbolic and economic value for the populations. According to the Quran, the destruction of these economic assets during warfare is forbidden and, if damaged, can heighten resentment toward the forces involved.[63]

Another illustration reflects the importance of cooperation between military and civilian counterparts to protect cultural heritage. When unrest surfaced in Libya in March 2011 as part of the Arab Spring sweeping the Middle East and North Africa, the US National Committee of the Blue Shield, an NGO, gathered information on important cultural heritage sites. The US government partnered with civilian institutions, particularly Oberlin College and New York University, to formulate Cultural Property Protection Lists, which were eventually passed to the special assistant to the US Army Judge Advocate General for Law of War Matters and Air Combat Command. These lists were transferred to the Department of Defense and shared with international partners such as the United Kingdom.[64] In this case, entering relevant information into a target database, coupled with the use of precision weapons, limited damage to the Roman fort Ra's al-Marqab.

Along with enhancing partnerships, Peter Chiarelli and Stephen Smith highlight the need to dominate the narrative in any operation, which is critical to successful US military operations in the twenty-first century. The vulnerability of information weaponization has strategic consequences for military operations. Dramatic improvements in technologies "allow instantaneous global transmission of information—and thus provide the potential to create weapons of almost unimaginable destruction."[65]

How adversaries and allies perceive war is critical even when the perception defies reality, as exemplified by the tactical defeat of the North Vietnamese during the TET offensive in 1968 that was perceived by Western powers as a strategic victory for the north.[66] In that particular case, the North Vietnamese precipitated over one hundred attacks on South Vietnam, which was allied with the United States, to pressure the latter

to end its support of South Vietnam and leave the region. The alliance held, but US public opinion further turned against the war.

The military performs for two audiences: "a global space where the world judges US actions and a domestic space where democratic citizens must remain convinced that action is necessary."[67] As Michael Danti notes, the use of social media platforms provides "near continuous streams of potential data and updates," although these are also "interspersed with distortions, rumor, propaganda, and deliberate misinformation." In other cases, as information is being shared and forwarded, people add spurious details which leads to an "obfuscating snowball effect."[68] As such, it is critical for the United States to develop capabilities to counter these threats.

The US Army acknowledges the importance of strategic communications and crafting messages that sway the audience to support the military's objective.[69] The concept of strategic communications is a vital element of US grand strategy and, along with the evolution of warfare, communications that formerly derived solely from the press and media but currently also emanate from the Internet. Even military manuals have changed to highlight that victory is critical in the war of ideas. As state and nonstate actors manipulate both domestic and global opinion through social media, the US military must respond with information operations to counter the adversary. In 2007, the US military fostered the use of the Internet in earnest and by 2009 military bases stopped blocking the use of Twitter, Facebook, and Flickr after Secretary of Defense Robert Gates and other high-level military officials articulated both the US deficiency in this area and the significance of communicating a particular narrative to the outside world. To combat the effective use of social media by adversaries, the US military needs a cohesive communications strategy that encompasses social media. This recognition is contributing to improvements in the military's information operations.[70]

Conclusion

Significant twenty-first-century challenges have complicated cultural heritage protection during military operations. The increased use of social media provides instantaneous viewing and propagandizing of cultural heritage destruction, while precision munitions heighten the expectation that cultural heritage will be spared during armed conflict. This perspective often leads to increased resentment and frustration when sites are not protected or become what the military refers to as "collateral damage." The US Army has created the modern-day Monuments Men to bolster the military's commitment to cultural heritage protection, but the topic will not be prioritized without mass training of soldiers to recognize and comprehend the strategic significance of cultural heritage protection, along with persuading commanders that cultural heritage protection has strategic value.

The US military has recently made positive strides in expanding the strategic context for preserving cultural heritage and adapting to twenty-first-century challenges, though much still needs to be accomplished. If prioritized, working with local military

personnel and civilians to protect and preserve not only cultural heritage but also cultural norms will continue to improve foreign relations and increase the effectiveness of overseas missions for the United States. A more universal cross-cultural competence, rather than specific cultural awareness training, will better equip military forces to adapt to situations involving cultural heritage preservation. Concurrently, damage to cultural heritage can be better anticipated and mitigated by understanding the impact of precision munitions on cultural heritage, and by networking with allies and local officials to identify accurately the locations of cultural heritage in areas where military operations will occur. Finally, including information warfare and social media into all types of military operations will help the United States protect the narrative of cultural heritage preservation against adversaries who leverage events and pictures for their own gains. Aside from further examination to improve incentives, skills, and resources for military forces to better preserve cultural heritage, future research on the ramifications of long-term occupations on cultural heritage protection will benefit the field.

SUGGESTED READINGS

Michael D. Danti, "Ground-Based Observations of Cultural Heritage Incidents in Syria and Iraq," *Near Eastern Archaeology* 78, no. 3 (2015): 132–41.

Jose Antonio González Zarandona, César Albarrán-Torres, and Benjamin Isakhan, "Digitally Mediated Iconoclasm: The Islamic State and the War on Cultural Heritage," *International Journal of Heritage Studies* 24, no. 6 (2018): 649–71.

Jeffrey A. Jacobs, "Integrate Civil Affairs into Institutional Army," *Army* 66, no. 4 (2016): 20–22.

Joris D. Kila and Christopher V. Herndon, "Military Involvement in Cultural Property Protection: An Overview," *Joint Forces Quarterly* 74, no. 3 (2014): 116–23.

Christina M. Knopf and Eric J. Ziegelmayer, "Fourth Generation Warfare and the US Military's Social Media Strategy: Promoting the Academic Conversation," *Air and Space Power Journal—Africa & Francophonie* 3, no. 4 (2012): 3–22.

Laurie W. Rush and Amanda Hemmingsen, "Partner of Choice: Cultural Property Protection in Military Engagement," *Military Review* 98, no. 6 (2018): 103–19.

Leedjia Svec, "Cultural Heritage Training in the US Military," *SpringerPlus* 3, no. 126 (2014): 1–10.

NOTES

1. Lieutenant General Karl Eikenberry (former US ambassador to Afghanistan, retired from the US Army), interview with authors, 23 October 2020.
2. The authors want to thank General Eikenberry for his initial abstract and close collaboration on the chapter.
3. Claire Smith, "Social Media and the Destruction of World Heritage as Global Propaganda," Inaugural Lecture, Proceedings of the II International Conference on Best Practices in World Heritage: People and Communities, International Institute for Conservation of Historic and Artistic Work, 2015, 29, https://core.ac.uk/download/33108062.pdf.

4. David Rapoport, "The Four Waves of Rebel Terror and September 11," *Anthropoetics* 8, no. 1 (2002), http://anthropoetics.ucla.edu/category/ap0801/.

5. Smith, "Social Media," 27, 32.

6. Christina M. Knopf and Eric J. Ziegelmayer, "Fourth Generation Warfare and the US Military's Social Media Strategy: Promoting the Academic Conversation," *Air and Space Power Journal— Africa & Francophonie* 3, no. 4 (2012): 5.

7. Jose Antonio González Zarandona, César Albarrán-Torres, and Benjamin Isakhan, "Digitally Mediated Iconoclasm: The Islamic State and the War on Cultural Heritage," *International Journal of Heritage Studies* 24 no. 6 (2018): 650.

8. Smith, "Social Media," 37.

9. Michael D. Danti, "Ground-Based Observations of Cultural Heritage Incidents in Syria and Iraq," *Near Eastern Archaeology* 78, no. 3 (2015): 138.

10. Knopf and Ziegelmayer, "Fourth Generation Warfare," 14.

11. Smith, "Social Media," 35.

12. John F. Burns, "A Nation at War: Looting; Pillagers Strip Iraqi Museum of Its Treasure," *New York Times*, 13 April 2003, https://www.nytimes.com/2003/04/13/world/a-nation-at-war-looting -pillagers-strip-iraqi-museum-of-its-treasure.html. See also Corine Wegener, "The Looting of the Iraq National Museum and the Future of Cultural Property During Armed Conflict," *The SAA Archaeological Record* 10, no. 4 (2010): 28–30, http://digital.ipcprintservices.com/publication/?i =47726&article_id=505045&view=articleBrowser.

13. Matthew D. Thurlow, "Protecting Cultural Property in Iraq: How American Military Policy Comports with International Law," *Yale Human Rights and Development Law Journal* 8, no. 1 (2005): 156.

14. Eikenberry, interview with authors.

15. Captain Kyle Staron (US Army Civil Affairs military government specialist) interview with Dexter Dugan, 15 October 2020.

16. Quoted in Congressional Research Service, "Defense Primer: US Precision-Guided Munitions," *In Focus*, updated 4 June 2021, https://crsreports.congress.gov/product/pdf/IF/IF11353.

17. Andrew Scott DeJesse (38G program director, Strategic Initiatives Group, US Army Civil Affairs and Psychological Operations Command, Airborne), telephone interview with authors, 9 December 2020.

18. Joris D. Kila and Christopher V. Herndon, "Military Involvement in Cultural Property Protection: An Overview," *Joint Forces Quarterly* 74, no. 3 (2014): 117.

19. Laurie W. Rush, "Cultural Property Protection as a Force Multiplier in Stability Operations: World War II Monuments Officers Lessons Learned," *Military Review* (March–April 2012): 37.

20. Rush, "Cultural Property Protection as a Force Multiplier in Stability Operations," 37–38.

21. Assad A. Raza, "Order from Chaos: Inside US Army Civil Affairs Activities," *Military Review* 99, no. 6 (2019): 26.

22. Department of the Army, *Field Manual 3–57 Civil Affairs Operations* (Washington, DC: Department of the Army, April 2019), 2–9.

23. Raza, "Order from Chaos," 21–22.

24. Jim Tice, "Reserve Officers Sought for New Civil Affairs Specialty," *Army Times*, 8 June 2015, https://www.armytimes.com/news/your-army/2015/06/08/reserve-officers-sought-for-new-civil -affairs-specialty/.

25. Department of the Army, *Field Manual 3–57*, 2–10.

26. Captain Matthew Salyer (US Army Civil Affairs military government specialist), interview with Dexter Dugan, 24 September 2020.

27. DeJesse, phone interview with authors.

28. Jacobs, "Integrate Civil Affairs into Institutional Army," *Army* 66, no. 4 (2016), 20.

29. Ralph Blumenthal and Tom Mashberg, "The Army Is Looking for a Few Good Art Experts," *New York Times*, 21 October 2019, https://www.nytimes.com/2019/10/21/arts/design/new-monuments -men.html. See also Colonel Andrew Scott DeJesse, "US Army Creates Cultural Heritage Task Force," interview by Leila Fadel, *NPR*, 3 November 2019, https://www.npr.org/2019/11/03/ 775907337/u-s-army-creates-cultural-heritage-task-force; and Jenae Barnes, "Modern-Day 'Monuments Men': Smithsonian, US Army Partner to Preserve Culture amid War," ABC News, 9 November 2019, https://abcnews.go.com/Politics/modern-day-monuments-men-smithsonian-us -army-partner/story?id=66614432.

30. DeJesse, interview with authors.

31. Salyer, interview with Dugan.

32. Raza, "Order from Chaos," 24.

33. Department of the Army, *Mission Command: Command and Control of Army Forces*, Army Doctrine Publication 6-0 (Washington, DC: Department of the Army, July 2019), 1–12.

34. DeJesse, interview with authors.

35. See interview with Rush: "Laurie Rush: Saving Culture amid Combat," *Military History* 34, no. 6 (2018): 11.

36. Laurie W. Rush and Amanda Hemmingsen, "Partner of Choice: Cultural Property Protection in Military Engagement," *Military Review* 98, no. 6 (2018): 103.

37. Gregory Williams, "Civil Affairs Soldiers Learn to Become Guardians of History," US Army, 8 January 2014, https://www.army.mil/article/117999/civil_affairs_soldiers_learn_to_become _guardians_of_history; and DeJesse, interview with authors.

38. Captain Kyle A. Staron (US Army Civil Affairs military government specialist), interview with Dugan, 15 October 2020.

39. James R. Ahern, "Cultural-Heritage Aspect of Stability Ops: The US Army Reserve Civil Affairs' Role," *The Officer* 86, no. 2 (2010): 59; and DeJesse, interview with authors.

40. Ahern, 59.

41. Jacobs, "Integrate Civil Affairs," 21–22; and Jeffrey Jacobs (former commanding general, US Army Civil Affairs and Psychological Operations), interview with authors, 30 December 2020.

42. Ahern, "Cultural-Heritage Aspect," 59.

43. Ahern. See also Department of the Army, "Civil Affairs Arts, Monuments, and Archives Guide," doc. no. GTA 41-01-002, 1 August 2009, and the updated version of October 2015.

44. Leedjia Svec, "Cultural Heritage Training in the US Military," *SpringerPlus* 3, no. 126 (2014): 5, 8.

45. DeJesse, interview with authors; and Jacobs, interview with authors.

46. Rush and Hemmingsen, "Partner of Choice," 103.

47. DeJesse, interview with authors.

48. Rush and Hemmingsen, "Partner of Choice," 117.

49. Eikenberry, interview with authors.

50. Deb Riechmann, "Restored Citadel Is Symbol of Hope in Afghanistan," *Boston Globe*, 17 October 2011, http://archive.boston.com/news/world/asia/articles/2011/10/17/restored_citadel_is_symbol _of_hope_in_afghanistan/.

51. Eikenberry, interview with authors.

52. Kila and Herndon, "Military Involvement in Cultural Property Protection," 116, 117.

53. See Matthew Sargent et al., *Tracking and Disrupting the Illicit Antiquities Trade with Open-Source Data* (Santa Monica, CA: RAND Corporation, 2020), https://www.rand.org/content/dam/rand/ pubs/research_reports/RR2700/RR2706/RAND_RR2706.pdf.

54. Yvette Foliant, *Cultural Property Protection Makes Sense: A Way to Improve Your Mission* (The Hague: Civil-Military Cooperation Center of Excellence, CCOE, 2015), 5–6.

55. Montgomery McFate, "The Military Utility of Understanding Adversary Culture," *Joint Forces Quarterly* 38, no. 4 (2005): 43.

56. Foliant, *Cultural Property Protection*, 5.
57. Peter W. Chiarelli and Stephen M. Smith, "Learning from Our Modern Wars: The Imperatives of Preparing for a Dangerous Future," *Military Review* (September–October 2007): 10.
58. Stanley McChrystal (former commanding general, US Joint Special Operations Command), interview with authors, 22 December 2020.
59. Rush, "Cultural Property Protection," 38.
60. DeJesse, interview with authors.
61. Rush, "Cultural Property Protection," 39–40.
62. Eikenberry, interview with authors.
63. Rush, "Cultural Property Protection," 38, 41.
64. Kila and Herndon, "Military Involvement in Cultural Property Protection," 120.
65. Chiarelli and Smith, "Learning from Our Modern Wars," 3, 9.
66. Chiarelli and Smith, "Learning from Our Modern Wars," 10.
67. Knopf and Ziegelmayer, "Fourth Generation Warfare," 4.
68. Danti, "Ground-Based Observations," 133, 134.
69. James G. Stavridis, "Strategic Communication and National Security," *Joint Forces Quarterly* 46 (2007): 4.
70. Knopf and Ziegelmayer, "Fourth Generation Warfare," 5, 8, 9.

30

Peace Operations and the Protection of Cultural Heritage

Richard Gowan

International peacekeepers have witnessed attacks on cultural heritage since the earliest days of United Nations peacekeeping. In 1948, the UN Security Council mandated the UN Truce Supervision Organization (UNTSO) to observe the armistice that ended the first Arab–Israeli war. The armistice line ran through Jerusalem, where Jordanian forces held the Old City and holy sites. Both sides were responsible for damage to historical buildings.[1] The Jordanians used synagogues in the Jewish quarter of the Old City as stables, while Israeli troops used churches on the front line as barracks. In 1954, new fighting erupted in Jerusalem, and while UNTSO observers tried to mediate cease-fires, Arab officials accused the Israelis of bombarding religious sites. The Lebanese permanent representative to the UN in New York complained to the Security Council that shells had hit the Old City's medieval citadel and Armenian monastery, and fallen close to the Church of the Holy Sepulcher.[2]

With just a handful of military observers on the spot, UNTSO had neither the mandate nor the resources to focus on cultural heritage issues. But in the decades since, peacekeeping forces have grown in size and ambition. There are currently approximately 125,000 troops and police serving in over sixty peace operations run by the UN, the North Atlantic Treaty Organization (NATO), and other multilateral organizations worldwide, many with significant military resources and expansive mandates to protect civilians in danger.[3]

These forces have also continued to encounter threats to cultural heritage. Fifty years after the clash over the Old City of Jerusalem, German peacekeepers faced another outbreak of violence in another "Jerusalem," this time in Kosovo. Since 1999 NATO forces had been patrolling what was then still a province of Serbia, in order to keep the peace between ethnic Albanians and Serbs. Yet in March 2004, Albanian rioters attacked a series of Serb communities and religious sites, including Serbian Orthodox churches dating back to the fourteenth century. Serb priests and polemicists had often described

both Prizren and Kosovo as a whole as their Jerusalem, reflecting the wealth of religious architecture in the region. But the German contingent stationed in Prizren was unable or unwilling to protect this heritage: "There were reports of soldiers stepping away from their checkpoint positions as mobs approached. According to one persistent rumour, troops guarding one of Prizren's religious buildings asked a mob for time to remove their own equipment from it before the mob burned it down. The violence left 'the pearl and Jerusalem of Kosovo' a disfigured, mutilated and blackened remnant."[4]

This crisis in Kosovo, described further below, came after dismal failures by international forces to protect heritage cites elsewhere. In Afghanistan and Iraq, the United States and its allies proved unwilling to secure museums and heritage sites from epidemics of looting after intervening in 2001 and 2003, respectively. These episodes fueled a lengthy debate, driven by the UN Educational, Scientific and Cultural Organization (UNESCO) and concerned countries, most notably Italy, about the role of international stabilization and peacekeeping missions in protecting cultural heritage. In June 2017 when the Security Council passed resolution 2347, its first general resolution on cultural heritage, sponsored by France and Italy, it affirmed that UN peacekeepers should, where appropriate, engage in "the protection of cultural heritage from destruction, illicit excavation, looting and smuggling in the context of armed conflicts."

Resolution 2347 was an important normative advance in discussions of peacekeeping and heritage. But as this chapter shows, its concrete impact to date has been limited. The Security Council has not followed up consistently, and the UN has not put heritage at the heart of its thinking on peace and security. Other multilateral organizations, including NATO and the European Union (EU), have also developed new policy guidance on heritage issues, but it is still not clear that this will be a priority for future peace operations.

Advocates of the protection of cultural heritage therefore need to redouble their efforts to convince policymakers at the UN and other multilateral organizations that heritage protection relates to three key aspects of peace operations. The first is that protecting heritage sites is tied to efforts to protect vulnerable civilians in conflict-affected areas. Second, the longer-term process of persuading the leaders of divided societies to agree to preserve heritage can be an important part of developing political settlements after war. And third, at a lower level, projects to reconstruct heritage sites can draw broken societies together. This chapter uses examples from past and current peace operations—including those in Cyprus and Mali in addition to Kosovo—to make this case, and it concludes with very brief thoughts on how to advance this agenda.

Protecting Cultural Heritage: Still Not a Peacekeeping Priority?
Discussions of protecting cultural heritage through peace operations have not resulted in comparable results on the ground. In 2013, the Security Council directed the UN Multidimensional Integrated Stabilization Mission in Mali (MINUSMA) "to assist the Malian authorities, as necessary and feasible, in protecting from attack the cultural and

historical sites in Mali, in collaboration with UNESCO."[5] This was the first time that the council had used such language in a peacekeeping mandate, and it reflected widespread international outrage over jihadist groups' attacks on Muslim sites around Timbuktu in 2013. But MINUSMA had only limited resources to put its mandate into practice. Two officials at mission headquarters in the Malian capital, Bamako, were tasked with identifying how to realize the council's instructions, although they were also responsible for environmental issues.[6] While MINUSMA's civilian component did launch useful projects to assist its peacekeepers and local communities in the rehabilitation of Timbuktu, described further below, the United States persuaded other Security Council members in 2018 that this was no longer a priority, and it was cut from the mandate.

Resolution 2347's broader injunction on peace operations to protect heritage also bore little fruit. To date, the council has not referred to this task in any UN mission other than MINUSMA. And since 2017, it has not even held a thematic debate on threats to cultural heritage—as a general issue or a peacekeeping priority. As of mid-2021, the UN Department of Peace Operations' internal think tank (the Policy, Evaluation and Training Division) had no staff member focusing on heritage.[7]

Other multilateral institutions have arguably outpaced the UN in developing relevant policy. NATO published guidance on what it calls "cultural property protection" in 2019.[8] In May 2021, the European Council (the EU's top intergovernmental organ) agreed on "conclusions on [the] EU approach to cultural heritage in conflict and crises," which included a call for a "dedicated mini-concept" on what the bloc's crisis operations could do in this area.[9] But these advances, while welcome, may have a limited impact. NATO, a major player in stabilization operations in the Balkans and Afghanistan, has now largely pivoted away from peacekeeping to refocus on its original role of deterring Russia in Europe. EU missions are mainly small security advisory efforts, lacking the muscle to provide security for cultural heritage sites directly. The European Council indicates that their focus is likely to be on "capacity building programmes or training activities."

By contrast, the UN continues to deploy over ninety thousand uniformed personnel worldwide and also acts as a hub for new policy thinking for other organizations fielding large-scale peace operations, such as the African Union. The UN's reluctance toward protecting cultural heritage is, therefore, not only troubling in its own right but also likely to influence other actors and thus requires explanation.

There are two main reasons for the UN's ambivalence. One is that Italy, the key proponent of resolution 2347, left the Security Council at the end of 2017, and no other member replaced it as a champion of cultural heritage, so the topic lost salience in UN debates. The second is more fundamental: diplomats and officials at the UN and other multilateral organizations worry that peace operations are overloaded with tasks. The Security Council regularly directs UN forces to address not only basic, but also human rights and gender issues as well as a host of other concerns. In 2018, UN Secretary-General António Guterres told council members that one UN mission—in South Sudan—had accumulated 209 tasks.[10] Comparing these to baubles weighing down a Christmas

tree, he pleaded with diplomats to simplify these mandates. It was against this backdrop that the United States persuaded other powers to drop cultural heritage from MINUSMA's mandate. This relatively new tasking may have looked like a more or less expendable point in contrast to well-established priorities such as human rights.

It is thus incumbent on those who believe that peacekeepers *should* concentrate on protecting cultural heritage to make a compelling case for why it should be a priority for troops, police, and civilians in difficult and often dangerous places. This needs to be framed not solely in terms of the inherent value of cultural heritage, but also in terms that make sense to those who direct and lead peace operations. Discussions of peace operations are distinct from those about the steps militaries should take to avoid damage to cultural heritage in wartime. While peacekeepers can use force to deal with violent groups, peacekeeping is not warfighting. UN and other forces may deploy to create stability in conflict zones, but they do not aim for victory in a traditional military sense. The goal of most operations is either to freeze a conflict while warring sides look for a political settlement—a process that can last indefinitely (UNTSO is still on the ground in the Middle East today)—or back the implementation of a peace agreement. International officials are humble about what peacekeepers can achieve, especially where parties to a conflict are not ready to make concessions to secure long-term peace. "A peacekeeping operation is not an army, or a counter-terrorist force, or a humanitarian agency," Secretary-General Guterres told the Security Council in 2018. "It is a tool to create the space for a nationally-owned political solution."[11]

Against this backdrop, UN officials have highlighted three main priorities for peace operations. First, insofar as missions use military force, the primary goal should be saving civilians facing imminent violence—a moral priority reinforced by the memories of past peacekeeping failures in the Balkans and Rwanda—and, where possible, deterring such violence before it begins. Second, missions should concentrate on the "primacy of politics," focusing their efforts on creating the best possible conditions for conflict parties to compromise. And third, for the citizens of conflict-affected states to feel real ownership of the resulting political bargains, peacekeepers should invest in community-level engagement to rebuild fractured societies rather than simply deal with political elites (an approach dubbed "people-centered peacekeeping").

It is in this context that the case for treating the protection of cultural heritage as a priority must be made. The rest of the chapter endeavors to make this case by exploring protection, politics, and people-centered approaches in turn, highlighting not only the military potential of peace operations to defend heritage sites, but also the importance of missions' civilian and political components. Although international media tend to highlight the successes and failures of the UN's photogenic "blue helmets," most peace operations involve sizeable civilian components as well. In early 2021, for example, MINUSMA employed not only 15,209 soldiers and police, but also 3,384 civilian staff.[12] This included logisticians and administrative staff, but also civil affairs officers, political advisers, and others who can contribute to preserving cultural heritage. Peace

operations also work closely with agencies including the UN Educational, Scientific and Cultural Organization (UNESCO) that offer further civilian expertise. Peacekeeping is not a solely military task—and its most effective contributions to heritage protection may often not be military at all.

Protection: Confronting Political Threats to Cultural Heritage

How can protecting cultural heritage contribute to broader efforts to halt and deter threats to civilians? The clearest case study of the problem in recent decades was in Kosovo, despite NATO's failure to protect Serbian Orthodox sites in Prizren in 2004. NATO troops and UN police were deployed to Kosovo in 1999 after a NATO-led air campaign and a conflict had already resulted in major damage to Kosovo's heritage. As the International Crisis Group (ICG) noted in early 2001, "Serb forces destroyed 218 mosques" in the relatively small territory in the late 1990s, and ethnic Albanian fighters launched reprisals including dynamiting Serbian Orthodox churches dating from the fourteenth and fifteenth centuries.[13] Nonetheless, culturally important Orthodox monasteries and churches remained, including four that are now collectively listed as a UNESCO World Heritage Site ("Medieval Monuments in Kosovo"). NATO recognized that it was necessary to secure them, as well as ethnically Serb towns and villages across Kosovo, to stem violence and discourage at least some ethnic Serbs from fleeing the area.

It was clear from the start that this was politically sensitive and potentially dangerous work. Canadian peacekeepers, for example, deployed to the monastery of Gračanica. This was not only one of the finest examples of ecclesiastical architecture in the region, with frescoes dating from the 1320s, but also the base of Bishop Artemije, a relatively moderate figure who had argued against ethnic violence but was still a target for Albanian radicals. The Canadians found themselves dealing with an unseen opponent—soon dubbed the "Mystery Mortar Man"—who would "set up on a hill, drop five or six mortar bombs, splash them down in the area of the monastery, and then disappear."[14] These small-scale attacks failed to either do serious damage to the monastery or to force the bishop to flee, but created a "political hullabaloo" as Serb leaders condemned NATO for failing to protect the monastery and the bishop effectively.

NATO and the UN nonetheless faced a shock in 2004 when ethnic Albanians—angry at slow progress toward independence for Kosovo and at economic problems—launched a wave of attacks on Serb communities and religious sites. In some cases, ethnic Serbs retreated to churches for sanctuary. Concerned for their own safety and for the lives of these civilians, NATO contingents had to make rapid judgments about how to react. Their choices differed: as we saw, German troops in Prizren took no such risks, whereas an Italian unit guarding a church in the town of Djakovica (in Serbian, Gjakova in Albanian) faced a particularly stark choice between protecting the building and protecting the lives of civilians inside. The Italians "opened fire to protect the church and four elderly Serb women living there. Nine rioters were wounded. The NATO troops

escaped with the Serbs, after which the crowd further damaged the church and burned down the women's homes."[15]

These events in Kosovo—where order was only restored after thirty churches had been damaged, some severely—remind us that protecting cultural heritage is not a risk-free mandate for peacekeepers. Nonetheless, they also illustrate why peacekeeping forces should see protecting cultural heritage and protecting civilians as interwoven challenges. In many conflict zones, combatants target cultural sites associated with their adversaries for obvious symbolic reasons: destroying a community's holy places or other historical sites is one step toward extirpating that community from a region altogether. "Many Serbs felt that the Albanians were trying to remove all evidence that Serbs had ever lived in Kosovo," the ICG observed of the destruction of Orthodox religious sites after the 2004 events.[16] In more practical terms, religious sites in particular become targets when vulnerable civilians flee to them for shelter in a crisis.

In this context, effectively protecting cultural heritage sites may be a way that peacekeepers can keep violence from escalating. A robust security presence at symbolically important sites may signal to potential bad actors that acts of violence are not worth attempting. After the 2004 events, NATO continued to provide direct security for thirteen Orthodox churches and monasteries as late as 2013.[17] As noted below, international political efforts reduced the need for this presence, but NATO personnel still maintain a post at one vulnerable monastery today, Dečani.

It is nonetheless hard for a peace operation to dedicate military resources to such tasks for extended periods. Both before and after the 2004 events, NATO leaders in Kosovo were keen to shift from a strategy of static defense of religious sites (relying on checkpoints) to a more agile posture requiring less manpower.[18] In Mali, UN officials concluded that they lacked troop strength to provide general security for heritage sites, as one told French researcher Mathilde Leloup, "the wording of the Security Council Resolution is confusing as it talks about 'sites in Mali' without mentioning anything specific. However, MINUSMA is not deployed everywhere in Mali and there are many historical and cultural sites outside our area of deployment."[19]

This cautious assessment should not come as a surprise. Although the Security Council and UN officials have emphasized the need to protect civilians from violence, peacekeepers are often unable or reluctant to do so in a crisis. Limited resources, poor intelligence, and a desire to avoid casualties are all factors. These issues are also likely to dog future attempts to construct mandates for peace operations that offer direct physical protection to cultural heritage, and it would be prudent to assume that peacekeepers will only ever fulfill this demanding task on a selective and limited basis.

Protection: Confronting Nonpolitical Threats to Cultural Heritage

Notwithstanding their limits in the face of political violence, peacekeeping operations can protect cultural heritage sites and the communities around them against other potential forms of damage and destruction. This can include technical work to remove

hazards like land mines and unexploded ordnance that threaten both heritage sites and civilians. In Afghanistan, NATO forces and UN demining specialists were able to take important steps toward rehabilitating the site of the Bamiyan Buddhas, destroyed by the Taliban in 2001. "An archaeologist commented how good the mine clearers were at excavating archaeological artefacts," according to one expert on the Buddhas, as "the care and delicacy they had learned in mine clearance was the perfect translatable skill."[20]

A broader task is to protect heritage sites and communities from *criminal* violence. As resolution 2347's emphasis on "illicit excavation, looting and smuggling" underlines, looters and traffickers are likely to target sites during conflicts and their immediate aftermath. This ties into another recurrent headache for peacekeepers and peacemakers: organized crime. "Transnational organized crime is a serious threat to long-term stability and/or undermines the establishment of functioning legitimate institutions in almost every theater where there are UN peace operations," as one study of the subject notes.[21] It is hard to offer genuine protection to civilians in areas where criminal gangs and networks threaten their day-to-day security. While these networks traffic humans, drugs, and multiple other products, looted archaeological and cultural artifacts are frequently in the mix.

Protecting cultural heritage sites—and by extension the communities around them—from criminal threats is a serious challenge for peace operations. Peacekeeping forces often lack intelligence and expertise on criminal actors. Some forces have, however, chosen to respond robustly to the threat of looting. Italian Carabinieri police officers in Iraq in the wake of the 2003 US-led invasion responded especially energetically to this problem. In reaction to widespread looting of archaeological sites in their area of responsibility, the Italians resorted to dramatic measures to take the culprits by surprise: "The Carabinieri would conduct raids using three helicopters coordinating together. On these raids the helicopters would approach the site from three directions. At the edge of the site, Carabinieri troops would slide down ropes to the ground, causing the looters to flee from them across the site. The helicopters would then fly to the opposite side of the site and land, trapping the looters between the helicopters and the advancing Carabinieri, who would capture them."[22]

The looters apparently found this experience "terrifying" but the Italian approach still had limitations. The sheer number of potential archaeological sites involved, the weakness of Iraqi security forces, and the need for helicopters for other missions meant that the Carabinieri were unable to stamp out looting during their tour of duty. Moreover, few current peace operations have the sort of resources available to the international force in Iraq in 2003—costly assets such as helicopters are often in short supply and some non-Western units are poorly equipped. But less well-resourced peace operations can still contribute to limiting the threat of looting by supporting the efforts of UNESCO and local authorities to combat trafficking. In Mali, MINUSMA has funded

antilooting projects and worked with local police to train guards for archaeological sites.[23]

Facing both political and nonpolitical threats, therefore, peace operations should recognize that protecting cultural heritage is—at least in some cases—a significant part of responding to both challenges. Rather than treat it as a distraction, planners and leaders should factor threats to heritage sites into their strategies for dealing both with threats to the security of civilians and with crime. Nonetheless, as the cases above indicate, providing physical protection to heritage sites can create risks for missions and strain their resources in ways that cannot continue indefinitely. This is one reason it is essential to focus on political and community-level approaches to heritage protection.

Political Approaches to Heritage Protection

If peace operations can offer only limited physical protection for cultural heritage, they may also facilitate more political approaches to the problem. As noted, UN thinking on peace operations now aims to create space for national ownership of political solutions. It is necessary to ask how the future of cultural heritage sites can be factored into political processes enabled by peace operations. Here again Kosovo offers a model.

In the wake of the 2004 riots, Western powers concluded that it was necessary to expedite the territory's formal independence from Serbia to avoid further disorder, while Russia and China argued against this in the Security Council. In the meantime, international officials recognized that it was necessary to frame Serbian Orthodox sites as possible loci for Serb–Albanian cooperation rather than conflict. Operating in parallel to NATO and the UN, the Council of Europe (a pan-European organization separate to the EU) launched a new Reconstruction Implementation Commission for the Balkans that brought together the Serbian Orthodox Church with Kosovo's fledgling (and ethnic Albanian–dominated) ministries to collaborate on rebuilding damaged buildings. A UN envoy, former Finnish president Martti Ahtisaari, worked up a plan (known colloquially as the "Ahtisaari Plan") for "conditional independence" for Kosovo, which proposed that the new country's police take responsibility for protecting most Serb religious sites. This also offered the Serbs some guarantees about the future of these sites, including the creation of surrounding "protective zones"—areas free from construction projects and other harmful activities—and reaffirming their ties to the Serbian Orthodox hierarchy.

The UN proposal sent Kosovo's ethnic Albanian leaders a clear message that they would be judged on how effectively they safeguarded Serbian Orthodox heritage. After Kosovo declared independence unilaterally in 2008, committing to fulfill Ahtisaari's proposal on cultural heritage, the United States and its European allies backed the creation of a new International Civilian Office to oversee the nascent state's behavior. The process was not entirely smooth. Serbia launched a prolonged diplomatic war of attrition with Kosovo within UNESCO over the status of the sites, including opposing the Kosovo government's efforts to join the organization in 2015.[24] Ethnic Albanians felt that the International Civilian Office was excessively focused on safeguarding Serb

heritage (implicitly relegating the importance of its Muslim heritage) and that the Ahtisaari Plan's proposal for protective zones granted "extraterritoriality to the Serb Orthodox Church and Serbia within the territory of Kosovo."[25] Perhaps as a result, there was an uptick in security incidents at Orthodox sites after 2008.[26]

Yet for all these complaints and objections, the Ahtisaari Plan achieved its basic goal: the Kosovo authorities have succeeded in preserving Serb Orthodox sites from further serious violence, allowing NATO to draw down its security presence around most of them. The monasteries and churches are also once again open to tourists. Kosovo and Serbia continue to try to negotiate a final settlement of their differences but have to date agreed to leave the issue of cultural heritage sites to one side. In essence, both parties have recognized that it is in their political interest to ensure the security of these sites rather than treat them as targets for symbolic violence.

The UN, the EU, and other multilateral actors have attempted to frame the preservation of cultural heritage as a focus for political cooperation in other divided societies, most notably Cyprus. UN peacekeepers originally deployed to the former British colony to manage violence between the Greek and Turkish populations in the 1960s. In 1974, the Turkish military invaded the north of the island, leaving the UN Peacekeeping Force in Cyprus (UNFICYP) to patrol the cease-fire line, or green line, dividing the country. Since the late 1970s, Cypriots and international observers alike have recognized that cooperation over cultural heritage could help ease tensions between the north and south of the island. In the 1980s, the authorities in the divided capital Nicosia agreed to work together on reconstruction projects.[27] Then, in 2007, UNFICYP and the EU brokered talks between the Greek and Turkish Cypriot authorities on the future of Famagusta, a port town famous for its Venetian architecture and as the setting for Shakespeare's Othello. The following year, the EU and other international actors supported the creation of a bicommunal Technical Committee on Cultural Heritage in Cyprus, modeled in part on the Reconstruction Implementation Commission in Kosovo. UNFICYP's direct role in many of these activities has been limited, as it is a small mission with a relatively straightforward cease-fire monitoring role. Nonetheless, its continuing security presence is the basis for other parts of the UN system, including UNESCO and the UN Development Programme, and human rights experts to monitor heritage-related issues.

As yet, intercommunal discussions of challenges such as the preservation of Famagusta remain incomplete, as Greek and Turkish Cypriot leaders have been unable to agree on plans to reunify the island. Heritage preservation in isolation is unlikely to offer a pathway to political settlements in divided societies. Nonetheless, the protection of heritage is one potential bargaining point in a wider political process. Moreover, the act of discussing heritage issues may reshape negotiators' perceptions of their opponents. Carlos Jaramillo, a technical specialist who worked on both the Reconstruction Implementation Commission in Kosovo and the Technical Committee on Cultural Heritage in Cyprus, observes that such heritage-related mechanisms require "a

redefinition of identity, nationality and ethnicity that is inclusive and participatory in order to replace the polarized vision currently separating something [heritage] that is indivisible."[28]

Jaramillo admits that this is not yet a reality in Cyprus, and that political dialogue and compromise may offer a more sustainable approach to securing the future of cultural heritage sites than does physical protection. This is a promising area for policy development. The EU's External Action Service (its foreign ministry) noted in 2021 that "the EU should seek to include cultural heritage as an important aspect in dialogue and mediation efforts, as a direct or a cross-cutting issue, considering its strong symbolic importance for both the State and its local communities."[29]

People-centered Peacekeeping and Protecting Cultural Heritage

While the cases of Kosovo and Cyprus may illustrate the advantages of a political approach to heritage protection through peace operations, some international officials and peacekeeping experts might argue that they are not relevant to many current conflicts. In both cases, peacekeepers have aimed to reconcile distinct ethnic communities: Serb/Albanian and Turkish/Greek. They have also been able to negotiate with reasonably coherent political actors and institutions based on European models. These conditions do not apply in cases such as Mali, where state institutions are weak and conflict involves multiple and often incoherent factions.

In such cases, peacekeeping experts have encouraged the UN and other institutions to look for ways to promote peace below the level of national politics, by reaching out to local leaders, grassroots organizations, and nonstate actors. It is difficult for large-scale peace operations to respond to local actors flexibly, as they are often explicitly mandated to reinforce state authorities. When it comes to protecting cultural heritage in particular, there is a risk that international actors can seem more attached to safeguarding "world heritage" for its own sake than addressing local needs and preferences. One critic of UN efforts to reconstruct religious sites in Mali notes that some local inhabitants believe the international community is more concerned about preserving the image of the city as a cultural center than the population's needs and concerns.[30]

Nonetheless, the case of Mali also offers evidence that peacekeeping missions can take a more people-centered approach to heritage protection. This has been carefully documented by Mathilde Leloup, who notes that once MINUSMA's leadership had concluded that the mission could not fulfill its heritage-protection component through military means, there was "more proactive engagement from its civilian component."[31] In the first instance, this involved providing logistical support to UNESCO officials and other experts on cultural issues. One former staff member jokes that the mission became "Air MINUSMA" in its early years, ferrying these experts around the country on transport aircraft and helicopters.[32] Nonetheless, the small office tasked with dealing

with cultural heritage developed more innovative—and people-focused—approaches to meeting the mandate.

These included triangulating with UNESCO officials to offer local communities support in recovering from attacks by jihadists. In one case, a MINUSMA official discovered that UNESCO had plans to restore a war-damaged mosque in Timbuktu, but not the building next door used for ritual ablutions. MINUSMA was able to fund the restoration of the latter. Leloup notes that the peacekeepers were able to take on this task speedily, as the mission (like most UN operations) had a budget for quick impact projects (QIPs): small, local initiatives aimed at improving relations with communities without the rigmarole associated with most large-scale development projects. MINUSMA also used QIPs funding to support antipillaging efforts and restore manuscript libraries damaged by the jihadists. UN officials saw a direct connection between these contributions to reconstructing heritage and boosting of social cohesion after conflict, and offering livelihoods to young people who might otherwise have joined armed groups for cash.[33]

This local approach to heritage management echoes past initiatives in the Balkans and elsewhere, where the UN and other international organizations saw small heritage management projects as vehicles for reconciling ethnic groups. Most of these projects focused not on the best-known cultural sites in post-conflict areas—which might suffer more damage from a botched if well-intentioned project—but on secondary sites that may have greater local than international resonance. These projects have a potential to facilitate community-level reconciliation after conflict, and peace operations are well placed to get them going.

Conclusion

This chapter has made two connected arguments about why and how peace operations can best contribute to the protection of cultural heritage. First, there are direct links between heritage protection and the three overarching priorities for peace operations (and especially UN missions) today—protection of civilians, enabling political processes, and taking a people-centered approach to post-conflict societies. This claim has been designed to appeal to professional peacekeepers and peacemakers as well as heritage experts. A UN official with absolutely no cultural sensitivities should be able to see that heritage sites are significant factors in her or his political and security work. An architectural historian or archaeologist with no interest in mediation or military patrols should, conversely, see the potential utility of working with the UN or NATO.

The second argument has been that the political and civilian work of peace operations may be equally or more important than their military components in the long term. This is not meant to suggest we discount the military dimension of protection altogether. During the early drafting of this chapter in late 2020, Russian peacekeepers were deployed to end the conflict between Armenia and Azerbaijan over the long-contested enclave of Nagorno-Karabakh. As Azerbaijani forces moved to take over

previously Armenian-held territory, the Russians had to work out how to protect medieval Armenian Christian sites such as the twelfth-century monastery of Dadivank. "As I spoke with the monastery's abbot," a *New York Times* correspondent noted while Russian troops tried to secure the area, "the monastery's guard house below went up in flames."[34] In some cases, military tools are essential to creating stability around heritage sites. Yet, as this chapter has shown, these tools need to be embedded in longer-term political–civilian protection strategies.

If the UN—and other multilateral organizations that take policy ideas from the UN—are to advance these arguments, it is time for the Security Council to take up the case for cultural heritage protection again after an unfortunate hiatus since 2017. The year 2022 will mark the fifth anniversary of resolution 2347. It would be fitting for the council to hold a fresh debate on the topic and ask UN Secretary-General Guterres to report on developments in the field of heritage protection—and how to better integrate this task into the work of both UN and non-UN peace operations to save lives, forge political settlements, and work to assist the vulnerable.

SUGGESTED READINGS

International Crisis Group, *Collapse in Kosovo* (Brussels: International Crisis Group, April 2004).

Carlos Jaramillo, "Famagusta, Cyprus: Cultural Heritage and the Center of Political and Cultural Contestation," in *Cultural Contestation*, ed. Jeroen Rodenberg and Pieter Wagenaar (London: Palgrave Macmillan, 2018).

Mathilde Leloup, "Heritage Protection as Stabilisation, the Emergence of a New 'Mandated Task' for UN Peace Operations," *International Peacekeeping* 26, no. 4 (2019): 408–30.

Frederik Rosén, *NATO and Cultural Property: Embracing New Challenges in the Era of Identity Wars* (Copenhagen: Nordic Center for Cultural Heritage & Armed Conflict, CHAC, 2017).

John M. Russell, "Efforts to Protect Archaeological Sites and Monuments in Iraq, 2003–2004," in *Catastrophe! The Looting and Destruction of Iraq's Past*, ed. Geoff Emberling and Katharyn Hanson (Chicago: Oriental Institute Museum of the University of Chicago, 2008).

NOTES

1. Andrew Gregory Theobald, "Watching the War and Keeping the Peace: The United Nations Truce Supervision Organization (UNTSO) in the Middle East, 1949–1956," PhD diss., Queen's University, Ontario, Canada, May 2009, 79, https://www.worldcat.org/title/watching-the-war-and-keeping-the-peace-the-united-nations-truce-supervision-organization-untso-in-the-middle-east-1949-1956/oclc/932839938?referer=di&ht=edition.
2. UN Security Council, "Letter Dated 5 July 1954 from the Alternate Representative of Lebanon on the Security Council Addressed to the President of the Security Council," UN doc. S/3264, 7 July 1954.
3. Timo Smit, *Multilateral Peace Operations in 2020: Developments and Trends* (Stockholm: Stockholm International Peace Research Institute, 26 May 2021).
4. ICG, *Collapse in Kosovo* (Brussels: International Crisis Group, 22 April 2004), 20.
5. UN Security Council, resolution 2100, 25 April 2013.

6. Mathilde Leloup, "Heritage Protection as Stabilisation, the Emergence of a New 'Mandated Task' for UN Peace Operations," *International Peacekeeping* 26, no. 4 (2019): 421.

7. Correspondence with UN official, 12 April 2021.

8. See NATO, "Cultural Property Protection," updated 17 March 2021, https://www.nato.int/cps/en/natohq/topics_166114.htm.

9. Council of the European Union, "Outcome of Proceedings: Council Conclusions on EU Approach to Cultural Heritage in Conflicts and Crises," doc. no. 9837/21, 21 June 2021, https://data.consilium.europa.eu/doc/document/ST-9837-2021-INIT/en/pdf.

10. UN News, "Unrealistic Demands on UN Peacekeeping Costing Lives and Credibility—Guterres," 28 March 2018, https://news.un.org/en/story/2018/03/1006181.

11. UN News, "Unrealistic Demands on UN Peacekeeping."

12. United Nations Peacekeeping, "MINUSMA Fact Sheet," https://peacekeeping.un.org/en/mission/minusma.

13. ICG, *Religion in Kosovo* (Brussels: International Crisis Group, 2001), 14.

14. Sean M. Maloney, *Operation Kinetic: Stabilizing Kosovo* (Lincoln, NE: Potomac Books, 2018), 186–87.

15. ICG, *Collapse in Kosovo*, 47.

16. ICG, *Collapse in Kosovo*, 11.

17. Frederik Rosén, *NATO and Cultural Property: Embracing New Challenges in the Era of Identity Wars* (Copenhagen: Nordic Center for Cultural Heritage & Armed Conflict, CHAC, 2017), 23.

18. Richard Gowan, "Kosovo: In Search of a Public Order Strategy," in *The Annual Review of Global Peace Operations 2006*, ed. Ian Johnstone (Boulder, CO: Lynne Rienner, 2006), 25.

19. Leloup, "Heritage Protection as Stabilisation," 419.

20. Llewelyn Morgan, *The Buddhas of Bamiyan* (Cambridge, MA: Harvard University Press, 2012), 200–201.

21. Walter Kemp, Mark Shaw, and Arthur Boutellis, *The Elephant in the Room: How Can Peace Operations Deal with Organized Crime?* (New York: International Peace Institute, 2013), 6.

22. John M. Russell, "Efforts to Protect Archaeological Sites and Monuments in Iraq, 2003–2004," in *Catastrophe! The Looting and Destruction of Iraq's Past*, ed. Geoff Emberling and Katharyn Hanson (Chicago: Oriental Institute Museum of the University of Chicago, 2008), 36–37.

23. Julia Stanyard and Rim Dhaouadi, *Culture in Ruins. The Illegal Trade in Cultural Property, Case Study: Mali* (Pretoria, South Africa: ENACT, November 2020), 3.

24. Stefan Surlić, "Constitutional Design and Cultural Cleavage: UNESCO and the Struggle for Cultural Heritage in Kosovo," *Croatian Political Science Review* 54, no. 4 (2017): 118–21.

25. Lorika Hisari and Kalliopi Fouseki, "Post-war Cultural Heritage Preservation in Kosovo: Rethinking the Implementation of Ahtisaari Plan Annex V," *Heritage* 3, no. 1 (2020): 103.

26. Surlić, "Constitutional Design and Cultural Cleavage," 117.

27. See Susan Balderstone, "Cultural Heritage and Divided Cyprus," in *Cultural Diversity, Heritage and Human Rights*, ed. Michele Langfield, William Logan, and Mairead Nic Craith (London: Routledge, 2009).

28. Carlos Jaramillo, "Famagusta, Cyprus: Cultural Heritage and the Center of Political and Cultural Contestation," in *Cultural Contestation*, ed. Jeroen Rodenberg and Pieter Wagenaar (London: Palgrave Macmillan, 2018), 165.

29. Council of the European Union, "Cover Note: Concept on Cultural Heritage in Conflicts and Crises. A Component for Peace and Security in European Union's External Action," doc. no. 9962/21, 18 June 2021.

30. Omar Ba, "Contested Meanings: Timbuktu and the Prosecution of the Destruction of Cultural Heritage as War Crimes," *African Studies Review* 63, no. 4 (2021): 12.

31. Leloup, "Heritage Protection as Stabilisation," 419.

32. Conversation with author, 12 June 2021.

33. Leloup, "Heritage Protection as Stabilisation," 421–24, 423.

34. Anton Troianovski, "Layers of Tragedy, in a Cemetery and in the Mountains," *New York Times*, 18 November 2020.

31

Protecting Cultural Property in Armed Conflict: The Necessity for Dialogue and Action Integrating the Heritage, Military, and Humanitarian Sectors

Peter G. Stone

Where they burn books, they will in the end burn people.[1]

This chapter explores cultural property protection (CPP) in armed conflict and is written through the lens of the international nongovernmental organization (NGO) the Blue Shield, an advisory body to the UN Educational, Scientific and Cultural Organization (UNESCO) Committee for the Protection of Cultural Property in the Event of Armed Conflict. It addresses five interrelated issues. First, the role, mission, and aspirations of the Blue Shield are outlined, which emphasize the need for partnership between the heritage,[2] humanitarian, and uniformed sectors; the latter include armed forces, police, customs, and emergency services. Second, the perhaps unexpectedly long history of CPP as a concept is sketched, with practical implications for those involved in armed conflict. Third, partly drawing on this history, the chapter discusses why the uniformed and humanitarian sectors should be interested in CPP, and what the heritage sector needs to do to gain traction with these, at first glance perhaps unlikely, bedfellows. Fourth, it outlines some of the key threats to cultural property in the event of armed conflict. Finally, it looks to the future role of CPP in armed conflict.

Since the early 2000s, the protection of cultural property has become a topic of increased interest. This follows its use, manipulation, and destruction during the fighting in the former Yugoslavia in the 1990s, its targeting in conflicts in Afghanistan

and Iraq since the early 2000s, and the more recent extremes of the self-proclaimed Islamic State of Iraq and Syria (ISIS, also known as ISIL or Da'esh). Despite this rising interest, almost no attention was paid to CPP during the political or military planning of the 2003 invasion of Iraq by the coalition led by the United States and the United Kingdom.[3] When the International Committee of the Red Cross (ICRC), perhaps the world's leading humanitarian organization, was contacted in early 2003 regarding the protection of some of the world's earliest cultural property spread across Iraq, its response was that the ICRC concentrated on the protection of people and did not want to introduce confusion by also working to protect cultural property.

The Blue Shield

The Blue Shield was created in 1996 by the International Council on Archives (ICA), the International Council of Museums (ICOM), the International Council on Monuments and Sites (ICOMOS), and the International Federation of Library Associations and Institutions (IFLA), known as the "Founding Four" organizations. It is established as an international NGO under Dutch law that is "committed to the protection of the world's cultural property, and is concerned with the protection of cultural and natural heritage, tangible and intangible, in the event of armed conflict, natural- or human-made disaster."[4] The Blue Shield currently comprises nearly thirty national committees, a number growing all the time, and an international arm, Blue Shield International (BSI), which comprises a board elected by the national committees and the Founding Four, and a small secretariat (one full-time and one part-time staff member, currently based at and funded by Newcastle University in the United Kingdom). The Blue Shield is committed to joint action, independence, neutrality, professionalism, and respect of cultural identity, and is a not-for-profit organization.[5]

The primary context for the Blue Shield is international humanitarian law (IHL), and in particular, the 1954 Hague Convention for the Protection of Cultural Property in the Event of Armed Conflict and its two protocols (1954 and 1999). It also works more generally within the context of the UN (e.g., Security Council resolutions 2199, 2347, and 2368) and UNESCO's cultural conventions and wider cultural protection strategy. It is also informed by international initiatives regarding natural/human-made disasters, such as the Sendai Framework for Disaster Risk Reduction. The organization has chosen to expand its remit from solely the protection of tangible cultural property during armed conflict, as identified in Article 1 of the 1954 Hague Convention, to one acknowledging that *all* cultural property, tangible and intangible, cultural and natural, is a crucial foundation for human communities. With this in mind, BSI coordinates and sets the framework for its own work and that of the national committees through six areas of activity: policy development; coordination within the Blue Shield and with other organizations; proactive protection and risk preparedness; education, training, and capacity building; emergency response; and postdisaster recovery and long-term activity.[6] All its work emphasizes the indivisible link between the protection of people

and their cultural property, and the idea that such cultural property is the tangible and intangible link to the past that helps to provide individuals and communities with a sense of place, identity, belonging, and through these, well-being, giving people a reason for living. Undermining this by allowing, or, worse, causing, the unnecessary destruction of cultural property removes a fundamental building block for the delivery of healthy, peaceful, secure, and sustainable communities.

The World Health Organization defines health as "a state of complete physical, mental and social well-being and not merely the absence of disease or infirmity" and notes that "the health of all peoples is fundamental to the attainment of peace and security and is dependent on the fullest co-operation of individuals and States."[7] The Blue Shield prioritizes the safety and social, mental, and economic well-being of people and their communities, but emphasizes that the protection of their cultural property is an indivisibly intertwined factor contributing to their well-being.

Over the last decade there has been a growing realization within the Blue Shield that, in order to help sustain such communities impacted by armed conflict, it must work across the heritage, humanitarian, and uniformed sectors to emphasize the importance of, and value to, these sectors' *own* agendas of integrating good cultural property protection into their thinking and practice. Strong and stable communities are prime goals for both the uniformed and humanitarian sectors. CPP cannot be a heritage-only aspiration, for if it remains so, it is doomed. To this end the Blue Shield has developed formal agreements with uniformed, humanitarian, and heritage partners, including the ICRC, the North Atlantic Treaty Organization (NATO), the UN peacekeeping force in Lebanon, and, in process, UNESCO. This structure is depicted in the following diagram (fig. 31.1).

The three points of the triangle show the interdependence of the three sectors, with the internal "safe space" within the triangle available for dialogue to mutually understand the importance of good CPP to the goals and aspirations of all three sectors

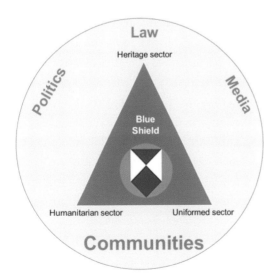

Figure 31.1 Structure of the work of the Blue Shield. The three points of the triangle show the interdependence of the three sectors, with the internal "safe space" within the triangle available for dialogue to mutually understand the importance of good cultural property protection to the goals and aspirations of all three sectors.

and to identify proactive actions relating to all sectors to implement good CPP. The triangle is set within the wider context of political, legal, and media influences, and, of critical importance, communities.

In order for this relationship to work, and for the uniformed and humanitarian sectors to take CPP seriously, there are three key factors that the heritage sector needs to take into account. First, CPP has to be presented in such a way that it fits existing uniformed and humanitarian agendas, and not as a heritage-specific (read "irrelevant") additional burden. This means emphasizing the indivisible link between the protection of people and their cultural property. Allowing or causing the unnecessary destruction of cultural property can undermine military and/or humanitarian mission success, whereas incorporating CPP can help achieve successful outcomes. The social, mental, and economic well-being of individuals and communities must be prioritized, but the case must equally be made that CPP is an intertwined, significant, contributory activity helping to achieve this priority. Second, the heritage sector must acknowledge the constraints under which the uniformed and humanitarian sectors work, understanding their existing priorities and concerns. And third, to be effective the partnership must be developed in *peacetime*, working for the long, medium, and short term, which will continue during armed conflict and post-conflict stabilization, and which clearly shows the importance of CPP to the uniformed and humanitarian agendas and how it can fit their existing practice. The Blue Shield refers to this as the "4 Tier Approach."[8]

This approach is bearing fruit, and the rather negative response noted above from the ICRC in 2003 has also changed. Yves Daccord, then the ICRC director-general, stated in 2020 that "protecting cultural property and cultural heritage against the devastating effects of war unfortunately remains a humanitarian imperative, today perhaps more than ever."[9]

A Brief History of Cultural Heritage Protection

Military theorists and commentators have discussed the methods by which war should be fought for millennia. The bulk of these writings have related to what we might now refer to as the humanitarian aspects of war, which is part of what militaries refer to as the "law of armed conflict" (LOAC). This includes the treatment of civilians and military prisoners, whether it is permissible to target civilian property, and whether it is either permissible or good military practice to destroy crops and/or other means of survival and livelihood.[10] One of the earliest of these authors was the Chinese theorist Sun Tzu, writing around the sixth century BCE.[11] He was very clear that fighting in war should be an absolute last resort: it was much better to defeat an enemy without spilling the blood of noncombatants or destroying property or crops, as, put simply, the defeated would be more willing to accept their fate if their country was left intact. In his writing, Sun Tzu almost anticipates the thirteenth-century writings of St. Thomas Aquinas discussing what became known as "just war theory": when a war should be waged and if it could be justified (*jus ad bellum*), and how it should be waged (*jus in bello*).[12] Neither author

specifically mentioned CPP during conflict, but it can be seen as an implicit extension of their wider arguments.

Despite such theoretical writings, for hundreds if not thousands of years, soldiers were frequently paid by being allowed to loot indiscriminately. Echoing Sun Tzu and Aquinas, a number of commentators—including the ancient Greek historian Polybius,[13] the seventeenth-century Dutch polymath Hugo Grotius,[14] and the nineteenth-century Prussian military theorist Carl von Clausewitz[15]—argued against such action, stressing that it contributed to the likelihood of future conflict and did the victors no credit. Such theorists were not alone: for example, a number of French artists and architects signed letters condemning the looting of Italian art by Napoleon, citing the importance of the original intended location and context for the art.[16]

The first practical record known to the author of such concern appears in the 1385 Durham Ordinances, a code of discipline for the English army drawn up immediately prior to King Richard II's invasion of Scotland. This was essentially a general *jus in bello* document that also included particular instructions not to plunder religious buildings on pain of death (the same sentence as identified for rape).[17] The protection of religious buildings and their contents is given effectively equal status in the code to the protection of people. While the authors may not have recognized it as such, cultural property protection had been explicitly written into an early example of national LOAC or humanitarian law.

Jumping forward, CPP was first enshrined in modern LOAC in the 1863 Instructions for the Government of Armies of the United States in the Field, known as the Lieber Code. Again, this was essentially a LOAC/humanitarian document that covered the usual array of humanitarian issues, as noted above. Its primary purpose was to define what was acceptable, or not, for Union soldiers during the later American Civil War and beyond. It was thus an explicitly military document, outlining military humanitarian responsibilities, and, in Article 35, stated that "classical works of art, libraries, scientific collections . . . must be secured against all avoidable injury."[18] A number of later international LOAC documents, e.g., the Hague Conventions of 1899 and 1907,[19] also included articles relating to CPP. These were all essentially military/humanitarian treaties that included CPP as an element of good practice in *jus in bello*. Given this history of the inclusion of CPP as a small part of wider treaties regarding the humanitarian conduct of conflict, it seems somewhat surprising that the modern humanitarian sector has generally failed to include such protection within its remit.

World War I saw the unprecedented destruction of cultural property, partly through the increase in scale and impact of munitions compared to earlier conflicts, and partly through the broadening of war to include bombardment of towns, both to target military factories and supply lines and to lower morale among the general population. The war also saw positive action. In 1915 a *Kunstschutz* (art protection) unit was created in the German army for the protection of historical buildings and collections (although its influence appears to have been fairly negligible).[20] More specifically, in capturing

Jerusalem in 1917, the British commander of the Egyptian Expeditionary Force, General Edmund Allenby, issued a proclamation stating that "every sacred building, monument, holy spot, shrine, traditional site . . . of the three religions will be maintained and protected."[21] And, showing a nuanced understanding of cultural sensitivities, he ensured that Muslim troops from the Indian army under his command were deployed to protect important Islamic sites. Someone on Allenby's staff was thinking about which sites needed protection to ensure a smooth occupation and which troops were best to use. This is an excellent example of CPP as good military practice. It took no additional forces and made no difference to the British as to which troops protected sites and places, as they all needed something to do. However, the use of Muslim troops showed sensitivity to the beliefs and values of a large section of the local population, thereby helping to "disarm" those who might think about opposing the occupation (fig. 31.2).

It was not until the 1935 Treaty on the Protection of Artistic and Scientific Institutions and Historic Monuments, known as the Roerich Pact,[22] that CPP became the subject of its own international law. It states in Article 1: "The historic monuments, museums, scientific, artistic, educational and cultural institutions shall be considered as neutral and as such respected and protected by belligerents." Unfortunately, the treaty was not taken up by the majority of the international community; it was signed by only twenty-one states, all in the Americas, and ratified by only ten.

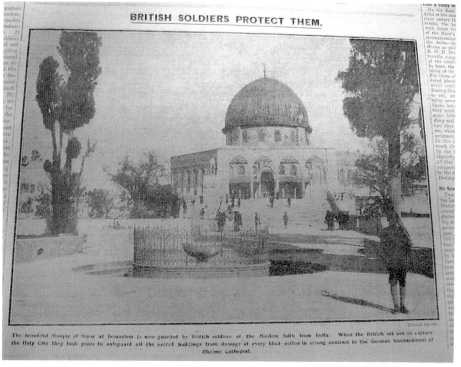

Figure 31.2 Protection of the Mosque of Omar in Jerusalem in 1917 by Muslim troops in the British Expeditionary Force. Image: © Courtesy of The Northumberland Gazette

The international heritage sector was still debating how better to protect cultural property on the eve of World War II, despite and perhaps because of the enormous damage to European cultural property, mainly along the Western Front, in World War I, and partly prompted by discussion of the Roerich Pact. During the war itself, cultural property protection was seen as the direct responsibility of the combatants, and the Western Allies and some elements of Axis forces took this duty seriously. In the German army, the Kunstschutz unit continued to operate, although much of its activity appears to have been more related to looting than protection.[23] The Monuments, Fine Arts, and Archives (MFAA) unit was created within the Western Allied armies, and these "Monuments Men"—and women—made enormous efforts to protect cultural property in all theaters of war where the Western Allies fought.[24] Importantly, the unit had the full backing of General Dwight D. Eisenhower, the supreme Allied commander in the Western European theater from 1943.[25] Regardless of LOAC, without the explicit support of senior officers such as Allenby and Eisenhower, introducing cultural property protection into military thinking would have been a significantly more difficult, if not impossible, task. Critically, both generals saw a *military* reason for CPP: Allenby using it to undermine potential unrest and Eisenhower to establish a positive spin on invasions that were, by their very nature, without doubt going to destroy large amounts of cultural property.

During World War II, many cultural sites, buildings, and private and public collections were, of course, destroyed, but where possible, a fair amount was done to limit the destruction and, following the war, much pillaged material was restored to prewar ownership by the Western Allies. While the scale of destruction was partially the result of the increased power of munitions, it was also due to decisions taken by both sides to target cultural property as a means of warfare, actions that today might be regarded as war crimes, such as in the Western Allies' raids on Lübeck, Germany, in March 1942 and the so-called Baedeker raids carried out in retaliation on historical targets in England.[26] The international heritage sector, reacting to the intentional and collateral devastation of much of Europe by the war, built on the inclusion of CPP in previous, more general treaties and, in 1954, developed the Hague Convention. Along with its protocols, it remains the primary piece of LOAC/IHL relating to cultural property protection.

Unfortunately, almost in parallel with the development of the convention, a key part of its potential practical support was dismantled. Article 7 requires countries to "establish in peacetime, within their armed forces, services or personnel" structures to implement CPP, yet at the end of the war the Allied Monuments Men went back to their civilian lives and, apart from somewhat limited awareness, e.g., in US Civil Affairs units, little remained of the military's interest in cultural property protection.

Equally detrimental to protection, the heritage sector's relationship with the military all but disappeared. Admittedly, some limited protection work was done, such as during the fighting in the former Yugoslavia in the 1990s.[27] And the international heritage

sector responded to the deliberate targeting of, and damage to, cultural property during these conflicts, and during the UN-sanctioned Operation Desert Storm of 1991 against Iraq, by producing the Second Protocol to the 1954 Hague Convention in 1999. However, it was not until the 2003 invasion of Iraq that CPP was brought back into sharp focus. Astonishingly, neither the United States nor the United Kingdom had ratified the convention at the time of the invasion. The United States ratified it in 2009,[28] though neither of the protocols. The United Kingdom ratified all three in 2017.

Another initiative is worth mentioning, as it may partially explain the previous reluctance of the modern humanitarian sector to engage with CPP. In the late 1940s, Polish lawyer Raphael Lemkin produced an early draft of what was to become the 1948 Convention on the Prevention and Punishment of the Crime of Genocide.[29] Lemkin invented the term *genocide* and in his early drafts wanted to include two forms of the crime: *barbarity*, defined as "the premeditated destruction of national, racial, religious and social collectivities," and *vandalism*, or cultural genocide, defined as the "destruction of works of art and culture, being the expression of the particular genius of these collectivities."[30] He was forced to drop "vandalism" at a meeting of the UN General Assembly's Sixth Committee (which deals with legal issues) on 25 October 1948, following twenty-five votes in favor of its omission to sixteen against, and four abstentions.[31] One factor was the resistance of countries with large Indigenous populations, whose governments feared that a legal prohibition against cultural genocide might be used against them by those populations for past sins. Regardless of the reason, the removal of cultural genocide from the convention must surely have been, perhaps subconsciously, a factor in the failure of the humanitarian sector to acknowledge cultural property protection as part of its remit. While CPP can be seen to have a long history as a small part of what would now be described as LOAC/IHL, until very recently its impact on most military and humanitarian practice has been limited, as it has not been regarded by either sector as contributing to the success of their activities.

Why Should Cultural Property Protection Matter to the Military and Humanitarians?

Many of the general problems faced by coalition forces in 2003 stemmed from the political decision to limit drastically the number of troops deployed. This was exacerbated by the failure of those planning the invasion to understand the importance of cultural property to Iraqi society, and thus its importance to military mission success. The planners therefore failed to insist on enough troops to ensure good cultural property protection.[32] A further, uncomfortable, contributing factor was the loss of the close relationship between the military and heritage sectors that had existed during World War II. If the military was unaware of the importance of cultural property, much blame needs to be placed with the heritage sector. Attempting to raise such awareness a few months before the invasion was too little, too late.[33] In 2002 and 2003, those advocating for the protection of cultural property by coalition troops met with

occasionally sympathetic but essentially deaf ears. Such advocates, the author included, started from the wrong point of view. We argued for the protection of cultural property because they were important *heritage* assets. While individual officers often sympathized, they did not see the value of protecting such places and things from a *military* perspective. We failed to make our case that such protection could contribute to the military mission, and we were therefore ignored as others made better cases for prioritizing the limited troop numbers for other activities.

This overlapped with the heritage sector's failure over the same period to position CPP as a key concern of the humanitarian sector, failing to make the case for the indivisible relationship between the protection of people and the protection of their cultural property. Once rebuffed by the ICRC, we accepted that the humanitarian sector was not interested, slowly learned from our mistakes, and reached out. The Blue Shield now endeavors to address these shortcomings and to influence, develop, and maintain a strong relationship with the uniformed and humanitarian sectors. It argues that CPP is important to the military and humanitarian sectors for six reasons.

First, people matter: cultural property protection is about the people, the population around and among whom any uniformed deployment takes place, and who are the primary focus for humanitarian organizations. As suggested above, the protection of people, enshrined as a military responsibility in wider LOAC/IHL, is indivisibly intertwined with the protection of their cultural property. This indivisibility was underlined, for example, in the fighting in the former Yugoslavia in 1992, when the slaughtered Muslim community of Brčko was buried in a mass grave sealed by the remains of its totally destroyed mosque,[34] and by similar attacks on the Yezidi population and their cultural property by ISIS, starting in 2014.[35]

Second, legal responsibilities are a humanitarian imperative. Any military or humanitarian mission must be fully aware of its legal responsibilities with regard to cultural property protection under IHL, and in particular the 1954 Hague Convention and the 1977 Additional Protocols to the 1949 Geneva Conventions;[36] international human rights law (where the former UN special rapporteur for cultural rights suggests making access to heritage a universal human right[37]); international customary law; and in certain situations international criminal law, in particular the 1998 Rome Statute of the International Criminal Court.[38] Understanding the overlap between the law of cultural property protection and more "mainstream" IHL is a key, but relatively recently accepted, humanitarian imperative.

Third, understanding and anticipating the manipulation of cultural property is a strategic imperative of which military commanders and humanitarian agencies need to be aware. Cultural property is frequently used before and during conflicts as an integral part of, usually national or substate, political strategy or tactics. Numerous conflicts, from the fighting in the former Yugoslavia,[39] which included the targeted shelling of the national library in Sarajevo that led to the loss of many thousands of irreplaceable books and manuscripts,[40] to the targeting of religious monuments by extreme groups, as

in Timbuktu, Mali, in 2012,[41] have moved targeting of cultural property firmly into those activities that potentially impinge on any military or humanitarian mission, and which constitute a war crime and arguably a crime against humanity.[42] If important sites are allowed to be destroyed, problems frequently follow.[43] The massive damage done in 2006 to the al-Askari Shrine in Samarra, one of the holiest Shia sites in Iraq, is frequently credited with moving the conflict from one responding to an international occupation resented by the local population to a full-scale sectarian civil war. That the shrine was left unprotected reflected a lack of political and military planning and understanding that contributed to coalition forces having to remain in Iraq for far longer than initially intended. It was not unavoidable "collateral damage" but a predictable, politically and sectarian-motivated event that might and should have been anticipated, and avoided, as it had been in 1917 Jerusalem (fig. 31.3).

Very important damage is not restricted to major monuments or national libraries, and destruction impacts every community differently. While the heritage sector and much of the world reacted in horror in 2015–16 to the intentional destruction by ISIS of parts of the World Heritage Site of Palmyra in Syria, for the population of the adjacent town of Tadmur, it was almost certainly the destruction of their cemetery, which ISIS forced male members of the community to actually carry out, that had the most telling immediate impact.[44] The use of such forced cultural property destruction as a punishment for minor religious crimes is thought unprecedented.[45] This was a clear demonstration of subjugation, intended to demoralize and emasculate, and it had obvious and significant implications for humanitarian assistance once access became possible. The destruction and looting of parts of the World Heritage Site may also have a

Figure 31.3 The extensive damage to the al-Askari Shrine in Samarra, Iraq in 2006 has been regarded by many as the tipping point that turned general unease with the coalition presence in Iraq into a full-scale, sectarian civil war. The minarets were destroyed in 2007. Image: PJF Military Collection / Alamy Stock Photo

damaging medium- and long-term impact, as it will presumably have a serious detrimental effect on the tourist trade, on which most of the local population relies either directly or indirectly.

Fourth, cultural property protection is important to the military and humanitarian sectors because looting undoubtedly contributes to the funding of armed nonstate actors. While such looting has been almost certainly an ever-present issue since war was first waged, it is claimed frequently to have become a more organized and important aspect of modern warfare. The UN Security Council has reacted to looting in Iraq and Syria with several decisions (including resolutions 1483, 2199, and 2368) that identify looting as a significant contributory element to the funding of armed nonstate groups. Most importantly, resolution 2347 focused entirely on "the destruction of cultural heritage in armed conflict." Despite several estimates,[46] no one knows how much financial support looting has contributed to funding such actors, but the World Customs Organization notes: "Clear linkages between this form of crime and tax evasion and money laundering have been evidenced over the past years. Estimates of the size and profitability of black markets in looted, stolen or smuggled works of art are notoriously unreliable, but specialists agree that this is one of the world's biggest illegal enterprises, worth billions of US dollars, which has naturally attracted [the] interest of organised crime."[47] To allow such a trade, much based on theft and looting, without at least acknowledgment if not mitigation, can only be judged to be poor military strategy, not least because it allows those reaping the benefit to continue to provoke humanitarian crises.

Fifth, cultural property destruction can undermine the economic recovery of a country. A military that has won a war frequently finds itself tasked with responsibility for ensuring that the post-conflict state is stable and economically viable before it can withdraw: the victor(s) must also win the peace.[48] Cultural property is frequently an important element of tourism that benefits communities and countries by creating jobs and businesses, diversifying local economies, attracting high-spending visitors, and generating local investment in historical resources. With respect to the Middle East and North Africa, a 2001 World Bank report emphasized the importance of this relationship, and placed cultural property and its exploitation at the heart of the economic development of the region—especially for those countries without oil revenue.[49] From military and humanitarian perspectives, the destruction of cultural property has the potential to undermine the economic recovery of a post-conflict country and may therefore lead to lengthening instability, the need for longer military and humanitarian deployments, and, quite likely, greater friction between the military and the host community, resulting in unnecessary military casualties. In such circumstances, the humanitarian role becomes more complex and difficult.

Sixth and finally, cultural property protection can be deployed as soft power. Humanitarian dollars spent on restoring religious buildings may reap the reward not only of community gratitude but also of strengthening the community to take its future

into its own hands. Sadly, there are numerous recent examples where Western troops have failed to carry out CPP effectively and have antagonized the local population unnecessarily, in some instances leading to an escalation of hostilities and casualties.[50] At the other end of the spectrum have been examples of excellent cultural property protection. One positive story comes from Libya in 2011, where NATO changed the proposed weapon for a planned attack on enemy forces to protect cultural property (see below). If the military gets CPP and the associated media communications right, it can make a significant contribution to winning "hearts and minds."

Given these reasons, it seems axiomatic that the military and humanitarian sectors should take CPP as a serious responsibility. And they are beginning to do so, as evidenced by the signing of formal agreements between the Blue Shield and NATO and the ICRC. The heritage sector needs to be ready to liaise with and support such acknowledgment of responsibility.

Key Threats to Cultural Property in the Event of Armed Conflict

While the major causes globally of destruction of cultural property are probably urban expansion, mining, increase in land under cultivation, and the development of agriculture-related technologies, the Blue Shield has identified eight threats specifically related to armed conflict that need to be addressed, where applicable, by all three sectors, if they are not to turn into specific and real risks.[51] Delaying or failing to address these threats will make matters worse and can raise the financial and human costs of a subsequent intervention.

First is lack of planning. The failure to plan in any coherent way for a post–Saddam Hussein Iraq prior to the 2003 invasion is a salutary lesson for the military, humanitarian, and heritage sectors.[52] The specific failure to plan for CPP led to the damage or destruction of countless cultural property assets, including the widespread looting of hundreds if not thousands of archaeological sites, and the looting of museums, archives, libraries, and art galleries.[53] It also contributed to the emergence of the sectarian civil war in Iraq, as demonstrated by the attacks on the al-Askari Shrine in 2006–7.[54] The attacks provided the oxygen for Islamist groups to grow and increase activity, which matured into the horrors of ISIS. The group later provoked a humanitarian catastrophe, with millions becoming internally displaced persons (IDPs) and a significant increase in the number of refugees risking their lives to cross the Mediterranean to a hoped-for better life away from armed conflict. Work since 2003 has significantly raised awareness of this issue, but much still remains to be done to incorporate CPP into political, heritage, military, and humanitarian thinking and planning at the national and international levels.

Second is lack of military and humanitarian awareness. Again, significant progress has been achieved since 2003, but until a structured, long-term partnership develops between the three sectors that fits easily with existing military and humanitarian planning systems already in place and that has been accepted as the norm, military and

humanitarian awareness of the potential importance of cultural property protection will be limited. Until CPP is integrated into peacetime education and training for the military and humanitarian sectors, it will not be regarded as an important consideration. The formal agreements between the Blue Shield and the ICRC and NATO are small, but extremely significant, steps toward this integration.

Third is collateral and accidental damage. By its nature, armed conflict causes significant unintended or accidental damage. It is inevitable that some cultural property will be damaged or destroyed during armed conflict. However, by raising awareness of the eight threats through good education and training, the likelihood of these turning into real risks should be lowered significantly.

Fourth is specific or deliberate targeting. Recent conflicts have seen the deliberate targeting of cultural property by armed nonstate actors as a weapon of war. On occasion, as acknowledged in the 1954 Hague Convention, even armed forces that have incorporated CPP into planning may have to target cultural property for reasons of "military necessity," but this should happen only as a last resort, and where there is no other military option.

Fifth is looting, pillage, and the "spoils of war." Armed conflict frequently creates a vacuum of authority in which noncombatants may loot cultural property, quite often as a last means of raising money to enable their families to eat. At the same time, foreign military or civilian personnel may buy objects as personal souvenirs or pillage items, so-called spoils of war, as communal mementos for regimental museums or dining areas. In some instances, as noted above, such activity becomes organized by nonstate armed actors as a means of income generation. Too often, private collectors of antiquities in what are known as "market countries" do not realize that the top dollar they pay for the privilege to personally own a piece of the ancient past may well be directly funding those that their country's armed forces are fighting.

Sixth is the deliberate reuse of sites. Cultural sites are frequently reused as shelters by internally displaced people and, breaking international law, by belligerents. This almost always damages the sites and may lead to planned and unplanned looting.

Seventh is enforced neglect. Much cultural property requires, by its very nature, constant expert monitoring, yet during armed conflict, such access frequently becomes problematic and/or impossible. As a result, for example, roof tiles slip on ancient buildings, letting in rain, or essential environmental conditions in an archive can fail due to electricity interruption—both of which can cause significant damage.

And finally, eighth is development. This is a constant threat to cultural property during peacetime, but the vacuum of authority exacerbates the problem during armed conflict, as individuals demolish or encroach on cultural property for their personal gain.

There is no space to discuss means to mitigate these threats, but the need to address them is clear: if all eight threats were addressed prior to armed conflict and embedded within normal political, heritage, military, and humanitarian processes and practices,

the impact of armed conflict on cultural property could be significantly reduced. This would not distract from overall mission objectives; indeed, it would perhaps contribute to them, and reduce the humanitarian impact of the conflict. The 1954 Hague Convention contains an adequate legal framework but has never been fully implemented.

A primary requirement is that military and humanitarian colleagues need to have access to lists of specific cultural property that should be protected if at all possible. The production of such lists is, technically, the responsibility of the state parties to the 1954 Hague Convention. However, in a number of recent situations, this has been impossible; led mostly by its US national committee, the Blue Shield has stepped in to produce lists as necessary, cross-checked wherever possible by colleagues from the relevant country. The current author, with colleagues in the United Kingdom and Iraq, completed an initial list for Iraq in 2003 for the UK Ministry of Defence, as did colleagues in the United States for the Department of Defense[55]—an attempt at good practice but uncoordinated and far too late. Similar lists have been produced by the Blue Shield for Libya, Mali, Syria, Iraq (far more detailed than in 2003), and Yemen. The aspiration for such lists is that they are transferred to the military's so-called no strike lists, a list of places, including hospitals, education establishments, and religious buildings, that should not be targeted unless military necessity dictates otherwise. Lists of cultural property are fraught with complications.[56] For example, who should set the standard and specification for such lists, and what should these be? How large should a list be? If it is too small, important cultural property will almost certainly be lost; too large, and the risk that the military will ignore the list increases, as it will be seen as an impossible constraint on mission operations. While the convention stipulates that *all* cultural property should be protected, it has proved to be extremely difficult to produce reliable lists of sufficient detail for libraries, archives, art museums, and galleries. This is a sad reflection on the changes since World War II, when the American Commission for the Protection and Salvage of Artistic and Historic Monuments in War Areas, known as the Roberts Commission, listed some forty thousand cultural properties, including many important archives and libraries, and distributed them to Allied forces. Much more work needs to be done (deciding, for example, what geospatial data is used and needed) before there will be an effective, efficient, and acceptable process and template for such lists, and the Blue Shield is working with NATO and others to develop a standardized template for such information.

As an example of the value of such lists, the cooperation between cultural property experts and NATO militaries over a list of relevant heritage in Libya in 2011 was perceived as a great success. In particular, intervention forces did not target and so protected the Roman fort at Ras Almargeb, where forces loyal to the government of Muammar Gaddafi had established a communications and radar unit inside and in close proximity to the Roman building. The site was on the list of cultural property submitted to NATO and, we can only assume, had been added to the military no-strike list. As a

Figure 31.4 Ras Almargeb, Libya, where forces loyal to the government of Muammar Gaddafi stationed six vehicles of a mobile radar/communications unit in the hope they would not be targeted because of the proximity to the Roman fort. All six were destroyed by precision weapons, leaving the Roman building intact. Image: © Karl Habsburg

result, its forces planned the precise destruction of military targets with very minimal shrapnel damage to the building. This proactive protection received significant positive media reporting—something NATO was somewhat unused to. This led the organization to commission an internal report, *Cultural Property Protection in the Operations Planning Process*, published in December 2012,[57] which recommended that NATO construct its own cultural property protection policy.[58] No such policy is yet in place, but a NATO-affiliated "Centre of Excellence" has been suggested that it is hoped will include CPP, and a CPP directive has been approved—the first step to the establishment of policy (fig. 31.4).

Despite such moves in the right direction, a great deal more work needs to be done before CPP is accepted by the political, military, and humanitarian sectors. The Blue Shield's six areas of activity provide a framework within which it will work toward such acceptance, forming a clear agenda of what needs to be done.

Conclusion: The Future Role of Cultural Property Protection in Armed Conflict

Cultural property protection in armed conflict will never be achieved by the heritage sector's simply shouting that it must be taken seriously by the political, military, and humanitarian sectors. We need to show the relevance and importance of good CPP

activity to all of these sectors; we also need to be inside the room in order to influence thinking and practice.

The Blue Shield's areas of activity, and the urgent need to address the eight threats outlined in the section above, taken together with the proactive signing of agreements with key military and humanitarian organizations (and with others in the pipeline), contribute to the development of a structured vision of how CPP might be integrated effectively into political, military, and humanitarian thinking, processes, and action. It also implicitly includes the need to stimulate extensive support across the whole of the heritage sector. This raises a fundamental point: that the Blue Shield, as the primary neutral and independent organization dealing with CPP that stresses joint action and emphasizes the respect of cultural identity, should perhaps not be regarded as an explicitly heritage organization, but rather as a vehicle where all of those involved in armed conflict can come together to the benefit not of any particular organization but of the whole of humanity. As the Preamble to the 1954 Hague Convention states, "damage to cultural property belonging to any people whatsoever means damage to the cultural heritage of all [hu]mankind, since each people makes its contribution to the culture of the world." By attempting to protect cultural property in armed conflict, the Blue Shield is attempting to protect that of all people, dead, living, and to come. As a spin-off, we may have the chance to make war slightly more humane. This is an extremely ambitious project that will not be delivered in my lifetime. However, if we do not start now, it will not be delivered in my grandchildren's lifetime either.

SUGGESTED READINGS

Robert Bevan, *The Destruction of Memory: Architecture at War* (London: Reaktion Books, 2006).

Emma Cunliffe, Paul Fox, and Peter G. Stone, *The Protection of Cultural Property in the Event of Armed Conflict: Unnecessary Distraction or Mission-Relevant Priority?* (Brussels: NATO, July 2018), NATO OPEN Publications vol. 2, no. 4, https://www.act.nato.int/images/stories/media/doclibrary/open201804 -cultural-property.pdf.

Geneva Call, *Culture under Fire: Armed Non-state Actors and Cultural Heritage in War* (Geneva: Geneva Call, 2018).

Roger O'Keefe, *The Protection of Cultural Property in Armed Conflict* (Cambridge: Cambridge University Press, 2006).

RASHID International, Endangered Archaeology in the Middle East and North Africa (EAMENA), and Yazda, *Destroying the Soul of the Yazidis: Cultural Heritage Destruction during the Islamic State's Genocide against the Yazidis* (Munich: RASHID International, August 2019), https://www.yazda.org/ post/new-report-cultural-heritage-destruction-during-the-islamic-state-s-genocide-against-the-yazidis.

Laurie Rush, *Archaeology, Cultural Property, and the Military* (Woodbridge, UK: Boydell & Brewer, 2010).

Peter G. Stone and Joanne Farchakh Bajjaly, eds., *The Destruction of Cultural Heritage in Iraq* (Woodbridge, UK: Boydell & Brewer, 2008).

NOTES

1. From Heinrich Heine's 1821 play *Almansor*. This refers to the burning of Islamic manuscripts and Muslims by the Spanish Inquisition. Peter Stone is responsible for the choice and presentation of views contained in this article and for opinions expressed therein, which are not necessarily those of UNESCO and do not commit the organization.

2. While relying on the legal terminology of the 1954 Hague Convention, referring to "cultural property" and "cultural property protection," the chapter uses the wider term "heritage sector" to refer to the many individuals and organizations involved in heritage, not just the very small number involved in CPP.

3. Thomas Ricks, *Fiasco: The American Military Adventure in Iraq* (London: Penguin Books, 2006).

4. Article 2.1 of the Blue Shield's Articles of Association, https://theblueshield.org/wp-content/uploads/2021/12/statute-Amendments_BSI_2016-1.pdf.

5. See the Strasbourg Charter of the International Committee of the Blue Shield, 2000, https://theblueshield.org/the-strasbourg-charter-2000/.

6. Peter G. Stone, "Protecting Cultural Property during Armed Conflict: An International Perspective," in *Heritage under Pressure*, ed. Michael Dawson, Edward James, and Mike Nevell (Oxford: Oxbow Books, 2019), 153–70.

7. Constitution of the World Health Organization, 1946, https://apps.who.int/gb/bd/PDF/bd47/EN/constitution-en.pdf.

8. See the website of the Blue Shield, https://theblueshield.org; and Peter G. Stone, "A Four-Tier Approach to the Protection of Cultural Property in the Event of Armed Conflict," *Antiquity* 87, no. 335 (2013): 166–77.

9. Quoted in ICRC, "The ICRC and the Blue Shield Signed a Memorandum of Understanding," 26 February 2020, https://www.icrc.org/en/document/icrc-and-blue-shield-signed-memorandum-understanding.

10. Sahil Verma, "Sun Tzu's *Art of War* and the First Principles of International Humanitarian Law," post, *Cambridge International Law Journal*, 30 August 2020, http://cilj.co.uk/2020/08/30/sun-tzus-art-of-war-and-the-first-principles-of-international-humanitarian-law/.

11. Sun Tzu, *The Art of War* (Boulder, CO: Shambhala Publications, 2002).

12. Charles Guthrie and Michael Quinlan, *Just War: Ethics in Modern Warfare* (London: Bloomsbury, 2007).

13. Margaret Miles, "Still in the Aftermath of Waterloo: A Brief History of Decisions about Restitution," in *Cultural Heritage, Ethics and the Military*, ed. Peter G. Stone (Woodbridge, UK: Boydell & Brewer, 2011), 29–42.

14. Hugo Grotius, *On the Law of War and Peace*, ed. Stephen C. Neff (Cambridge: Cambridge University Press, 2012).

15. Carl von Clausewitz, *On War*, trans. J. J. Graham (Ware, UK: Wordsworth Editions, 1997).

16. Miles, "Still in the Aftermath of Waterloo."

17. Rory Cox, "A Law of War? English Protection and Destruction of Ecclesiastical Property during the Fourteenth Century," *English Historical Review* 128, no. 535 (2013): 1381–417. For the text of the Ordinances, see Anne Curry, "Disciplinary Ordinances for English and Franco–Scottish Armies in 1385: An International Code?," *Journal of Medieval History* 37 (2011): 269–94.

18. For the text, see Yale Law School, "General Orders No. 100: The Lieber Code," the Avalon Project, https://avalon.law.yale.edu/19th_century/lieber.asp.

19. Convention (II) with Respect to the Laws and Customs of War on Land and its Annex: Regulations Concerning the Laws and Customs of War on Land, 1899, https://ihl-databases.icrc.org/ihl/INTRO/150; and Convention (IV) Respecting the Laws and Customs of War on Land and its Annex: Regulations Concerning the Laws and Customs of War on Land, 1907, https://ihl-databases.icrc.org/ihl/INTRO/195.

20. Roger O'Keefe, *The Protection of Cultural Property in Armed Conflict* (Cambridge: Cambridge University Press, 2006), 41.

21. Quoted in Firstworldwar.com, "Primary Documents: Sir Edmund Allenby on the Fall of Jerusalem, 9 December 1917," http://firstworldwar.com/source/jerusalem_allenbyprocl.htm.

22. US Committee of the Blue Shield, "Roerich Pact," https://uscbs.org/1935-roerich-pact.html.

23. Headquarters Allied Commission, *Report on the German Kunstschutz in Italy between 1943 and 1945*, doc. no. T/209/30/3, The National Archives, Kew, United Kingdom.

24. Lynn Nicholas, *The Rape of Europa: The Fate of Europe's Treasures in the Third Reich and the Second World War* (New York: Vintage Books, 1995); and Lenard Woolley, *A Record of the Work Done by the Military Authorities for the Protection of the Treasures of Art and History in War Areas* (London: His Majesty's Stationery Office, 1947).

25. Greg Bradsher and Sylvia Naylor, "General Dwight D. Eisenhower and the Protection of Cultural Property," blog of the Textual Records Division at the National Archives, 10 February 2014, https://text-message.blogs.archives.gov/2014/02/10/general-dwight-d-eisenhower-and-the-protection-of-cultural-property/.

26. Robert Bevan, *The Destruction of Memory: Architecture at War* (London: Reaktion Books, 2006).

27. Joris Kila, *Heritage under Siege* (Leiden, the Netherlands: Brill, 2012).

28. The full US Senate voted to ratify the treaty on 25 September 2008, but the United States did not deposit its instrument of ratification until 13 March 2009.

29. See John Cooper, *Raphael Lemkin and the Struggle for the Genocide Convention* (Basingstoke, UK: Palgrave Macmillan, 2008).

30. Raphael Lemkin, "The Evolution of the Genocide Convention," Lemkin Papers, New York Public Library, cited in Bevan, *The Destruction of Memory*, 210.

31. Cooper, *Raphael Lemkin and the Struggle for the Genocide Convention*, 158.

32. Ricks, *Fiasco*; and Lawrence Rothfield, *The Rape of Mesopotamia: Behind the Looting of the Iraq Museum* (Chicago: University of Chicago Press, 2009).

33. Peter G. Stone, "The Identification and Protection of Cultural Heritage during the Iraq Conflict: A Peculiarly English Tale," *Antiquity* 79, no. 4 (2005): 933–43.

34. UN Security Council, *Final Report of the UN Commission of Experts Established Pursuant to SC Res. 780 (1992)*, UN doc. S/1994/674, 27 May 1994, Annex X: Mass Graves, http://heritage.sensecentar.org/assets/bosnia-herzegovina/sg-5-05-destroyed-buildings-eng.pdf.

35. See the website of Yazda, https://www.yazda.org/.

36. See ICRC, "The Geneva Conventions and Their Commentaries," https://www.icrc.org/en/war-and-law/treaties-customary-law/geneva-conventions.

37. See Karima Bennoune, *Report of the Special Rapporteur in the Field of Cultural Rights*, General Assembly, UN doc. A/71/317, 9 August 2016, https://www.ohchr.org/EN/Issues/CulturalRights/Pages/Intentionaldestructionofculturalheritage.aspx.

38. For the text of the statute, see ICC, https://www.icc-cpi.int/resource-library/documents/rs-eng.pdf.

39. See, e.g., Helen Walasek, *Bosnia and the Destruction of Cultural Heritage* (Farnham, UK: Ashgate, 2015).

40. Munevera Zećo and William B. Tomljanovich, "The National and University Library of Bosnia and Herzegovina during the Current War," *The Library Quarterly: Information, Community, Policy* 66, no. 3 (1996): 294–301.

41. UNESCO, "UNESCO Director General Condemns Destruction of Nimrud in Iraq," 6 March 2015, http://whc.unesco.org/en/news/1244. The destruction of religious sites in Timbuktu led to the first prosecution at the International Criminal Court for crimes against cultural property: see ICC, "Al Mahdi Case," https://www.icc-cpi.int/mali/al-mahdi.

42. UNESCO, "UN Security Council Adopts Historic Resolution for the Protection of Heritage," 24 March 2017, https://en.unesco.org/news/security-council-adopts-historic-resolution-protection-heritage.

43. Benjamin Isakhan, "The Islamic State Attacks on Shia Holy Sites and the 'Shrine Protection Narrative': Threats to Sacred Space as a Mobilization Frame," *Terrorism and Political Violence* 32, no. 4 (2018): 1–25.

44. Joanne Farchakh Bajjaly, personal communication with the author.

45. See American Society of Overseas Research (ASOR), "Weekly Report 73–74," 23 December 2015–5 January 2016, http://www.asor.org/chi/reports/weekly-monthly/2016/73-74.

46. Sarah Cascone, "Syria's Cultural Artefacts Are Blood Diamonds for ISIS," Artnet, 9 September 2014, https://news.artnet.com/art-world/syrias-cultural-artifacts-are-blood-diamonds-for-isis-96814; and Simon Cox, "The Men Who Smuggle the Loot That Funds IS," BBC, 17 February 2015, http://www.bbc.co.uk/news/magazine-31485439.

47. World Customs Organization, "Cultural Heritage Programme," http://www.wcoomd.org/en/topics/enforcement-and-compliance/activities-and-programmes/cultural-heritage-programme.aspx.

48. Thomas Hammes, *The Sling and the Stone: On War in the 21st Century* (St. Paul, MN: Zenith Press, 2004).

49. World Bank, *Cultural Heritage and Development: A Framework for Action in the Middle East and North Africa* (Washington, DC: World Bank, 2001), vii.

50. See, e.g., Geoffrey Corn, "'Snipers in the Minaret: What Is the Rule?' The Law of War and the Protection of Cultural Property: A Complex Equation," *The Army Lawyer* 2005, no. 7 (2005): 28–40; John Curtis, *Report on Meeting at Babylon 11th–13th December 2004* (London: British Museum, January 2004); and Michael P. Phillips, "Learning a Hard History Lesson in 'Talibanistan,'" *Wall Street Journal*, 14 May 2009, http://online.wsj.com/article/SB124224652409516525.html.

51. See Blue Shield, "Threats to Heritage," https://theblueshield.org/why-we-do-it/threats-to-heritage/.

52. See Ricks, *Fiasco*.

53. Peter G. Stone and Joanne Farchakh Bajjaly, eds., *The Destruction of Cultural Heritage in Iraq* (Woodbridge, UK: Boydell & Brewer, 2008).

54. See, e.g., BBC, "Iraqi Blast Damages Shia Shrine," 22 February 2006, http://news.bbc.co.uk/1/hi/world/middle_east/4738472.stm; Damien Cave and Graham Bowley, "Shiite Leaders Appeal for Calm after New Shrine Attack," *New York Times*, 13 June 2007, https://www.nytimes.com/2007/06/13/world/middleeast/13cnd-samarra.html; and Benjamin Isakhan, "Heritage Destruction and Spikes in Violence: The Case of Iraq," in *Cultural Heritage in the Crosshairs*, ed. Joris Kila and James Zeidler (Leiden, the Netherlands: Brill, 2013), 237–38.

55. Stone, "The Identification and Protection of Cultural Heritage"; and McGuire Gibson, "Culture as Afterthought: US Planning and Non-planning in the Invasion of Iraq," *Conservation & Management of Archaeological Sites* 11, nos. 3–4 (2009): 333–39.

56. Peter G. Stone, "War and Heritage: Using Inventories to Protect Cultural Property," *Conservation Perspectives* (the Getty Conservation Institute newsletter), Fall 2013, http://www.getty.edu/conservation/publications_resources/newsletters/28_2/war_heritage.html; and Emma Cunliffe, "No Strike Lists—From Use to Abuse?," *Heritage in War* (blog), March 2020, https://www.heritageinwar.com/single-post/2020/01/24/trump-and-iranian-cultural-property-heritage-destruction-war-crimes-and-the-implications.

57. NATO, *Cultural Property Protection in the Operations Planning Process* (Lisbon, Portugal: NATO's Joint Analysis and Lessons Learned Centre, 2012), unclassified report.

58. NATO, *Cultural Property Protection in the Operations Planning Process*, iv.

32

When Peace Breaks Out: The Peril and Promise of "Afterwar"

Hugh Eakin

On 17 November 2020, Catholicos Karekin II, the supreme head of the Armenian Apostolic Church, made an urgent international appeal. "One of the last remaining regions of our ancient culture," he warned, "is at risk of destruction." After weeks of fighting in the South Caucasus territory of Nagorno-Karabakh, several of the world's oldest monasteries, along with hundreds of medieval churches, sacred sites, and *khachkars*—intricately carved cross-stones—had fallen into the hands of Armenia's archenemy, Azerbaijan. The government of Azerbaijan had a history of destroying Armenian sites, Karekin II noted, and there was now an imminent danger of "cultural cleansing."[1] Soon after, the Armenian patriarch's warnings were echoed by Western scholars, with one asserting in the *Wall Street Journal* that "ancient national treasures" were "at risk of complete erasure."[2]

At first glance, it was an all-too-familiar story of cultural destruction amid vicious armed conflict. Like other recent wars in which religious monuments have been targeted, the crisis in Nagorno-Karabakh was an interconfessional struggle, with Christian Armenians on one side and Muslim Azeris on the other; it involved large-scale human displacement, with an estimated 130,000 ethnic Armenian inhabitants forced to flee to neighboring Armenia, and the potential return of equal or larger numbers of Azeris uprooted during an earlier war; and it was accompanied by telltale forms of ethnic violence, including reports of atrocities and heavily armed men ransacking towns. Even as Armenians were warning of deliberate Azerbaijani attacks on Armenian churches and monasteries, Azerbaijani officials and many Azeris, on social media and elsewhere, claimed that Armenians themselves had been vandalizing Azeri mosques and Muslim graveyards.[3] Once again, human populations and centuries-old

monuments—storehouses of culture, faith, and communal identity—had become twin casualties of the modern battlefield.

Yet there was a crucial difference: the war in question had already happened. Karekin II was making his plea more than a week after Armenia and Azerbaijan reached a cease-fire agreement. His concern was not the military confrontation between the two sides, but the uneasy peace that followed. In accordance with the terms of the truce, Armenia was turning over to Azerbaijan a series of districts around Nagorno-Karabakh containing numerous ancient Armenian sites; their survival would now depend on the goodwill of a government that was actively hostile to Armenia and for which the scars of war were still fresh.[4] Conceptually, then, the case of Nagorno-Karabakh poses a challenge to the conventional framing of cultural heritage in armed conflict: the crux of the problem is not ongoing military action or extremist activity, but rather a sovereign government taking control of territory to which it has a recognized claim. In particular, the problem concerns threats to cultural and religious heritage that arise once a military conflict has run its course.

Though the questions raised by the Armenian–Azerbaijani truce have been little studied, they are hardly unusual. In almost any conflict in which de facto or de jure boundaries are redrawn, the fate of religious and historical sites that fall within those boundaries is newly at stake. And what happens in the aftermath of war may be as important to determining their survival as the war itself. New threats can emerge as a victorious power consolidates control over a contested region, and local and national identities are forcefully redefined. And in the absence of open warfare, a sovereign government may have greater opportunity to desecrate, repurpose, or destroy the monuments of an unwanted group with little international scrutiny.

In many recent peacebuilding efforts, the extent of such threats has been downplayed. International stabilization missions in war-torn countries or regions tend to focus on economic redevelopment and basic security; cultural issues are regarded as secondary. At the same time, communities or nations emerging from war are frequently described as "post-conflict" societies, a terminology that may suggest that the struggle in question has ended, or that the overall risk of violent attack is lower than during "conflict" itself. Yet sacred spaces, monuments, and other cultural sites have often become the principal loci of conflict between groups once the shooting stops. In *Violence Taking Place*, a study of cultural heritage in Kosovo after the 1998–99 war, Andrew Herscher adopted the memorable term *afterwar* to describe this process, noting that "the violence of war did not so much end as shift its direction."[5]

For contested cultural sites and monuments, the neglect of the afterwar problem is also a missed opportunity. While afterwar situations may pose serious new dangers to cultural heritage, they also offer unusual opportunities to save and preserve. Implicit in Karekin II's warning about Nagorno-Karabakh was that the ancient monuments in question were for the moment intact; acts of destruction could still be prevented. Unlike in a hot war situation, moreover, foreign intervention in civil society is often not only

possible but expected. If the fighting has come to an end through a truce or a peace agreement, as in Nagorno-Karabakh, the terms of the peace typically depend on one or more outside guarantors, as well as the deployment of peacekeepers. In such circumstances, foreign governments, international donors, and private organizations may be able to build and enforce local safeguards for sites and monuments—even when those sites belong to an opposing group or confession.

Still, a cultural intervention in the aftermath of military hostilities may carry significant risks of its own. As with rescue actions during armed conflict itself, success almost always depends on the involvement of people who live around the sites in question. Without such cooperation, any foreign-supported safeguarding action may backfire. At the root of the Nagorno-Karabakh crisis and other similar situations, then, is the question of how local populations themselves relate to cultural monuments that do not belong to their own tradition. Whether or not threatened heritage can survive may depend on the extent to which international organizations can identify and harness effective local players to prevent new attacks from occurring, while also creating the ground conditions needed—in funds, expertise, knowledge, and even legal arrangements—for a new preservation ethos to take hold.

In recent years, innovative efforts have been made to extend the UN's responsibility to protect (R2P) doctrine—the evolving norm that international forces have a responsibility to intervene when a population is threatened with genocide, war crimes, crimes against humanity, or ethnic cleansing—to imminent threats against cultural heritage. The elaboration of these principles has helpfully reframed our understanding of such threats, bringing new global awareness that attacks on cultural sites are often directly connected to attacks on human populations. Yet the R2P approach has proven extraordinarily difficult to translate into meaningful action to protect heritage, whether in the face of full-blown armed conflict, such as the Syrian Civil War, or in a "peacetime" situation in which a sovereign government is firmly in control, as in China's devastating crackdown on Uyghurs. Nor does R2P offer a durable basis for the preservation of sites and monuments. Peacekeepers may pave the way, but ultimately it is local populations and local authorities who will be in charge. In confronting the limits of current approaches to heritage destruction, the afterwar problem suggests an urgent avenue of inquiry. If the long-term survival of sites and monuments almost always depends on the communities that surround them, then any effective approach to heritage protection must give central emphasis to people as well as property. Put another way, under what circumstances can an international responsibility to protect be converted into a local impulse to preserve?

The Flaws of War

Over the past two decades, the international response to heritage destruction has overwhelmingly focused on wartime combatants, nonstate armed groups, and terrorists. Following the US-led invasion of Iraq in 2003, a broad consensus emerged

around the long-standing effort to establish rules of engagement to prevent cultural crimes during conflict. And with the rise of new forms of extremism in Africa and the Middle East, international bodies, including the UN Security Council and the International Criminal Court (ICC), have shown a growing commitment to holding extremist groups accountable for intentional attacks on historical and religious monuments. Yet until now, this two-pronged approach has had depressingly little effect.

The push to regulate the treatment of cultural sites by belligerents is founded on the 1954 Hague Convention for the Protection of Cultural Property in the Event of Armed Conflict, a treaty spurred by the widespread destruction of museums, libraries, art collections, and historical monuments in Europe during World War II. Taking as its starting point the observation that "cultural property has suffered grave damage during recent armed conflicts," the convention set rules of engagement designed to limit or prevent such damage by military forces. International support for the treaty grew slowly, with the United States and the United Kingdom delaying ratification until 2008 and 2017 respectively, well over a half century after its creation. At the time of this writing, however, the convention has acquired almost global membership, including by all five permanent members of the UN Security Council and all parties to the North Atlantic Treaty Organization (NATO) except Iceland. Joining them are nearly every member of the European Union, twenty-seven countries in sub-Saharan Africa, twenty in Latin America, forty-four in the Asia-Pacific region, and sixteen in the Middle East.[6] Notably, the list includes most of the countries where military conflicts have taken place over the last three decades.

Significantly enhancing this regime, if less widely embraced, has been the convention's 1999 Second Protocol. (The First Protocol was written at the time of the original treaty in 1954.) With the violent breakup of the former Yugoslavia freshly in mind, the authors of the Second Protocol sought to strengthen the convention in a number of important ways. Among its noteworthy provisions, the Second Protocol tightened a loophole for "military necessity"; updated the treaty's protections to apply to civil wars as well as international conflicts; added an "enhanced protection" regime for specially designated sites that are "of the greatest importance for humanity"; and set down procedures to prosecute parties or individuals for attacking, vandalizing, or looting cultural sites. Two decades after its writing, the Second Protocol has been ratified by more than eighty countries, though it continues to lack the support of the United States, Russia, China, India, Turkey, and Switzerland, among other states.

Since the early 2000s, the Hague principles have been supplemented by parallel efforts to address purposeful destruction by nonstate armed groups and terrorists. The widely publicized targeting of cultural sites by the Taliban in Afghanistan, Ansar Dine in Mali, and especially the Islamic State of Iraq and Syria (ISIS, also known as ISIL or Da'esh) in Syria and Iraq has drawn unprecedented world attention to the problem. In recent years, international organizations and world leaders, up to and including the UN Security Council, have condemned such attacks as a threat to international security and,

significantly, begun to recognize them as a direct extension of crimes against human populations.

International alarm about extremist groups has also led to some important policy innovations. The ICC, established in 2002, has included attacks on cultural heritage among the crimes of war under its jurisdiction, and in 2016 the court convicted a Malian extremist for the destruction of mausoleums in Timbuktu. Western governments and international agencies have also devoted increasing attention to the protection of so-called movable heritage—including paintings, museum objects, and archaeological artifacts—that may be vulnerable to theft or destruction in regions of conflict or general instability. Interpol, working together with national law enforcement, has sought to crack down on the cross-border trade in looted artifacts from war-torn countries, while other groups, such as the Geneva-based International Alliance for the Protection of Heritage in Conflict Areas (ALIPH) Foundation, have established substantial resources for emergency rescue actions, including the creation of temporary safe havens for threatened artifacts. Coinciding with these developments has been the effort, explored at length by Thomas G. Weiss and Nina Connelly, to apply the R2P doctrine to cultural heritage threatened with destruction.[7]

Yet this growing international framework has failed to stop the accelerating destruction of cultural sites. By its own members, the 1954 Hague Convention has often been honored in the breach. The newly created Republic of Croatia, for example, ratified the treaty in 1992; sixteen months later, Croatian-backed paramilitary forces deliberately targeted and destroyed the sixteenth-century Mostar Bridge in neighboring Bosnia, in what has become one of the most infamous attacks on cultural heritage in recent decades.[8] In the Middle East, Libya (1957), Syria (1958), Lebanon (1960), Iraq (1967), and Saudi Arabia (1971) ratified the convention soon after its creation, yet they have all since been involved in wars in which deliberate or indiscriminate destruction of cultural heritage has taken place. Still more recent is the case of Ethiopia, which ratified the treaty in 2015. Amid a brutal offensive against rebels in the sealed-off region of Tigray in 2020 and 2021, Ethiopian government forces were accused of shelling and looting numerous cultural monuments, including several historical churches as well as the revered seventh-century al-Nejashi Mosque, which had previously been proposed as a UN Educational, Scientific and Cultural Organization (UNESCO) World Heritage Site.

The American military has also been implicated in damage to heritage sites in the years since the United States joined the convention. For nearly six years (2015–21), US forces backed the Saudi-led offensive against Houthi rebels in Yemen with munitions, intelligence, logistics, and other forms of support. Though the US military has denied involvement in the selection of targets, US weapons systems were deployed in a Saudi air campaign that damaged or destroyed numerous Yemeni historical sites, including large parts of the old city of the capital, Sana'a, the medieval citadel of Kawkaban in the north of the country, and the ninth-century Mosque of al-Hadi in Saada, one of the oldest Shiite mosques on the Arabian Peninsula.[9]

Western leaders and international organizations have been even less successful in preventing acts of destruction by extremist groups. In the face of diplomatic and political constraints, nonconsensual intervention to protect populations from imminent attack has been extremely rare; for cultural sites, taking action has proven even harder. Even where concrete steps could, in theory, be taken, the odds of success are long. Often a threat may emerge only after an attack is already underway, or has been publicized by the perpetrators themselves. And in instances where imminent danger is apparent, international responses may make things worse. As the Taliban's dynamiting of the Bamiyan Buddhas in 2001 and ISIS's destruction of the Temple of Bel and other ancient structures at Palmyra in 2015 suggest, international media coverage and/or verbal condemnation by world leaders has often seemed to provoke rather than prevent. Notably, many of ISIS's most devastating attacks on cultural sites in Iraq and Syria occurred months *after* the alarm was sounded by Western officials, including then US secretary of state John Kerry. Lacking a clear path to hindering or preventing such acts, international bodies such as UNESCO, Interpol, and the ICC have largely been limited to dealing with the consequences, whether by policing the trade in already-looted antiquities or seeking individual accountability for the perpetrators. In such cases, though, the damage has already been done.

At the same time, the war-and-terrorism approach to addressing cultural heritage destruction also tends to leave out the groups who are most affected: the people who live around the sites in question. Implicit in much of the policy discussion is an opposition between internationally recognized monuments and sites, on the one hand, and local combatants or extremists, on the other. Even as the Security Council and other international organizations such as UNESCO increasingly link attacks on cultural monuments to crimes against human populations, the prevailing framing often pits international "good guys"—Western governments, security officials, and law enforcement agencies—against local or regional "bad guys" who threaten to blow up temples and bulldoze monuments. However well intended, such an approach may appear condescending or tone-deaf to local communities, which are themselves often bearing the terrible human costs of war. While world leaders and the international media lamented ISIS's destruction of the uninhabited site of Palmyra, there was scant mention of the adjacent modern city of Tadmur, where the Syrian government had long kept a notorious prison for torturing political dissidents. As important, the overwhelming emphasis on sites and monuments, rather than the populations around them, may obscure the crucial part that these same host communities have long played in effective preservation—both during and after war.

Manuscripts in the Canoe

In contrast to international action, local efforts to safeguard monuments and artifacts threatened by conflict and extremism have a considerable record of success. Much deserved credit for the recovery of displaced European art collections during World

War II has gone to the Western Allies, the Roberts Commission, and the "Monuments Men." Yet their efforts were often made possible by years of daring work by local officials. In Nazi-occupied Paris, Rose Valland, the curator of the Jeu de Paume art gallery, secretly documented the location of more than twenty thousand looted artworks, allowing for their rapid recovery; in Italy, the museum curator Giovanni Poggi successfully hid many of Florence's most important treasures and prevented their shipment to Nazi Germany. Particularly remarkable were the efforts of the so-called Paper Brigade, a group of Jewish residents of Vilnius, Lithuania, who, during the Nazi occupation, managed to rescue a large proportion of one of the most important collections of Jewish rare books and manuscripts in existence.[10]

For much of the Lebanese Civil War (1975–90), the National Museum of Beirut was on the front lines of battle, marking a frontier between opposing factions. Yet its director, Maurice Chehab, managed to save nearly all of its extraordinary antiquities collection by hiding it in sealed basement storerooms; monumental statues that could not be moved were encased in cement.[11] When the Taliban first took control of Afghanistan in the early 1990s, the director of the National Museum in Kabul was able to hide the Bactrian Gold, the country's most important collection of ancient Silk Road grave ornaments, in a vault deep under the Afghan central bank. The rare artifacts came out of hiding more than fifteen years later, having survived years of war as well as a Taliban effort to destroy much of the museum's collection with hammers. Six months before the Taliban retook Kabul in 2021, the speaker of the Afghan parliament suggested the Bactrian Gold be sent abroad for safekeeping, but no action was taken. In August 2021, at the time of the US withdrawal, the artifacts were believed to be in secure storage at the central bank, though their current status could not be established at the time of this writing.[12]

Even in the lethal conflicts in Mali and Syria, local activists were able to save artworks and artifacts from near certain obliteration, often at great risk to themselves. In 2012, as extremists seized control of Timbuktu, local archivists quietly hid and removed tens of thousands of medieval Islamic manuscripts threatened with destruction. The much-celebrated—if somewhat exaggerated—rescue operation involved rice sacks and even canoes to ferry the documents downriver to safety in Bamako, the country's capital.[13] During the Syrian Civil War, activists in Idlib and Aleppo were able to protect the cities' museums from destruction, even as surrounding areas, and the museums themselves, were hit by bombs. Youssef Kanjou, the director of the Aleppo Museum at the time, told me he had only $2,000 to spend on sandbags and other protective measures, yet that was sufficient to protect immovable works from damage or destruction.[14] At one point, when a town in northwest Syria was captured by the al-Nusrah Front armed group (now the Jabhat Fatah al-Sham), a local archaeologist persuaded the group that the population would rebel if non-Islamic sites were attacked. At Palmyra, Khaled al-Asaad, the site's distinguished eighty-three-year-old chief archaeologist, managed to evacuate many of the antiquities at the Palmyra Museum

before he was captured and killed by ISIS, in what became one of the most horrific episodes of the war.[15]

That local activists were motivated to risk their lives to defend Syria's museums and monuments may seem surprising. In the years before the civil war, the government of Bashar al-Assad had a poor record of caring for cultural heritage. Many ancient settlements, including, for example, the ruins of the Semitic city of Mari in the east and those of the Hellenistic city of Cyrrhus in the northwest, had been looted and neglected for years. Nonetheless, the country hosted more than a hundred foreign archaeological missions between the early twentieth century and the start of the war, helping to some extent build local knowledge and expertise about the country's rich archaeology and historical monuments. At the same time, there was a small but dedicated cohort of Syrian heritage professionals who were prepared to act with the limited resources available to them.[16]

Local activism can work both ways, however. In conflicts involving sectarian violence or an uprising against an oppressive government, there may be powerful social forces working against preservation. In Iraq, Saddam Hussein had long appropriated the country's ancient heritage in propaganda by his Sunni-dominated Ba'ath Party. Partly as a result, some Iraqi Shiites viewed looting the Iraq Museum in Baghdad and plundering archaeological sites as legitimate forms of retribution following the US-led invasion in 2003. Illegal excavations were finally curtailed not by international intervention but by the Ayatollah Ali al-Sistani, Iraq's highest Shiite cleric, who issued a fatwa or religious ruling against archaeological pillage. As in other cases, local authority proved far more important than international norms.[17]

Remembered today as one of the worst cultural heritage disasters since the Cold War, the US occupation of Iraq also highlights the strategic importance of protecting cultural sites in a volatile afterwar environment. Though there were incidents of carelessness by US forces during the invasion, the looting and destruction overwhelmingly occurred after Saddam Hussein's government had been defeated. At the time, a new local order, dominated by the country's long-oppressed Shiite majority, was taking shape under American suzerainty. The failure of US forces to manage sectarian tensions—and to provide adequate security at religious sites—led to growing violence, culminating in the 2006 attack by Sunni extremists on the al-Askari Mosque in Samarra, regarded as one of the most sacred Shiite shrines in the world. In the violent civil war that followed (2006–8), numerous Sunni and Shiite religious sites were targeted while some seventy thousand civilians lost their lives. In the years since the US invasion, much has been said about what American forces might have done to secure Iraq's heritage. What is less often noted is the extent to which attacks on cultural heritage became a driver of new conflict.

If afterwar settings offer unique opportunities for international actors to intervene to protect and preserve heritage sites, the case of Iraq after 2003 shows how much can go wrong. When intercommunal and interconfessional tensions are allowed to fester, no

amount of external protection for sacred sites may be sufficient to neutralize continuing threats. And without buy-in from the communities themselves, any attempt to provide such protection may stir tensions further. The underlying challenge, then, is how to persuade local populations to respect and value the sites in question—or at least refrain from damaging them—until a more durable peace can be established. Though the task is a formidable one, recent history provides several examples of how it can be done.

A Strongman's Promise

Few contemporary afterwar situations have presented as great a long-term challenge for cultural heritage as Kosovo. For a number of years after its 1998–99 war with Serbia, Kosovo served as a cautionary tale. As the latest installment in the brutal disintegration of the former Yugoslavia, the war in the breakaway Balkan region played out as a struggle between ethnic Serbs, who are Christian Orthodox, and Kosovo Albanians, who are predominantly Muslim. During the sixteen-month conflict, hundreds of thousands of Kosovo Albanians were forced to flee the region to neighboring countries, while Serbian forces devastated hundreds of mosques and Muslim sites in Kosovo, continuing the strategy of ethnic and cultural warfare they had previously undertaken in Bosnia. Sufi lodges were burned down, and libraries containing thousands of rare books and Islamic manuscripts, some dating from the Middle Ages, were destroyed.

With the entry of NATO forces into the war, however, the tables were turned. Following its victory, the Kosovo Liberation Army (KLA) gained possession of a territory that contained dozens of Serbian Orthodox churches and monuments. Among them were several of Serbia's oldest monasteries, including the fourteenth-century Visoki Dečani, a domed, five-nave building featuring one of the largest surviving frescoed interiors from the Byzantine tradition. Having experienced the Serbs' vicious campaign against historical Muslim sites, Kosovo Albanians now had the fate of some of the most prized Orthodox monuments in their hands. Meanwhile, a large majority of the refugees who had been brutally uprooted by the Serbs were able to return. Although military hostilities had ended, the conflict had not.

At the time, Kosovo was nominally under the control of some twenty thousand peacekeepers from NATO's Kosovo Force (KFOR) and the UN Interim Administration Mission in Kosovo (UNMIK). While the peacekeepers were able to maintain general order, they were largely unprepared to protect heritage sites. For months after the war, former members of the KLA and other armed groups in Kosovo attacked Serbian historical and religious sites, mostly with impunity. In March 2004, a wave of anti-Serb violence, led by former KLA leaders, quickly spread across the country. Along with the killing of nineteen civilians, the riots culminated in a devastating series of attacks on Serbian houses, buildings, and religious sites. Faced with overwhelming numbers, KFOR troops put up little resistance. Some thirty churches were burned down, some of them hundreds of years old, while monasteries, graveyards, and hundreds of Serbian homes were vandalized and destroyed.[18]

The violence very nearly consumed Visoki Dečani, where there was also a minimal peacekeeping presence. In the end, the monastery was spared not because of KFOR but through the personal intervention of Ramush Haradinaj, a former KLA leader and local strongman. Shortly before the unrest began, then US senator Joseph R. Biden visited the monastery and was told by Serbian monks that there was a growing threat of attack. As Biden recounted in Senate testimony:

> Knowing that the territory around Dečani is Mr. Haradinaj's political base, I sent him a confidential letter after I returned to Washington. In it I wrote that I was counting on him to personally guarantee and protect the Serbian Orthodox monastery I had just visited. In March of 2004, serious riots against Serbs and other non-Albanian minorities broke out across Kosovo. . . . KFOR proved unable or unwilling to prevent this destruction. In fact, in several cases, the outrages occurred while European KFOR troops stood by. One of the few venerable monasteries that remained untouched was Visoki Dečani. Mr. Haradinaj had kept his promise.[19]

If Biden's account is accurate, the revered Orthodox monument owed its survival in 2004 to actions taken within the community around the site: international pressure on a local figure of authority turned out to be far more effective than thousands of blue helmets. As in the case of the Ayatollah Sistani's fatwa against looting in Iraq, it was Haradinaj's resolve, not international forces, that proved decisive.

Coming shortly after the looting of the Iraq Museum, the Kosovo riots underscored the crucial importance of cultural heritage in postwar stabilization efforts. After the riots, KFOR peacekeepers deployed heavily around Serbian Orthodox sites. One result was a growing push by the United Nations to incorporate the protection of minority cultural sites directly into peacekeeping mandates, as was done in Mali beginning in 2013. In Kosovo itself, protection of minority heritage became one of the formal benchmarks in the country's path toward full independence. Drawn up in 2008, the so-called Ahtisaari Plan, the international framework for Kosovo's new constitution, spelled out specific rights and protections for the Serbian Orthodox Church, including the creation of forty special "protective zones" around Serbian cultural and religious sites. These provisions have since largely been incorporated into Kosovo law.[20]

In recent years, despite continuing tensions between Kosovo and Serbia, the threat of violence against Kosovo's remaining Serbian community has largely dissipated and some of the churches damaged in the 2004 riots have been restored.[21] The heightened preparedness of NATO's KFOR peacekeepers has played a part. But equally crucial has been the gradual push, in tandem with Kosovo's statebuilding process, to transfer responsibility for heritage sites to local authorities. While Dečani remains under the protection of KFOR troops, other prominent religious complexes, including Gračanica and the Patriarchate of Peć, have been handed over to the jurisdiction of Kosovo's own police forces.[22] At the same time, as Kosovo continues to seek formal recognition from

numerous countries, its leaders have held up their efforts to safeguard Serbian heritage as a symbol of Kosovo's status as an emerging state based on the rule of law.

The complicated fate of Serbian Orthodox churches in Kosovo since the 1998–99 war raises important questions about international efforts to protect cultural heritage. How might the country's recent progress be replicated, while avoiding the terrible legacy of destruction that preceded it? If international forces alone are not sufficient to provide durable safeguards, including for monuments of enormous religious and historical significance, what other forms of international engagement might be most effective in supplanting them?

Sandbags and Glue

Along with local activism, there has been another common ingredient in many successful interventions to protect museums and monuments in conflict zones: outside support. In Timbuktu in 2012, the difficult evacuation of Islamic manuscripts by local librarians was greatly facilitated by European cash. The costs of the rescue and subsequent storage were supported by an emergency grant of €100,000 from the Netherlands-based Prince Claus Fund, a €75,000 grant from the DOEN Foundation, and €323,475 from the Dutch foreign ministry.[23] Two years later, during the Syrian Civil War, modest foreign backing helped Syrian activists protect a series of threatened mosaics at the Ma'arra Museum in the opposition-controlled Idlib Province. With materials and financing provided by the Safeguarding the Heritage of Syria and Iraq (SHOSI) Project—a US-based consortium that was itself funded by grants from the J. M. Kaplan Fund and the Prince Claus Fund—the activists were able to encase the mosaics in glue and fabric and line them with sandbags. Shortly afterward, the museum suffered a direct hit by a barrel bomb, but the mosaics survived.

Such rescue actions show that international support can play a decisive role in heritage protection in crisis situations where direct foreign intervention is impracticable. In light of these successes, other foundations have begun to support similar emergency efforts, including the US-based Whiting Foundation and the Gerda Henkel Foundation in Germany. By far the largest and most ambitious player is ALIPH, which was founded in Geneva in 2017 by the governments of France and the United Arab Emirates, together with large-scale private funders, and which has raised tens of millions of dollars for local emergency actions in countries experiencing or emerging from conflict. To date, it has funded projects in Iraq, Syria, Yemen, Afghanistan, and Lebanon, among other countries.

For Western governments and international organizations, supporting local efforts can carry important advantages over more direct forms of intervention. Local activists are far more likely to gain the trust and support of their communities, and even of hostile groups that may otherwise pose threats to sites. And by catering to the needs of people who are already on the ground, rather than bringing in outside experts, such an approach can avoid the waste and corruption of more traditional international aid

efforts. As SHOSI's backing of the Ma'arra Museum intervention demonstrates, small grants and provision of in-kind assistance may also go a very long way, and, when they can be delivered quickly, can be transforming. As a growing number of foundations and private funders have discovered, small-scale local rescue actions with limited, attainable goals may also stand a better chance of success than broader efforts to stop conflict-driven destruction. At the same time, foundations may be able to circumvent ordinary legal barriers to international involvement, for example in rebel-controlled regions of Syria. When successful, such targeted interventions bring important local buy-in and reinforce a new understanding of cultural preservation in the context of war. "Perhaps the greatest conceptual challenge for the archaeological community," the US-based Syrian archaeologist Salam Al Quntar wrote during the Syrian Civil War, "is to reimagine heritage protection as one of many humanitarian actions that offer direct support to populations in crisis."[24]

Despite some noteworthy achievements, however, targeted local interventions may have limited impact during major armed conflicts. Emergency funding alone cannot protect a temple or religious building from damage or destruction, and funders may be reluctant to risk resources—and lives—in a hot war situation. By contrast, in the immediate aftermath of military hostilities, or in a situation in which a conflict has become "frozen," such efforts can make a significant difference. Many recent projects funded by ALIPH, the Prince Claus Fund, the J. M. Kaplan Fund, the World Monuments Fund, and other foundations have been directed not at war zones per se, but at sites that are at grave risk as a result of recent war damage or regional instability.

Though they have received negligible attention in the international media, private funders have been particularly active in Yemen, supporting crucial rescue efforts of buildings and sites even as the conflict has continued to unfold in other parts of the country. Among these projects is the salvage effort for the Dhamar Museum, which housed one of Yemen's most important archaeological collections and was hit in an air strike in 2015, and the rehabilitation of the Old City of Sana'a, a World Heritage Site in a crucial urban center that has been damaged by both air strikes and frequent flooding. In such cases, private funders can fill critical gaps where mainstream aid programs, because of continuing conflict or other logistical limitations, may be unable to intervene.

For populations emerging from intercommunal strife, the rehabilitation of threatened religious sites and monuments can also serve as an engine of reconciliation. In Cyprus, for example, a long-frozen conflict has bitterly divided the island between its Greek population, who are predominantly Orthodox Christian, and its Turks, who are Sunni Muslim. (Cyprus also has smaller minorities of Armenian Orthodox, Maronites, Roman Catholics, and Jews.) Yet over the past decade, stewardship of the island's diverse cultural and religious heritage has become an important meeting point between the two sides. Peacekeepers have played a significant part: ever since the 1974 invasion, the UN has maintained a force on the island, one of its longest continuing missions in the world,

which has controlled a buffer zone between the two sides and ensured basic stability. But a larger cultural breakthrough came during a round of peace talks in 2012. Although the negotiations failed to make progress toward a political settlement, the parties agreed to establish a joint heritage preservation commission to strengthen relations between the Turkish Cypriot and Greek Cypriot communities. Called the Technical Committee on Cultural Heritage (TCCH), the body was designed to include heritage specialists from both sides, and was given a mandate to restore and conserve endangered sites in both the Republic of Cyprus and Northern Cyprus.

Since then, the TCCH has proven remarkably successful. Its funding and support have come from traditional international sources—the European Union, which has provided close to $20 million, and the UN Development Programme, which has contributed technical assistance. As with recent foundation-supported projects in other countries, however, the work has been driven by members of the two communities themselves. The mandate of the TCCH is particularly significant in view of the geography of the Cyprus conflict: when the island was divided in 1974, many Greek churches were stranded in Northern Cyprus, on the Turkish side, while more than a hundred Turkish mosques and religious schools were left in the south, on the Greek side. For the first time, local conservators and officials from both sides could visit and evaluate these sites. To date, the TCCH has restored several dozen historical mosques and churches, as well as Ottoman buildings, Venetian fortifications, and ancient sites, and its efforts have been generally embraced by both the Greek and Turkish populations. Coinciding with these projects has been a series of reciprocal visits by Christian and Muslim leaders to places of worship on both sides of the island.[25] Significantly, when a historical mosque that had been restored by the TCCH in the Greek city of Limassol was firebombed in 2020, the attack was quickly condemned by leaders of both faiths.

Although the achievements of the TCCH may be difficult to replicate among populations emerging from full-scale armed conflict, they show the extent to which cultural heritage can help bridge ethnic and confessional divides once a stable security environment begins to take hold. In Iraq and Syria, for example, an interfaith panel could support urgent interventions for war-damaged Muslim, Kurdish, Christian, and Yezidi heritage, as well as secular sites like historical marketplaces and old city centers. Such a confidence-building approach could do much to encourage displaced Syrians to return and communities to rebuild. In Serbia and Kosovo, even in the absence of formal relations, a bilateral, technical commission could support endangered Ottoman-era mosques in Serbia and Serbian monasteries in Kosovo, extending the progress on minority heritage that has already been made in Kosovo itself. With the achievement of greater stability and détente, in future years such an approach might also be possible with the handful of Muslim sites in Armenia and Armenian churches in Azerbaijan, as the Azerbaijani journalist and commentator Cavid Ağa has suggested.[26] As in Cyprus, any such effort will need robust outside financing and support, strong local leadership,

and the ability to produce meaningful results on projects of local and national significance. It will also need to coincide with other, more traditional forms of institution building and social reconciliation. Conceptually, though, the Cyprus model points to a crucial insight about contested religious and cultural sites: rather than engines of conflict, they can, under the right circumstances, become instruments of peace.

Conclusion: An Impulse to Preserve?

In the months after Catholicos Karekin II's warnings about cultural cleansing in Nagorno-Karabakh, the conflict between Armenia and Azerbaijan quickly evolved into an uneasy afterwar standoff. In an escalating rhetorical battle, each side continued to accuse the other of destruction of cultural sites, while a tenuous calm prevailed in the zone of conflict. For the moment, the most important Armenian sites were left undisturbed, with Russian peacekeepers deployed at Dadivank Monastery; in the spring of 2021, a group of Armenian pilgrims were allowed to visit the complex under the escort of Russian troops.

Yet the outlook for Armenian heritage in the territories newly controlled by Azerbaijan was grim. The Azerbaijan government denied repeated requests by UNESCO to inspect cultural monuments in the Nagorno-Karabakh region, and there was scant information about the current status of many Armenian sites. In March 2021, a British Broadcasting Corporation (BBC) investigation was able to confirm the destruction and razing of at least one Armenian church since the war.[27] Following a tendentious national historiography, Azerbaijan's leaders have also asserted that historic Armenian churches in the region were built by "Albanian Caucasians," distant Christian ancestors of Azerbaijanis, and were falsely appropriated by Armenians in later centuries. Since the 2020 cease-fire, Azerbaijan has used this unfounded theory to argue that Armenia has no legitimate claim to church complexes in the Nagorno-Karabakh region. Alarmingly, in February 2022, Azerbaijan's culture ministry announced that it was establishing a commission to "remove the fictitious traces written by Armenians on Albanian religious temples," effectively declaring its intent to erase the thousands of inscriptions that adorn medieval *khachkars* and form a crucial part of historic Armenian church decoration.[28]

Such destructive acts might be prevented with the right kind of international pressure, though Armenian sites are widely scattered, and it would be difficult to deploy international peacekeepers at many of them. Amid the lingering hatreds of a brutal war, moreover, persuading local communities to defy their own government and preserve monuments that represent the culture of their adversaries seems unlikely, and the risk of further destruction remains high. Nevertheless, as the case of Kosovo suggests, the challenges of such a situation may not be insurmountable. The government of Azerbaijan has previously shown that it is not indifferent to international opinion and has long sought to promote itself as a secular, multifaith state with strong ties to

UNESCO. In early 2022, Turkey, long a supporter of Azerbaijan, also began direct talks with Armenia, holding out the possibility that Ankara could serve as a potential intermediary on fraught heritage questions. When tensions cool, the Azerbaijan government may find it more expedient to preserve these vital monuments than to vandalize or obliterate them.

The urge to destroy a defeated enemy's culture is as old as war itself. In 149 BCE, Cato the Elder advised the Roman Senate that a defeated Carthage needed to be razed to the ground. Since the end of the Cold War, the destructive drive has taken on horrifying new dimensions in violent interethnic conflicts, from the Balkans to Myanmar's Rakhine State. Yet equally old may be the impulse to preserve, an impulse that has often transcended confessional and ethnic boundaries. The survival of the Pantheon in Rome, perhaps the greatest pagan temple of antiquity, is owed in significant measure to its adoption by the Catholic Church in the seventh century, when much of the city was falling into ruin; the Byzantine Empire's Church of Hagia Sophia in Constantinople, now Istanbul, was left standing through five hundred years of Ottoman history because it was highly prized by Mehmed the Conqueror. Of course these cases involved the conversion, and to some extent alteration, of the original structures, but the monuments themselves survived, despite being controlled for centuries by groups of a different faith. Notably, until its reclassification as a mosque by Turkish president Recep Tayyip Erdoğan in 2020, Hagia Sophia spent nearly a century as a secular monument and museum, an early recognition of the transcendent value of cultural heritage.

Nor are such examples of interconfessional preservation absent from conflicts in the twentieth and twenty-first centuries. In the Old City of Jerusalem, perhaps no sacred site is more contested than the Holy Esplanade, the complex that Jews refer to as the Temple Mount and Muslims as the Haram al-Sharif. With two of Islam's most revered shrines, the al-Aqsa Mosque and the Dome of the Rock, built on what is believed to be the site of the Second Temple, the area has been an inevitable flash point of intercommunal tensions. Notably, in the spring of 2021, the worst Israeli–Palestinian violence in years was set off, in part, by an Israeli police raid on Palestinian protesters at the al-Aqsa Mosque.

Less well known, however, is the remarkable peace that has held for decades at the Holy Esplanade, largely as a result of Israeli policies adopted after the 1967 Six-Day War. In its sweeping victory, Israel gained control over East Jerusalem and the rest of the West Bank, including the Old City and its Islamic sites. Given their location on the Temple Mount, the dome and the mosque were particularly at risk of destruction. One hard-line rabbi proposed to Uzi Narkiss, the Israeli general who led the offensive, blowing up the Dome of the Rock with one hundred kilograms of explosives. Yet Narkiss, and Israeli defense minister Moshe Dayan, resisted these efforts, and together with the Israeli government reverted management of the entire complex to Muslim authorities and prohibited Jews from entering the precinct. Most crucially, a few months after the war, dozens of leading rabbis declared that Jews should not pray on the mount because

the exact location of the destroyed temple was unknown. It was an ingenious solution. As Ron E. Hassner recounts in *War on Sacred Grounds*, Jewish Israelis overwhelmingly accepted the government's prohibition on entry to this sacred precinct because of the rabbinical ruling. The result was more than two decades of peace at one of the most contested religious sites in the Middle East, even as other, less significant religious monuments in the West Bank came under frequent attack.[29]

As the Israeli example illustrates, even in the aftermath of a violent conflict in which control over crucial sacred monuments is at stake, the heritage of the defeated adversary has often been spared harm. Sometimes, sites and monuments belonging to former or present antagonists are preserved for strategic reasons, whether as a means to long-term stability or as a way to gain international legitimacy. As often, though, they may survive because they speak to the people who live around them, regardless of the identity of their creators. Aided by a growing number of tools for action—whether in the form of diplomatic pressure, funding for local initiatives, positive recognition, or actual peacekeepers—international actors can contribute meaningfully to this preservation ethos. In afterwar situations in particular, they may be able to confront or contain the dynamics that lead to attacks on cultural heritage before the damage is done. As the record of recent conflicts amply demonstrates, however, successful intervention will nearly always require the primary engagement of local leaders and the local community. And it must be durable. In the long run, any effort to protect sites and monuments during armed conflict will stand little chance of success without a strategy to preserve them when the fighting ends.

SUGGESTED READINGS

Robert Bevan, *The Destruction of Memory: Architecture at War*, 2nd ed. (London: Reaktion Books, 2016).

Charlie English, *The Storied City: The Quest for Timbuktu and the Fantastic Mission to Save Its Past* (New York: Riverhead, 2017).

Ron E. Hassner, *War on Sacred Grounds* (Ithaca, NY: Cornell University Press, 2009).

Andrew Herscher, *Violence Taking Place: The Architecture of the Kosovo Conflict* (Stanford, CA: Stanford University Press, 2010).

Lynn Meskell, *A Future in Ruins: UNESCO, World Heritage, and the Dream of Peace* (Oxford: Oxford University Press, 2018).

NOTES

1. Catholicos Karekin II, "A Plea to Save Artsakh's Armenian Heritage," *Christianity Today*, 17 November 2020.
2. Christina Maranci, "Cultural Heritage in the Crosshairs Once More," *Wall Street Journal*, 18 November 2020.
3. Thomas de Waal, "Now Comes a Karabakh War over Heritage," Eurasianet, 16 November 2020.

4. The territories ceded to Azerbaijan include the Agdam District, the Kalbajar District, and the Lachin District; the core Armenian enclave of Nagorno-Karabakh has remained in Armenian control.

5. Andrew Herscher, *Violence Taking Place: The Architecture of the Kosovo Conflict* (Stanford, CA: Stanford University Press, 2010), 124.

6. For a list of parties to the 1954 Hague Convention and its protocols, see UNESCO, "Armed Conflict and Heritage: States Parties," http://www.unesco.org/new/en/culture/themes/armed -conflict-and-heritage/convention-and-protocols/states-parties/.

7. See, for example, Thomas G. Weiss and Nina Connelly, *Cultural Cleansing and Mass Atrocities: Protecting Heritage in Armed Conflicts*, Occasional Papers in Cultural Heritage Policy no. 1 (Los Angeles: Getty Publications, 2017), https://www.getty.edu/publications/occasional-papers-1/; and "Protecting Cultural Heritage in War Zones," *Third World Quarterly* 40, no. 1 (2019): 1–17.

8. The newly independent Republic of Croatia ratified the Hague Convention, as well as the First Protocol, on 6 July 1992. The shelling of the Mostar Bridge by Croatian-government-supported paramilitary forces called the Croatian Defence Council (HVO) took place on 9 November 1993.

9. Iona Craig, "The Agony of Saada: U.S. and Saudi Bombs Target Yemen's Ancient Heritage," *Intercept*, 16 November 2015; and Sudarsan Raghavan, "'Why Is the World So Quiet?' Yemen Suffers Its Own Cruel Losses, Far from Aleppo," *Washington Post*, 18 December 2016.

10. See the exhibition *The Paper Brigade: Smuggling Rare Books and Documents in Nazi-Occupied Vilna*, YIVO Institute for Jewish Research, 11 October 2017–14 December 2018.

11. Robin Wright, "Beirut's Museums of War and Memories," *New Yorker*, 12 October 2016.

12. TOLOnews, "Bactrian Gold Sent Abroad for Display, Safekeeping," 28 January 2021.

13. See Charlie English, *The Storied City: The Quest for Timbuktu and the Fantastic Mission to Save Its Past* (New York: Riverhead, 2017).

14. Youssef Kanjou, telephone interview with author, January 2021.

15. Hugh Eakin, "Ancient Syrian Sites: A Different Story of Destruction," *New York Review of Books*, 29 September 2016.

16. Youssef Kanjou, "The Role of Syrian Archaeologists and Foreign Archaeological Missions in the Protection of Syrian Heritage," in *Proceedings of the 11th International Congress on the Archaeology of the Ancient Near East* 1, ed. Adelheid Otto, Michael Herles, and Kai Kaniuth (Wiesbaden: Harrassowitz Verlag, 2020), 339–50.

17. Hugh Eakin, "The Devastation of Iraq's Past," *New York Review of Books*, 14 August 2008.

18. Herscher, *Violence Taking Place*, 142–43.

19. Ramush Haradinaj was a leader of the KLA who served briefly as Kosovo's prime minister. See testimony of Joseph R. Biden, "Indictment of Ramush Haradinaj," *Congressional Record—Senate*, vol. 151, no. 27, 9 March 2005, 2334–40, https://www.congress.gov/109/crec/2005/03/09/CREC -2005-03-09-pt1-PgS2306-2.pdf.

20. Stefan Surlić and Igor Novaković, "Serbian Cultural and Religious Heritage in Kosovo from Ahtisaari's Special Zones to the Final Status," National Convention on the European Union (NCEU) 2019/2020, Working Group for Chapter 35, http://www.isac-fund.org/wp-content/uploads/ 2020/06/2020_Serbian_Cultural_and_Religious_Heritage.pdf.

21. See, for example, Daniel Petrick, "Return to Kosovo: The Serbs Who Re-Embraced Their Hometown," Balkan Insight, 14 January 2020.

22. Lawrence Marzouk, "Kosovo Police to Protect Serb Monasteries," Balkan Insight, 5 August 2010.

23. English, *The Storied City*, 252–53.

24. Salam Al Quntar, Katharyn Hanson, Brian I. Daniels, and Corine Wegener, "Responding to a Cultural Heritage Crisis: The Example of the Safeguarding the Heritage of Syria and Iraq Project," *Near Eastern Archaeology* 78, no. 3 (September 2015): 155.

25. US Department of State, *2019 Report on International Religious Freedom: Cyprus*, 10 June 2020, https://www.state.gov/reports/2019-report-on-international-religious-freedom/cyprus/.

26. Cavid Ağa, interview with author, 18 November 2020.

27. Jonah Fisher, "Nagorno-Karabakh: The Mystery of the Missing Church," BBC, 25 March 2021, https://www.bbc.com/news/av/world-europe-56517835.

28. Amos Chapple, "'Forgeries': The Armenian Art That Azerbaijan May 'Erase' From Churches," Radio Free Europe/Radio Liberty, 9 February 2022.

29. Ron E. Hassner, *War on Sacred Grounds* (Ithaca, NY: Cornell University Press, 2009), 117–23.

Conclusion: Toward Research, Policy, and Action Agendas

James Cuno

Thomas G. Weiss

This book's chapters were written and copyedited late in 2021, a year that reminded us of the intimate link between the targeting of cultural heritage and the targeting of people. This conclusion quickly recalls recent history as a prelude to discussing why we should care about such connections; then it discusses what can be done about it in terms of setting research, policy, and action agendas.

A Decade of Examples

On 13 April 2021, the first day of Ramadan coincided with Israel's Memorial Day. Israeli riot police fenced off the Damascus Gate—a traditional gathering place for Palestinians and one of the principal entrances into Jerusalem—and entered the al-Aqsa Mosque armed with clubs, guns, stun grenades, tear gas, and tools to cut the cables to the loudspeakers broadcasting the call to prayer from four minarets.[1] The stated objective was to ensure that a speech to be given that day by Israeli president Reuven Rivlin would not be disturbed for the annual Kafr Qasim memorial service. Israeli police knew the reverence in which the al-Aqsa Mosque is held among Muslims; it is considered the third holiest site in Islam and built on the Temple Mount, also known as the al-Aqsa Compound. Many Muslims believe that the Prophet Muhammad was transported from the Great Mosque of Mecca to the al-Aqsa Compound during the Night Journey, from which he ascended into heaven. Since the Six-Day War of 1967, Israeli security forces have routinely patrolled and conducted searches within the perimeter of the mosque. That said, al-Aqsa was the provocation that reflected a disregard for a subject community's cultural heritage at a sacred moment in its annual calendar. Widespread violence, suffering, and war crimes from both sides followed, together with civil strife and mob attacks in mixed Palestinian-Jewish cities across Israel and the occupied West Bank.

A few months later, in August, the ill-fated US withdrawal from the two-decade war in Afghanistan ushered in a return to state power by the Taliban, an Islamist political movement that had conducted arguably one of the most visible and infamous acts of

destruction of cultural heritage in recent history: the March 2001 demolition of the Bamiyan Buddhas. The leader of the Taliban at the time, Mullah Omar, afterward used the destruction of the ancient Buddhist sculptures to argue that international actors, particularly Western powers, cared more about such artifacts than they did about the poor desperate Afghan population. The Taliban sought to conceal the human catastrophe in its accompanying campaign of atrocities against the Hazara ethnic minority. While not Buddhists, the Hazaras lived in the valley where the Buddhas had dominated for fifteen centuries, and they respected them. As Shiite Muslims, the Hazaras are considered heretics by the Sunni Taliban; their true crime was not only idolatry but also, and perhaps more crucially, being members of the armed opposition to the Taliban.

With the Taliban back in power, and a growing alliance between al-Qaeda and the Islamic State Khorasan Province (ISIS-K), an Afghan affiliate of the Islamic State of Iraq and Syria (ISIS), there is the renewed and perilous potential for further violence against the region's cultural heritage and peoples. Of paramount importance is safeguarding the Afghan population, especially women, girls, and other vulnerable or marginalized members of society, as well as the country's extraordinary cultural legacy. It is not hard to imagine a future fatwa that targets pre-Islamic cultural heritage together with the "heretics" themselves.

On Easter Sunday 2019, suicide bombings claimed the lives of more than three hundred people in three churches and three hotels in the majority-Buddhist state of Sri Lanka. ISIS, which was said to have been totally defeated two months earlier, took credit for the attacks. It released a video of its leader, Abu Bakr al-Baghdadi, seen for the first time in five years, calling on his jihadist followers to rally around his vision for ISIS. "Our battle today," he said, "is a battle of attrition, and we will prolong it for the enemy. And they must know that the jihad will continue until Judgment Day." The Sri Lankan Islamist group Jamiyyathul Millatu Ibrahim recruited for ISIS and joined forces with the Islamist preacher Zahran Hashim, the alleged organizer of the Easter Sunday attacks, days before he reportedly also organized attacks on Buddhist sculptures.[2]

The Rohingya people are one of Myanmar's many ethnic minorities; their plight has been especially evident in the last few years. An Indo-Aryan ethnic group, they predominantly follow Islam, have their own language and culture, and are said to descend from Arab traders. Some 750,000 Rohingya fled Myanmar for Bangladesh in 2017 alone; the number may have doubled since, with some half million still residing in Myanmar. The flight took place after troops supported by Buddhist mobs destroyed their villages and mosques. Within a month, more than 6,700 Rohingya had been killed. UN investigators accused Myanmar's military of mass killings and rapes with "genocidal intent." Kutupalong is home to more than six hundred thousand Rohingya refugees in Bangladesh, and is the world's largest refugee settlement.[3] UN officials have called the persecution of the Rohingya tantamount to ethnic cleansing and crimes against humanity.

Since 2017, at least one million Uyghurs have been interned in more than eighty-five camps within the Xinjiang Uyghur Autonomous Region in northwest China. For years, the Chinese government denied the presence of such camps; images showing them, complete with watchtowers and barbed wire, forced the government to acknowledge their existence. Beijing rebranded them "reeducation centers."[4] In the same year, the Xinjiang regional government passed a law prohibiting men from growing beards and women from wearing veils, traditional Uyghur customs.[5] Recently the Chinese government has forced Uyghur women to be sterilized or fitted with contraceptive devices, "tightening its grip on Muslim ethnic minorities and trying to orchestrate a demographic shift that will diminish their population growth."[6] Also since 2017, according to a report by the Australian Strategic Policy Institute, around 8,500 Uyghur mosques have been damaged or destroyed, domes and minarets removed, and numerous shrines demolished, including the shrine of Imam Asim, a Muslim holy man.[7]

Sana'a, the oldest and largest city in Yemen, is thought to have been founded two and a half millennia ago. In 2011, it was at the center of the Yemeni Revolution, followed three years later by the Houthi takeover. Officially called Ansar Allah (Supporters of God), the Houthis are an Islamist political and armed movement, predominantly a Zaydi Shiite force supported by Iran and opposed by Saudi-backed Yemeni Sunnis. At the same time, al-Qaeda in the Arabian Peninsula (AQAP) and ISIS have carried out attacks against both factions. Mainly as a result of Saudi-led coalition air strikes, the Armed Conflict Location and Event Data Project (ACLED) claims to have recorded more than 130,000 deaths. The humanitarian group Save the Children estimates that some eighty-five thousand children suffer severe malnutrition, twenty-four million people require humanitarian assistance and protection, and some four million have been displaced.

At the same time, Saudi jets have bombed the Old City of Sana'a, destroying mud-brick tower houses that date back thousands of years. Their destruction follows a pattern of targeting. The Antiquities Coalition claimed in 2019 that "blood antiquities"—artifacts looted from museums, libraries, and ancient sites—were being sold illegally to help finance the civil war that the revolution had deteriorated into. Archaeological sites in Yemen, including the Great Dam of Marib, built in the eighth century BCE, have also been heavily damaged or destroyed by Saudi air strikes. More than eighty historical sites and monuments have been destroyed, including the historical center of Sana'a itself. As architectural historian Michele Lamprakos reports, "cultural heritage is unique in Yemen in the sense that it's still a living heritage. It's not antiquities or ancient history. It's about everyday environments that still have meaning." And "when you hit the heritage of a place like that, you're really hitting at their identity."[8] The once proud and beautiful ancient city is now the backdrop to one of the world's greatest human tragedies, directly linked to the destruction of much of its treasured historical urban fabric.[9]

We began with this recital of six recent cases of brutal attacks on and disregard for cultural heritage. Tens of thousands of people dead. Millions forcibly displaced. And all within two decades. This leads us to ask a probing question and to hazard an answer.

Why Should We Care?

The thirty-two preceding chapters shed light on how tortuous and complex it is, analytically or practically, to disentangle the twin imperatives of safeguarding human life and protecting cultural heritage. This concluding chapter looks to the future, building on the numerous contributions of our distinguished authors and pointing the way toward setting agendas—for research, policy, and action. First, however, we must remind readers of the rationale behind this book.

The Convention Concerning the Protection of the World Cultural and Natural Heritage of the UN Educational, Scientific and Cultural Organization (UNESCO) was approved in 1972 by the General Conference—the biannual meeting of its member states—and went into effect in 1975. It recognizes a cultural monument or site as having cultural, historical, or scientific significance to humanity. By signing the convention, every country "pledges to conserve not only the World Heritage sites situated on its territory, but also to protect its national heritage." State parties are obliged to report regularly to UNESCO's World Heritage Committee on the status of conservation of their inscribed properties, to strengthen their citizens' regard for world heritage, and to "enhance their protection through educational and information programmes."[10]

Earlier we mentioned the Old City of Sana'a, a site inscribed on the World Heritage List in 1986. It includes 103 mosques, fourteen hammams, or public steam baths, and over six thousand houses, all built before the eleventh century, with its Great Mosque said to be the first built outside Mecca and Medina. The deadly violence, depredation, and human suffering Sana'a has experienced over the past two decades has only exacerbated the effects of assaults on its cultural heritage. The World Heritage Committee inscribed the Old City of Sana'a on its List of World Heritage in Danger in 2015 to reflect the extensive damage from the most recent armed conflict.

The ancient city of Damascus was the first site in Syria to be inscribed on the World Heritage List, in 1979; the ancient city of Aleppo was added in 1986, becoming the fourth Syrian site on the list. Along with Syria's other four current World Heritage Sites, they were both added to the List of World Heritage in Danger in 2013 as a result of the country's civil war. Among Aleppo's most important structures is the Great Umayyad Mosque, built on the site of a Hellenistic agora between the eighth and twelfth centuries; it is purportedly home to the remains of Zechariah, the father of John the Baptist— revered in both Christianity and Islam. In 2013, it became a target of fighting between President Bashar al-Assad's forces and the al-Nusrah Front, an Islamist militant faction of the insurgency. Each side blamed the other for the destruction of the mosque. Anti-Assad forces posted a video saying, "If he attacks all of the mosque, we will stay here, we will stick with our position, we won't abandon our Islam even if all the world does."

Irina Bokova, then UNESCO's director-general, "called upon all those involved in the conflict to ensure the respect and protection of this heritage."[11]

We do not need to continue with our lists in order to ask the question, Why should we care about such damage or destruction? As noted in our earlier examples, an obvious reason is that the people affected by government repression, international and civil wars, or jihadist violence care deeply about their cultural heritage themselves. For example, in 2017, Mustafa Kurdi, the supervisor of the reconstruction of the Great Umayyad Mosque of Aleppo, said in the midst of ongoing military and social instability: "We are preparing now to bring the equipment to move the stones of the minaret and put them together and start to build as close as possible as the original minaret was. Maybe some of the stones cannot be used again because they are broken. We shall have to find new stones from perhaps other old stones. If need be, we can make new stones look like old ones. This is a vast task but we consider our main work is the rebuilding of the minaret."[12] Kurdi's response to the destruction was practical: "We have the materials and the experience in dealing with damage of this sort but we must remember that when the mosque is restored, everything else will return—not only those who pray but people shopping who stop in the colonnades to rest—because the mosque is the heart of this area. This is not just a religious symbol. It is a social place, part of our culture."

Other responses have been more emotional. It is not only the material remains of ancient cultural heritage that people care about, but also the memories and meanings associated with them. Haymen Rifai, a sixty-year-old Aleppo resident, explained gravely as she stood with her two daughters in the war-pulverized center of Aleppo, "Each time we come here it feels worse." Mohammed Marsi, standing with his son, shook his head and sighed, "The destruction for the whole country is indescribable, just like what happened to the mosque. If you knew the mosque before the damage, and saw it now, it is like someone who lost a child or part of his body."[13] As Oxford University classical archaeologist Judith McKenzie noted about the mosque's destruction, "The built environment is part of people's identity. Historic buildings are part of people's culture, history, and memories. And handing down cultural heritage from past to future generations reaffirms identity . . . 'intangible heritage'—the value that people and buildings have mutually generated across time."[14]

Another reason we should care is that the protection of cultural heritage, like that of hospitals and schools, can be justified as part of a counterinsurgency strategy, or a comprehensive civilian and military effort to defeat and contain insurgency and address its root causes. Joseph Felter and Jacob Shapiro, in an issue of *Daedalus* on the theme "The Changing Rules of War," argued that "if minimizing civilian casualties helps advance strategic goals in certain conflicts, then the standards for protection might be much higher."[15] The long and complicated history of counterinsurgency doctrines reflects this essential perspective from the trenches. For example, US General Stanley McChrystal argued bluntly about the prospects for success of the International Security

Assistance Force (ISAF) strategy in Afghanistan: "We will not win based on the number of Taliban we kill, but instead on our ability to separate insurgents from the center of gravity—the people. That means we must respect and protect the population from coercion and violence—and operate in a manner which will win their support."[16] Another US general, David Petraeus, argued that counterinsurgency is a tactic that can only be effective if it involves the use of public diplomacy in an effort to render the insurgents ineffective and noninfluential. In short, strong and secure relations with the local population of the occupied state are critical for the prospect of peace and stability. Admonishing coalition forces, he wrote that "we must continue—indeed, redouble—our efforts to reduce the loss of innocent civilian life to an absolute minimum. Every Afghan civilian death diminishes our cause."[17]

In times of civil wars such as Syria's, with so many fronts and overlapping alliances and agendas, counterinsurgency would seem an effective means to restore civil society after an armed conflict. Protecting cultural heritage is crucial for such a strategy. It is part of what civilian populations return to in order to restore their lives once fighting has ended; it is what they identify with in forging and strengthening identities.

Another reason that we should care is that cultural heritage's power and authority lie in its integrity as evidence of the continuing, inspiring genius of humanity; it is a source of local and communal identities as well as economic recovery. The devastation to cultural heritage in Aleppo was aimed at destroying the collective identity of a subject people. Reiterating that murder and destruction of culture were inherently linked, Bokova said in response to attacks on Palmyra, another Syrian World Heritage Site, "This is a way to destroy identity. You deprive [people] of their culture, you deprive them of their history, their heritage, and that is why it goes hand in hand with genocide. Along with the physical persecution they want to eliminate—to delete—the memory of these different cultures."[18]

Her further perceptive remarks were inspired by the grisly 2015 public beheading and display of the headless corpse of Khaled al-Asaad, the eighty-two-year-old archaeologist and keeper of Palmyra's antiquities. The justification? His refusal to reveal where Palmyrene antiquities were hidden for safekeeping. "The destruction of funerary busts of Palmyra in a public square, in front of crowds and children asked to witness the looting of their heritage is especially perverse. These busts embody the values of human empathy, intelligence, and honor the dead."[19]

In September 2015, Bokova issued a statement addressing the protection of victims of ethnic and religious violence in the Middle East, pointing to mass atrocities and redoubling her criticism of cultural intolerance: "All of this shows the humanitarian crisis cannot be separated from cultural cleansing. These are part of the same strategic imperative and must stand at the heart of all efforts for peacebuilding. The cultural heritage and diversity of this region must be safeguarded for future peace, as part of the identity of all humanity."[20]

What Can Be Done?

Two significant anniversaries demarcated the writing and publication of this book: the fiftieth anniversaries of both the UNESCO 1970 Convention on the Means of Prohibiting and Preventing the Illicit Import, Export and Transfer of Ownership of Cultural Property, and the organization's already-mentioned 1972 Convention Concerning the Protection of the World Cultural and Natural Heritage. In light of the extensive and continuing attention that the earlier convention receives—both as a source of illicit funding and as a contested topic over the proper restitution of heritage acquired illicitly—we elected to stress the most significant parts of the 1972 convention relating to tangible and immovable cultural heritage.

To that end, we have written and commissioned a diverse range of scholars and practitioners to write about "Cultural Heritage and Mass Atrocities" from five distinct angles: "Cultural Heritage and Values," "Cultural Heritage under Siege: Recent Cases," "Cultural Heritage and Populations at Risk," "Cultural Heritage and International Law," and "Cultural Heritage and Military Perspectives." The specific contexts for conscience-shocking attacks on peoples and their heritage cover a wide spectrum of actors and crimes: by major powers (e.g., China against the Uyghur communities in Xinjiang); by vengeful or rogue states (e.g., the governments of Sri Lanka and Afghanistan against ethnic minority communities in the northeast of Sri Lanka and the Bamiyan Valley); by outside allies abetting repressive governments (e.g., Russia and the Assad government in Palmyra and Aleppo); by nonstate terrorists (e.g., Islamist militants in Timbuktu, Mali); and by successive governments in a small state (e.g., the destruction of Maya heritage in Guatemala). We do not presume comprehensiveness in our approach, only fresh perspectives from experts representing diverse views and a wide range of academic backgrounds. They include the scholarly and analytical communities embracing (in no particular order) cultural history, philosophy, anthropology, sociology, architecture, humanitarianism, international law, military science, international relations, economics, contemporary politics, and human rights.

We hope and anticipate that the labors of our contributors and our own editorial approach will stimulate additional and better research by others. We also expect new policy initiatives and action agendas by governments, international organizations, cultural institutions, and foundations. To that end, we spell out our initial thoughts about the priorities and components for such agendas.

Elements of a Future Research Agenda

We intend this collection of essays to move the interest in this subject beyond mere anecdotes, conjectures, and metaphors. Whatever one's views about the details in the individual recommendations below, the overriding and indisputable requirement for future applied research is more and better transdisciplinary approaches. The broader and deeper research agenda should encompass all of the disciplines and orientations mentioned above, and others that we undoubtedly have failed to enumerate. We have

consciously chosen a "nondisciplinary" approach in these pages because a wide range of experiences and professional expertise is required to understand the human and heritage costs as well as the substantial benefits of protecting people and their cultures. Not only is the subject matter itself capacious, but also it stimulates an extensive and overlapping range of professional responses. In designing and developing this book, we convened its contributors and other advisers multiple times over three years to provoke and encourage the discovery of shared interests arising from diverse disciplinary orientations. Political scientists engaged with philosophers, humanitarians with military specialists, economists with cultural historians, and classical scholars and museum directors with international lawyers.

The rich potential and greatest opportunity for future research is to break out of our disciplinary silos in order to determine empirically the precise relationship between mass atrocities and cultural heritage destruction, and vice versa. Better understanding the links between attacks on people and those on cultural heritage is complicated. It demands far more detailed and sustained efforts than those that have already gone into these pages. As productive as our effort might be or might have been, it was obvious to all participants that more basic data gathering and in-depth research are required; it will involve long-term commitments to exploring what goes beyond the narrow disciplines espoused by those who study cultural heritage and those who study law, politics, economics, the military, and humanitarianism. Both strategies and tactics could and should change as a result of more granular and evidence-based analyses.

From the beginning, we opted for the term *mass atrocities*, as opposed to a more limited reference to military actions in recognized wars. The emphasis on the destruction of immovable cultural heritage amid mass atrocities, wherever they occur, means that our preoccupation has been with the intersection of human life and cultural heritage; it matters not that they are threatened during an "armed conflict" (that is, a war declared or not, international or non-international) or civil strife or routine repression by political authorities. Given the nature of the topic, which includes so many nonstate actors and minority community members, military action makes it difficult to gauge local views regarding the state ownership of cultural heritage. It is no less difficult to distinguish the opinions of authorities, governments, and belligerents, especially with the advent and spread of social media. At present, perpetrators who kill people and destroy cultural heritage have the functional equivalent of a television or radio station in their pockets, making every belligerent's contact a potential lethal performative source.

From our perspective, the purely national "ownership" of cultural heritage is questionable. Who owns Palmyra and to what effect? The legal scholar John Henry Merryman proposed a triad of principles to evaluate how best to proceed: preservation (how can cultural heritage be best protected and preserved?); quest for knowledge (how can we best advance our search for valid information about the human past?); and access (how can we best assure that cultural heritage is optimally accessible?). These

principles are noble—we have used them before.[21] Their applicability and relevance are obvious in a state-based system, where possession equals ownership—especially where state-based identities can be determined.

But what of the ancient traces of Palmyra? Within just a few years, they were the property of and policed by the government in Damascus; subject to theft during the Syrian Civil War; contested by the Syrian army and multiple groups of the armed opposition; attacked, damaged, and ultimately much destroyed by ISIS fighters in a performative display of dominance and destruction matched in military might only by that of the Syrian state. A key component was Russian air strikes, which were accompanied by a performance of the Russian Mariinsky Orchestra in Palmyra's Roman Theatre, Moscow's signing of a memorandum of understanding (MOU) in support of the Assad government against the US-backed Syrian Democratic Forces, and Russia's Hermitage Museum's signing of another MOU with the Syrian Museum and Antiquities Authority to restore some of Palmyra's historical sites.

However, this rapidly changing combination of responsibilities over a decade is merely the most recent manifestation of a more profound concern that reflects the basic quandary about the nature of heritage—in the past, present, and future. The current "owner," Syria, is a twentieth-century creation. The name historically had referred to the wider region—more or less a synonym for the Levant—and previous recent "owners" included the French and the Ottomans. But what about the Romans, who built Palmyra in the first place? Was their ownership only temporary? If so, has it devolved to Italy? Is the current government in Damascus a temporary trustee or an all-powerful owner that can make decisions for humanity? While our answer should be clear, we appreciate the reasons for a host of other perspectives, and this leads us to propose deeper inquiries to determine the costs and benefits of better protective measures.

Researchers require more precise metrics to determine, for instance, the relative value and impact of "hard" public international laws versus, for instance, "softer" rules, norms, principles, and standards. More granular empirical data are necessary to even begin to answer the previous questions about the status of Palmyra and myriad other cultural heritage sites under siege or already destroyed or compromised. A comprehensive database should be compiled. There are a host of relevant elements—including those related to war, forced migration, human rights, and aspects of heritage preservation and endangerment—that could be drawn on, improved, and consolidated. However, there remain numerous missing elements as well as the singular challenge of putting the various puzzle pieces together.

So, too, research and data are required for us to have a firmer basis on which to gauge whether moral hazard is relevant in evaluating possible measures thought to be helpful in counteracting mass atrocities and cultural heritage destruction. What are the pluses and minuses, for example, of declaring a visible heritage site off-limits for the military? Such a designation may provide an incentive to an enemy's armed forces (regular troops or the armed opposition) to deploy there because they are less likely to

be attacked. Similarly, will media and diplomatic coverage of visible monuments make them more attractive targets? The implications of social media and "performative" destruction are anything except obvious without better in-depth investigations into their use in perilous situations. The parsing through of case studies of nonstate actors would be an essential component in this task—attempting to identify which ones are more likely to refrain from heritage destruction and respect the provisions of international law.

Among other broad-gauged questions requiring far better answers than we have at present are some related to the use of armed force: Is it possible to disentangle cultural heritage protection from broader peace and security measures? Does the protection of cultural heritage and human populations distract from or facilitate peace negotiations and an eventual accord? Is there evidence of a virtuous circle between protecting heritage and people so that such protection can act as a force or diplomatic multiplier? In short, military and civilian officials require more knowledge to inform their standard operating procedures.

Finally, future efforts to improve the prospects for preventing both atrocities and heritage destruction relate to the comparative advantage of various institutions. What are the pluses and minuses of different intergovernmental organizations in mitigating mass atrocities and heritage destruction (e.g., the United Nations, the European Union, or the Organisation of Islamic Cooperation)? What about nongovernmental organizations (e.g., Human Rights Watch, Geneva Call, or the International Committee of the Red Cross)? What is the best use of resources from philanthropic organizations (e.g., the Ford Foundation, J. Paul Getty Trust, or Aga Khan Development Network)? Are specialized organizations in the cultural heritage arena (e.g., UNESCO or the Blue Shield) better placed than less specialized ones for operational assistance as well as monitoring? What are the most relevant contributions from encyclopedic museums (e.g., the Louvre in Paris and Abu Dhabi, the Smithsonian, or the British Museum)? How do the answers to these queries differ when applied to states versus nonstate actors, or to industrialized countries of the Global North versus those emerging economies and developing countries of the Global South?

The dimensions of the requisite research agenda are vast. That said, the governing boards of individual institutions should consider commissioning specific investigations and evaluations to shed light on how best to modify their own orientations, projects, and priorities, as well as how best to scale up activities and identify the most attractive potential partners.

Formulating Policy and Action Agendas

One of the primary objectives of commissioning the range of views in this volume was to stimulate creative thinking about changing governmental and institutional policies toward cultural heritage and mass atrocities. Ultimately, of course, we also sought to advance action agendas. Here we organize our brief synthesis of the overall suggestions

emerging from our deliberations about how best to achieve these aims under two headings: cross-cutting considerations, and more specific activities for prevention and reaction.

Cross-Cutting Considerations

Universal jurisdiction has been a tool increasingly applied to addressing the aftermath of human rights abuse wherever violators may be located. A similar approach could be relevant for iconoclasts who have fled the scene of their cultural devastation in order to avoid prosecution. Given international mobility, universal jurisdiction for cultural heritage crimes could constrain the movement of such criminals as well as restrict their access to funds and future mobility. The possibility of an eventual conviction could act as a deterrent for prospective destroyers of cultural heritage.

Although only states sign and ratify international agreements, some nonstate actors have determined that it is in their interest to abide by the provisions of international law—for example, to attract donor support or strengthen their legitimacy in negotiations as a possible future government. Determining why some nonstate armed groups restrain their members from attacking cultural heritage, including looting of artifacts to fund activities, is essential. So too is making it attractive over the longer run for nonstate actors to respect codes of conduct and adopt guidelines for the protection of cultural heritage as well as basic human rights treaties.

The widespread abuse of selective memory, of cultural heritage to tell only part of any story, is a problem that invariably colors any publicity about and history of sites that have changed hands. An important step in the direction of respectful truth-in-packaging would be to make an objective and complete portrayal of any site part of the requirement for its designation by UNESCO as a World Heritage Site. Surveying and cataloguing accurately the previous uses and users should be essential for such locations. Controversy and alternative interpretations of the glorious pasts of Hagia Sophia and the Mosque-Cathedral of Córdoba, for instance, could help contemporary viewers of all persuasions and faiths understand the meaning of a "world" as opposed to a "state" heritage site.

An important balance needs to be struck by the media, which generally are keen to cover high-visibility catastrophes but should be made aware of the significance and power of even the simplest immovable heritage to communities in which such structures are located. World Heritage Sites make for dramatic images and media coverage, but also newsworthy should be less visible and modest sites for the vulnerable populations subjected to atrocities; such broader coverage is an essential component of the media's role as guardians of the public interest.

Local, national, regional, and global lenses provide alternative ways to evaluate the exact impact of mass atrocities and cultural heritage destruction, in addition to helping to determine the priorities for action and funding. The free-for-all in competing for limited resources often results in a race to the bottom by competing recipients, both

outsiders coming to the rescue and local counterparts. Bilateral and multilateral donors as well as private sources (foundations and businesses) should better appreciate and attenuate competitive turf battles; they should formulate measures to avoid wasteful zero-sum contests, including incentives for enhanced cooperation.

Training soldiers, humanitarians, and human rights monitors in the nuts and bolts as well as the importance of cultural heritage protection would be a helpful step toward enlarging the audience for and safeguarding of such heritage. In addition to the contents of their normal job descriptions, an exposure to the basics of international humanitarian law as it applies to cultural heritage would be a helpful point of departure. Moreover, the potential for contemporary technologies to monitor sites and behavior should also form part of any training.

Prevention and Reaction Activities

Our own discussion agenda for the two parts of our book's title reflects the original three-pronged approach to "mass atrocities" that launched the norm of the responsibility to protect (R2P)—to prevent, to react, to rebuild—which also coincides with the phases and conceptual frameworks applied by many cultural heritage specialists. In addition to the specific thoughts in individual chapters, we highlight here our own recommendations to advance prevention and reaction agendas. The reader should note that we are finessing the third responsibility, *reconstruction*. The questions of whether to rebuild or not, and if so, how, are completely and perhaps impossibly politicized and fraught at present. Several chapters underline the obvious difficulties: too little money, too much interference, and too few consequences. No matter what one's views on the topic, however, the fundamental principle to guide future reconstruction that no one disputes is the crucial importance of inclusive agency in decision-making, and also relying more on local architects, materials, and artisans for whatever rebuilding occurs.

A central conclusion—surprising for a group of authors that contains so many legal experts on a topic that has been dominated for over a century by the pursuit of better public international law—is that there is little to be gained from refining existing laws. The absence of political will, not of law, invariably explains inaction. What seems more worthwhile and pragmatic is a twofold emphasis: strengthening the emerging R2P norm, which includes the protection of cultural heritage, and mobilizing the political will to act in a timely fashion to implement existing laws and enhance compliance with their tenets. That said, an immediate priority would be to encourage over sixty reticent or hostile member states—there are only 133 state parties—to ratify the 1954 Hague Convention for the Protection of Cultural Property in the Event of Armed Conflict and its First Protocol of the same year. The absence of three permanent members of the UN Security Council (China, Russia, and the United States) is an especial shortcoming for the 1999 Second Protocol, which presently has merely eighty-four state parties.

There is a pressing need to build on the precedent of the International Criminal Court's (ICC's) first sentence for the war crime of attacking cultural heritage, in the *Prosecutor v. Al Mahdi* case concerning the wanton destruction in Timbuktu. This recommendation is relevant for both enhanced prevention and reaction. An essential diplomatic effort is required to get the holdouts, especially the same three permanent members of the Security Council, to ratify the ICC's Rome Statute and join the court. It should be recalled that Mali's ratification of the statute was essential for the extradition, trial, and conviction of Ahmad al-Mahdi.

In addition, transitional justice is a promising and related but not strictly judicial response that has been pioneered in reaction to atrocities and massive violations of human rights; it also could be applied to the prevention of and reaction to cultural heritage destruction. Transitional justice was developed as a technique for post-conflict peacebuilding in general. Its adaptation would not emphasize the letter of international heritage law but rather more immediate and practical solutions for communities that have suffered both heritage loss and mass atrocities. This tool seeks to clear the air through public admission of past crimes without necessarily including punishment. Some fifty truth commissions have been used over the last four decades to address numerous atrocities in countries as different as Argentina, South Africa, Guatemala, Liberia, and Cambodia. They need not address only recent events—for example, in 2021 France decided to organize a Commission mémoires et verité sur le passé algérien de la France (Memories and truth commission regarding the country's role in the Algerian Civil War) for the war that had ended almost six decades earlier. The goal of cultural heritage commissions would be to not ignore cultural cleansing but simultaneously to not exacerbate the fragile equilibrium of a country in transition; they would aim at a reckoning, one that could help countries emerging from traumatic periods to confront their past, to interrupt cycles of atrocities, and to move on.

There are, of course, missing elements from the heritage-protection regime. But the emphasis should be on reinforcing and publicizing the fledgling institutions that are in place—despite their evident political and administrative shortcomings—rather than building new ones. For instance, UNESCO's current total annual budget of some $535 million is completely insufficient for an expanded agenda to document, protect, and rebuild cultural heritage. Similarly, the International Alliance for the Protection of Heritage in Conflict Areas (ALIPH), a multilateral but essentially French-led initiative that began in Abu Dhabi in December 2016, does not require competitors but reinforcement and reform.

Peacekeepers from both the North Atlantic Treaty Organization (NATO) and the UN, in Kosovo and Mali respectively, have illustrated the utility of heritage protection, for both major and minor sites, in the mandates of peace operations. This relatively new dimension of the daily work of outside soldiers tasked with keeping the peace has illustrated the value of military protection. These two examples highlight the potential for a routine expansion of such efforts, which can improve the military's relationships

with local populations as well as protect heritage. Short-term reconstruction through quick impact projects (QIPs) could usefully be an additional component in the international mandates of peace operations and political missions. Military academies and defense departments worldwide should critically examine past experiences with protection and investment with an eye to a future expansion of such efforts as routine tasks that immediately have a dramatic impact on their relations with the local community. They also improve post-conflict investment opportunities for reconstruction, a factor often overlooked or underestimated in determining the value of intervention.

We maintain, despite notable skepticism from pundits and vagaries across changes in administrations and governments, that the political climate remains propitious for more robust efforts to improve the prospects for halting atrocities and cultural heritage destruction. It is unwise to minimize new nationalisms and populisms, but the unrelenting US siege against multilateralism and a major brake on international initiatives has abated with the 2020 election of US president Joseph R. Biden.

While evidence is short as of this writing, the necessity to address the pandemic and climate change—and the requisite international collaborative efforts to provide such global public goods—could help nudge the momentum as well as address the effective protection of cultural heritage. The widespread worldwide outrage that greeted the destruction of such visible monuments as the Bamiyan Buddhas and the Mostar Bridge in Bosnia and Herzegovina as well as US president Donald Trump's cavalier threat against Iranian cultural sites indicates the potential of mass atrocities and cultural heritage destruction to mobilize domestic and international support for enhanced protection for people and the cultural heritage that sustains them.

One category of vulnerable civilians is especially crucial for cultural heritage and could perhaps be protected and temporarily sheltered. The chaos in Afghanistan during the withdrawal of US troops in August 2021 exposed the precarious position of international cultural workers. Curators, conservators, artists, museum directors, educators, and administrators—whose lives are imperiled by remaining in their home country—should attract particular attention. Supportive external actors remain unprepared to act in a coordinated and cohesive manner in response to cultural crises with humanitarian dimensions. Despite the existence of numerous international agencies designed to protect cultural heritage, it is imperative to explore the feasibility of establishing an international consortium of museums, universities, nongovernmental organizations, and government agencies to develop a better coordinated network of services and placements to protect imperiled cultural workers. While the temporary relocation of cultural objects remains fraught, the protection of trained and knowledgeable local cultural custodians is not—the idea has its roots in the Monuments Men and Women of World War II. By establishing a network of organizations that can assist with documentation, travel, and placement, it should be possible to provide such colleagues with a means to continue their work, even while displaced.

Finally, a substantial commitment is necessary to advance education at several levels. An immediate task is to make the various audiences to which readers belong—for instance, in the heritage, scholarly, humanitarian, legal, and military communities— aware of the mutually reinforcing links between their concerns with halting cultural heritage destruction and mass atrocities.

A Final Thought

The proverbial bottom line: all people share a common human heritage—as intricate, complex, and representative of diverse cultures as they may be. This concluding chapter draws attention to the plight of endangered populations and revives the case for the protection of their cultural heritage. That said, the potential "network" of interested actors for this endeavor is large, but the actual network at present is loosely knit and ill-prepared at best. We hope that this volume represents a modest but meaningful step in mobilizing the rich and real potential of soft power to make a lasting difference in the lives of people and the communities with which they identify.

NOTES

1. Patrick Kingsley, "4 Weeks on Path to War: From Raid on a Mosque to Middle East Carnage," *New York Times*, 16 May 2021; and Iyad Abuheweila and Patrick Kingsley, "Deadliest Day Yet in Gaza as Efforts at Cease-Fire Fail," *New York Times*, 17 May 2021.
2. Amresh Gunasingham, "Sri Lanka Attacks: An Analysis of the Aftermath," *Counter Terrorist Trends and Analyses* 11, no. 6 (2019): 8.
3. BBC News, "Myanmar Rohingya: What You Need to Know about the Crisis," 23 January 2020, https://www.bbc.com/news/world-asia-41566561.
4. Bryan Wood, "What Is Happening with the Uighurs in China," PBS NewsHour, https://www.pbs.org/newshour/features/uighurs/.
5. BBC News, "China's Uighurs: Xinjiang Bans on Long Beards and Veils," 1 April 2017.
6. Amy Qin, "China Targets Muslim Women in Push to Suppress Births in Xinjiang," *New York Times*, 10 May 2021.
7. Chris Buckley and Austin Ramzy, "China Is Erasing Mosques and Precious Shrines in Xinjiang," *New York Times*, 25 September 2020.
8. Michele Lamprakos quoted in Frederick Deknatel, "Tearing the Historic Fabric: The Destruction of Yemen's Cultural Heritage," *Los Angeles Review of Books*, 21 February 2017. See also Michele Lamprakos, *Building a World Heritage City: Sanaa, Yemen* (Farnham, UK: Ashgate, 2015).
9. BBC News, "Yemen's Crisis: Why Is There a War?," 23 September 2014, updated regularly, https://www.bbc.com/news/world-middle-east-29319423.
10. UNESCO, "The World Heritage Convention," https://whc.unesco.org/en/convention/.
11. Hwaida Saad and Rick Gladstone, "Minaret on a Storied Syrian Mosque Falls," *New York Times*, 24 April 2013.
12. Robert Fisk, "Syrians Aren't Just Rebuilding an Ancient Mosque in Aleppo—They Are Rebuilding Their Community," *Independent*, 26 July 2017.
13. Patrick J. McDonnell, "'There Are No Words That Can Describe My Sadness': Syrians Return to Aleppo to Find Their Beloved Mosque Destroyed," *Los Angeles Times*, 15 May 2017.
14. University of Oxford, "Why Oxford Archaeologists Dream of Seeing the Palmyra Arch Rebuilt by Syrians," https://www.ox.ac.uk/oxford-heritage-projects/oxford-heritage-conflict.

15. Joseph H. Felter and Jacob N. Shapiro, "Limiting Civilian Casualties as Part of a Winning Strategy: The Case of Courageous Restraint," *Daedalus* 146, no. 1 (2017): 45.

16. General Stanley McChrystal, International Security Assistance Force, "Tactical Directive," 6 July 2009, Kabul, https://upload.wikimedia.org/wikipedia/commons/2/2f/ISAF_Tactical_Directive_Unclass_2009JUL06.pdf.

17. International Security Assistance Force, "General Petraeus Issues Updated Tactical Directive, Emphasizes 'Disciplined Use of Force,'" news release, 4 August 2008, https://www.dvidshub.net/news/53931/gen-petraeus-issues-updated-tactical-directive-emphasizes-disciplined-use-force.

18. Josh Niland, "UNESCO Chief Decries ISIS 'Cultural Cleansing' in Erbil Speech," Artnet, 12 November 2014, https://news.artnet.com/art-world/unesco-chief-decries-isis-cultural-cleansing-in-erbil-speech-166080.

19. UNESCO, "Irina Bokova Condemns Latest Destruction of Cultural Property from the Site of Palmyra in Syria," UNESCO, 3 July 2015, www.unesco.org/new/en/world-conference-on-ecce/single-view/news/irina_bokova_condemns_latest_destruction_of_cultural_propert/.

20. Irina Bokova, "Preserving the Cultural Heritage and Diversity of Syria and Iraq Is Essential—Irina Bokova Welcomes at UNESCO UN Deputy Secretary-General Jan Eliasson," UNESCO, 7 September 2015, https://en.unesco.org/news/preserving-cultural-heritage-and-diversity-syria-and-iraq-essential-irina-bokova-welcomes.

21. James Cuno, *Who Owns Antiquity? Museums and the Battle over Our Ancient Heritage* (Princeton, NJ: Princeton University Press, 2008), 12–16.

Contributors

James Cuno is president emeritus of the J. Paul Getty Trust and cochair of its Cultural Heritage at Risk Project. His recent single- and coauthored books include *Museums Matter: In Praise of the Encyclopedic Museum* (2011), *Whose Culture? The Promise of Museums and the Debate over Antiquities* (2009), and *Who Owns Antiquity: Museums and the Battle Over Our Ancient Heritage* (2008).

Thomas G. Weiss is cochair of the Cultural Heritage at Risk Project of the J. Paul Getty Trust and Presidential Professor of Political Science at the CUNY Graduate Center; he is also Distinguished Fellow, Global Governance, at the Chicago Council on Global Affairs, and Global Eminence Scholar, Kyung Hee University, Korea. His recent single- and coauthored books include *The "Third" United Nations: How a Knowledge Ecology Helps the UN Think* (2021), *Rethinking Global Governance* (2019), *The United Nations and Changing World Politics* (2019), *Would the World Be Better without the UN?* (2018), and *Humanitarianism, War, and Politics: Solferino to Syria and Beyond* (2018).

✦ ✦ ✦

Simon Adams is president and CEO of the Center for Victims of Torture, the world's largest organization for the treatment of torture survivors. CVT also publicly advocates for an end to torture around the world. From 2011 to 2021 Adams served as executive director of the Global Centre for the Responsibility to Protect, an organization that provides policy advice and carries out advocacy with the UN Security Council and Human Rights Council regarding the prevention of crimes against humanity, war crimes, and genocide. Adams is the author of five books on international conflict, and regularly appears in the media on matters related to human rights.

Kwame Anthony Appiah is professor of philosophy and law at New York University. He has taught philosophy in Ghana, France, Britain, and the United States. He has written the *New York Times* column "The Ethicist" since 2015. His most recent book is *The Lies That Bind: Rethinking Identity* (2018).

Lazare Eloundou Assomo is director of the UNESCO World Heritage Centre and was previously director of Culture and Emergencies in the Culture Sector of UNESCO and UNESCO's head representative in Mali. He joined UNESCO in 2003, and from 2008 to 2013 was head of the Africa Unit of the World Heritage Centre. Together with Ishanlosen Odiaua, he is coauthor of *African World Heritage: A Remarkable Diversity* (2012). He holds degrees in architecture and urban planning.

Francesco Bandarin is an architect and urban planner. From 2000 to 2018 he was the director of the World Heritage Centre and Assistant Director-General for Culture at UNESCO. He is currently special advisor of the International Centre for the Study of the Preservation and Restoration of Cultural Property (ICCROM), senior advisor of the Aga Khan Trust for Culture, a member of the Advisory Board of the Smithsonian Center for Folklife and Cultural Heritage, and a founding member of the international nongovernmental organization OurWorldHeritage. His recent publications include *The Historic Urban Landscape* (2012), *Reconnecting the City* (2015), and *Re-shaping Urban Conservation* (2019).

Ruth Margolies Beitler is professor of comparative politics at the United States Military Academy at West Point. She is the director of the Conflict and Human Security Studies Program and author or coauthor of four books and numerous book chapters and journal articles.

Glen W. Bowersock is professor emeritus of ancient history at the Institute for Advanced Study in Princeton, New Jersey. He was professor of history and classics at Harvard University from 1962 until 1980, when he accepted a professorship in the School of Historical Studies at the Institute for Advanced Study. He retired in 1986. His many books range from *Augustus and the Greek World* in 1965 to *The Crucible of Islam* in 2017. He is a member of numerous academies, including the Russian Academy of Sciences, the Accademia dei Lincei, the Académie des Inscriptions et Belles-Lettres, and the American Philosophical Society.

Benjamin Charlier is a legal adviser at the International Committee of the Red Cross. From 2016 to 2021, he was the ICRC coordinator for the protection of cultural property in armed conflict. During that time, he acted as a legal expert on cultural property protection and coordinated the ICRC's operational, capacity-building, and diplomatic initiatives in that field. Prior to that, he worked at the Office of the Belgian Federal Prosecutor in Brussels and carried out field missions for the ICRC in Myanmar, Darfur, Kosovo, and Rwanda.

Alessandro Chechi is a lecturer at the University of Geneva, at the Geneva Academy of International Humanitarian Law and Human Rights, and at the

Université Catholique de Lille. He serves as a member of the editorial boards of the *Italian Yearbook of International Law* and the *Santander Art and Culture Law Review*. He was consultant for the European Committee on Crime Problems (CDPC) of the Council of Europe for the revision of the Convention on Offences Relating to Cultural Property. He is the author of *The Settlement of International Cultural Heritage Disputes* (2014).

Frederick Deknatel is the executive editor of *Democracy in Exile*, the journal of Democracy for the Arab World Now (DAWN). His writing and reporting have appeared in the *Nation, Foreign Policy*, the *New Republic*, the *National* (UAE), and the *Los Angeles Review of Books*, among other publications. He was previously the managing editor of *World Politics Review* and has also been a staff editor at *Foreign Affairs*. Deknatel is a former Fulbright fellow in Syria, where he also worked for the Office of the United Nations High Commissioner for Refugees.

Dexter W. Dugan is an active-duty major in the US Army and teaches at the United States Military Academy at West Point as an assistant professor in international affairs. His military experience includes battalion and brigade staff officer positions in the Republic of Korea and Kuwait. With an academic focus in international security, he was a contributing author for the 2019 Columbia University report to the United Kingdom Home Office on prevention and deterrence strategies for transnational organized crime.

Hugh Eakin is a senior editor at *Foreign Affairs*. He has written on cultural heritage and international politics for the *New York Review of Books, New York Times, Washington Post, New Yorker*, and other publications. His work has been supported by numerous fellowships and grants, including the National Endowment for the Humanities, the Cullman Center for Scholars and Writers, and the Fritt Ord Foundation. His book *Picasso's War* will be published in 2022.

Francesco Francioni is professor emeritus of international law, European University Institute, and professor of international cultural heritage law, LUISS University, Rome. A member of the Institut de Droit International and of the American Law Institute, he was chair of international law at the University of Siena from 1980 to 2003 and a visiting professor in the law faculties of Cornell University, the University of Texas, the University of Oxford, Columbia University, and Panthéon-Assas University (Paris 2). He is the author and editor of a large number of books and articles on cultural heritage and international law, including *The Oxford Commentary to the 1972 World Heritage Convention* (2008), with Federico Lenzerini, and *The Oxford Handbook of International Cultural Heritage Law* (2020), with Ana Filipa Vrdoljak. He participated in the negotiation and drafting of the 1995 UNIDROIT Convention, the 1999 Second Protocol to the

1954 Hague Convention, the 2003 Convention for the Safeguarding of the Intangible Cultural Heritage, and the 2003 UNESCO Declaration Concerning the Intentional Destruction of Cultural Heritage. In 1997–98, he was President of the UNESCO World Heritage Committee.

Patty Gerstenblith is distinguished research professor of law at DePaul University and faculty director of its Center for Art, Museum & Cultural Heritage Law. In 2011, President Obama appointed her to serve as chair of the President's Cultural Property Advisory Committee in the US Department of State, on which she had previously served as a public representative during the Clinton administration. She is currently the president of the board of directors of the US Committee of the Blue Shield and chairs the Working Group on Illegal Trafficking of Cultural Objects of Blue Shield International. She publishes and lectures widely in the United States and abroad on the international trade in art and antiquities and the protection of cultural heritage during armed conflict. The fourth edition of her casebook, *Art, Cultural Heritage, and the Law*, was published in 2019.

Richard Gowan is UN Director at the International Crisis Group. He has worked with the European Council on Foreign Relations, the New York University Center on International Cooperation, and the Foreign Policy Centre (London). He has taught at the School of International and Public Affairs at Columbia University. He has also worked as a consultant for organizations, including the UN Department of Political Affairs, the UN Office of the Special Representative of the Secretary-General on International Migration, and the British, Canadian, and Finnish foreign ministries.

Rachel Harris is professor of ethnomusicology at SOAS, University of London. Her research focuses on expressive culture, religion, and the politics of heritage in China's Muslim borderlands, and she has conducted long-term fieldwork with Uyghur communities in the Xinjiang Uyghur Autonomous Region, Kazakhstan, and Kyrgyzstan. She led the Leverhulme Research Project "Sounding Islam in China" (2014–17) and a British Academy Sustainable Development Project to revitalize Uyghur cultural heritage in the diaspora (2018–21). Her latest books are *Soundscapes of Uyghur Islam* (2020) and, coedited with Guangtian Ha and Maria Jaschok, *Ethnographies of Islam in China* (2021).

Ron E. Hassner is the Chancellor's Professor of Political Science and Helen Diller Family Chair in Israel Studies at the University of California, Berkeley. He is also the faculty director of the Helen Diller Institute for Jewish Law and Israel Studies at Berkeley. He studies the role of ideas, practices, and symbols in international security with particular attention to the relationship between religion and violence. His books include *War on Sacred Grounds* (2009), *Religion in the Military*

Worldwide (2014), and *Religion on the Battlefield* (2016). He is the editor of the Cornell University Press book series "Religion and Conflict."

Neil MacGregor was director of the National Gallery and British Museum in London, and a founding director of the Humboldt Forum, Berlin. He is the author of many books, including *Seeing Salvation: Images of Christ in Art* (2000), *A History of the World in 100 Objects* (2011), *Shakespeare's Restless World: An Unexpected History in Twenty Objects* (2012), *Germany: Memories of a Nation* (2016), and *Living with the Gods: On Beliefs and Peoples* (2018).

Victor Montejo is a Jakaltek Maya originally from Guatemala and a retired professor of Native American Studies at the University of California, Davis. His academic interests focus on Latin American diasporas, human rights, migration, transnationalism, Native knowledge, and Indigenous literatures. From 2004 to 2008, he served in the Guatemalan National Congress. He has also served as Minister of Peace, in which capacity he worked out the National Program for Reparation to the victims of the armed conflict in Guatemala. Montejo is a nationally and internationally recognized author, whose major publications include *Testimony: Death of a Guatemalan Village* (1987), *Voices from Exile: Violence and Survival in Modern Maya History* (1999), *Maya Intellectual Renaissance: Critical Essays on Identity, Representation, and Leadership* (2003), *Entre dos Mundos: Una Memoria* (2021), *The Rabbit and the Goat: A Trickster's Tale of Transnational Migration to the United States of America (El Norte), and Other Stories* (2021), and *Mayalogue: An Interactionist Theory on Indigenous Culture* (2021).

Tural Mustafayev is associate programme specialist at the Cultural Heritage Protection Treaties Unit at UNESCO. He specializes in cultural property protection legislation in the context of armed conflict and advises on the execution of UNESCO's program related to the 1954 Hague Convention for the Protection of Cultural Property in the Event of Armed Conflict and its two protocols. Previously he was the director of research and the Education Department of the NATO International School of Azerbaijan and worked at the Department of International Law and Treaties of the Azerbaijani Ministry of Foreign Affairs.

Hermann Parzinger was appointed director in 1990 and president in 2003 of the German Archaeological Institute, where he headed archaeological excavations in the Near East and Central Asia. Since 2008 he has been president of the Prussian Cultural Heritage Foundation, one of the largest cultural institutions in the world. For his academic work he has received awards and memberships from academies in Russia, China, Spain, Great Britain, the United States, and Germany. He is the author of fifteen books and over 250 essays on research and cultural policy issues.

Joseph Powderly is associate professor of public international law at the Grotius Centre for International Legal Studies, Leiden University. His research focuses broadly on issues relevant to international criminal law, international human rights law, and cultural heritage law. He published *Judges and the Making of International Criminal Law* in 2020.

Ashrutha Rai is a doctoral candidate at the University of Cambridge, where her research focuses on the protection of intangible cultural heritage in armed conflict and forced displacement. She was previously an associate legal officer and judicial fellow at the International Court of Justice.

Marc-André Renold is professor at the University of Geneva Law School, where he teaches art and cultural heritage law and, since 2012, has held the UNESCO Chair in International Law for the Protection of Cultural Property. In this capacity he established the ArThemis database on the resolution of disputes relating to cultural heritage. He serves as the director of the Art–Law Centre, which is dedicated to research and teaching on legal issues relating to works of art and cultural property. Renold is also a practicing attorney and member of the Geneva Bar, where he practices in the fields of art and cultural heritage law, international civil and commercial law, and intellectual property law.

Marwa al-Sabouni is an award-winning architect, author, and well-known international public speaker. She holds a PhD in architectural design and Islamic architecture and has published two books, *The Battle for Home* (2016) and *Building for Hope* (2021). She received the Prince Claus award in 2018 and was recognized as one of the BBC 100 Women in 2019.

Scott D. Sagan is the Caroline S. G. Munro Professor of Political Science and senior fellow and codirector at the Center for International Security and Cooperation and the Freeman Spogli Institute at Stanford University. Sagan is the author of *The Limits of Safety: Organizations, Accidents, and Nuclear Weapons* (1993) and, with Kenneth N. Waltz, *The Spread of Nuclear Weapons: An Enduring Debate* (2012). Sagan previously was a lecturer in the Department of Government at Harvard University and served as special assistant to the director of the Organization of the Joint Chiefs of Staff at the US Department of Defense.

Philippe Sands is professor of law and director of the Centre on International Courts and Tribunals at University College London, and the Samuel and Judith Pisar Visiting Professor of Law at Harvard Law School. He is a practicing barrister at Matrix Chambers with extensive experience litigating cases before international courts and tribunals including the International Court of Justice, the

International Tribunal for the Law of the Sea, the International Criminal Court, and the European Court of Justice.

Sabine Schmidtke is professor of Islamic intellectual history in the School of Historical Studies at the Institute for Advanced Study, Princeton. Her research interests include Shi'ism (Zaydism and Twelver Shi'ism), intersections of Jewish and Muslim intellectual history, the Arabic Bible, the history of Orientalism and the Science of Judaism, and the history of the book and libraries in the Islamicate world. Her recent publications include *Muslim Perceptions and Receptions of the Bible: Texts and Studies* (2019), with Camilla Adang; *Traditional Yemeni Scholarship amidst Political Turmoil and War: Muḥammad b. Muḥammad b. Ismāʿīl b. al-Muṭahhar al-Manṣūr (1915–2016) and His Personal Library* (2018); and *The Oxford Handbook of Islamic Philosophy* (2017), coedited with Khaled el-Rouayheb.

Ismail Serageldin is emeritus librarian of Alexandria and was the founding director of the Bibliotheca Alexandrina, the New Library of Alexandria in Egypt (2001–17). Before that he was vice president of the World Bank (1993–2000). He has received many awards including the Order of the Rising Sun of Japan. He is a knight of the French Légion d'honneur and a Commander of Arts and Letters of the French Republic. He has lectured widely, published more than one hundred books and five hundred articles, and has received over thirty-five honorary doctorates.

Kavita Singh is professor at the School of Arts and Aesthetics of Jawaharlal Nehru University, where she teaches courses in the history of Indian painting, particularly the Mughal and Rajput schools, and the history and politics of museums. Singh has published on secularism and religiosity, fraught national identities, and the memorialization of difficult histories as they relate to museums in South Asia and beyond. She has also published essays and monographs on aspects of Mughal and Rajput painting, particularly on style as a signifying system. In 2018 she was awarded the Infosys Prize for Humanities and in 2020 was elected to the American Academy of Arts and Sciences.

Hugo Slim is a senior research fellow at the Las Casas Institute for Social Justice at Blackfriars Hall at the University of Oxford and at the Institute of Ethics, Law and Armed Conflict at Oxford's Blavatnik School of Government. He is also a visiting professor at Schwarzman College at Tsinghua University. He was previously head of policy and humanitarian diplomacy at the International Committee of the Red Cross in Geneva. His most recent books are *Solferino 21: Warfare, Civilians and Humanitarians in the Twenty-First Century* (2022) and *Humanitarian Ethics: The Morality of Aid in War and Disaster* (2015).

Gil J. Stein is professor of Near Eastern archaeology at the University of Chicago and director of the Chicago Center for Cultural Heritage Preservation. His research investigates ancient colonialism, the development of early urban civilizations in Mesopotamia, and cultural heritage preservation. He has directed archaeological excavations in Iraq, Syria, and Turkey. Since 2012 he has led six US State Department–funded cultural heritage projects in Afghanistan and Central Asia. He is lead editor of *Preserving the Cultural Heritage of Afghanistan* (2017).

Peter G. Stone is the UNESCO Chair in Cultural Property Protection (CPP) and Peace at Newcastle University, the United Kingdom, and president of the nongovernmental organization the Blue Shield, an advisory body to UNESCO on CPP in the event of armed conflict. He has worked in CPP since 2003 and has written extensively on this topic, including editing with Joanne Farchakh Bajjaly *The Destruction of Cultural Heritage in Iraq* (2008) and editing *Cultural Heritage, Ethics and the Military* (2011). His article "The 4 Tier Approach" in *The British Army Review* led directly to the establishment of the Cultural Property Protection Unit in the British armed forces.

Sabine von Schorlemer holds the chair of international law, European Union law and international relations, and the UNESCO Chair in International Relations, both at Technische Universität Dresden. From September 2009 to November 2014, she served as the Saxon state minister for Higher Education, Research and the Fine Arts. She is an elected member of the German Commission for UNESCO, the German Foundation for Peace Research, and of the International Law Association Committee on Participation in Global Cultural Heritage Governance, among others. Von Schorlemer has published several books and more than one hundred articles on the United Nations, many related to cultural heritage.

Jennifer M. Welsh is the Canada 150 Research Chair in Global Governance and Security at McGill University. She was previously chair in international relations at the European University Institute and professor in international relations at the University of Oxford, where she cofounded the Oxford Institute for Ethics, Law and Armed Conflict. From 2013 to 2016 she served as the special adviser on the Responsibility to Protect to UN Secretary-General Ban Ki-moon. She has published several books and articles on humanitarian intervention, the "responsibility to protect" in international society, the UN Security Council, norm conflict and contestation, and Canadian foreign policy.

Paul H. Wise, MD, MPH, is the Richard E. Behrman Professor of Child Health and Society and professor of pediatrics and health policy at the Stanford University School of Medicine. He is also senior fellow in the Center on Democracy, Development, and the Rule of Law and in the Center for International Security

and Cooperation, at the Freeman Spogli Institute for International Studies at Stanford University. His research focuses on protecting health in violent and politically complex environments.

Index